FACE OF THE SPIRITS

MASKS FROM THE ZAIRE BASIN

The exhibition 'Face of the Spirits - Masks from the Zaire Basin' was realized in conjunction with ANTWERPEN 93 Cultural Capital of Europe.

On the initiative of Hon. H.B. Cools, Burgomaster of the City of Antwerp.

The exhibition takes place in the Ethnographic Museum, Antwerp, from September 18 to December 31, 1993; and in the National Museum of African Art, Smithsonian Institution, Washington, D.C., from April 20 to September 25, 1994.

Concept and organization:
Antwerp: Frank Herreman, Associate Director, Historical Musea/Ethnographic Museum;
Washington: Roslyn A. Walker, Curator, National Museum of African Art

Coordination, City of Antwerp:
Francine de Nave, Director, Historical Musea

Coordination, ANTWERPEN 93:
Marjan Knockaert, Jan Van der Stock

EXHIBITION

Scientific preparation:
Frank Herreman,
assisted by Constantijn Petridis

Concept and composition:
Frank Herreman, Ann Op de Beeck

CATALOGUE

Editors:
Frank Herreman, Constantijn Petridis

Contributors:
M.-L. Bastin, D.P. Biebuyck, A.P. Bourgeois, E. Bruyninx, H. Burssens, R. Ceyssens, J. Cornet, M.L. Felix, F. Herreman, D. Hersak, R. Lehuard, A. Lema Gwete, F. Neyt, C. Petridis, J. Vansina

Catalogue descriptions:
F. Herreman (F.H.), C. Petridis (C.P.)

Translations:
R. Falvey-Tracy (French-English), Hilde Pauwels (French-Dutch), Alger D. Buat (Dutch-English), Wilfried Van Damme (English-Dutch)

Copy editing:
Hilde Pauwels,
assisted by Constantijn Petridis

Photography:
Dick Beaulieux, Brussels

Maps:
Charles Meur & Marc Leo Felix, Brussels (sponsored by Tribal Arts)

Concept and design:
Jean-Jacques Stiefenhofer

Printed by:
Snoeck-Ducaju & Zoon, Ghent

We acknowledge the following for their valued collaboration:
V. Rutten, M. Blanckaert, F. Therry, R. Adriaenssens, R. Thijs, S. Verheijen. We should also like to thank the personnel of the various musea and municipal departments for their generous help and support.

Cover illustration, cat. 78; back cover, rear view of cat. 29

D/1993/0012/27
ISBN 90-5349-0671

The realization of this exhibition was made possible thanks to the financial support of the Generale Bank, Belgolaise S.A., Sibeka, Société Générale de Belgique, and Janssen Pharmaceutica S.A.

KONINKLIJK MUSEUM
VOOR MIDDEN-AFRIKA
TERVUREN, BELGIE

ANNALEN
MENSWETENSCHAPPEN

VOL. 140

MUSEE ROYAL DE
L'AFRIQUE CENTRALE
TERVUREN, BELGIQUE

ANNALES
SCIENCES HUMAINES

FACE OF THE SPIRITS

Masks from the Zaire Basin

EDITORS

Frank Herreman
Constantijn Petridis

PHOTOGRAPHY

Dick Beaulieux

With contributions by

M.-L. Bastin, D.P. Biebuyck, A.P. Bourgeois, E. Bruyninx, H. Burssens, R. Ceyssens, J. Cornet,
M.L. Felix, F. Herreman, D. Hersak, R. Lehuard, A. Lema Gwete, F. Neyt, C. Petridis, J. Vansina

1993

Foreword

Within the extensive program of ANTWERP 93, attention has also been given to non-European cultures. This initiative wishes to denote the fact that Europeans of the late 20th century are more than ever before inhabitants of a single large world, one wherein the value of the rich cultural and artistic heritage of all peoples deserve their due recognition. This is the *raison d'être* for Antwerp's Ethnographic Museum. Established in 1953 within the group of municipal Archeological Musea, it has since 1991 operated as a daughter institution of the city's Historical Musea.

From September 15th to November 15th, 1956, the Royal Museum of Fine Arts of our city presented the exhibition 'The Mask; All Peoples - All Times'. The aim was daring, but nevertheless spawned a great success. This initiative brought the still young Ethnographic Museum its first international attention, and also provided the requisite stimulus for its further expansion. In October of 1988 this institution was able to move into their own brand-new premises, offering the public exhibitions mounted in fully-fitted exhibition spaces.

Today, nearly 40 years after the first mask exhibition, this theme is again taken up. In contrast to the first initiative, this time a global survey was not opted for. Indeed, since the 1950s the study of non-European art has grown into quite an extensive discipline, one where a well-considered focus is advisable. Consequently, a question of selection imposed itself, and the theme decided upon was masks and masking practice in the Zaire Basin - a strikingly rich cultural area well-deserving of a special exhibition.

In the basin of the Zaire River, with its numerous tributaries, over the course of millennia there developed an important part of Bantu civilization. Among the numerous peoples concerned, the mask is an important and basic cultural element. Masks are the dynamic incarnations of omnipresent spirits, and so come to directly intervene in individual and community life. Peoples such as the Yombe, the Yaka, the Pende, the Luba, the Songye, etc., use the medium of the mask to bring ancestor and natural spirits to life in a fascinating, and unusually varied way.

At the beginning of this century, the sculpture and masks from the Zaire Basin aroused the attention of the European avant-garde. From Paris to Berlin to Dresden, artists were influenced by the inventive form-language of these objects. During the 1920s this interest bloomed into a mode that spread over the whole of Europe, and was not limited to painting and sculpture. In fact, this influence also made itself felt in diverse areas of the decorative arts, from textile design to furniture making. Thus developed so-called 'primitivism', an artistic current which really wasn't one, but rather more a philosophy formally translated in the sculpture and painting of cubism, expressionism, and surrealism.

African sculpture and masks should not, however, be approached exclusively from the viewpoint of their role within European art history. Indeed in this respect Europe owes a debt to Africa, and not the other way around. As a consequence we must direct our attention to the African and his culture, to his masks and sculptures which are first and foremost ritual objects, employed within a prescribed socio-cultural pattern. Their design answers to their own plastic norms, arising from a basis in mythology and past down from one generation to the next.

This exhibition examines the mask as an artistic product, and masking as a socio-cultural fact in the Zaire Basin. It wishes to salute the unknown sculptors who carved these magnificent art works, and who unwittingly have also made an essential contribution to the artistic heritage of all mankind.

H.B. Cools
Burgomaster

LENDERS

Etnografisch Museum, Antwerpen
Kongo-Kwango Museum, Heverlee
Musée Royal de l'Afrique Centrale, Tervuren

Jacques Blanckaert, Brussels
Pierre Dartevelle, Brussels
Count de Grunne, Wezembeek-Oppem
Marcel de Toledo, Antwerp
Felix, Brussels
Anne & Jean-Pierre Jernander, Brussels
Eric Kawan, Brussels
Isabelle Landuyt, Heusden
Jean Willy Mestach, Brussels
Piet Sanders, Schiedam (Netherlands)
Christian Van Lierde, Brussels
René Vanderstraete, Lasne
Lucien Van de Velde, Schilde
J. R. Van Overstraeten, Brussels
Line & Hippoliet Verbeemen, Bonheiden
Vranken-Hoet, Brussels
and other lenders who wish to remain anonymous

AUTHORS

Marie-Louise Bastin, Emeritus Professor, Université Libre de Bruxelles

Daniel P. Biebuyck, H. Rodney Sharp Emeritus Professor, University of Delaware, Newark

Arthur P. Bourgeois, Professor of Art History, Governors State University, Illinois

Elze Bruyninx, Professor of Art History, Universiteit Gent

Herman Burssens, Emeritus Professor, Universiteit Gent

Rik Ceyssens, Anthropologist and art historian, Helchteren

Joseph Cornet, Former Director, Institut des Musées Nationaux du Zaïre, Kinshasa

Marc Leo Felix, Expert in Central African art, Brussels

Frank Herreman, Associate Director, Historische musea/Etnografisch museum, Stad Antwerpen

Dunja Hersak, Professor of Art History, Université Libre de Bruxelles

Raoul Lehuard, Director and Editor-in-Chief, Arts d'Afrique Noire, Arnouville

Alphonse Lema Gwete, Director, Institut des Musées Nationaux du Zaïre, Kinshasa

François Neyt, Reader in Art History, Université Catholique de Louvain

Constantijn Petridis, Assistant Researcher, National Fund for Scientific Research, Brussels

Jan Vansina, John D. MacArthur & Vilas Professor of History and Anthropology, University of Wisconsin, Madison

Abbreviations:

M.R.A.C.: Musée Royal de l'Afrique Centrale, Tervuren
I.M.N.Z.: Institut des Musées Nationaux du Zaïre, Kinshasa

Capitalized names of authors in the bibliography refer to contributions in this catalogue.

Introduction

The reputation held today by the Ethnographic Museum both at home and abroad is in large measure based on its collection of statuary, masks and other artefacts from Central Africa, most particularly from Zaire. In 1922 Antwerp's municipal administration purchased 1500 African objects from Henry Pareyn, merchant and fellow townsman. Nowadays this group of works still forms the core of the Museum's Africa collection. The collection has subsequently been systematically expanded to a total of some five thousand objects. For the present exhibition, 'Face of the Spirits; Masks from the Zaire Basin', a selection was made from among the Museum's collection of masks and related objects. This selection, supplemented with masks from the collection of the Musée Royal de l'Afrique Centrale, Tervuren, and with loans made available to us by a number of private collectors, is intended to offer a survey of masks and masking practice in the socio-cultural and art-historical context of the peoples who inhabit the Zaire Basin.

This exhibition was deliberately conceived for presentation in a single large exhibition space on the Ethnographic Museum's ground floor. The arrangement of the objects makes immediate reference to the geographic distribution of the cultures under discussion. By way of illustration: when, at the center of the exhibition space, the visitor is confronted by the Kuba masks, one regards them as the masks of a people who live centrally in the Zaire Basin. Radiating from this nucleus, as the four directions of the wind, are arranged the masks from this region's other peoples. This presentation simultaneously confronts the viewer with the respective mask types and the different style traditions of the various peoples, so that in one sweep of the eye an idea may be gathered of both the affinities and the differences which have evolved over the course of time in the rich cultural expressions of this area. For this reason, on the suggestion of Messrs. M.L. Felix and C. Meur, the exhibition includes a geographical map whereupon the respective peoples are represented along with graphic illustrations of their masks. This map is also an especially useful supplement to the catalogue, serving as a direct reading of the spatial distribution of mask production in the Zaire Basin. We express our deep thanks to the aforementioned collaborators for this excellent idea and the manner of its execution.

We are also most obliged for the splendid cooperation received from both the private sector and our sister institutions for making loans available to this exhibition. Reverend Father De Graeve, S.J. † responsible for the Kongo-Kwango Museum (Leuven-Heverlee), Messrs. D. Thys van den Audenaerde, director, G. Verswijver, head of department, and Mrs. V. Baeke, scientific assistent, at the Musée Royal de l'Afrique Centrale (Tervuren), as well as Messrs. J. Blanckaert, P. Dartevelle, Count de Grunne, Messrs. M. de Toledo, M. Felix, Mr. and Mrs. J.-P. Jernander, Mr. E. Kawan, Mrs. I. Landuyt, Mr. J.W. Mestach, Professor P. Sanders, Messrs. C. Van Lierde, R. Vanderstraete, L. Van de Velde, J.R. Van Overstraeten, Mr. and Mrs. Vranken-Hoet, and the lenders who wish to remain anonymous - to all the above we are deeply grateful for the support offered this project.

Our appreciation equally extends to the specialists who not only provided their valuable written contributions to the catalogue, but also generously brought their knowledge to bear on this initiative. Thanks to their expertise we could incorporate into this exhibition the latest data concerning socio-cultural and art-historical investigations related to the peoples inhabiting the Zaire Basin. In this regard we would particularly wish to acknowledge the contributions of M.-L. Bastin, D.P. Biebuyck, A.P. Bourgeois, E. Bruyninx, H. Burssens, R. Ceyssens, J. Cornet, M.L. Felix, D. Hersak, R. Lehuard, A. Lema Gwete, F. Neyt, C. Petridis, and J. Vansina.

To render the fruits of this exhibition more internationally accessible, from the outset the decision was taken to publish accompanying catalogues in Dutch and English, including detailed descriptions of the exposed objects. For the translations of the various contributions to the catalogue and the informative exhibition texts, we deeply thank R. Falvey-Tracy, Alger D. Buat, and Wilfried Van Damme. Also, we should sincerely wish to acknowledge Hilde Pauwels who, in addition to her contribution as translator, also took on the role as copy editor of the catalogue. We are equally indebted to the designer, Jean-Jacques Stiefenhofer, who has given shape to this volume.

Particular recognition must be paid to Dick Beaulieux, photographer, whose dedication and inventiveness has yielded the magnificent photographs which have helped make this catalogue a valuable publication.

Finally we wish to offer a special word of thanks to Constantijn Petridis, at present research assistant with the National Fund for Scientific Research, Brussels. His collaboration when temporarily attached to the Museum was in part determinative for the conceptual formulation of this exhibition and its realization. We retain excellent memories of his inspiring contribution and constant enthusiasm.

Dr. Francine de Nave
Director,
Historical Musea

Frank Herreman
Associate Director,
Historical Musea
Ethnographic Museum

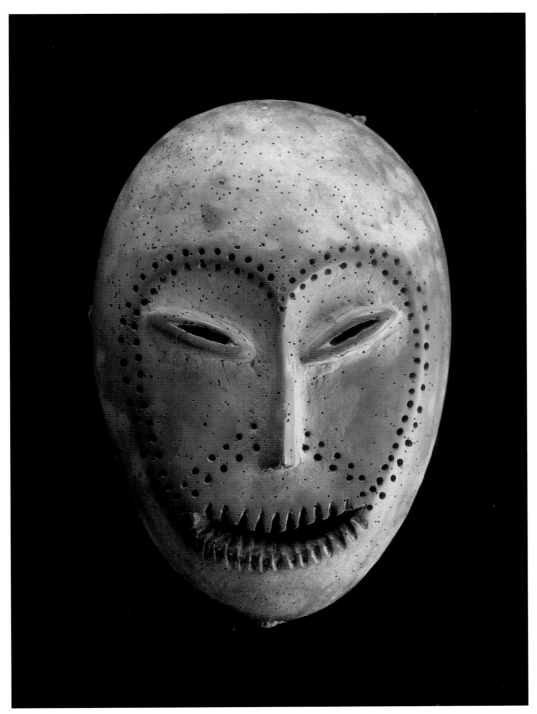

Cat. 93 (p. 188)

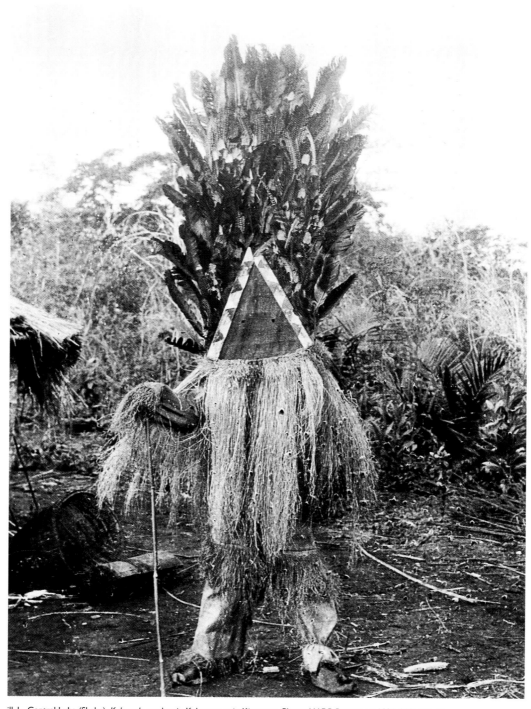

ill. 1. Central Luba (Shaba). *Kalengula* masker in Kabongo or in Kisengwa. Photo: W.F.P. Burton, ca. 1936. M.R.A.C., Tervuren (E.PH. 3452).

Face of the Spirits

Frank HERREMAN

The exhibition and catalogue 'Face of the Spirits; Masks from the Zaire Basin', present a view of masking practice and the mask as work of art among the peoples who inhabit the region of the Zaire River's basin. The masks were primarily chosen for their artistic qualities. It would, however, be remiss to limit our treatment to the plastic aspect of these artefacts. One should also endeavor to uncover the reasons behind their creation. These were dictated from out of a belief in the supernatural wherein may be counted a number of spirits or beings that, incarnated in the form of masks, actively appear and intervene during the course of the lives of the people concerned.

The Zaire Basin and its Inhabitants

Great waterways and their tributaries play an important role in the cultural history of many peoples. For primarily economic and other practical motives, people settle on or in the vicinity of their banks. The most important waterways in Africa are the rivers Nile, Niger, Zambezi, and Zaire.

The basin of the Zaire River encompasses a surface area of approximately 3,691,167 km[2]. This roughly coincides with the present-day Republic of Zaire and the North of Angola. The Zaire River originates in the extreme south of Shaba Province, and has a length of some 4,700 kilometers. From its source to the city of Kisangani, it is known as the Lualaba (Cornet 1989: 22). The river's course first runs northwards, and then makes a braod bend of more than ninety degrees in a southwesterly direction to finally discharge into the Atlantic Ocean. The system of the Zaire River is composed of various rivers and their respective tributaries. From the river's source to its Atlantic estuary, the most important branches are the Lomami, the Ubangi with the Uele, the Kasai with the Lukenie, the Sankuru and the Luluwa, and finally the Kwango with the Kwilu.

Over the course of many millennia various peoples came to settle in this extended area. They are subdivided into two large complexes: that of the Bantu-language family, and a second complex composed from groups of other language families. The Bantu peoples are the most important in scale and number. They live throughout the entire area, with the exception of the northeast. In around the year 1000 there came an end to the great migrations, aside from in the aforementioned northeast. In the subsequent stage, each of these peoples was to develop its own proper culture. Superimposed upon this, consequent to increasing mutual contact, a spiritual and material interchange came into being. The religious inheritance, too, was a component of this — to which masking practice formed a substantial part.[1]

Most Bantu peoples believe in the existence of a creator who fashioned the universe. This universe comprises two entities: the world lived in by people and animals, and the supernatural sphere inhabited by gods and spirits. The spirits are invisible but nonetheless omnipresent — in mountains and rocks, in trees, in springs and rivers, etc. Spirits were also associated with, among other phenomenon, storms, lightening and thunder. At the same time, the ancestor cult is also of significance.[2] Particular to the ancestor spirits is their role as important mediators between man and the complex supernatural realm. Given the spirits' ubiquity, one believed that everything was laden with intangible and unpredictable forces. These must be favorably disposed, or held in check — less they be a source of calamity. By way of protection, one would make of the dwelling or village a demarcated space within which one could feel relatively safe. However, one remained dependent on nature — the extension of the everyday world — as the source of one's material needs. This led to the seeking out of contacts with the supernatural. One would attempt to gain the favor of these spirits, or control over them. This is accomplished in two ways: by religious and magical practices. In traditional African culture, religion and magic are difficult to separate from one another. In the course of a ritual they are often used together, and one does not know where the one ends and/or the other begins. The priest is the specialist who requests the favor of the su-

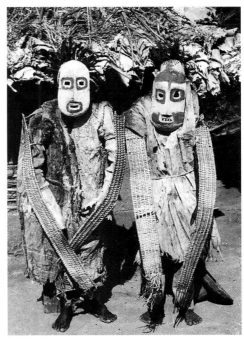

ill. 2. Komo (Kivu). *Kuku* (male) and *lungundu* (female) in the village Benekwa Babatume. Photo: C. Hénault, 1973. *See cat. 100*

YAKA

Zaire, Bandundu

zoomorphic helmet mask

H. 46 cm. Wood, pigment, fiber

In this zoomorphic composite mask the polychrome wood face is sculpted in the form of a bird's head, possibly an owl, and the headdress is crowned with two horns made out of raffia cloth filled with grass. This zoomorphic mask type probably performs at the end of the initiation when the anthropomorphic *kholuka* masks also appear. Masks with animal faces are the lowest-down in the hierarchy. This, however, is not to say that they are the last to perform. The order, first the human and then the animal masks or *vice versa*, depends on the dramatic effect wished to be evoked, or the quality of the presentation. Just as with most of the Yaka's other masks, here too a thick fiber collar is affixed. Aside from concealing the wearer, this also has a symbolic function. The palm tree, whose leaf-fibers are used in the making of such a collar, is also valued as a fertility symbol. (F.H.)

Lit.: Bourgeois 1984; BOURGEOIS (p. 49)

pernatural through prayers and offerings. The magician manipulates certain powers which can force the supernatural into action.[3]

The Mask

One of the most dramatic manners whereby the contact between humans and the supernatural acquires a visible form is at the moment that spirits under the form of masks appear. According to our understanding, the mask is a means of partially or wholly covering the face or the body to render it unrecognizable, and through which the masker acquires another identity. In large parts of the world the original function — associated with the supernatural — has declined, and masking has evolved into a form of profane recreation coming to the fore only once or at most a few times per year, for example during carnival (Cole 1985: 19). In West and Central Africa, the function of a number of masks has remained much closer to its original significance. Consequently, such masks still manifest at crucial moments during the cycle of the seasons, and within the course of an individual's life cycle as well. The mask wearer in this context is, therefore, also a more important person than someone who masks for purely recreational motives. In the African context the mask wearer is always an initiated person whose identity is not made known. He undergoes not only a physical, but also a psychic transformation. He comes under the spell of the spirit that he incarnates, and one believes that he so disposes of the supernatural characteristics of the latter. Since the supernatural stands outside the law of the living, one supposes that the mask acts according to its own whimsy. In these acts, however, sits a structure that is dictated by the priest, the magician, the society, the elders, or other forms of the power structure. They must watch over the observance of religious rules, the common law, and the maintenance of various rituals which must be carried out within the scope of events in life's cycle. Thus, the masks are important instruments that aid in the consolidation of the position of power of the various authority structures.

Mask wearers are as a rule very active in their movements. They run, turn about, and express themselves by means of a sign language, or by expressing sounds which only the initiated understand. Usually they are accompanied by one or more musicians who incite them to dance. The dynamic of the mask marks a shrill contrast to the static ancestor or power statues that the believers themselves go to seek out.[4] The maskers demand a great deal of physical participation on the part of their public. They must immediately react to the actions of the spirit's incarnation. Just which spirit the mask represents is generally determined by mythological motifs. In the design three motifs are usually recognizable: the human or anthropomorphic, the animal or zoomorphic and, finally, the hybrid wherein human or animal forms or physiognomic elements of several animals are combined. Pure abstraction does not exist. Each mask, no matter how seemingly abstract, refers to human and/or animal forms.

The sculptor does not work directly from nature. His point of departure is conceptual. What he directly perceives is of secondary importance; what he knows of his subject predominates. In the design he integrates the spiritual and moral characteristics, or still other concepts, which in his culture are associated with that which is to represented.[5] How a particular mask type first came into being is generally a question no longer answerable. At some time one or several sculptors created a mask that was accepted by their group as the right image for the spirit that was to be represented. Once the prototype was made, other examples were cut to this example. These came to be circulated and in turn served as models for other examples. Nonetheless, one may accept that it was not always exact copies that were desired, and that after a time consciously chosen variants came to be carved. Here, the individual qualities of each sculptor would play a role. It is certainly the case that the masks of some peoples became known far beyond their area of origin, and thus began to influence production among their neighbors. As a rule this was paired with a partial or complete adoption of the functional characteristics pertaining to these masks. Thus, the Yaka and the Suku exercised great influence on the initiation rituals of the Eastern Kongo peoples, including the Sosso, the Zombo and the Nkanu. This also applies for the *bwami* society of the Lega, which was adopted by several neighboring peoples. In both cases it is sometimes difficult purely on the basis of design to determine the place of origin for a particular mask.

Certain types of masks sometimes offer their makers greater leeway. For example, the *kholuka* masks of the Yaka are extremely varied (cat. 12-16). Their facial representation, which differs

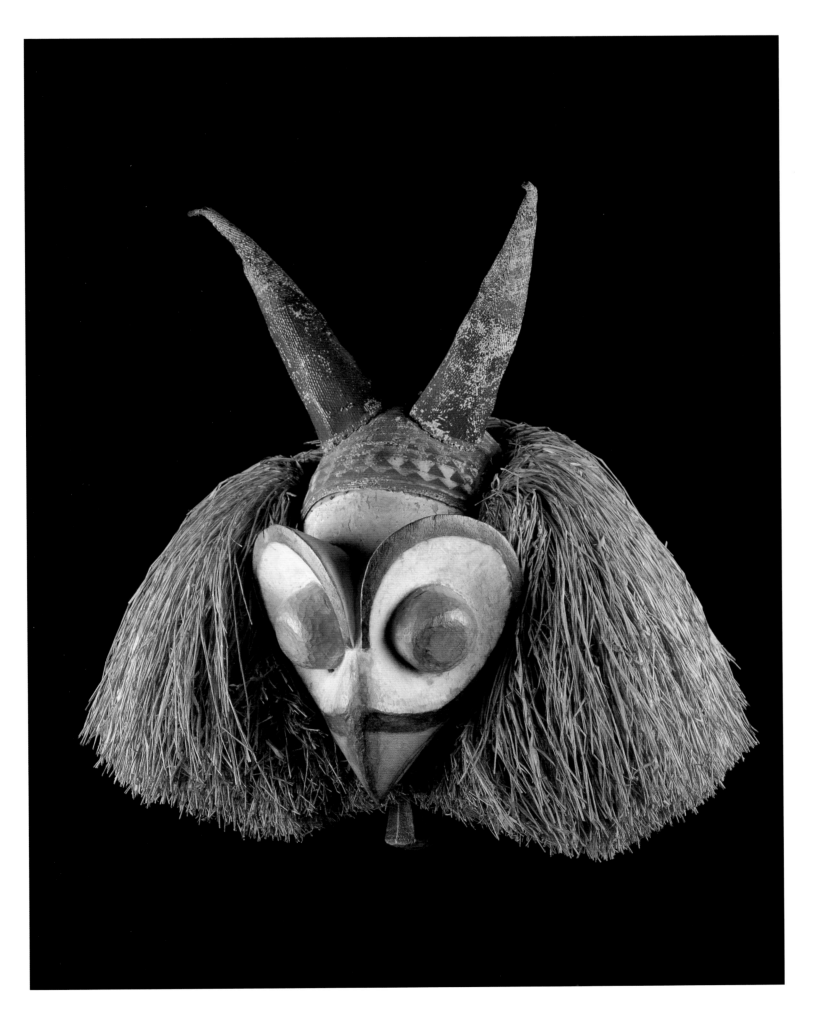

according to regional style differences, always remains rather stereotypical. By contrast the crowning of the mask, either carved together from one piece of wood or else appended, is extremely variable. In other cases the development of form led to the creation of a mask whose modeling was perfected to such a degree, that marked variation was near-excluded. Among others, this holds for the masks of the Lwalu (cat. 44-45) with architectural austerity being their leading characteristic.

Most masks that we know of are carved in wood, though this is not the only material made use of. Other materials of vegetal origin are raffia fiber, leaves and tree bark. Components of animal origin are bone, ivory, hair, feathers and skin. Aside from ivory and bone, which are only used by a limited number of peoples, most of these other raw materials are more perishable than wood. The Luba mask of the *kalengula* society (ill. 1), made of fibers and feathers, is a striking example of this. Marie-Louise Bastin (p. 79) considers that the Chokwe make a conscious choice in the matter of which materials are used for a particular type of mask. Thus, their initiation masks — which are only employed for a limited period — are fashioned from twigs, fiber and resin. According to this author, such was also originally the case for the dance masks known as *cihongo* and *pwo* (cat. 36 and 38). Because these are to be used on repeated occasions, they must be more durable and are consequently carved in wood. Without wishing to generalize this hypothesis, one may presume that among other peoples as well, different prototypes of masks could have existed which were initially fabricated from materials other than wood.

Generally speaking, the mask consists of two parts: the head covering and the costume. Further, the masker holds one or more attributes in his hands. The head covering, or mask proper, is the most striking. According to the nature of the costume, which contributes to determining the form, there are several mask types. The two leading types are the bell mask that completely covers the head, and the face mask which conceals the wearer's face. To the mask is applied fiber or cloth which serves to cover the rest of the head and part of the body. The mask costume must serve to further augment the incarnation's authenticity. It is made from materials which have a common metaphorical significance. In this connection one must also make mention of the amulets, usually charged with a magical substance. These, too, highten the mask's efficacy. The symbolic meaning of each component is sometimes difficult to ascertain. They can only be interpreted against a more profound knowledge of the mask in its context. By way of example we refer to the contribution of Dunja Hersak (p. 145), which offers a detailed enumeration of the components of the Songye *kifwebe* mask and associated costume, giving their names and symbolic references. As already mentioned above, the masker may often be holding all manner of attributes. Usually these are weapons or symbols of authority, which may also be carried by the chiefs, notables, or magicians. Thus the Chokwe use the *mukwale*, a sword which is both an authority symbol as well as an actual weapon of execution. The *cikungu* masker (cat. 34) holds a *mukwale* in each hand, used in the sacrifice of a goat (Bastin, p. 79).

Masks appear in different formation: alone, in pairs, or in a group. Among the Tabwa, the female ancestor mask *musangwe* (cat. 80) and the buffalo mask *kiyunde* (cat. 81) are linked. They incarnate, among other things, the mythological couple who gave rise to Lolo Inangonbe, the most important *mbudye* spirit. Among the Southern Bushoong and the Northern Kete, the *inuba* mask (cat. 67) is preceded by the *bishuadi* mask. The latter is subordinate to the former, and must mark out the terrain. During the feasts which close the initiation period among the Northern Yaka groups, appear masks known as *kholuka* or *mbala* (cat. 12-14). Together they are magico-religious mediators that serve to guarantee and protect male fertility.

The Function of Masks

The mask is a medium through which the supernatural takes on a physical reality. A great number of masks have multiple functions.[6] The performance of one or more masks depends on several factors. These are largely determined by feelings of uncertainty. Among other occasions, they manifest during the course of the cycle of life: when the male individual passes in his life from one phase to another; at times of sickness among the people, or disease in their animals or crops; during legal disputes where the final decision is left to the supernatural; and when the structures of authority or community are threatened to befall danger. The clearest expression of these feelings of uncertainty become manifest at the two most important human rites of passage: transition from child to adult, and from life to death.

19
MBALA

Zaire, Bandundu

anthropomorphic bell mask

H. 29 cm. Wood, pigment, metal

The Mbala live in an area bordered by the Wamba and Bakali Rivers, and the Kwilu and Lutshima Rivers. This is a markedly mixed ethnic region, and the various peoples are closely related to one another. As to culture, a differentiation may be made between a Northern and a Southern Mbala group. The rare bell-shaped masks which are attributed to the Mbala derive from the area near the Kwilu River, and are essentially near-indistinguishable from those of neighboring peoples such as the Suku, the Kwese, the Hungana and the Pende. Here, we have to do with a "supra-style", or interethnic style tradition. Characteristic of these masks are the concave heart-shaped faces and the lobed headdresses. In the example exhibited here, the headdress is realistically decorated with brass nails. The custom of rubbing the body with red oil is mirrored perhaps in the mask's red polychromy. It is accepted that the bell-shaped masks play a role among the Mbala people in the circumcision ceremony, fertility rites and other ceremonies. It cannot be ruled out that the masks together with the tradition of circumcision were imported by the neighboring Suku or Yaka peoples. (C.P.)

Lit.: Biebuyck 1985; Bourgeois 1990

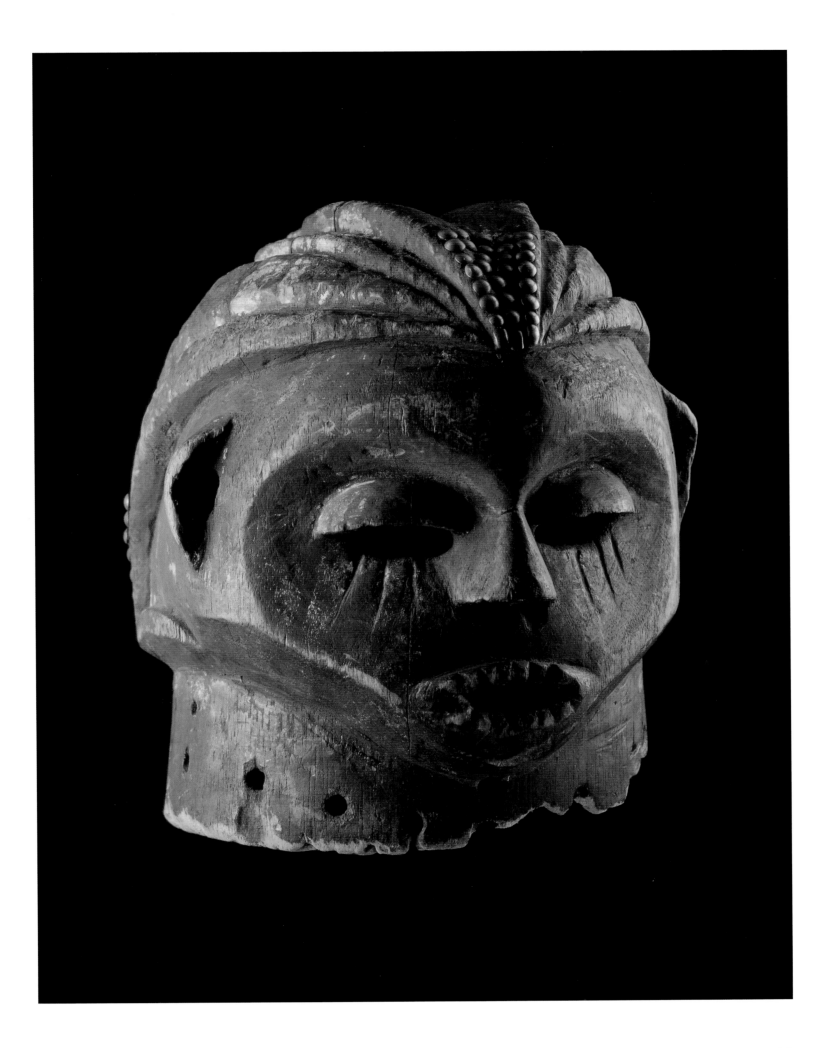

55
BAKWA MPUTU

Zaire, West Kasai

anthropomorphic face mask

H. 28 cm. Wood, pigment

The Bakwa Mputu are a people numbering some twelve thousand individuals. To present there has been practically nothing published concerning their culture. They live in the area of Lusambo on the Sankuru, and are surrounded by the Tetela, the Binji, the Luntu, and the Luba. According to the Bakwa Mputu themselves, they share a common origin with the Binji. In the published ethnographic notes of Leo Frobenius from 1905-06 are found twelve drawings of female faces from the Bakwa Mputu (Baqua Nputu). Their cheeks, temples, and sometimes foreheads as well, have copious tattoos. This facial decoration, including the spiral-shaped motifs, is also seen on the reproduced mask and serves as the basis for the attribution. (F.H.)

Lit.: Boone 1961; Klein 1985

ill. 3. Salampasu (West-Kasai). Masker of the *idangani* society in Mukasa. Photo: C. Lamote, ca. 1950. M.R.A.C., Tervuren (E.PH. 3053). *See cat. 52*

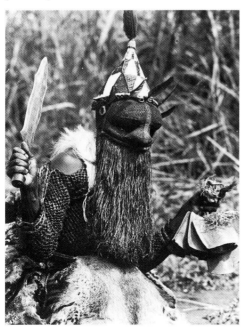

The young boys and girls, prior to puberty, are not yet considered as fully-fledged. They are usually segregated from each other when the first signs of physical maturity appear. Together with their contemporaries of the same sex they are secluded in a camp outside the village, where the initiation commences. The boys are symbolically separated from their mothers. So, for example, a kidnapping might be stage-managed. Circumcision will usually be the physically enduring manner by which boy passes to man, and girl to woman. This whole process may also be described as a symbolic death of the child who will be reborn as an adult.

Masks appear during the course of the boys' initiation. During the initiation proper, the adult males pass the foundations of their technical, social and religious knowledge on to the boys. They are taught how to work the land, hunt, build a dwelling and make tools. Instruction in techniques of fighting and defense is also given. Of importance is the acquisition of the social rules which set out one's place and role within the community. The third facet, wherein the existence of the supernatural is made known to the initiates, is certainly the most secret. The boys learn who their creator is and how he conceived the universe. They are introduced into the existence, the importance and the role of the spirits of the ancestors, of nature, and others. Furthermore, they are shown the diverse sacred items whose origin and appearance are extremely heterogenous. These include both objects of natural origin as well as man-made ones. To the latter belong the statues and masks. The meaning of all these sacred items is explained. The masks are shown both worn and unworn. This revelation, however, does but in part desacralize their role.

The initiate is also introduced to their metaphysical characteristics, and he retains the belief that when the masker appears it disposes of supernatural powers. The neophyte learns to know the mask as a gift of the creator. It represents a spirit that will aid him in times of uncertainty. This support is also experienced during the course of the initiation period, itself a time of crisis. Here, the spirits themselves — in the form of maskers — accompany the boys at different stages of the learning process. The maskers keep a close watch over the correct progress of the various rituals and imposed tasks. These must be carried out in a prescribed way and with the appropriate discipline. *Kakuungu* (cat. 10), a mask that performs among the Yaka and the Suku, is a striking example of a mask to which is ascribed a number of these functions.

Among various peoples in the south and southwest of Zaire, the initiates themselves also wear masks. Among others, this applies to the Zombo (cat. 5), where the neophytes during their period of seclusion may only appear before their parents if masked. This occurs in public, where the boys sing and dance, receiving rewards of money and other gifts. Special to the Yaka and the Suku one knows respectively of the *mbala* or *kholuka* masks (cat. 12-14) and the *hemba* or *geemba* masks (cat. 18). These are worn by the initiated when, accepted as adults, they leave the camp to return to the village. What the masks represent and how one dances and sings with them, clearly alludes to sexuality.

Certain masks can, owing to the spirit they incarnate, play an educative role. Among others, this is the case for the *mbuya* initiation masks (cat. 22-23) which originally performed among the Pende following the circumcision ceremonies. They incarnate different types of folk and, for example, represent the sluggard, the disheveled man, the public woman, etc. Also portrayed are various occupations such as the woodsman and the hunter, or animals may be incarnated. Equally, some masks represent different historical characters such as the Pygmy, the foreigner, the Luba, and the missionary. Thus, a metaphorical image was given to the various archetypes of the Pende world.

Death is a second important stage of transition. For the next of kin it is imperative that the funerary rituals are correctly executed. If not, the soul of the deceased would take revenge. This especially pertains to the souls of the chiefs and notables. Here we may make mention of the *mukyeem* or *mukenga* mask (cat. 63) that is known to the Kete, the Ngongo, the Ngeende and other component peoples of the Kuba kingdom. It performs at funerary rituals of notable persons, and evokes death. The predominating white color of the cowrie shells serves as a sign of mourning and is associated with the desiccated bones of the ancestors. *Inuba* (cat. 67) is a mask seen both among the Bushoong and the Kete. When the mask appears at the funeral bier, the women — who hold the wake — would be chased back to their homes, and the deceased would come under the exclusive purview of the initiated males and the mask. Then begin the *kuela lusanzu* negotiations. Here the mask speaks to the spirit of the dead, called *mwendu*. He attempts to win the spirit over, and to convince it to harbor no malevolent intentions toward his relatives and fellow-villagers. To this

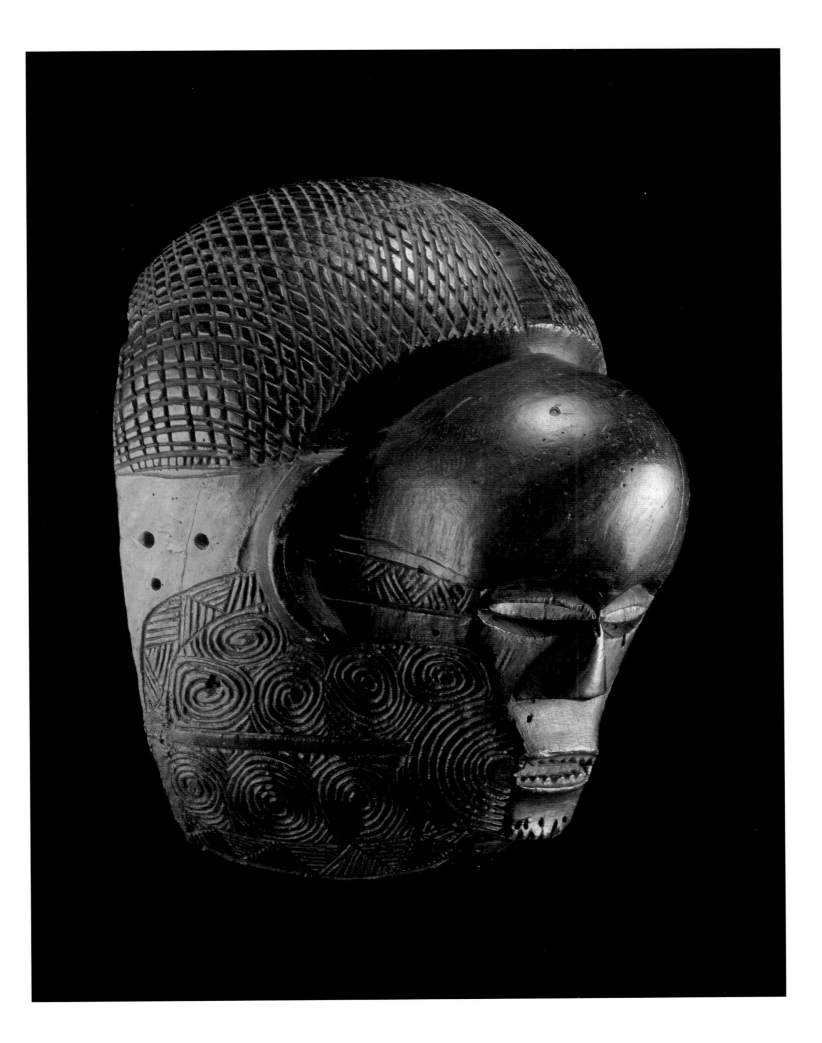

purpose, the mask makes it known to the spirit that the rituals due to the deceased have been carried out, and also that his successor has been selected. The *so'o* mask (cat. 85-86) of the Hemba represents the like-named chimpanzee. He stands as symbol for the untouched and untamed wilderness. This mask performs during the course of festivals which are part of a long series of funerary activities. The *ubuzha malilo* festival would serve for the reconciliation of the living and the dead (Blakely & Blakely 1987). The miniature masks of the Lega, called *lukwakongo* (cat. 96-98), are not representations of specific ancestors, but rather act as remembrances of the deceased among the ranks of the initiated.

The causes of sickness and death are described throughout Black Africa as unnatural. When signs of illness manifest, these are attributed to neglectful behavior toward ancestors and the supernatural or, alternatively, the cause is sought in sorcery. Similar reasoning is also applied to disease in animals or crops. The appearance of masks or a prolonged period of contact in isolation with a mask, can bring healing. Among others, this applies for the *kakuungu* and the *mbawa* masks (cat. 10-11) of the Yaka and the Suku, which are invoked to cure impotence and sterility. Moreover, *mbawa* can also ward off rain or whirlwinds. A separate category related to sicknesss and healing are the small amulet masks which one encounters, for instance, among the Pende *ikoko* (cat. 26-29). These are miniature representations of initiation masks which were given to the youths at the initiation's conclusion, but were also given to the ill in order to provide continuing protection following the healing practices.

The role of the closed societies is ever important within the various forms of authority structures in the Zaire Basin. They see to the observance of religious rules, assure proper execution of rites within the scope of events in the year- and life-cycle, and are guarantors of traditional law. Furthermore, there are societies which serve to adjudicate legal disputes and carry out executions. The closed societies are also described as the prime guardians of the community's traditional structures. In many cases the masks are placed under their custody, and the societies decide when they are to appear. Among the Songye the *bwadi bwa kifwebe* society functions as a mechanism of control in the service of the ruling elite. It aids the leaders in the maintenance of their economic and political power. In this regard, the society does not shy from invoking the support of supernatural forces by way of witchcraft, *buchi*, or sorcery, *masende*. Among the most potent of the *bwadi bwa kifwebe* society's resources are the *kifwebe* masks (cat. 68-74). According to the Songye, they stand beyond the normal order of the universe and incarnate bizarre and heterogenous beings. The *ndunga* mask (cat. 1) that performs among the Woyo and the Vili, belongs to a like-named society that stands in the service of the *ntinu* (king) and the chiefs of the "great families". It has a policing and military function. The members of the *ndunga* are guarantors for the upholding of order and respect for the law. They track down sorcerers, agitators, thieves and murderers. The *nduga* also intervenes when traditions and moral codes are violated. It is also their mission to execute judgements.

56
WONGO
Zaire, West Kasai
anthropomorphic face mask
H. 29.5 cm. Wood, pigment

The Wongo inhabit an area between the Kasai and Sankuru Rivers, and are closely related to the various Kuba groups. Their culture has been exposed to influences from the neighboring peoples, and consequently is quite fragmented. This particularly applies to the Wongo people dwelling on the Loange's left bank, in the Idiofa region, who are strongly influenced by the Pende. The art of the Wongo unites elements of style proper to the Pende as well as the Kuba. The masks primarily exhibit traces of the Katundu style of the Central Pende. This style, named after the chiefdom between the Kwilu and Loange Rivers, has supplanted many of the local mask styles and forms of the neighboring peoples. The example exhibited here, with shut eyes and colored with red camwood powder, called *tukula*, was probably used in initiation ceremonies. The Wongo also produced ivory pendant masks after the *ikoko* example of the Pende. (C.P.)

Lit.: Vansina 1954; de Sousberghe 1959; Biebuyck 1985; Felix 1987

ill. 4. Kete (West-Kasai). Masker and musicians. Photo: E. Luja, 1914. M.R.A.C., Tervuren (E.PH. 1339).

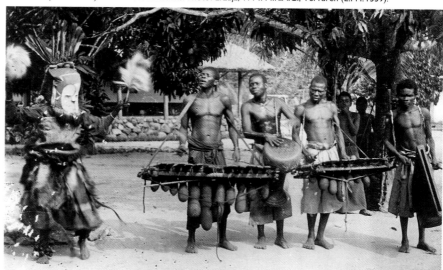

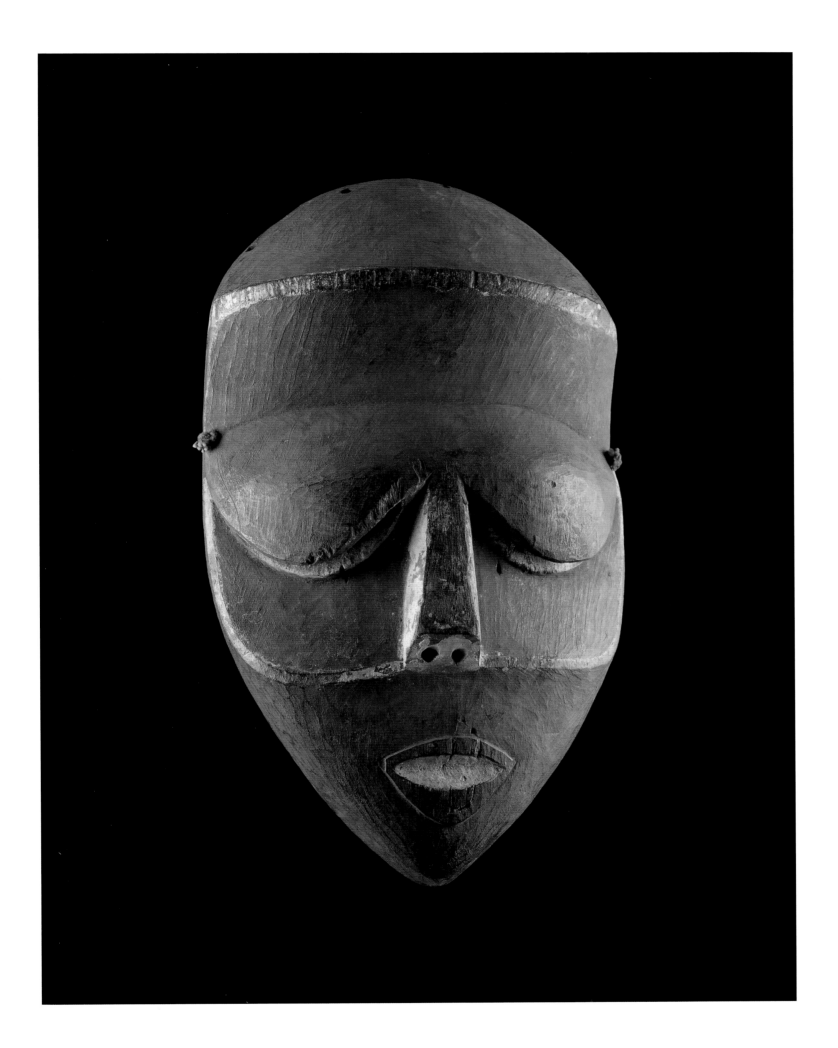

26

PENDE

Zaire, Bandundu, Katundu?

anthropomorphic miniature mask

ikoko

H. 6 cm. Ivory

27

PENDE

Zaire, Bandundu, Katundu?

anthropomorphic miniature mask

ikoko

H. 7.5 cm. Ivory

28

PENDE

Zaire, Bandundu

anthropomorphic miniature mask

ikoko

H. 6 cm. Bone

29

PENDE

Zaire, Bandundu, Katundu?

anthropo-zoomorphic miniature mask in Janus-form

ikoko

H. 4.5 cm. Ivory

Pendant masks in ivory, bone, and a variety of other materials, demonstrate that masks exert an influence on the community's well-being. They would have been invoked during healing rites, where the patient was obliged to wear a miniature version of the mask around the neck, by way of protection. These pendants were also formerly presented as trophies to the boys following their initiation, *mukanda*. Ivory pendant masks are always in pure Katundu style, and usually originate from the Katundu chiefdom. Such Katundu replicas may only be worn by men. It is apparent that the *ikoko* are mostly copies of masks known for their healing powers. Evidently, it is the *fumu* mask — distinguished by the horn-shaped ornamentation, in imitation of an old chief's headdress — which is usually so portrayed. Remarkably enough, we know nothing of the mask's healing properties. The sole example (cat. 29) in Janus-form, shows the combination of a human face and a buffalo head. (C.P.)

Lit.: de Sousberghe 1959; de Sousberghe 1960; Mudiji-Malamba 1989

Some masks fall under the prerogative of a chief or monarch. Consequently, such political leaders have at their calling a supernatural means to aid them, both symbolically and practically, in the exercise of their political function. Normally the leaders alone would be the wearers of these masks, or they would determine who among their relatives or notables may do so. The *cikungu* mask (cat. 34) of the Chokwe belongs to the master of the earth, *mukishi wa mwanangana* (the highest political title), and the mask incarnates — as one of the most important symbols of authority — the ancestors of the *mwanangana*. In bygone times when the chiefdom was confronted by a crisis, the masker would appear brandishing a *mukwale* in each hand. This sword served as both symbol of authority and actual weapon of execution. Using these weapons the masker would kill a goat whose blood was then sprinkled before the holy tree, *muyombo*, as an offering. Among the Bushoong — the leading group within the Kuba confederation, and also the one from among whom the king is chosen — the monarch has three royal masks under his province: *moshambwooy* (cat. 59), *ngady amwaash* (cat. 62) and *bwoom* (cat. 60). They form the prototypes for the masks which are also worn by the various chiefs, for the most part relatives of the king. Here, too, the masks legitimize the system of rule. *Moshambwooy* is worn by the king or chief. It incarnates Woot, the founder of the Kuba. *Ngady amwaash* represents Mweel, sister of Woot. The Kuba came to exist out of their incestuous relationship. The *bwoom* mask portrays a hydrocephalic prince or a Tshwa Pygmy. The Tshwa are considered as the oldest inhabitants of the Kuba kingdom. When the masker dances, his movements make reference to events from out of the Kuba people's history (Cornet 1982: 249-271).

The Mask as Work of Art

With the presentation of the mask as a ritual object, the term art work is deliberately shunned. To satisfy its principal function — the incarnation of supernatural beings — there is no essential requirement that it be a work of art. Nonetheless, the perfection to which they are created serves to amplify their efficacy, and they so acquire an artistic dimension.

The African sculptor does not make his art as "art". He carves a mask or statue that must optimally satisfy the given requirements. The representation must answer to the iconographic standards determined by tradition. At the same time, the sculptor must also convey the spiritual, moral and other abstract concepts which are associated with that to be represented. It is astonishing to note how many peoples from the Zaire Basin make masks which fulfill such ideals. The models for these masks are human and/or animal. The respective form traditions developed by these peoples may be situated between two poles — a measure of fidelity to nature along with a taste for abstraction. True naturalism and pure abstraction, however, do not exist. That the concept is more important than the imitation of nature, brings about a conscious simplification of form. This does not exercise an impoverishing effect, but rather offers the sculptor — as interpreter of his community — the possibility to plastically express his belief in the supernatural and the associated moral and philosophical values. Thus, the artist bestows upon the spirits a face that is timeless.

1. For more information, see VANSINA (p. 235).

2. See Sieber & Walker (1987: 22) and Mbiti (1969: 53 and 75-83).

3. The difficulty of separating the religious from the magical, is one of the reasons why in the contemporary literature one has abandoned the idea that the content of these two concepts differs. Under the term religion one usually takes to mean a single whole wherein both entities are subsumed. Still, we consider that the maintenance of a distinction between the supplicating (religion) and the coercive (magic) can be useful. Asserting that magical practices are always associated with negative aims and religious acts with positive ones, is mistaken. Both forms of contact with the supernatural are from the standpoint of the believer directed toward a positive result.

4. Even when the statue is carried around, something which for example occurs with rituals having a processional character, the contact between the supernatural and the believer remains less dynamic.

5. Thus, among the Yaka and Suku or the Holo and the Tabwa, for example, the buffalo was chosen as the symbol of male power (cat. 9, 11, 81-82); and among the Yaka and Suku the monumental *kakuungu* mask with its hypertrophied cheeks and chin is associated with fertility (cat. 10).

6. The texts which treat the function of the mask generally discuss but one aspect of this. Such is not in keeping with the functional plurality which they as a rule possess. Here, this was opted for in the interest of clarity.

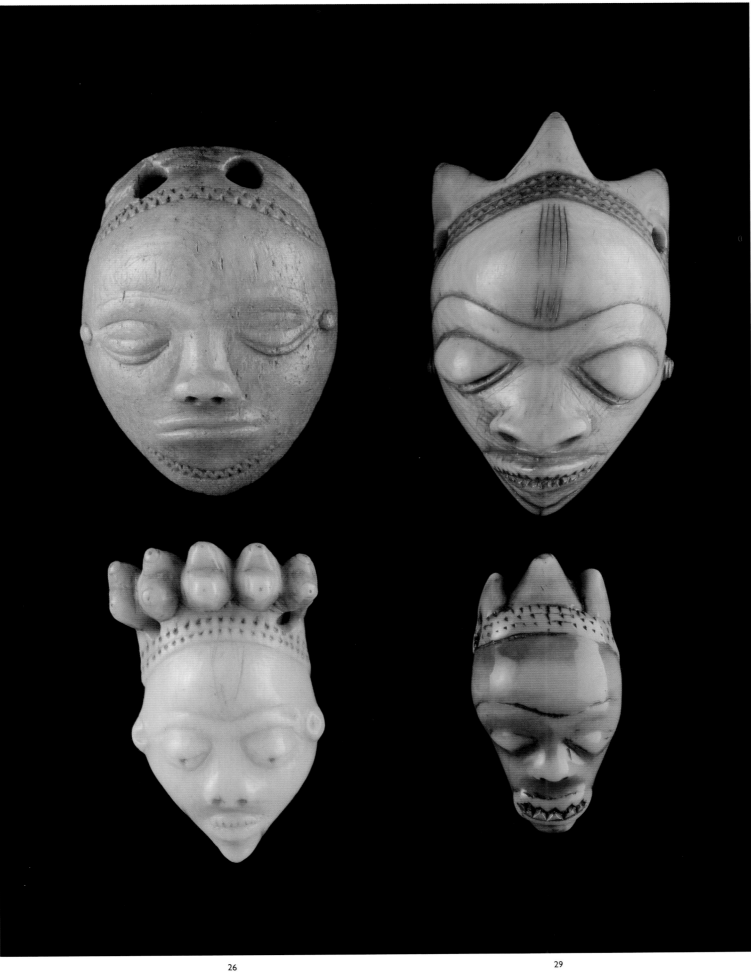

83
TABWA?

Zaire, Northeast Zambia, Shaba
anthropomorphic face mask
H. 34 cm. Animal skin, pigment, beads

The bead-covered leather face masks of the
Tabwa are likely related to *mbudye* practices.
The decorative beadwork spirals on the
example shown here, in other cases
combined with rows of isosceles triangles,
are also encountered on the *nkaka* crowns of
the adepts of the *bulumbu* cult. The spiral
motif is a symbol of life, growth and
genesis. In bygone times the Tabwa
represented kinship and time as a spiral.
The motif placed between the eyes equally
indicates the location where prophetic
dreams arise. Finally, it refers to Kibawa, an
earth spirit called on for aid in times of
adversity during colonial reign. Possession
by spirits is primarily characteristic of the
bulumbu cult. It is supposed that possession
leads to enlightenment, and imparts a
catharsis. The *mbudye* and *bulumbu*
societies share the same fundamental
metaphors. Also, *mbudye* members of
higher rank wore a headdress (*nkaka*), and
were esteemed to be possessed by spirits. In
general, the masks symbolize
enlightenment, hope and courage, as well as
progress, fertility, and contact with
ancestors. Thus, it is curious that the form
of the example shown here is reminiscent of
an owl — a nocturnal bird associated with
sorcery. (C.P.)

Lit.: Roberts 1986a; Roberts 1990a; Roberts 1990b

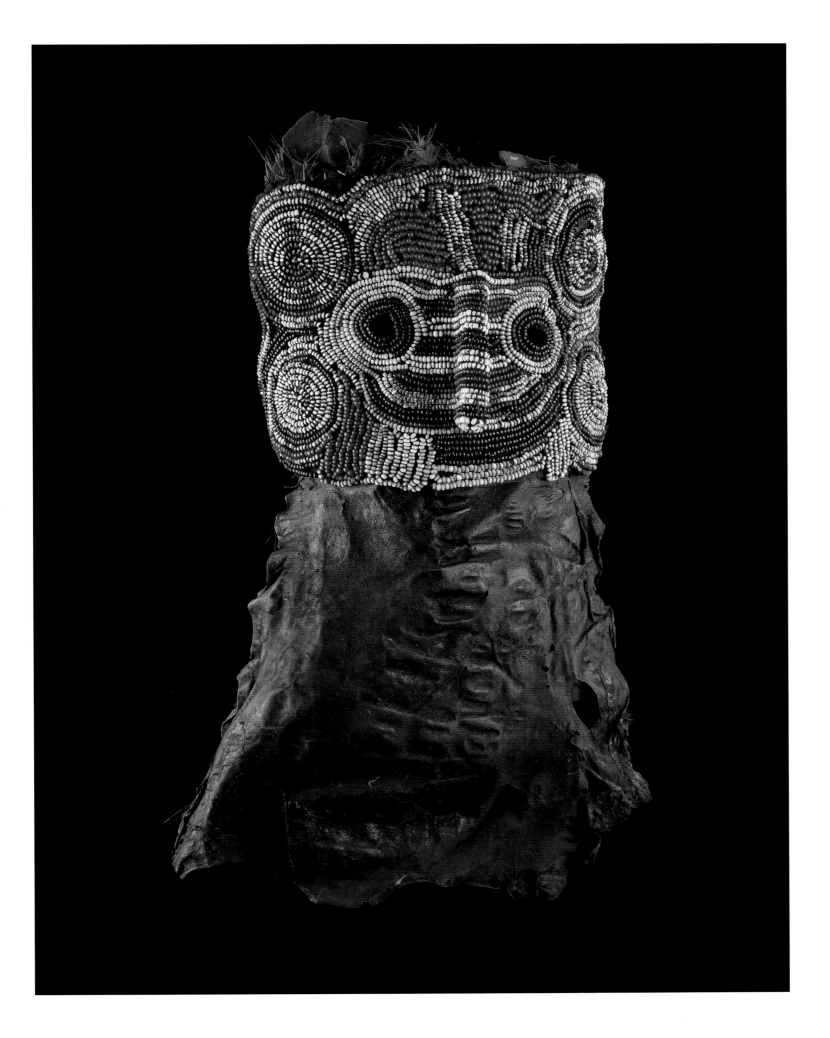

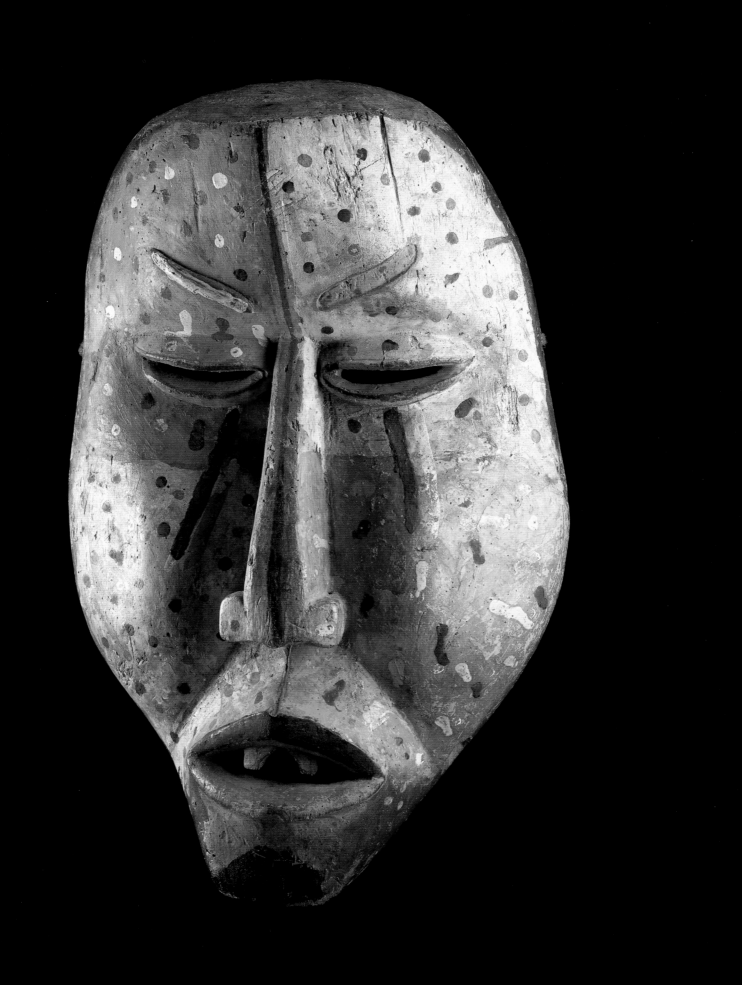

Masks Among the Kongo Peoples

Raoul LEHUARD

The use of face masks carved in wood or made from vegetable material, and corresponding to social, magical, religious and political preoccupations, seems to be fairly common throughout Black Africa, particularly in the Zaire river basin. However, the inhabitants of the Kongo area, situated on the lower reaches of the river, are exceptional in having very few masked ceremonies, apart from the Woyo and Vili tribes, while some ethnic groups like the Bembe, the Lari, the Kamba and the Kougni seem never to have known them.

One cannot deny the poverty of information and references on this subject when one looks at the documentation held in our Western museums. If one compares the number of anthropomorphic statuettes collected by scientific expeditions since the end of the 19th century with the number of masks, the score comes out at about seventy to one in favor of the former.

One sole masked association did exist amongst the Kongo (and still exists as entertainment) though it was still only definitively known in the Woyo and Vili tribes. This is the *ndunga*, a police association in the service of the *ntinu* (king) and the chiefs of the "great families". Amongst the Vili, the *ndunga* finally disappeared with the death of the last dancer, Mr. Dika, in the village of Diosso (Bwali) during the 1970s.

Apart from the *ndunga*, some very rare masks are found in the *khimba* society, whose purpose is to prepare boys for adult life while giving the support of a sort of closed institution. However, it should be noted that Leo Bittremieux (1936) who devoted an entire work to the *khimba*, never speaks at any time of the presence of a masked instructor.

Another kind of association whose members also have a face mask is that of the *banganga diphomba* (sing. *nganga*), a group of diviners and wisemen whose principal task is to identify witches and to ensure that their actions do no further harm to society.

To this list can be added the *bukusu* mask of the Woyo, which comes out at night, to find out everything which goes on in the village under cover of darkness and to expose illicit dealings, and the *kayinkibi* mask, which embodies the spirit of an ancestor, and of which one example was collected by Albert Maesen in 1953.

One should also cite the first text to mention masked dancers (Degrandpré 1801: 118), which was published to mark the burial of the king of Loango. But these masks are of cloth, stitched over with white feathers, and the wearer covers his head with a helmet made from the upper part of a hornbill's head; there is no question of a mask carved in wood. Finally we should not forget the masks made for dramatic purposes, usually carved but not according to precise rules. I intend here to discuss only the masks of the *ndunga* and those used by the *nganga diphomba*, which are by far the two most important sources of masks amongst the Kongo.

The Ndunga

The first writers to discuss the *ndunga* (Bastian 1874-75; Dennett 1887 and 1906) only go back to the 19th century. Nevertheless, taking into account what is known about it, this institution is the most important in Lower Zaire, where it produces the most masks and masked dancers, especially among the Woyo, Solongo and Vili. There are some signs of it among the Yombe and Kougni, though it certainly did not have the influence there that it had further west. The *ndunga* is a sort of state police force, military police (or militia), whose prerogatives derive both from the laws established by the secular power and from the obligations operating in the invisible world of the spirits, the realm of the ancestors.

1
WOYO or VILI
Angola, Cabinda & Zaire, Lower Zaire
anthropomorphic face mask
ndunga?
H. 51 cm. Wood, pigment

This multicolored painted mask, larger than the human face, is worn on a costume that completely cloaks the wearer and is made of dried banana leaves or plumes of the turaco. In the hand is held a besom of twigs with which he can whip, or the rostrum of a swordfish or a sword of European origin. The *ndunga* society stands in the service of the *ntinu* (king) and the chiefs of the "great families". This society has a policing and military function. The members of the *ndunga* are guarantors of the maintenance of power and respect for the law. They track down sorcerers, troublemakers, and murderers. When rules of tradition and the moral code are breached — particularly with respect to sexual relations — this society intervenes. It is also their task to execute sentences. Although a penalty can be contested, in no case may one thwart the action of the masks. They represent the will of the ancestors and the supernatural. (F.H.)

Lit.: Volavka 1976; Lehuard 1993a; LEHUARD (p. 25)

2

YOMBE

Angola, Cabinda & Zaire, Lower Zaire
anthropomorphic face mask
diphomba
H. 28 cm. Wood, pigment, fiber, animal skin

The naturalism of this mask resembles the modeling of the heads of a well-known type of mother-and-child statuary from this culture. Its beard identifies it as a male mask. Female masks also exist. It can, however, not be proven if they would perform as a pair. Together with the mother-and-child statuary, this mask belongs to the *nganga diphomba*. He is the specialist who seeks out the cause of any variety of trouble: crime, accident, death, drought, paucity of game, etc. For the Yombe, these misfortunes are attributable to sorcery upsetting the existing order. Such can only be enervated by pointing out the culprit. The *nganga diphomba* is the only masked diviner. He also ports a skirt of turaco feathers, a belt with small brass bells, and is sometimes painted on the arms and legs with red, white, and black pigments. According to the collector of this mask, it was used within the *khimba* society that initiates the youths. The masker may indeed be the *nganga diphomba*, who appears within the scope of this rite. (F.H.)

Lit.: Maesen 1960; Demoor-Van den Bossche 1981; Lehuard 1993a; LEHUARD (p. 25)

Ndunga is pronounced according to witnesses as *ndunga, ndungo* or *ndungu* but it seems that *ndunga* is the correct pronounciation, though Bastian wrote (1874-75) it as *ndungo* and Dennett (1887 and 1906) as *ndungo* and *ndungu*. As Volavka (1976: 29) pointed out, *ndunga* is the name of a type of mask, of a dance, of a social institution, of the organizers and performers of the dance and of one of the two drums which are used at the ceremony (the longest, the "father"). In the plural the term becomes *zindunga, badunga* or *bandunga*.

In the 19th century Dennett (1887 and 1906), like Bastian (1874-75), reported that the *ndunga* were the country's police force. This is a region where frontiers were fluid and easily breached; where quarrels and internal strife were fermented by the way in which those in authority, great or small, were chosen; where the contacts between neighbors to control trade (including slaves) were often lively; and where the influence since the 16th century of European foreigners settled on the coast was a destabilizing factor requiring delicate control. So it is clear that the local authorities had to equip themselves with a police force, which would guarentee stability of power and respect for the law, through the rigor of the penalties it imposed at the least sign of social disorder (or anything resembling it).

According to Dennett (1906: 34) the breach of a moral law involved the whole community. In their phraseology this was termed "God's palaver". Any offence against a spirit could be raised there and might be sufficiently important to penalize a family or a whole tribe. Justice was so organized that "God's palaver" was its instrument; punishments were inflicted by the *bandunga* acting on the orders of the king. And penalties could also be applied to Europeans, because Dennett (1887: 106-108) describes the activities of the *bandunga* on the occasion of reprisals carried out against a European merchant who had unfortunately diverted a route traditionally used by the inhabitants of the region. Seeing that no other solution was possible, the "prince" came with his *ndunga* adherents, followed by a crowd, reopened the road by force and killed the merchant and his two neighbors who came to his assistance. But the writer does not on this occasion describe the role of the *bandunga*, he merely speaks of their presence.

The masks take the form of a face carved in wood and the dancer is covered in feathers or dried banana leaves. He brandishes a sort of broom of branches, with which he strikes careless spectators who come too close, or a swordfish blade or a European sword as a mark of his status. The costume of leaves or turaco feathers conceals the wearer, whose identity must not be revealed. Volavka (1976: 31) is explicit; "La face, inhabituellement large, qui semble hors de proportions, comme une pièce à part, ne peut se comprendre qu'à partir de l'importance du costume. Celui-ci ressemblant à l'amas végétal laissé par les femmes lorsqu'elles nettoient les plantations, ne prend sa signification que quand il est vu en action."

Though today the members of the *ndunga* are recruited from among the young males in the population who know how to dance, it is clear that at the time when the role of these organizations was to keep order in the kingdom, their members were also recruited for their physical strength, since they might need to use force in the exercise of their functions. Maintaining the social order did not just consist in keeping the peace between individuals or between families under royal jurisdiction; it also covered the application of the law. The *ndunga* had to seek out offenders of all kinds (particularly witches, scolds, thieves and assassins), bring them to justice and carry out sentence. This also meant ensuring that the decisions of a tribunal were respected, where a case involved two parties, or sometimes a dispute between a white man who had activities within the kingdom and a local individual. The *ndunga* discharged its obligation to recruit warriors as long as the situation required, to pursue deserters and to carry out ceremonies assuring the soldiers of the protection of the nature spirits of earth and water (*nkisi nsi, nkisi masi*) and the ancestors.

If anyone wanted to challenge the sentence of the tribunal or could not accept the decision of the court, no one could thwart the action of the mask, which symbolized the will of the ancestors, of the spirits, of the invisible world. From the moment when the mask intervened, even to give the death sentence, no debate was admissable. Among the Vili, however, the carrying out of the sentence had to be confirmed by the *maloango*, the spiritual leader based at Loango, who reigned over the seven great families representing the kingdom of Loango.

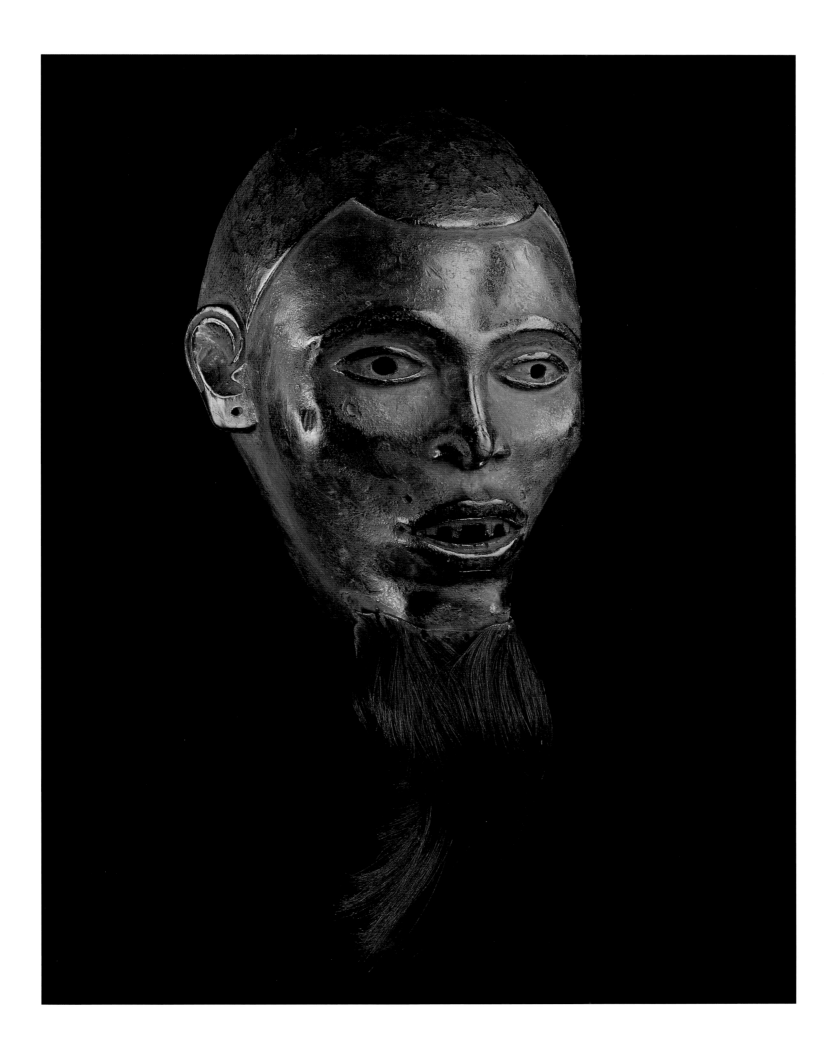

3

YOMBE

Angola, Cabinda & Zaire, Lower Zaire
anthropomorphic face mask
H. 40 cm. Wood, pigment

This massive mask has a black patina, with
eyelids tinted rather violet-red. Its design is
related to the several examples published in
Lehuard, which — taking into account
certain differences in total form, color, and
the finish of details — exhibit great mutual
similarity. With the exception of the
posterior aspect, the massive volume
represents an entire head. A border of
parallel running incisions depicts a
headdress. Strikingly powerful is the
aggressive modeling of the facial features,
with protruding lips surrounding an open
mouth provided with filed teeth (and, in
two examples, a tongue). An important
point of correspondence is also seen in the
manner by which the surface of these masks
is worked; one may still see traces of the
adze's carve-marks. Together these elements
lead us to suppose that these masks were
made in the same locality, or even by one
and the same sculptor. This powerful form-
language contrasts with the gentle
naturalism of the *nganga diphomba* masks
(see cat. 2). This expressive mask type finds
its similarity more in the facial modeling of
the power statues, *nkisi*, of the Yombe.
Information concerning the function of the
mask is lacking. (F.H.)

Lit.: Herreman (*in* Herreman, Holsbeke & Van Alphen
1991: 20); Lehuard 1993a

But assuring social order was not limited simply to applying the laws; it also involved ensuring
that traditions and morals were respected, particularly those concerning sexual relations. And in
addition to this often onerous requirement, the *ndunga* investigated the causes of anything which
might lead to trouble, even if it was of natural origin. So, if the rainy season was late in coming,
for example, they sought to find the person whose actions were holding back the rain. The
culprit, unaware of the wrong he had done society, was condemned without appeal and his sacri-
fice was supposed to restore order to the elements which had been temporarily disturbed.

Two *ndunga* are known: the regional *ndunga* dependent on a great family, and the senior *ndunga*
deriving authority from the *ntinu* or *maloango* (the ruler, according to the province). In Cabinda,
the Woyo's *ndunga* had its base at Kisu, east of the town of Cabinda. We may assume that this was
a center where the different regional masked groups gathered and where the senior *ndunga* was
also established. No other specific information can be given, since no one was allowed in this
forbidden place without invitation, at the risk of being rendered blind. A similar situation applies
to the secret villages where the *bandunga* kept their equipment and which were generally situated
in the forest valleys.

Among the Woyo, the masked society comprised nine masks, each representing a great family
nkanda (Martins 1972). Among the Vili of Loango, there were seven (some accounts say eight) of
which two were still remembered by old inhabitants in 1991. These were *vudu ku sale*, worn by
Ngoma Léon, who died at Diosso around 1960, which represented the great family Tchiboua-
Toufi, and *tshitomi-bata*, worn by the dancer Dika, who died about 1970, representing the great
family Bouya. We know the names of two other masks which were part of the *ndunga* of the *malo-
ango*: *navala i nanga*, a two-faced mask, and *ntumbu nsoni* (Hagenbucher-Sacripanti 1973). The
other names of the dancers have been forgotten; though this conflicts with the evidence of some
witnesses that no one was supposed to know the identity of the mask. In fact it is quite natural
that the identity of the dancers should be known at least to some people, if not to the whole fam-
ily. This is why, when a serious case had to be decided, those responsible always appealed to a
ndunga from a distant province.

Each great family had its school where the young were trained. Their role was to support the chief
masked dancers, to assist them to conserve the feathered headbands, to find the colors to paint
the mask for judicial occasions or festivals, to maintain the place where the association's equip-
ment was kept and the dancers and musicians practiced.

Tchikaya André (one of our informants) in his youth saw one of these masked dancers covered in
feathers leap on the roof of a house, turn over the ridge beam and slide down the slope of the roof,
returning to the ground to somersault amongst the amazed and delighted spectators.

It is not known if the members of the *ndunga* originally spoke a secret language; on the other
hand when the masked dancer spoke, he always did so in a whisper, disguising the tone of his
voice, and only the leader and the master of ceremonies could understand and interpret his inten-
tions. According to Cornet (1980) the mask spoke a good deal with the people, modifying its
voice so as not to be recognized. It would provoke the spectators of its own accord to create situa-
tions where fines could be imposed.

It is likely that the rules of the *ndunga* were inspired by the spirit *lusunzi*, a tutelary spirit, the
child of *bunzi*, the earth "fetish" *nkisi nsi*, and the protective force of the mouth of the river
Chiloango. Because of this, the *nganga lusunzi* (priest), the trustee of the *nkisi lusunzi*, was not
only charged with maintaining discipline within the organization, but also watched over the
moral and social order, like a policeman, always ready with his masks to condemn any failing
amongst the villagers, particularly if taboos were broken or to find the cause of any trouble. In his
role as the person responsible for the organization he was associated with the *mfumu nsi*, the chief
of the area and the representative of the *nkisi nsi*, whose ritual ceremonies he led, during which he
would address prayers and sacrifices on behalf of the *bandunga*. Certain members of the *ndunga*
were responsible for ceremonies, prayers and propitiatory offerings arranged in honor of *lusunzi*.
Each great family took charge of the needs of its mask, when this was sent to take part in the
senior *ndunga*.

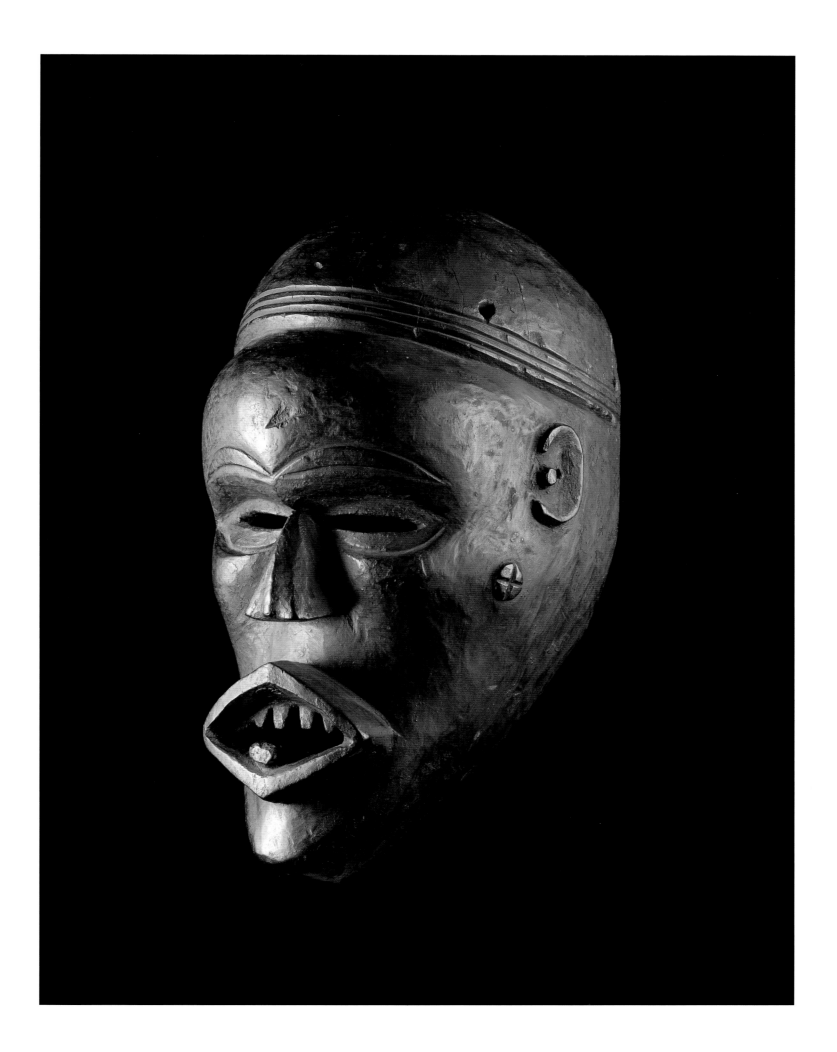

4
VILLI

Angola, Cabinda & Zaire, Lower Zaire
anthropomorphic face mask
H. 34 cm. Wood, pigment, fiber

This mask is sculpted in a light-brown variety of wood. The face itself is colored with kaoline and ocher. Hereby, the black-colored eyebrows come especially to the fore. Fragments of threaded rope still sit between the holes which perforate the mask's edge. These serve to make fast the headdress. Together with this mask, Raoul Lehuard published a dark brown-red mask exhibiting a very much similar form. We lack information regarding the mask's function. Due to its serene expression, it is possible that this is an *nganga diphomba* mask. On the other hand, its dominant white color suggests another, or supplementary, hypothesis with regard to this mask's function. White masks are taken as representations of spirits of the dead. Further, white is also associated with a whole panoply of positive characteristics, such as: justice, order, reason, truth, health, generosity, happiness, invulnerability, rule, obedience, manliness, matrilinearity, intelligence, and clear insight. (F.H.)

Lit.: Maesen 1960; Jacobson-Widding 1980; Demoor-Van den Bossche 1981; Lehuard 1993a

In ancient times the senior *ndunga* was closely associated with royalty, but it also participated in the investiture of chiefs, at the funerals of important people, particularly at those of the chief of the country, at alliances between states and in curing the ills of society, the seeking out of witches and dancing at festivals in honor of *nkisi nsi*. The *ndunga* attached to a great family fulfilled the same functions.

The adherents would meet at night on the edge of the village where they would appear in the morning, and begin preparations, concealing their identity by a fiber curtain hung across the road. But no one would try to see them. At the appointed time, the costumes of banana leaves would be remade, the masks repainted, the equipment distributed, the skins of the drums warmed. The earth "fetish" (representing *bunzi*) would receive the blood of a hen. Volavka (1976:31-32) thus describes a dance at the village of Nsiamfumu (Zaire): "*Ndunga* se déplace lentement et majestueusement. Ce grand costume en forme de cloche semble gigantesque bien que le porteur n'utilise pas d'échasses. Son apparition impressionante, que fait se taire la foule, visuellement motivée, est encore accentuée par le bruissement du costume. Lorsque le danseur commence à s'approcher, se mouvant lentement avec un petit bâton, les spectateurs ressentent comme une oppression au contact de l'énorme volume. Le climax de la danse soudain explose comme ferai une tornade. Tous les masques participant se rejoignent dans un nuage de poussière créé par des mouvements d'une rotation violente et dispersent la foule bruyante. L'espace de l'énorme place est maintenant dominée par les spirales monumentales que font les feuilles. Le mouvement décroissant par le haut semble venir de la terre. C'est l'instant précis où l'on réalise toute la finesse et la sophistication de la forme et de la structure de ce costume. Encore une fois, l'effet du masque est polysensoriel. Les aspects visuels sont renforcés par la résonance des végétaux séchés qui, en plus, stimule les sensations tactiles des spectateurs par la texture des feuilles dressées, roulées ou pointues, comme tranchantes."

In the pre-colonial period, the youngsters (non-initiates) did not have the right to approach the masks, even when they paraded through the village. The women hid in their homes. When youngsters took part in the ceremonies it was because they were directly concerned and implicated. In such a situation all the inhabitants had to attend the event which served additionally as a lesson.

So, when a man had seduced a girl who had not yet passed the initiation, *tshikumbi*, both would be judged equally guilty before the court, during a session known as *mbumba mbitika*, and there, completely naked in the center of a circle formed by the masks and surrounded by the spectators, they had to dance to the sound of the drum, while being whipped not only by the masks but by the villagers as well. Such an offence was regarded as a direct affront to the earth "fetish", who would react at once against the community as a whole, holding back the rains, making the game scarce, provoking some accident, etc. And the severity with which an offence of this kind was punished was sufficient to show the *nkisi nsi* the good faith of his administrators... And the rains returned...!

As long as the organization was all-powerful, penalties could apply to a simple failure to observe the laws or any attitude interpreted as an offence directed against the *bandunga*. When the contravention was attributed to an entire village the masks would descend suddenly upon it and pillage everything they could, without any warning. They then presented themselves to the local landowner to explain the reasons for their behavior and to seek reparation by a fine, which did not take account of the initial sack. On occasion, some houses were damaged, even completely burnt.

Such power certainly lay at the root of some excesses and makes one think of the Inquisition. One understands how these associations were feared, and those who did not participate in them directly often showed considerable zeal in according to their demands.

A group of *bandunga* dancers originally comprised nine masks, though sometimes one might find seven, eleven or twelve. However, when one inquires about the names of the masks, each of which linked to a proverb, knowledgeable people always mention nine. Nine recalls the number of provinces which comprised the kingdom of Kongo at its inception and the number of his sons

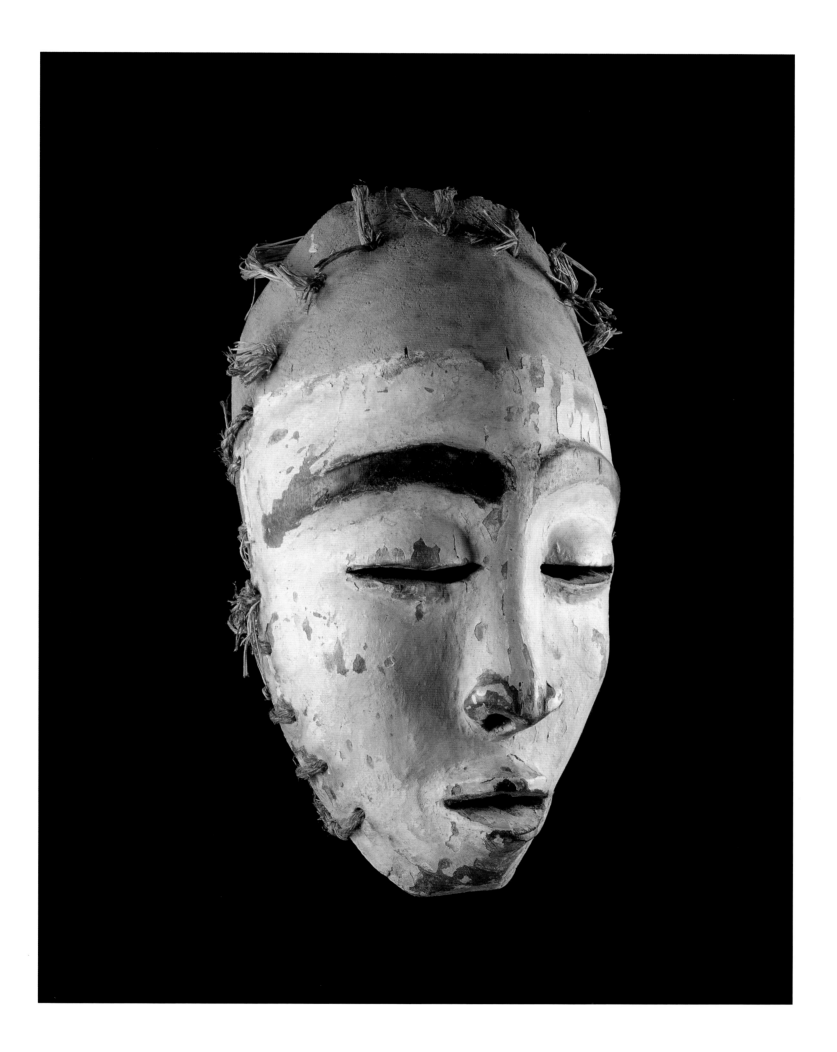

5
ZOMBO

North Angola & Zaire, Bandundu
anthropomorphic helmet mask
19 cm. Wood, pigment, fiber, beads, buttons

Together with the Lula, the Dikidiki, the
Mbeeko and the Mbinsa, the Zombo people
— just as the Eastern Kongo group — are
strongy influenced by the Teke and the
Yaka. Most of the Zombo live on Angolan
territory, on the banks of the Inkissi.
According to Raoul Lehuard, basing himself
on a text in a Christie's auction catalogue,
this mask was collected in the early 1930s by
a missionary in the Uige district, North
Angola. The initiation society, *nlongo*,
which inaugurates the young men, is
strongly influenced by analogous
institutions among the Nkanu, the Yaka,
and the Suku. As with these other peoples,
here too the initiation rites commence with
circumcision. After the circumcision ritual
itself, following healing of the wounds, the
masks are carved and each of the initiates is
given one. Thereafter, in the isolation of a
secluded camp, they learn the social and
economic rules which hold in the
community, and are introduced into the
religious world. This life in seclusion may
last one to two years. During this period the
initiates may only come into masked
contact with their families. This occurs in
public, where they sing and dance, and are
rewarded with money and other gifts. It is
within this framework that this mask most
likely functions. More precise data is
lacking. (F.H.)

Lit.: Lehuard 1993a

which the *ntinu* set each at the head of these provinces. Many proverbs allude to this symbolic
figure.

The mask is thus linked with a proverb, sometimes with several; this is a function of the role
which is assigned to it during an event. Under the same name, a mask will have more or less
importance in relation to the group according to the proverb which it enacts; its position in the
mask hierarchy will also depend on its role. In the same way, a dancer is never assigned perma-
nently to the same mask. As the best dancer is the one who is most often in the limelight, he will
wear the mask which is the leader for that occasion, depending on the main idea being enacted
through the dance. The order of precedence in which an observer will rank the masks will change
with the next dance. For this reason, when two masks have the same name but come from two
different groups of masks, they do not necessarily occupy the same place or have the same value.

Because of the limitations of space here, it is not possible to list the series of proverbs with their
meanings, but all the same it should be made clear that the carved mask by itself is not enough to
evoke the proverb; various everyday objects fixed to the front of the mask, and associated with
different colors, reinforce the idea expressed.

The Forms of Ndunga Masks

Most masks are carved from a light wood, of a whitish tone sometimes tending to yellow, easy to
carve and whose finished surface does not take on that glossy patina beloved by ignorant collec-
tors. According to the work of Deschamps (1987) on the objects from Lower Zaire, 64% of the
masks preserved at the Musée Royal de l'Afrique Centrale at Tervuren (M.R.A.C.) are made from
Alstonia congensis, 31% from *Ricinodendron heudelotii* and 5% in *Bombacaceae sp*. Masks made in a
dense grained wood are rare.

If the tradition continues amongst the Woyo, it is because the sculptors still produce masks. In
1953 Maesen acquired a mask (M.R.A.C., R.G. 53.74.916) which had been carved by Lobata
Lucien. Volavka reports (1976:40): "Encore aujourd'hui, les artisans de la partie zaïroise du
Ngoyo se rappellent le nom du sculpteur Futi Daniel qui, en 1940, se rendit même à Bomba afin
de travailler pour le marché." She also mentions the name of Nduli Ngoma who worked during
the 1970s at Mfuma Luzitu in the Woyo territory of Zaire. On the other hand, we have not heard
of any mask carver still active amongst the Vili or the Yombe of the Congo.

Most masks seem to have been carved either according to the same model, or by the same work-
shop at a similar period of time, or by the same craftsmen. If one looks at those seen and photo-
graphed in action by Martins, Volavka or Cornet, the morphology seems so similar that it must
be up to the mask associations to enable the spectators to identify the masks at an event. Tchikay
André's remark that "it is not the carving that counts but the painting" (and he might have said -
"and the accessories") bears this out. Moreover, the painting is not exactly the same for the same
mask in two different dances. The impression gained from examining various families of *ndunga*
is that the coloring is more or less improvized. No exact rules were quoted to us. It is possible that
the rigors of tradition have been replaced by lively improvization encouraged by the decline of
that tradition. However, masks in the older collections show a face entirely colored in white or
ocher, a black streak down the nose and forehead, two oblique red and black marks on the cheeks,
red lips and eyebrows picked out in black.

From the front the mask is an almost perfect oval. In profile it forms a half-oval. The prominent
brow shadows the eyes, simple horizontal slits, completely enclosed by the arch of the brow and
the cheeks, which echo the bulging forehead. The nose, slightly hooked, is placed solidly between
the ridges of the cheeks. The nostrils are often marked, flattened, and the mouth with thick
projecting lips sometimes seems to have an exaggerated realism, opening on teeth sometimes reg-
ular, sometimes filed. Sometimes the teeth may be arranged in groups of five. Finally, in some ex-
amples the mouth gapes toothlessly, sometimes with the tip of the tongue resting on the lower lip.
The chin is noticeably flattened. This description is valid for the masks of the most widespread
type. Sharing this common series of forms, the individual artists have leant sometimes towards
realism, sometimes more to expressionism, even cubism (cat. 1 and ill. 1).

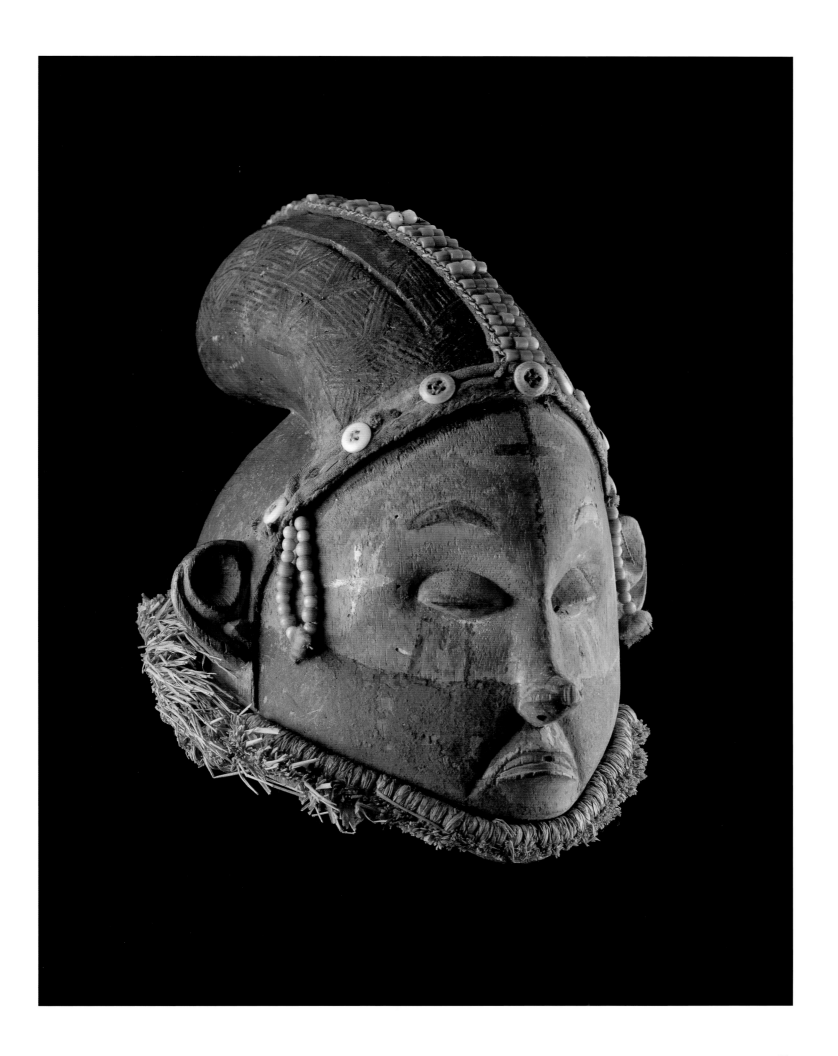

The Nganga Diphomba

The function of the *nganga diphomba* (*dip'omba*) in Kongo society is to bring hidden matters to light, to put a name to the author of an offence, to reveal the reasons for an accident, an illness or a death (whether the causes are natural or not). His services are sought to explain and put an end to drought, or the scarcity of game, or to solve a theft or other crime, to predict the outcome of a court case, to resolve inheritance disputes, etc. There is a very long list of services which one may expect from this very important, indeed indispensable person. But the reason for which the *diphomba* is still frequently solicited is to get him to reveal the machinations of a witch (an "eater of souls"), someone who consciously or unconsciously calls the established order into question by some irregularity, which may victimize a whole group or harm the health of one individual, or damage his goods, endangering his business. Anything which runs counter to obvious logic may find its justification in the malevolence which the diviner or wiseman explains by denouncing one culprit.

The accusation may take two forms: the ill-fortune is desired either by the ancestors or by an individual. In the first case, the family concerned has to carry out sacrifices and offerings designed to appease the wrath of the dead, who are always at the edge of the village or on the summit of a nearby hill, like sentinels keeping watch on their descendants. In the second case, the person implicated has either to show his good faith by compensating the wronged family or the community, while giving assurances of future good behavior, or he can challenge the case and submit to the test — the ordeal — which the *nganga diphomba* may impose.

Though many *banganga* in Lower Zaire practice (or used to practice) divination, only the *diphomba* wears a facial mask, and in the hierarchy of diviners he is the most important and one was retained permanently in the service of the *maloango*. In addition to the carved wooden mask hiding the face and the identity of the wearer, a robe of turaco feathers completed the outfit, to which a girdle was sometimes added, with brass bells attached to it. The body of the man was naked, the arms, chest and legs being sometimes covered with geometrical designs in red, black and white.

The skills of a *nganga* are usually learnt from a master, whom the pupil's family pay for the teaching given. No one gains a reputation as a specialist in herbal treatments, a healer, or a diviner (who is sometimes also a member of a "secret society"), without first having undergone a long apprenticeship, sometimes much longer than the skills required for the craft, whatever the speciality. The majority of pupils are consigned to the master at the age of twelve or thirteen. These boys serve him as his assistants and so learn from day to day.

Though knowledge of the social context and its psychology are important for the *nganga*, and this knowledge guides him at the appropriate moment to his conclusions, it is nonetheless true that the proof which he suggests must be physically "seen" by all the witnesses. If a manoeuvre, a trick, is carried out in a convincing way, if an inevitable event does not occur, it demonstrates the proof of the guilt of the person suspected of preventing some achievement. And how else are the public to be convinced, unless one can produce a successful proof of one's skills, even if this is by a hoax or sleight of hand?

Apart from training designed to produce a specialist whose field of activity is very narrow, there are various "chapels" which train their followers, overseeing the quality of the initiation, requiring a period of probationary tests and requiring a pre-initiation final payment in the form of a human sacrifice. The victim is designated by the tribunal of masters and is generally chosen from the family close to the new initiate.

The members of these "chapels" spoke a language between themselves which was incomprehensible to others, and were not allowed to learn a white man's language at any price. In the Pointe-Noir region we have met such a *nganga*. He had never been to a mission school and had been placed in the service of a *nganga* when very young. We wanted to meet this man but despite his obvious efforts, he spoke such poor French that we had to speak to him in Kikongo, using the services of an interpreter.

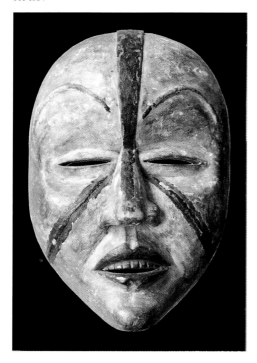

ill. I. Woyo (Angola). Mask of the *ndunga* society. H. 30 cm. In 1979 collected by G. Vidal in Cabinda. Private collection. *See cat. I*

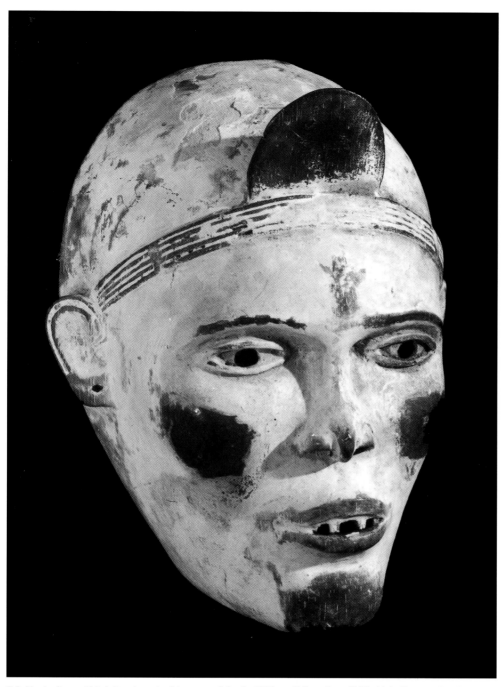

ill. 2. Yombe (Lower-Zaire). Female mask of the *nganga diphomba*. H. 25 cm. Collected pre-1943by N. de Cleene in the village Makaï Pumba. M.R.A.C., Tervuren (R.G. 43573).

There is no doubt that the *nganga diphomba*, of whose exact role little is known except that he was masked and was a diviner, belonged to an "association" or secret society as Bittremieux states implicitly in the ethnographic files he has deposited in the M.R.A.C., Tervuren. In these he discusses a figurine of a "mother and child" (ill. 3) (which we have attributed to the Kasadi Master, 1989: 459). He says, using Maesen's translation (1960: ill. 1): "La pièce semble avoir joué un rôle non précisé dans les rites préparatoires à la divination telle qu'elle est pratiquée par le *nganga diphomba*. Celui-ci l'honorait du nom de *phemba* et (...) prétendait qu'elle représentait sa "mère" qu'il aurait "mangée" avant son inititation à la divination."

It would not be surprising in view of the sacrifice required, real or symbolic, if the "chapel" of the *banganga diphomba* consisted of "witches"; that is to say men who had given proof that they themselves had the power of witchcraft (*kundu*) which allowed them to counteract the activities of other witches and identify those who, wilfully or not, harmed society, since they could not master and control the *kundu* which they had. We cannot be certain but this situation, with some

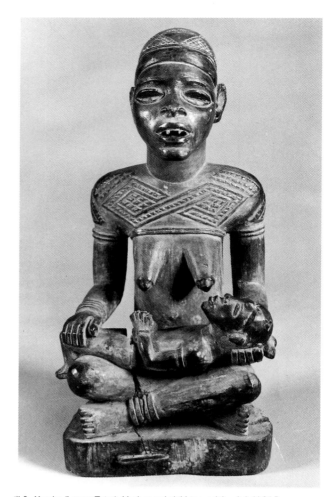

ill. 3. Yombe (Lower-Zaire). Mother-and-child-image (*phemba*). H. 26,5 cm. Collected pre-1937 by L. Bittremieux in the village Kasadi. M.R.A.C., Tervuren (R.G. 37964).

witches opposed to others, demonstrates that two levels of witchcraft are to be found in Lower Zaire, one a controlled power which is opposed to the second, unfettered and dangerously unpredictable in its activities. One must therefore be a witch oneself to successfully combat the witchcraft of others, and the *banganga diphomba* fulfil this role.

We can neither explain nor demonstrate the exact role of the figurine of a mother and child in the hands of the *nganga diphomba*, especially as the child is represented inert and dead, which raises a problem in relation to the information given by Bittremieux. That this *nganga* had had to "eat" his mother is perhaps true, but the idea that her spirit must therefore dwell in a sculpture representing a mother with a dead child does not accord with what we know of the use the Kongo make of their sculptures. The form matters little, it is only the "force" and the "spirit" which is attributed to it, or which comes to dwell there, that counts.

One can only deduce from all this that the *diphomba* holds a "force" certainly invested with the spirit of a parent (perhaps) recently sacrificed, to whom in one way or another he renders homage and from whom he expects some guarantee or service in return. This "force" could very well be found enshrined in a figurine and nothing prevents this figurine taking the form of a woman sitting cross-legged and holding a child in front of her. To my knowledge this is the only carved object, apart from the mask, which the *nganga diphomba* used to prove his status, and also, possibly in the case of the figurine, in the process of his divination. When Dennett (1887: 33) described and drew the taking of poison by a woman suspected of witchcraft, the masked figure making her drink the liquid is seen in front of a statue stuck with nails, not a figure of a mother and child. And when he drew the same man, trying to diagnose the illness from which a noble was suffering, one can quite easily make out the figurines in the house, and there is no "mother and child" among them.

The Forms of Nganga Diphomba Masks

The masks which can be definitively attributed to *nganga diphomba*, in our on-going work on the masks of Lower Zaire, all belong to the Yombe style. Moreover, the ethnographic information which is available, (M.R.A.C., Tervuren, and the Museo L. Pigorini in Rome), makes it clear that except for one piece at the M.R.A.C., Tervuren and three others which belong to a mask collected around 1898 and preserved in Rome, all the others were collected in Mayombe. It is only a step from there to conclude that the *diphomba* were exclusively of Yombe origin, but I would prefer to leave the question open. It is certain that of the masks recorded, some have been carved by the same artist, or at least by the same stylistic center, where the artists have carried out their work respecting identical formal criteria, since so many details are found echoed from one mask to another.

One of the best, from a realistic point of view, is a piece (ill. 2) (M.R.A.C., R.G. 43573) collected by Nathaniel De Cleene in the village of Makai Pumba. It shows the face of a woman with realistic, even refined modelling, which forms a parallel with the face of statuettes of "mother and child" (see above). Rarely has realism in African art attained such a level, except for the terra-cotta heads from Ife. The brow is bound with the cord worn by young women, from which a semicircular detail of the headdress rises at the forehead. Its meaning is unknown but it is found on feminine statuettes. The eyes are edged with lids made by two opposite arcs of a circle, the straight nose is a little short, the cheekbones just sufficiently prominent to slightly slim the cheeks, and the pointed teeth can be seen in the half-open mouth. The chin which comes a little low and the stylized ears are a nice allusion to the canons of African style. The face is white, picked out with black on the cheekbones and a red streak runs from the brow to the tip of the nose; the lips and chin are red. The wood is a fairly dense grain, dark brown in color.

The mask R.G. 37966 (ill. 4) from the M.R.A.C., Tervuren is a piece actually collected by Bittremieux in the village of Kasadi in Mayombe. Did it belong to the *nganga diphomba* who gave the priest the famous "mother and child" (see above)? Its vernacular name was *ngobudi*, a term which describes something frightening, a spirit or a force which spreads terror. It is not unlike that described above, though with exaggerated emaciation achieved by drawing out the chin to which is nailed a hairy beard made from buffalo skin. The face is whitened and the head, covered with the dignitary's skull cap, is black.

Other *diphomba* masks, even the most expressionist, are still not far removed from "naturalism" and often their gentleness of expression contradicts the epithet of *ngobudi*. In their outward form the masks do not spread terror, they generate rather a kind of soothing calmness, once one can get over the problem that they are invested with a spirit whose nature is to stimulate fear.

When lists of these masks are examined, it appears that they fall into almost equal numbers of masculine and feminine types. Does this indicate that they formed a couple during a display? There is no record of this anywhere. Or did the *nganga diphomba* own a mask of each sex? The information which would confirm this is lacking, and we would have to know what differentiated the use of one from the other.

The principle ennunciated by our informants in the country should always be kept clearly in mind: "What counts in a sculpture, even a mask, is not the form which the artist has given it but the spirit or force which it represents and which inhabits it; and the function of a *ndunga* mask is not displayed in its features but in the colors which one applies." So, whether the mask is masculine or feminine may not be the essential question.

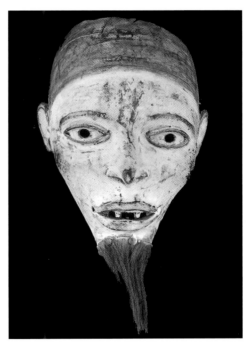

ill. 4. Yombe (Lower-Zaire). *Ngobudi* of the *nganga diphomba*. H. 23 cm. Collected pre-1937 by L. Bittremieux in the village Kasadi. M.R.A.C., Tervuren (R.G. 37966). *See cat. 2*

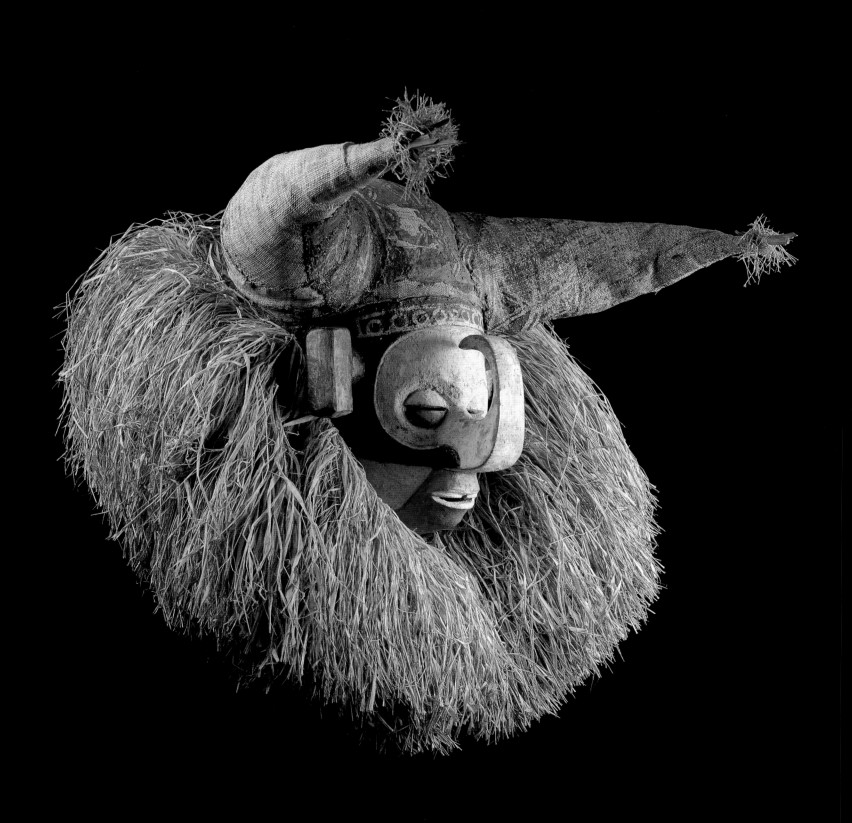

An Introduction to Nkanu and Mbeeko Masks

Alphonse LEMA GWETE

Together with the Mbata in the west, the Zombo in the south and the Lula and Dikidiki in the north, the Nkanu and Mbeeko form a bridge between the Kongo and Yaka on one hand and the Kongo and Teke on the other. So as a result of intermarriage and gradual migration, the Nkanu and Mbeeko peoples comprise elements from different stock, though the majority of their chiefdoms trace their line back to the ancient kingdom of Kongo. Nevertheless, to understand certain aspects of their culture, the influences of all the peoples who surround them has continually to be taken into account.

Situated in the Kimvula area, the Nkanu are mostly found in the Lubisi community. A small group occupies the Benga community, mainly in the settlements of Kongo Mbuda and Kimvidi, and to a lesser extent in the Kinankudi settlement. The Mbeeko inhabit the area between the rivers Nsele and Lumene. They are intermingled with the Mpangu and Mbata to the west and with the Dikidiki and Lula to the north and east (Boone 1973: 146-148). They are Kongo who are strongly marked by the Yaka influence (Mertens 1942: 4-5).

Though the Yaka, Teke and some other groups from the Kongo complex, like the Yombe, Manyanga and Ntandu, are quite well known in general terms,[1] the Nkanu and Mbeeko have not been the subject of any in-depth study, especially as to the role of their carvings. Perhaps this is because they are often confused with the Yaka, or because they are indiscriminately included among the Eastern Kongo, who are chiefly represented by the Ntandu, Mbata and Mpangu (Van Wing 1938; Mertens 1942).
No doubt this deficiency will be made good by the studies devoted to the culture of these peoples now in progress.[2] During an initial visit to this area, I noted that several aspects of the culture of these two peoples could still be observed as totally authentic, side by side with others which were already marked by the influence of modern civilization and Christianity. For example, masks, like the initiation society to which they belonged, have changed rapidly. Ancient ones have become extremely rare. Those carved recently sometimes retain the traditional form and name, but they are now usually ordered for commercial purposes.

So there are cases where one manages to recapture aspects of knowledge of their traditions only by recovering information and reconstructing oral evidence. Time is still needed for an in-depth examination of the different questions one would like to comprehend. The work thus far carried out only represents a preliminary enquiry, whose aim is to provide a more precise focus for further research.

The Loongo Among the Nkanu and Mbeeko

The *loongo* is a social institution whose main purpose is still the circumcision of youngsters (between ten and twenty years old), their training for adulthood and their official introduction into public life.
This institution is very widespread. In practice it is shared by the Chokwe, the Lwena, the Pende, the Yaka and the Suku; in short, by several ethnic groups living in the Kwango-Kwilu region in Zaire and the Upper Zambezi in Zambia, including the Lunda in Angola. Plancquaert (1930: 58-59) has also noted its existence amongst the Nkanu, Zombo and Lula. The term usually used to describe it includes the root *khanda*, whose principle variants are *mukaanda*, *m-khanda* and *n'khanda*.

The Nkanu and Mbeeko call it both *n'khanda* and *loongo*. The term *loongo* is also found amongst other Kongo peoples, (Ntandu, Mpangu, Mbata, etc.) but the institution to which it is applied does not seem to have retained the same degree of complexity in all cases. As far as is presently

6
SOSSO
North Angola, Quimbele
anthropomorphic helmet mask
H. 34 cm. Wood, pigment, fiber

This mask strongly resembles an example preserved in the M.R.A.C., Tervuren, published by Bourgeois and attributed by this author to the Sosso, a neighboring people of the Yaka and the Nkanu. Just as the case with the Nkanu and the Zombo, the Sosso also belong to the Eastern Kongo peoples. Culturally this region was strongly influenced by the Yaka and the Suku, and manifests in the initiation rituals, form-language, and thematics of the associated masks. This certainly holds true for the form — with the large upturned nose — and the use of blue, red, and white pigments. These elements are related to the sculpture of the Southern Yaka. There is rather sparse knowledge of this mask type's exact function. Bourgeois associates the example that he published with the *mbawa* masks of the Yaka; a mask type without fixed form, but with horns as the only consistent feature. This refers to the buffalo, an animal that is both realistically (cat. 8) as well as more abstractly (see cat. 16) portrayed. The Yaka from the extreme south and the Southern Suku also call the *mbawa* mask by the name *kudi*, and presents with a human face, carved in wood, combined with conical horns made from a tissue of palm fibers intersticed with dried grass. (F.H.)

Lit.: Bourgeois 1991

known, among certain Kongo tribes circumcision has remained an operation which involves neither a systematic initiation nor the wearing of masks. So this leads to the hypothesis that the development and importance of the *loongo* among the Nkanu and Mbeeko results from their contacts with the Yaka. This hypothesis could be verified by studying the Nkanu and Mbeeko's western neighbors.

The institution as such has been studied broadly amongst the Yaka, Suku, Pende and Chokwe (Devisch 1972: 151-176; Bastin 1982: 49-52; Bourgeois 1984: 119-144; Mudiji-Malamba 1989: 54-63). The reconstruction taken from information supplied by Nkanu and Mbeeko sources can be divided into four principal sequences; preparation, entry into the camp/retreat, circumcision, bathing the newly circumcised and their return to public life.

Ritual Objects Used in the Loongo

It is known that the Nkanu use gigantic masks, statuettes, posts and panels, all with polychrome decoration, though it is still not clear whether these objects have been carved by the Nkanu or by Yaka sculptors who live amongst the Nkanu. Nevertheless, as Biebuyck (1985: 197) notes, despite stylistic similarities with Yaka work, Nkanu objects have specific characteristics which allow them to be considered as a true distinct stylistic sub-division. So the hypothesis that these are properly the work of Nkanu craftsmen remains more than likely and is reinforced by the fact that certain Nkanu carvers in the area are still making masks. However, this is not to say that the tradition was not originally introduced into the region by the Yaka (Van Wing 1921: 65). The terminology described below seems to confirm this.

Use of Masks

Mbawu and *nkisi* are the two common words for masks. They describe them as carved objects and in terms of the function which they fulfil, since it seems that some were used to maintain order in camp by beating or spreading panic among non-initiates. Masks are also associated with healing rituals, varying according to the evils to be warded off or the illnesses to be treated. Others also inspire fear though this seems to be largely a kind of reverential awe. The spectacle they present delights and entertains, but the non-initiated take care not to approach too closely, since these are sacred objects.

But what do the terms *mbawu* and *nkisi* mean? *Mbawu* seems to mean the mask as a carving, as an actual material object. *Nkisi* relates more to the mask's spiritual connotations and to the force which gives it healing powers. However, in common usage each of these names can designate at one and the same time the carved object, the disguise which completely transforms the wearer, and the display which he presents. One could say that the masks are the ancestors, moving

7
NKANU
Zaire, Lower Zaire and Bandundu
anthropomorphic helmet mask
kakuungu?
H. 51 cm. Wood, pigment, cotton

The Nkanu live between the rivers Lwidi (west) and Lubisi (east). They comprise the most easterly branch of the Kongo peoples and are, just as the Mbeeko and the Zombo, strongly under Yaka influence when it comes to culture. Among other manifestations, this is expressed in the *loongo* — the social organization responsible for the initiation of the young men, and the associated masks and sculpture. Thus arose the hypothesis that Yaka woodcarvers, who lived among the Nkanu, would have been the creators of their ritual objects. Upon closer investigation there indeed seems to be sufficient difference to draw a distiction. This mask consists of two parts: a wooden face, with deep eye sockets and a spherical headdress made of cloth, upon which are painted vertical white and black bands. The color white is associated with the world of the ancestors and with protective spirits from the natural world; black denotes tribulation and dangerous forces. The hypertrophied facial features have reference to the *kakuungu* (cat. 10) and *kazeba* masks of the Yaka and the Suku. These, however, are completely carved in wood. Also among the Nkanu, the *kakuungu* is the oldest and most important mask. For them, it is neither female nor male. It was worn by the *mbaala*, the first circumcised, chosen from among the eldest of the *bikuumbi* (initiates). (F.H.)

Lit.: Biebuyck 1985; LEMA GWETE (p. 39)

Nkanu (Lower-Zaire and Bandundu). Group of maskers with central *kakuungu*. M.R.A.C., Tervuren (E.PH. 13036). *See cat. 7*

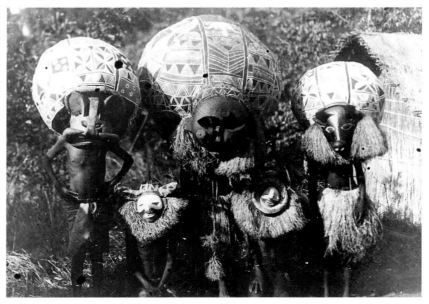

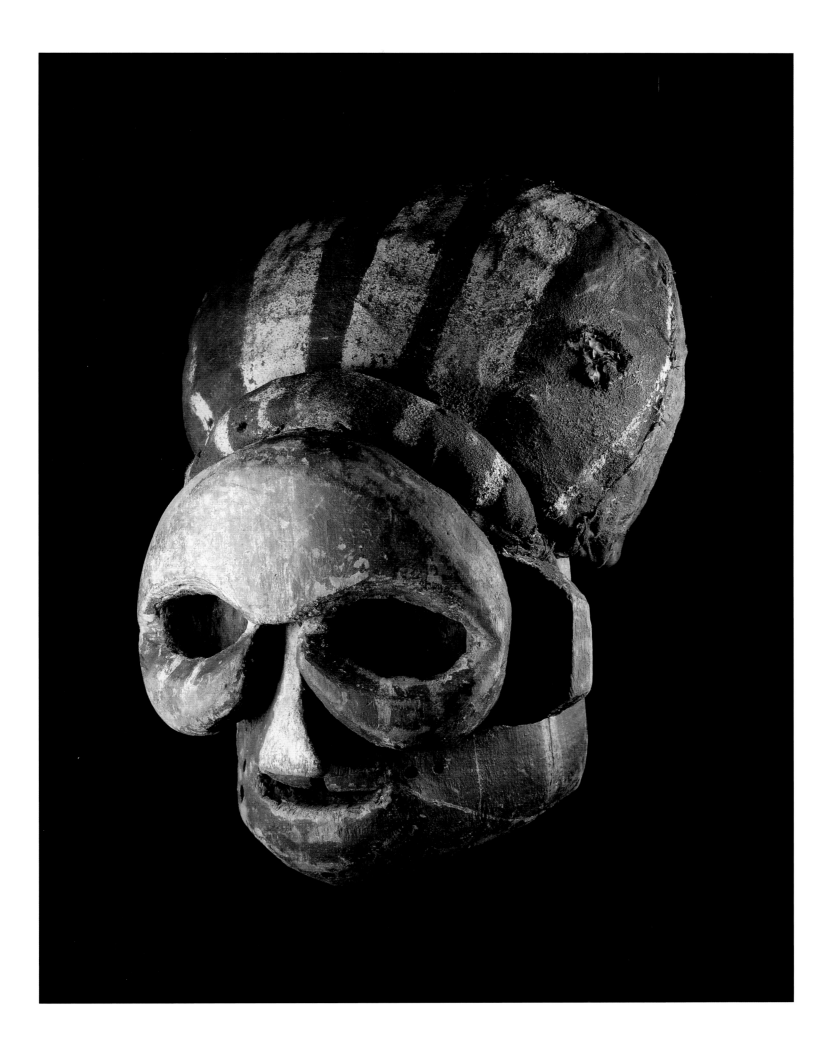

HOLO

North Angola & Zaire, Bandundu

anthropomorphic helmet mask

matemu

H. 50 cm. Wood, pigment, fiber

On the upper course of the Kwango River, which forms the border between North Angola and Zaire, live the Holo. Only a small proportion inhabit the Zairian side. They live in large measure mixed with the Southern Suku, and with the Chokwe, Yaka, Shinji and Minungu groups as well. The design of their sculpture is strongly influenced by that of their neighbors, and it cannot be ruled out that they purchase ritual objects from non-Holo sculptors. The design of the helmet masks, as with this example, exhibits a certain similarity to those of the southern Yaka and Suku. These masks perform at the conclusion of the mens' initiation period. There also exists a similarly-named type with horns. This is employed, among other occasions, within the scope of hunting and healing rituals. (F.H.)

amongst the living, and as Mudiji-Malamba (1989: 65) has said of the Pende, their mission is to bring the spirit world into contact with and enrich the living. The term *nkisi* covers this last aspect exactly. This varied background helps to explain the range of evidence when establishing a typology for these masks.

Nkanu and Mbeeko nomenclature gives us certain categories which refer to stylistic values and to actual shapes, as well as to the roles fulfilled by the masks. Even though the shapes might be the same, the names of certain categories may change from one ethnic group to another or even from one clan to another within the same group. The series of masks described cover the following types: *kisokolo* (known as *matuunga* to the Mbeeko), *nkooso, kakuungu, makeemba* (*kisyoona* to the Mbeeko), *mangoomba, mbawu, nsaamba, nkoombo, mpakasa* and *mundele*.

This series is still provisional, since there has not been a field visit to every village, and the collection at the Institut des Musées Nationaux du Zaïre has only a few specimens. Nevertheless, the names of the types listed support the conclusion that there is a certain similarity between them and Yaka types, demonstrated by the masks *kakuungu, mbawu* and *nsaamba*. On the other hand, as has been shown elsewhere, a new type has been added to the traditional series. This is the *mundele* mask reprsenting the white man. Statuette sculptors continue to exist in certain areas, but those who carve masks are becoming very few, as the *n'khaanda* associations disintegrate.

The only village where I have found masks carved recently is Kisona, situated on the borders between the region of Bandundu, Angola and Lower Zaire. This quite important center produces various kinds of objects (masks, statuettes, pipes, the diviner's small slit-drums, etc.) for the local people and for the art dealers who come by. My brief stay in the village gave me a chance to see the *kisokolo, nkhooso, makeemba, mbawu* and *nsaamba* masks. The collection at the Institut des Musées Nationaux du Zaïre contains two masks identified locally as *kakuungu* and *kisokolo*. So the key point is that despite their affinities with Yaka work, these masks have their own stylistic identity, though from a morphological viewpoint the types are less individualized than they are among the Yaka.

Though the dominant characteristics of these masks are common to all these peoples' figurative sculpture, each type can be distinguished in formal terms and variations within the same type often arise from different workshop practices. An examination of some of the types will demonstrate which features are common to all.

The *kisokolo* mask is male. It consists of a wooden carving representing a large human face. It always has excrescences jutting out from each side of the head like horns; these are made from palm leaves, carefully bound together and wound round with raffia or strips of cotton cloth. Like the other masks, the *kisokolo* mask is carved from a light spongy wood known as *kingela*. There are no rituals associated with the collection of the raw material, but the cut wood is brushed over with kaolin some time before carving, to place it under the spirits' protection to prevent cracks to the wood or any injury to the sculptor. The broad face has a strongly marked nose, sometimes up-turned, and the teeth within the mouth show a gap between the incisors. A raffia fringe encircles the chin and in some examples, the top of the head as well. In one particular type, the whole face seems to develop out of a slightly concave, overall circular form. Like the other masks it is very richly painted and the motifs of the polychrome decoration seem to derive from the personal imagination of the craftsmen, varying as they do from one *kisokolo* to another.

The second mask is called *nkooso*. Its shape barely relates to the human head. It is not properly speaking a wooden carving, but rather a construction of vegetable material, covered with raffia. Where the eyes and mouth are situated, parallel stems are inserted (pieces of gourd stalk) called *mahoodi*, under which holes are formed to allow the dancer to see through. According to some witnesses the three pieces of stalk actually represent the eyes and mouth. The stalks are fixed with binding which conceals a layer of resin. The top of the head is crowned with a plume, made of the feathers of *mbudi khoko, mbulukomba, nkumbi, nkubi, mbanzi,* or *ndwa* etc. On this mask, only the chin is surrounded by a raffia fringe. The polychrome coloring is applied over the resin which covers the armature.

Another type of mask is the *kakuungu*, a type which also exists, as mentioned above, amongst the Yaka and Suku (cat. 7 and ill. p.40). This is characterized by the forceful convex masses of the

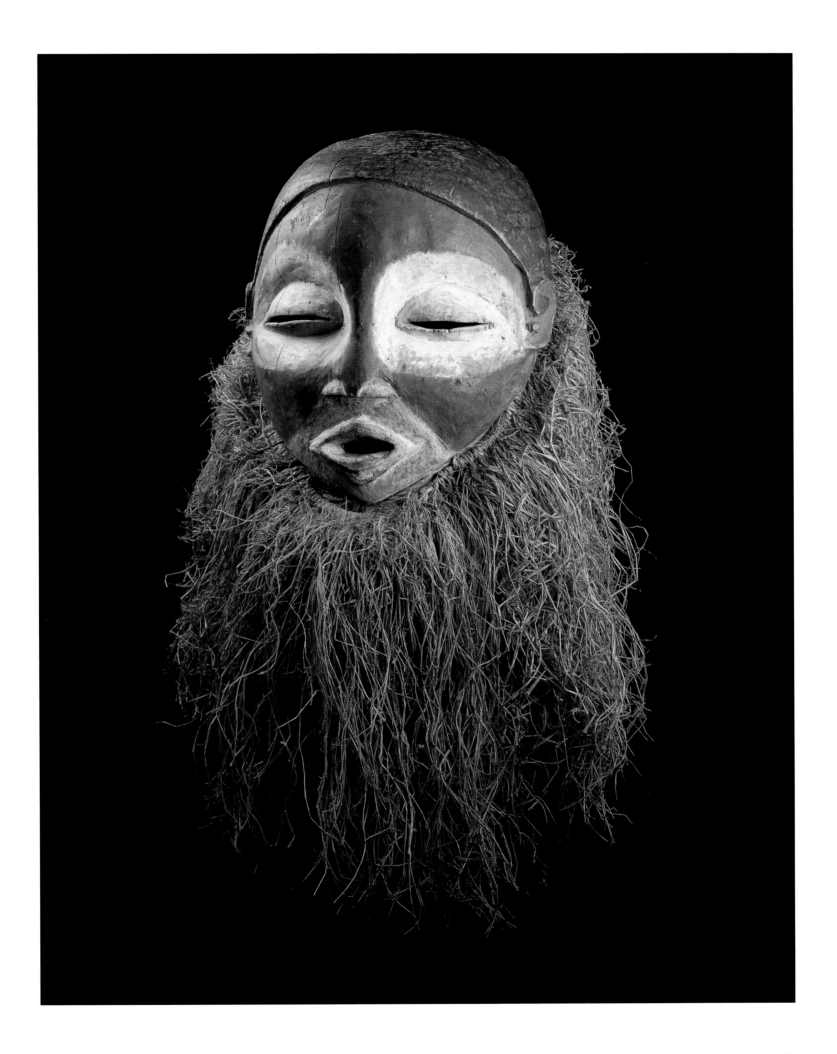

brow and cheeks. The example in the Institut des Musées Nationaux du Zaïre, reproduced many times, shows large, deep-set eyes which contrast quite strongly with the rest of the face, and divide it into two equal parts (Cornet 1975: ill. 26; Lema Gwete 1986: ill. 7.34). The upper part has a headdress made of an enormous armature covered with very richly painted cotton cloth. This compares with the Suku mask published in Maesen (1960: ill. 12). *Kakuungu* is a major mask, which is neither masculine or feminine. Our witnesses explained its great size by the fact that it is the most senior of the masks.

Makeemba, also called *mama-boola*, seems to be one of the masks typical of this region. It is the image of the fertile woman. This concept is emphasized by the upper part being presented as a woman with very realistic characteristics, as can be seen in the sole example in the Institut des Musées Nationaux du Zaïre.

Among the animal types, the *mpakasa* mask deserves a mention. In the Institut des Musées Nationaux du Zaïre there is a fairly recent example, collected in 1991. The mask has a long muzzle and almond-shaped eyes and has real horns fixed to the sculpture; the wooden parts are entirely painted in red clay (*diimba*).

The Role of Masks

From the preceding descriptions it can be seen how the *loongo* has stimulated the creative abilities of the Eastern Kongo. The majority of the art objects for which they are famous seem to have been used in the context of this initiation ceremony. Masks, posts and panels played a central role in setting out the basic concepts underlying the links between the actors in the ritual, the community as a whole, and the world of the ancestors.

The masks participate right from the initial preparatory festivities, which take place before the withdrawal of the candidates into seclusion. Previously initiated persons from the village and neighboring villages take part in this event. Their procession includes initiation dances and they return later to take part in the celebrations to mark the appearance of the new initiated.
As mentioned above, on their temporary return to the village, those just circumcised use two masks, *kisokolo* and *nkhooso*. These two masks also accompany the new initiates on the day they go to the camp. In the secluded camp the masks are continually present during the period that the young man learn the dances and their different meanings. *Kisokolo* and *nkhooso* ensure discipline in the camp. They surround the *bikuumbi*, the newly circumcised, when they assemble and whenever they move around as a group. The masters who carry out the circumcision are also masked, to dramatize the occasion and, in effect, to conceal their cruelty. Through this metamorphosis the initiate is made to feel that the ordeal he has to undergo is of great importance and that at the crucial moment he is in the hands of the ancestors.

Exact details of the display at the formal return to the village cannot be given. The literature available is mute on this subject and the evidence gathered so far is imprecise. The masks were worn by the previously initiated and by the oldest of the newly initiated; the very young novices had to be content with their grass skirts and body paint. There could only be a single *nkhooso* mask at a *loongo*. Anyone from among the initiates could wear it, except for the person with the title of *mbaala*, who was considered as the mask's father-in-law, *mzitu*. He appeared with a whip, *nswaswa*, from which he got his reputation for being fierce. The other masks might be duplicated or even appear several times. *Kakuungu*, the most important and the senior mask, appeared last. It would be worn by the *mbaala*, the leading initiate, chosen from amongst the oldest *bikuumbi*. *Magoombo*, representing the diviner, appeared with a rattle, *nsaansi*, in his hand. *Kisokolo*, regarded as unwarlike, was the favorite of the women and non-initiate children.

Van Wing (1921: 369) records that the *mbata* used a large mask called *mbawu* during an initiate's feast, which included a special ritual. As a test, each initiate had to bite the piece of meat and manioc porridge placed on the mask's nose. Since the *mbawu* mask also exists among the Nkanu and Mbeeko, it is possible that the same practice was known there, too. The same ritual has been described in connection with the *kipoko* mask belonging to the Kasai-Pende.

9

SUKU, YAKA or HOLO

North Angola & Zaire, Bandundu
zoomorphic bell mask
mbawa
H. 58 cm. Wood, pigment, fiber

This type of buffalo mask is the only of the *mbawa* masks that is sculpted entirely of wood. Strongly comparable examples were found among the Suku and the Southern Yaka, as well as among the Holo. This mask type also represents an *mpakasa* buffalo or a large, not precisely specified, type of antelope. The mask is worn horizontally, and the person porting it sees through the snout. Represented in red and white pigment between the horns and upon the snout is a lizard-like animal. The same animal is found on the *kholuka* mask (cat. 14), here in three dimensions. The function is the same as that of the large like-named mask under cat. 11. (F.H.)

Lit.: Bourgeois 1991; BOURGEOIS (p. 49)

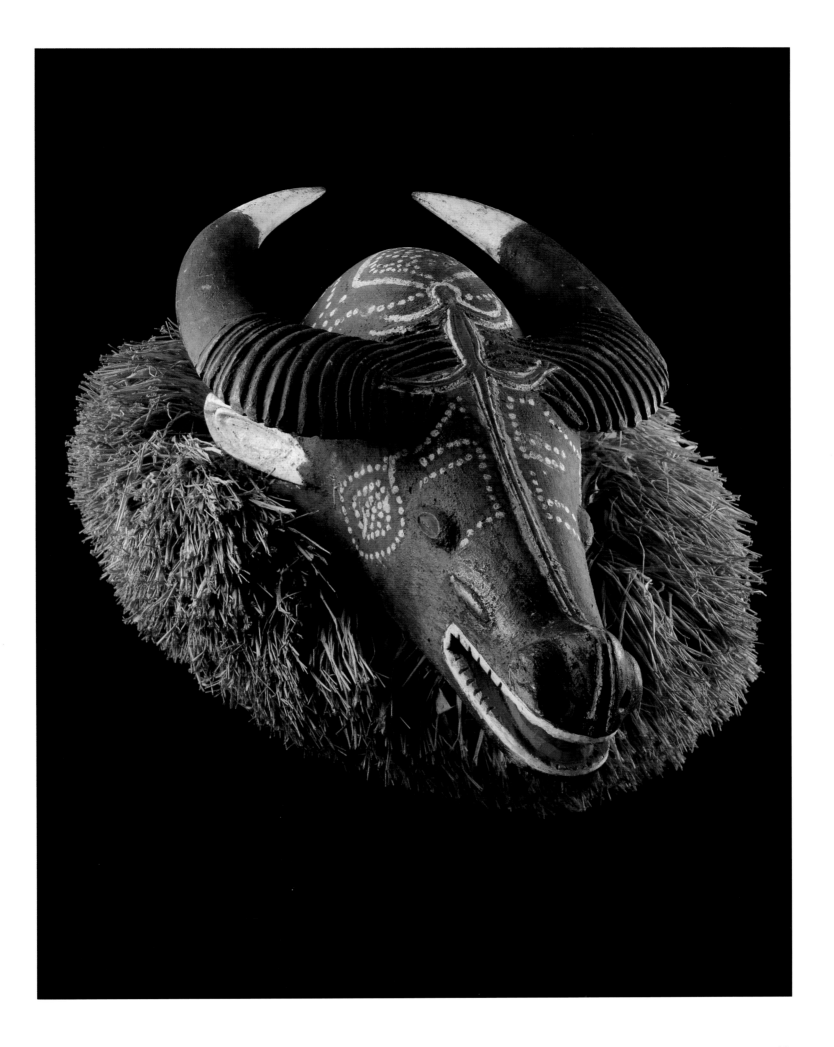

Generally speaking, as is the case with the Yaka and Suku, the Nkanu and Mbeeko masks were also used by the experts who directed the rituals, as signs of their status and symbols of their control over the forces which influence the processes of initiation.

Posts and Panels

Among the various ritual materials used in the *loongo*, posts, *makala* (singular *kala*), are an important category. They exist in large, medium and small formats. The majority consist of a log, left largely in its natural state but carved at the upper end in the form of a head, similar to certain masks. The part projecting above the head is sometimes decorated with the same motifs as the upper parts of the masks; the face, rarely multi-colored, is often painted simply red or white. Some represent the beard and hair by a fringe of raffia, as on the masks.

One can also find complete figurines at the initiation house, both male and female examples, some carved very realistically. Sometimes these figures also have animal characteristics. Some parts of the bodies and clothing are also painted.

Many wooden panels were also used in the institution of *loongo*. These were pieces of planking, often rectangular and multi-colored. They are well-known and described in the literature on Nkanu and Mbeeko sculpture. They were used to decorate the initiation huts in the camp. Here the decoration was much richer and combines geometric motifs with others taken from masks, either animal forms, or figures of men, sitting or standing. The latter occupy the center or upper part of each panel.

What appears to be common to all these categories of ritual objects is their tendency for shapes to retain strong sturdy masses, with vivid polychrome decoration, in a palette dominated by red, white and black, which seem to be the basic colors. Dark or bluish green and yellow are added to these colors. The motifs used in this polychrome work are quite varied and consist of different geometric shapes (lozenges, rectangles, triangles, circles, clusters of dots, lines, etc.) whose outlines are precisely drawn. This polychrome painting, which is unequalled throughout Kongo sculpture, gives an air of gaiety to all the sculpture of these peoples.
As to whether these different motifs form a coded language, witnesses agreed that this is simply a matter of decoration, such as can also be found on the ritual participants in certain ceremonies. However, in my view, body painting itself seems to play the same role as the mask, in the sense that it transforms and changes the individual before he receives, or at any rate represents, the spirits of the ancestors. It seems obvious that on panels, masks and posts the motifs of the decoration are used in the same sense, to form a link with the principles and ideas behind the different initiation rites. As Biebuyck (1985: 198) says, they may also encapsulate the ideas expressed in proverbs, tales and sayings. Additionally, as the period of seclusion during initiation is largely devoted to learning moral and social principles, it seems likely that these objects covered with various geometric motifs might serve as a visual aid. Revealing the meaning of all these designs to the new initiates is recognized everywhere as one of the tasks of a secret association or society.

The masks in particular are constructed in three parts, structurally linked; a large face in polychromed wood, an enveloping fringe of raffia representing the beard, and a large headdress, consisting of an armature covered with cotton cloth or raffia and daubed with resin, on which various geometric motifs are painted. Most of the colors are of mineral origin, (red, black, yellow and white clays). But red may also come from *nkula* and the black can be derived from charcoal. The colors are first mixed with water and palm oil, which helps them to adhere easily to the wood or resin. As for their symbolic meaning, white seems to represent the world of the ancestors and nature spirits, and in some cases evokes the idea of innocence or spiritual purity. Red is the color of life and fertility; black suggests ordeals and dangerous powers. The others appear to be complementary or substitute colors, which retain the same meaning as the basic colors.

Links Between Posts and Masks

Earlier in this text I mentioned the term *nkisi*, which relates to the mask associated with healing rites for some illnesses. The post, *kala*, is also used in the same rites. Some masks had one or more

posts, their joint action being required to cure illnesses linked to the *loongo*. The *nkhooso* mask had two posts, one male and one female. The first, called *n'luwa*, cured a series of illnesses linked to mental disturbance, provoked by the spirit of the *nkhooso* mask. The second, *mbadi kadiimba*, looked after patients who had urinary or bowel problems. This latter post worked in conjunction with a statuette, *kiteki ki kadiimba*, characterized by a swollen stomach. In fact it was the initiate wearer of the *nkhooso* mask who cured the ailments, in so far as initiation studies had developed his skills. The basic ritual for transmitting *nkhooso*'s powers was the following; "With *nkhooso* I will calm, cure, and re-establish strength."[3] The initiate also had to learn the techniques, taboos, and all the substances required for the treatment of illnesses. When using the totem post *mbadi kadiimbi,* for example, the patient was forbidden to eat *mbendi* (a striped rat) and *mbubu* (a large long-haired rat which lives in the valleys), the fishes *ntoondo* (eel) and *kela*, and the bird *mbweela*.

The mask *kakuungu* was associated with three posts which corresponded to three types of illnesses; *kaselo, kambiinza*, and *luvuumbu*. For illnesses believed to be promoted by *kakuungu*, the three posts were invoked and were effective together, but each also seems to have had its own basic rationale and specific function. It was said "*kaselo* who identifies the illness, who diagnoses the cause of the illness."[4] and "it is *luvuumbu* who cures the person afflicted with impotence or sterility and who re-establishes power and strength."[5] *Luvuumbu*'s specific function related to lumbar pains, kidney diseases and sexual impotence and sterility. *Kambiinza* took especial care of frequent miscarriages or loss of blood.

The *makeemba* mask had a *kala* which was in the form of a statuette, beside which was kept everything needed for treatment, including various substances. It cured heavy losses of mother's milk in particular. One of the principal products used was *nzyanzi*, a sort of creeper containing a sap, which the *ngaanga* sprinkled over the patient. A spatula of manioc was applied to the breasts from time to time. The patient also had to eat kaolin, mixed with certain plants.

It should always be borne in mind that all the medicine associated with the *loongo* and with masks was basically practiced by those carrying out the circumcisions, or *ngaanga tsyaabula*, who were the most skilled among those who understood the practices of initiation.

Despite the many lacunae which still remain in our knowledge of the Nkanu and Mbeeko culture, the outline presented here is sufficient to provide an idea of the creative genius of the Nkanu and Mbeeko. It shows us how the masks and the other ritual objects, like the initiation societies that used them, played a considerable part in maintaining traditions, education and training of the younger generation.

In examining the nomenclature of these objects, their forms and various functions, it is apparent that the development of the *n'khanda* society among the Eastern Kongo was very probably due to their numerous contacts with the Yaka. In fact, to satisfy the needs of a ritual transformation, the masks from both peoples have acquired various comparable physical characteristics, which sometimes give them the appearance of marvellous or fantastic beings, sometimes terrifying and frightening, sometimes superb and appealing.

The wide range of forms which they take, their vivid polychrome decoration, as well as their superstructure, make them something more than simple carved objects. They doubtless underpin a code of moral and social values, and the different precepts necessary for the survival of the community. There is nothing remarkable in this, since the use of masks among these peoples is closely linked with the societies for circumcision and initiation, whose purpose is to train youngsters so that they are better able to adapt to adult life. In this way, each generation undergoes a passage of initiation in which the young people are made aware of their new role in the community. One might say that a kind of renewal of society takes place, reminding its members of the archetypes or ideals of the main social roles, by means of the mask ceremonies.

In conclusion it must be said that this study of the artistic world and initiation ceremonies of the Eastern Kongo needs to be pursued further. The position of these peoples, in the midst of Yaka and Teke influences, is one reason why they arouse such great interest.

1. Amongst others, we should mention the works of Plancquaert (1930), Himmelheber (1939), Huber (1956), Devisch (1972), Bourgeois (1984), on the Yaka; the work of Van Wing (1938) on the Mpangu; and of Bittremieux (1936), Doutreloux (1959) and Lehuard (1989) on the peoples of the Lower Kongo.

2. There are three researchers now working among the Nkanu and the Mbeeko: Annemieke Van Damme (Universiteit Gent) is working on a doctoral thesis on Nkanu, Lula and Mbeeko art; another thesis in preparation at the Katholieke Universiteit Leuven is concerned with the Nkanu's traditional medicine.

3. *Tuula tuula, tuula ituula, ye nkhooso, ye ngolo, ye kukola, ye kusyaama.*

4. *Kaselo usolula mpasi.*

5. *Luvuumbu uvuumbula muuntu ufwa nima, ufwa mabuta; uvuumbula muntu kakola nkonsu, kakola ngolo.*

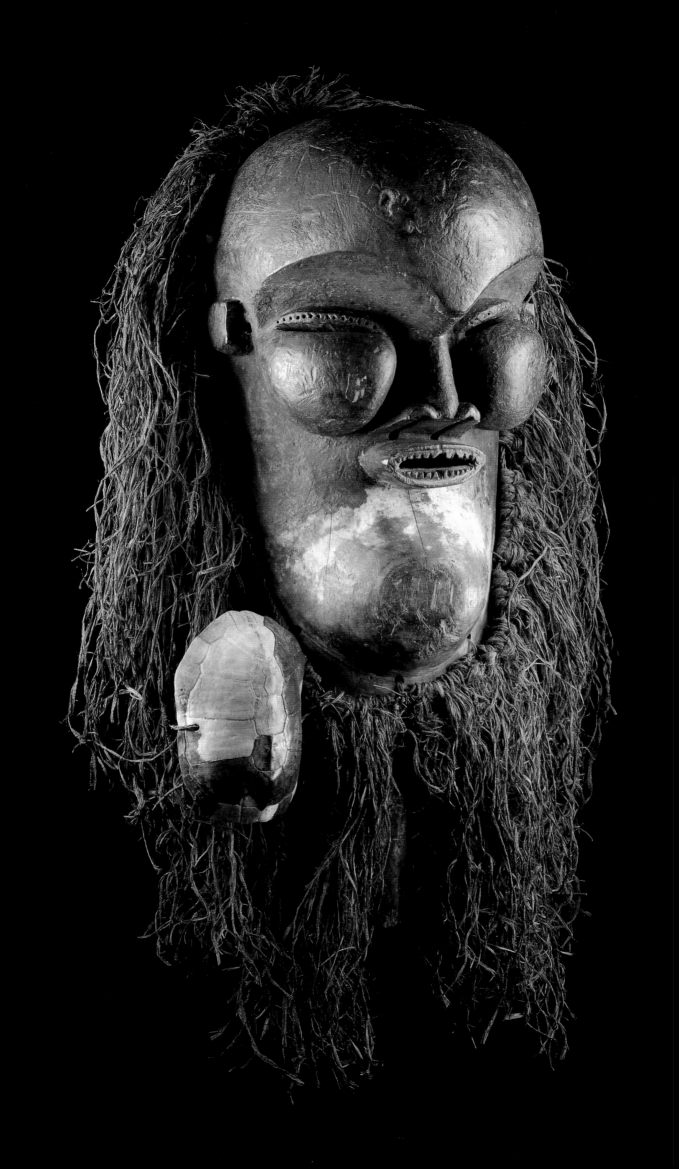

Masks and Masking Among the Yaka, Suku, and Related Peoples

Arthur P. BOURGEOIS

The Yaka inhabit Popokabaka, Kenge, and Kasongo Lunda sectors of Bandundu Province of southwestern Zaire and Uige Province of northern Angola. The Yaka are bordered on the west by various groups of the Kongo ethnic complex, e.g., Nkanu, Lula, Zombo, and Sosso; Teke-Mfinu and Mbala peoples to the north; Suku and Luwa-Sonde to the east; and Holo, Southern Suku, and Chokwe to the south. Yaka ethnicity is internally complex. Before 1930, the Yaka were ruled by Luwa overlords of Lunda origin but equally incorporated enclaves of Tsaamba and Suku as well as political splinter groups such as the Pelende. Yet the range of diversity in style and function of their masking traditions cannot be directly correlated with either political loyalties nor particular lineage segments.

Masks are used in association with coming to manhood and circumcision rites known as *mukanda* or *n-khanda*, that impose rigid discipline on adolescent males, teach respect for elders, endurance, and mores of behavior in adult society. The variety of masks assure and protect the future fertility of the initiated young male and cover a range of ritual importance that stretches from an awesome cursing-healing role to a minimal role as ensurers of a generous reception for initiates following their period of seclusion.

The largest and most powerful masks present a terrorizing aspect in their performance and include a wooden mask called *kakuungu*, averaging some 85 centimeters high, characterized by inflated cheeks, massive features, and a prominent chin (cat. 10). The basic painted colors are red and white with the chin area generally white or the face vertically divided with white on one side and red on the other. Regarded as the oldest as well as the most powerful of all masks, the *kakuungu* variety was owned and often worn by *yisidika*, the charm specialist of the initiation camp, and it was one of a series of charm instruments that he might employ to assure the well-being of the youths. The *kakuungu* masked personage customarily appeared the day of circumcision, the day of departure from the *n-khanda* camp, and occasionally for the breaking of food restrictions. Its principal function was to frighten the candidates into obedience and respect for their elders, and to threaten any person who would secretly harbor evil intentions against one of the young initiates. The mask would also appear in the event of a crisis, or be used outside of initiation to treat impotency in men and sterility in women.

A second terrorizing mask called *mbawa* is clearly distinct from *kakuungu* both conceptually and structurally. *Mbawa* is constructed of bamboo splints bound into an oval or near spherical structure covered with painted raffia cloth (cat. 11). At the top of the mask are attached two horns, either extended from two armature-like basketry cones or actual animal horns directly appended to the mask. Stretching in front of the horns and crowning the head runs a raised border serving as a decorated headdress. Frequently, a ridge vertically divides the face and serves as a nose. The raffia cloth surface is first painted with a resin which upon drying is covered in solid colors. Measuring up to 150 centimeters between the tips of projecting horns and 100 centimeters in diameter of the head, *mbawa* masks dwarf those of *kakuungu*. Like *kakuungu*, however, they were used on the day of circumcision, the going-out from *n-khanda*, and the breaking of food restrictions but rarely if ever did the two masks appear together. In its imagery, the horned *mbawa* mask is associated with the buffalo *mpakasa* (*Syncerus caffer*), the largest of African bovines (cat. 9 and ill. 3). In the far south, it is carved of wood and may depict either the *mpakasa* buffalo or a horse-sized variety of antelope, or found as a composite mask bearing a human face with animal characteristics.

The most widespread mask variety throughout the Kwango River region is a netted head-covering made of twined raffia fiber to which are attached a profusion of feathers and named

10
SUKU
Zaire, Bandundu
anthropomorphic half-helmet mask
kakuungu
H. 82 cm. Wood, pigment, fiber, tortoiseshell

Kakuungu is the name of this imposing mask which is seen both among the Yaka and the Nkanu. Depicted is a human face with a large forehead, bulging cheeks, and a heavy chin. This example, attributed to the Suku, originates from the Kitoma region. The *kakuungu* mask is worn by the *nganga yisidika*, the ritual expert, who performs as master-initiator and the specialist of magical means. It is reckoned to be the oldest and most powerful of all masks. *Kakuungu* is often accompanied by a female mask, named *kazeba*, which is smaller but of more or less the same form. The mask appears during circumcision to awaken the boys' courage. Important is its function as bogeyman, to instill the candidates with obedience and respect for their elders, as well as to frighten off those with evil thoughts toward the young initiates. *Kakuungu* is more powerful than the *mbawa* mask. It is called upon for the treatment of impotence and sterility. *Mbawa* would be more efficacious for the warding off of torential rainfall and storms. Both masks perform upon the same occasions, however never together. (F.H.)

Lit.: Bourgeois 1980; Bourgeois 1984; Bourgeois 1991; BOURGEOIS (p. 49)

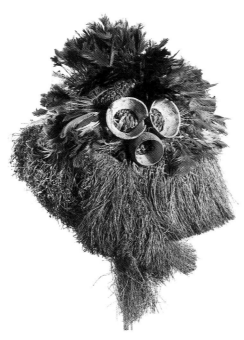

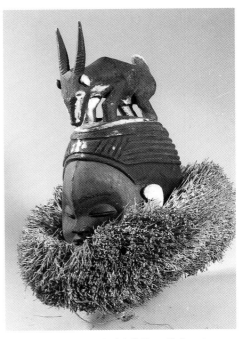

II
YAKA or SUKU

Zaire, Bandundu

anthropo-zoomorphic bell mask

mbawa

H. 165 cm. Wood, fiber, bamboo, pigment

As already mentioned (cat. 9 and 10), one associates the *mbawa* mask with a large antelope or with the *mpakasa* buffalo. Sometimes real horns surmount the mask, though in most cases they are imitated in stuffed raffia fiber. The anthropomorphic facial features are typified by eyes — from small tufts of hair — and a carved nose and mouth attached to the oval facial plane. This mask type is not made by a professional sculptor, but by the specialist of the ritual. *Mbawa* is of lesser importance than the *kakuungu* mask. It nevertheless appears on the day of circumcision, or upon departure from the initiation camp, or with the breaching of dietary restrictions. The mask is also attributed with therapeutic properties, including the healing of impotence and sterility. The patient would spend several days in isolation with the mask. *Mbawa* can also ward off rain or tornadoes. (F.H.)

Lit.: Himmelheber 1939; Bourgeois 1991; BOURGEOIS (p. 49)

ill. 1. Northern Yaka (Bandundu). *Mweelu*. H. 40 cm. Collected pre-1926 in Gingungi-Lukula. M.R.A.C., Tervuren (R.G. 26514).

ill. 2. Southern Yaka (Bandundu). H. 44 cm. Collected pre-1942 in Pandzi. M.R.A.C., Tervuren (R.G. 42.19.12).

mweelu (ill. 1). Facial features may consist of painted calabash or bamboo segments or attached upturned beak of a hornbill bird. *Mweelu* is considered the most essential mask of *n-khanda* worn by camp officials in charge of food supplies. In augmenting the normal rations provided by village women, the *mweelu* masked personage descends upon the village to snatch edibles such as peanuts, manioc, or corn from their startled owners or may beg further foods by means of signs. *Mweelu* is not regarded lightly and all uninitiated flee and take cover at its approach. Following an adequate preparation, the initiates themselves might don the mask for an occasional raid. But *mweelu* is equally a charm of safe conduct for the boys at their emergence from the *n-khanda* camp. The masked personage first dances into the village, and thereafter seeks the gift of kaolin (*pemba*) from the village chief or charm specialist *yisidika*, and from anyone under treatment of a powerful lineage charm.

A wooden helmet-shaped mask with exterior carved into a human face and coiffure, often surmounted by an animal or personage (cat. 18 and ill. 2), derives from some Yaka enclaves (some asserting relationship to the Suku before their dispersion) and their Suku neighbors to the east and south. As incorporated into Yaka *n-khanda* festivities, the helmet mask is generally called *mbala* although termed by both northern and southern Suku groups as *hemba*. The *hemba* mask is first danced within the initiation camp at the occasion when other important charms are shown in the traditional initiation of the Suku. A notable of the village had previously treated the mask with a concoction of powerful ingredients and the blood of a cock had been sprinkled over it. This activated the mask-charm and no one could casually touch it without harm. With careful instruction, the older initiates are taught to dance and then permitted to wear a pair of *hemba* masks into the village at the closing festivities. For this dance, additional charms are placed inside the mask or attached to its shaggy fringe that would "shoot" any witch who might attempt to harm the dancer.

Most widely known for their creative ingenuity are dance masks of the Northern Yaka that perform as a series: namely, *kambaandzia* and *kholuka* (*mbala*) with pairs of *tsekedi*, *myondo*, and *ndeemba* appearing between them. The most significant as mask charms are the first and last of this series, namely *kambaandzia* and *kholuka*.

Kambaandzia is constructed as a wooden armature in the shape of a cap with an oblong brim mounting upwards and assuming a miter-like appearance. In front of the projecting brim is a small oval head nearly hidden in the surrounding fringe of straw-like fiber. Over this surface is

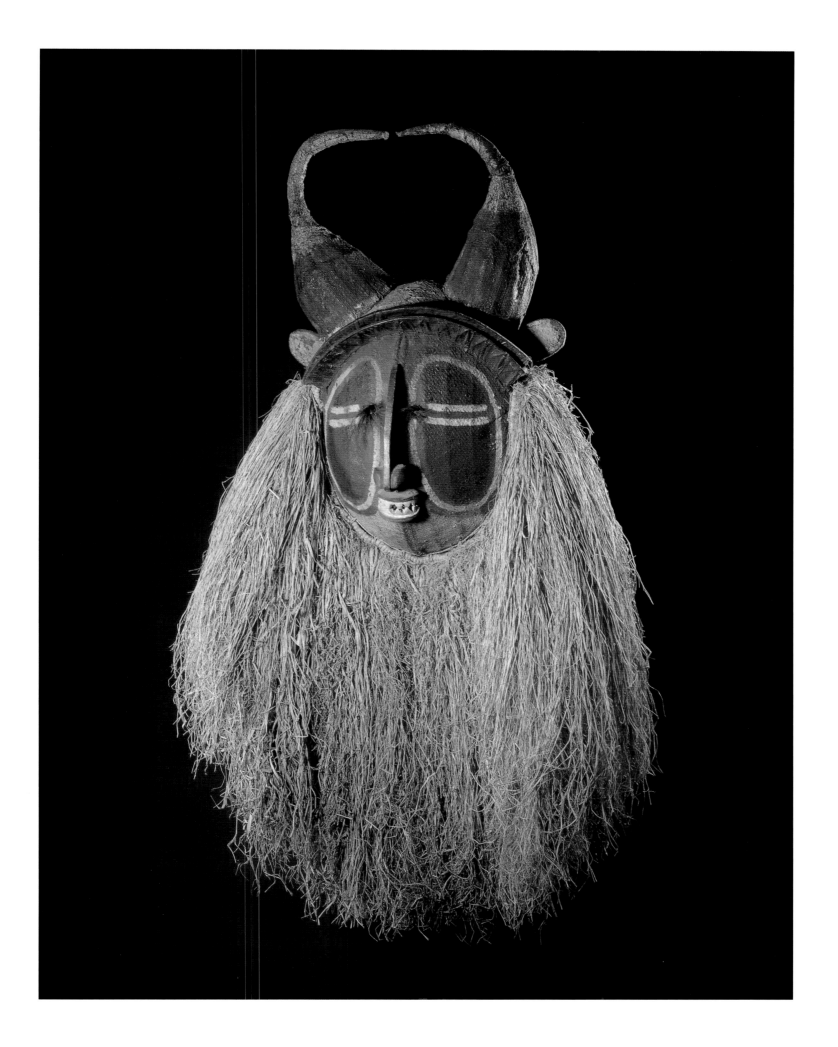

12
YAKA

Zaire, Bandundu, Popokabaka
anthropomorphic half-helmet mask
mbala or *kholuka*
H. 65.5 cm. Wood, pigment, fiber, hair

In this mask the face is replaced by a fully sculpted female figure with emphasized breasts and genitalia, complete with pubic hair. During the feasts which conclude the initiation period among the Northern Yaka groups, songs are sung whose content lays stress on the difference between the sexes. Masks are worn, called *kholuka* or *mbala*, which make visual the songs' texts, whereby their metaphorical role is stressed in scenes crowned by these masks. They are the magical-religious means through which male fertility is assured and protected. The three-dimensional representations on the masks often poke ridicule at women and female attributes. Not rarely one sees representations of male figures with erect sexual organs, or portrayals of copulation scenes of humans and animals. The mask is worn by the *n'langala*, or camp leader. (F.H.)

Lit.: Bourgeois 1982; Bourgeois 1984

stretched raffia cloth, or more recently cotton material, covered with a black resin and painted in rows of triangles and cross-hatched areas set off in colors of red, white, blue, and yellow. The *kambaandzia* mask is worn the evening before the appearance of other masks in the Yaka exhibition series where it briefly dances and receives the gifts of bystanders. Later it is placed on the ground before the drummers as an honored emblem rather than being worn. At the end of the festivities and subsequent tour throughout the region, it was returned to the sculptor, who placed it near a termite hill, later burned it, and then was anointed with its ashes. The *kambaandzia* mask symbolizes the gazelle *tsetsi*, a slight animal that inhabits the tropical valley forests and maintains a reputation among hunters and in popular tales as a clever prankster.

Kholuka (*mbala*) and the preceding pairs of this mask series have the head and coiffure portion made of splints and raffia fabric, while the facial features flanked by projecting ears are carefully carved of wood (cat. 12-14). The nose is notably prominent and occasionally presents a greatly elongated appendage that encircles upward. Puppet-like images surmount the conical coiffures of *kholuka* masks and feature a variety of scenes including sexuality and procreation expressed in both human and animal models.

Elements that distinguish one variety of named dance mask in this series from another are arbitrarily chosen, the decision being left ultimately to the sculptor who names them. Wooden faces are ranked according to their size, with the largest or most expressive face assigned to those of higher rank. Animal faces (cat. 16, p. 13) rank lowest in the series, but this can occasionally be reversed for dramatic effect or if the image is regarded as exceptionally well made. Similarly, those coiffures with the tallest projections are generally associated with higher ranking masks.

Puppet-like images surmounting the *kholuka* mask partake of major motifs introduced earlier by dance leaders and sung in chorus by bystanders or dancing crowds. Although individually composed, these verses function as jolting abuse that is socially sanctioned. Highly ribald and lewd references are directed toward the women, and local authorities are ridiculed. All of this proceeds much to the amusement of the crowd participating in the sung refrains. Yet as a mask-charm, powerful ingredients are inserted within the *kholuka* mask together with ashes from the nose of a mask from a prior initiation, thereby retaining ritual continuity with a previous *n-khanda*.

Certain masks have either animal or human attributes intended to startle the viewer beyond categories and relationships that they have up to now taken for granted. As Turner (1967: 105) has suggested with regard to the Ndembu and Lovale masking traditions in Angola, elements are taken from their usual setting and recombined into a totally unique configuration. Participants step out of ordinary daily life into another reality of heightened aesthetic significance. Yet to some degree it is a repeat performance, it is not completely unexpected. Some elements endure since the last like experience and build upon them. Social messages are communicated and reinforced not only to the audience but within the performers themselves.

One aspect of the message undoubtedly concerns life force. According to Devisch (1985: 611-612), the vital force or life principle (*m-mooyi*) of the Yaka — which effects bodily transitions, invigorates and animates — is thought to be concentrated in both male semen and hard boney structures of the human body such as the skull. Although Devisch does not relate this to facial features of masks, visual characterizations of the human head and exaggerations of sense organs of the face in masking can be viewed as explicitating vital force by dramatizing the functions of listening, smelling, speaking and seeing. As presented by Devisch (1985: 606-610), listening for the Yaka implies reflection and understanding and accepting orders via the ear. Speaking authoritatively implies the assertive power of ancestral words and wisdom. A keen sense of smell denotes for the Yaka a comprehension of signs that pass unnoticed to others as well as an anticipation of the smells of sexual intimacy. Finally, sharp vision implies superior perception and memory of distant persons and situations, including the ancestors and the deceased. Super-vision, an attribute of chiefly investiture, detects a path toward unity and permanence in plurality and transcience, and order in disorder.

Animal imagery can humorously make reference in their peering stances, olfactory alertness or

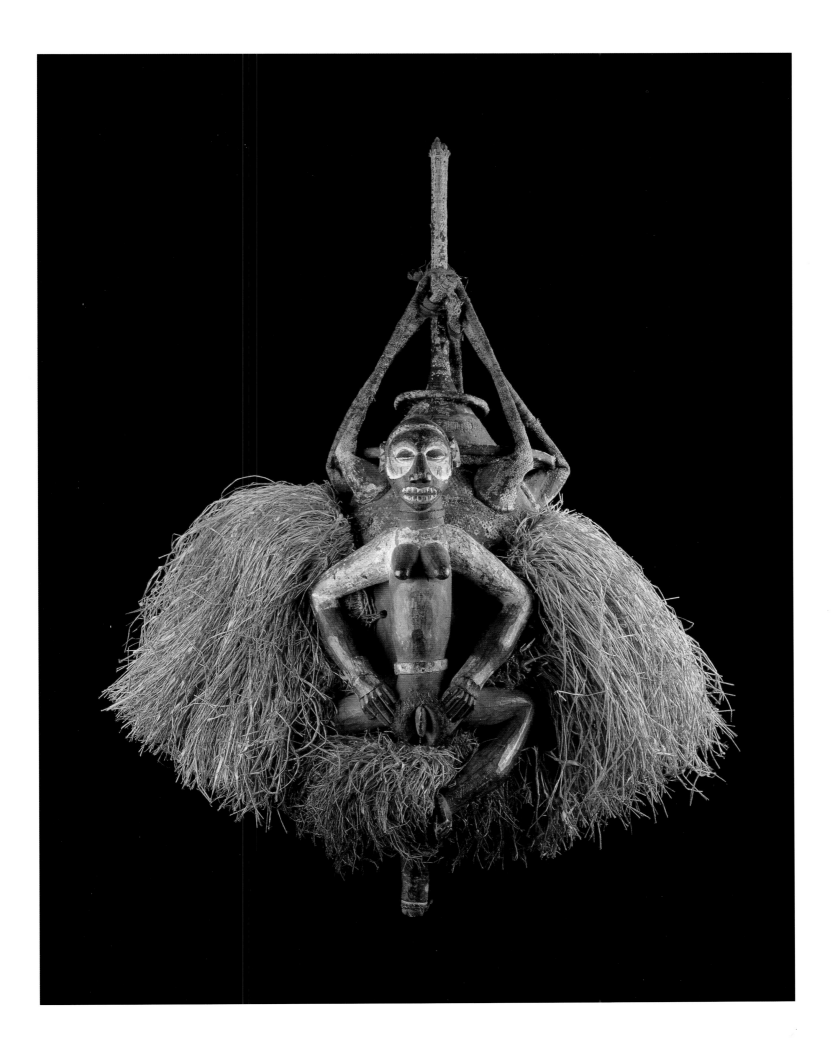

sexual interaction to corresponding human models. Parallels to human behavior can also be seen with regard to the *mbawa* mask with its *mpakasa* buffalo reference as unpredictable bullish strength or, in its human counterpart, like an irascible elder who can in turns be menacing or helpful. Yet all *n-khanda* maskers retain something of an animal aspect by the skins of wild animals attached to their loosely hanging fiber fringe or skirt, the location of the initiation camp in the bush, nudity of initiates and their remaining in the open for the first few days. Moreover, the symbolic importance given to *tsetsi*, the gazelle, places the *n-khanda* institution itself within the animal realm. The initiates as animals are thus at a threshold or "betwixt-and-between" state. They are dangerous to others and vulnerable themselves to embodied envy or ill will under the guise of witches. Terrorizing masks like *kakuungu* or *mweelu* elicit the arcane and malevolent reputation of the *mumfwa* or disembodied spirits, vengeful and jealous aspects of disgruntled elders and ancestors. To summarize their function, Yaka masks function as personalized extensions of charm specialists that shield and protect potential fertility against harmful influences.

Stylistic interrelationships between masks of the middle Kwango region and Chokwe masking to the southwest can be readily observed in surmounting gradations of disk shapes, miter-like elements, and resin covered surfaces that are brightly painted. In the main, Yaka and Suku masking contrast sharply with masks of their southeastern neighbors in the widespread use of masks carved in part or wholly of wood. (Although wooden masks are presently carved by the Chokwe and allied peoples, they are generally acknowledged to be a recent innovation; Chokwe ritual masks associated with powers of leadership are notably made of resin and fiber stretched over a constructed framework).

Masks carved of wood appear to be linked stylistically to a tier of wooden masks characteristic of populations living near the northern edge of the savanna. The earliest collected helmet-shaped examples derive from the middle Kwilu. Kwango examples are closely related and apparently derive from this northeastern source. Helmet-shaped masks that bear a definite affinity to Suku masking are similarly used by the Mbala (cat. 19, p. 15), Kwese, and Western Pende even though they present a distinct interpretation of the crested coiffure and descending camber-shaped eyes. In the south, the Holo have recently adopted the red-faced Southern Suku renditions of helmet-shaped masking (ill. 2).

Puppetry-like or carved imagery surmounting certain Yaka and Suku mask types would appear to derive either from Luwa [Lunda] directives that their totemic animals be added atop masks used by indigenous populations as suggested by Leo Frobenius (Klein 1985: 49-50; Bourgeois 1990:

YAKA

Zaire, Bandundu

anthropomorphic half-helmet mask

mbala or *kholuka*

H. 31 cm. Wood, pigment, fiber

The design of the face with wooden grip below it, characterizes the Yaka masks from the area between Kimbau on the Inzia River (east) and the land inhabited by the Nkanu and the Zombo (west). The painting harks back to the Eastern Kongo peoples, to which the Nkanu also belong. The pinnacle in the form of a house indicates that this is an *mbala* mask, also named as *kholuka*. As with the preceding example, this mask is also laden with sexual connotations. The meaning of the representation on this mask, a house, perhaps at first sight appears less evident. It is explained by the following fragment of verse, recited during the initiation: "You have not been introduced so do not build a house yet." The content alludes to the conjugal rights attained by a young man after the payment of the brideprice. As is the case for many Yaka masks, this face has a prominent upturned nose. This is inspired by the elephant, an animal admired by the Yaka for the way that its trunk can penetrate hollows, or root in the ground. (F.H.)

Lit.: Bourgeois 1982; Bourgeois 1984

ill. 3. Holo (Bandundu). Antelope mask in Kinzamba. Photo: C. Lamote, 1950. M.R.A.C., Tervuren (E.PH. 14690). *See cat. 9*

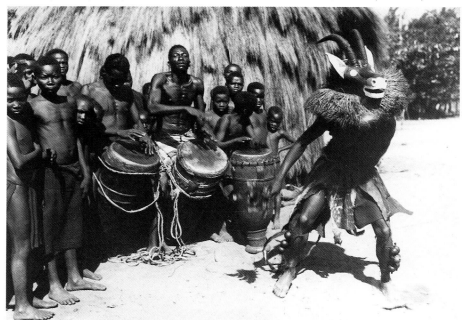

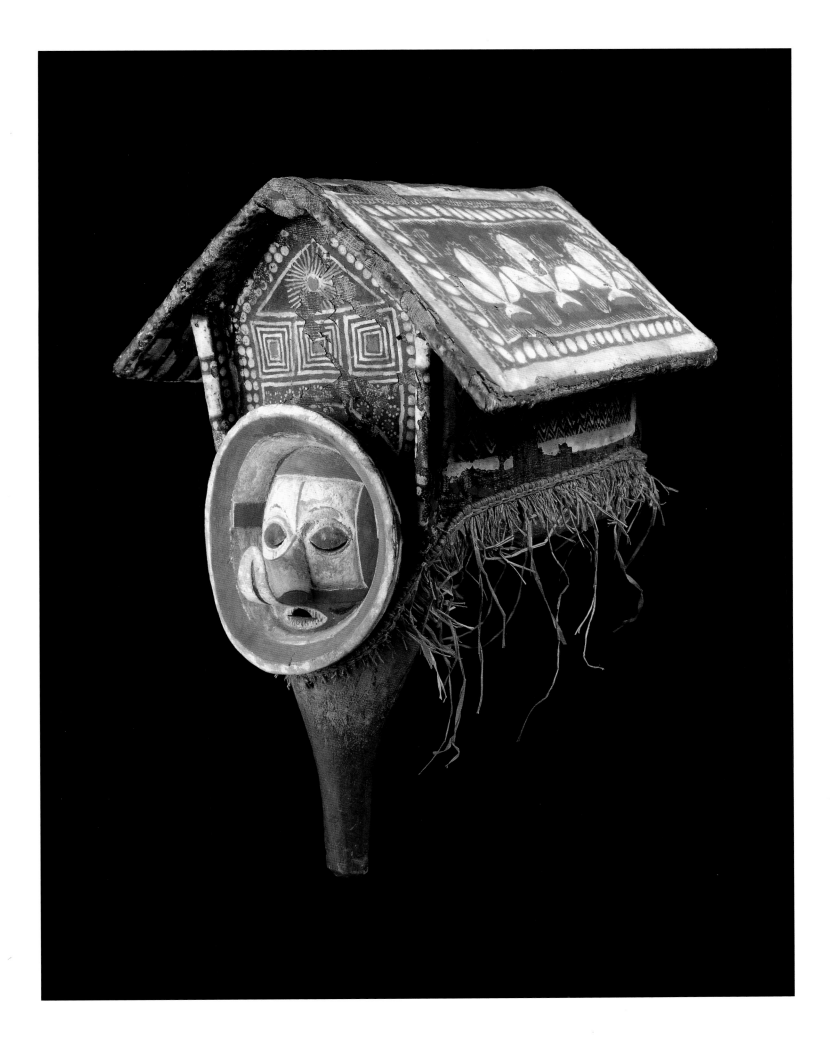

126), or may owe something to whimsical imagery of 19th-century imported European clay pipes (Bourgeois 1992). Greatly exaggerated facial features of Yaka masks appear to be unique, although this too could have been stimulated either by imported European imagery or use of natural forms such as attachment of calabash sections as eyes or the inverted beak of the hornbill bird as nose. Sexual imagery such as copulation scenes and display of enlarged or erect male or female genitalia reflect magico-religious concern for male fertility, male solidarity and group humor all integated into coming-of-age contexts for young males (Bourgeois 1982).

Use of polychrome in Yaka mask decoration as well as expressive sculptural interpretation of facial forms extend west of the Kwango River to the Lula, Nkanu (cat. 7), Zombo (cat. 9) and Sosso (cat. 6) who utilize similar masks in initiation context known as *nzo loongo*. Here a tendency toward more carefully rounded forms, incorporation of a raised circular frame, and bag-like textile extensions behind the wooden mask are distinctive.

The visual spectrum within the corpus of collected masks run riot in color and expression. Bulging cheeks, eyes, trumpeting noses, flanking ears, paired or clustered vertical projections, and towering cones surmounted with feathers, disks and images, contribute to this. Staid helmet masks of wood catch the eye with the haunting white faces riding over thick raphia collars and topped by animal imagery that in their proper context leap together with the pulsed gestures of the dancer. Masking of the Yaka, Suku and their neighbors in the range of its diversity defies reduction to a simple stylistic formula or description of functional intent.

14
YAKA
Zaire, Bandundu
anthropomorphic half-helmet mask
mbala or *kholuka*
H. 58 cm. Wood, pigment, fiber

The morphology of the face, with spherical protruding eyes and large nose, situates this mask's origin in the Northern Yaka region. In front, on the conical apex, sits a lizard-like animal with its head down and tail upright. The head and toes are carved in wood. The body is made of stuffed raffia cloth. It is usual to garnish the *kholuka* masks with magical materials and objects. Thus, the ashes — coming from the nose of a *kholuka* mask used in a former initiation — are applied to the mask. By this one neutralizes the dangers bound to this magical material, and the mask can then protect the young initiates from this power. Likewise, continuity with previous initiations is so assured. (F.H.)

Lit.: Bourgeois 1982; Bourgeois 1984

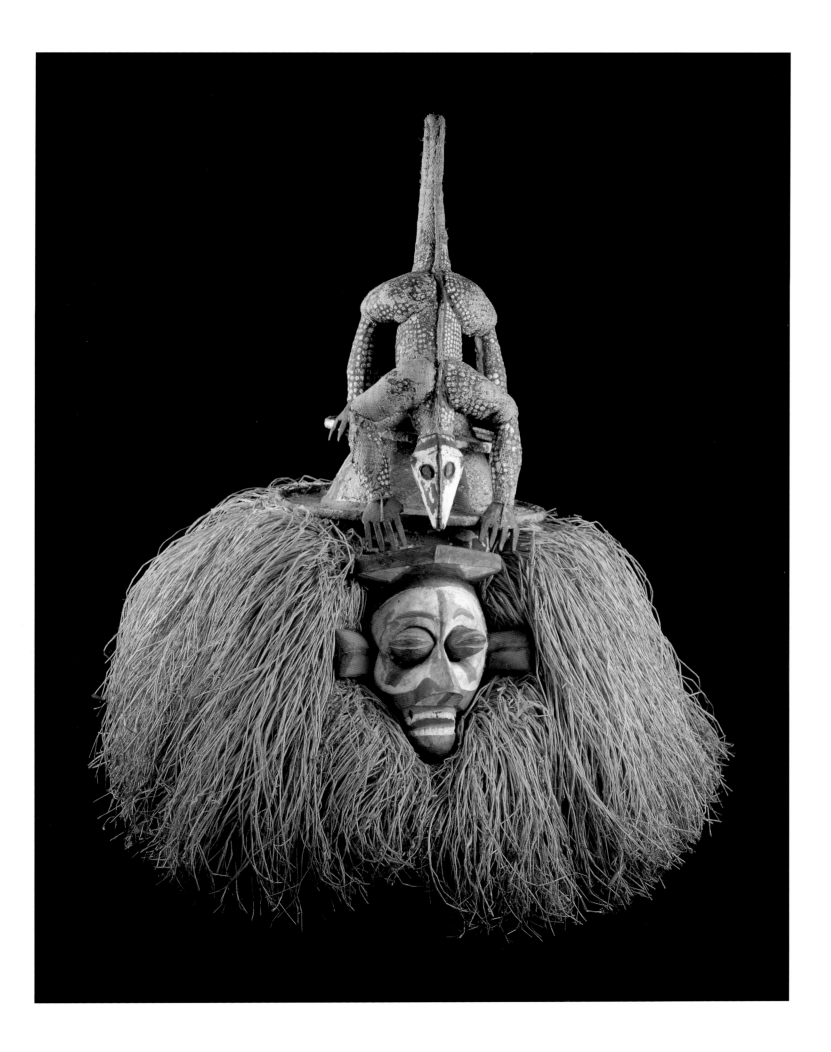

17
YAKA

Zaire, Bandundu
anthropomorphic helmet mask
H. 28 cm. Rattan, fiber, pigment

This mask has an ovoid face, smoothed with lengthwise-running sections. The facial features are depicted in pigments of brown, black, and white. The border of the forehead is given in a spherical, flanged edge. Generally with this type of mask the head is crowned with a conical headdress consisting of horizontal discs, decreasing in size as they mount. On each side sits a protuberance that perhaps represents a horn. In comparison with other examples, it may be presumed that this mask originates from the Southern Yaka region. The manner of these masks' making, with their undercarriage of twigs over which is stretched painted-upon raffia cloth, exhibits a certain similarity to the Chokwe initiation masks. (F.H.)

Lit.: Bourgeois 1984; BOURGEOIS (p. 49)

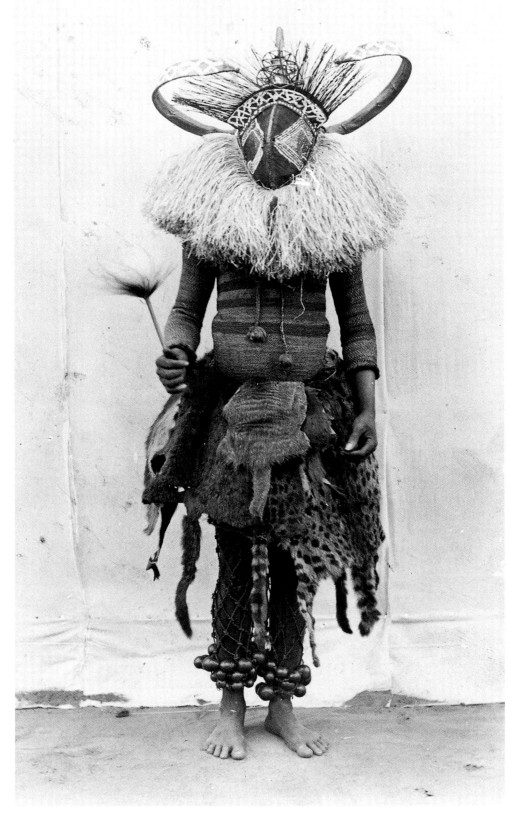

ill. 4. Sonde (Bandundu). Photo: L. Huet, between 1896 and 1899. M.R.A.C., Tervuren (E.PH. 4594). *See cat. 17*

58

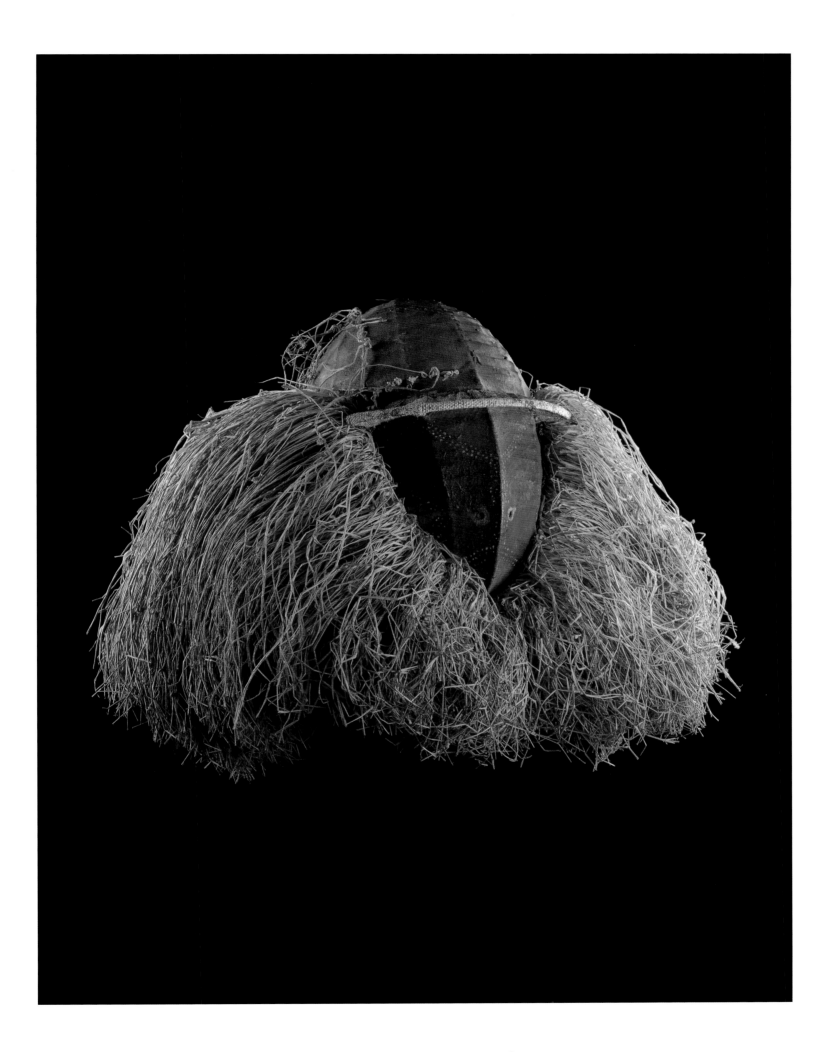

18
SUKU
Zaire, Bandundu
anthropomorphic bell mask
hemba or *geemba*
H. 38 cm. Wood, pigment, fiber, animal skin

This wooden bell-shaped mask originates
from the Northern Suku who live by the
rivers Luie and Lukula, more particularly
around Kingungi. Their neighbors are the
Yaka (west), the Mbala (north and east), the
Kwese (east) and, still further to the east,
the Western Pende. All these peoples use
bell-shaped masks. This mask has a certain
affinity to the Mbala mask under cat. 19,
p. 15. Both have a lobed headdress, which
corresponds to the traditional head-covering
of the Mbala and various other neighboring
peoples. Indeed, it is accepted that the Suku
adopted the bell-shaped mask from their
eastern neighbors, and then added elements
such as the representation of a man or
animal on the pinnacle. In turn, this was
probably inspired by the *kholuka* masks of
the Northern Yaka (cat. 12 and 24). The
absence of such a crowning element on this
mask leads one to suspect that this mask is
female. Together with her male partner she
incarnates the complementary ideal that
must lead to propagation. These masks
perform within the scope of initiation
practice. Equally, *hemba* masks are magical
agents that can heal, assure a successful
hunt, and neutralize those harboring evil or
wicked intentions. (F.H.)

Lit.: Bourgeois 1981; Bourgeois 1984; Biebuyck 1985

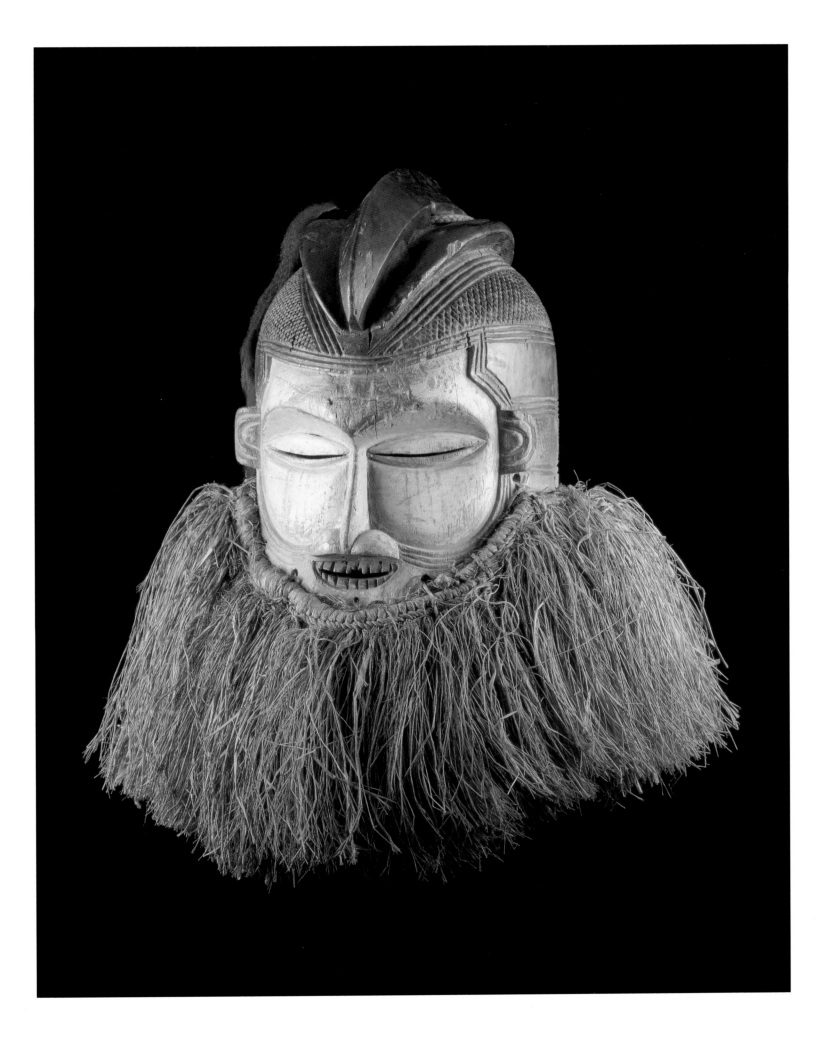

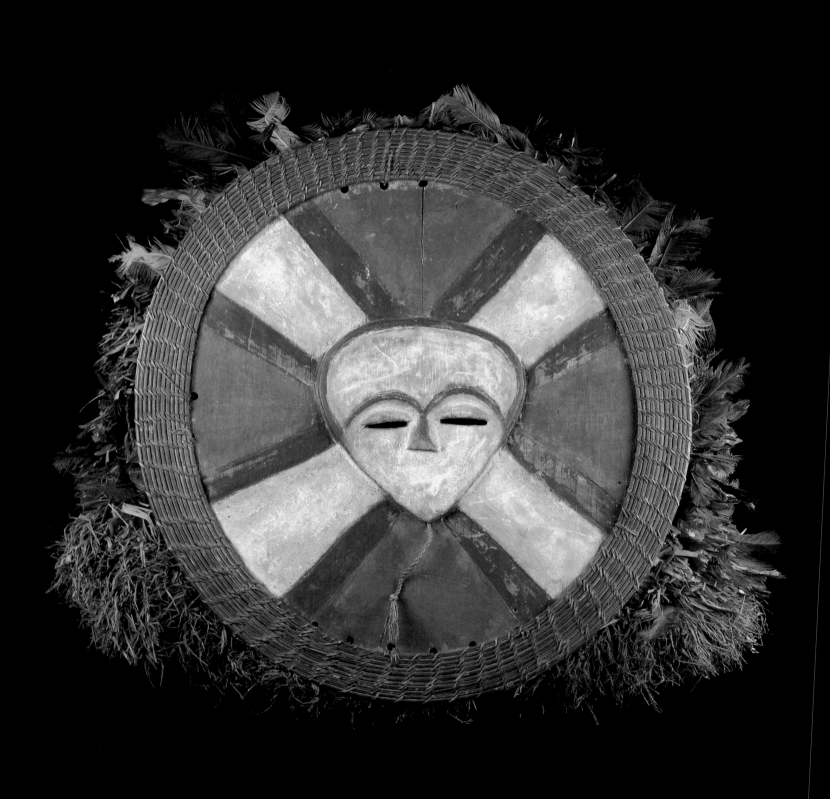

Pende Mask Styles

Constantijn PETRIDIS

Pende masks, which have been repeatedly published in the specialist literature, are characterized by a surprising diversity of forms and types. It is primarily thanks to Léon de Sousberghe and his *L'art pende* (1959), that Pende sculpture has become more widely known.

A distinction may be drawn between three geografically determined style-regions, each with its own sculptural forms: the left bank of the Kwilu in the west, between the Kwilu and the Lutshima; Katundu (Gatundo) in the center, after the like-named chiefdom between the Kwilu and the Loange; and Kasai in the east, laying between the Kwilu and the Kasai. Although de Sousberghe (1959: 19) points to the neglect of the Kasai and the left bank of the Kwilu, Pende art is still today often spoken of exclusively in light of the Katundu style.

In this text we shall endeavor to identify and distinguish the diverse styles and forms in a more objective manner, based on a morphologic-stylistic investigation. Such a study serves then as a basis for analyzing the use, the function(s) and the meaning of the masks in their original, local surroundings. These aspects cannot, however, be comprehensively treated here. Only in the case of the mask types on exhibition, will their particular descriptions delve deeper into the local context.[1]

Though a number of authors, among whom McNaughton (1991: 52), adopt a sceptical attitude with regard to an approach which separately considers morphology and function/meaning, it is in our opinion better — for analytical reasons — to maintain this separation. Indeed, it should be emphasized that the case of the Pende seldom permits a precise demonstrable correspondence between form on the one hand, and function/meaning on the other.

Especially with regard to masks typical of the Katundu region, it is only posssible to discover which particular personage is being represented when the sculpture is considered in combination with the costume, attributes, dance steps and the accompanying music and song. Put even stronger, de Sousberghe (1959: 32; 35-36) and Mudiji-Malamba (1989: 79) assert that even the identification of a personage on the basis of a performance context must be taken relatively, seeing that the same mask forms are employed for the representation of various different characters, and *vice versa*. This is why the masks will here be approached as they are presented in public and private collections: as static and autonomous sculptures, stripped of their costume and attributes. It goes without saying that this approach has little in common with the manner in which the mask disguises are experienced by the local audience.

In addition to wooden masks, generally designated *mbuya*, the Pende are also makers of fiber masks, called *minganji* (ill.1). Nonetheless, some *minganji* are provided with a sculpted wooden face, and a few specimens are even wholly made from wood. The perishable nature of the chosen material led to only a few *minganji* masks being preserved. In this text the focus of our discussion will be on the atypical completely wooden version of the *gitenga* mask. Here, we may also note that the polychromy of the wooden masks is most often limited to the colors red, white, and black.

A stylistic classification is not only arbitrary, but also inevitably leads to a simplification of reality. Indeed, as a starting point one takes a number of "typical" masks, which serve as reference. The choice of these masks is in itself something subjective, and often there are just as many variants and aberrant forms. The fact that a particular sculpture does not answer to any one of the various styles or types, thus in no way means that it cannot be attributed to the Pende. The limits of the present text's purview obviously leave no room for the numerous anomalous forms.[2]

Any classification, moreover, is negated by the many overlaps, interchanges and mixtures on the stylistic plane. With the Pende, influences of style may either be attributed to mutual interaction within the three style-regions, or else through contact with neighboring art traditions. In reality, the coupling of styles and types with spatial factors is hardly tenable, given that this takes no ac-

21
PENDE
Zaire, Bandundu, left-bank Kwilu?
anthropomorphic face mask
gitenga
H. 45 cm. Wood, pigment, fiber, feathers

Although the *minganji* face masks, with a decidely aggressive character, make an appearance at a wide variety of occasions (such as the investiture ritual of a local chief, or the construction of a new chief's residence), their primary role is as guardian of the initiation encampment. The *gitenga* mask is described as the grandfather or the chief of the *minganji*. The masker is distinguished by a dignified gait, and carries a bell and a staff. The mask itself is conceived as a flat disc-form which is either totally worked from fibers and raffia, or alternatively provided with a small sculpted face. Exceptionally, as is the case here, the entire disc-form is sculpted in wood. The mask serves as a representation of the sun, a symbol of life and regeneration. The fiber-type is largely red colored and represents sunset, while the atypical wooden mask is white colored and refers to the rising sun. The *gitenga* mask thus stands in diametrical opposition to the other *minganji* characters, which embody death, uncertainty, and darkness. The *minganji*, together with the kindred *mungonge* funeral rite, were probably adopted from the Lunda. (C.P.)

Lit.: Maesen 1975; Ngolo Kibango 1976; de Sousberghe & Mestach 1981; Petridis 1992b

22
PENDE
Zaire, Bandundu
anthropomorphic face mask
mbuya jia muketu
H. 25 cm. Wood, pigment, fiber

Wooden *mbuya* mask-types in Katundu style normally portray various village characters such as the prostitute, the sorcerer, the chief, the clown, or the coquette. Aforetimes, these masks performed alone or in pairs following the young boys' seclusion in conjunction with circumcision and initiation, called *mukanda*. For some time now, they usually perform primarily for profane occasions, such as the visit of foreign travelers. The performance is always connected with a variety of prohibitions, and the dancers dress secretly within an enclosure. First there appeared a limited number of personages, with each performance alternating with a collective round-dance. The total number and the order of the maskers can differ widely, but the performance is most usually ushered in by the *tundu* mask. The mask personages, who themselves make no sound, are accompanied by song and music. The examples shown here most likely represent female characters, collectively known as *mbuya jia muketu*. These female roles are portrayed by men. Character and personality impress their mark on the human face, and thus on the mask as well. The peace-loving and tolerant character of women is embodied in the mask's smooth forehead and rounded face. The sculptures bear witness, moreover, to the great diversity seen within a paticular mask type. Female masks may have different names, and it is impossible to determine the particular personage on the basis of a mask's design. The *gabuku* personage represents a coquettish woman, the village beauty, appointed with beautiful cloth and conspicuous artificial breasts. She makes herself up with a mirror and comb, and

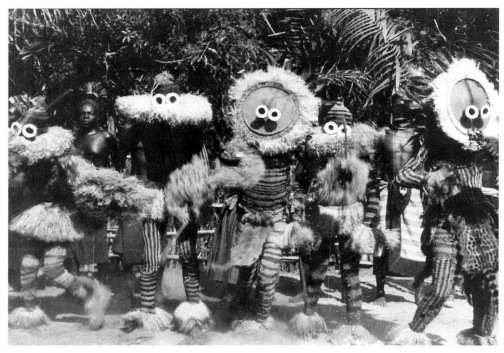

ill. 1. Western Pende (Bandundu). *Minganji* group, including two *gitenga*, in Gungu. Photo: A. Scohy, 1950. M.R.A.C., Tervuren (E.PH. 11531). *See cat. 21*

count of the dynamics of mutual borrowing and mixture. Furthermore, the data is often simply not available to link the differences within a particular style or type with precise spatial factors. One exception is the case of the Kasai masks which were gathered by Albert Maesen in the area around Tshikapa during 1953-54, upon commission of the Musée Royal de l'Afrique Centrale in Tervuren.

A further problem arises in relationship to the historicity of the various forms. It is no easy matter to accurately place the evolution of styles and types in time; this is due not only to the absence of historical indices, but also because we lack a scientific dating-method. A few sculptures which are part of museum collections, such as in the M.R.A.C., Tervuren, indeed are documented, though this information never sheds light on the period of a sculpture's creation, and even rarely relates the exact date of its collection.

The notion "one people, one style" is not applicable in the Pende context, for the simple reason that on the one hand more than one single Pende style exists, and on the other that the diverse styles are sometimes distributed across ethnic borders. For that matter, McNaughton (1987: 76) stresses that "African art has never been a slave to ethnicity, and that ethnicity itself is a most fluid and simple designation."

As concerns their use, function and meaning, the masks were seen as incarnations or personifications of ancestor-spirits, *mvumbi*, and serve as intermediaries between the dead and the living.[3]

In the Katundu area, the wooden *mbuya* would in former days primarily appear during the initiation and circumcision ceremonies, *mukanda*; more specifically, during the concluding dances following the boys' seclusion in the forest. The sculptures were also used for healing the sick, and would have a further role during the millet sowing and harvest feasts. For quite some time they have come to be exclusively used upon more profane occasions, such as the visit of foreign travelers or a local chief. The masqueraders dance is a veritable spectacle wherein various village-characters "perform", alone or in pairs.

The masks of the Kasai region seem to play a manifest role in community life, and have a more mysterious character. Animal mask-characters are apparently still today closely connected with the initiation rite and embody the idea that the initiates, during their period of seclusion in the forest, find themselves in "nature" as opposed to in "culture". Furthermore, the masks also perform during important events such as the appointment of a new chief, the construction of a new

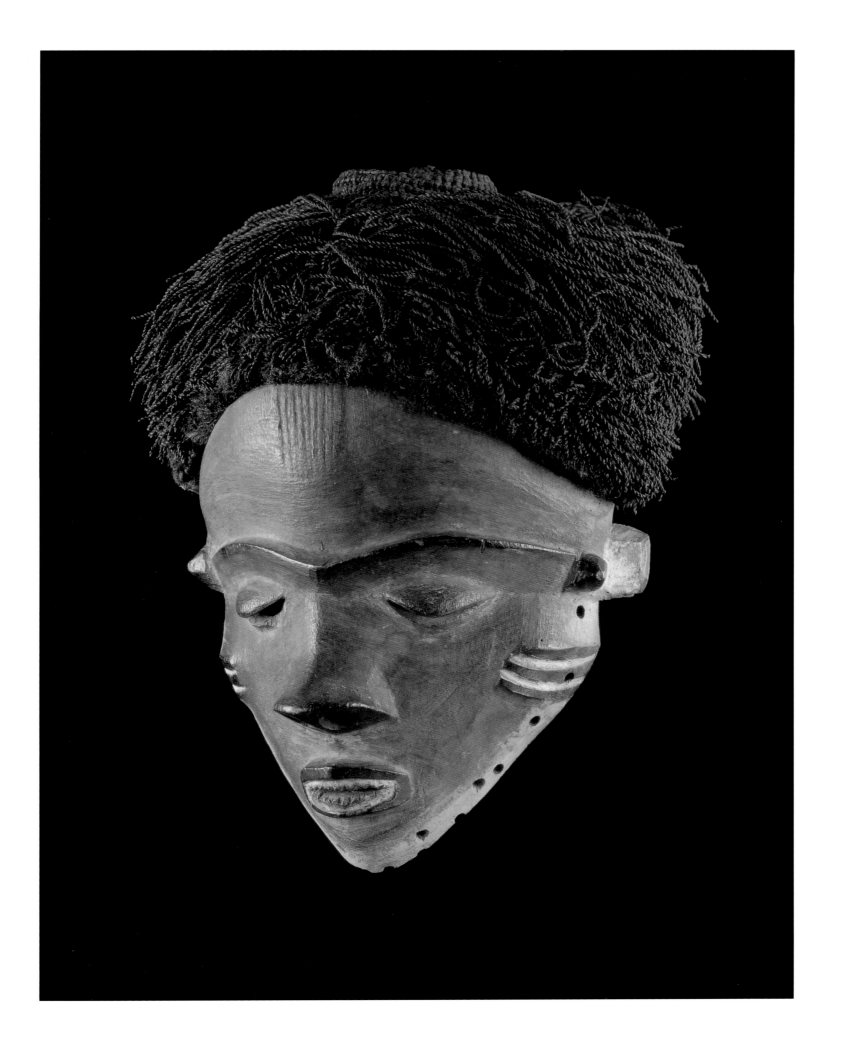

house for the chief, the healing of the ill and rites to mark the end of the farming-cycle. Finally, a few mask types adorn the posts surrounding the chief's compound, and exceptionally one may even encounter an imitation *kipoko* bell mask as a crowning roof ornament.

Concerning the mask sculptures belonging to the Kwilu's left bank, finally, there is nothing of certainty to be said. For that matter, we have but one photograph of masked dancers *in situ* taken by Helen Porter in the Kwilu district during the 1930s (see *Sotheby's London, Tribal Art, 26th June 1985*, p. 193).[4]

Masks in Katundu Style

Masks in this style were the most accumulated and are consequently the best represented in public and private collections. The majority of the Pende masks in the collection of the M.R.A.C., Tervuren are also in Katundu style. It may claim to be the most original stylistic creation of the Pende.

The Katundu style has left its mark on a number of other art forms. Best known are the miniatures in a variety of materials, called *ikoko*, which are worn around the neck as amulets (cat. 26-29). The style was to spread beyond the borders of its native region, and was adopted by other Pende chiefdoms of the central region. Furthermore, it also partly took the place of local mask forms in the Kasai and on the left bank of the Kwilu. Finally, one finds it among a number of neighboring peoples such as the Mbuun, the Pindi, the Wongo (cat. 56, p. 19) and the Lele. The Katundu origin and the mastership of the Katundu-Pende are always acknowledged here.

Katundu masks which come to be found in other chiefdoms mostly are the work of emigrant Katundu-Pende or of sculptors who had learned their craft with the Katundu. Because the Katundu-Pende were dependent to the administrative center in Tshikapa until 1930, the Katundu masks were spread in an easterly direction. Thereafter, they were subordinate to Kikwit and Gungu on the left bank of the Kwilu, with a consequent reverse diffusion in the westerly direction (de Sousberghe 1959: 59, n. 1).

De Sousberghe (1959: 22-23) emphasizes that the Katundu region can only lay claim as "fatherland" of the style, and does not constitute an indication of provenance. The term Katundu can thus only refer to the region of origin. Therefore one should really speak of a "mask in Katundu style". Moreover, it concerns a local style, typical for the area between the Kwilu and the Loange, notably within the territory belonging to the Katundu chiefdom of Kilembe. The territory to the south of Kilembe is namely characterized by a number of local mask forms.

De Sousberghe (1959: 32) also distinguishes between old and recent Katundu masks. The first series would, apart from a number of mysterious characters, be strongly individualized and therefore well-identifiable, while the second would be more stylized and thus less easy to identify. The author considers, namely, that in bygone times the sculptor was specialized in the making of one particular mask type (1959: 34). That a few masks may be identified without problem, is in fact primarily thanks to the existence of accompanying documentation and information.

Although the Katundu style often represents the human face, in this region one also encounters a number of masks which are interpreted as having a zoomorphic meaning. As a rule even when animals are represented, this is apparently done from an anthropomorphic starting point. A number of animal characters are further represented through sculptures and assemblages made from more perishable materials. The only purely zoomorphic wooden type field-collected among the Pende, a buffalo mask named *pakasa*, differs little from similar masks of neighboring peoples (cat. 9) (see Bourgeois 1991).

The Katundu style was strikingly described by Olbrechts (1946: 48) as follows: triangular closed eyelids, tightly drawn and emphasized cheeks, prominent cheekbones, small upturned nose and visible nostril holes, mouth with closed lips and downturned corners, or an oval partially open mouth with teeth visible. The most characteristic element is certainly the unbroken V-shaped eyebrow line in relief. On many of the masks tattoos are reproduced upon the forehead, cheeks and temples. One often also sees filed-teeth mimicked. Within this style a trio of types may be distinguished, taking into consideration the beard-like chin extension and headdress. The many differences within these types can most likely be attributed to the individuality of the sculptor

23
PENDE
Zaire, Bandundu
anthropomorphic face mask
mbuya jia muketu (*ngobo?*)
H. 25 cm. Wood, pigment, fiber

then dances with fly whisks in hand. The same mask is sometimes seen as representing the prostitute, *ngobo* or *tambi*. One may perhaps relate the example under cat. 23 to this personage. The figure is closely allied to the circumcision rite. By tradition, it appears that the young boys paid an obligatory visit to the public woman following their intiation-seclusion. The *kambanda* mask would portray the wife of the chief. This figure often performs together with the *tundu* mask, the clown who calls established values into question. Taken as a whole, female masks offer representations of typical female tasks and activities, and are closely associated with concepts of fertility and well-being. (C.P.)

Lit.: de Sousberghe 1959; Mudiji-Malamba 1989; Strother (*in* Beumers & Koloss 1992: 325, no. 123)

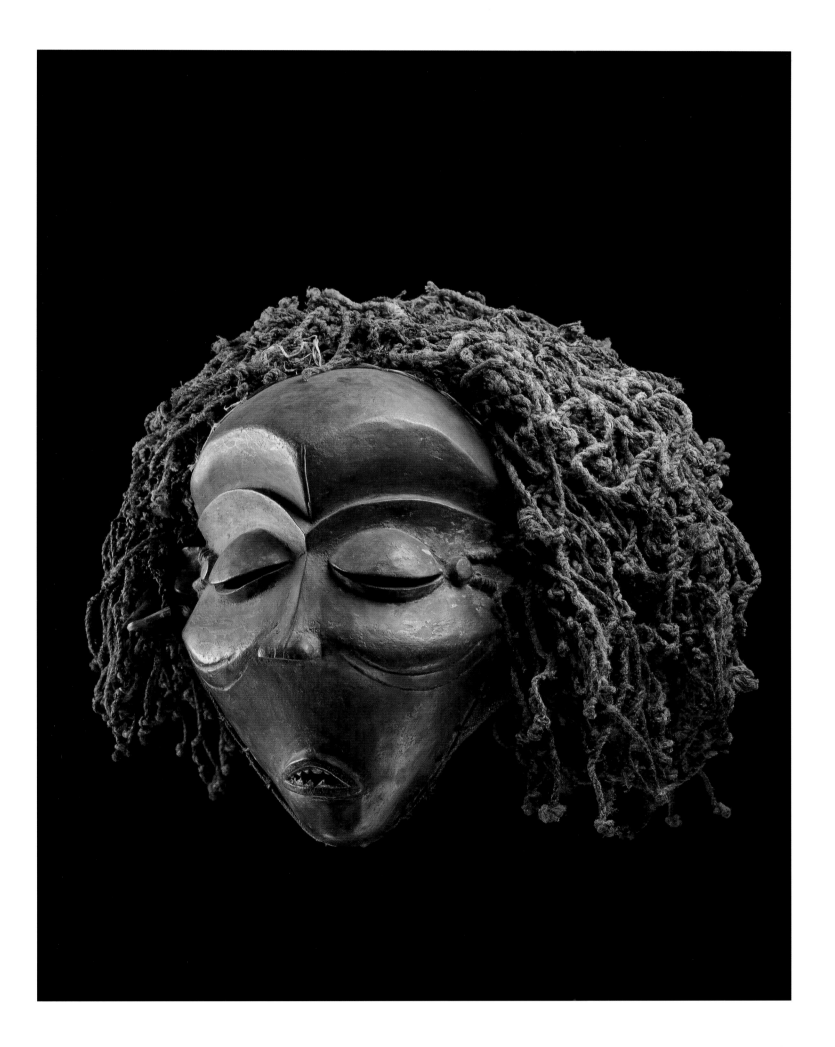

PENDE

Zaire, Bandundu
anthropomorphic half-helmet mask
giwoyo, muyombo, or *kinjinga*
H. 51 cm. Wood, pigment, fiber

Masks with a wooden beard-like chin extension, known as *giwoyo, muyombo,* or *kinjinga*, cannot be identified with certainty outside of a performance situation. On the basis of beard length and the mimicking of tatoos on the forehead, the example shown here — of the half-helmet type and worn horizontally — could be a *giwoyo* mask. Feathers were attached to the cylinder-shaped extension on the crown. The chin extension apparently represents the ancestral beard, and the decorative pattern of triangles or diamond-shapes are perhaps imitative of the skin of an adder or pangolin. The dancers carry fly swatters, and have cat-like skin attached at the belt. While these attributes are related to leadership, the dances and songs refer rather to the hunt. In former times the farming cycle was paired to collective hunts, and the sowing of millet provided an occasion for the mask's performance. The *giwoyo* mask belongs to the *mafuzo* mask-category: malevolent apparitions who close the performance. The personage dances on the border between the village and savanna; his function is to assure the sunrise. (C.P.)

Lit.: de Sousberghe 1959; de Sousberghe 1960; Mudiji-Malamba 1989

who, despite being strongly bound to certain stylistic forms, would still have considerable leeway to express his creative freedom.

The first type, lacking the beard-like chin extension, can be further divided into three subtypes based on the headdress. These are all face masks. A first subtype is characterized by a triangular (when seen frontally) headdress of woven raffia upon a fiber armature. A second subtype exhibits a large headdress of raffia braids or fibers with a central knot upon the crown. Such masks are usually included in the category *mbuya jia muketu*, the generic nomenclature for female characters (cat. 22 and 23). A third subtype features a raffia headdress with three to five horn-like raffia extensions, *gipo gia mbudi*. This mask form is in practice seen as the representation of *pumbu*, the warrior; *fumu*, the political chief; or *nganga ngombo*, the diviner.

The second type is noted by a beard-like chin extension (cat. 24). This "beard", called *mutumbi*, is usually rectangular in form, and when seen in profile it is often discretely inclined. It is richly decorated with diverse geometric patterns in relief. The often seen motif of black and white triangles in a checkerboard pattern is named *njege* or *pashi*. There exist some examples with a wooden headdress, and others with headdresses of raffia. While some specimens sport a short beard, others are provided with a long extension from the chin. There is, however, no firm correlation between headdress type and length of beard. The sculptures with a wooden headdress are of the half-helmet variety. On the skull cap one finds a headdress in bas-relief with a cylindrical protrusion surmounting the crown. Although specimens with a wooden skull cap and long chin extension are usually designated as *giwoyo* and the examples with a raffia headdress and a short beard as *muyombo*, in practice this contradistinction appears untenable. Both mask types, for that matter, are of mysterious nature and the represented characters are presumably related to hunting and the millet harvest.

The third type is comprised of masks with facial distortions. Typical are the sculptures with a face in Katundu style and cylinder-shaped eyes. These mostly denote *tundu*, the village fool or "clown". Other masks show a face divided into black and white, with a strongly bent nose and a near-vertically positioned mouth (cat. 25). Often one side of the face exhibits perforations which mimic smallpox scars. This mask can perhaps always be associated with the character of the bewitched, known as *mbangu*.

Mask Styles of the Kasai-Pende

The masks of the Kasai region are generally described as geometric and abstract, in contrast to the more naturalistic masks in Katundu style. And though the Katundu specimens' representation of the human face indeed rests upon a number of conventions, the Kasai masks are composed from near-geometric forms and the similarity with the human face is less evident.

According to de Sousberghe (1959: 24) the Katundu style differs from the Kasai styles on the basis of the former's originality and its being true to type, while those of the Kasai region show similarities to the sculpture of the Kete, the Luluwa, the Songo, the Bena Mai and other less-known peoples. A few superficial similarities, however, do not enable one to draw any conclusions concerning reciprocal influences or a mutual origin. Moreover, it is quite difficult to exactly determine possible influences, and it is probably more appropriate to think in terms of an ongoing interaction with numerous overlaps.

De Sousberghe (1959: 22) is also of the opinion that, with the exception of the Katundu style, the other eventual styles must be described as the production of a particular atelier. This position is very attractive in terms of explaining the variety seen within the styles and types, but once again we simply lack sufficient data to confirm it.

Despite the fact that the Kasai masks must as to meaning be classified into zoomorphic and anthropomorphic characters, to our knowledge there are no known pure animal masks proper to the Kasai region. A number of specimens do exhibit the combination of a schematized human face with animal horns. Once again, it appears that the equating of form with function/meaning is altogether wrong. In addition, there are a number of masks with known proper names — thus referring to a particular meaning — which owing to the lack of a morphological description or representation, cannot be linked with a particular form.

In our opinion a distiction may be drawn between three styles. It cannot be ruled out that the "discovery" of new mask forms will fundamentally alter the proposed classification.[5] Moreover,

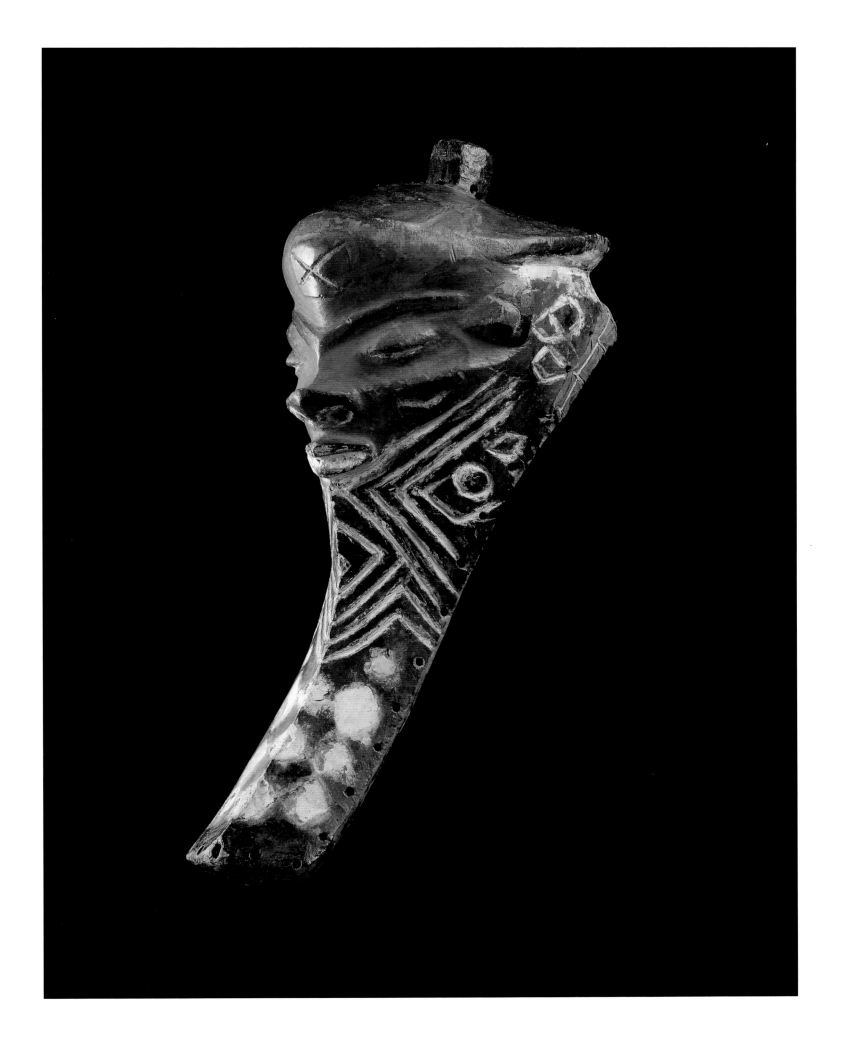

25
PENDE

Zaire, Bandundu
anthropomorphic face mask
mbangu
H. 22 cm. Wood, pigment, fiber, feathers

The physiognomy of this mask type is related to the sequelae of a facial hemi-paralysis, while the black face-half is seen as a burn wound consequent to an accident by the fireplace. The contrasting opposition between white and black could thus symbolize the conflict between good and evil. Although Léon de Sousberghe suggests that this mask figure portrays an epileptic, others state that it represents someone bewitched. However, the attributes of the masker — such as the tuft with feathers of the coucal, guinea fowl, and sparrow hawk; the hunt-bells on the hips and bow-and-arrows in hand — indicate a hunting connection. Thus, perhaps this personage refers to a hunter who owing to his success was bewitched by an envious sorcerer. The arrowhead planted into the hump so serves as a metaphor for sorcerers who strike their victims by this means. Moreover, the facial features and burn-wound scarification, also point to the sorcerer's power. (C.P.)

Lit.: de Sousberghe 1959; Mudiji-Malamba 1989; Strother (*in* Beumers & Koloss 1992: 326, no.124)

the fact that a particular style or type is described upon the basis of only a few sculptures, rather detracts from the inherent continuity of the notions "style" and "type".

The first Kasai style consists of relatively small triangular masks with a concave heart-shaped face. This style can be subdivided into at least four types.
A first type is provided with a sculptural upper part that may take considerably different forms. One finds sculptures with horns, knives, geometric patterns, openworked diamond-shapes and various other designs of upper parts. It cannot be ruled out that these different designs reflect different meanings. Although a distinction needs to be drawn between specimens with slit-shaped and others with cylinder-shaped eyes, no relation seems to exist between a particular eye form and a specific type of upper part. Just as with the other Kasai types and styles, many examples are decorated with a border of triangles in relief with alternating colors of black and white. These triangles are known as *ibeka* and would refer to tattoo patterns. There are only two known generic names for this mask form, *tungolo* and *minyaangi*, about which we have very little information. Furthermore, from de Sousberghe's data (1959: 66) it appears that the identification of these triangular masks also differs according to their dimensions.
A second triangular type has a headdress in bas-relief and perforations over the entire surface of the cheeks (cat. 33, p. 239). These perforations, by way of analogy with the *mbangu* type of the Katundu region, presumably represent pox scars. Only a few masks of this type have been published. The stylistic and formal differences found here are striking. A number of authors, including Cornet (1972: 165) and Fagg (1980: 130), refer to the connection with a particular Biombo type. A possible Biombo influence, or a Pende influence in a reverse direction, is indeed difficult to prove. The mask type is usually called *kindombolo*, and refers to the "trickster" or "sly one" who pokes fun at the people and calls established values into question.
A third type offers us but three examples.[6] It is characterized by a flat triangular design and a large headdress, with the surface of the mask decorated with various geometric patterns. Typical are the rectangular segments at the level of the temples, possibly representing the coiffure. The mask in the M.R.A.C., Tervuren was acquired in 1954 by Albert Maesen in Luaya Ndambo from the Akwa Pinda clan, and was sculpted by a certain Kiyova (de Sousberghe 1959: ill. 72). Belonging to the *minyaangi* series of masks — which represent village elders, and may only be worn by the family and entourage of the local chief — this mask would more specifically have performed in dances prescribed by the diviner, *nganga ngombo*, in cases of epidemic disease and repeated miscarriage. Given the originality of the mask type and the great uniformity among the known examples, we consider it justified to associate this mask form with the above-named clan, or even with an atelier or artist — Kiyova? — of this clan. More information is indeed required to confirm this hypothesis. Furthermore, one notes a certain formal similarity to the rare Lele masks with regard to the headdress and flat frontal interpretation (cat. 57). It should be remarked that the Lele, in contrast to the Biombo, are close neighbors of the Pende.
A fourth triangular type is distinguished by its horizontal design and protruding ears. The basic form is sometimes nearly rectangular or even hexagonal. Also characteristic is the decorative motif of triangles in relief. Though some examples are provided with a broad collar of raffia fibers in a row of perforations at the mask's edge, this mask form is usually represented as a decorative element gracing the lintel of the chief's house. The mask then acquires, together with the other adorning sculptures, the name *kenene* (cat. 32). An example of smaller dimensions in a private collection in Brussels, was purportedly used as a dance mask (cat. 31). In this case it is called *panya ngombe*, the wild cow or buffalo, and is related to circumcision and initiation.

The second Kasai style encompasses the much collected cylinder-formed bell masks provided with a wooden skull top with a headdress in bas-relief, and a central cylindrical protrusion surmounting the crown (cat. 30 and ill. 2). Most typical is the horizontal disc-shaped projection at chin level, which possibly serves to mimic a beard. This projection is often decorated with a border of triangles in relief. It is the only Kasai mask type that is also considered as a style by de Sousberghe (1959: 64). There is considerable diversity among these masks, with respect to decorative motifs as well as to general design and proportion. Perhaps this variety may be put down to the involvement of different ateliers or sculptors. The mask form, called *kipoko* or *mukishi wa mutue*, represents the local political leader and symbolizes ancestral authority. A number of formal characteristics, such as the chin plateau and the triangular decoration, undoubtedly bear witness to Chokwe influence. Bastin (1961: 38) considers that the form of the *kipoko* bell-shaped

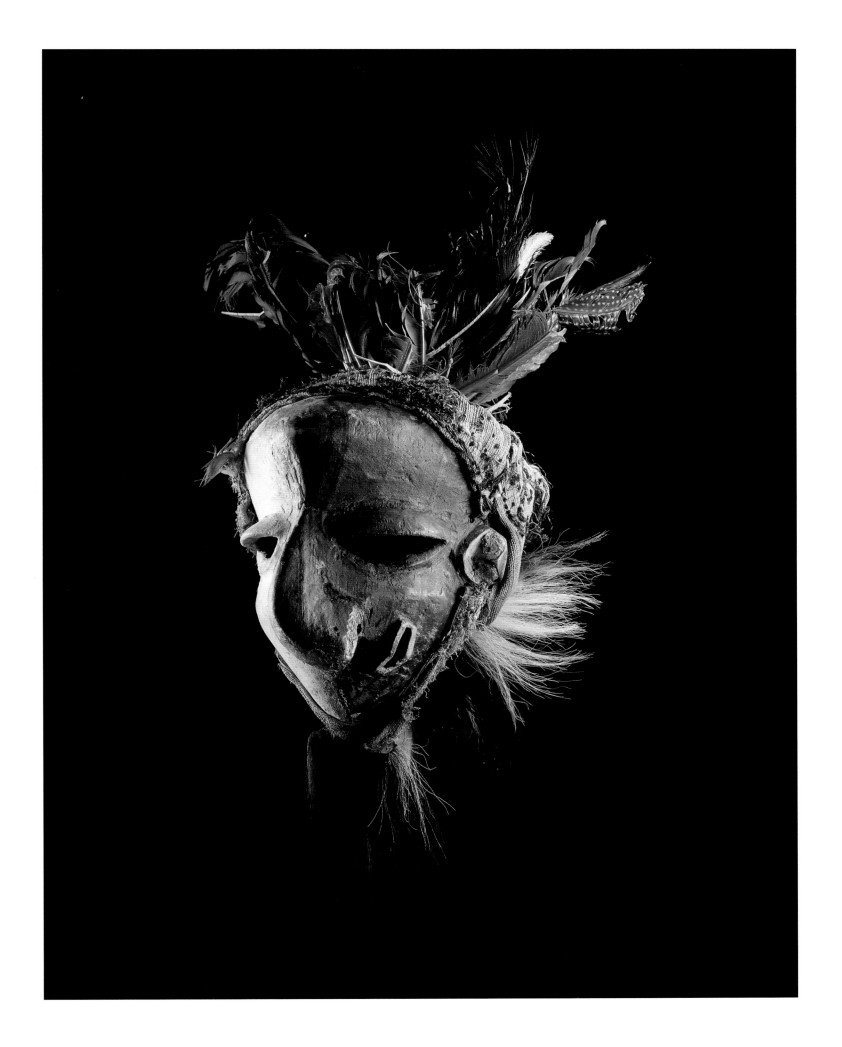

30
PENDE

Zaire, West Kasai
anthropomorphic bell mask
kipoko
H. 36 cm. Wood, pigment

The *kipoko* mask, proper to the Kasai-
Pende, forms part of the chief's treasure,
and is kept in his residence together with
other sacred objects. These objects are
considered to exert direct influence upon
the community's health and welfare. The
masked figure represents the political leader
and symbolizes ancestral power. The
sculpture was originally adorned with an
ape-skin and feathers, in imitation of an old
chief's headdress. While Malutshi Mudiji-
Selnge refers to the life-taking character of
the figure (manifested in the color red and
the swords held in hand), Zoë Strother
emphasizes that the mask brings into focus
the chief's benevolent role. The hypertrophy
of eyes, nose and ears suggests a
hypersensitivity of the senses, characteristic
for political leaders. Certain sources classify
this mask type under the category of village
masks, *mbuya jia kifutshi*, which perform
during the ritual dances of renewal that
accompany millet sowing. According to Zoë
Strother, however, it belongs to the *mbuya
jia ufumu*, "masks of the chiefly insignia".
Among other uses, it is associated with
healing of the sick. (C.P.)

Lit.: de Sousberghe 1959; Malutshi Mudiji-Selnge (*in*
Vogel 1981: 229, no. 41); Petridis 1992b; Strother 1993

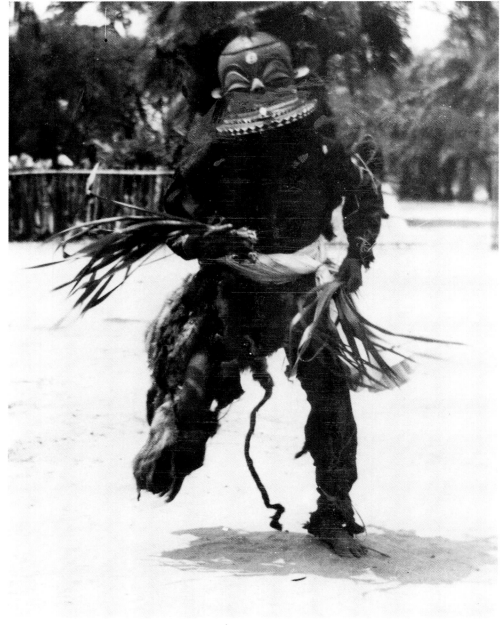

ill. 2. Eastern Pende (West-Kasai). *Kipoko* in Kitangwa. Photo: C. Souris, ca. 1950. M.R.A.C., Tervuren (E.PH. 12247). *See cat. 30*

mask can be traced back directly to certain Chokwe types, and that it is younger than the homo-
nymic Pende mask type with a knife-like upper part. Moreover, the bell masks of the Pende repre-
sent a stylistic transition between the bell masks of the Kwilu region and mask types which are
distributed to the east (Bourgeois 1990: 124).

The third Kasai style is represented by large helmet masks with a wooden skull cap and a vertical
beard-like chin extension (ill. 3). In this case too, the skull top is provided with a headdress in bas-
relief and a cylindrical protuberance on the crown. The chin extension is decorated with a variety
of geometric patterns. A succession of parallel rows of triangles in relief is the most frequently
seen array. The masks have large cylinder-shaped bored-through eyes. A representative example
was in the collection of P. & R. Tishman (Robbins & Nooter 1989: ill. 1028). The general form of
this mask style is rather reminiscent of the *dakakulo* mask type of the Kete (Redinha 1956: ill. 7). A
few of the published examples share a common formal likeness, and are possibly the work of a
single atelier or artist (e.g. Institut des Musées Nationaux du Zaïre, Kinshasa; National Museum
of African Art, Washington, D.C.; the former P. & R. Tishman Collection). The specimen in the
I.M.N.Z., Kinshasa was acquired in 1971 at Mavakini, near Tshikapa (Sura Dji 1982: 66). These
helmet masks are called *pumbu a mfumu*, and are interpreted as representing the executioner.[7]

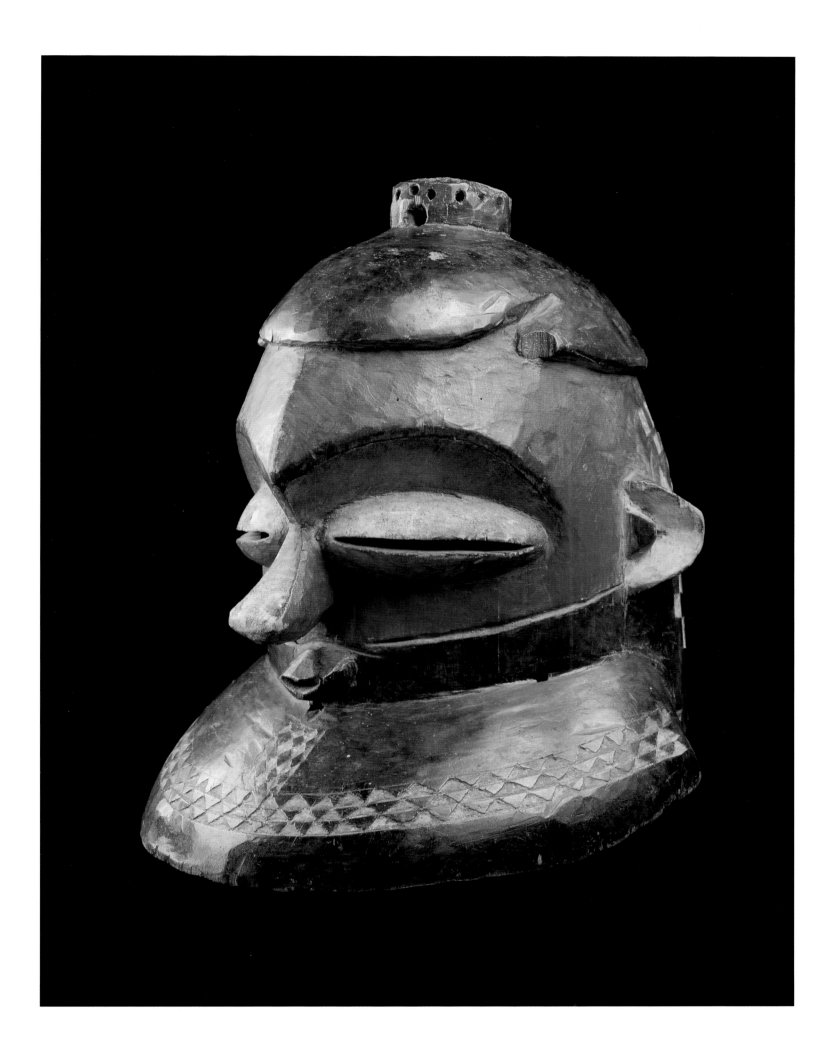

31
PENDE

Zaire, West Kasai

anthropo-zoomorphic face mask

panya ngombe

H. 19 cm. Wood, pigment

The *panya ngombe* mask type makes reference to the wild cow or buffalo, symbol of prestige and high rank. Léon de Sousberghe has described a ritual where, together with a *pakasa* buffalo mask in Katundu style, it would plant *mahamba* branches and sticks in honor of the ancestors around the chief's house. Although a number of sources also count this mask type among those of the circumcision or initiation category *mbuya jia mukanda* (zoomorphic masks which serve to keep women and children at a safe distance from the initiation camp), according to Zoë Strother it only belongs to the *mbuya jia ufumu*, "masks of the chiefly insignia". It is, moreover, reserved for the most important chiefs. Nevertheless, in former times it would have exclusively appeared during the *mukanda* initiation. It would collect gifts at the end of the initiation to defray the cost of the attendant closing festivities. It danced with a sword or machete in hand, and was clothed in attire proper to chiefs. The rarity of the *panya ngombe* type is perhaps attributable to the fact that circumcision — the ritual to which it had originally been closely allied — has not been carried out within the scope of the initiation since the 1930s. The mask is, however, still reflected in high-relief in the lintel to the door of the chief's house. In such cases this sign indicates that the owner belongs the highest class of chiefs. The literature contains no explicit reference to separately sculpted masks as decorative emblems on dwellings. Nevertheless, taking certain indications from the example shown under cat. 32 — such as the absence of "traces of wear", the large dimensions and weathered appearance — one might suspect this particular usage. (C.P.)

Lit.: de Sousberghe 1959; Janzen & Kauenhoven-Janzen 1975; Petridis 1992b

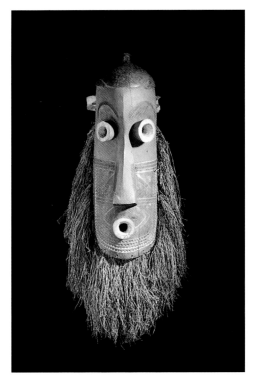

ill. 3. Eastern Pende (West-Kasai). *Pumbu a mfumu.* H. 77 cm. Collected pre-1966 by P. Timmermans in the village Kayala Holo. Afrika Museum, Berg en Dal (no. 72-1).

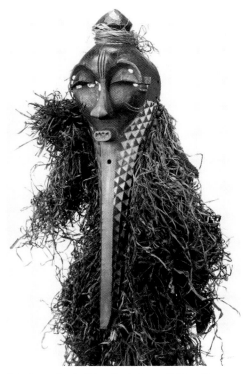

ill. 4. Eastern Pende (West-Kasai). *Kiwoyo.* H. 47 cm. Private collection. *See cat. 24*

In the Kasai region as well, there were masks made which conform to one or other of the indicated styles and types to only a limited extent. In addition to sculptures which have clearly come under the influence of neighboring peoples, a number of specimens must be seen as local adaptations of imported Katundu types with Kasai features (compare ill. 4 and cat. 24).

Masks from the Left Bank of the Kwilu

Little is known about the left bank of the Kwilu. Due to the fact that this area has a strong ethnic mix, one can hardly attribute the sculptures found here to one particular people. As Biebuyck (1985: 254) notes, it is close to impossible to distinguish between the artistic originality of the various small, and mutually related, ethnic groups. The Pende bell masks of the region can but with difficulty be distinguished from those of the Suku, the Yaka and the Mbala. That the similarity to Kwese sculpture is particularly strong, is shown by the fact that a mask in the collection of J. W. Mestach in Brussels was alternately published as Pende and Kwese (cat. 20, p. 237).[8]

For that matter, de Sousberghe (1959: 69-70) proposes that most specimens were ascribed to the Suku or the Yaka on a largely hit-or-miss basis. This naturally poses problems when such an "accidental" reference is chosen without informing the reader of it being so. Given the uncertainty of the ethnic origin, it seems to us — following Bourgeois (1990: 124) — that particularly with regard to this area it is preferable to omit all ethnic attribution, and opt for a general geographic reference such as "masks from the left bank of the Kwilu".

Only a bell mask with a lobate helmet-like headdress and a small concave heart-shaped face, is relatively well represented in public and private collections. The face is usually painted white and has eyes closed with only the upper eyelids being represented. One often sees three short blue parallel lines under the eyes, which are called *masoji* (tears). Among the Pende this mask type is known by the name *kiniungu* or *mayombo* (de Sousberghe 1959: 69).

The similarity of facial expression between these bell masks and the small sculpted face of the wooden disc-shaped *gitenga* mask is striking (cat. 21). This mask type is a variant of a form which is normally made from raffia and other fibers (see ill. 1). The affinity between the facial representations of both mask types brings Mestach (*in* de Sousberghe & Mestach 1981: 24) to suppose that the wooden *gitenga* mask originated on the Kwilu's left bank, subsequently to be spread through other Pende areas. The cosmological and mythological dimensions of the *gitenga* mask

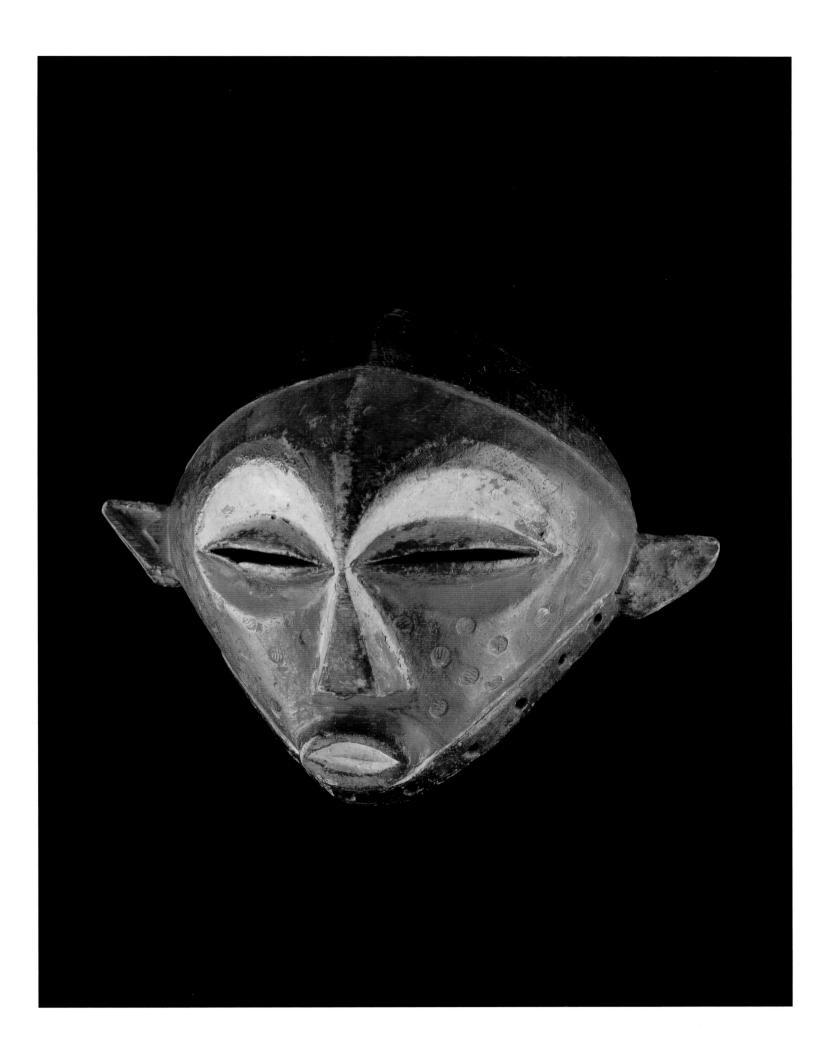

have often been recognized (see Maesen 1975; de Sousberghe & Mestach 1981; Petridis 1992b). In conclusion, we should primarily like to stress the great formal diversity found among the Pende masks. What is above all striking is the fundamental distinction between the Katundu style on the one hand, and the Kasai styles on the other. Neyt (1981: 148) points to the possibility of a combined investigation of linguistic data, archeological sources and sculpted specimens. The hope of archeological discoveries is, however, rather remote. There might be more to be gained from an investigation of the creative process itself (see Vansina 1984a: 136-174). A knowledge of the techniques and working methods could perhaps shed some light on the evolution of the different styles and types. As to the figure of the sculptor and methods of work, there is but little known. And with regard to the psychological aspect of artistic creation there is nothing known (see, among others, Anderson 1979: 111-152). It is precisely this less material dimension which might hold an answer to the questions in point.

This said, it is essential that fieldwork be pursued to determine the spatial distribution of the various styles and types of masks, with the aim of establishing connections between styles and ateliers; as well as to elucidate the many remaining questions related to their use, function and meaning. In this regard, the publication of the results of recent investigations by Zoë Strother (Yale University, U.S.A.), will undoubtedly much extend our knowledge of Pende art.

32
PENDE
Zaire, West Kasai
anthropo-zoomorphic lintel mask?
panya ngombe
H. 26 cm. Wood, pigment

This text is based on museum and bibliographical investigations carried out during the course of 1990-91 in connection with our licentiate's thesis (M.A.) at the University of Ghent.

1. For the masks of the Katundu area, data from de Sousberghe (1959; 1960), Muyaga Gangambi (1974) and Ndambi Munamuhega (1976) has been summarized by Biebuyck (1985). In 1989 a substantial study has appeared by Mudiji-Malamba. Regarding the Kasai masks, one avails of scarce information in Bittremieux (1937), de Sousberghe (1959), Himmelheber (1960), Janzen & Kauenhoven-Janzen (1975) and Cornet (1978). In *Wooden Masks of the Kasai Pende* we have attempted to present a concise survey of the literature on Kasai masks (Petridis 1992b).

2. Vansina (1984a: 175) argues that "the style of each ethnic group is characterized by the style of the 'typical' icon only... 'typical' because well known from collections and illustrations". The author notes that "the characteristics of 'typical' works are developed out of an examination of an extant corpus and... there is no guarantee that the corpus used is in fact representative. Thus an 'atypical' object may be genuine and the attribution correct" (1984a: 22).

3. Elsewhere de Sousberghe (1960: 513-514) suggests that only the feared *minganji* raffia masks represent ancestral spirits, while the largely benign wooden *mbuya* incarnate non-ancestral, foreign spirits. The author, moreover, distinguishes between old and more recent *mbuya*. The stylized older masks, about which informants no longer know the significance and meaning, could refer to the above-named foreign spirits, while the more recent masks represent local characters (1960: 527, 530). It is precisely these mysterious old masks which are mimicked in the *ikoko* pendant masks.

4. This photograph shows a number of bell masks which strongly differ from one another, together with a *gitenga* fiber mask and a wooden mask with tube-like eyes and strongly bent nose. This last-mentioned sculpture is probably a local variant on the *mbangu* type from the Katundu area. De Sousberghe (1959: 72, ill. 100-101) discusses two comparable masks from the collection of the Kongo-Kwango Museum of Heverlee. These were acquired in 1932 on the shores of the Lutshima River, and carried the name *gibola-bola* or *bwala-bwala*.

5. As for the triangular mask type, called *pota*, until recently there was but one illustration known (Gardi 1986: ill. 53). For this reason this *pota* mask (acquired in 1938 by Hans Himmelheber, and preserved in Basle's Museum für Völkerkunde) was not included in the stylistic classification of a former publication. A second example (in the M. and B. Stanley Collection of Iowa City was recently published in Roy (1992: 222). The information provided by the aforementioned author regarding the use and meaning, however, does not accord with other writers on the subject (see Petridis 1992b).

6. The oldest known mask of this type is found in the collection of J. Schwob in Brussels (de Sousberghe 1959: ill. 73), with a nearly identical example in the M. and B. Stanley Collection in Iowa City (Roy 1985: ill. 94). A private collection in Washington contains a mask sculpture, to be sure of larger dimensions, which in terms of form relates to the Akwa Pinda masks (Robbins & Nooter 1989: ill. 1030). This sculpture was kept together with the initiation masks in a special building, and whose purpose was to transfer the power of the old masks to the new ones. It is thus, in contrast to what we initially thought, not a real mask.

7. A style variant, which to our knowledge is represented by only two examples, in the Harrison Eiteljorg Collection in Indianapolis (Celenko 1983: ill. 182), and in the Institut des Musées Nationaux du Zaïre in Kinshasa (Sura Dji 1982: ill. 3.34), is characterized by its smaller dimensions and a triangular beard-like extension at the chin. The decoration is in this case limited to a border of triangles in relief, with striking perforations under the eyes for eyeholes.

8. Torday & Joyce (1922: 313-314) probably must bear reponsibility for the confusion between the Pende and the Kwese. These authors describe the Mushinga chiefdom on the left bank of the Kwilu River as Kwese. One should nevertheless emphasize that the Pende, the Kwese, the Mbala and the Sonde in former times considered themselves as one people, and would readily call themselves by the others' names.

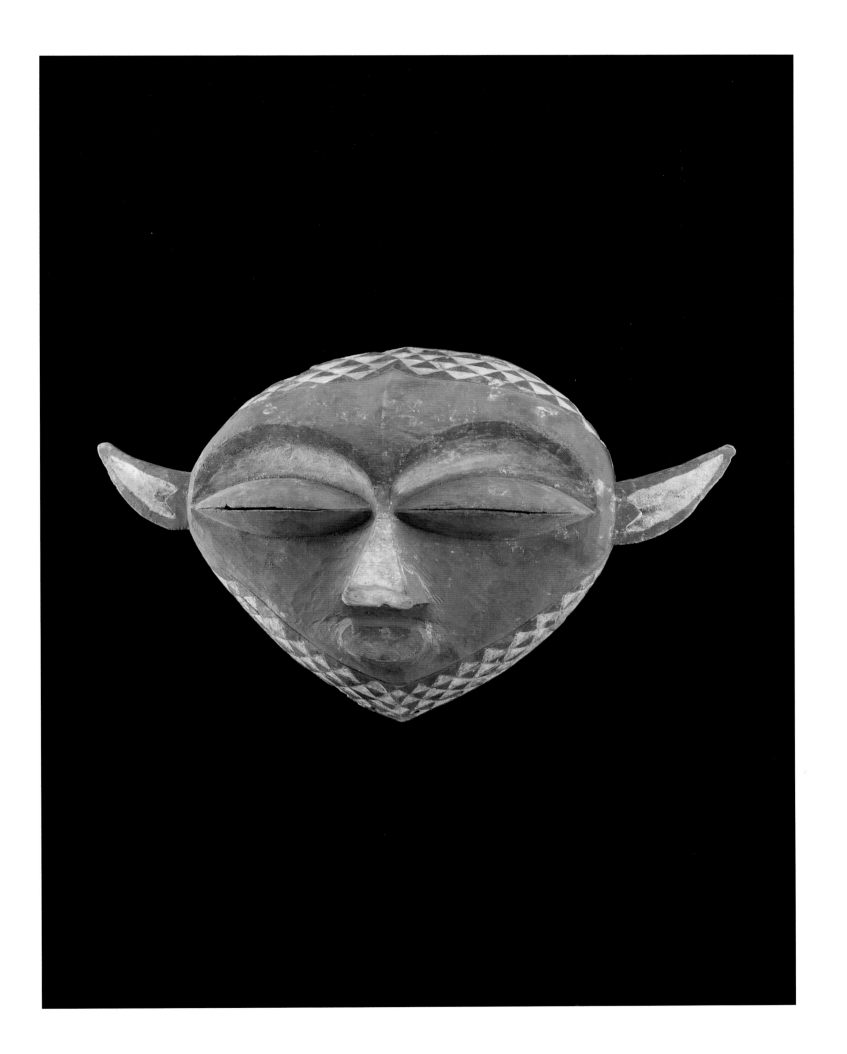

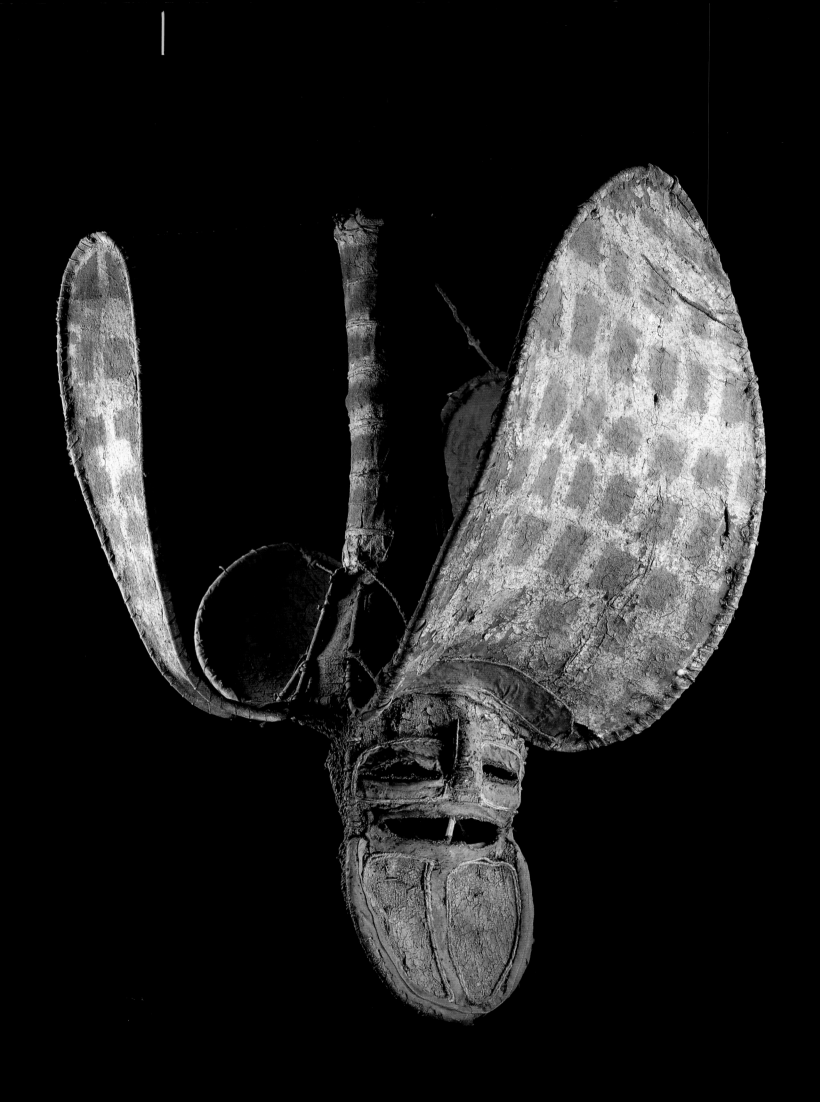

The Akishi Spirits of the Chokwe

Marie-Louise BASTIN

It is through masks that the *akishi* make themselves known. The *akishi* are ancestors, abstract beings or forces of nature that are honored and respected quite as much as they are feared. Some may not be seen at all by women. For the uninitiated in particular, they are seen as either spirits risen from the dead or apparitions, sprung fully endowed, from the earth. *Akishi* (singular *mukishi*) is the global term for these kinds of spirit, but each of them has its own name and is identified by a costume or special attribute. Particular behaviors aid identification, as well. Among the Chokwe — originally from Angola, and also dwelling in Zaire since the end of the last century — the *akishi* are many and varied.

A *mukishi* is always incarnated by an adult man (except in one instance where a woman takes the role, *see below*), whose identity is sometimes only concealed by simple body-painting. However, as a general rule a woven costume is required, which completely hides the man's body, and which may be worn with a hood, though more usually with a mask shaped in resin or wood. All the beings thus evoked are masculine; only the *mukishi wa pwo* idealizes the female ancestress of the lineage, the perfect model of this matrilineal society, endowed with all the human, family and social virtues.

The ritual appearance of *akishi* is linked to power, to the initiation of adolescents, to secret societies and to the rules for the control and the beliefs of those societies, as well as — to some extent — to entertainment. But it is always clearly understood that the intervention of a *mukishi*, whatever the circumstances, essentially falls within the domain of the sacred, that one must be entitled to assume its charge, and that it can even be sacrilege for the uninitiated to come upon these secrets unawares.

The Chokwe themselves distinguish broad, well-defined categories amongst the various roles assigned to *akishi*. For it is totally artificial and a reflection of Western conceptions to classify masks according to the primary materials used; — fiber ("aus Rindstoff"), resin ("mit Harz modelliert"), wood ("aus Holz") — as the ethnographer Herman Baumann does in his memorable monograph *Lunda. Bei Bauern und Jägern in Inner-Angola* (1935: 110-116), which deals largely with the Chokwe. Doing so also gives rise to a serious drawback, since the same kind of mask may be made at the same time in resin and in wood. This is particularly true of the dance-masks for *cihongo* and *pwo*, which evoke respectively the spirit of wealth, and the ancestress of the female line. No doubt after the age-old usage of a simple fiber hood, came the idea of attaching facial features modeled in black resin onto the front. This innovation, so telling, must soon have become widespread. However, in this human representation the features are excessively schematic, due to the limited malleability of the employed *mupafu* gum (*Canarium schweinfurthii Engl.*), which dries quickly and then shatters like glass. This vitreous material is used to make all the masks which appear during the adolescent initiation rite, *mukanda*. Their use is ephemeral. Traditionally they were actually burnt at the end of the ceremony. This is not the case for masks designed for the dance, where a long life is desirable. Although originally made in *mupafu* resin, the custom of sculpting them in wood probably grew out of the need to make them less fragile in their constant transport from village to village (the dancers are itinerant) — and this is particularly true of female masks. In fact, apart from those preserved in Switzerland at the Musée d'Ethnographie of Neuchâtel (Bastin 1982: ill. 38) and the very fine *pwo* published by Baumann (1935: ill. 78), all other masks of this very common type are in wood.

While on this point, a comment on morphology may also be appropriate. To represent the physiognomic features of the mask in a material as rigid as *mupafu* resin results almost inevitably in producing a pattern of simplified forms, geometric in style and with limited modeling. Their later treatment using the new material (wood), which may be worked more easily with a knife and

34
CHOKWE

East Angola & Zaire, Bandundu, West Kasai and Shaba
anthropomorphic helmet mask
cikungu
H. 69 cm. Bark, twigs, resin, pigment

The Chokwe people are originally of Angolan origin. Chokwe groups have since the 19th century found themselves in various parts of south Zaire. The design of the impressive headdress which crowns the face of this mask leads one to believe that this is *cikungu*, the mask belonging to the master of the earth, named *mukishi wa mwanangana*. *Mwanangana* is the highest political title among the Chokwe. He and his heirs are indeed the only persons entitled to wear the mask. In bygone days, the mask would appear in times of great adversity carrying a *mukwale* in each hand. This sword was both symbol of authority and weapon of execution. It was also used to sacrifice a goat, whose blood would then be sprinkled before the holy tree, *muyombo*. (F.H.)

Lit.: Bastin 1982; Bastin 1984b; BASTIN (p. 79)

with greater finesse, nevertheless retains the same overall rigid and austere appearance. This explains the retention of the markedly deep concave eye-sockets (with eye slits like coffee beans) and the linear aspect of the thick-lipped mouth, despite the transfer of these anatomical features to a material better suited to naturalistic expression. Did the artist want to remain faithful to the archetypes handed down from past ages, from his forefathers? Moreover, these features are also an important established aspect of Chokwe statuary. So much so that the remarkable characteristic of "the eye half-closed at the base of large concave sockets" has served to define the art of these people — in the work of Frans M. Olbrechts (1946/1959: 79), where he was seeking to establish indisputable criteria for categorizing the arts of Zaire.

Designs based on the most common ethnic tattoos are generally reproduced on the mask itself. The facial features are accompanied by a headdress which varies according to the *mukishi* evoked.

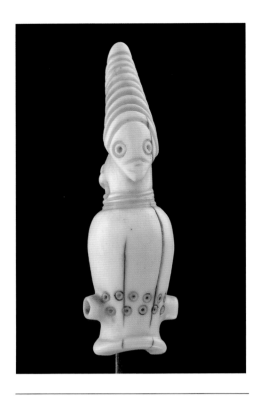

35
CHOKWE

East Angola & Zaire, Bandundu, West Kasai and Shaba
whistle
H. 9 cm. Ivory

This amulet-whistle is a representation of *mukishi wa cikunza*, the most important of the initiation masks. *Cikunza* is the "patron saint" of this initiation, the name referring to a variety of locust whose claim to fame rests on its procreative capacity. This makes the mask a fertility symbol. At base one has a modeled face with, above, an elongated conical pinnacle with rings. This represents the horn of a *tengu*, the bearded-antelope (*Hippotragus equinus*). This stands as a symbol for power and manliness. The mask seeks out the youths who are to be circumcised, gives the starting-signal for the initiation, and is also the initiates' primary protective spirit. Outside of the initiation context this mask aids hunters and infertile women, who may wear its representation as an amulet. Marie-Louise Bastin (1982) counts this amulet-hunting whistle as an example of the expansion style. (F.H.)

Lit.: Bastin 1982; Bastin 1984b; BASTIN (p.79)

36
CHOKWE

East Angola & Zaire, Bandundu, West Kasai and Shaba
anthropomorphic face mask
cihongo
H. 23.5 cm. Wood, pigment, fiber, copper, brass

This mask was classified by Bastin (1982) as an example of the Kwilu-Kasai substyle. It incarnates *cihongo*, the male spirit symbolic of power and riches. Just as with the *cikungu* and the initiation masks, the Chokwe also make their *cihongo* masks from resin, bark, and cloth. With an eye toward preservation, examples in wood were also carved. The rigor imposed by the original material is often maintained. Upon the forehead, the *cingelyengelye* scarification is represented in relief. This harks back to a similarly shaped iron cross, originating from the Portuguese and spread via Chokwe merchants. For the Chokwe this scarification symbolizes Nzambi, or Supreme Being. Over the ridge of the nose runs the *kangongo* scarification, an old tribal sign characteristic to the Chokwe, inspired by the stripe of the treemouse's back. Animal and scarification carry the same name among the Chokwe. Underneath the eyes one notes the presence of *masoji* (tears), here strongly emphasized by their representation in high-relief. This scarification is usually represented by a few vertical incisions. (F.H.)

Lit.: Bastin 1961a; Bastin 1982; BASTIN (p.79)

37
CHOKWE

East Angola & Zaire, Bandundu, West Kasai and Shaba
comb
H. 12 cm. Wood, pigment, copper

Just as the crown of the small ivory hunting-whistle (cat. 34), it may be presumed that this ornamental comb is crowned with a miniature representation of the *cihongo* mask. For that matter, the morphology of the face with the disc-shaped chin corresponds with that of the exhibited mask (cat. 36). Thus, the comb may most probably be considered as being a product of the Kwilu-Kasai substyle. An ornamental comb with this sort of representation would, according to Bastin, be the property of the dancer who performs with the *cihongo* mask. (F.H.)

Lit.: Bastin 1982

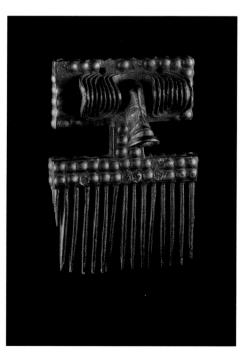

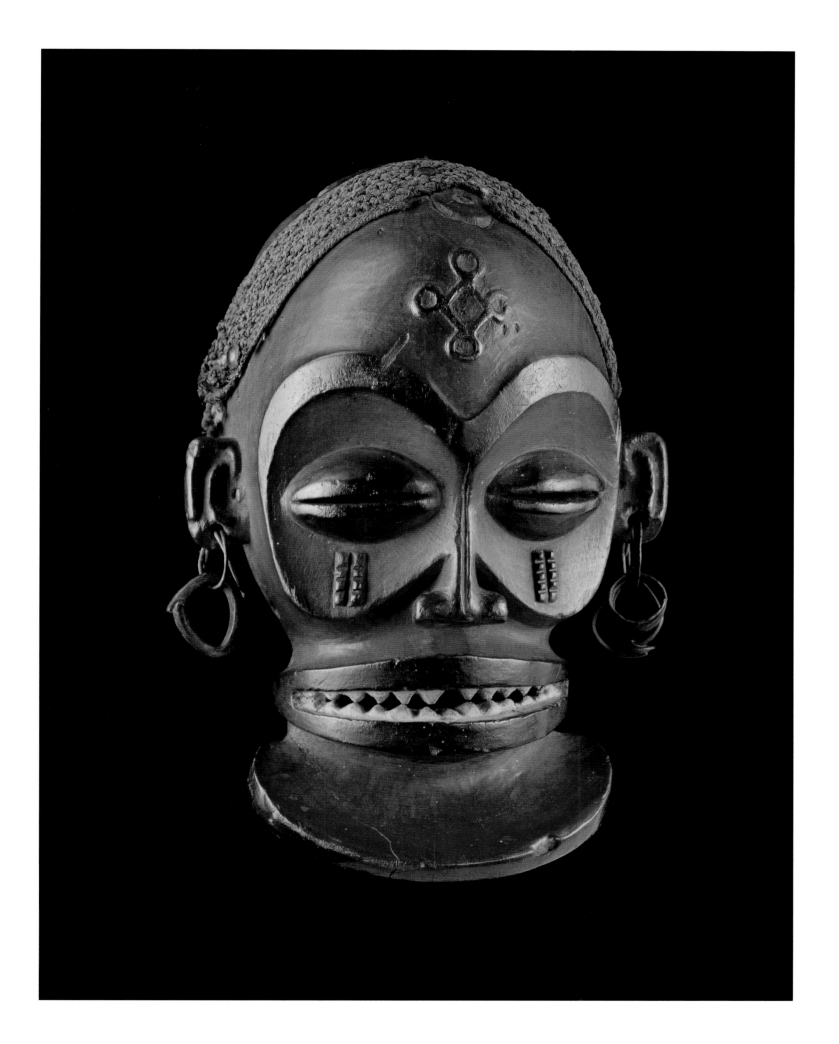

38
CHOKWE

East Angola & Zaire, Bandundu, West Kasai and Shaba

anthropomorphic face mask

pwo

H. 26 cm. Wood, pigment, fiber, metal

The *cihongo* (cat. 36) and the *pwo* mask, that represents a girl, belong to the group of *akishi a kuhangana* or dance masks. The dancers went from village to village and were rewarded for the beneficent influence which would follow from their performances. *Pwo* evokes the female ancestor who watches over the fertility of future generations. The dancer dresses with care, and instructs the women on how they must move gracefully. The commission of a *pwo* mask is considered as a mystical marriage. The dancer gives, as a symbolic price for his "fiancée", a copper ring to the sculptor. After his death the mask is often buried in isolation, for superstitious reasons. So, as a symbolic return of the brideprice, an armband would be buried. If the possessor of a *pwo* mask falls ill, then this would possibly be due to his neglectful behavior toward the mask. If destroyed, then he must arrange for a new mask to be made and show it on the market-place to viewers, mostly women, who hope to benefit from the fertility engendered by *pwo*. (F.H.)

Lit.: Bastin 1982; BASTIN (p. 79)

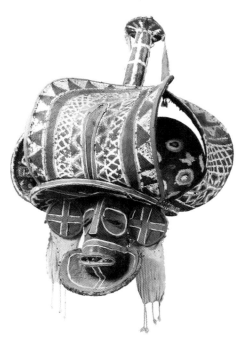

ill. 1. Chokwe (Angola). *Cikungu.* H. 118 cm. Museu do Dundo (1177).

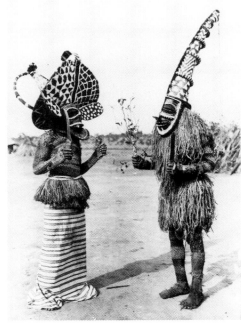

ill. 2. Chokwe (Shaba). *Akishi* masks, with *cikunza* right, in Sandoa. Photo: E. Steppé, ca. 1935. M.R.A.C., Tervuren (E.PH. 9420). *See cat. 35*

For resin masks, the headdress is usually a vast edifice, made of beaten bark cloth, *mwanji*, stretched over an armature of fine twigs. The whole construction is enhanced by clay pigments with ritual significance, white *pemba* and red *mukundu*, traditionally used in religious contexts, which are used to draw numerous geometric motifs with symbolic meanings. The headdresses on masks for the dance correspond to the usual conventions, influenced by regional variations in hair styles.

All the masked participants wear a fitted garment, *civuvu*, in plaited fibers which form a bi-colored pattern in black and yellow in its very tight weave. This garment is common to all the *akishi*, and over and above this they are distinguished from each other by different accessories.

The designs on faces, headdresses and mask costumes are traditionally identified by vernacular names, with a picturesque or symbolic meaning, based on metaphor or metonymy, and serve to represent a particular graphic motif in a constant way, so as to be recognized by everyone, and capable of being reproduced on the most varied occasions and with very different materials and techniques. In this way the Chokwe people, who have no written culture, do have what we might consider as a functioning system of communication, based on a wide vocabulary of ideographic signs of their own devising (Bastin 1961a).

Cikungu, the Mask of the Ruler of the Country: Mukishi Wa Mwanangana

Few people have seen this mask and examples in collections are rare (Bastin 1961a:afb. 231 and 232). Baumann (1935) does not mention it. The reason lies in the sacred and secret nature of this *mukishi* which is only worn personally and on very rare occasions by the chief of the country, *mwanangana* himself, and which is kept in the bush, hidden from view under the guard of a notable, inside a little hut, *mutenji*. The *mwanangana* puts it on during his enthronement and in special circumstances, such as a serious threat to the chief and the life of his subjects. This may be any scourge which the diviner attributes to the wrath of the dynasty's ancestors — whom *cikungu* symbolically represents — as a punishment incurred for negligence in their worship. A propitiatory sacrifice is then necessary. Wearing the mask, the chief appears in the public square of the village, which on this occasion is emptied of its population, who have sought refuge in their homes. A goat is tied at the foot of the *cota*, the shelter under which the court sits. The sacrificial masker should not be seen by anyone, man or woman, (except for certain very old nobles who aid him to dress). Costumed and armed with a sword, *mukwale*, in each hand, he proceeds with slow

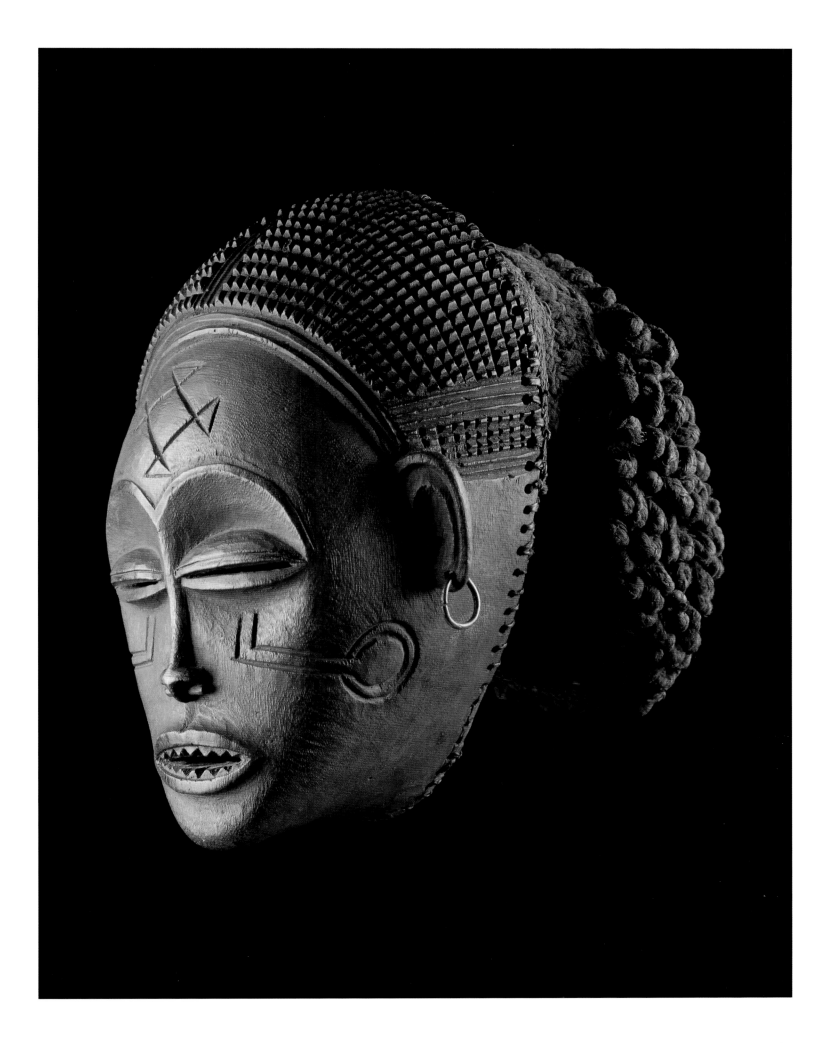

solemn steps, howling like the wind through a kind of small pipe, *ludandji*, fixed in the open mouth of the resin mask, and carries out the sacrifice. The animal's throat is cut and *cikungu* drinks a little of the spilt blood as a sign of communion with the spirits. He then returns to the bush, with the same terrible menacing aspect, and would not hesitate to immediately behead any intruder he happened to encounter.

The headdress and costume of the actor in this psycho-drama are impressive in themselves. The mask is never carved from wood. It is always modeled in *mupafu* resin. The features are set off with patches of red cloth glued and braided with white cotton. The wide winged superstructure is made of beaten bark cloth, stretched over a complex armature of reeds and painted with various colored motifs, chiefly evoking heavenly bodies. A red scarf, *muya wa ponda*, frames the face. The whole recalls the little black Cape stork, *khumbi* (*Sphenorynchus abdimii*), that symbolizes the sun, the sovereign lord of the sky, just as the *mwanangana* rules in his domains. Over the body garment of plaited fibers, a long black loin cloth, *lubula*, and a sort of apron, *mukambo*, in embroidered red cloth, complete the costume. The double-bladed sword, *mukwale*, is a sign of supreme authority, an attribute of the sole ruler of the country. *Cikungu* is the terrible evocation of this authority, made manifest by the most majestic mask created by the Chokwe (ill. 1).

Masks for the Initiation of Adolescent Boys: Akishi A Ku Mukanda

At puberty every boy has to be circumcised and initiated into adult life, through the *mukanda*, a kind of bush school which in the past lasted for two or three years. Many masks were used during the ceremonies, from which women were totally excluded.

Katwa is the first mask which was used in this rite of passage (*katwa, mukishi mutangu wa ku mukanda*). That it is the most ancient of this type comes as no surprise, as it is only a simple hood, surmounted by a tuft of sala fiber, which covers the head of the wearer and joins onto the plaited body garment which entirely conceals him. A fringed skirt, *nzombo*, covers his thighs and he holds two short stick in hard wood, the *mishipo*, which he strikes loudly together to announce his presence and chase away the women and children. Apart from this warning noise, *katwa* is silent. He is also called *katwa melolo*, an allusion to the alarm call of "ho-ho-ho" set up by the women at his approach. This is made by rapidly clicking the tongue against the palate while striking the mouth continually with the hand. There is also a variation, *katwa wa mutemba or wa mbwembweto*. These alternative names come from the word for the sagittal crest of the skull, *mutemba*, or recall the crested bird *mbwembweto* (*Hupupa africana*) (Bastin 1961a: ill. 240.2).

Another hood-mask, also silent, has large concave eyes, formed by the lower parts of two gourds, one picked out in white, the other in red. This mask is called *ngondo*, like the African long-tailed monkey (*Cercopithecus ascanius*), and it also clashes *mishipo* sticks together, at the sound of which the women flee in fear into their dwellings. Baumann (1935: ill. 73) illustrates three examples of *ngondo*. The Musée Royal de l'Afrique Centrale in Tervuren possesses one (Baeke 1992: 95). These minor masks, though the most ancient, are the heralds of the masks with resin faces, when they come to the village in search of food for the candidates for circumcision.

The important tutelary spirit *cikunza* is the patron of the *mukanda* and presides over the good conduct of this rite of passage. He appears in the form of a mask in black resin, worn by a man with experience of the world, and is characterized by a very high conical headdress, representing the horn of the antelope *tengu* (*Hippotragus equinus*), the large and powerful savanna antelope, very hard to track and to kill. On the front portion of the cone, formed from a light armature covered with beaten bark cloth and ringed with circular ridges, mimicking the projecting horns of the model, the long nose of *cikunza* runs right down from the top. Various geometric motifs, painted in the ritual colors red and white, enliven the whole pointed construction. At its base, a fringe of fibers hides the wearer's neck. Another longer fringe surrounds his waist, the individual's body disappearing completely under the woven body garment (Bastin 1961a: ill. 233) (ill. 2). This weird apparition also evokes the species of grasshopper *cikunza*, whose name it shares, so adopting by association the well-known prolific virtues of the insect. These metaphorical allusions to the antelope and the grasshopper embody the qualities attributed to the spirit *cikunza*, patron of hunting and fertility. The importance of this mask is also indicated by the wearer sometimes

carrying the sword, *mukwale*, in the right hand, while he carries a spreading branch, *citete*, in the other. It is he who goes solemnly to the village to seek out the children for circumcision and initiation, so signaling the beginning of the ritual.

If the minor masks are mute, all the others who take part in this rite of passage are known as *akishi a kukumbuka*, or howlers, from the cry "we-he we-he" made through a voice modifier, *lundandji*, to announce their presence and frighten off intruders. The spreading branches, *yitete* (singular *citete*), which the *akishi* carry in their hands, serve the same purpose. Apart from individual headdresses designed to distinguish them, their general appearance is always the same: a body garment, *civuvu*, and a fringe, *nzombo*, around the pelvis (Bastin 1982: ill. 24). However their behavior is not entirely uniform.

There are the important masks *kalelwa*, *cinyanga* and *citamba*, whose roles are to conduct (*kutwala*) the children to the place of circumcision and to accompany them home after their stay in the bush; and who throughout this go to the village to collect (*kutambuka*) food when this runs short in the camp. The lesser masks *mbwembweto*, *mbwesu* and *cilomwena* are also associated with this second task. There is also *citelela*, that has actually been functionally designed for this purpose. This is not a herald mask, since a simple hood hides his face. His body is covered by a huge structure within which are two shelves to hold the cooking pots which the masked man seizes in the village. *Citelela* is derived from *kutelela*, meaning either to hover like a hawk (which stoops on its prey and then flies off with it), or to walk while balancing a heavy burden. Though the cries of the other masks frighten off the housewives, they do not take the food. This is the task of the *yikolokolo*, mature men — the parents of initiates — who are responsible for them to their families throughout the rite and who serve as guides and teachers.

Fine examples of the masks cited above are illustrated in my publications, *Art décoratif tshokwe* (1961: ill. 233-241) and *Entités spirituelles des Tshokwe* (1988: ill. 14-19). They all come from the Museu do Dundo in Angola. Nowadays all the masks no longer participate together in a *mukanda*, since making a complete set requires too much specialist skill (which has become rare), and perhaps it is also too costly for the community.

Apart from *cikunza*, the presence of *kalelwa* seems to be indispensible. His name comes from *lelwa*, cloud, and he moves at a run. His headdress is winged. Usually the names of the other masks come from the principal attribute represented on their head-gear. *Cinyanga* alludes to the spherical nest of the tree termites. The hurdle on which manioc is dried before it is pounded by the women is the origin of the name *citamba* (which also means a table). We have already seen that the crest of *mbwembweto* recalls that of the hoopoe. *Mbwesu* has a winged headdress similar to — though smaller — that of *kalelwa*. *Cilomwena* is identified by the miniature model of a bow.

A memorable event occurs in the ritual, in the isolation of the camp, at the moment when the truth about the *akishi* is revealed to the astounded initiates: that they are simply the human beings who have given them life. Another solemn moment is the oath which is then taken individually; never to divulge the secret to non-initiates, on pain of a curse (ill. 3).

Mask for the Initiation of Young Girls: Mukishi A Ku Ukule

To my knowledge, this is the only time among the Chokwe when a woman takes a mask role. This is during the ritual accompanying the initiation of a young girl, at the time of her first menses, *ukule*. At the beginning of the rite and before the traditional period of isolation (which lasts the length of the physiological cycle), a woman is chosen to play the *mukishi*. With her face hidden under a cloth and holding in her hands the *yitete*, spreading branches also carried by some masculine *mukanda* masks and shouting "we-he we-he" like them, she goes through the village threatening the men and frightening the children, so that they will not disturb the process of the initiation. On return from the ritual site she strikes the girl twice to show that she has now become an adolescent ripe for marriage.

ill. 3. Chokwe (Angola). Oath taking on the head of a mask by a young initiate. Photo after J. Redinha (1965: ill. 234).

Masks for the Adult Initiation: Akishi A Ku Mungonge

Though circumcision is compulsory, the initiatory test of *mungonge* is optional. The complex secret ritual takes place at night and lasts twenty-four hours. Strictly speaking, actual masks do not appear. The *akishi* are simply smeared with body paint, mostly in white clay, *pemba*, which is entirely beneficent, while red *mukundu* denotes evil and witchcraft, which the secret *mungonge* society is designed to combat. It also provides its members with the benefits of an exemplary life and, after death, the joy of joining the ancestors in the hereafter.

A rectangular piece of ground, *zemba*, oriented East-West and straddling a path which crosses its width, is cleared in the bush, not far from the village. At the eastern end a small curved palisade is built, behind which the notables and initiators gather round a large fire at nightfall. The candidates wait at the western end, kneeling side by side in a row.

The *akishi* taking part in the ritual only have their bodies picked out in *pemba* clay and the protective "medicines", *yitumbo*. *Samakhokho*, the master of ceremonies, wears a headdress made of the feathers of the *kolomvu* (a crested bird with red and green plumage), guinea fowl, *khanga*, scarlet touraco, *nduwa*, and white hen, *kasumbi mutoma*, as well as the sheaths of maize cobs, *yisuwi ya civale*. The *cimbungu*, hyena, is a man crudely masked by a half calabash or a sort of conical basket, who moves on all fours on very short stilts (ill. 4). The stilt-walker, *mbongo*, wears a conical headdress, *lunguwa*, in starred basket-work, to which is attached a cord, *mukumbi*, decorated with the feathers of a white hen (perhaps in the past feathers from the stork *khumbi*).

All this takes place on the night of *yiphuphu* or miracles (and not that of witchcraft, *wanga*) which are designed to astonish and terrify the neophytes, *mwali*. At the sound of the beating of drums, the hyena, *cimbungu*, symbol of fear and ferocity, comes out from the palisade on his short stilts and waving his tail, to whirl round as the candidates kneel prostrate, before making off on the transverse track. During this fleeting display the *afu a zemba*, the adult initiates, await the moment to intervene, their bodies painted with kaolin, and armed with hooks and spikes. They are supposed to be the risen dead (and in this form probably also ought to be considered as *akishi*). At the signal given by the *samakhokho* silence falls and the *afu*, emerging from the East, encircle the patch of land slowly in indian file, on all fours, like a long white snake, crushing the grass as they go. This puts the candidates on their guard, making them alert and increasingly anx-

39
CHOKWE
East Angola & Zaire, Bandundu, West Kasai and Shaba
zoomorphic face mask
ngulu
H. 27 cm. Wood, pigment, fiber

Aside from the *cihongo* and *pwo* dance masks, there remain a few additional sorts of dance masks such as the *mungenda*, the *katolo* and the *ngulu* masks, often made from resin. They have a ritual function, though their performance has a largely entertaining character. Moreover, the Chokwe also have zoomorphic masks which represent a guinea fowl (*khanga*) or an ape (*hundu*). The mask shown here is called *mukishi wa ngulu*, and represents a pig. It moves on all fours, and makes rooting gestures with its snout. It sometimes performs together with the *pwo* and *katoyo* masks. It is forbidden for women to touch the mask. (F.H.)

Lit.: Bastin 1982; BASTIN (p. 79)

ill. 4. Chokwe (Angola). *Samakhokho* and *cimbungu* hyena masker in the vicinity of Dundo, 1953. Museu do Dundo, Arquivo Diamang.

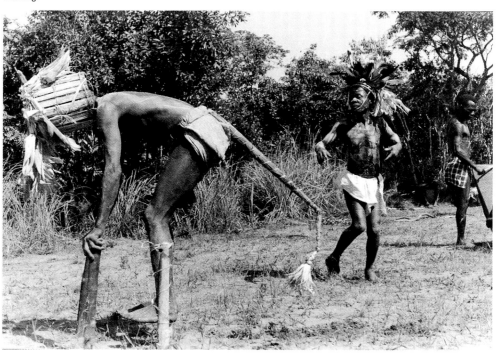

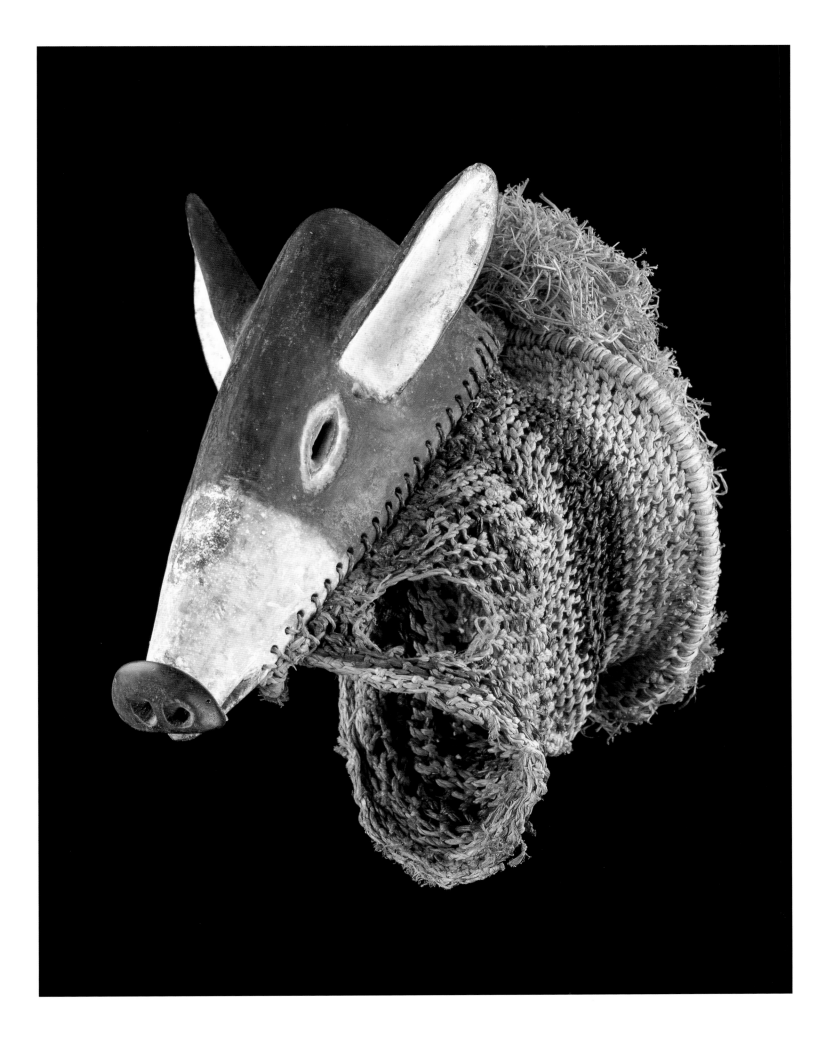

ious, until the "dead" spring out from behind and fling themselves roughly on the candidates, provoking a stampede in which each tries to escape. Immediately the orchestra of drums begins again, not only to drown the shouts of fear and pain but also to excite and urge the *afu* on to their task; which is to scratch, pinch and beat. The *samakhokho* surveys the battle, standing at the side on the edge of the *zemba* so as not to be seen; this is one of the *yiphuphu*. The right to signal for calm falls to this mysterious character. The drums cease thundering and in the ensuing silence the group of notables then chant the litany of the *phango*, a kind of play on words, evoking myths which the *mwali* have to memorize. And so in turn throughout the night, after a period of calm the tortures begin again to the sound of the unleashed orchestra. Dawn brings an end to this brutality with the appearance of the stilt-walker, *mbongo*, who in total silence comes from the East, entirely in white, advancing with his open hands raised, walking slowly and solemnly the whole length of the cleared area, whistling while muffled drums play. The vision has a redemptive aspect but also inspires fear, as white is the colour of death. It is also considered as one of the miracles, *yiphuphu*.

As the ritual continues, in the course of a new ordeal the *mwali* are obliged one after the other to confess their past crimes (theft, adultery, etc.), to gain an irreproachable moral stature and to show themselves henceforth to be honest, courageous and self-controlled, and to be able to swear *kayanda*, an oath which requires their fellows to take their word as true, on pain of paying compensation. The ultimate aim of *mungonge* is to benefit from funeral rituals. A similar institution exists for women, which is also optional and has the same aims. This is the *ciwila* at the end of which a *mbongo*, the only male actor, also takes part.

Masks for the Dance: Akishi A Kuhangana

We now turn to territory more familiar to the art lover, to a group of masks which for the most part have major, and sometimes exceptional, aesthetic value. These are the *akishi*-dancers, who traditionally were itinerant and lived off the gifts offered by the community, in exchange for the beneficent influence which they dispensed during their displays. As with the previous categories, some are more important and distinguished than others. This is the case of *cihongo* and *pwo* (cat. 36 and 38). As we have seen, originally masks for the dance were made both in resin and in wood. But it is in the latter that the sculptors have managed to create their masterpieces, amongst the finest in Black Africa.

All masks, ritual ones included, are distinguished by their headdresses, attributes and bearing. If the audience for whom they perform includes women, these may only watch from a distance and never touch them, on pain of being cursed for sacrilege. This is the origin of the legend of the *mwana cimbinda*, who was born with only one arm and one breast (Bastin 1982: ill. 184) because her mother had made a love charm from a small scrap of fabric cut from the costume of a *mukishi*, and was consequently cursed by the spirit, causing her to give birth to a monster.

Cihongo embodies the spirit of strength and wealth. As Mesquitela Lima (1967: 160) also notes, sometimes during his displays in yesteryear, he could serve as the instrument of justice, not hesitating to point out someone guilty of a crime amongst the spectators, and this party could immediately be put to death. Usually this mask is made of resin, but there are some remarkable examples in wood (cat. 36). *Cihongo* is distinguished by his feathered headdress in the form of a fan, sometimes covered by imported cotton fabric in more recent examples. Over his body-garment *cihongo* wears the girdle *cikapa*, characterized by panniers down his legs with a heavy fringe, which he swirls round with strong hip movements (Bastin 1982: 87).

Especially if the face is in wood, this *mukishi* should not be confused with the *kalelwa* from the *mukanda* rite, as Huguette Van Geluwe has done (1989: 17), in a recent exhibition at Tervuren devoted to masks and their costumes. The leading authority Herman Baumann (1935:pl. 28 and 29) more than fifty years ago already showed examples of both these masks, which are differentiated both by their dress and by their function in traditional society. Most notably *cihongo*, the dance-mask, usually holds rattles in his hands and has others attached to his shins. One never sees this on a *mukanda* mask. Then, like all the other dance masks, he is mute. Because traditionally he could only be worn by a chief's son to mark his high rank, he sometimes held a ceremonial axe

40

LWENA

Angola, Zaire & Zambia

anthropomorphic face mask

H. 31 cm. Wood, pigment, fiber, feathers, animal skin

The Lwena live east of the Chokwe on the borders of Zaire, Angola, and Zambia. Their culture is associated with that of the Chokwe. This is expressed in certain mask types which may nonetheless be distinguished on the basis of form and finish. The headdress of the Lwena masks has the form of a miter. It is connected with a lost Chokwe hair style at one time sported by men, but more frequent among women. In contrast to the Chokwe, the Lwena seldom patina their sculptures. Though, indeed, the scarification motifs on the masks of both peoples is often the same. Bastin has published a *pwevo* mask that strongly resembles this example. The function corresponds with that of the *pwo* mask of the Chokwe. According to this author the Lwena, in contrast to the Chokwe, have no male partner for their *pwevo* mask. On the example shown here, however, there is a piece of animal skin with hair applied to the place of the beard. This element would presumably suggest that this is a representation of a male being. Perhaps this mask, in contrast to the opinion of Bastin, is the male counterpart to the *pwevo* mask and the equivalent of the *cihongo* type of the Chokwe. (F.H.)

Lit.: Bastin 1969a

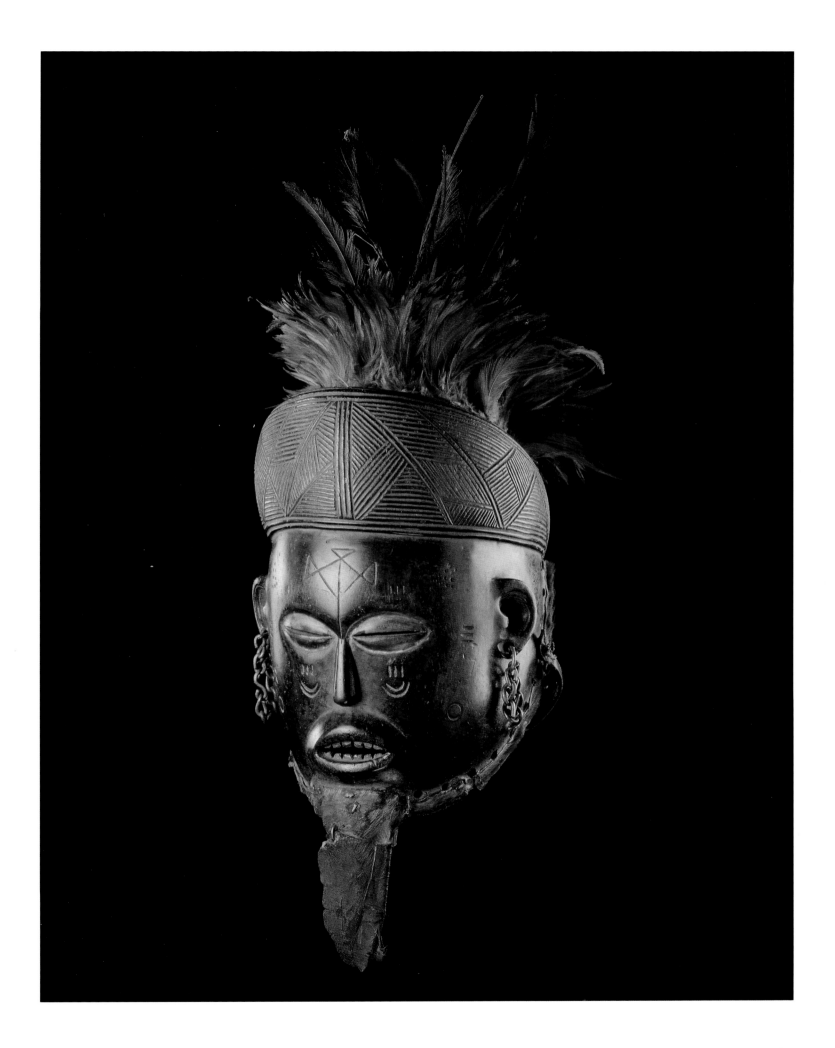

41
LWENA

Angola, Zaire & Zambia
anthropomorphic face mask
pwevo
H. 18 cm. Wood, pigment, fiber, beads

Of this mask type, called *pwevo*, a few
similar examples have been published. A
cross-motif is represented on the forehead
by means of perforations. Other
scarifications are seen on the nasal ridge,
temples, cheeks, and chin. The hair is made
from sansevieria fibers. The headdress type
is inspired by a hair style popular there in
the 1930s. The symbolic meaning of the
pwevo mask rather well-corresponds to that
of the Chokwe's *pwo* mask. It incarnates the
female ancestor. The fact that the Lwena are
ruled by female leaders, perhaps adds still
further to the meaning of these masks.
(F.H.)

Lit.: Bastin 1969a

ill. 5. Chokwe (Angola). Mask representing an old man.
Drawing after V.L.Cameron (1885: 427).

SHAM DEVIL.

(Lux 1880: 80 quoted in Bastin 1982: ill. 27) or a commander's baton (Capello and Ivens 1881: 266
quoted in Bastin 1982: ill. 26). Now any good dancer may take this role.

The mask called *pwo*, woman, or *mwana pwo*, young girl, is the symbolic pendant to the male
mask, *cihongo*, and evokes the female ancestress, propitious for the fertility of the tribe. Dressed
with care and charm, the dancer moves with elegance in front of the audience and teaches the
spectators grace and good manners. She holds a rattle or a fly-whisk in her hand (Bastin 1982:
ill. 28). In creating the facial expression for this mask, the sculptor sometimes comes near to
portraiture (cat. 38).

According to the description of these two dance-masks published by Albert Maesen (1960: ill. 31),
it is still common to hear them described as "the old man and the young girl". Though the term
to describe the second is correct, it seems more than likely that in regard to the first the author has
been misled by a completely subjective remark from a collector, which is to be found typed on
Page 28 of the ethnographic file 929 in the "Collection Dr. Fourche", which relates to the male
mask R.G.43146: "Realistic in style, expressing very clearly the physiognomy of an old Tshok
man, bearded and with exaggerated characteristics." This magnificent wooden example of a
cihongo mask (whose vernacular name is not even mentioned) was brought from the village of
Tshiwandawanda in the district of Kasai in Zaire. With its vast sunken eye-sockets and its gaunt
emaciated cheeks, one might indeed at first sight take it for the portrait of an old man (Bastin
1982: ill. 36). But as I have already indicated above, the majority of *cihongo* masks were made in
resin, following an almost unchanged stereotype for the conception of the features in this inflex-
ible material; and it is these same highly stylized facial characteristics which were later faithfully
reproduced in wood. So, in this particular case, we find ourselves confronted by the exceptionally
successful work of a master sculptor, who has managed to transpose the actual image of a *mukishi*
from one material to another in a full and effective way (which to my knowledge is unique). It is
the essence of *mukishi*, as this is embedded in the collective sub-conscious of the Chokwe from
time immemorial.

For these people have another mask which actually represents the "old man", and this is what its
name *kashinakaji* literally means. In 1956 I only heard of its existence by word of mouth, and the
Museu do Dundo did not possess one. But Baumann (1935: ill. 71.3) shows one amongst the
minor resin masks reproduced in his monograph. Its main characteristic is a high forehead,
largely undecorated. This immediately helps to identify it and suggests that it might also be the
"sham devil" (ill. 5) discovered in the center of Angola by Commander V. L. Cameron of the
Royal Navy during his crossing of the African continent from Zanzibar to Benguela in 1873-75.
Passing south of the source of the Kasai, through the country of the Chokwe, the explorer saw
masks performing there which roused his interest sufficiently to make sketches. Amongst them an
undoubted *cihongo* can be identified from his feathered headdress and girdle with panniers
(Bastin 1982: ill. 25). Describing one in particular, shown here in ill. 5, Cameron (1885: 427) noted:
"The mask was painted to resemble an old man's face with enormous spectacles, and some grey
fur covered the back part. In one hand he held a long staff and in the other a bell, which he
constantly tinkled." In the engraving it is not just the representation of baldness which leads us to
think of the image of an old man, but also the extremely evocative depiction of the hesitant steps,
aided by a stick. According to information I have received from Gaston Kahilu from Shaba, *kashi-
nakaji* traditionally joked with the onlookers; behavior which is inconceivable from the severe
and noble *cihongo*.

Moreover, I have nowhere found any confirmation of the idea also advanced by Albert Maesen —
in the same publication — that the male (*cihongo*) and female (*pwo*) Chokwe masks dance
together, to underline "d'une façon impitoyable les difficultés entre l'homme et la femme, les tra-
vers de chacun des conjoints, etc. Ces scènes mimées et dansées peuvent se situer au niveau de la
naissance du théâtre." I have never witnessed such displays in Angola and the photographic
archives concerning Zaire have not preserved any examples either. True, over the years mask
dances have undergone a certain loss of their sacred character, though without sacrificing their
popularity. They are still regularly taught to young initiates after circumcision in the bush camps.
And on their return to the village they demonstrate their new talent spectacularly in front of their
enthusiastic families, during a great celebration. The favorite dances, learnt individually, are those

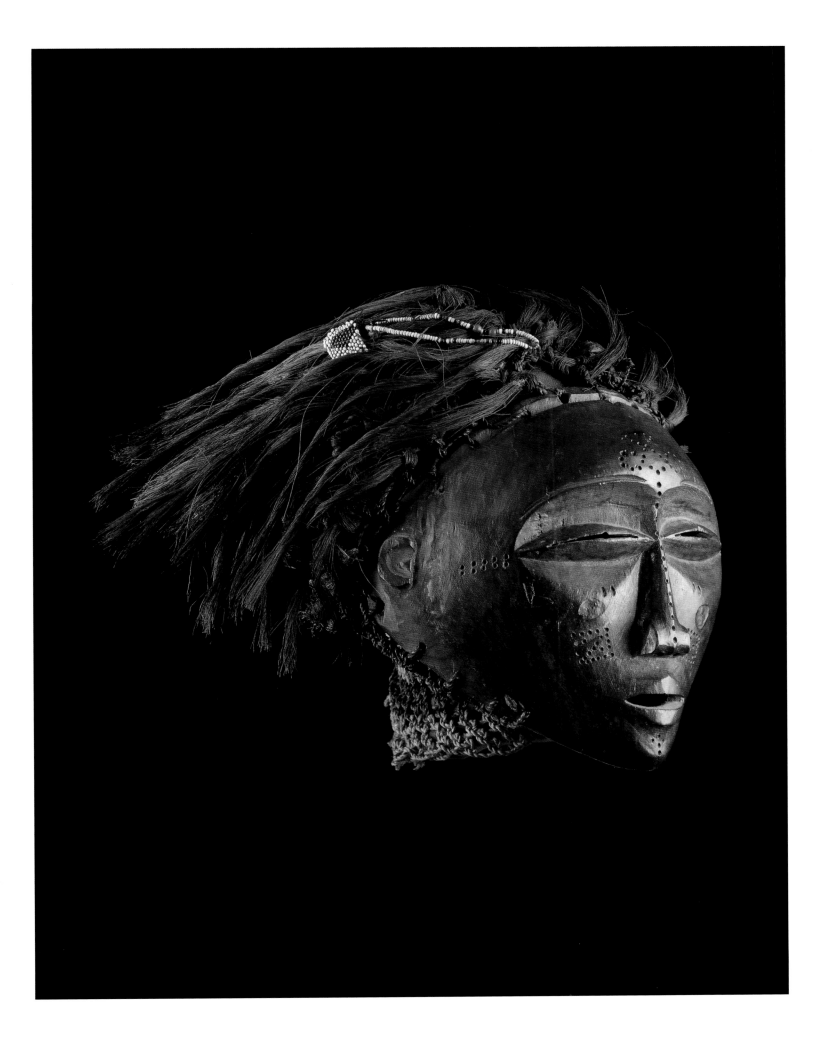

42

NGANGELA

Angola

anthropomorphic face mask

H. 37 cm. Wood, pigment, fiber

Marie-Louise Bastin ascribes this mask to the Ngangela, a people living in the region of the Cubango River and her tributaries, the Cuchi and the Cuebe. They are the southern neighbors of the Chokwe. Their masks show a certain similarity to those of the Ovimbundu. This is especially the case regarding the application of scarification motifs. Little is known of this mask's function, though Ngangela masks are used within the scope of initiation rituals. Possibly its meaning is related to that of the *pwo* and *pwevo* masks, respectively of the Chokwe and the Lwena (cat. 38 and 41). Further information is lacking. (F.H.)

Lit.: Bastin 1971

for *cihongo* and *mungenda*. I saw them as recently as 1978. And on a Sunday afternoon spent in the village of my colleague Muacefo, I was even surprised to see some youngsters amusing themselves by "playing *mukishi*" (or more precisely one *cihongo* and the other *mungenda*) with costumes improvised from leaves.

The further one goes back, one finds that these two masks, *cihongo* and *pwo*, that culturally do form a pair and for this reason are sometimes associated with the symbolic iconography of the thrones, nevertheless were always shown singly in publications. A *cihongo* is illustrated by Lux (1880: 88); Capello and Ivens (1881: 266); Buchner (1884: ill. 1 and 3-5) and Cameron (1885: 428), while Carvalho (1890: 244) shows a *pwo*. Though there is an archive photo at Tervuren, taken in the Kahemba region showing the two masks posing together, standing side by side, we cannot arbitrarily deduce from this that they usually danced together.

Other less prestigious dance-masks are *mungenda*, *katoyo*, and *ngulu*, often made of resin. *Mungenda*'s characteristic attribute is a huge symbolic penis, *muwango*, S-shaped and fixed between the legs. *Katoyo* with his jutting brow like the peak of a cap represents and caricatures the White Man. The pig, *ngulu*, moves on all fours and appears to dig in the ground with his snout (cat. 39). Certain other masks are presented more as clowns, largely to amuse the audience, though they nevertheless retain some ritual significance (Bastin 1982: ill. 30-32).

Akishi Endowed with Hamba Characteristics

A *hamba* (plur. *mahamba*) is an ancestral or nature spirit, round which a cult has grown up, through the intermediary of a sacred tree, or a statuette, or a mask. Prayers, offerings, and sacrifices are offered to these symbolic representations, in order to obtain the protection of the particular spirits concerned. Amongst the numerous *akishi* masks in the Chokwe culture, four also have the character and powers of a *hamba*; *cikungu*, *cikunza*, *cihongo* and *pwo*. Each may cause sickness if an offence is committed against them.

The sacred mask *cikungu* — as we have seen — personifies the ancestors of the dynasty, at the same time exalting the power of the ruler of the country, *mwanangana*, and his beneficent control over his subjects. If the cult of this mask is neglected, the diviner (*tahi*) may attribute responsibility to the mask for any illness which exclusively affects a member of the royal family. To appease the spirits and to obtain a cure for the patient, a solemn sacrifice is organized, at which the *mwanangana* himself participates as celebrant, in the same way and with the same taboos as those described above. However, before going back to the hut in the forest, *mutenji*, the celebrant gives the patient's wife a vegetable remedy, *cisukolo*, to use, made from sprigs of plants of the savanna (*cisangu*, *cikuku* or *mutundu*). The leaves are pounded and mixed with kaolin *pemba* and the product is then rubbed on the body of the patient to cleanse him symbolically of guilt and restore his health. The chief's brother or his nephew on the mother's side then cooks the head of the goat sacrificed in the *mutenji*, which is eaten in the bush, with manioc porridge, by the male members of the chief's family; the carcass of the goat forms a communal meal, eaten in the village by the rest of the community. The following day a hunt is arranged, to kill a small antelope. The dead animal is taken to the *mutenji* and a little of its blood is rubbed as an offering on the brow of the mask. A meal for friends of the chief and certain notables is also held in the bush. *Cikungu* occupies the leading place in the hierarchy of *akishi* and as a *hamba* particularly protects the ruling family. However, he is never represented in this way in sculpture. But in the statuary and decoration of ceremonial objects linked to the exercise of power, it is doubtless he who is evoked by the figures of rulers represented with broad composite winged headdresses.

The patron of the initiation of adolescent boys, *cikunza*, with his tall pointed and ringed headdress is honored as a *hamba* by hunters and barren women. This was remarked early on by H. Baumann (1935: 110), who noted too that this "Dämon" sometimes took possession of someone who then fell ill. Because of his particular cult, hunters hang amulets representing him on their guns, and women who want children attach them to their belts (cat. 35) (Bastin 1984b: ill. 5). In this miniature form he appears as a symbolic object in the diviner or seer's basket *ngombo ya cisuka*, where under the name of *samukishi* he represents all the masks. Under the same name he is also placed in the sanctuary of the *mahamba*, in the form of a little totem-post, which passes

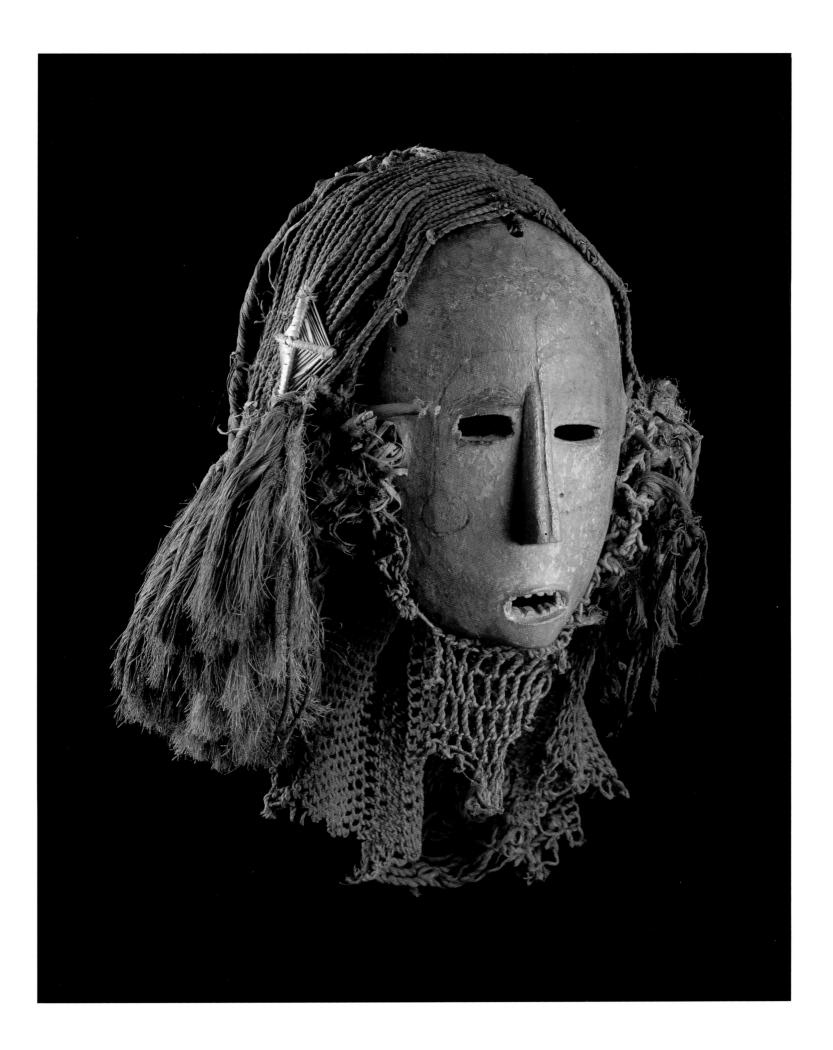

through a kind of small table (Bastin 1961a: ill. 102).

The mask *cihongo*, evocation of the spirit of wealth, also has a religious connotation, under the name of *cimyanji*, and if this spiritual-being is irritated it can cause various evils. So the chief *mwanangana* decides to appease it by a propitiatory sacrifice. On the appointed day, to give more solemnity to the occasion, the mask is sometimes worn by the *mwanangana* himself, who appears early in the morning in the public square carrying a leafy *cisukulo*. In front of the assembly gathered round him, the chief's head wife, the *namata*, sacrifices a hen, cutting the throat so as to let the blood run onto the headdress of *cihongo*, and by the same token to indicate the high rank of the mask's wearer. He then begins to dance and gives the *cisukulo* to the wife of the sick man. She pounds the leaves and mixes them with the white clay, *pemba*, finally rubbing the mixture over the body of the patient. I was able to observe a special veneration for *cihongo* on the part of Samuzanga, in the region of Dundo (Angola). On the death of his maternal uncle Satshombo, who had worn and danced *cihongo*, the nephew inherited his mask and performed in it regularly. However, one day he neglected to do so and abandoned it. As punishment for his offence Samuzanga fell ill. On the advice of the diviner, he had to make a new mask and honor it by sacrificing a hen and dancing regularly again. Between dances, he places *cihongo* inside the sanctuary, *katunda*, with the other personal *mahamba* (ill. 6), and honors it at each new moon with prayers and offerings of manioc flour (less costly than kaolin) and the blood of a wild animal.

The powers of *hamba* are also attributed to the feminine mask *pwo*, embodying the founding ancestor, but it is only ever ritually honored by its owner. If he falls ill as the result of negligence, the diviner, after having diagnosed the cause of the illness, declares that he must carve a new mask, if the old one has been destroyed. The object is consecrated by the blood of a hen offered as a sacrifice, and displayed afterwards in the public square in front of a crowd of spectators, particularly women, who wish to benefit from the propitious influence of *pwo* on their fertility. Of these three *akishi*, the feminine mask *pwo* has the least prestige as a *hamba*.

Akishi Having the Character of Wanga

Wanga are evil forces, manipulated by the sorcerer *nganga* in order to cause harm. The *akishi katwa*, *cihongo* and *pwo* figure among them, representing the opposites of their beneficial characteristics. They may be represented as statuettes charged with harmful powers, which are concentrated in a piece of the heart of a dead man (usually enclosed in a small horn or in a cavity in the statuette's chest); in the red clay, *mukundu*; in pieces of mirror *talatala* (often encrusted on the statuette's eyes), or in small red and black seeds which have medicinal value but are also toxic, the fruit of the creeper *Abrus precatorius L.* (which throughout black Africa denotes danger).

Above all it is *katwa*, the messenger, sometimes armed (ill. 7), who is sent by the *nganga* at night with orders to kill ("eat the soul"), after supposedly having been changed into a small living being by reciting an incantation of a cabalistic formula. *Wanga* have powers which are exclusively hostile and totally evil.

ill. 6. Chokwe (Angola). Shrine of the guardian spirits (*mahamba*) of Samuzanga, where the *cihongo* mask and its belt (*cipaka*) are kept. Photo: E. Ramos, 1978.

The Mask as Art

Though from a functional point of view the mask is a ritual object with religious connotations, and *cikungu* and other *akishi* have *hamba* characteristics too, when creating the mask a deliberate attempt is also made to achieve beauty. To make a mask in resin requires the skills of a specialist in this material (which is worked with hot iron), who has to both conceive and decorate the vast superstructure which helps to give it identity. There are clear differences in the appearance of examples of this type, which may range from the most simple forms, sometimes even verging on coarseness, to those of extreme refinement. The majority of *akishi* in the Museu do Dundo in Angola show this refinement, as do the series of magnificent *mukanda* masks collected by Delachaux in the Angolan region of the Cunène in the early 1930s, for the Musée d'Ethnographie at Neuchâtel in Switzerland. The black resin has not only been used to model the faces, but the beaten bark cloth stretched over the headdress frame is also carefully covered with a thin coating of this material, which is then decorated with various traditional colored designs (Wassing 1969: ill. VIII).

The Chokwe have a marked taste for creating well-made work which also has aesthetic qualities, which they themselves call *utotombo*, and this is found in an even more fully developed form in the creation of wooden masks by professional sculptors (*songi*) who have learnt their skills in a master's workshop. However, the artist has to conform to an entire ritual. The dancer himself commissions the mask and, in the case of *pwo*, at that point gives the artist a brass bracelet; the symbolic bride-price. From then on there will be a sort of mystic marriage between the dancer and his feminine mask (Redinha 1965: 14). To create the mask the sculptor begins by choosing the tree and, before cutting it down, buries the brass bracelet at its foot as an offering to the spirit believed to dwell in it, and to avert reprisals on its part. The sculptor's work on the mask is carried out entirely in the bush. But before making it, the artist begins by carefully observing a woman in the area whose beauty he admires. This is to inspire him and to enable him, while working in his retreat, to recall from memory the proportions of her face, the design of her tatoos and even her favorite expression, not forgetting her hair-style, which the sculptor will imitate when making the wig. When delivered to the dancer, the mask will accompany him all his life. In the past, at his death it was often the tradition to go and bury it in an isolated marshy place, out of superstitious fear, while a bracelet would be put near him, to signify the restitution of the bride-price. Dancers would also bury worn-out masks which could no longer be used, in the same way (Redinha 1956: 22-28).

The fact that the resin masks used for *mukanda* were burnt at the end of the rite and that the feminine mask was buried at the death of the dancer, would explain why there are not, as far as I am aware, any Chokwe masks of great antiquity. Though it is proved (Bastin 1981) that from the last quarter of the nineteenth century onwards many statuettes were brought back to Europe and put in museums, there is not a single mask amongst the objects collected at this period. Confirmation may perhaps be found in the work of the young Leo Frobenius, who in 1898 published a remarkable and detailed illustrated-catalogue of African masks already held in the principal European museums. Amongst these there is none of Chokwe origin. In general it was only as of the 1920s and 30s that examples from this area came to enrich ethnographic collections. So it was by way of pure hypothesis that I suggested to have seen in two superb female masks, works from the original land of the Chokwe (Bastin 1982: ill. 45 and 46). And yet it is indeed the manner in which physiognomic details of the ritual mask were stylized that often imposed itself to the sculptor as a paradigm when working on statuary: the transposition of the ideal image of the *akishi* into the universe of plastic forms of this people.

ill. 7. Chokwe (Angola). *Katwa* statuette for black magic. H. 21 cm. Museu do Dundo (M 38).

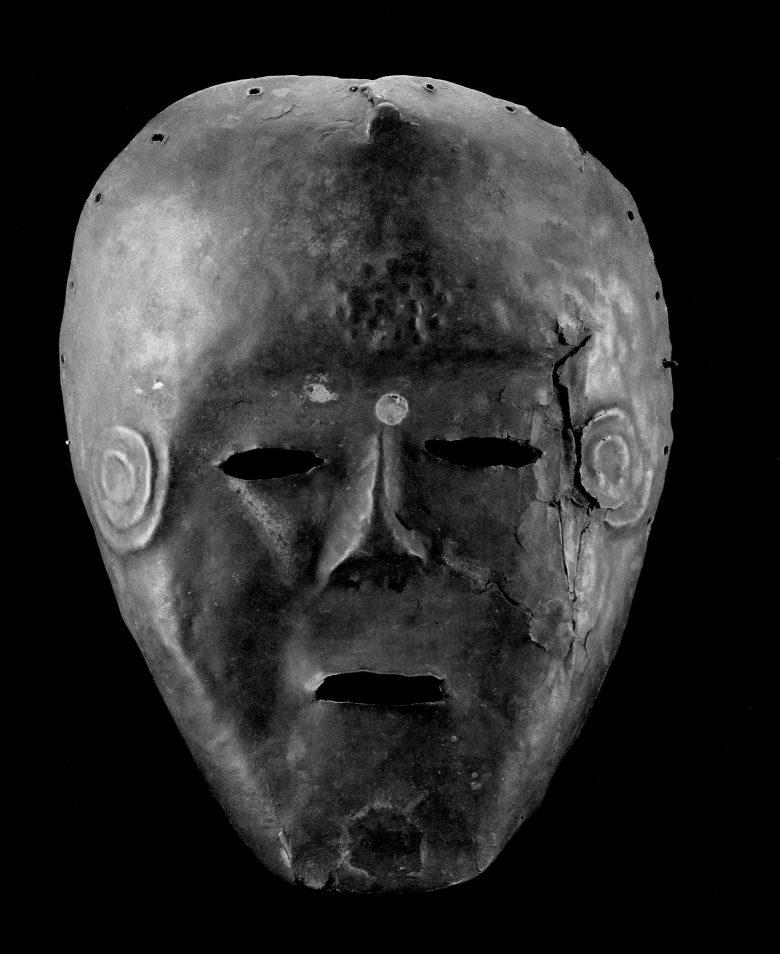

Material and Formal Aspects of Copper Masks from the Upper Kasai

Rik CEYSSENS

The ugly one is coming for you,
the pretty boy goes elsewhere.
My faltering arrowhead conforms
to your quiver, exactly to size...
Where have the flawless missiles gone?
The beneficent water perfectly fits the calabash.
The tender mouse is eaten because of her plumpness...
As the maiden goes down well because of her beauty.
Whistle of mine, whistle that I wear warmly around the neck.
You shine like a sun-drenched mask of red copper.
You are the flower's equal, flaunting like a parrot.
You spring to the eye like the bird
with a tricolor flourish about the neck.[1]

In this study I will be discussing copper masks and copper- covered wooden masks from Central Africa. These were brought to the attention of the art-history community by Bastin in 1961, and have appeared on the open art market since around 1985.

The copper masks were found on the left bank of the river Kasai (Luka), roughly between latitudes 7°05' and 7°35' South and longitudes 21°25' and 21°50' East (see map). Within these narrow confines belong those peoples one might call Kongo-Dinga[2] and Kata.[3] The copper-covered masks are found just east to the full-copper masks, on the Kasai's right bank, among the Lwalu[4] and — somewhat further away — with the Salampasu people.

In a parallel contribution I will show that, with respect to content, these masks are closely related, particularly to those of the Kete, the Kongo and the Lwalu. What is more, I will be obliged to extend beyond this limited area in order to describe and "read" the message.

In brief, and to aid understanding, one can start by saying that the copper masks are the striking emanations of the land-bound community (*ekuluwanda*). More specifically, they are expressions of collective management (*mukanda*), as concerns the land and the society in the broad and spatial sense. In times of prosperity and peace, a quiet *mukanda* will move in the shadow of the village-bound authority of the chief, occupied with the mundane affairs of marriage and other questions of exchange. When any sort of calamity occurs — infertility, war, poor hunting — the *mukanda* comes collectively to the fore, by way of adjuration.

As already mentioned, the copper masks are a relatively recent "discovery". By this I mean that already in 1952 the museum of Dundo (Angola) seems to have known of their existence (Lima 1967: 264, n. 4). In 1953 Pinho Silva and Osório de Oliveira were able to view a copper mask, and photograph it (1958: 146)[5]; the following year a short text was published, a first as concerns this subject (Oliveira 1954: 62). In 1954 it was Baumann's turn to be confronted with a hammered specimen (1969: 40, 29); this example was probably the mask of the Mayayi, in Shinkolondo. Two years later M.-L. Bastin made photographs and casts of that same mask; in 1957 the replicas arrived at what was then the Musée Royal du Congo Belge, presently the Musée Royal de l'Afrique Centrale (M.R.A.C.) in Tervuren.[6] The 1960s saw the appearance of several pertinent publications (Bastin 1961; Lima 1967; Escultura Africana, 1968; Baumann 1969). These contributions only dealt with copper masks from Angola.

I myself "brought to light" copper masks from the Zairian side: this was in December of 1969. This new fact was transmitted in a second generation of publications (Neyt 1981), after an interlude of many years.

43
KONGO-DINGA

Northeast Angola & Zaire, West Kasai
anthropomorphic (face) mask
bintsanga or *kamukeenyi*
H. 29 cm. Copper

One finds full-copper masks on the left bank of the Kasai among the Kongo-Dinga and the Kata. The flattened masks consist of a single piece of copper and have no wooden supporting armature. They are closely related to the copper breastplate, called *ekalangu*, belonging to the chief and his wife. Both objects are made by the same person, using the same materials and means. It is possible that some were made from chest-decorations fallen into disuse. Moreover, both the pectoral and the mask denote the sun. Striking are the imitations of knob-like scarifications, *tunkolo* or *madjindula*, between the ear and eye, and the rosette-like painting, *kankolo*, upon the forehead. The generic mask name *ngongo munene* relates to the society that preserves and uses the masks. The *bintsanga* mask type is described as more important than the *kamukeenyi* type. Although provided with a row of holes, the copper masks are rarely worn. In bygone days, it would have exceptionally performed in cases of disaster and misfortune. Generally speaking the mask, which is stored in a basket, after a thorough cleaning and out of sight of the non-initiated, is put "on view" for several days as a mark of respect for a deceased member of the society. (C.P.)

Lit.: CEYSSENS (p. 97); Ceyssens (*forthcoming*)

97

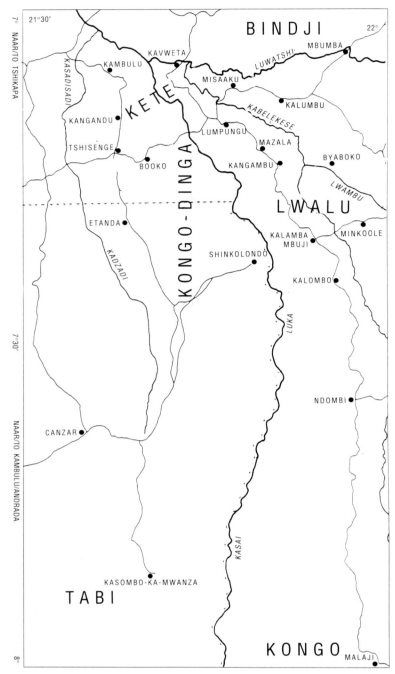

The land between the rivers Kadzadi and Kabelekese

ill. 1. *Shabaaba*, in Kangambu village, among the Mbamba.
Photo: R. Ceyssens, 1971. M.R.A.C., Tervuren (E.PH. 9122).

ill. 2. *Mwana-a-nzanza*, in Mushidi village, among the
Kandunda. Photo: R. Ceyssens, 1971. M.R.A.C., Tervuren (E.PH. 9123).

ill. 3. *Ikalu*, in Kalombo village, among the Kamooko. Photo:
R. Ceyssens, 1974. M.R.A.C., Tervuren (E.PH. 11236).

In 1971 I was able to purchase a mask taken as booty by the Kongo-Dinga from the Kata, and thus no longer in use. This was most likely the first copper mask to be removed from its milieu, and it still remains in my possession.[7] I should immediately add that at the time this could be easily "exported", due to the fact that it had already been uprooted and "stolen"!

The rapid loss since 1985 of this important component of cultural heritage cannot be put down to my scientific indiscretion or over-zealousness, but is indirectly attributable to the gradual deterioration of living conditions in Angola as well as Zaire. This depletion was more a direct consequence of a collapse of the trade in smuggled diamonds which occurred in the area around 1981 (Ceyssens & Kankunku 1982). From 1985 on, the value of the mask was virtually expressed in karats; moreover, the mask and *la pièce* have generally come to replace the no longer available stones... so long as the supply lasts. Noteworthy in this connection is the fact that the *jeunesses* carry out point-blank holdups of elders to whom the masks and images are entrusted for care; without doubt in many cases these perpetrators are the hirelings of specialized traders who remain in the shadows. Or, more truly expressed, has this perhaps rather to do with the easygoing and joking relationship that exists between alternate generations?

By the end of 1990, to the best of my knowledge a dozen copper "Dinga" masks had found — or perhaps lost — their way to Europe or the United States.

Distribution

In December of 1969, after protracted negociations with the Luvungula I was able to photograph their *kamukeenyi* mask (Cornet 1989: 262). Over the years since then I have seen other masks, called *kamukeenyi* or *bintsanga*, among the Shimpembi, the Nkuluwanda, the Keeseedji, the Munkuluba, the Mpika, the Mpoopo (Roy 1992: 233), and the Kabadi: taken together, eight copper masks from Zaire.

There are reasons to think that in the 1970s there were approximately twenty-five masks in use by the Kongo-Dinga (Ceyssens 1984: 353-356). The great majority of these were to be found in Angola, including that of the Mayayi (Shinkolondo), whose likeness has so often appeared in the literature (Bastin 1961b: 30-33; Lima 1967: 261; Neyt 1981: 205; Felix 1987: 31).[8]

Among the Kata of Kangandu I was able to identify and photograph four copper masks: a *kamukenge*[9] in the village of Kalaala among the Ndjinga; a *nzaji yaakwakula* ("The thunderous lightning")[10] with the Ndambu; a *kamwanga* with the Kamisenge;[11] and again a *kamwanga* among the Kandangala people at Mbudi, just north of Kangandu. North of Mbudi, I have no knowledge of the presence of copper masks.

On the right bank of the Luka, namely with the western Lwalu, one finds copper-covered masks, generally known as (*ngongo wa*) *shimbungu* (cat. 46) (Neyt 1981: 204, ill. X.4). I have localized and identified some ten of these...

In 1976 I photographed the mask *munene-a-kakumbi* ("Who gathers many around him") in the village of Mwana-Kavunga with the Kazanza people (Lumpungu); it was made by Kashaasha-Kapulumba (*ka Mulunda*), of the Kaali. This mask has since been lost to the pulverizing effect of termites on the *shimene* wood[12] support structure (*cf. infra*). To my knowledge, this was the most northerly Lwalu mask with copper covering. In the village of Mpata-Isaka of chief Mandala, the Biisaka possess a mask called *motolototo*; Mulumba-Mbonji, of the Keeseedji, made it around 1958. In the village of Kangamb(u)(o), the *shabaaba* mask is found among the Mbamba people; its maker was Kabwanyi, of the Mbundi. He died in 1961 (ill. 1). The mask known as *mwana-a-nzanza* of the Kandunda, in the village of Mushidi, was made by one Ilunga-Bwazwa, a local sculptor who died in 1970 (ill. 2). The *mutenyewu* mask of the Ndaji, with chief Malongila, was made by Mwinyi-a-mikumbi, of the Wanga, and it closely resembles the last-cited mask. Striking in both is the vertical arrangement of the copper strips.[13]

The Muwampa people, in the village of Mu-Isanza-dya-Byasamba, also have their *shimbungu* mask. The mask of the Luyambi, in the village of Kalamba-Mbuji, is called *shabaaba*. Opposite to Kalamba-Mbuji, on the right bank of the Kabelekese, the Mwanda of Minkoole possess an *ikalu* mask, made by Bwalama from the village of Boovo (Muwampa). The mask *ikalu-dya-wayinda-mpanji* ("Only child, without brother or sister") belongs to the Mukunda, in the village of Mulaanyi, close to Kalombo (*Arts d'Afrique Noire*, 1988, 67: 61).[14] Then there is another *ikalu* in Kalombo itself, which brings me to the edge of the *shimbungu* range of distribution (ill. 3). This mask of the Kamooko is closely akin to that of Mulaanyi; both have a markedly pointed chin, quite common in the wooden masks but rather rare in the copper-covered examples and near in-

44
LWALU

Zaire, West Kasai

anthropomorphic face mask

nkaki

H. 32 cm. Wood, pigment

The Lwalu, earlier named incorrectly as Lwalwa, are from a historical point of view unmistakably related to the neighboring Kongo-Dinga. They are primarily known as mask makers, and sculptors occupy a privileged place in society. As concerns the wooden examples, one may distinguish — upon the basis of the nose — a formal difference between female and male masks, the latter disposing of three different types. The variety of nose forms would pertain to different birds. The wooden masks exhibited here are both male. The example under cat. 44 is of the *nkaki* type, while that under cat. 45 belongs to the *mfondo* type. Striking are the imitations of scarifications, called *tunkolo* or *madjindula*, in the form of rounded elevations between ear and eye. These are applied for both medical and aesthetic reasons. Underneath the eyes, sometimes parallel vertical incisions — *mbadji ya wa nkiiki* — are mirrored. Additionally, one encounters imitations of face-painting with white kaoline. Through the hole under the nose is secured a small piece of cord, used to clench between the teeth to keep the mask in place during the dance. The masks perform in conjunction with ritual dances of the *bangongo* or *ngongo* society. Initiation into the society follows the circumcision rite, and encompasses a series of esoteric practices. The accession formerly culminated in the ritual murder of a number of persons. Masks are used for various rites, but performances of masks are usually launched with the aid of spirits to ward off repeated misfortune during the hunt. While unmasked dances go on during the day, the masked personages only appear after nightfall. Nowadays, performances are also given for primarily financial motives. The

existent in full-copper specimens. Both masks would most likely be of Mayayi origin.

Once again linking up with a point raised in the prologue, it should be underlined that though the masks can be localized in a village, they are nonetheless not attributable to a village, a physical agglomeration of people, but rather to a "large village" or *ekuluwanda*, a grouping of villages or, better still, matrilineal familial conglomerations with the land that they had settled "from old" and collectively ran.[15]

As to content, the *shimbungu* masks are quite close to those of the left bank. Is it then not significant that Timmermans (1967) had not made any mention of these? They were then also nearly simultaneously "discovered" with the copper masks of the Kongo-Dinga of Zaire. From a purely geographical point of view, and as far as memory serves, there is no continuity between the masks of the western Lwalu on the Kabelekese River and the masks of the eastern Salampasu on the Luluwa River (Tulume, Nsele, Mukelenge-Muloolo, Mundembo). Between the two poles extends a maskerless if not a sculptural-plastic vacuum of 70 km. in diameter (Ceyssens 1990: 15, 21, n. 41).

With respect to content, however, there would exist some connection between the copper masks on the Luka and those on the Luluwa, certainly if one bears in mind what Pruitt has to say concerning the Salampasu masks (1973: 165, 169-173). Further investigation is here imperative. The existence of a morphological link is beyond doubt. Already with respect to the wooden masks, the *shifoolo* mask[16] of the western Lwalu is clearly recognizable in the Salampasu. And then there are the copper strips, nowadays rectangular and horizontal parallels, seen in the masks of both peoples. Nevertheless, in order to avoid misunderstanding, one must state at the outset that the strips are more massive in the traditional pieces as opposed to what one sees in contemporary examples, and that their arrangement is totally unreminiscent of flawless "cross-bond" masonry. Additionally, owing to the larger size of these strips, they were more flexible, could be placed in parallel, and so adapted themselves to the underlying volume.

Material Culture and Morphology

Are the *shimbungu* masks openly derived from the wooden masks with their so-characteristic morphology, and which were in use on the river Luka's left and right banks, from Kadzadi to Kabelekese? At times one cannot escape the impression that these are masks which had led an autonomous existence as wooden dance masks, prior to being covered with metal strips or plates. And though such was certainly sometimes the case, there is no indication that this recycling-scenario was the rule. It was clearly in fashion to invest masks of the *mfondo*[17] and the *nkaki* types with copper, and even sometimes the *mushika (kashika)*, as in Kalamba-Mbuji.

In these examples we are dealing with "patchwork" on wooden sculptures; that is to say, upon a supporting base with some measure of presumption as to form.[18] Patchworks or collages which, as such, are easily mimicked with modern — usually thin — recuperated materials. Metal cans are skillfully cut to restore deteriorated masks or to make new ones. Formerly, each "strip" was individually secured with copper nails[19] (cf. in Kandunda, ill. 2, and in Ndaji), or — like in a patchwork quilt — it could also be nailed to the wooden base-structure and "sewn" sideways onto the adjacent piece (cf. in Muwampa and in Mbamba, ill. 1).

In essence, the creative process takes place in two stages. First executed is the sculpture in wood, and though worthy of our appreciation, this is not the primary focus of our concern here. The subsequent "canning" is undoubtedly a considerable creative achievement, but in my view seems significantly inferior when compared to the full-copper masks from the left bank side, wrought from the void without "formal" precursors.

Masks from the left bank are from a single piece of copper sheet, not supported by a wooden *Unterbau* and thus invested with its "own face", with little or no reference to the wooden masks (cat. 43). All the more in view of the millimeters-thick sheet itself, stubborn and not supple enough to reproduce the relevant forms of a wooden mask. By reason of this compelling material premise, one could only but expect an end product which is relatively flat and weakly assertive.[20] There is then also no sufficient reason at hand for "estranging" the copper masks, as Oliveira and Lima have attempted to do (Lima 1967: 264). Admittedly, the material is not indigenous, not gained locally. But full-copper and wooden masks could not and still cannot be expected to yield a "uniform" visual result: copper sheet and wood do not have the same receptive capacity, and different form-creating techniques are required.

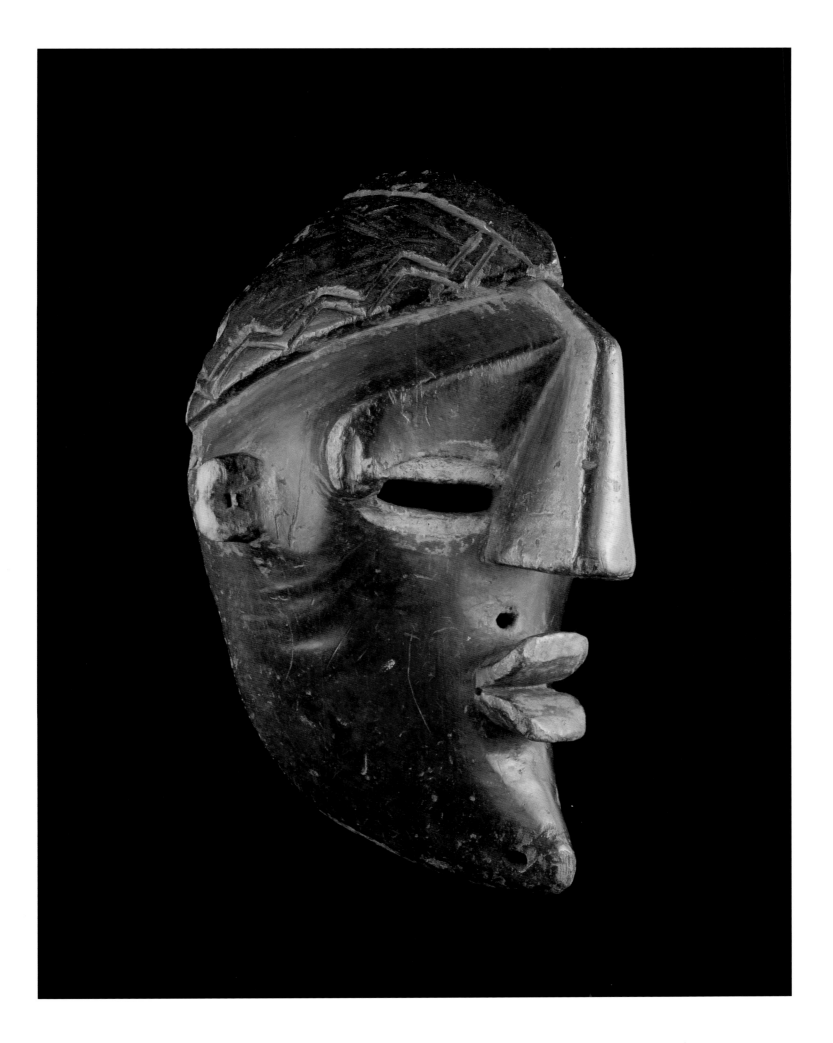

ill. 4. Mask of the Keeseedji displayed together with two shoulder-rings and four "ribs". Photo: R. Ceyssens, 1971. M.R.A.C., Tervuren (E.PH. I 1205).

45
LWALU

Zaire, West Kasai

anthropomorphic face mask

mfondo

H. 31 cm. Wood, pigment

dancers, always in groups of around ten, perform dressed in skirts made from the skins of a particular type of ape and genet-cat. The fly whisks and antilope horn held in the hands, function to keep malevolent spirits at bay. Each dance movement has a specific name and a well-determined meaning. (C.P.)

Lit.: Timmermans 1967; Van Geluwe (*in* Fry 1978: 82-85, no. 8); CEYSSENS (p. 97)

On the left bank, copper masks are in large measure the result of hammering. And this is obvious, if one realizes that the hammer technique is not only applied in mask making, but also — and perhaps in the first instance — for the round copper pectoral. This piece is worn around the neck on a leather string by the chief *kalamba* and by *shitadi*, his elder sister, who are enthroned together (ill. 5). Thus indeed a "formal" precursor! This disc, called *ekalangu*, was found over the entire investigation area, among the Salampasu, Tabi and Kongo peoples, as well as with the Kambulu[21], as an identifying sign of societal success; ask me not in which period of time. All around, in the border of the concave side, one finds a decorative element called *byolo* (ill. 6).[22]

Thoroughly shined, this disc reflects the sun and is indeed the sun, just as *kalamba* (and *shitadi* at the same time) and the copper mask itself are associated with the sun... "I am the first-born and therefore entitled; for was I not the first to behold the sun and the moon?" (*Ami yandza a kumana etangu ya ngondi?*)... "*Shitadi, kalamba*'s sister; *shitadi*, obligatory companion; sun upon which one cannot fix, from which the gaze must be averted" (*Shitadi mpaanyi a tulamba; shitadi, shaak-ulamyeka; etangu bakaakutalanga meesu*). It is well to understand that these sorts of bold pronouncements are taken for what they are, namely, bold pronouncements.[23]

With respect to the meaning of the word *ekalangu*, the situation is unclear. Among the Kongo-Dinga, there is *ekalangu* (*dya twiyi*): spark; yet the word *ekalanga* also exists: mat. Masks and the accompanying accessories normally remain stored in a carefully closed basket. When the occasion arises, for instance in the case of an interested and paying outsider such as myself, they are timidly displayed upon a mat *ekalanga* and/or — indeed — upon a copper disc *ekalangu!*[24] I saw there, for example, the copper "atlas-vertebra" (*kayongeelu*), which is pinned to the neck on the back of the raffia dance costume (*esasa*). A somewhat peculiar business, since it is extremely rare that the copper mask is "worn". Sometimes the atlas-vertebra takes the form of a flat ring or a bored-through disc, or perhaps a half-moon.[25] As such, the atlas is located behind and "to the west", at least in relation to its logical pendant, *ekalangu*, with the sun's dawning on the front side.[26]

In the basket and upon the mat also lay the copper strips, *makete*, which are to represent the "ribs" (*mbambi*). Their number depends on the type of mask. The example with superior status (*bintsanga bya nkoole* or *ndzadji*) would have 8 on the front side and 8 along the back, always with 4 to the right side and 4 to the left. The somewhat less-valued variant (*kamukeenyi* or *kwakula*) may claim but 6 strips on the front side and 6 on the back, always three to each side.[27] I must also make mention of some copper rings (*makanga*) which the supposed dancer would wear at the shoulder girdle (ill. 4).

All this notwithstanding, the difference between the right and left banks is not quite so radical and unbridgeable as may seem. But indeed, the viewpoint of the designer is exclusively from the "outside-in" (*à l'endroit*) in the case of the copper-covered masks[28], rather than "inside-out" (*à l'envers*) as seen in the full-copper masks.

But might the *makete* strips, belonging to the regular attributes of the mask — also on the Luka's left bank — lay at the origin of the nailed-strip masks of the right bank?[29] This is a possibility, but no more, keeping in mind that the influence may just as well have flowed in the opposite direction. Nonetheless, it is difficult to accept that the copper pectorals would have been unknown to the Lwalu. In short, I may only conclude that the one rules out the other. If one opts for a wooden base-structure, which may be of worthy sculptural value in its own right, then no homo-

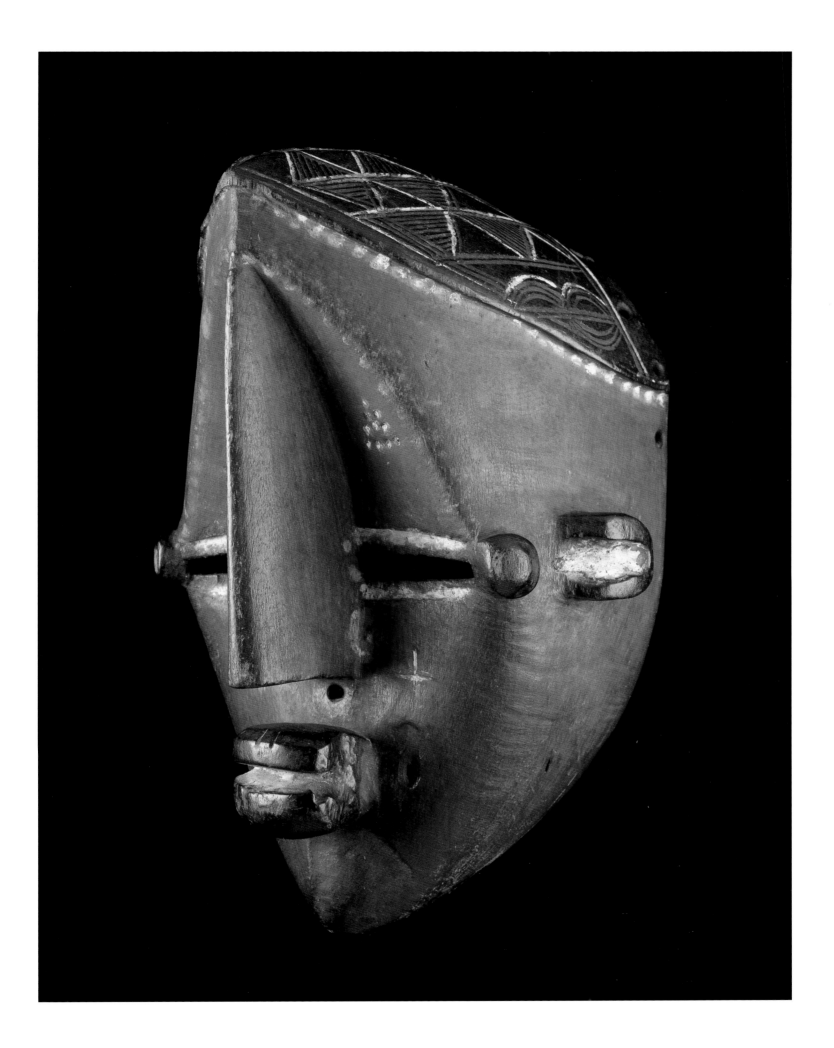

genous copper sheet could be hammered upon or around it; in other words, one would be obliged to divide and cut the sheet into small pieces of varying size.

The copper mask made from a single piece, as we have seen, refers directly to the pectoral *ekalangu*. Both are intimately related, and this in a twofold way. First, the same craftsman made both the chest adornment and the mask, employing the same materials, the same techniques, the same array of tools. Second, and perhaps more importantly, the hammer and chasing techniques were first used in making the chest piece, which was then later recycled into a facial mask via this pectoral route.

The "mat" and the mask were not founded in smelters or ovens; indeed, neither copper mining nor founding are to be seen anywhere within hours of this vicinity. Both pieces, and especially the saucer-shaped mat, are made — through the techniques of hammering and chasing — from copper Saint Andrew's crosses (*mwambu, myambu*), imported from the southeast; or from rings for ankles, arms and neck.[30]

The copper cross is not only a means of exchange and unit of currency; it is also the entity or base material of choice for use by the Tabi and Kongo smiths.[31] Further, one may compare the copper crosses, *makalangu*, and the all-metal masks according to weight...

46
LWALU

Zaire, West Kasai
anthropomorphic face mask
(ngongo wa) shimbungu
H. 32 cm. Wood, metal

The Lwalu also make copper covered masks which are in form closely linked to their wooden examples. The specimen shown here is related to the *mfondo* type. It cannot be confirmed if these copper covered masks first served as wooden dance masks, prior to their being bedecked with metal. It is generally supposed that the pieces of covering metal sheet, attached to the underlying wooden armature with the aid of spikes or nails, were larger and more massive in the old masks than is the case with contemporary examples. As to whether or not the metal bands hark back to the copper strips — called *makete*, and which are among the mask's attributes — remains an open question. Concerning their meaning and content, the masks are closely related to the full-copper masks of the Kongo-Dinga (cat. 43). The name *ngongo wa shimbungu*, by which the Western Lwalu designate these masks, refers to the society within whose scope they perform. In contrast to the strongly similar *ngongo munene* society of the Kongo-Dinga, the *ngongo wa shimbungu* deals exclusively with lesser offenses. (C.P.)

Lit.: CEYSSENS (p. 97); Ceyssens *(forthcoming)*

Selected Crosses:	Full-copper Masks:		
• 980 g 23.2 cm. diameter	Ndambu	960 g	28.7 cm. height
• 940 g 23.5 cm.	Mpoopo	896 g	32.2 cm.
• 1020 g 25.7 cm.	Kabadi	875 g	31 cm.
	(Berlin)	621 g	28.5 cm.
	Tshibanga	390 g	27.8 cm.[32]

Other important questions of a material nature concern diachrony. The Lwalu say quite frankly that, as regards the copper-covered masks, they cadged from their brothers on the left bank of the Kasai. Both the Kata as well as the Kongo-Dinga invariably refer to the south when it comes to indicating the origin of the mask. Some remarks in this regard...

In this region, "the south" must be interpreted in a broad sense: south, east (and above) go hand in hand, just as do north, west (and under) (Ceyssens 1984: 103-119). It is therefore not surprising that some among the Kata contend that they consulted the *Mbala* with regard to the copper masks. But we should not forget that *mbala* is used to indicate the east, "the Levant, where the red morning sky dawns, ever and again" (*ku mbala ya mbalanga*!). The Atlantic coast and Europe are most definitely excluded as suppliers of the copper base material.

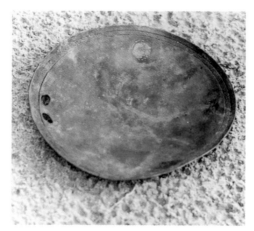
ill. 5. *Ekalangu* of the Mpika people (I.M.N.Z., Kinshasa, no. 73.581.20). Photo: R. Ceyssens, 1973. M.R.A.C., Tervuren (E.PH. 10301).

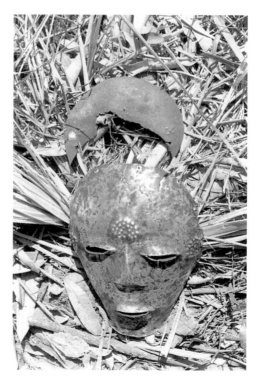

ill. 6. *Ndzadji yaakwakula* of the Ndambu people. Photo: R. Ceyssens, 1977. M.R.A.C., Tervuren (E.PH. 11579).

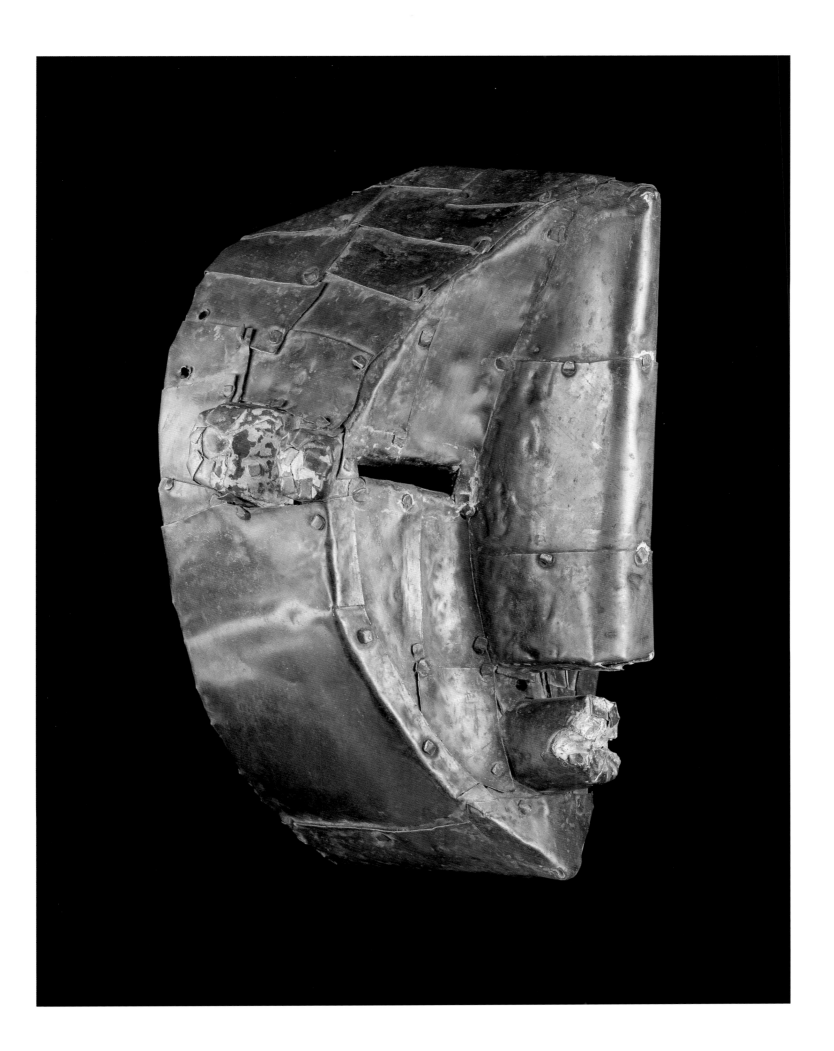

47
BINDJI (MBAGANI)

Zaire, West Kasai

anthropomorphic face mask

H. 32 cm. Wood, pigment

The Bindji, also called Mbagani, are
neighbors of the Lwalu people, the Kete and
the Kongo-Dinga peoples, and live in the
border area between Zaire and Angola, to
the Kasai River and her tributaries. There
are but few masks known that may be
attributed with certitude to Bindji
production. These rare sculptures bear
witness not only to a great diversity of form,
but are moreover very closely related to
those of neighboring peoples, as well. While
certain examples are clearly reminiscent of
Lwalu masks, others bear affinities to
Chokwe specimens. The remarkable
specimen under cat. 47, with the authentic
restoration which "joins" the two face-halfs,
is similar to an example in the M.R.A.C.,
Tervuren, and is related to certain pieces
attributed to the Luluwa. The example
under cat. 48 most probably takes the name
kibwabwabwa. According to François Neyt,
the striking white eye sockets symbolize the
presence of ancestor spirits. As is the case
with the Kongo-Dinga and the Lwalu,
among the Bindji masks are also associated
with practices of the *mukanda* society.
Masked dancers perform during times of
crisis pursuant to unsuccessful hunts, or
general sterility among the women. The
kibwabwabwa masker is accompanied by a
masked "girl", called *gashiga*, and by an
unmasked figure named *gabamba*. (C.P.)

Lit.: Neyt 1981; Felix 1987; CEYSSENS (p. 97); Ceyssens
(*forthcoming*)

Local specialists distinguish between a western route (where the masks are known as *ndzadji* or
kwakula), starting from the Tabi, going to the Kongo-Dinga, living on both sides of the Kasadi-
sadi River (*beeshi Kadzadi*), to the Kata;[33] and an eastern route (where the masks are called *bint-
sanga* or *kamukeenyi*), along the Luka River, coming from the Nkandza, through the Wanga
(Shinkolondo), to the Luyambi of Zaire. It is chiefly the eastern variant and tradition that has left
its mark on the western Lwalu.

When one refers to "the south", could it be that confusion arises between the mask and the metal-
lurgy? Message and medium? It would in all respects be premature to formulate a definitive an-
swer on this matter, though it is now already established that, among other things, content may
be implied from travel patterns.

I have disposition of information regarding the time span wherein the first copper masks
appeared among the Shinganga, Mpika, Mpashi and Nkandza peoples. This concerns four
genealogies, real or functional, where — around 1975 — dignitaries sent at the least the great-
grandfather, at the most the great-great-grandfather, "to the south" (Wanga, Kaluwu) to earn and
fetch the *ngongo munene*. In any event, this was prior to the Chokwe raids, as several informants
explicitly state. This presents no bar to the dispersed Chokwe having to an important extent con-
tributed to the distribution or transfer of copper and copper objects and, thus, of a portion of
copper-culture.[34]

Now I must address the question of whether a connection might exist between the decline of the
pectoral and the ascent of the copper mask. Was the one a substitute for the other, and actually an
exemplary form of recycling? Unlikely, for the chest ornament of the chief was still in use only a
few decades ago (cf. note 21). On the other hand, the success of the copper bracelet, under
Chokwe influence and thereafter reinforced by the colonial authorities, occurred possibly at the
cost of the *ekalangu*; indeed both reflected the status of the *kalamba*.

In any event the cross, the "mat" and the face mask may be differentiated into at least two, and
possibly three, functional and thus also technological moments in time. If we stay to consider the
third moment and the creative treatment concerning it, the following question arises: how does
one form a face from a possibly deteriorated *ekalangu*?

The primary chasing is in large measure already done, but nonetheless is carried further. My
starting point is that the convex side of the disc was to become the visible face and that initially it
was this convex side that was chased. The *byolo* ornamentation, generally on the inside, would be
destined to disappear owing to the various manipulations it would undergo. Nevertheless, it still
rankles me to not have seen a single mask with demonstrable traces of the decorative element on
the inner side.

In this connection I should like to emphasize that in no sense have I been able to ascertain the
technical procedure, as Roy describes: "a malleable sheet of metal is hammered over a wooden
form" (1992: 233). In my view the making of a full-copper mask is forge work, and the smith
worked with hammer and (metal) anvil. If one draws from the case of the breast plate, then the
uppermost part of the face — the convex forehead — requires not much in the way of chasing;
the lower half of the circle must be elongated, possibly in a concave fashion[35], and this in all direc-

ill. 7. Notables of the Shinganga people. Photo: R. Ceyssens, 1974. M.R.A.C., Tervuren
(E.PH. 11247).

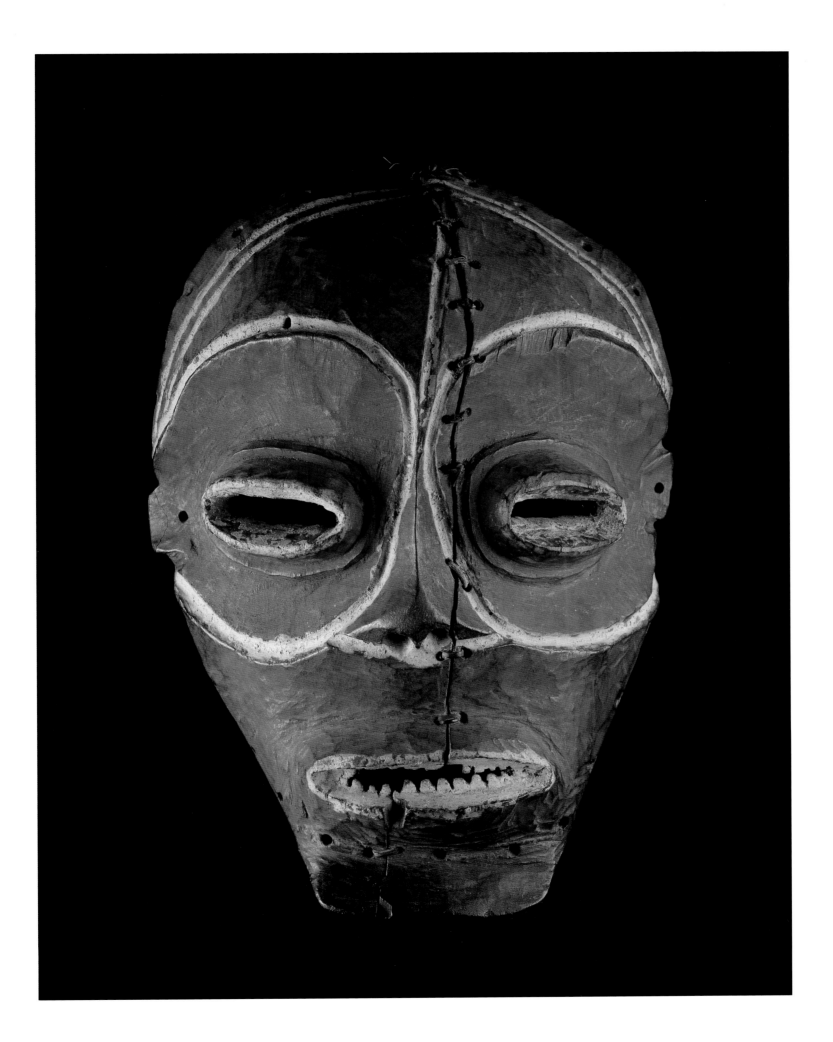

tions. The undermost point becomes the "chin": the original edge must be hammered from inside to out, and changes into a practical grip for the hand, which will wave the mask — almost as a hand-mirror — back and forth in front of the face.[36]

With the exception of the edge, the chasing and chisel work on this millimeters-thick copper sheet does not impart a marked relief.[37] The noses are rather modest in breadth, height and depth, in contrast to the case with respect to the wooden masks.[38] Eye sockets and rims may also be present, but then are shallow.[39] I repeat: the general form of the copper masks are on the one hand determined by the material employed, and on the other by the previous incarnation of the material (*ekalangu*).

The forming of the face, and the imparting of specific characteristics, occur near-exclusively through treatment of the concave side, in "mirror image" so to speak. There are two ways of working bidimensionally and linearly. First, one can split the copper plate to achieve elongated openings, taking care that the edges remain wide-open to the outside and that no disagreeable burring or "bearding" occurs. This technique is used to good effect for the eye "slits" seemingly rimmed with lashes, and also for the mouth opening, which gives the impression of being bordered by lips. Note that the mouth opening was sometimes provided with pointed sawteeth; this unambiguous reference to the teeth is again encountered in Kandangala, Shinganga and Mayayi.

A second procedure used to "draw" or to "underline" amounted to secondary hammering, hammering to the second degree; in other words, by placing adjoining round points in the intended arrangement. This is also adopted for eyebrows (Luvungula), tattooing and hairlines (Mpoopo).

Some further elaboration concerning these facial decorations. Approximating actual tattooing, there are the *mba(d)ji*, vertical parallel lines on the forehead, from the base of the nose to the hairline; at the time these were very popular among the menfolk. We also have the *bapuupa* (sing. *mpuupa*): round, in relief or countersunk, and placed on the ladies' cheekbones. To the *bapuupa*, "under the eyebrows", connect the *mbadji ya wa nkiiki*: parallel vertical tattooed lines. None of the above-cited facial decoration is to be found in the full-copper masks; we only come across them in the classic wooden masks.

The most important patterns of scarification, at least in terms of the present subject, are the *tunkolo* or *madjindula* (sing. *kankolo, edjindula*): round bumps, in the area between the eye and ear (*ibulukusu*). First made are vertical and horizontal incisions, criss-crossed through each other; thereupon a calabash functioning as a pipette (*lu(d)jimbi*) is introduced, whereby the underlying skin is sucked into relief. Finally, soot is rubbed into the bump. *Tunkolo* could be employed for both medical (tapping blood) and esthetic ends.[40] On the masks the *tunkolo* have a diameter of between 2.5 (Tshibanga) and 4.5 cm. (Kabadi). They are made analytic-pointillistically: one must reckon on a minimum of 25 secondary hammered points, sometimes neatly arranged in rings (Ndambu, Luvungula, Berlin).

Still the question remains: why these particular facial decorations and not others? Face paintings were not reproduced on copper masks, though they were on wooden masks[41] — with the painting being freshened up on the occasion of each public showing. White stripes or points would be lost on a surface bathed in light, as is the case with the copper masks. The same goes for the tattooing. Yet here there probably comes an additional factor into play: since the hammering and chasing are in "mirror image", a raised volume is thus created (the keloids, for example). To reflect the relatively "sunken" tattooing, engraving or chiseling is required, and that on the convex side — what for one or another reason was seldom done.[42]

Just as one can hammer round points in low relief, one can also bore through the copper sheet to yield holes, functional or not. Accordingly, the nostrils strike me as purely being a descriptive rendering; in contrast, the numerous rim holes would serve for the attachment of the mask to the raffia costume.[43] Theoretically, at any rate: by now we well know that the copper mask is seldom if ever put on show with all its available accessories.

The exact sequence of the above-mentioned procedures in the making of copper masks on the left bank of the Luka remains unclear. Perhaps such a sequence does not exist, or strictly determined work routines are simply not followed. As a regular visitor between Kadzadi and Luka from 1970 to 1980, I must admit to having once seen imitations of full-copper masks from the hand of youths, who really maintained no connection with the classic smiths of such masks. As for these traditional craftsmen, I have never personally had the occasion to see them at their work — most likely because they were no longer to be found.

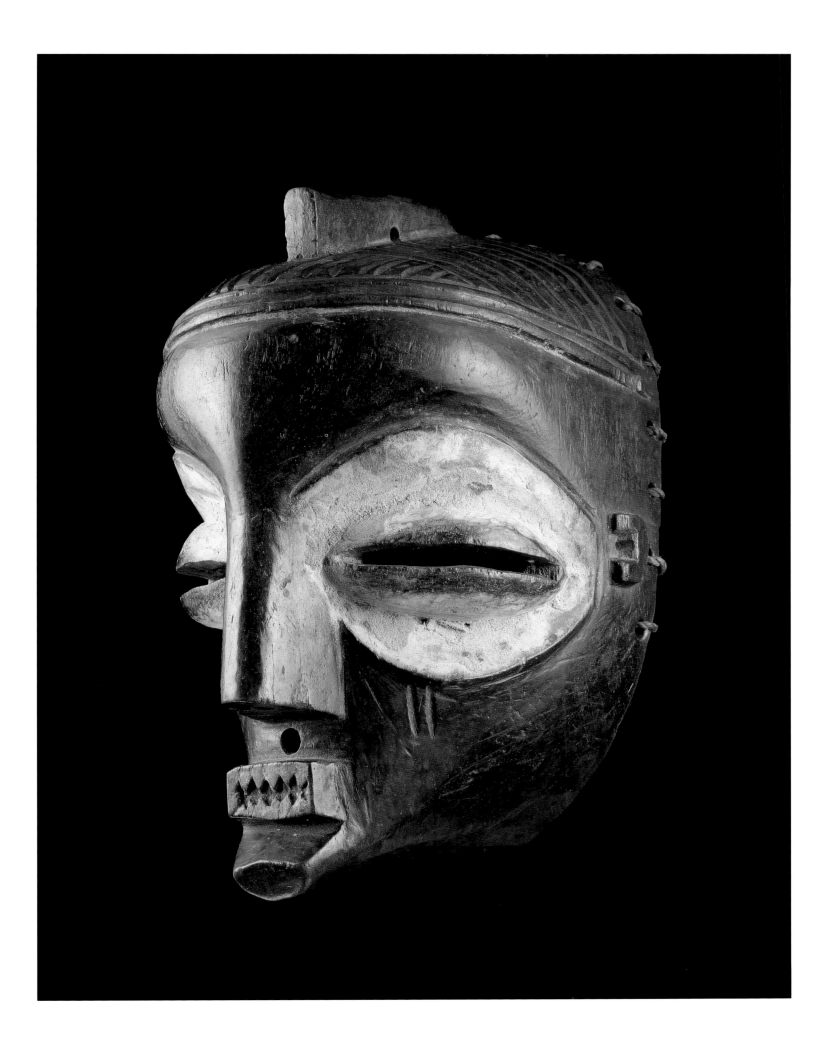

49
KETE

Zaire, West Kasai, Mzanz
anthropomorphic face mask
mkaj ankalab
H. 46 cm. Wood, pigment

Traditional mask performances among the Southeastern Kete last took place prior to 1935, in conjunction with the birth of twins. At the beginning of this century Leo Frobenius was witness to such a mask dance, and the well-known "Kanyok" mask in Hamburg's Museum für Völkerkunde would most likely be of Southeastern-Kete origin. In 1952, 1968 and 1986, mask sculpture enjoyed a revival in the village of Mzanz on the left bank of the Wivij. Newly made masks then performed on the occasion of the naming of local religious authorities and the establishment of a mission post. The dancers were disguised with a sort of harnass made from plant material. Originally, masks were buried in a mud pool following use. One distinguishes, in addition to male and female specimens, masks representing children as well. The example shown here, made in 1952, is of the female type. The comb on the forehead perhaps refers to a tattoo, and a mouth with bared teeth does not square with the norms of behavior. Especially striking is the morphologic similarity with certain Salampasu masks. The face on a plank is probably directly derived from the Salampasu's reliefed panels, encountered on doors and sacrificial altars. (C.P.)

Lit.: Ceyssens 1973 & 1974; Ceyssens 1990

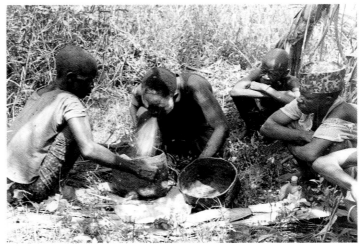

ill. 8. Nkuluwanda notables spray the mask with palm wine. Photo: R. Ceyssens, 1971. M.R.A.C., Tervuren (E.PH. 11210).

Before each exhibition the masks had to be well rubbed and polished. The outside of the mask is sprayed by mouth with the somewhat acidic palm wine (ill. 8), or alternatively with sap drawn from the bark of the *shilolo* plant (*Annona cuneata*, var. *genuina*).[44] These products make the copper masks sparkle, especially if shown in brilliant sunshine, which was the case at the times their use was required. From there, the praiseworthy term *shabaaba* is applied to the mask: "the red stunner", a message one also recognizes from the opening lines of this study: "... *sha babala ngongo*"!

As modern observers we must take duly into account that the traditional way that the copper mask was seen, both aesthetically and as to content, was strongly determined by the gleaming chest decorations of the notables.[45] And furthermore, in an authentic context the uninitiated viewer only got to see the mask from a certain distance away, bathed in light.[46] The overpowering sunlight would smoothen and blur what were the already rather superficial features of the facial mask; a tactile and detailed perusal was ruled out for the local viewer.[47]

A mask left in disuse for a time may well oxidize and corrode, becoming warmer in tone and more matt (*Arts d'Afrique Noire* 1988, 67: 61; Neyt 1981: 203 and Ndambu). It would not surprise me if this discrete patina (acquired during periods of non-use), however spurious it would appear to the eye of the original user, was determinative for the international public at large in its appraisal of the copper art of the Kongo-Dinga. A patina that one enjoys, a relief bearing witness to restraint, even reserve... and it is then only a short step to "the deathlike calm of the Kongo masks" (Herbert 1984: 226). Forgetting that form is determined by the material and the technique; and also far from how the shining disc is experienced by its users.

Still a bit further along this same line, a less lofty, and thus more down to earth interpretation, perhaps puts things better into perspective and is more contextual! Tracks of soot and deep scratches are not normally the consequence of a wash with palm wine.[48] The cleaning process — with the polishing products on the one hand and the transmitted pressure of the rubbing on the other — wears down and thins the copper sheet with time, especially on the protuberances, large and small, such as the point of the nose, the *tunkolo*, the burr of the holes' edges (Ndambu).

The Artists

There are few "names" associated with the full-copper masks. The most prominent is possibly that of Kamoyi-Katambi. On his mother's side (*ka Kampa-Mbuyi*) he descended from Washita; his paternal descent was from Kabadi. This sculptor-smith has several masks to his credit, among which those made for the Musengu, the Kabadi and the Mayayi. From this last-named group we know that Kamoyi's commission dated from around 1945, and was to replace a piece that had gone missing. For this particular assignment Kamoyi was to have used an *ekalangu* and, moreover, was reportedly inspired by the mask of Kabadi. What also implies that the mask photographed by Bastin in 1956 in Shinkolondo was virtually new... as a mask, that is! Kamoyi died in 1975, and I did not have the opportunity to avail myself of his counsel.

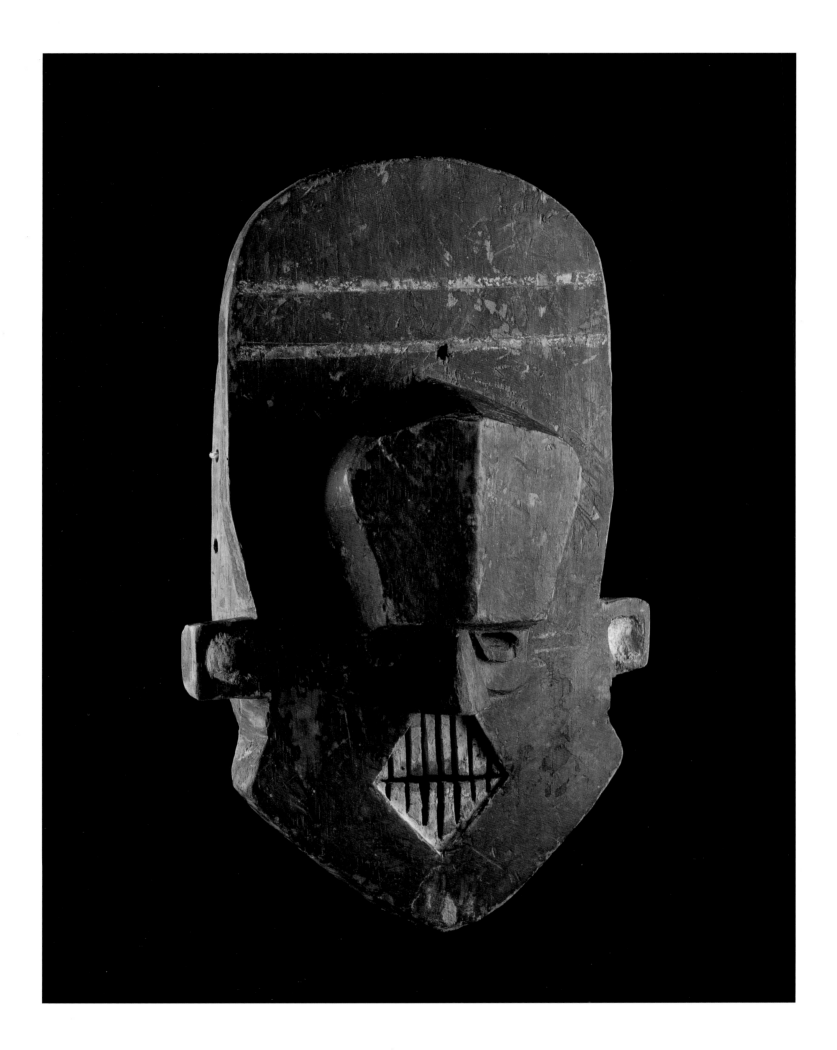

III

One has put forward other names, such as there are: Bwalama, Mulumba-Mbonji (Keeseedji), Kabwanyi (Mbundi), Ilunga, Mwinyi-a-mikumbi and Kashaasha (*ka Mulunda*), or "twin brother" Mbuyi (*a Mulunda*) (Kaali), who would have created Keeseedji and Kazanza masks. Names of lesser renown, possibly, if only because one cannot attribute any real full-copper masks to them.

Despite our limited knowledge concerning the makers of these masks, it is beyond question that artists from the left bank were well a match for their colleagues from the right bank. Furthermore, they themselves would work on the right bank itself, just a stone's throw away and easily accessible. I readily admit that the division between left and right banks is not relevant, and even not justified in this context. Kongo-Dinga and Lwalu share the same culture and get along well together (Ceyssens 1984: 41-42).

To conclude, one may say that the above discussion gives no complete view of the plastic arts of the Upper Kasai. Several sculptors-carvers in wood are known to me who have enviable reputations as concerns masks and statues. These have not been treated within the scope of this article, as they form a completely different category of work.[49]

1. *Kabi akakaakwenu, kasunda kaana ka nkanyi. Kapundza kabi akeenyi a musaka; a ba-bushika kuyi baadi? Maashi maakukunda, a makendanga a mu mbinda. Ncika beemudilanga mandji; mukaatu beemukwacilanga bushika, kasembu kaami, kasembu ka mu ncingu. Shintsengu-a-mbamba, bushika bwendi mu ncingu, sha babala ngongo; shikene-a-nkusu.* Behold this lover's monologue or *lusooso* of the Kongo-Dinga: in a romantic tête-à-tête, in stops and starts, the young man attempts to persuade his partner.

2. The most appropriate name is indeed Kongo, because this is the name preferred by that people (Ceyssens 1984: 33-39).

3. As the subjects of chief Kangandu call themselves; their neighbors would sooner use the term Kete. If we may hazard to speak of a single large ethnic Kete entity — which is less than obvious — then Kete-Kangandu would be my preference, or even: southwestern Kete, to distinguish from the northern Kete of Lwebo and from the southeast Kete between the rivers Luluwa and Bushimaayi.

4. It somewhat disturbs me to note that there is still talk of the name Lwalwa for this ethnic group, where the final vowel indicates Luba influences (Ceyssens 1984: 40-41). I recall that linguists have long adopted the use of the name Lwalu (Hulstaert 1948; Van Bulck 1955).

5. Roy wrongly places this in the 1930s (1992: 233).

6. Formally speaking, this was a gift of the Companhia de Diamantes de Angola (Diamang) of Dundo. The accompanying dossier no. 57.3 contains sparse lines from the hand of M.-L. Bastin, the result of a few hours stay in Shinkolondo. Long will they echo: I come across them in practically every publication to do with copper masks, even in thematic exhibitions, right up to today. In short, and provisionally, I reject the "established values" as put forth in the original texts of Oliveira and Bastin. One: the masks pertain to the village chief only in so far and if he was part of the *mukanda*. Two: the masks have only a subsidiary connection with funerals, once again, if the deceased was a member of the select society. A suitable occasion to also reject the coupling mask/authority, as Cameron makes with respect to the Salampasu masks (1988: 41-42), at least in so far as this seems to be deduced, read-out as it were, from Herbert (1984) and perhaps Baumann (1969: 29), and not based on hard input from the field.

7. Bastin is definitely not responsible for the first "export", in 1961, as Roy suggests (1992: 233). Dr. Koloss maintains that the mask acquired in 1989 by Berlin's Museum für Völkerkunde was already in private Belgian possession before the Second World War. Nothing in this personal communication permits one to confirm or deny this statement.

8. Some other illustrations of full-copper masks: Oliveira (1958: 146), Fermino (1970-1971: ill. 23), Neyt (1981: 203, ill. X, 3), Felix (1987: 31), Cornet (1989: 262), *Arts d'Afrique Noire*, (1989, 72: 29), Koloss (1990: 50), Roy (1992: 233), Beumers & Koloss (1992: 316, ill. 121).

9. In the mouth of the Kata (and among tshiluba speakers in general) the final consonant is a nasal velar; the Kongo-Dinga palatalize the nasal consonant: thus, *kamukeenyi*.

10. *Kwakula*: join in, take over, connect... like thunder follows lightning. The western Kongo-Dinga mostly distinguish between two types of mask: the *ndzadji* and the *kwakula*; with the Ndambu, the two names unite in one. With regards to naming, the greatest of confusion reigns. Taken broadly, I differentiate three levels. First the generic names, such as *ngongo munene, ngongo wa shimbungu*, in the first instance alluding to the organization, *mukanda*, which utilizes and "lodges" the masks. Then there are specific or proper nouns, like *bintsanga, kamukeenyi, ndzadji, kwakula*, perhaps *kamwanga*. Finally we have countless names of praise, under which I place: *shabaaba, kampembi-kampombo, kamwanga*, and others.

11. The mask offered to me in 1971 in Shiseenyi (Tshisenge), would be of Tshibanga origin. They form the Shinganga together with the Kamisenge. Around 1900 a hunting skirmish degenerated into an outright war, if on a somewhat modest scale. Beaten into flight, the Tshibanga of Muzodi lost their mask. The victors have retained it since then simply as war booty. Out of sheer necessity the Tshibanga took recourse in the mask of the Kamisenge, so becoming the primary integrating factor among all Shinganga.

12. The Kongo-Dinga would say: *shibidji*; in the tshiluba language: *nkanga-bakishi*; in Latin: *Lippia adooensis*.

13. The mask of Ndaji would now reside in the collection of Reginald Joss in Los Angeles (U.S.A.).

14. After a series of births of the same sex, the baby born of the opposite gender is given the name *ikalu*. The Mulaanyi mask would originate from the Kamooko of Kalombo. These last-mentioned are originally Kaalumuna from the opposite bank of the Luka (Angola). They have gone through many border disputes with their neighbors before settling by the Kamooko River (Zaire). The reconciliation with the Mukunda came about after the handing over of a "placation offering", *muswiku*, in this one case a copper mask.

15. This goes in all respects for the Lwalu and the Kongo-Dinga. The group-names have a spatial component: "the people near that stream", "... from that hill", "... along the swamp", etc. This translates as follows: *Beeshi Luvungula, Baka Mpika* (among the Dinga); *Baka Luyambi, Biishi Kazanza* (among the Lwalu); *Bana Cibanga, Ba(a)na Kandangala* (among the Kata).

16. *Shifwala*, one would say on the left bank of the Luka. Oddly enough, one never finds a genuine *shifoolo* with copper covering.

17. *Mvondo*, say the youth, inclined to mimic the vehicular Tshiluba language.

18. When the wood decays, eventually there remains only a sad, formless little pile of copper. Thus decayed the *munene-a-kakumbi* from Kazanza. In 1980 I purchased the residue of its former glory. The Musée Royal de l'Afrique Centrale in Tervuren attempted to reconstruct the mask on a clay mould, and this based on photographs from 1976; the result was, however, not convincing (M.R.A.C., R.G. 81.19.1).

19. One can equally speak of copper cord or copper wire.

20. One mask from the left bank, that of the Keeseedji — the closest neighbors of the Lwalu — indeed has a wooden armature (ill. 4). This infrastructure was originally not a mask which was worn. Which is not to say that wood was applied afterwards by way of support for a weakened copper superstructure. This is a possibility, but the question remains open.

21. Maesen sketched the customary head of the *Bana Kambulu* — probably Mbumba-Tshindoolo — adorned with a *"dikalanga"* (1955: 50, 51). The Institut des Musées Nationaux du Zaïre possesses an *ekalangu*, purchased by me among the Mpika (I.M.N.Z., no. 73.581.20).

22. I may only suppose that this simple motif in the copper sheet is chased and engraved. Eyebrows were grooved on the Mpoopo mask; on the chin one finds a flower-motif, probably chased. One may naturally ask oneself if this has not rather to do with kauri, placed in the form of a Chokwe cross (Bastin 1984c: 375, 377, 378).

23. According to Struyf, the chief (Kasongo-Lunda) wore a large disc, *yimba*, on the chest. Allow me to be skeptical when the author, after many detours, recognizes the moon in this chest plate (1948: 372). Also see Bastin with regard to *cimba*, in Beumers & Koloss (1992: 65). The copper mask, as object, may indirectly and with reference to the pectoral, be related to the shell-like *"pandé"*, which in large parts of Central and East Africa represents the political authority (Baumann & Westermann 1948: 80, 163-164; Vellut 1972: 85, n. 42). Once viewed by de Sousberghe was the head of a *Sphenorynchus abdimii*, a sunbird *par excellence*, as a pectoral on a Pende chief (1956: 24; also see de Heusch 1988: 22 ff.).

24. By reason of its function as platform, I have sometimes heard the round disc named "chin" (*kabakwele*). Within the framework of the *ngongo munene* we thus have to do with a multifunctional *ekalangu*: (a) authority symbol worn around the neck by the mask bearer, (b) support surface or "pedestal", (c) copper sheet *in petto*. In Keeseedji the requisites are displayed on a leaf from the banana tree (ill. 4).

25. With the mask of the Ndambu (Kata) belongs a "cervical vertebra" in the form of a half-moon, apparently cut from a relatively small pectoral, as the decorative element *byolo* is still clearly visible (ill. 6). Could it be that the *byolo* element is reminiscent of the spiral-formed plaiting? And/or of the spiral courses within the *conus* shell?

26. "Le soleil invisible est l'eclat de son Front; la lune invisible est l'eclat de son Occiput" (Fourche & Morlighem 1973: 222).

27. This typology can best be founded on arguments with respect to content; they will be treated in detail in a separate contribution. This does not apply to the ambiguous typologies raised by Fermino (1970-71: 27, *munene/budimbu*) and Lima (1967: 264, 266, *munene/kamacaka*).

28. And this is a permanent feature, from wooden mask to copper or can-covered end product, though it may have to do with two separate artists.

29. I once came to hear that deceased guardians of the mask are buried with an *ekete* placed in the hand. Elsewhere it is said again that on the day following the interment of a *kayaana* (highest rank in the *ngongo munene*), the remaining members adjourn to the house of the dead and straightaway set out to send-off "the mask"... More specifically *nkele*, third in rank of the *minene*, holds in his hand a folded leaf of the *mutaba* plant, containing a splinter, coming from an *ekete*. He buries the metal there, where the head of the deceased rested, saying: "Take your mask and leave us in peace; look rather to the one who has killed you" (*Kwata ngongo'aku, kweshi watutala ba, tala wakudyaka*). Among the Salampasu of Nsele the small copper cover-plates are called *madjendji*; *kudjendje*, "to tinkle" — though they do not tinkle once riveted to the mask.

30. The question is then whether the copper sheet or the copper cross were worked cold or warm? "...cold-hammering hardens it and makes it brighter and shinier but more brittle; heating softens and darkens" (Herbert 1984: 76).

31. Cf. Redinha (1964), Herbert (1984: 154-160, 186-191). The copper cross has long been a much valued

means of exchange and payment. In the diary of Msgr. Declercq one reads in the entry of 1920.07.06, when he was east of the Kanyok people: "Hier lijk in andere dorpen, ontmoeten we menschen van Tielen en omliggende die van Kanzenze komen geladen met koperen kruisen."

32. From data supplied by the I.M.N.Z. of Kinshasa, the *ekalangu* in their possession — until now the only available example — has a diameter of 21 cm. and a weight of 280 g For these two reasons no mask could have been made from this disc.

33. Although no copper masks have yet been found among those of chief Kasombo-ka-Mwanza!

34. Among others the epithet *Mingendi (Minjenji)*, which the Kongo and Lwalu give to the Chokwe, is indicative. The prefix *mi-* refers to the mediating role of the broker and the go-between. According to one of the many explanations, the root of the word meaning "tinkling" is imitative of the sound of the copperware imported by the Chokwe wanderers. *Kudyondji*: to tinkle (see note 29).

35. The *shimbungu* masks of the southern Lwalu (Kalombo, Mulaanyi) have a wooden armature clothed with a copper skin, on first sight not flawless, and markedly disfigured; nonetheless, they reflect the concave face concept of the original wooden masks (*Arts d'Afrique Noire*, 1988, 67: 61; ill. 3).

36. This function does not prevent me from referring to the characteristic chin of the Chokwe masks (Art et mythologie 1988: 62, 99). The *kamwanga* of Shinganga (Kata) has nothing of the protruding chin (M.R.A.C., E.PH. 11244).

37. In the mask the facies is held in a quasi-upstanding border, at any rate in comparison with the gently inclined border of the pectoral. That, together with a multiplicity of attachment-holes and the fact that the copper sheet thins toward the periphery, accounts for breaks in this same edge.

38. In the mask of the Kamooko the nose becomes a flattened tripod: a bidimensional projection, which could be of cubist signature (ill. 3).

39. The mask of the Ndjinga (Kata) and that of Berlin (Koloss 1990: 50, ill. 28) are in that respect more and less pronounced. Morphologically the whole eye section recalls the wooden *kibwabwabwa* masks of the Kata, Kambulu, Nkuba and western Bindji (*cimbwambwambwa, cibwabwabwa, cimbambambwa, cimbwambwambu*), which, in their turn, "turn an eye" to the wooden Chokwe masks (among others, the black and white *pwo* mask in the National Museum of African Art, Washington, D.C.).

40. *Kudjindula*: unstop, uncork. Rarely one found, instead of "unstopped" *tunkulo*, two concentric tattooed circles: the Luvungula mask exactly reflects this, more chiseled (and lined) than hammered (and pointed).

41. Although I saw white-rimmed eyes and white *tunkulo* on the *motolototo* mask from Mpata-Isaka. The Ndaji mask which found its way to the Joss Collection, also has over-painting; this was not the case when I photographed it in 1972 (M.R.A.C., E.PH. 9571). With full-copper masks I have never seen over-painting, since the coppersmith achieved volume and (flat) color with a single approach, namely point-hammering. More than once one finds low on the forehead a *kankolo*, or something that could pass for such. It seems that the central rosette represents ordinary kaolin-mark, as it appears from ill. 7 with those responsible for the mask of the Shinganga.

42. Only on the Mpoopo mask do "outside-in" interventions occur. Who knows if they were perhaps later introduced?

43. Of note is that the edge-holes are invariably beaten from "inside" to "outside", opposite to what is the case for the nostril holes. This last-named method of working moreover meets the requirements of a naturalistic way of seeing, which also applied to the representation of the lips and eyes.

44. This same sap heals wounds, it is said, and is also employed as a varnish for ceramics. The inside of those masks known to me remained untreated; one finds no traces of contact with the human skin (cheekbones, chin, nose,...), so characteristic for the wooden dance masks.

45. On the occasion of an exhibition, by the Mpika I witnessed not only that the mask itself was cleaned, but also the *ekalangu*, this as well along the convex side.

46. Pointing to the mask in the distance could bring bitter consequences: one could catch leprosy, so it was threatened, or one's finger might simply drop off. Pointing would only be done with the balled fist. *Minene* themselves, during the untying of the basket, the cleaning of the mask and its display, held their hands closed, after carefully hiding the penis between the legs.

47. The *byolo* on the concave side of the pectoral (and the eyebrows in Mpoopo...) were undoubtedly more efficient: the furrows were filled-in dark (ill. 6); moreover, the pectoral was observed from a relatively short distance.

48. The original mask of the Tshibanga remained uncleaned for around 90 years, and carries the soot traces of the houses were it was for so long stored unused. The mask in Berlin, as well, must have no longer been in use at the time of its uprooting, since it seems hidden under a layer of soot (Beumers & Koloss 1992: ill. 121). Note well that an "active" copper mask is never kept above a functioning hearth. What is more, one does not expect to find "a thick layer of sacrificial material" (Roy 1992: 233). Cleaning with sand is to be avoided; such a pernicious and irremediable occurrence preceded the sale in 1988 of the Kabadi mask. A similar treatment had already been undergone by the Mpoopo mask when I photographed it in 1973!

49. A statement by Cornet, to which I do not subscribe: "L'art ding est modeste et ne vaudrait guère une mention sans la présence, exceptionelle, de masques en cuivre ou laiton martelé..." (1989: 264).

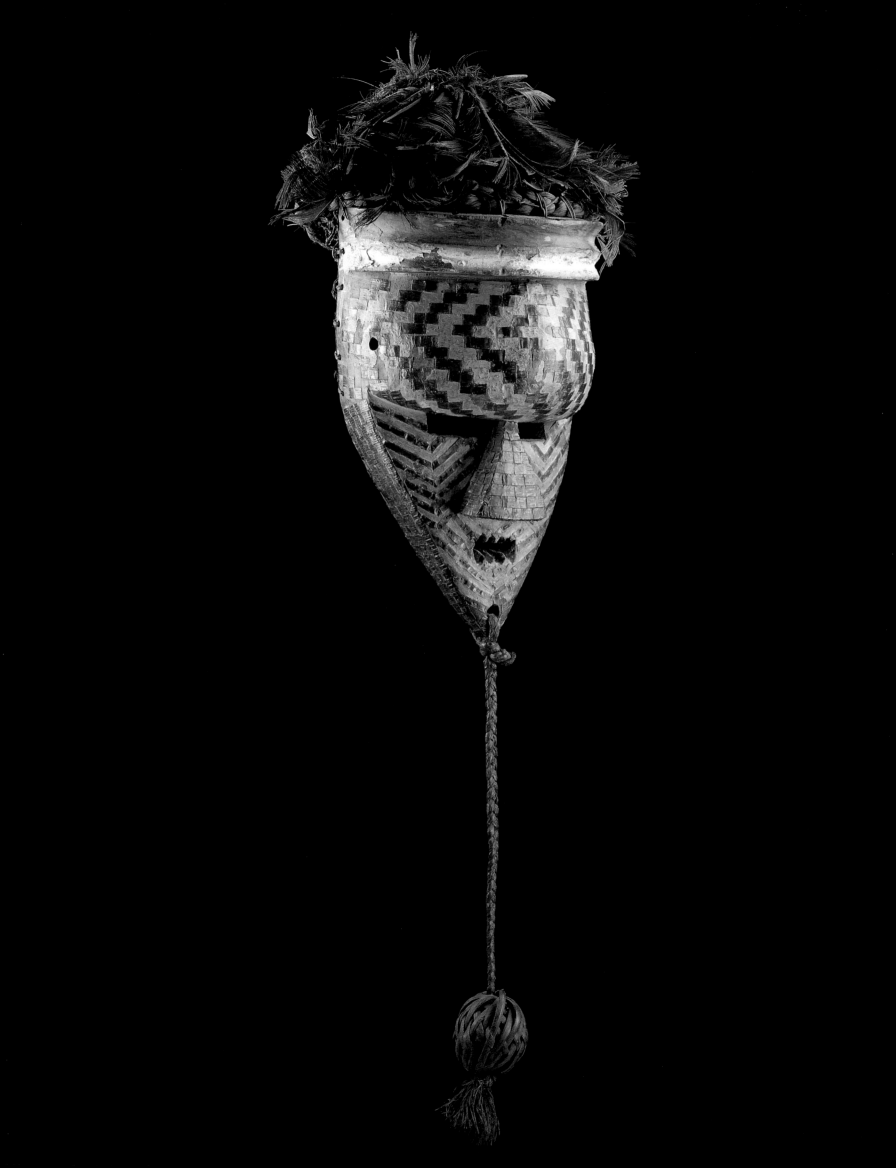

The Practice of Metal Application
to African Masks

Elze BRUYNINX

African masks may be made from a variety of materials. The vast majority are made from wood, this material being abundantly available and practically free. Nonetheless, there are also metal examples. These are mainly made from iron, copper, brass, and — more recently — from aluminum as well.

Iron masks are extremely rare in sub-Saharan Africa. One sheet-iron zoomorphic Mossi mask (Burkina Faso) in the Museum of Anthropology at Berkeley (U.S.A.) was published a quarter of a century ago by Bascom (1967: 19, ill. 22). I came across a similar face mask — undoubtedly made by the same smith, and exhibiting clear traces of polychromy — in 1968 in an Amsterdam collection. Both examples have an upper part, giving them respective heights of 95 and 86 cm. In this same Dutch collection there was a steelplate anthropomorphic Mossi face mask where the ajour-worked superstructure was riveted to the face. A nearly identical piece was in a Parisian collection. These two examples, no doubt from the same hand, respectively measure 61.5 and 60 cm. Much smaller in format (20.5 cm) is the wrought-iron mask which we came across in a Belgian private collection, supposedly of Lobi (Burkina Faso) origin (Bruyninx 1970: 146-149, ill. 92-95; 274-275, ill. 241). Blier (1991) has recently made known a remarkable iron example from Danhomé, which is currently in the Barbier-Mueller Museum in Geneva.

Much more prevalent are masks made from non-ferrous metals. In contrast to the iron examples, the non-ferrous masks are usually cast using the lost-wax technique. The technique of making masks from cut and beaten brass or copper sheet is also seen. Examples of both methods are principally found in West Africa. Specimens of such a format that may be worn upon the head or in front of the face are less frequently seen. The Temne (Sierra Leone) possess face masks of hammered copper. Hart (1990) comprehensively discusses a piece from the Barbier-Mueller Museum. In an earlier publication this author had already called attention to examples made from brass sheet by the Lima, who live to the north of the Temne (Hart 1988). The helmet masks which were found in the Senufo territory (Ivory Coast) and made from a copper alloy, became better known by way of Ravenhill's publication (1986). Of the Senufo, it has long been known that they made masks of the so-called *kpélié* type from cast brass, and that they now use aluminum as well (Glaze 1986). Also from the Ivory Coast, from the Upper-Cavally region where the Dan and Wè peoples live, come two brass examples which were first published by Holas (1966: ill. 61 and 130). Here one must specify that, format notwithstanding, they were probably never actually worn as face masks.

Concerning Nigeria, aside from the well-known Igala pectoral, one should also make mention of the *alakoro* masks made from brass sheet, and published by Thompson (1971: ill. CH 3/4). As additional examples, we note a mask originating from the Lower-Niger area and a rare tin Ijo specimen, both published by Brincard (1982: ill. H 14, H 37). Large examples are cast in an alloy of copper, for the tourist market as well as for traditional use. Examples of these are the two Bamum masks (Cameroon) in Prague's Naprstek Museum, having respective heights of 31.5 and 43.6 cm (Kandert 1990: 73 ill. 70, 74 ill. 71). Outside of West Africa, examples made exclusively of metal are an exception. That the Dinga people of northeast Angola used face masks made from hammered copper sheet, only became widely known from Bastin's publication (1961b).

In addition to the so-called "large" metal masks one also encounters small, even extremely small examples — all cast using the lost-wax technique. These miniature masks have primarily a protective function and are worn, for example, around the neck or on, or behind, the belt. Those of the Dan and Wè, measuring on the average between 5 and 15 cm, are stuck behind the belt and serve

50
SALAMPASU
Zaire, West Kasai
anthropomorphic face mask
mukinka
H. 46 cm. Wood, pigment, metal, feathers, fiber

The Salampasu live around the city of Luiza in West Kasai. Together with other non-centralized neighboring peoples, they have long resisted the expansive Lunda and Luba kingdoms, and endeavored to maintain their political and cultural autonomy. The literature related to their material culture is rather scarce. In the written sources one chiefly encounters a number of names of masks which, owing to a lack of illustrations or descriptions, cannot be equated with a particular form. Salampasu masks, whose forms and materials are not specified, were in the past mainly associated with societies of warriors, called *mungongo*. Among other functions, these groups saw to the organization of pacific activities such as dances and meetings. The masks reflected the various titles and ranks within a particular *mungongo*. A warrior obtained the right to wear a mask by executing prescribed tasks and the payment of a sort of initiation fee for entering a particular society. Thus, on the one hand masks served as proof of membership in the *mungongo*, and on the other were indicative of the owner's economic status. The funeral of a renowned warrior was paired with the performance of all his masks, after which his riches would be divided among the dancers. The most important masks were probably worn by members of the *matambu* society. The highest level within this society had the name *mukish*, and there possibly existed two sorts of *mukish* — each with its own mask. Also other societies, about which no details are known, made use of masks. Here, too, they danced on the occasion of important passages in human life (birth, puberty, marriage, and death).

as amulets. They would have the same function as the wooden miniature examples, or *nyonkula* (Bruyninx 1986). In general, one may state that the fabrication and use of such masks within the traditional context occurs near-exclusively in West Africa. In the way of tourist-art, similar miniature objects are offered for sale in the Ivory Coast, and elsewhere as well. The design refers back to the usually more carefully finished traditional masks. Baule pieces and replicas of the Benin masks are much in demand, and small Bamum examples are better sellers than the larger ones.

Application of Metal on Masks

As has been previously mentioned, the overwhelming proportion of African masks are made of wood. Various examples — anthropomorphic, anthropo-zoomorphic, as well as purely zoomorphic — are decorated with all manner of added elements. In the main these were not applied for purely decorative reasons, but rather because these elements added their own protective, power-enhancing or other quality. The metal additions might be placed at various locations on or around the wooden mask-part. Dan and Wè masks are here, once again, well-illustrative. On Wè specimens there are regular rows of headed-nails or studs hammered into the wooden face mask, or series of brass bells are attached around it. These last-named objects may be spherical in form and exhibit a narrow elongated sound-split, or conversely, they may be bell-shaped. The small bells, imported from Europe, were sometimes used as models by indigenous brass founders. Not infrequently both types would be combined on the same mask. In certain examples of Dan masks, the eyes are rimmed with a strip of metal sheet, and two or more metal teeth were set in the mouth. One encounters the application of metal to masks made by other peoples, for instance the Bobo (Burkina Faso), the Baga and Nalu (Guinea), and the Bete (Ivory Coast). Examples near-completely covered with metal strips, usually from brass sheet, were according to Hart (1987) used by the Temne. The most striking, however, are the masks bedecked with strips of metal sheet (copper, brass, or aluminum) made by the Marka (Burkina Faso). Herbert (1984: 225-226) rightly noted that with regard to metal application, the Marka of West Africa were the most remarkable. As concerns those areas outside of West Africa, this author only cites the Salampasu of Zaire. Undoubtedly, to this list one must add the Lwalu — better known under the name Lwalwa — and the Kuba. An interesting observation with regard to Cameroun was made by Kandert (1990: 60): "Predecessors of the Grassland metal masks may have been very rare wooden masks, the surface of which is covered with thin copper sheet. One of these pieces is part of the collection of the Tikar-Bafut ruler, another was used by the Bangwa, albeit made in the Foubam city in the territory of the Bamum." Ultimately, in surveying mask production in Africa one comes to the conclusion that it is in West Africa that the application of metal to wooden examples is most frequently employed.

In Central Africa many peoples use metal additions to embellish statues, weapons, and other objects of use. Herbert (1984: 230) recalls Stanley's observation when in the area of the Ubangi River's confluence with the Congo, that the weapons there were appointed with fine metal wire and brass nails. The Songye, the Luba, and the Chokwe have something of a penchant for this. Striking in this regard are the Songye figures and the Kongo power-statues with their covering of strips and nails, where these added metal elements have anything but a decorative function. The materials used for such applications are broadly the same throughout sub-Saharan Africa: namely, pieces of hammered metal sheet or small lamellae, stud-nails, and wire. These may be used separately or in combination. The use of iron wire to embellish objects is somewhat less frequent than that of copper or brass wire.

Certain peoples show an alternating preference for copper and brass. Among the Dinga, copper has pride of place and brass is considered to be of lesser worth. Conversely, the Chokwe have a preference for brass and find copper an inferior metal. Sundström (1965: 226-227) relates the Kuba liking of brass over copper, and provides many other examples of such preferences. Among other population groups the type of metal employed is of lesser importance, or plays no role at all; rather, more importance is placed on the quantity of the metal.

Copper and brass, in various forms and sizes, served as means of exchange in commercial transactions — in small trade as well as that centered around ivory, slaves, and rubber. In connection with the transport routes in Central Africa, and more specifically with respect to Zaire, Sund-

51
SALAMPASU
Zaire, West Kasai
anthropomorphic face mask
kasangu
H. 35 cm. Wood, pigment

The wooden Salampasu masks are characterized by a domed forehead, sunken eye-chambers, a large triangular nose, and an aggressive toothed mouth. Wooden *mukinka* masks which are in part or wholly covered with copper were associated with the *ibuku* society. In the hierarchy of the society they stood a step above the *kasangu* masks. The regular arrangement of small right-angled pieces of copper metal in a V-shaped pattern (cat. 50) apparently strongly deviates from the traditional practice of employing more massive, and larger copper strips. Elisabeth Cameron proposes that the practice of bedecking wooden sculptures with copper probably only began at the end of the 19th century, under Lunda influence. According to Rik Ceyssens, among the Salampasu copper was certainly not a sign of power, authority, and well-being. As concerns content, furthermore, no connection exists between the aforesaid masks and the copper-covered masks of the neighboring Lwalu (cat. 46).
The headdress of the wooden masks generally consisted of a tuft of feathers, or a coiffure with balls of cane. The example shown under cat. 51 is distinguished by the division of its surface into black and red sections. The masqueraders were mostly clothed in a costume of knotted fibers and a catskin skirt. In their hands were carried antelope horns or double-edged swords. Such wooden masks, called *kasangu*, represented warriors and were part of the *ibuku* society. While any of the warriors may wear other masks, the *kasangu* masks were reserved for those who had killed an opponent in battle.
Aside from wooden and copper covered Salampasu masks, some examples made from fiber remain extant. Masks of plaited

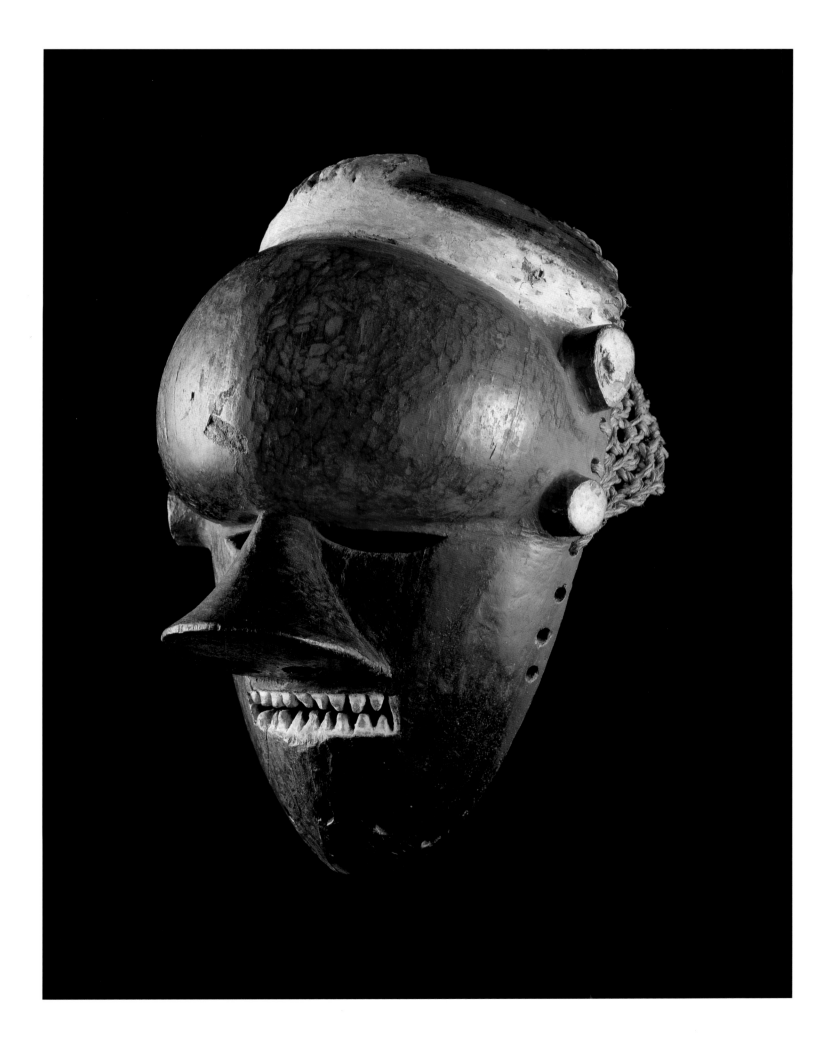

52

SALAMPASU?

Zaire, West Kasai

anthropomorphic face mask

H. 31 cm. Fiber, pigment

raffia, mainly direct transpositions from wooden examples, were used in the *idangani* society. However, the specimen shown here (cat. 52) has a rather atypical design with its painted pinnacle in the shape of a trident. The whole is in a way reminiscent of the "dog masks" discussed by Rik Ceyssens (1990), made of twigs and bark, from the Ana Rumb (Southeastern Kete) of Masaala. These last-mentioned masks perform during initiations and funerary rites, and are associated with a society called *ukabw*, which controls the possessions and the power of the chief. (C.P.)

Lit.: Bogaerts 1950; Neyt 1981; Cameron 1988; Ceyssens 1990; Cameron 1992; CEYSSENS (p. 97)

ström (1965: 247) writes the following: "In the Congo Basin the evidence on exchange routes centers round the copper-mining areas of the lower Congo and Katanga. The evidence for exchange routes for brass in this area, which passed along the Congo and its tributaries, as well as across Northern Angola, is rather scarce, presumably for the reason that brass here was a coastal import largely distributed by the offices of colonial or other European agents." An important means of exchange consisted of staves and bars of diverse shapes and sizes. Sundström (1965: 237) also refers to a specific sort of currency, namely the *mitako*: "*Mitako* is the common term for bent lenghts of brass or copper wire which functioned as a medium of exchange especially on the Middle Congo." Aside from staves and wire, other objects such as rings and kettles were also traded. In Central Africa metal was sufficiently available due to the presence of a local copper industry, and the importation of primarily European brass. Vansina (1962: 386) long ago called attention to the importance of Katangese copper. In staves or in the form of Saint Andrew's crosses, a well developed inter-regional trade circuit saw to their spread throughout Central Africa. It may well be said that for several centuries the inhabitants of Zaire had the possible means to bedeck their masks with metal, or even to make them entirely from this material. The reason why this only occurred in a few exceptional cases still remains unclear.

Materials Used for Application

WIRE Metal wire may be obtained by several means. The first consists of prolonged hammering of a small piece of copper or brass until wire is attained, or by forging a piece of iron. The surface of such an end product will invariably exhibit irregularities. A less-blemished result is obtained by pulling thin metal strips through a wiredraw, with one or more openings of differing diameters. To achieve the desired thickness, the wire is successively drawn through smaller and smaller holes. Lagercrantz (1989: 232) relates, for example, that in Africa a staff of from 20 to 25 cm in length would be used in the making of iron wire, with discarded articles such as hooks used sometimes as well. Not infrequently the metal worker — who, according to Sundström (1965: 223), is a different specialist than the smith — would buy thick wire of domestic manufacture which he would then draw to size. After several 'pulls', the wire is made red-hot and the process recommences. In order to reduce the diameter from 5 mm to 1 mm, a minimum of 200 pulls would be required (Lagercrantz 1989: 232). In addition to wire made of iron, copper, brass, and aluminum (according to Herbert, even bronze was used), in Africa wire was also drawn from precious metals such as gold and silver. In Central Africa the accent is indeed on the first three metals, with aluminum joining the group since the end of the last century.

As to the distribution of wire and the technique of wiredrawing in Africa, the existing literature is extensive. Lagercrantz (1989) has offered a very interesting survey of the subject. Seeing that metal wire on masks is rather infrequently encountered, it suffices to remember that three wiredrawing systems are known in Africa, and that this practice primarily occurs in East Africa. That it has long been known of in Central Africa, is shown in this quote from Herbert (1984: 81): "At Ingombe Ilede, bangles of fine copper and copper alloy abound, along with unworked trade wire bobbins of fine copper, as well as wiredrawing implements. Moreover all sites associated with Great Zimbabwe have proven rich in finds of copper and brass wire, and it is ubiquitous at Mapungubwe Hill. One may infer, therefore, that by the fourteenth or fifteenth century A.D., wiredrawing was a highly developed and widely disseminated skill throughout Central Africa and into Highveld."

Lagercrantz (1989: 243) also refers to the fact that wiredrawing was known in Africa prior to the European presence there. Concerning the distribution area, this author relates the following: "However, bearing in mind the technical procedures, we should rather reckon that there were three regions of distribution — a north-eastern, a West African and an East African — which are completely independent of each other, both chronologically and geographically." For East Africa, knowledge of iron-drawing was concomitant with the Arabian-Indian influence in the coastal regions. From there it would have spread to the south and to Central Africa. In the Zaire Basin this technique was less well-known, and the metal worker here would mainly have made wire by forging iron or hammering copper. Additionally, finer domestic types of wire were imported from the east. It is then hardly surprising that in the beginning of the colonial era, there was a great demand in this area for European wire.

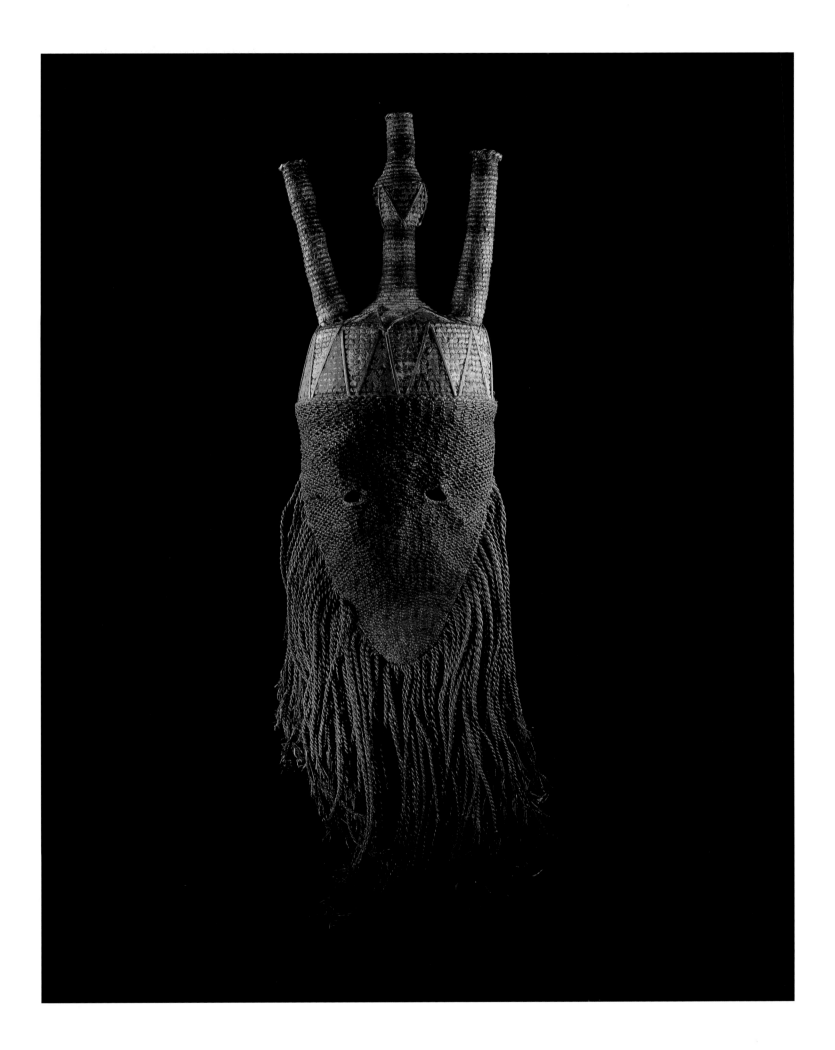

53

LULUWA

Zaire, West Kasai

anthropomorphic face mask

H. 26 cm. Wood, pigment, fiber, metal, beads

The name Luluwa (or Bena Lulua) refers to a group of small autonomous groups who live along the Luluwa River, and exhibit linguistic and cultural similarities with the Luba people. Their unsettled history brought them in contact with peoples such as the Kuba, the Pende, the Chokwe and the Songye. Moreover, there are a number of groups now counted as Luluwa who are essentially of foreign origin. These factors together offer an explanation for the lack of unity in their material culture. The sculptures and masks of the Luluwa clearly betray a variety of ethnic influences. Especially the masks, which are indeed rather scarce, are characterized by a marked diversity. This is also attributable to the fact that the Luluwa apparently possess no veritable mask tradition. The example under cat. 53 shows clear Pende and Kuba influences, both as to style and decoration. Striking is that the characteristic tattoos proper to Luluwa sculpture are either painted on the masks, or else completely absent. The specimen under cat. 54, whose attribution as Luluwa is hypothetical, is particularly notable with its assymetric perforation of the cheeks and the inset teeth. Also worthy of note are the small red seeds set in a row of holes on the mask's border. The Maltese cross on the forehead is a decorative motif seen primarily among the Chokwe. As to use and function, it is presumed that Luluwa masks — which probably represent spirits of the dead — are employed in conjunction with circumcision rites. (C.P.)

Lit.: Timmermans 1966; Van Geluwe (*in* Art of the Congo 1967: 14-15, no.14; Maesen 1982; Cornet (*in* Schmalenbach 1989: 263, no.164))

That wire was already being traded in Africa quite early on, is illustrated in this comment by Fritze (1928: 473) concerning the export to Rwanda: "Die Metallwerke Oberspee der AEG liefern seit über 25 Jahren Kupfer-, Messing- und Aluminiumdraht in grossen Mengen über hamburger, englische und holländische Exporteure an verschiedene afrikanische Hafenstädte." From there the wire — packed in cases and barrels — would be distributed throughout the whole of sub-Saharan Africa by Indian and European traders. That such a trade could flourish alongside the domestic product, was explained by this author in terms of the wires' thicknesses. The European wire had a more uniform structure than did the domestic variety. In contrast to the African, with a diameter usually not less than 1 mm, the European was far finer, between 0.3 and 0.8 mm. It is also worth noting that the domestic wire was normally oval in cross section, while the mechanically produced imported product was circular or triangular. As a consequence, European wire was highly esteemed, particularly because it could be more easily wound round weapons and decorative objects, and yielded a result more pleasing to the eye.

It serves well to recall that wire had already been a means of exchange on the coasts of Africa since the Portuguese presence in the 15th century. Obviously, wire from this period had a different structure than that made at the turn of this century. The early product did not yet have the technical standard of the later, mechanically produced wire. The fabrication process had indeed not only made strides in Africa, but in Europe as well. For example, the machines in use at the beginning of the Industrial Revolution were not so perfect as to yield a faultless product. Tylecote (1976: 133) gives the following description: "This sort of non-continuous machine would leave 'stop-marks' on the wire, but presumably these were smoothed out by continuous drawing at a later stage."

HEADED NAILS Another type of application-material comprises headed or round-headed nails, with examples in copper and brass being the most frequently seen in Africa. Information in the specialist literature on this typically Western import product is extremely scanty. The nails (studs) have a rounded and concave head, which sometimes rests upon a small cylindrical component from which the sharp end extends. The cylindrical part adds additional strength to the nail. The majority of examined specimens, however, lacked this reinforcement. The pin — circular in cross section — is attached directly to the head. The manner by which such nails were fabricated in Europe from wire is related by Tylecote (1976: 133), and illustrated with pictures from the *Encyclopédie ou dictionnaire raisonné des sciences, des arts et des métiers*, by Diderot & D'Alembert. Tylecote succinctly summarizes the process as follows: "From about 1550 until well into the 19th century the heads usually consisted of wire spirals later set by small drop hammers. Occasionally, the heads were made by soldering on discs of brass sheet and rounding these to give a semicircular form."

Such round-headed nails or studs had been used in large numbers by European decorators since the 17th century to attach cover material to chairs. As to the question of when round-headed nails were exported from Europe to Africa, we remain largely in the dark. To our knowledge no research has yet been conducted to address this. Such investigations must take place on two fronts: namely, the consultation of archival resources on the one hand, and the chronological classification of African objects with such round-headed nails in museum collections on the other. All that we can presently assume is that significant export of these items probably dates from the 17th century. If this is so, it would mean that from that period on, African objects — and more specifically, Central-African weapons and objects of use — could be adorned with such round-headed nails. In any event, their use was known in Zaire prior to colonialization in the 19th century. Round-headed nails are less frequently seen in Central-African statues and masks. Here, they are most often encountered on Songye and Chokwe figures. On masks their use is rather rare. Such examples are encountered among the Kongo, the Pende and the Chokwe, among others. The amount of round-headed nails on the Kongo mask published by Cornet (1972: 35, ill.13), may be said to be exceptional.

The round-headed nails which were used in Africa — mostly for a purely ornamental, and not functional end — came in a variety of sizes. There are examples with diameters of six, eight, and ten millimeters. Sometimes studs of the same size would be used, hammered-in in rows or in a regular pattern. It also happened, however, that round-headed nails of different diameters were employed as well. For objects, or parts thereof, which one wished to cover completely, nails of a very small size would be used to fill in any remaining open areas. The heads of these small exam-

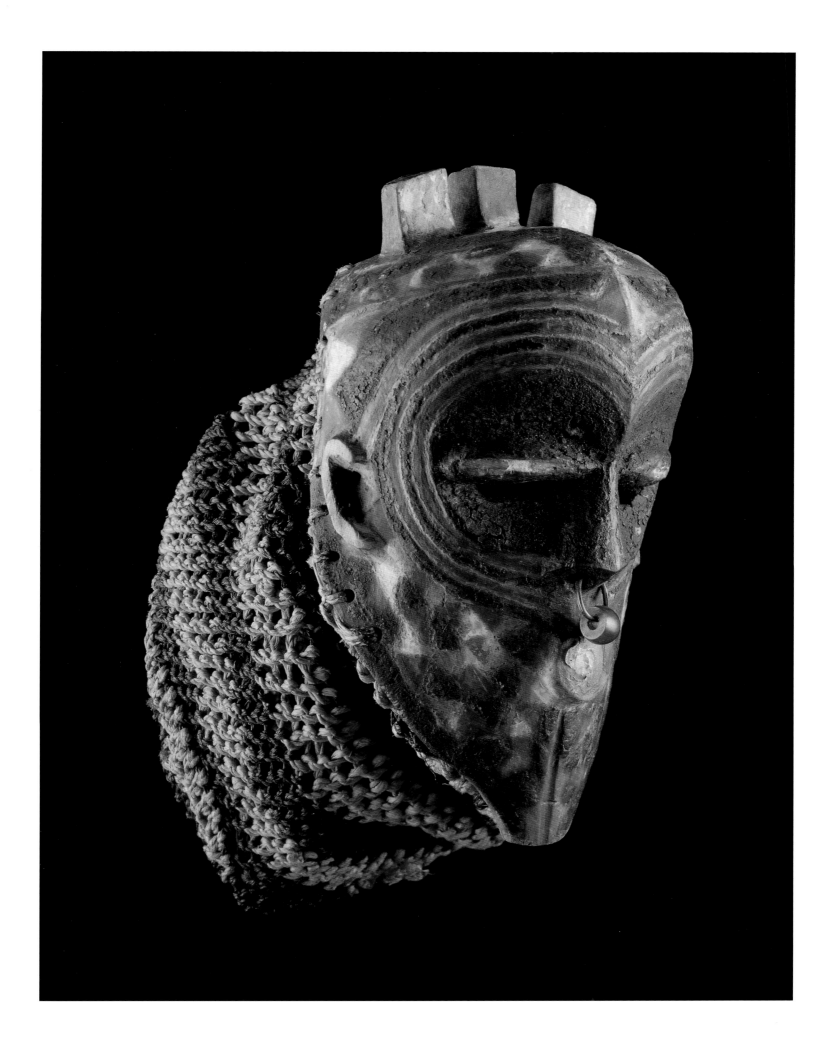

ples usually have diameters of between three and four millimeters. On closer examination one notes that these are not round-headed nails, but regular brass nails — Lambert-nails, or other types common in carpentry. With the technical proficiency possessed by the African metalworker, here and there headed-nails would even be forged. Herbert (1984: 226), referring to Cornet (1978: 159), reports this among the Songye. Here it has to do with headed-nails having a solid, and more or less angular upper part. We see such forged indigenous examples used on the faces of some statues made by this people. These impressive nails, however, differ fundamentally from the imported round-headed variety.

The use of nails as decorative elements may well be a very longstanding practice. In a work by de Maret, reporting the results of his excavations in the Upper-Lualaba region, we read the following interesting information. At a burial place in Katongo he found along with the iron axe-blade, seven nails with lengths varying between 37 and 54 mm. They exhibit conical heads with a diameter of between 14 and 18 mm. De Maret (1985: 229) gives the following interpretation: "D'après la position du fer de hache et des clous, on peut supposer que ceux-ci ornaient la manche du côté opposé au fer de hache." The object is placed by the author in the Old Kisalien, thus situating it between the end of the 8th and the end of the 10th century. On the borders of Lake Kisali, thus, nails would have been in very early use as an applied material, and this specifically with an eye to the embellishment of an object. This, then, could also mean that here the decorative technique was not introduced by Westerners. The question may, therefore, be raised as to if in certain parts of Central Africa the imported round-headed nails had not simply replaced the traditional decorative nails. At present we may only suggest that this specific mode of decoration is the most frequently employed type in this part of Africa.

Nails which are not used as decorative elements are used for the fastening of tin to weapons, for example, as well as to all manner of prestige objects, including statues and masks. In the Zaire Basin the metalworkers seem to have long remained faithful to the traditional indigenous types. Along with iron rivets, forged copper nails with lengths of approximately one centimeter are also used here. The head is forged in the shape of a short four-sided pyramid; the upper surface is rectangular. They seem somewhat like our clog-nails, but the upper part differs in being smaller and rectangular. Prior to hammering-in these nails, the nail hole is made with a punch or drift. We encounter this, for example, on decorated axes of the Songye or on Salampasu masks. This preliminary hole-making with an iron tool is necessary because the copper nails would otherwise bend when hammered into a fairly thick piece of domestic sheet metal. Another advantage of using a punch is that, on impact, the sheet metal is driven into the wooden template. This is the initial attachment-phase of the tin. When the nails are then hammered-in, wood and metal finally become definitively fixed to one another.

T I N The term tin is used here not in the narrow sense of thin tinned sheet steel, but more broadly as a sheet metal made from iron and various non-ferrous metals. Domestic tin is yielded in Africa by first forging a piece of iron and then hammering it out in length and breadth until a thin sheet is attained. The same technique is employed for all other metals, thus also for copper and imported brass — to name only the most important non-ferrous metals made use of in Central Africa. During this process the smith or tinsmith was obliged — and this was true for whatever metal was being used — to take into account the particular characteristics of the respective material. If hammered repeatedly and intensively, the molecular structure of the metal is disrupted. By bringing the material back to glowing-hot at regular intervals, hammering and then finally allowing it to slowly cool, the structure is to a certain extent restored. Thus, the sheet avoids becoming fragile or brittle. The tin finally so obtained had indeed to be of good quality if one expected to achieve a satisfying result in its subsequent application.

In contrast to the case in Africa, manual hammering in Europe was quite rapidly replaced by mechanically moveable hammers. The most significant development in the fabrication process occurred in the 17th to 18th century with the introduction of rollers. The quality of the product improved to a significant degree. When it landed on the African market it fast became a recyclable material, used by traditional craftsmen for a variety of purposes, including its use as a material applied to masks. In the art of Central Africa, and more specifically in the Zaire Basin, sheet metals from copper or brass were predominanty made use of. Lamellae, small pieces, bands, or strips — with or without regular contours — were applied to wooden armatures. In the study of

54
LULUWA?

Zaire, West Kasai

anthropomorphic face mask

H. 28.5 cm. Wood, pigment, teeth, seeds, metal

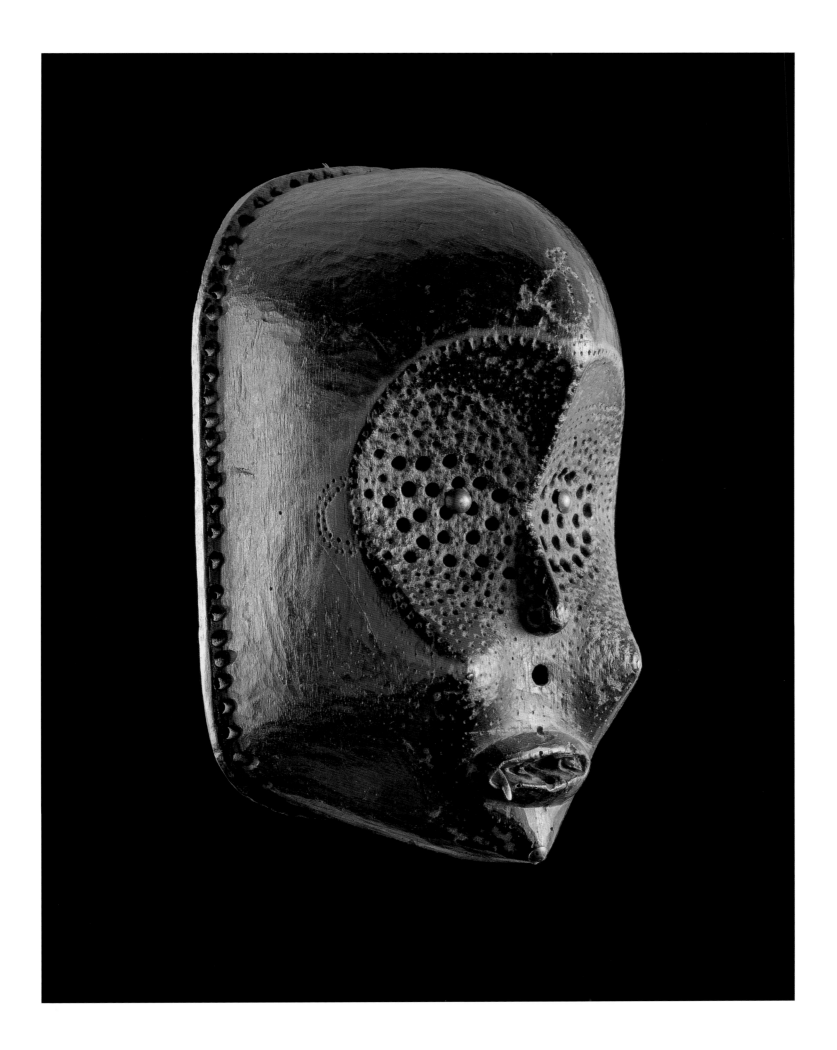

57
LELE

Zaire, West Kasai

anthropomorphic face mask

H. 28 cm. Wood, metal, pigment, raffia, fiber, shells, beads

This mask is of Lele origin, and was collected in the area of Ilebo. This locality is at the confluence of the Sankuru and Kasai Rivers, where the Lele and Bushoong territories border one other. Their language and other cultural elements exhibit notable similarities. This also explains the form of the headdress, attached to this mask, which betrays Bushoong influence. The application of small metal plates on the nose and under the eyes also show a similarity to the *bwoom* masks of the Bushoong. The flat wooden face and the headdress form are in their turn related to the face masks of the Akwa Pinda, a constituent group of the Kasai-Pende living in the area of Tshikapa. No information is known to us concerning the function of the Lele masks. (F.H.)

Lit.: Torday & Joyce 1911; Neyt 1981; PETRIDIS (p. 63)

African art, and more particularly of Central Africa, the technique for applying such sheet metal has to date received little or no attention. To our knowledge no single detailed study has yet been carried out. Due to the lack of written sources, in the future it will be difficult to ascertain just to what, if any, extent the application technique evolved over the course of time.

As stated above, in Zaire metal application is seen primarily among the Lwalwa, the Salampasu, and the Kuba. The Lwalwa, who are situated to the east of the Dinga, are credited with a few face masks which are covered with tin (cat. 46). Stylistically they belong to one of the four mask types as distinguished by Timmermans (1967: 85). Neyt (1981: 204 ill. X.4, 205) has published a similar mask, known as *ngongo wa shimbungu*. He describes the object as follows: "Des languettes de cuivre sont fixées par des attaches métalliques sur une âme de bois au profil allongé: front large bombé, menton triangulaire et fuyant. La ligne médiane au milieu du front, l'arête nasale, les lèvres étroites et proéminentes, les yeux étirés et ajourés, ont des traits morphologiques analogues à ceux qui caractérisent les masques en bois." One notes that the Lwalwa generally use relatively large pieces of metal sheet, and these are applied with such care as to completely conceal the wooden face. The various strips are hammered so that the tin well-adjoins to the wooden form. Two to three horizontally placed bands cover the nose and sometimes further extend over the eyes and cheeks. The tin sheet edges the slit-like eye openings: for this the tin was sometimes chiseled-out. To affix the tin, usually nails — though not necessarily round-headed — and rivets were used.

Masks of the Salampasu were strikingly described by Neyt (1981: 212) as follows: "Ces masques, portés par les maîtres des diverses sociétés, se caractérisent par un front ample largement bombé, un nez épaté volumineux et arrondi, entre les yeux en quartier de lune, ajourés. Le plan des joues est uniforme, le menton souvent large. La bouche rectangulaire, ajourée, se caractérise par deux rangées de quatre dents pointues, huit dans les masques plus anciens. Les oreilles sont petites ou inexistantes. Lèvres et dents sont couvertes d'une poudre blanche (*pemba*)." The most important examples, he writes, have copper sheets affixed with brass nails. Herbert (1984: 226), as well, relates that "the Salampasu of the left bank of the Lulua River cover their masks with hand-worked copper, in strips or more commonly in thin sheets ornamented with large brass nail-heads." The masks indeed are completely or partially covered, but the affixing is not always accomplished with round-headed nails.

In contrast to the Lwalwa, among the Salampasu we note two methods of working; namely, complete covering and partial additions by application. Furthermore it is noteworthy that among this people, more so than with the Lwalwa, a clear pattern is followed. In the completely covered examples the method is to array horizontal rows of square to rectangular pieces of tin. Sometimes, however, long and broad rectangular strips are arranged horizontally. By way of example, we cite a mask published by Huet (1978: ill. 238), and a specimen described by Fagg (1980: 135). The question of whether the first working method is the oldest or not, remains open. In any case, we may state that the second procedure is also used for those pieces that are destined for commercial sale, and not for traditional use. In examples used for commerce, one sometimes notes extremely fine wooden pins or pegs driven into the nail holes, instead of nails. In partially covered specimens the forehead is provided with vertically positioned rectangular bands, sometimes with differing breadths. On the cheeks, lamellae are arranged obliquely and in parallel with one other. A characteristic example has been published by Neyt (1981: 213). Only exceptionally do the small square to rectangular lamellae form a V-like pattern, as seen on an example from a private collection in Belgium (cat. 50).

Compared to the Lwalwa and the Salampasu, the Kuba — who live in the Lower Kasai region — are rather modest when it comes to the use of metal on masks. If one encounters tin, then it is usually on the *bwoom* specimens, imposing pieces which are often richly embellished with pearls and cowrie shells. One notes as well the application of copper sheet, usually on the forehead, the cheeks, and sporadically also on the mouth (see ill. p. 126). As previously stated, the Kuba — at least according to Sundström — were to have exerciced a preference for brass. On masks there is little of this material to be seen, and there is a clear predilection for the use of copper sheet. The tin is affixed to the wooden masks with nails and rivets, after having been carefully adapted to the base-form. On the object published by Cornet (1972: ill. 63), one notes that the maker first worked the sheet metal from the interior. He accomplished this with a fine stylus, so creating a pointed-relief decoration on the front side of the object.

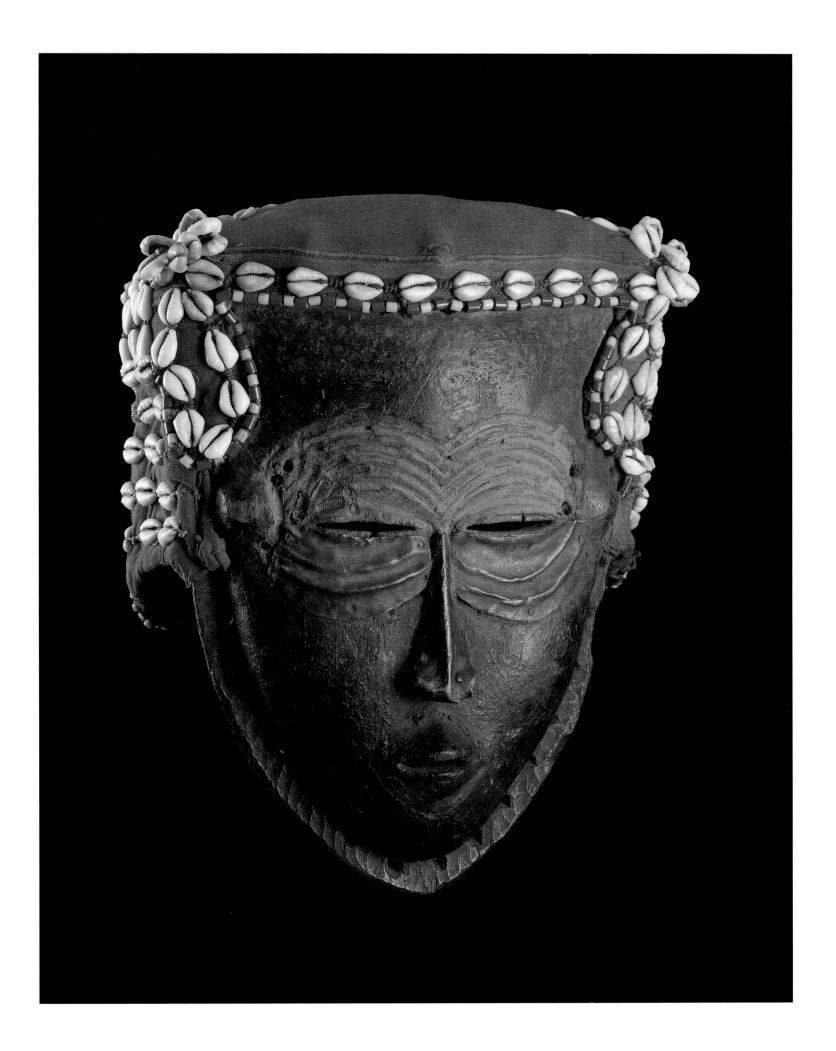

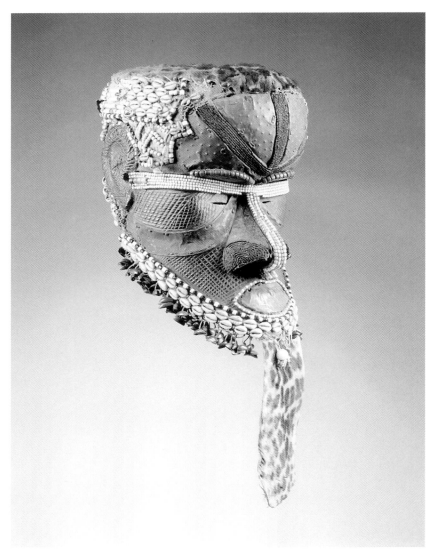

Kuba: Bushoong (West-Kasai). *Bwoom*. H. 58 cm. Private collection. *See cat. 60*

The Meaning of Metal on Masks

The communication of Herbert (1984: 230) concerning the application of metal additions to objects of use, decorative pieces or weapons, to a certain extent also holds true for the masks. She writes, "In many cases, it can... be argued that such additions serve a practical purpose", and then continues, "So widespread is the custom of decorating African weapons with copper and brass in every conceivable form — wire, discs, and studs — that utility alone cannot be an adequate explanation, however." That the addition of metal to a mask is carried out for purely decorative reasons, indeed does not seem to be a correct argument in terms of explaining this practice. The covering with metal sheet does not enhance the life-expectancy of such pieces. Throughout Africa as a whole, it is the case that metal application is usually only partial and, moreover, the protruding parts are those most likely to run the greatest risk of being damaged — and these areas are usually not involved in being covered by metal additions. The argument that a wooden mask would last longer if it were completely covered in metal sheet, is also flawed. Parasites such as woodworm may well infest such masks, seeing that the mask's interior is never similarly bedecked with metal. If the presence of metal on the hilt of certain weapons, for example, might make for more efficient handling, then such is not the case for masks. After all, the fitting of metal to a mask makes the object heavier — and all the more so when the covering is complete. It goes without saying that it is easier to dance with a mask made wholly of wood, than with an example clothed with fairly heavy domestic copper sheet. Let us in this regard recall that the Lwalwa masks were held by the mouth. Beneath the nose of such specimens, there are two openings provided

through which a rope is tied on the inside, and held between the teeth during performance. Clearly, there must be reasons other than purely functional ones to explain the addition of applied metal elements to masks.

Metal is not only a sturdy material, it at the same time possesses intrinsic power. The power ascribed to metal has, among other things, to do with the manner by which it comes into existence — namely, from out of "earth and fire". The ore obtained from the ground indeed undergoes a veritable metamorphosis through fire. For pre-industrial man, this transformation is shrouded in mystery, and can only succeed if the smelters follow a strict set of rules. The process, therefore, is surrounded by many taboos. At further stages in the fabrication process as well, such as forging and casting, account must also be taken of numerous prohibitions. As mentioned, metal is indeed described as a power-laden material. Particular qualities are chiefly ascribed to iron, copper, and alloys of this non-ferrous metal. This is not true only for Africa. Elsewhere as well — in other traditional or pre-industrial communities — these materials are invested with similar attributes. In the first place, metal has a repelling and a protecting power. It possesses the strength to hold pernicious supernatural forces at bay, to protect against a broad variety of dangers. Thus iron, copper, and brass play an important role in the religious as well as the profane sphere. Aside from their magical significance, they are also related to well-being. Indeed, the possession of metal objects is indicative of status. They are symbols of wealth and power. One important attribute of metal is its power-enhancing function. When one applies this to an implement, a statue or a mask, then they become invested with additional power, and so become more effective.

The color, the glittering effect of the material and even the sound that it can produce, are all of significance. For copper and its alloys, Herbert (1984: 277) maintains: "Without minimizing the importance of scarcity, durability, and workability, I suggest a further triad of complementary importance: redness, luminousity, and sound. All of these qualities serve to embed copper in ritual and mythological systems which classify the world, and through classification, aim for a measure of control." The author refers to the fact that few African peoples have separate words to signify copper and brass, and that one normally speaks about red iron or red metal. Consequently, color is the most typical characteristic of the mentioned non-ferrous metals. Copper's red color is associated with blood, and thus with sacrificial offerings, executions and war, but equally with fertility and vitality.

Herbert (1984: 279) reports that the presence of copper refers to bellicosity or the power to take life. In this context, she presents as examples the inlaid work and wire-embellishment seen in Kuba weapons. With regards to the glittering effect of copper and brass, the author again refers to the Kuba people: "While the word for copper in many African languages emphasizes its redness, the Kuba words for copper and brass derive from roots concerned with luminousity, with what attracts the eye. The implications of luminousity — both of glare and of reflecting power — help to explain the frequent use of bright metal in the eyes of masks and statues: it attracts, dazzles, repels, looks beyond" (1984: 280). Finally, there is the sound that metal, in various forms of bells, can produce. These are given to the masks as gifts, and may be affixed to them. The sound of the bells attracts the attention of the villagers. It is also known that their sounding on certain occasions — both in Africa, and elsewhere — not only has the function of keeping evil at bay, but is also related to fertility. One does not usually encounter such elements as these on masks originating in the Zaire Basin. However, masked dancers do frequently carry iron bells or are accompanied by them, as is the case among the Salampasu for example.

Quite a number of elements thus indicate that metal is applied to masks for other than purely decorative motives. Given the fact that a metal is attributed with a deeper meaning, it is not unusual that one encounters it on important masks such as the *bwoom* examples from the Kuba people. The qualities assigned to metal, and particularly to copper and brass, probably also explain why masks of the Lwalwa people — that perform during a ritual dance after an unsuccessful hunt, or as part of initiation rites — are covered with metal sheet. Of the Salampasu's masks which are also used during initiation ceremonies, it is known that they have a fear-inducing function. The use of shining copper undoubtedly contributes to this effect. The specific values placed upon these metals by the people who use them, and exactly what connotations they contain, is a topic worthy of further investigation. Only then shall we be able to formulate a clear answer to the question of why additive elements of metal are seen on their masks.

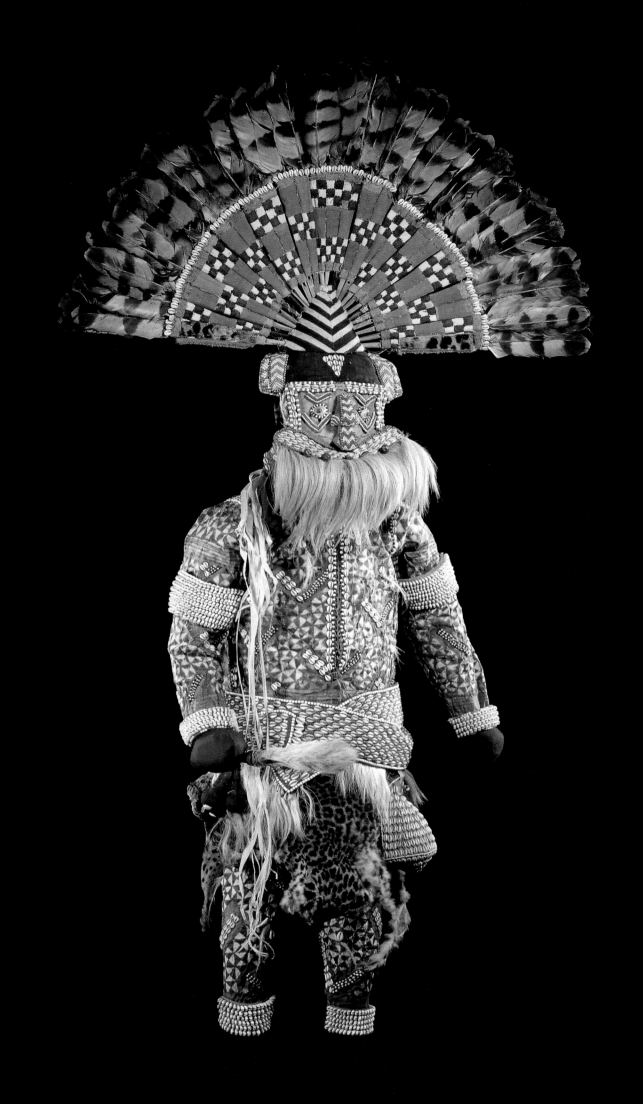

Masks Among the Kuba Peoples

Joseph CORNET

In central Zaire, a region dominated by the forests and savannas of the Kasai, the kingdom of the Kuba is long established, its institutions dating back to the 16th century. The main group, the Bushoong, are second to none in terms of their attention to the symbols of authority and prestige.

In this society masks function as an expression of man's unquenchable need to temporarily take on a new personality; indeed, is not this the very essence of the mask? But besides the extreme richness to be expected from peoples whose traditions exalt the power of quasi-divine chiefs, the rules governing Kuba masks show some peculiarities, particularly among the Bushoong, whose particular chief is the *nyimi*, king of all the Kuba groups.

So leaving aside the ephemeral productions linked to initiation ceremonies, which today have almost disappeared, royal masks are limited to only two types, but they are still rigorously controlled with respect to their making, the costumes which complement them, the places and situations in which they are presented as well as the dances, songs and instruments which accompany them.

The main royal mask is the *moshambwooy* (cat. 59). Or rather one should say *moshambwooy mushal*, the "feathered" *moshambwooy*, for the meaning and authority of the king's mask are such that all the chiefs' masks derive theirs from it, and also have the name *moshambwooy*. Thus even the masks of modest village headmen are directly influenced by, and are variants of, the *moshambwooy*, e.g. the *washamboyo* of the Shoowa.

Among the Kuba in particular, oral tradition has accumulated an impressive number of stories, even if they are sometimes difficult to reconcile with each other. They are said to explain various customs. According to the elders, the *moshambwooy* is essentially the symbol of Woot, the founding hero of the tribe, and the Kuba are considered to be his sons.

Two divergent groups of stories explain the mask's origin: one tells the tale of a vision inspired by a spirit called *moshambwooy*; the other is more strictly an etymological type of explanation. As all Africans know, the forests, lakes and rivers are the favourite haunt of numerous spirits, some beneficent, others malign. Among the latter was a formidable water spirit, called *moshambwooy*, who struck down the inhabitants of the kingdom, spreading cases of blindness and even mortal illnesses. One day a certain Bokomboke, going through the forest, found himself suddenly in the presence of this spirit. Dreadfully frightened, the man fled and returned to the capital Nshyeeng (more usually called Mushenge) where he told the King of his adventure. The King asked him for a detailed description of the spirit, including a drawing of it. Then with the aid of bark cloth, skins and feathers, Bokomboke constructed a weird costume, which first astonished the king, but then gave him an idea, to use it for a singular purpose. Enjoining silence on the man, the King disappeared. Shortly thereafter, one evening, a bewildering personage appeared in the capital. It was the King himself, disguised by the spirit costume. It danced in front of the prostrated townsfolk and then went and hid. In the morning the king appeared amongst his people and pretended great surprise at the tale of the visit of the mysterious apparition. Seeming to consider deeply, he declared that it was the spirit *moshambwooy*, who was responsible for the illnesses and who had come to find out if there were any shrewish women or disobedient youngsters in the town. This, it is said, was the origin of the *moshambwooy* mask. Even today, when the royal mask appears, the king is supposed to be away on a journey, though everyone knows that it is he who is the masked dancer.

Other stories attribute the creation of the mask to a certain Mbwooy, a sculptor by trade. He had heard a wine drawer telling how, in the course of his visits to the palm trees in the forest, he had

59

KUBA: BUSHOONG

Zaire, West Kasai
anthropomorphic bell mask and costume
moshambwooy
H. 26 cm. Wood, pigment, fiber, metal

The Kuba kingdom is a confederation of peoples drawn from the following ethnic groups: Bushoong, Ngeende, Ngongo, Shoowa, Bieeng, Idiing, Ilebo, Kel, Kayuweeng, Kete, Bulaang, Pyaang, Mbeengi, Maluk, Ngombe, Bokila, and Kaam. The Bushoong are the leading group, from whom the king, *nyimi*, originates. Around the monarch, who lives in the capital city Nshyeeng (also called Mushenge), has over the course of centuries developed a court culture where much attention was paid to ceremonial proceedings. Thus, one has come to know the royal masks of which the *moshambwooy mushae* mask is the most important. This serves as a prototype for all other chief's masks, which carry the name *moshambwooy*. According to oral accounts, the mask is above all a symbol for Woot, the founding father of the Kuba. The mask has the traits of an old man with white beard. It symbolizes Woot, as well as the wise man with rich experience. The mask is worn by the king, but also by the representatives of the peoples. Even village-heads sport this mask when receiving the respects of their subordinates. After death, as well, this right holds. They are buried with the mask. (F.H.)

Lit.: Torday & Joyce 1911; Cornet 1982; CORNET (p. 129)

60

KUBA: BUSHOONG?

Zaire, West Kasai

anthropomorphic bell mask

bwoom

H. 31 cm. Wood, pigment

These wooden bell masks are called *bwoom* and *bongo*, respectively. Hierarchically *bwoom* holds the second place as king's mask, after *moshambwooy*. Apart from the Bushoong tradition, within various Kuba groups (Pyaang, Ngeende, Kete and Tshwa) one knows of morphological variants, but all have a massive design. This certainly applies to the mask under cat. 61, that may probably be attributed to the Ngeende. The example under cat. 60 is stripped of its adornments, but admirably exhibits a powerful form with its bulging forehead and large nose. This example is probably of Bushoong origin. Among different Kuba groups the *bwoom* masks are abundantly adorned with beads, hides, cloth, etc. Metal sheet may cover the forehead, cheeks and mouth. With the Ngeende mask this sort of decoration is replaced by painting. In many cases eye sockets are lacking. Holes bored

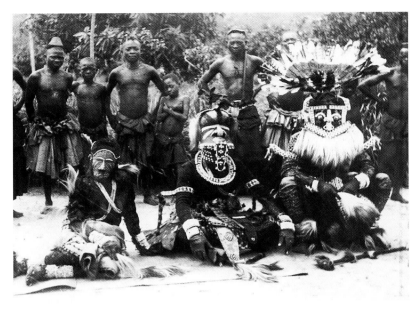

ill. 1. Kuba: Bushoong (West-Kasai). *Ngady amwaash, bwoom* and *moshaambwooy* in Mushenge, 1909. M.R.A.C., Tervuren (E.PH. 9435).

met a spirit. The artist asked for details of its appearance and used them as the basis for a strange new mask. Perhaps ironically, people called the mask the portrait of the sculptor's wife, the *mwaamsh a mbwooy*. Hence the name given to the mask, *mwaashambwooy*.

The general form of the *moshambwooy* mask is that of an old man with a white beard. It symbolizes both the ancestor Woot and the wisdom of the man of great experience. It is in this double symbolic role that the kings, those responsible for the tribes, and even the village headmen, appear from time to time before their people wearing the mask, to receive homage from their notables and the people. The privilege of wearing the *moshambwooy* extends beyond the grave, for they are buried with the mask covering their head.

The *moshambwooy*'s face is not the usual wood sculpture. It consists of a flat surface, made by a rigid frame over which animal skin is stretched. (In the case of a king this is leopard skin). In principle it is a blind mask; under the eyebrows, picked out in beads, the eye is represented simply by a cowrie shell, with no exterior aperture. The nose, carved in wood, is added on and is decorated with a vertical row of beads. Around the lower part of the jaw, long hair is attached to a string of cowrie shells. The face is extended by a neck-guard of raffia, covered with cowries and beads; the ears are carved separately in wood and attached. Finally a half crown, stiffened by a cane armature, acts as the base of the superstructure, where a spongy material is prepared to hold the long feathers, and, in the case of a royal mask, a huge fan of colored cloth called *ibeky*.

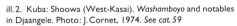

ill. 2. Kuba: Shoowa (West-Kasai). *Washamboyo* and notables in Djaangele. Photo: J. Cornet, 1974. *See cat. 59*

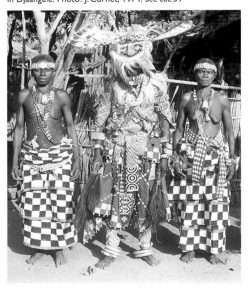

The costume which complements the mask is even more elaborate. A tunic with sleeves is made up of small alternating black and white triangles of beaten bark; in simpler versions these are just painted on cloth. The costume for a royal mask shares the extraordinary richness of royal dress and is accompanied by numerous additional symbolic attributes. As the masked man is supposed to be a spirit, it is important that no part of his body is visible and capable of being recognized. Gloves and shoes made of raffia hide his hands and feet. For the king, the hand and toe nails are made of ivory, one of the rare decorative uses of this material, showing the importance of emphasizing the king's prestige, since ivory was usually reserved for use in the ethnic groups' trade. Strictly speaking, royal masks are called *mbeyanyim* — that is "the king's friends". They are so important that each has its own name. Famous in their day, they only survive in exceptional cases, since they normally accompany the king to his grave.

In the capital, all the *moshambwooy* masks belong to the king; no one can make one or dance it without his permission. If the caretaker of a mask dies, the mask has to be returned to the palace. The dance of a *moshambwooy*, and of royal masks generally, is very odd, if it can even be called a "dance". The fact that the wearer is blind certainly does not allow for wild or vigorous move-

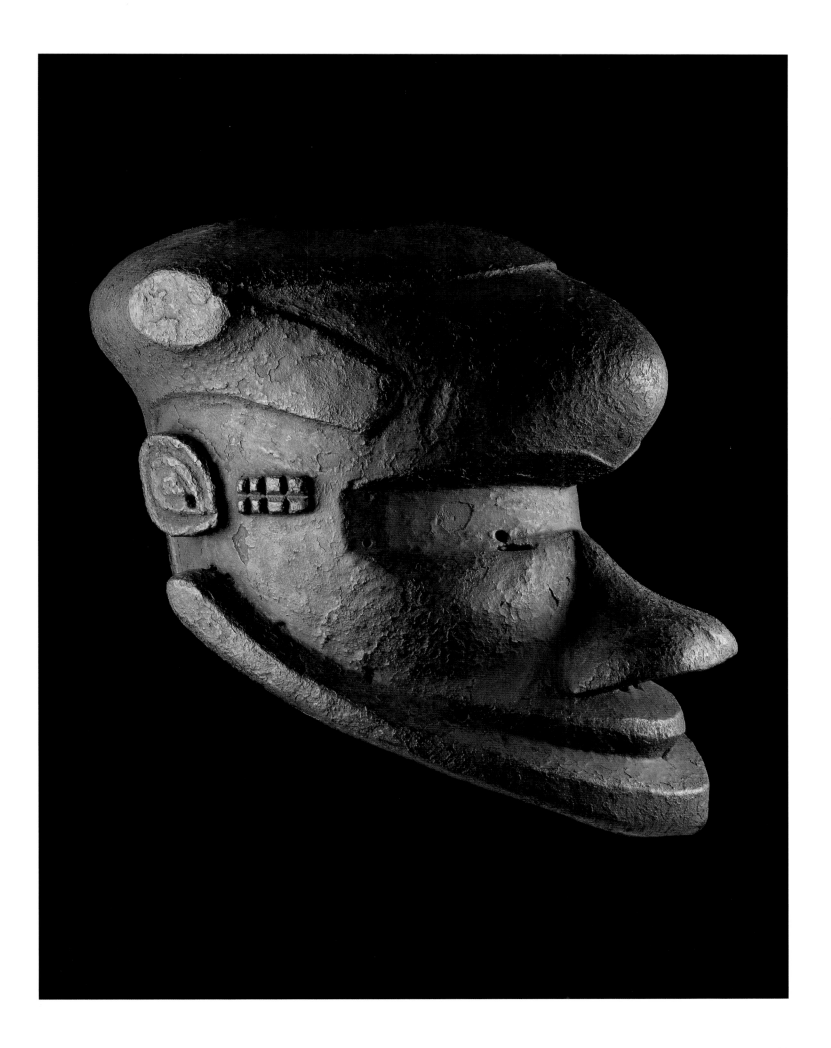

ments. However each movement has a particular significance; they mirror gestures and steps invented by some long dead king, or recall past events. For the spectators, the subtle pleasure lies in recognizing the allusions. The movements of the *moshambwooy* are full of gravity, pride and dignity, as is proper to an old man. The songs which accompany the dance make an important contribution to what is an occasion of high culture.

The *moshambwooy* mask has inspired three variants at the royal court. Among the Bushoong, a *moshambwooy* mask deprived of its flat face is called *mbelepey*. The king has a mask of this sort, made in readiness for his death. In effect it is a funerary mask, placed over the dead king's face during the long lying-in-state before the burial. The *mbelepey* is buried with the body.

In the Kuba capital a curious tradition has given birth to the *nshomoshambwooy*. This is a clown's mask, which is worn the day after the dance of the royal *moshambwooy*. The king chooses one of his slaves to wear the mask and gives him a bow and arrows with which he can shoot at anyone he meets. The arrows are tipped with hard knobs, which hurt rather than wound. In addition the masked man is accompanied by attendants carrying sacks, since he has the right to carry off anything to which he takes a fancy. First he dances in the harem with the king's wives, even despoiling them if the chance arises. Then he walks through the royal village, where the youngsters lie in wait for him, to see the sport. The *nshomoshambwooy* shoots his arrows, which the boys try to stop with shields. The dancer and his attendants have the right to visit any householder and take what they like. No one may reclaim this goods or complain of any damage. It is a sort of ritual compensation for the discomfort the king has endured during the royal dance, for the long robing ceremony and wearing the mask and heavy raffia costume weighed down with cowrie shells and beads is far from being a pleasurable affair. Here one can see the well-established custom among the Kuba of recompensing the king for his sufferings by penalties imposed on the people.

The third variant of the *moshambwooy* mask does not come from the royal entourage but is often found in the great tribes of the kingdom, among the Kete, Ngongo, Ngeende, Shoowa, etc. It is the most splendid of the mask types, the elephant's trunk mask. The appearance of an elephant as a mask image is even more surprising since it is very rare in Kuba artistic iconography. Not that ivory is scarce; in the past the thick forests of the kingdom bordering the Sankuru River were rich in big game, and the concepts of ivory and kingship were associated. In the hunt, the ivory tusks were reserved for the king, just as the leopard skins and eagle feathers. But ivory was rarely used by sculptors.

When the upper part of a *moshambwooy* mask, designed to hold the feathered crest, is replaced by a long cone, which develops progressively into an elephant's trunk, accompanied by two mock tusks, one gets the *mukyeem*, also called *mukenga* (cat. 63). It is possible that in the past the leopard skin on the face was replaced by elephant skin.

The elephant mask accompanies the funeral ceremonies of the great notables. The *mukenga*'s role is, moreover, danced by a notable. This doubtless explains its dominant white color, resulting from the many cowrie shells, which are used to fullest effect on this mask. The mask evokes death, symbolized by the dominant white decoration; white is a sign of mourning, the color of the white bones of the ancestors. The finest examples are remarkable creations in their own right and take pride of place among all the non-royal Kuba masks, both for their richness and their aesthetic qualities. The harmony of the shell decoration is particularly fine, shells of the same size being chosen with care and attached with great regularity, despite the unevenness of the surfaces. The two "tusks" are also covered with cowrie shells and, amongst the Bakuba, almost always framed in rows of beads. The end of the trunk, trimmed with red parrot's feathers as a final flourish, curves round in front of the flat face of the mask. It is well known that the red tail feathers of the grey parrot are reserved for notables. It could be said that *mukyeem* masks can already be considered as regional variations. Others will be discussed below, after consideration of *bwoom* masks.

The *bwoom* mask is the second of the royal masks (cat. 60). Unlike the *moshambwooy* it belongs to the extensive family of helmet masks carved in wood, and has inspired many variants throughout the royal Bushoong tradition.

61

KUBA: NGEENDE?

Zaire, West Kasai

anthropomorphic bell mask

bongo

H. 36 cm. Wood, pigment

through the upper lip are used to thread a cord of raffia that the masker grips with his teeth, so stabilizing the mask during dance. With the mask worn pushed back over the head, the bearer sees through the mask's nostrils. This explains why various masks lack sculpted eye-holes. Joseph Cornet offers a variety of legends pertaining to the *bwoom* mask's origin. These speak of the representation of the head of a hydrocephalic prince or of a Tshwa Pygmy (the Tshwa count as the oldest inhabitants of the Kuba kingdom). The dance movements with this mask refer to historical events which the spectators must attempt to decipher. In contrast to the *moshambwooy*, the *bwoom* mask is not buried with its owner. It is, conversely, preserved with care as a symbol of the continuity of the families. (F.H.)

Lit.: Cornet 1975; Neyt 1981; Cornet 1982; CORNET (p.129)

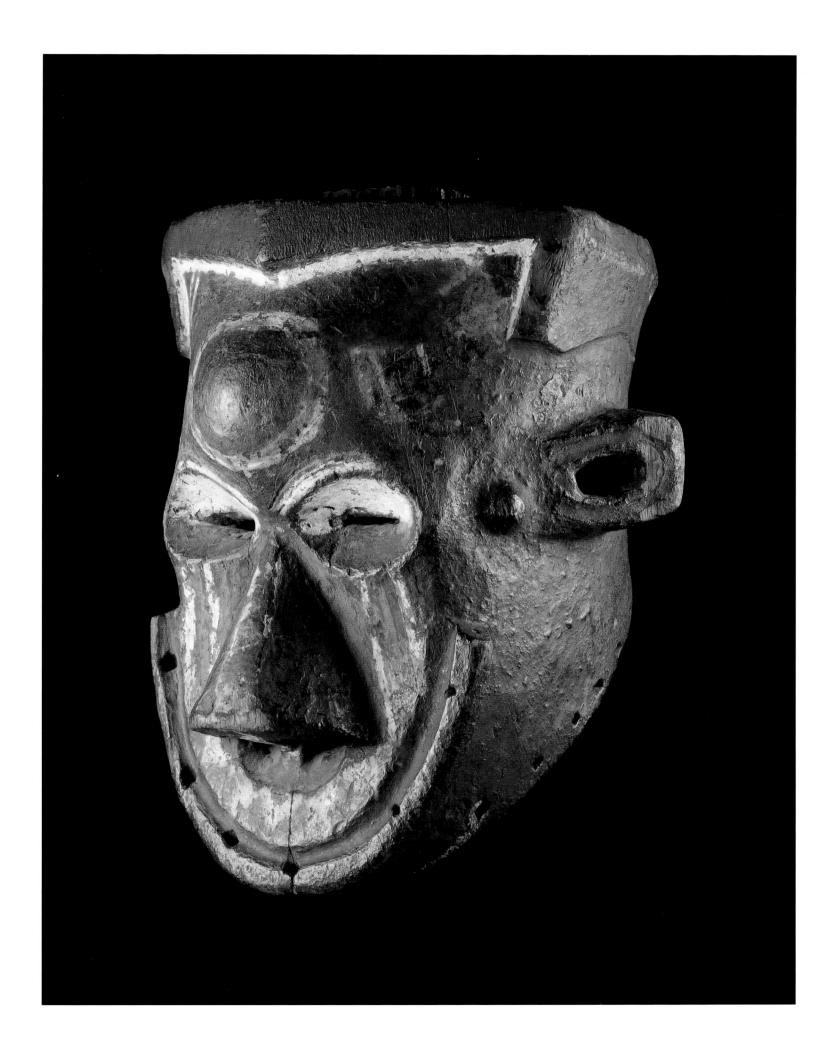

62

KUBA: BUSHOONG

Zaire, West Kasai

anthropomorphic face mask

ngady amwaash

H. 40 cm. Wood, pigment, fiber, beads, shells

Queen Ngokady, who lived during the First Dynasty, wished to emphasize the cultural role played by women. Seeing that women could not themselves wear masks, she had them design and execute the dance costume which, equally, would be worn by a man. The mask represents Mweel, the sister of Woot, and dances together with the *moshambwooy* mask that this mythical hero symbolizes. They had an incestuous relationship from which offspring emanated. The *ngady amwaash* mask is striking with its richly geometric painted face. Moreover, beads are applied as eyebrows and a beaded band is attached from the base of the nose to the chin. Here, too, there are no perforated eye-holes and thus the mask must be worn somewhat back on the head. The parallel lines running under the eyes represent tears, *byoosh'dy*. The costume resembles that of the *moshambwooy* mask. There are, however, some added female attributes: a woman's loincloth, *atshak*, and two pointed wooden breasts. (F.H.)

Lit.: Cornet 1975; Neyt 1981; Cornet 1982; CORNET (p. 129)

The legends explaining the origins of the *bwoom* mask are also many and varied. One might be tempted by a tale recounted by Emil Torday which goes back to the 14th century, according to which a certain Shyaam a-Tul wanted to use a mask to imitate a prince with hydrocephaly (Torday & Joyce 1911: 24). Lavachery (1954: 10), for his part, suggests that this mask represents an interpretation of a pygmy head, especially in the bulging forehead and the broad triangular nose. This is not a totally arbitrary comparison, since the Tshwa Pygmies were the first inhabitants of the area which forms the kingdom and the kings still continue to officially recognize their rights, to the extent that the investiture ceremonies have to include a rite in which the Tshwa are the main protagonists.

A similar explanation, which also includes the pygmies, attributes the carving of the first mask of this type to a Tshwa called Mbo Mbakam. This story goes back to the time of King Miko mi-Mbul, that is, to the first third of the 19th century. The king, who was fascinated by dance, was delighted with the pygmy's invention.

The best substantiated story is also linked to the same character, Miko mi-Mbul, and is an extension of the above. The *nyimi* had made away with the children of his predecessor, in one of those succession tragedies which occurred so often in the old kingdoms. But he paid for his crime with inconsolable remorse, which brought on a period of madness. Periods of remission followed, but the chief had a relapse every time he danced wearing the *moshambwooy*. Having tried the new mask he found that the harmful effects no longer occurred. So he adopted the Tshwa mask and gave it a second place in the hierarchy of royal masks.

Since there are many masks influenced by the Bushoong's *bwoom* mask, it is worth describing it in some detail. The wooden part is the most important, even if the decoration of beads, cowrie shells, fabric, feathers and skins, even painting, sometimes almost swamps it. In the royal entourage, where attention is always strictly paid to aesthetic qualities, the fine proportions of the *bwoom* mask are important. Certain masks are truly remarkable in this respect. In the countryside the proportions are often less pure and more imaginative, which sometimes gives them an admirable originality. The most elaborate examples are found among the Tshwa, who have sometimes ventured to make imitations of the *bwoom*, covering it afterwards with such a mass of beads and shells that it often offends our ideas of good proportion. These are nonetheless interesting examples, whose main point is to draw attention to the sculptural sense of the pygmies, who are usually noted only for their musical skills.

Wood is the usual material for *bwoom* masks, except for some very rare royal masks which are made from antelope leather. After having roughed out the exterior shape, the sculptor hollows out the interior, beginning by making a series of cylindrical bores, which explains the circular hole nearly always found in the upper part of the head. At the nose, two holes are pierced with red hot metal spikes. These holes have a certain practical importance, since as the mask is blind like the *moshambwooy*, they give the dancer the possibility of seeing through the nose, the whole mask being distinctly pushed back when worn. Old examples often even show signs of later enlargement, presumably to aid vision. Once the basic form is produced in this way, the wood is dried out with great care, to avoid cracks. It remains vulnerable to damage from cracking and it is not unusual to see very old masks with ancient repairs done with cane.

The mask's bulging forehead (often exaggerated in more recent examples) is sometimes covered with leaves of metal, gilded metal being reserved for the king (see ill. p. 126). But in every example, three lines, usually of beads, occasionally in paint, mark out a kind of trident, one prong vertical in the middle of the forehead and the other two pointing towards the top of the head over the temples. This decoration, known as *bwoong*, may consist of up to six rows of beads. Below the hollow which marks the beginning of the forehead a horizontal line of beads indicates the level of the eyes, but these are not shown, their place being marked only by arched shapes in beads representing the eyebrows. On the temples, three large beads represent the ethnic tattoo named *masheshel*. The nose is carved from the main piece, not added as in the *moshambwooy*. But as in this latter mask, a row of beads runs from the top of the nose down its length and ending at the mouth. This decoration is reminiscent of certain royal headdresses made from skins, where the animal's tail dangles down in front of the wearer's face. The mouth is generally carved and some-

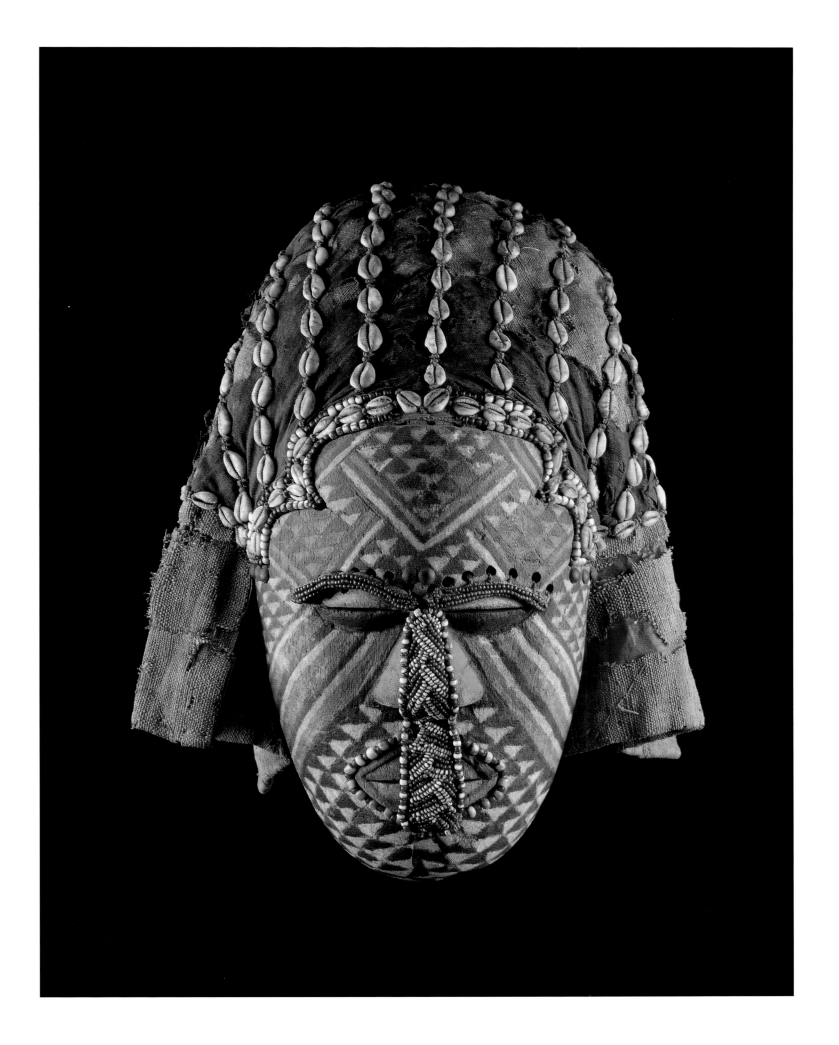

63
KUBA

Zaire, West Kasai

anthropomorphic bell mask

mukyeem or *mukenga*

H. 48 cm. Wood, fiber, cloth, beads, shells, animal skin

Mukyeem **is morphologically a variant of the** *moshambwooy* **mask. It is crowned with a bent-forward representation of an elephant trunk with two tusks. The** *mukyeem* **mask does not appear in the immediate vicinity of the king, but rather is seen among the Kete, Ngongo, Ngeende, and also with some other constituent peoples of the Kuba kingdom. It performs at funerary rituals of notables and evokes death. The predominant white color of the cowrie shells serves as a sign of mourning and is associated with the desiccated bones of the ancestors. When the mask performs, red parrot feathers adorn the trunk's end; this is a privilege of the notables. (F.H.)**

Lit.: Paulme 1956; Maesen 1960; Cornet 1982; CORNET (p.129)

ill.3. Kuba: Bushoong (West-Kasai). *Ngady amwaash* in Mushenge. Photo: J.Cornet, 1971. *See cat.62*

times covered with metal. In ordinary masks there is a hole between the nose and mouth, through which a short cord is passed, ending in a knot which the dancer holds in his teeth to keep the mask in place. The chin and jaws are outlined by rows of tiny bells or rattles, made from dried seeds cut in half. In royal masks these are replaced by cowrie shells. In addition, a narrow pointed beard is hung from the chin, made of cloth decorated with beads, cowrie shells and elephant's hair. The *bwoom* mask also has a typical decoration on the nape of the neck, which is generally rounded; it is particularly elegant and consists of a broad design of beads forming interlacing curves in the *myeeng* style.

The costume for the *bwoom* mask remains very elaborate, even if it is not as sophisticated as that of the *moshambwooy*. Apart from the raffia tunic, in this case decorated with painting, its main peculiarity is the decoration round the hips made from freshly cut leaves. This is called *mashoshwoom*, the name of the plants used, which have therapeutic powers and which were introduced originally by King Miko mi-Mbul, who we have already seen was the king who had problems with the dance masks. The mass of leaves is trimmed off just above the knee. However, this does not detract from the rest of the costume, which shows the wearer's rank. The arms and legs are completely covered, so that no part of the wearer's body can be seen. Flight feathers are fixed to the top of the head and parrot feathers added under the chin. The costume is typically completed by yellow fluttering palm fronds.

The dance of the *bwoom* mask is in the same style as that of the *moshambwooy*, but with a different emphasis; instead of the chief's gravity it expresses exuberance and delights in posturing. The carefully executed steps often have historical overtones and are recognized by the audience with pride and obvious satisfaction.

Unlike the *moshambwooy* mask which often ends in its owner's coffin, the *bwoom* mask is carefully guarded as a permanent symbol of a family's continuity. The kings own valuable *bwoom* masks and they give them special names. The most famous of those which have survived is called *lwoop lambwoom*; this is the one made at the beginning of the 19th century by King Miko mi-Mbul, and was reconstructed by King Kot a-Pey after damage sustained in the troubled period at the end of the century. Handed down religiously from one king to the next until 1969, the mask itself is now in the Presidential collection, though the rest of the costume is still in the royal treasury at Mushenge (Nshyeeng).

The third mask which is found among the Bushoong in the royal entourage, and which has percolated widely among the other Kuba groups, is a feminine mask, the *ngady amwaash* (cat. 62). This is a very fine mask, known through many varied examples. There is a legend concerning its original creation. In the time of the first dynasty the Queen Ngokady, who was acting as regent during the minority of her son Mbwoong a-Lyeeng, wanted to promote the cultural role of women. As they could not wear masks, she had a dance costume made, with feminine attributes but worn and performed in by a man.

The mask itself is in wood, decorated on the face with numerous little alternating dark and white triangles (*lakyeeng lanyeny*). On the brow is a large design consisting of two facing triangles, which are the elements of the well-known motif *ntshuum anyim*, "the king's house". The eyes are modeled in relief, each eyelid being colored differently. The eyes are not pierced: the *ngady amwaash*, too, is a blind mask. Parallel lines run down from under the eyes to the jaws; these are "tears", *byoosh'dy*. The nose and mouth are closed by a row of beads like the two previous masks. The headdress is in raffia, decorated with cowrie shells, with a bunch of shells at the back. The ears are carved separately and added on. Two pieces of decorated raffia cloth frame the wooden face. The *ngady amwaash*'s costume is a little like that of the *moshambwooy*, but a woman's loin cloth called *atshak* is used and two pointed wooden breasts appear on the chest (ill.3).

After this rather detailed discussion of the masks of the central Bushoong kingdom, it remains to consider the general appearance of the masks of the neighboring peoples; whether they are other Kuba groups, mostly Shoowa, Ngongo, Ngeende, Pyaang, or their immediate neighbors, the Lele, Biombo, Luluwa, Bakwa Luntu, Binji and Dengese. Very varied trends and influences circulate between types and sub-types, which as a result fall into groups whose definition is always a delicate question.

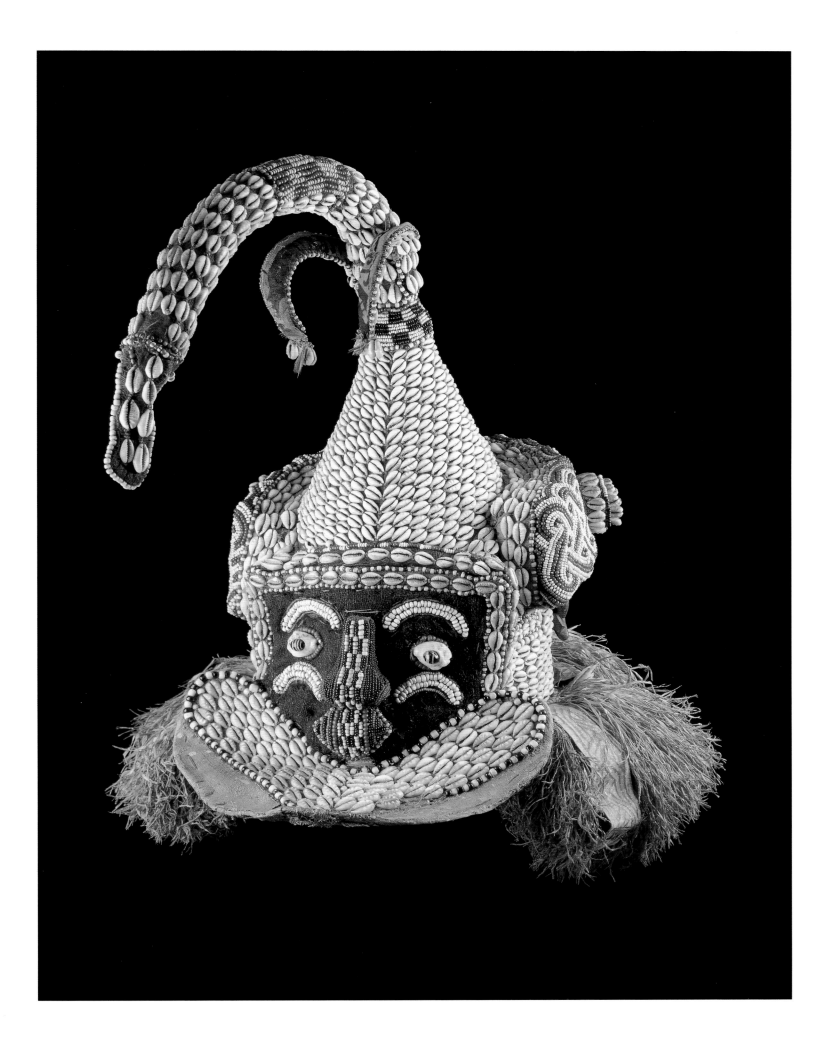

64
KUBA: BUSHOONG or NGEENDE

Zaire, West Kasai

anthropomorphic face mask

pwoom itok, ishendemala or *ishyeenmaal*

H. 24 cm. Wood, pigment, metal, fiber

Aside from the royal masks, among the Kuba a number of other mask types are also seen. The mask here is such an example, and is known as *pwoom itok, ishendemala, ishyeenmaal* or *shene malula*. One encounters this type of mask among various Kuba groups, including the Bushoong and the Ngeende. According to Joseph Cornet this mask is rather a creation of the Ngeende. It appears during the young men's initiation and also performs as a dance mask. Striking are the large round eyes with protruding pupils, here represented by a copper nail, with multiple perforations in the surrounding white of the eye through which the masquerader sees. *Pwoom itok* incarnates an old wise man who is consulted by the other dancers. Emil Torday and Thomas Joyce write that this mask type, named by them as *shene malula*, is among the Bushoong worn by members of the *babende* secret society. This society is responsible for the apprehension of criminals. Each *babende* group possesses three different masks which are alternately worn by each of the members. When a woman dares to touch them, they kill the first goat they see and eat it. The woman is obliged to make good this loss to the owner. (F.H.)

Lit.: Torday & Joyce 1911; Cornet 1975; Neyt 1981; CORNET (p. 129)

The Shoowa do not seem to have used masks for dances but they do use the *moshambwooy* type for the presentation of the chiefs (ill. 2). The chiefs like to present themselves before their people, clad in the finest of these costumes, their faces hidden by masks which are close copies of those used by the Bushoong. They are welcomed with chants of homage, surrounded by the chief notables, who are also dressed in ornaments hallowed by tradition and inspired by the costumes of the capital. The Bushoong names are adapted with local variations.

Amongst the Ngongo the tradition is more distant from that of the Bushoong, with whom in the past they have had recurrent problems of political integration, sometimes being independent, sometimes being subject to the Kuba kings. Many of the strictly Ngongo masks derive from the *bwoom* type. There are some which are remarkable from an artistic point of view, particularly those in the form of enormous helmet-like masks with strong features, whose principal characteristic is a very sure sense of the proportional relationships between the geometric elements. Some of these masks are also painted. One of their general features is the enlargement of the head above the ears, encouraging the sculptor to terminate the brow in a steep angle, by which one can usually recognize a specifically Kuba form. They also borrow the *nyibita* mask from the Ngeende, which is characterized by elongating the vertical features.

Amongst the Ngeende the art of masks seems to be more extensive than among their neighbors. They owe this profusion to their history, which has bound the tribe closely to the Bushoong. So the royal mask forms are found here, adapted to a more provincial style, to which are added special devices, these various forms being individualized by names in the local language. It should be noted that Emil Torday, who stayed in the territories of the Ngongo and Ngeende before he was authorized to enter the capital, frequently retains the provincial names, which he then applies to the similar objects in the royal household.

The *moshambwooy mu shall*, which becomes *shala-mashamboji*, retains the essential features. It is worn by the nobles and the chiefs. Its variant, *mukyeem* or *mukenge* is none other than the elephant-trunk mask discussed above.

The *bwoom* mask becomes *bongo*. The most important features are retained, notably the enlargement of the brow and temples, the width of the nose and its link with the mouth in the form of a vertical band in relief (cat. 61). But unlike the *bwoom*, these masks show their artistic merit by the direct expression of their forms in the wood, without needing to be covered with the heavy ornamentation, metal plaques, cowrie shells, beads, etc., so beloved of the Bushoong.

Much more specific to the Ngeende is the *ishyeenmaal* or *ishendemala*. This is a wooden face mask, its forehead usually sloping back, with a nose strongly marked with flared nostrils and a prominent mouth. But it is primarily noted for the very special form of the eyes. The socket is deeply hollowed, with the eye itself in the centre, modeled on the eye of a chameleon, in the form of a little cylinder or cone, jutting out and surrounded by a circle of small holes (cat. 64). Their artistic merit is sometimes very considerable, particularly when they are enhanced with color. The upper part of the head is extended by a structure composed of cane and tufts of raffia. Some of these masks are decorated with horns and are called *ishendemala dia masheke*. They are linked to initiation ceremonies.

One final mask which is typically Ngeende and sometimes very large is the *nyibita*, with strange proportions since it is exceptionally elongated (cat. 66). The rounded brow develops out of a wooden ridge, the eye sockets are emphasized by a hollow between the arches of the eyebrows and curves indicating the cheeks, the nose forms one of the essential elements in relation to the overall volume, the triangular shape of the lower face reduces the size of the mouth and brings the chin to an end in a point.

According to legend, some of the Lele are, like their Kuba brethren, descendants of Woot. Certainly, the history of the two peoples was once intimately linked, before the departure of the former for the western lands beyond the Kasai. So the many cultural parallels between them are not surprising. Lele art is centred on drums, oracles to be rubbed and the cups used for palm wine. Mask art occupies a more modest place.

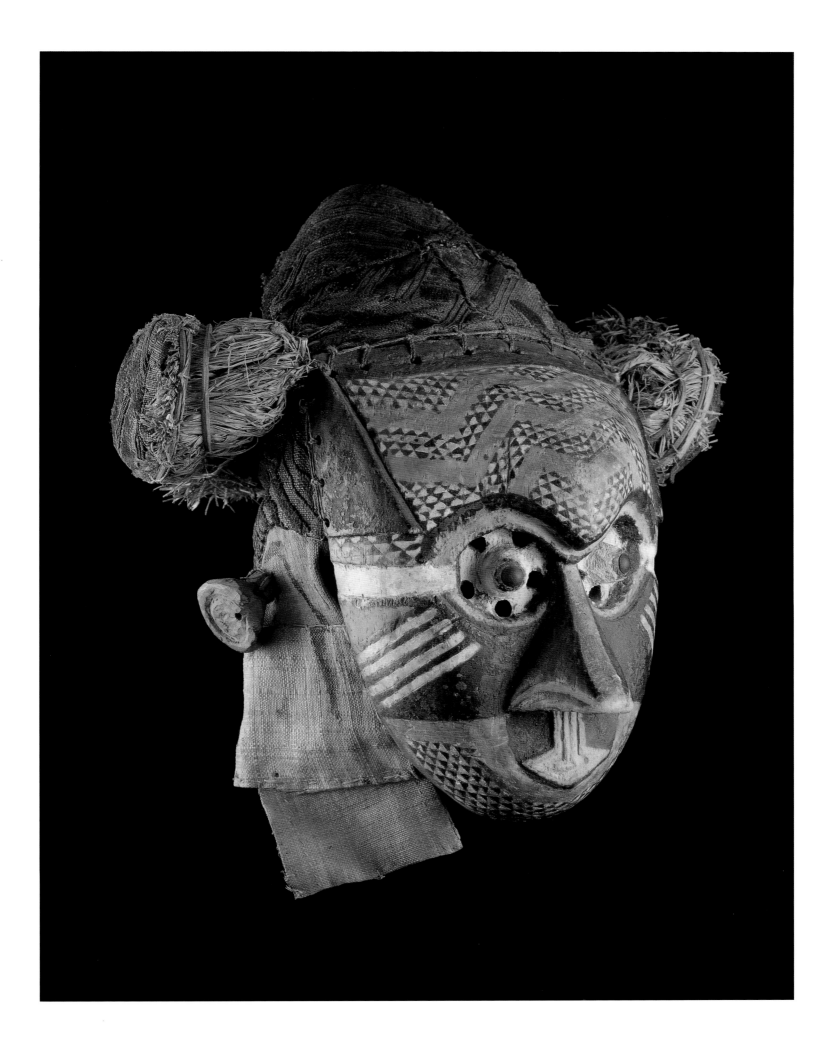

66
KUBA: NGEENDE

Zaire, West Kasai
anthropomorphic face mask
nyibita or *nyimbiti*
H. 63 cm. Wood, pigment, rattan

Information concerning this mask, called *nyibita* or *nyimbiti*, is extremely scarce. Striking is the long facial form which narrows to the bottom. This markedly contrasts in the first instance with the massive and broad *bongo* masks (cat. 61) from the same people, and the *bwoom* masks (cat. 60) of the Bushoong. A more extensive comparison of both mask types also reveals similarities. This is certainly the case for the domed forehead and heavy nose. With the *bwoom* mask and with this *nyibita* mask as well, bore-holes are absent at the eyes. The *nybita* mask is associated with a young warlord, and would have danced at the court of the Kuba monarch. (F.H.)

Lit.: Bastin (*in* Utotombo 1988: 302, no. 207)

Their masks are fairly flat, made of wood and usually painted (cat. 57). The types are not very numerous. In general they are distinguished by the symbolic form of the eye, like a coffee bean or slightly curved slits (a very typical characteristic of their small sculptures, too) with eyebrows formed by a series of lines, echoed by another series of lines below the eye itself. The brow is sometimes marked with the triangular design which comes directly from the Kuba. The cheeks may be scarified. In some cases metal teeth are added. The edge of the face is pierced with a line of holes, used to attach additional ornaments; hair, feathers, etc. The colors follow a simplified palette of red, black and white, typical of the peoples throughout the region where the Wongo, Njembe, Lele and Biombo are found.

Crossing the Kasai again, in a restricted area to the southwest of the Kuba, not far from the mouth of the Luluwa River, are the Biombo or Bashibiombo, known particularly to art lovers for their masks. They are a Kuba tribe, which separated from the others over a very ancient dynastic quarrel.

Their masks are used at initiation ceremonies and at burials. They are bell masks in light wood, surrounded by a thick fringed collar of raffia, very richly decorated. Mostly they can be divided into three categories. Apart from the predominantly red polychrome painting and deep eye sockets, their common elements include a vertical central line in the middle of the brow, a nose with very distinct nostrils as in Kuba masks, and a surface decoration of small triangles, as is sometimes found among the Pende, while on top of the head are projections to support the external additions of the headdress, etc.

Munjinga masks have finely arched eyebrows; they are the first to appear in the dances. The *tshimwana* are feminine masks, with exaggerated wide eyes and protuberant mouths, the cheeks decorated with a triangular surface pattern (cat. 58, p. 241 and ill. p. 240). The central ridge of the brow is very marked. The *maluala* masks are distinguished from the previous two types by the prominence and form of the eyes, jutting out in small pyramids with variously colored segments. The different plane surfaces of the mask are divided into small triangles, covering the cheeks and the chin too. There is a wooden projection on top of the head. These are funerary masks.

The Luluwa are one of the great tribes of the Kasai. Their civilization looks more to the east, rather than to the northwest where their fellow Kuba are settled. Their sculpture is more often found in collections than their masks, which nowadays are no longer used. Ancient examples are very rare, though much sought after. They were essentially circumcision masks, though others were used at the funerals of notables. The most striking characteristic of these masks is the broad hollow of the face around the eyes. Some retain traces of the scarifications once used very freely by this people and which can also be seen particularly on their large and small statues (cat. 53).

That part of the Kuba kingdom which has integrated some of the Kete is one of the richest in terms of mask types. They are adjuncts to funeral or initiation ceremonies. Some are helmet-shaped masks, with a transverse crest or horns and large oval or pyramidal eyes, the brow decorated with painting, flaring nostrils and the lower part of the face open in a protuberant mouth. The painted decoration is usually lavish. Others are closer to the flat masks of the Lele or the Kuba *ngady amwaash*. The most remarkable are the funerary *kamboko*, whose lower part extends in a narrow appendage, while the eye sockets contain pyramidal eyes.

Returning towards the north, we find the Binji and discover similarities with the Kuba. But this should come as no surprise, since the purest Binji are in fact dissident Kuba, who fled the overharsh ordeals of circumcision rituals. Their masks, which are important, are linked to the initiation camps. Some simply serve as head-coverings of raffia cloth, finishing with a fringed collar. But others are the famous *tshibangabanga*, massive bell masks, all in black, except for a few touches of white and rows of red seeds stuck along the eyebrow line. There is a projection on top of the head in which great "wings" of dark feathers are inserted, front and back. All the evidence suggests these are the descendants of the *bwoom* masks of their ancestors. The brow juts forward over the line of the eyes. The enormous nose has small side openings to allow the dancer to see a little of what is going on around him. The lower edge of the jaw is trimmed with a fiber beard. The various scarification designs are analogous to Kuba models.

In concluding the list of the neighbors of the Kuba, the Dengese should also be mentioned. But there is little to be said about the few masks attributed to them, except that they are variations very similar to the masks of their southern brethren who live beyond the Sankuru River, which marks the northern frontier of the Kuba kingdom.

The masks of the Kuba and neighboring peoples are some of the richest and most significant among the immense production of masks in Zaire. The exceptionally high quality of those ancient examples which have miraculously survived, makes one regret that usually we only know of this artistic world through recent production. But this is the cruel fate of this "negro art", made from materials that were too perishable and for purposes that were too often ephemeral.

67
KUBA: BUSHOONG or KETE

Zaire, West Kasai
anthropomorphic bell mask
inuba?
H. 42.5 cm. Wood, pigment, hair

This mask originates from the area where the Southern Bushoong and the Northern Kete live. It was collected in Kasai Province and is strongly similar to a mask acquired by Leo Frobenius between 1904 and 1906 (preserved in the University Museum of Art in Philadelphia). This is possibly an *inuba* mask, that performs during the initiation rituals and at the funerary rites of the village community's most prominent political leaders. At the funeral *inuba* is preceded by a low mask incarnating a warrior, named *bishuadi*, who announces the former's arrival. When the *inuba* mask appears at the bier, the women who were holding the wake are chased back to their homes, and the deceased comes under the exclusive province of the initiated men and the mask. Then begin the *kuela lusanzu* negociations. Here, the mask speaks with the spirit of the dead, called *mwendu*. He attempts to win the spirit over, and to generally disuade it from harboring any eventual malevolent intentions toward his relations and fellow-villagers. Moreover, the mask indicates that the rituals that are his due have been executed and that a successor for him has been indicated. (F.H.)

Lit.: Leuzinger 1963; Wardwell 1986; Binkley 1987

The Kifwebe Masking Phenomenon

Dunja HERSAK

The term *kifwebe* (pl. *bifwebe*), used by both the Songye and Luba peoples of Zaire, has become a household word among enthusiasts of African art. It is associated with the striated, wooden facial masks, especially the better known Songye types which exhibit highly geometric facial configurations. Perhaps partly because of the visual distinctiveness of these masks, and the overriding market demands on their formal properties, they have fallen prey to a kind of stifling, timeless typecasting.

Like many other cultural practices, the reality of *kifwebe* masking is far more dynamic, having undergone substantial change in form, context and meaning both regionally and temporally. But since serious scholarly field research on this topic only began in the 1970s, and data recorded by early travellers, missionaries and administrators is most fragmentary, a comprehensive and clear picture of this diversified development process is difficult to reconstruct in its entirety. Nevertheless, the early contributions, which are confusing and at times contradictory, do provide some useful insight. I propose to review some of these patchy findings, particularly as they continue to fuel the realm of the imagination, and then to examine aspects of the more contemporary period. Though my task is to deal with the *bifwebe* as an inter-cultural phenomenon, I intend to gravitate more toward the Songye perspective since this is the area of my field research.

A major effort in mapping out the early history of the *bifwebe* among the Songye, has already been undertaken by Alan Merriam in his 1978 overview article of the sources. In this study Merriam focuses cautiously on the documented use of the term "*kifwebe*" and on the chronology of museum acquisitions. He refers to the famous black and white striated mask at the Linden-Museum, Stuttgart, which was collected by Leo Frobenius in 1905-6 (acc. no. 43811), as the first, though isolated Songye example of this mask type (Merriam 1978a: 72). He then points out that the actual use and definition of the word, though cited in reference to the Ankoro region of the Luba in 1912 and 1913 (Colle 1913: 440; Maes 1924: 36), appears in print in Samain's Kisongye dictionary surprisingly as late as 1923 while most of the clearly identified *kifwebe* masks from the central Songye region, acquired by the Musée Royal de l'Afrique Centrale in Tervuren, only date back to about 1928 (Merriam 1978a: 72). Although Merriam postulates on the movement of the *kifwebe* cult from an eastern locality of origin westward across Songye territory, his argument appears tenuous due to lack of concrete examples from the eastern Songye sector and, in particular, an unexplainable time gap for reports on *kifwebe* masking in the central Lomami River region (Merriam 1978a: 72).

This apparent void in the masking map seems to have inspired some writers to hypothesize on the opposite directional movement of the cult and on sources of influence for the development of the *kifwebe* form which are largely based on visual comparisons (Felix 1992a: 4-5). Contributing to this line of thinking is the fact that masks are indeed first mentioned in reference to the northwestern region of the Songye by Hermann Von Wissmann after his 1886-87 expedition to Central Africa with Ludwig Wolf (Von Wissmann 1891: 50). Moreover, numerous examples of stylistically similar conical, helmet-shaped masks with painted linear patterns reached the museum in Tervuren by 1910, hence much earlier than most of the *bifwebe* pieces. These were clearly identified by Müller, the collector, as being from the Tempa, a sub-group of the Songye, located precisely in that north-western region of Lusambo (Maes 1924: 33). Unfortunately, despite this more consistent and earlier pattern of masking evidence, the conical masks, some of which may be described broadly as having striated painted designs, though not the grooved lines that commonly characterize the *bifwebe*, are not only entirely different in form from the early Songye and Luba examples but their "painterly" surface treatment exhibits quite another aesthetic approach. Also, a field photograph of a similar example collected by Major John Noble White in the mid-1920s shows that the costume worn with these masks was very different from those of Songye

68

SONGYE
Zaire, Shaba
anthropomorphic face mask
kifwebe
H. 34 cm. Wood, pigment

The *bwadi bwa kifwebe* society is present both among the Songye and the Luba. It probably originated in North Shaba, in a mixed area inhabited by Songye and Luba groups. According to the Songye, it was the Luba who established the *bwadi bwa kifwebe* society. The Luba assert just the opposite. For this reason the Luba maskers speak in the language of the Songye, while the Songye maskers express themselves in Kiluba. The Luba ascribe the origin more particularly to the Songye village Ngyende-Majaja in the chiefdom of the Bena Gende. Generally the Songye indicate the place of origin as the mountains to the east, while for the Luba it is the water-rich lowlands in the west. For the Songye the society functions as a mechanism of control in the service of the ruling elite. It aids the leaders in the exercise of their economic and political power. They do not shrink from invoking for their ends the help of supernatural forces under the form of witchcraft, *buchi*, or magic, *masende*. *Buchi* is hereditary and the natural possession of the chiefs and of the high-placed members of the society. Magic, or *masende*, comes from the spirits of the deceased from whom services could be obtained by way of magical operations. Anyone who wishes to may learn such procedures, and the members of the *bwadi bwa kifwebe* have *buchi* or *masende* available to them. One of the most powerful instruments of the *bwadi bwa kifwebe* are the *kifwebe* masks. Of these it is said that they stand outside the normal order of the universe. For the Songye they are the incarnations of bizarre heterogenous beings. The costume of the masker and certainly the mask itself contribute greatly to this effect. *Kifwebe* masks, among both the Luba and the Songye, possess various

and Luba *bifwebe* maskers (Elisofon Archive, National Museum of African Art, Washington, D.C.).[1] More importantly, the term *kifwebe*, as Merriam points out as well, is not cited in connection with this region (Merriam 1978a: 64). Müller and Noble White refer to the term *ruadi/mwadi* which is merely a generic designation, of quite widespread distribution, for the transformational state of a masker rather than a specific appellation such as *kifwebe* or *kalengula* which relate to particular socio-cultural practices (Maes 1924: 34; catalogue notes National Museum of African Art, Washington, D.C.).[2]

My own field research in the central and eastern Songye chiefdoms during 1977-78 as well as that of Mutimanwa Wenga-Mulayi in 1974 in the Luba region of Ankoro confirm Merriam's origin hypothesis and point to an area of Songye/Luba admixture and convergence in northern Shaba as the place where the *kifwebe* tradition emerged (Mutimanwa Wenga-Mulayi 1974: 120; Hersak 1986: 42). Luba oral tradition even specifically attributes these early beginnings to the Songye village of Ngyende-Majaja in the chiefdom of the Bena Gende (Mutimanwa Wenga-Mulayi 1974: 120; Hersak 1986: 42). In consideration of this problem, a few early findings seem to have been overlooked. For one thing, the term *kifwebe* makes its appearance in connection with Songye masquerades long before the frequently cited 1923 source by Samain. A recent publication of Frobenius' 1905-06 field notes and personal correspondence reveals that he actually did refer by name to "*kifebbe*" masks (Klein 1990: 107). Furthermore, his mention of the Bena Mpassa (first cited by Vatter 1926: 181) as mask makers and users is not as problematic and vaguely defined a locality as Merriam reported (Merriam 1978a: 63), nor does it merit speculation leading as far afield as the region of the Salampasu people (Felix 1992a: 22-23). Frobenius indicates quite clearly that the Bena Mpassa are a "Kalebue" group of the "Bassonge" located west of the Lomami River (Klein 1990: 107), an identification which has been confirmed by Cynthia Anson (Merriam 1978a: 63) and by my own research. Frobenius even specifies the names of two villages (Tschikangalla and Maloba) known as the seat of reputed carvers (Merriam 1978a: 63) and, although these are difficult to locate, they were undoubtedly situated in the extreme southeastern region of the Kalebwe since this is the only area east of the Lomami with a substantial Kalebwe population (see Boone 1961: 214).

This provenance data by Frobenius is therefore not as isolated in space and time as thought at first. In fact, it provides an important link with the visual documentary evidence of masking activity collected during the opening decade of this century in the region east of the Lomami. As shown by Frobenius' 1899 study of museum collections, round, non-striated Luba masks reached European collections well before this period; however, one of the first examples with a distinct *kifwebe* linear pattern was acquired from Deininger by the Museum für Völkerkunde in Munich in 1905 (Kecskesi 1987: 347-348).[3] In 1910 the museum in Tervuren received its first striated Luba mask from the White Fathers at the Lukula mission who reported to have collected it in Kifwamba, a village in the Soswa chiefdom (Maes 1924: 36). Then in 1913 Father Colle published the now famous plate of a similar type of Luba masker, not only identified as "*Kifwele*" but seen in full dress (ill. 3) (Colle 1913: ill. XII). The following year equally important documentation reached Tervuren. Field photographs were received from a Mr. Dirieck, two of which illustrate maskers in performance wearing white, oblongue *bifwebe*. They were reported to be from Kisengwa which is a village and chiefdom of the so-called Eastern Songye just east of the Lomami and adjacent to the Kalebwe area referred to by Frobenius (Maes 1924: 38, ill. 42).[4] It is also situated not far to the north of the Gende chiefdom referred to by the Luba as the origin place of the *bifwebe*. These somewhat neglected photographs are therefore not only the earliest specifically localized field shots from the Songye region, but they are also the earliest evidence to date of kifwebe masquerades from the southeastern sector which resemble the Eastern Songye types I witnessed still in use in the late 1970s.

During this second decade *kifwebe* masking seems to have spread rapidly and widely throughout Luba and Songye regions although its hold appears to have been short-lived in some areas such as among the Bala (Merriam 1978b: 90). Specific reports about its purpose and function up to that point in time are as scarce as the visual documentation but also intriguingly diversified. Frobenius, in a somewhat dramatic vein, emphasized the extraordinary power of these masks, attained by consecration through human sacrifice, and related their role to healing and protection against death (Vatter 1926: 181). Colle dealt with the Luba *bifwebe* under the rubric of "fetishes" and curi-

69
SONGYE
Zaire, Shaba
anthropomorphic face mask
kifwebe
H. 42 cm. Wood, pigment

morphological constants which serve to physically emphasize their supernatural character. One notes a human face with a markedly abstracted nose, mouth, and eyes. Perhaps it is in the manner that the surface of the *kifwebe* masks are worked which constitutes the leading morphological characteristic. The entire face is bedecked with a pattern of geometric grooves which is unique in all of African sculpture. These grooves lend to the sculpted human face an added dimension that leads to the creation of a being that seems to stand beyond the normal order of the universe: the ideal for a *kifwebe* mask. Still, these grooves are not purely abstract. They find their origin among various animals with striped quills, fur or skin. These are the striped porcupine, the zebra, the forest antelope, and a snake which bears the native name *ngulungu*. These are but some references to certain of the more or less striking physical characteristics of the enumerated animals. To these should be added still other characteristics which are ascribed to them in mythology. (F.H.)

Lit.: Merriam 1978; Hersak 1986; HERSAK (p.145)

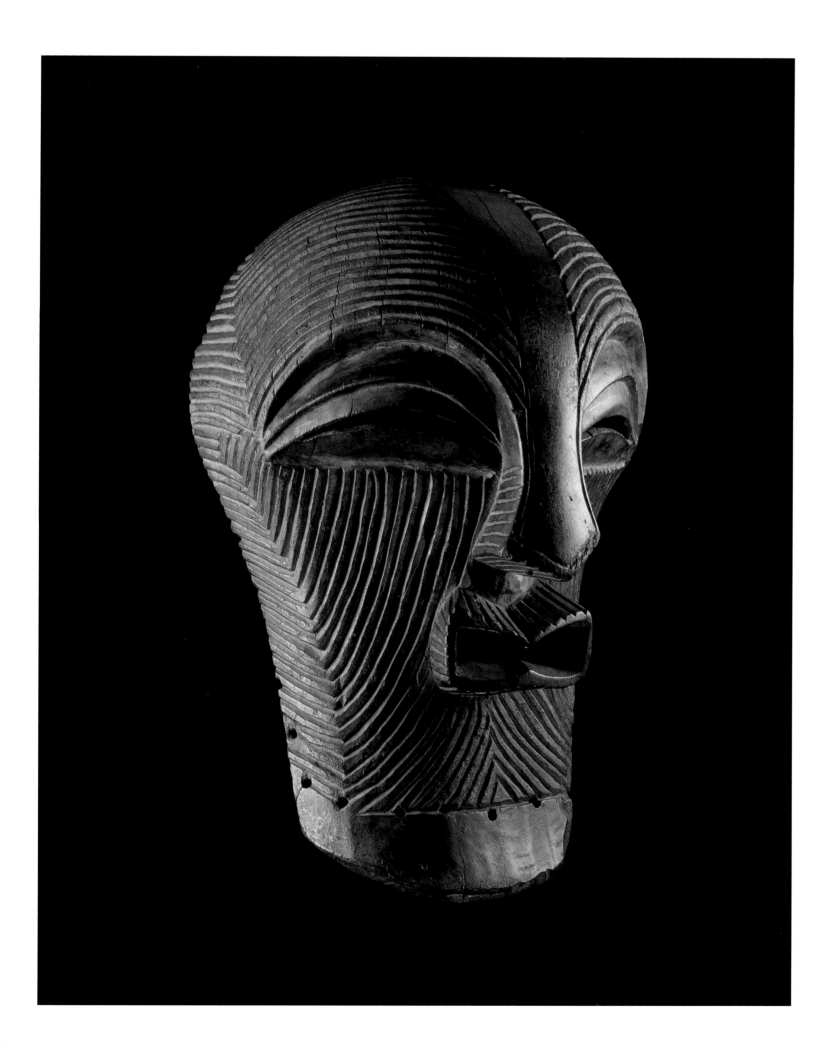

ously noted that these may take the form of power objects or masks. According to the White Fathers, the latter are danced at funerals of chiefs or dignitaries, title-taking ceremonies or visits of important dignitaries (Maes 1924: 36-37). Dirieck's information accompanying Tervuren's 1914 acquisition of the two masks and photographs, though puzzled over by some subsequent authors, echoes Colle's notes in that the term "fetish" is used simultaneously in reference to the *bifwebe* and in connection with a power object said to function as their custodian (Maes 1924: 38). Finally, Samain in his notes on the Songye, refers more specifically to the manipulation of magico-religious powers. He draws a distinction between benign maskers and those possessed of strong, feared medicine (*manga*) referred to as "*ndoji*", meaning witch (*ndoshi*) or according to him "sorcerer" (Samain 1923: 95; Hersak 1986: 34).

From all of these brief statements, it is clear that the *bifwebe* phenomenon was not merely a game or diversion as stated to numerous sources and initially to me as well, but a powerful social instrument probably associated with healing and ritualized forms of mystical and transformational control (Merriam 1978b: 93; Hersak 1986: 38). The brevity of the reports, undoubtedly due in part to concealment strategies before the prying eye of the colonial and missionary presence, unfortunately leaves many questions unanswered. Still, in spite of this handicap of historical circumstance, some of the early comments highlight the diversification of the *kifwebe* tradition among the Songye and Luba which became more evident with research in the post-colonial period. For example, both Colle in his observations on the Luba and Samain in his comments on the Songye note the male/female mask dichotomy (Colle 1913: 440; Samain 1923: 95). However, in the Luba case this gender distinction is of primary importance and related to ancestral spirits, the animation of dance and significantly different visual forms and dimensions. Among the Songye, on the other hand, the aspect of gender is overlayed by an all-important power distinction related to magical practices exercised by the living rather than by spirits of the dead. As we will see, this fundamental difference between Songye and Luba contexts was perpetuated in ideology, practice and visual forms by *kifwebe* societies that still existed in the 1970s.

The Songye Context

In the post-independence period *kifwebe* masquerades developed concurrently along two different lines: both as a popular form of entertainment and as a secret regulatory association. As the organization seems to have been closely interwoven with the polity since its inception, in formerly powerful chiefdoms such as that of the Kalebwe whose centralized, highly hierarchical structure collapsed in the late 1920s, these masquerades were secularized. However, among the small Songye chiefdoms of the Lomami River where a seemingly older, rotary political system reigned in which lineage leaders were elected to power for a 4-5 year term, the *bwadi bwa kifwebe* society continued to function as an effective controlling mechanism (Hersak 1986: 22, 37; Vansina 1990: 182). The maskers were visible emissaries of the ruling élite who relied on the ideology of witchcraft (*buchi*) and sorcery (*masende*) to sustain their rule, both politically and economically.[5] They intimidated rivals and even obliged potential adversaries to undergo *masende* initiation.

The latter was, and still is in some areas, an independent, anti-social organization, open to anyone keen on acquiring potent, mystical powers. These are said to derive from spirits of the dead who are enslaved into service through material, magical formulae. In comparison to this learnt operation, witchcraft is regarded as an inherent, hereditary potential which is exercised consciously or unconsciously. It is the innate, ambivalent power that chiefs and other high ranking members of society are assumed and expected to possess. According to most Eastern Songye sources, however, the incorporation of *masende* into the *bwadi bwa kifwebe* society is a recent and perhaps even regional innovation, while witchcraft beliefs were an integral part of the ideology defining *kifwebe* masking even in the early stages, as suggested by Samain's comments. *Masende* practices have perhaps enlarged the power hierarchy within the *bwadi* organization and consequently also the typology of masks.

The impact of the *bifwebe* maskers and their effective deployment of these mystical powers is enhanced by their ambivalent identity of "otherness". They are not entirely human, animal nor spirit and as such they defy classification within the normal order of the universe. They are said to come from the east, from a mountainous wilderness outside the bounds of Songye territory which

ill. 1. Eastern Songye (Shaba). Female *kifwebe* mask in the village Ngoma (Munga chiefdom). Photo: D. Hersak, 1978.

ill. 2. Eastern Songye (Shaba). Mask of an "elder" (*ndale*) in the village Kikomo (Kiloshi chiefdom). Photo: D. Hersak, 1978.

70
SONGYE

Zaire, Shaba

anthropomorphic face mask

kifwebe

H. 30.5 cm. Wood, pigment

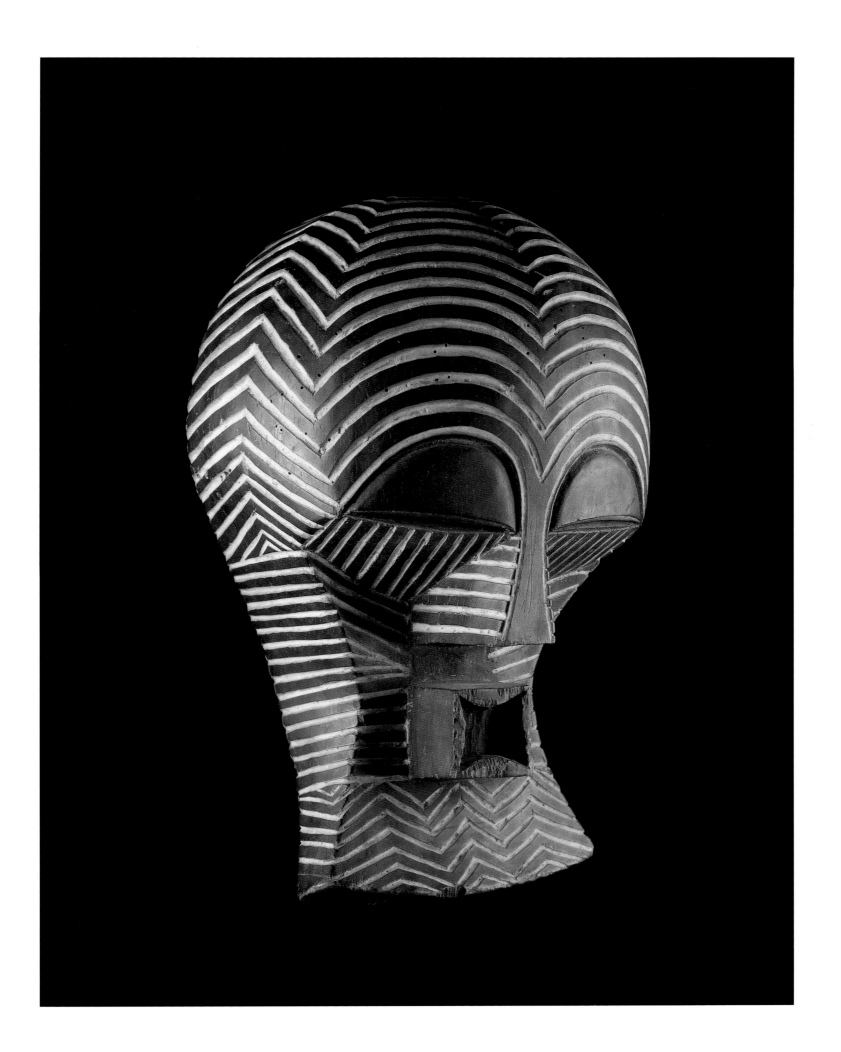

is said to exist within a different time frame. Upon entering the human arena they infuse it with energetic movement and unusual sounds, playing simultaneously upon the polarity of gender and a triadic power structure (Hersak 1990).

Within this scenario each *bwadi* ensemble comprises one female masker, the first to be introduced upon the founding of a new group, and an unlimited number of males (ill. 1-2). Color, its physical properties and quantity of application, is the primary sign distinguishing gender, thus all female masks are identified as being primarily white, even though their eyes and mouth may be accentuated with black and some red. But there are even masks devoid of pigmentation, or whose powdery white application has worn off, which are still said to embody whiteness probably on the basis of the pale color of the wood (cat. 68).[6] Male masks, on the other hand, are said to be striated in red, white and black (cat. 71) and, although they must bear all three colors, it is the red pigmentation that is viewed as their active, identifying sign.

Symbolically, whiteness is undisputably auspicious and associated with all the positive attributes of the inner and outer being. It signals goodness, health, purity, reproductive capacity, peace, wisdom and beauty and is in turn associated with the moon, light, manioc flour, mother's milk and sperm. The use of white coloring is pervasive in ritual and its fabrication from powdered clays from river beds or forests link it with the sacred, ancestral domain and concerns with continuity. In comparison, red is more potent, ambivalent, and used only sporadically in ritual contexts. It denotes strength, courage, knowledge, completion and achievement but it also encompasses the malevolent aspect of witchcraft and sorcery, blood and flesh. Black on its own is regarded as meaningless and is only used as a qualifier in combination with the other two colors. As such it signals impending danger and is therefore associated with clouds, smoke, darkness and, in particular, with *buchi* among the Eastern Songye.

In addition to gender, the male maskers are ranked into two power grades that correspond to their inherent and acquired expertise in magical operations. These I have designated by the descriptive terms "youth" and "elder" although, as Samain previously noted and some of my informants also confirmed, the most powerful elder is still frequently referred to as *ndoshi*, or witch (Samain 1923: 95; Hersak 1986: 76). This appellation may not be an entirely accurate description since the power of these maskers is invariably due to their exceptional reputation as sorcerers (*sha masende*). What it does do, however, is to emphasize the prestige aspect of witchcraft associated with key members of society while evading publicly reference to *masende*. In reality, certain morphological aspects of the masks, in particular the height of the crest, are a clear indicator to the entire community of the nature and degree of mystical power exercised by the masker (cat. 71). This visual sign is relative and varies according to the hierarchical composition of each ensemble but generally the highest crest is worn by the elder, that is, the most powerful masker. In comparison, at the bottom end of this hierarchy are the female maskers whose nose-forehead extension is flat and who correspondingly are not actively, aggressive agents. Like the role they are intended to embody of constancy and continuity, female maskers seem to have retained a resemblance through time and space, with little variation in color and morphology, whereas on male masks morphological features have been prone to greater exaggeration and innovation (cat. 68 and 69).

In performance, these gender and rank distinctions seem to reflect the physical and biological certainties as well as the change and unpredictability of socially constructed space. Female maskers, more closely linked with the physical world and procreative functions, are associated with the moon, lunar rites and cooling, controlling actions. Their mode of behavior comes into prominence through regular, staged dance performances during which they are said to activate the benevolent spirits that allow for many offspring (Plasmans 1967-68, interview with Yamulenda Ebombo from village Butu, Kalebwe chiefdom; Hersak 1986: 44). In contrast, male maskers tend to exhibit erratic behavior; their appearances are unpredictable and largely linked to their policing roles. Even in the past when the *bifwebe* were more active participants in ritual, the male maskers maintained a regulatory function at rites such as circumcision and *bukishi* intiation (proceedings concerned with socio-religious teachings), ensuring that roles and spatial designations were respected, while the female masker's presence during lunar rites, funerals and enthronement ceremonies was more symbolically linked to concerns with cyclicity, continuity and balanced transitions.

71
SONGYE

Zaire, Shaba

anthropomorphic face mask

kifwebe

H. 62 cm. Wood, pigment

72
SONGYE or LUBA

Zaire, Shaba

anthropomorphic miniature mask

kifwebe

H. 9.5 cm. Wood, pigment

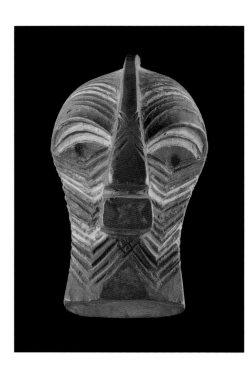

It is possible to differentiate male and female masks. Among the Songye this can first be made on the basis of color. Masks which are predominantly white (cat. 70) or which have retained the color of the wood (cat. 68), are described as female. Male masks, as a rule, are applied with red (cat. 71). A second sign for gender identification is determined by the form. Male masks have an upstanding comb which extends over the head into the modeling of the nose (cat. 71). The format

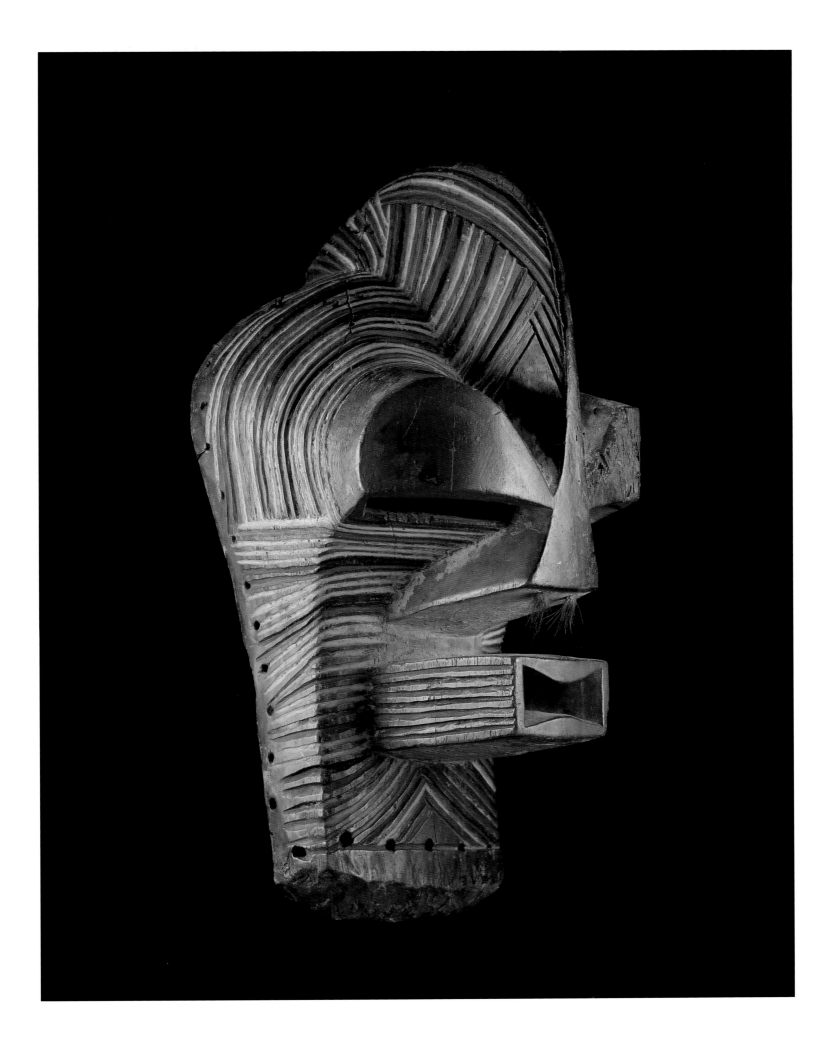

73
SONGYE
Zaire, Shaba
anthropomorphic face mask
kifwebe
H. 42 cm. Wood, pigment

of the comb has hierarchical significance within the domain of male masks. The larger the crest, the greater the magical potential and mystical strength of the masked figure. This has led to a greater degree of diversity of design among the male masks than is the case for the female examples. Among the male masks one finds specimens with an exceptionally large comb, bulging eyes, and a protruding mouth. Conversely, the design of female masks remains far closer to the original conception of form (cat. 68-70). Equally, the manner in which *kifwebe* masks perform among the Songye also emphasizes the gender of the mask. Female masks are more closely related to the physical world and reproduction, and their movements are calmer and more controlled. They must activate the benevolent spirits which contribute to the birth of the coming generation. They watch over the cyclic course of things, assuring continuity and smooth transitions. The control function of the male maskers is expressed in their fitful and unpredictable movements. (F.H.)

Lit.: Merriam 1978; Hersak 1986; HERSAK (p.145)

Apart from public and common lore about the *bifwebe*, the society also established itself as an exclusive and powerful operation by initiatory rules and procedures and, especially, a body of esoteric and secret knowledge. This information, exposed only to in-group members in its coded form, was in fact based on a series of more widely known references to culture, nature and cosmology. A singular image of the *kifwebe* creature, in particular that of the male masker, served as the mnemonic for these references. Thus the component of secrecy was the contextually specific, often unexpected associational link, between every part of the mask and costume and not only its esoteric term but also its corresponding multireferential definitions.

Within this scheme the face of the *kifwebe* is represented as the concentration of its power; hence the right side is referred to as *nguba*, the sun, and the left as *mweshi*, the moon. Sun and moon like east and west, day and night, right and left and male and female are the complementary pairs that are inextricably linked in an ongoing pattern like the lines on the face of the *kifwebe*. But this facial design, referred to as *bikoko*, a term which suggests something transformed, is also indicative of a diversity of other terrestrial sources of power which are exposed sequentially, revealing different associational clusters. Thus the eyes/eye slits (*mitoshi/miteshi*) are referred to as "holes of territaries" and also as "a fistful of sorcerers" or "the swelling of sorcerers", the nose or nostrils (*mbaso*, also *mbuanya*) is the opening of a furnace, the nasal hair (*mpo*, also *nungu*) refers to the porcupine, the mouth (*etondo*) is "the beak of a bird" and also "the flame of a sorcerer" and the chin (*mukombo*) is said to be "the snout of a crocodile". All the parts of the costume are similarly accounted for. For example, the mass of raffia fibers attached to the chin of the mask is said to be "the mane of a lion" and is identified both literally as a beard (*mwefu*) but also as *mpasu*, meaning "locust". The neck is first referred to as "a metal" and subsequently as "bees". The goat skins covering the hips are said to be the "leaves of the *kishiushiu* tree" and the cords used to fasten them are referred to literally as a "snake" (*nyoka*). The legs (*mishi*) are initially identified as a "mortar and pestle" and then as "roots"; the feet are likened to those of an elephant and the cords used for sewing the soles to the leggins are referred to as "fleas" (Plasmans 1963-74; Hersak 1986: 60).[7]

Although these findings are extremely difficult to obtain in their entirety, the available data is sufficiently revealing of the heterogeneity and complexity of the *bifwebe* code. The symbolic microcosm it defines seems to be constructed of different series and levels of meaning. If we examine only the animal references, from a general viewpoint the *kifwebe* creature is likened to a series of species — mammals, reptiles and insects — that inhabit water, earth and sky and are potentially menacing and dangerous because of their size, strength or particular natural defense. But beyond this level there appear to be more veiled associational clusters of creatures that underscore the anomalous character of the *bifwebe*. One of these seems to include the category of striated animals such as the porcupine, the zebra, the bushbuck and a snake called *ngulungu*. The porcupine (*nungu* in Kiluba, *Hysterix galeato*) with its long and deadly black, brown and white quills is, as stated earlier, evoked by the masker's nasal hair while reference to the zebra is related to the striations or crest on top of the head or forehead (Plasmans 1954; Van Avermaet & Mbuya 1954: 468; Dorst & Dandelot 1978: 34, 49). Curiously, the latter are called *ngulu*, literally meaning "mountain", which recalls that "other" alien world from where the *bifwebe* descended. At the same time, it is probably an allusion to a particular species of zebra, now rare in the area, namely the *Equus [Hippotigris] burchelli*, whose stiff upright mane resembles a crest or horn-like projection frontally, like that on the *kifwebe* (Dorst & Dandelot 1978: 162, 164, 197). The horned bushbuck (*Tragelaphus scriptus*), a small but potentially vicious type, is drawn into this category of animals through the masker's name *ngulungu* (Dorst & Dandelot 1978: 198, 199, 223).[8] Unlike the almost extinct Burchell's zebra, this dark brown to chestnut colored antelope is a fairly familiar sight in the area of Kisengwa, but it also shares similar physical peculiarities: its body is covered with white striations and a dark vertical band extends between its eyes and muzzle like the nose/crest delineation emphasized on the masks (Dorst & Dandelot 1978: 198; Plasmans, personal communication, October 1979). *Ngulungu*, however, is also the name of a highly poisonous and supposedly "horned" serpent whose significance is multifold (Van Overbergh 1908: 75). Its venom is as potent as the magic of the *bifwebe*, while its horns allude to the extraordinary wisdom and power acquired by the elders (Wauters 1949: 338). Horns in general are a common visual indicator among the Songye of power objects and thus of therapy as well as violence. More broadly, snakes also feature prominently in the cosmology of the Songye as intermediaries relating to the dualities and interconnections between the terrestrial and cosmic domains (Wauters 1949: 237;

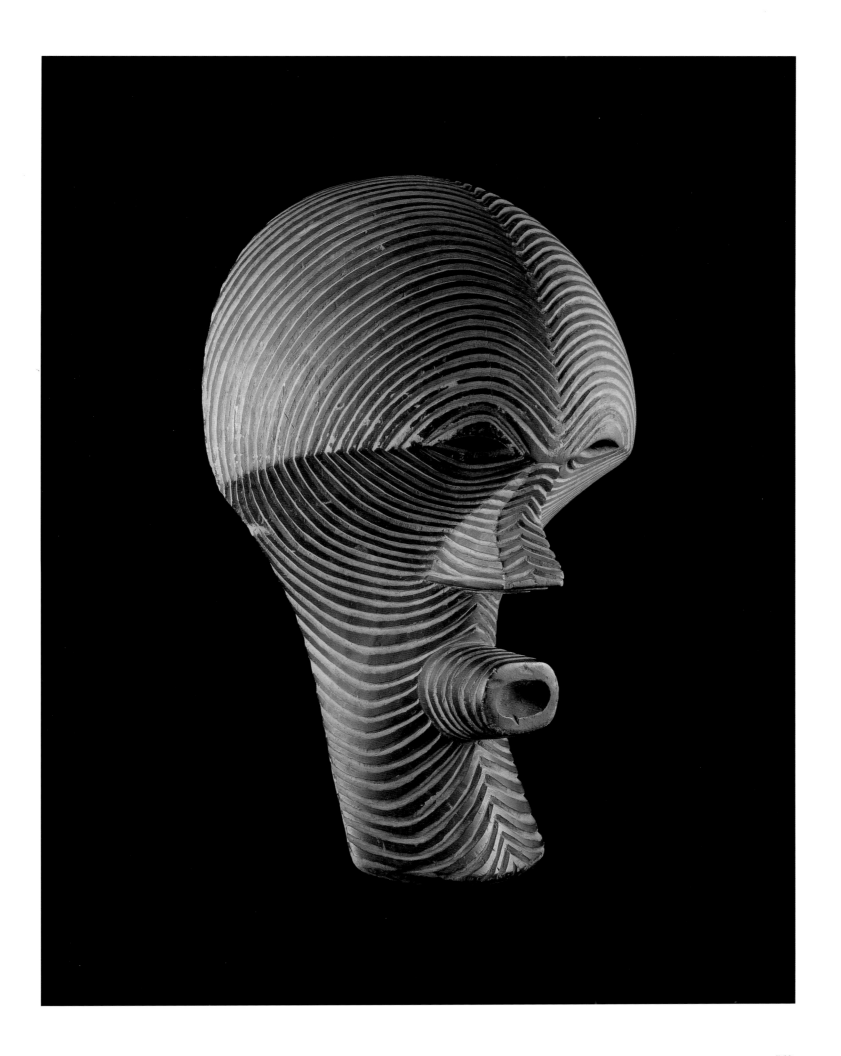

Hersak 1986: 63).[9] Thus as the common denominators of stripes and horns link up and fan out, we are led to other symbolic clusters and further and further into a conceptual and philosophic maze.

Aspects of the Luba Context

Apart from Mutimanwa Wenga-Mulayi's quoted, though often misread or misunderstood M.A. thesis (1974), *kifwebe* masquerades of the Luba have been virtually bypassed by researchers. As a result, Luba masks that appeared in the West since the 1960s have all too often been mistaken for Songye examples or for fakes, and their contextual and iconographic interpretation has either remained a void or been hopelessly muddled with data on the Songye. Although Mutimanwa Wenga-Mulayi was primarily concerned with the morphological analysis of *bifwebe* collections at the Institut des Musées Nationaux du Zaïre in Kinshasa and Lubumbashi, even the brief period of field research he conducted in the village of Lukunde near Ankoro (zone of Manono) brought to light significant differences and symbolic inversions from the Songye context which have so far only been noted by Luc de Heusch (1989).

To begin with, as I discussed elsewhere (1986, 1990), in order to maintain the alien, power-laden character and mystique of the *bifwebe*, both the Luba and Songye claim that these creatures originate from the other's land, from outside the familiar sphere, and that they therefore speak in the odd tongue of their neighbors, that is Kiyembe (meaning Kisongye) or Kiluba, respectively. Thus while the Songye look to the mountains in the east for this place of origin, the Luba refer to an aquatic lowland in the west.

This ideological divergence mirrors other fundamental oppositions between the two *kifwebe* traditions which are set into prominence by a Luba myth about the origin of these maskers. According to this account, the founding *bifwebe* were three spirits, two male and a female, who emerged from a ditch near a large, supernatural lake. Although all three were different in appearance from humans, the female, called Kyeusi, decided to go and live in the nearby village and to adapt to the diet of humans. The males refused to leave the bush and continued to consume grasshoppers, the wild fruit eaten by monkeys and other such spoils of nature, but they did eventually agree to come and dance in the village. The inhabitants were so drawn by their performances that they requested to be initiated so as to learn these dances and vowed not to divulge the secret of the *bifwebe* (Mutimanwa Wenga-Mulayi 1974: 116-118).

Unlike Songye assertions of bizarre, heterogeneous creatures, this myth clearly emphasizes the spirit identity of the *bifwebe*. These are independent entities associated with water and benevolent actions rather than the fiery, "monstrous" beings empowered by the living. Although they appear as a triad, which would seem to relate not only to gender but also to rank distinctions upheld by the Songye, the Luba focus singularly on the male/female dichotomy as mirrored by the bush and village.

In the past this duality was expressed mainly through differences in form; that is, female masks were round and, as Father Colle (1913: 440) noted, somewhat larger (cat. 76), while male masks (cat. 77) were generally oblong (Mutimanwa Wenga-Mulayi 1974: 24, 76). They danced in male/female pairs whereas nowadays they appear as an ensemble comprising one female and up to eight males (Mutimanwa Wenga-Mulayi 1974: 77). In the post-independence period, and perhaps earlier, visual indicators began to shift with iconographic elements taking precedence over form or color. Thus as round masks became increasingly rarer, replaced by various oblong shapes, scarification patterns, both figurative and geometric, incorporated into the overall design, became the main feature distinguishing female masks from their male counterparts (Mutimanwa Wenga-Mulayi 1974: 74). These are placed under the eyes or on the cheeks and consist of dots, crosses, triangles, chevrons, hearts as well as plant and animal depictions which often relate to the name of the mask (Mutimanwa Wenga-Mulayi 1974: 75-76). Apart from serving as a form of identification, these facial scarifications are viewed as an important aspect of female beauty, clearly evident in most Luba figural sculpture, and are associated with the cultural practices that distinguish the realm of the village from the wilderness beyond. As in the myth, therefore, the female *bifwebe* bear the "marks of civilization" while the males that chose to remain in the bush are devoid of this cultural alteration.[10]

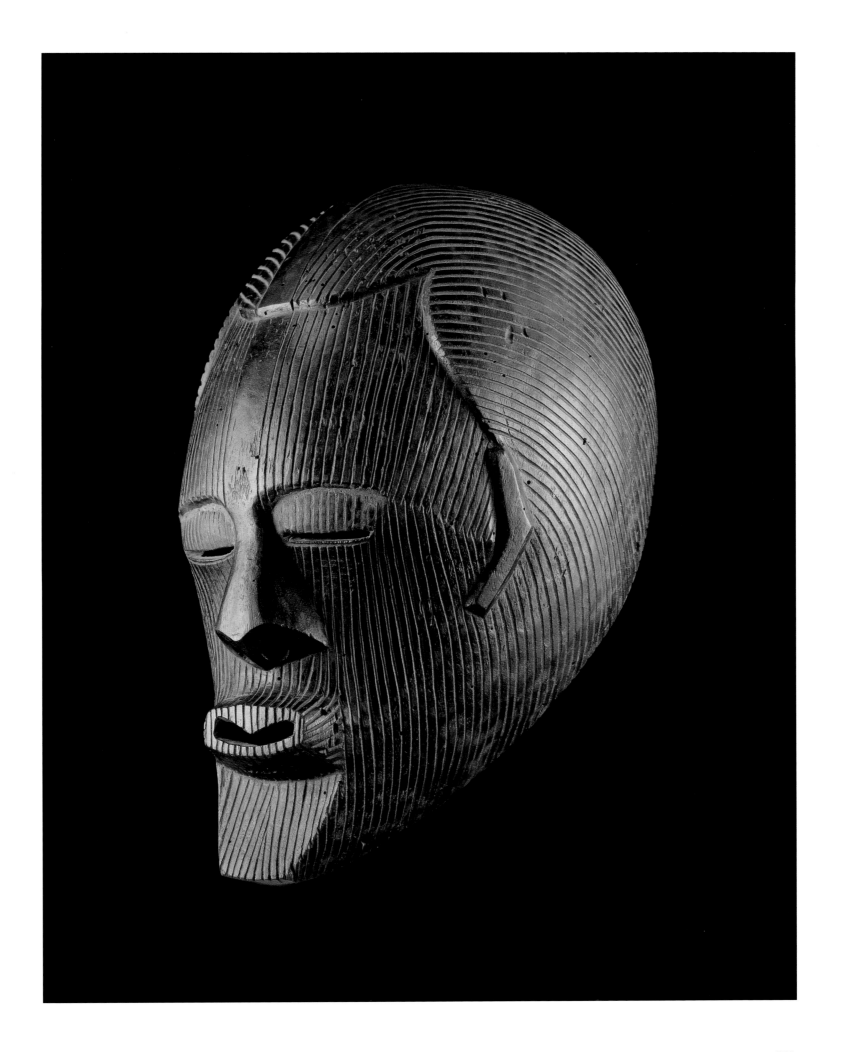

75
LUBA or SONGYE

Zaire, Shaba

anthropomorphic face mask

kifwebe

H. 28 cm. Wood, pigment

According to the myth which relates the creation of the mask dances of the Luba, three spirits of the *bifwebe* — two male and one female — appeared out of a brook nearby a supernatural lake. They differed from humans, but the female spirit (Kyeusi) decided to go live in the village and to adapt to the food of the people there. The male spirits, however, rejected this, but they would come to the village to dance and evoked great wonder among the spectators. Those watching the dance wished to be initiated so as to learn the dance themselves. Thus, they swore to not reveal the secret of the *bifwebe*. This myth situates the identity of the Luba *bifwebe*. They are associated with water and benevolent practices, in contrast to the rather unpredictable supernatural beings of the Songye. For the Luba attention is primarily paid to the distinction between male and female. The genders are represented in the opposition of wilderness (male) and village (female). The Luba also express this difference in the design, use and function of their *bifwebe* masks. Female masks were originally round (cat. 76) and larger than their elongated male counterparts (cat. 77). In a later evolution female masks also became elongated, but the gender distinction was maintained by the application of scarification patterns — a symbol of female beauty. These scarifications are seen as signs of civilization, thus of the village. For the Luba one function of the mask was to offset the malevolent activities of the Songye sorcerers. The mask would also dance during rites associated with the new moon, funerals, and initiations of the *baksanji* society. Their function is to purify the community of the evil spirits of sorcerers and the dead. Their role is less negative or

Other than these scarification patterns, Luba male and female masks share many common features. In form, most are either oblong with flat facial planes or hourglass shaped and slightly concave (Mutimanwa Wenga-Mulayi 1974: 61). Their frontal width tends to be greater than on Songye masks and the features are less protuberant. The nose is often broad and rather voluminous while the rectangular mouth extension tapers to narrower, usually squared lips. On most examples the crest is flat, as on Songye female masks, but where it is expressed in high relief, it is not a marker of rank or power as among their neighbors.

Also in color, male and female masks are similarly coded. The dominant colors are white and black with red and occasionally blue, green, orange, gray and brown used to highlight certain facial details (Mutimanwa Wenga-Mulayi 1974: 69-70). Mutimanwa Wenga-Mulayi's data is not adequate for an extensive symbolic analysis, nonetheless, it is interesting to note that the classic color triad of red, black and white receives a different contextual emphasis than among the Songye. White is still perceived by the Luba as positive and is associated with seemingly benevolent spirits of the dead and, as we shall see, with healing. Black, the "silent qualifier" for the Songye, is clearly linked to death and sorcery among the Luba but is used instead on their masks as a powerful, protective antidote against such vengeful misfortunes. Red, though defined as a potentially active signifier as among the Songye, said to be associated with power, force, blood, wealth as well as with ritual prohibition and avoidance, seems to be muted and symbolically suppressed as if concealing another reality (Mutimanwa Wenga-Mulayi 1974: 69, 70, 110).

In fact, as one probes deeper into this context of Luba masquerades one finds an intriguing element of paradox and illusion. Official ideology reveals a society opposed in practice to the malign workings of Songye sorcerers. Luba maskers refer to themselves as *nganga*, healers and magicians, who dance at new moon rites, as well as funerals and initiations of the *baksanji* association, cleansing the community of evil spirits of the dead and of sorcerers. They also participate in the *kyeusi*, a cult whose beginnings are attributed to the legendary first female *kifwebe* and which is devoted to healing through spirit possession (Mutimanwa Wenga-Mulayi 1974: 30-34). In addition, all the *bifwebe*, male and female, are instrumental in the investiture and funerary proceedings of chiefs and members of their own society and, as among the Songye, they appear on the occasion of important visits (Mutimanwa Wenga-Mulayi 1974: 124-127).

All these ritual and secular contexts point to the socially sanctioned and benevolent role of the *bifwebe*. Also in dreams, images of the *bifwebe* are not negative, threatening omens as among the Songye. Luba women who experience such nocturnal visions during pregnancy, welcome their newborn ritually as a *kifwebe* child, name it after a masker, care for it in its own *mutamba*, or enclosure, next to the house, and they wear a miniature mask (cat. 72) around the neck to indicate their special status as mothers of the *bifwebe* (Mutimanwa Wenga-Mulayi 1974: 126).

This beneficent role of the *bifwebe* is even confirmed by the coded nomenclature of the parts of the mask and costume. Not only are almost all of the initiatory terms used by the Luba different from those of the Songye, apart from reference to the sun and moon which is also evoked by the facial halves, there are also other important indicators of an alternate conceptual framework. For example, the thin grooved striations (*mpongo*), essential on all *bifwebe* masks, represent the ditch and the underworld abode of the cult's three founding spirits (Mutimanwa Wenga-Mulayi 1974: 72). Similarly, a line of continuous triangles (*kasila*) under the eyes, which seems to be classified as a category of markings separate from scarifications, is reminiscent of the forest where these spirits came to rest after leaving the underworld (Mutimanwa Wenga-Mulayi 1974: 74). Another revealing example relates to the conspicuous horn at the back of the head which is woven as an integral part of the raffia fiber costume and crowned with the feathers of a chicken (or rooster among the Songye). While the Songye do not seem to emphasize the importance of this feature, the Luba stipulate that it is filled with magical ingredients and that it stands upright when danger lurks in the vicinity and especially when "sorcerers" are present (Mutimanwa Wenga-Mulayi 1974: 113). Visually and conceptually there is a relationship drawn with figural power objects whose magical medicines contained in their horns on their heads embody protective and destructive capacities. This ambivalent aspect of "white magic" is alluded to through the initiatory terms defining the *kifwebe*'s horn. The Luba call it *mutenga* (Mutimanwa Wenga-Mulayi 1974: 113) which means literally "antenna", "tentacle" or "the long tail feather of a cock", but it is also

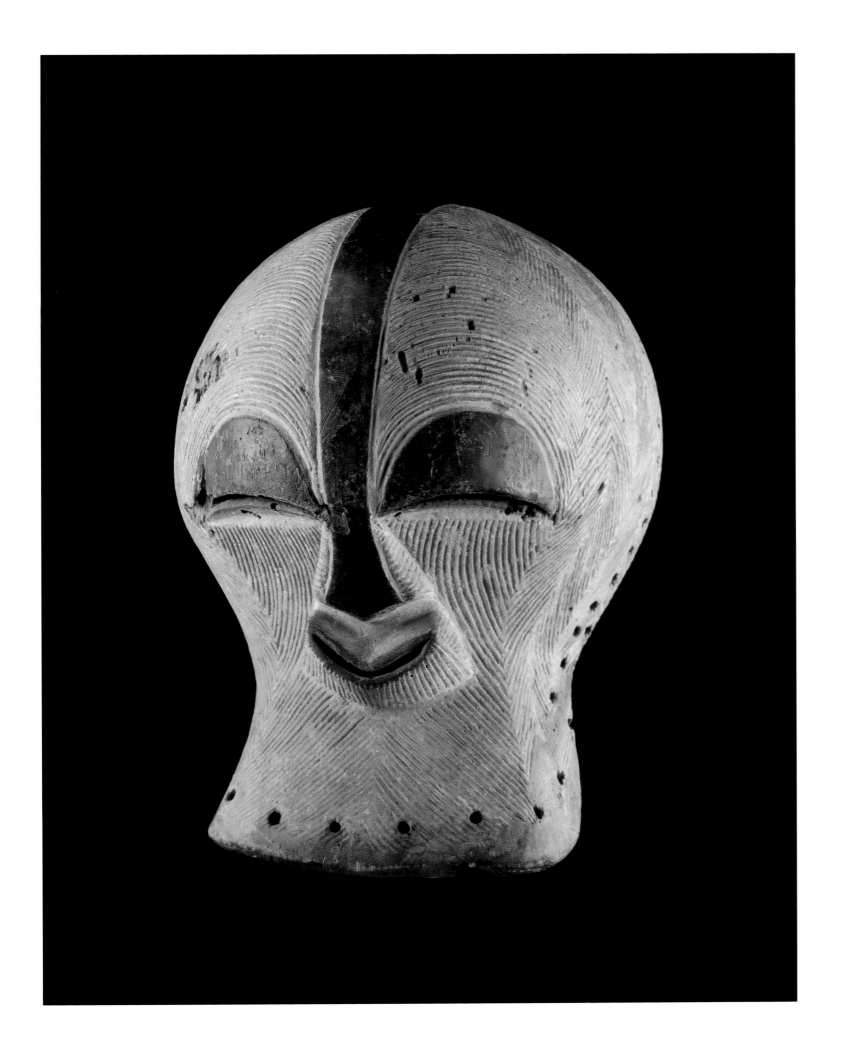

sometimes used in reference to the chief who wears such accoutrements (Van Avermaet & Mbuya 1954: 693). But in addition to this reference to chiefship there is another aspect to this power recalled by the chicken feathers surmounting the horn. These are designated as *bulumbi*, a term which may be related to the red turaco feather insignia worn by those who have shed blood (Van Avermaet & Mbuya 1954: 381). Effective power, then, even if sanctioned as with recognized leadership roles, is of necessity double-edged and ambivalent.

In the case of the Luba *kifwebe* society there is more than ambivalence defining this power. What we are made to see are spirit agents whose symbolic identity and social function arise from the domain of protective magic. Yet, it is also revealed that their underlying power is based on *majende* (*masende*) magic which is qualified as being different from sorcery (Mutimanwa Wenga-Mulayi 1974: 147). As de Heusch (1989: 273) points out, the Luba are certainly aware of the precise connotation of this term but it is as if the same word, pronounced in the Luba context by agents said to speak Kisongye, loses its pejorative connotation and undergoes an inversion of meaning.[11] In this contortion of reality lies a fundamental paradox, a glaring illusion which seems to be part of the secret of these maskers' empowerment.

76
LUBA

Zaire, Shaba
anthropomorphic face mask
kifwebe
H. 41 cm. Wood, pigment, hair

threatening than among the Songye. When images of the *bifwebe* appear in the dreams of pregnant women, this is taken as a positive experience and one ritually welcomes the newborn as a *kifwebe* child, named after the mask. As a sign of this special status their mothers would wear a miniature representation of a *kifwebe* mask around the neck (cat. 72). (F.H.)

Lit.: Merriam 1978; Hersak 1986; HERSAK (p. 145)

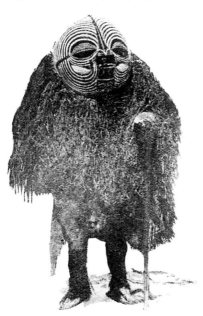

ill. 3. Eastern Luba (Shaba). *Kifwebe* mask in Kifwamba (Soswa chiefdom). Photo after P. Colle (1913: pl. XII). *See cat. 76*

1. Although John Noble White identifies the masker in the photograph (E 3 TH) as Tetela, he states that it is from the village of Ona Kasongo. According to Frobenius, "Mona Kassongo" is located on the Luidi River clearly within Songye territory (Frobenius 1907:map 8). Maps by Verhulpen (1936) and Boone (1961) confirm this, as does the information furnished by Müller who was an administrator in the area and who collected the conical masks now in Tervuren (catalogue files; Maes 1924: 33).

2. *Muadi* is also the general term for any initiated member of the *kifwebe* society, including those who appear publicly unmasked, such as musicians and singers (Hersak 1986: 46). *Kalengula* is a raffia constructed mask type used for amusement by youths (Hersak 1986: 42). Merriam perceives it as a cult distinguished from the *kifwebe* in ideology and practice which replaced the *kifwebe*, at least in the Bala area (Merriam 1978b: 96). He also suggests that the three masking cults known among the Songye, *kifwebe - kalengula - lumacheca* (the latter, a gourd mask used by children), may be part of a broader pattern of associated age levels (Merriam 1978b: 99).

3. There may be older striated *kifwebe* masks in existence; however, no convincing documentary proof has yet been produced to substantiate such claims.

4. The peoples of the small chiefdoms east of the Lomami River who share many socio-political affinities refer to themselves as "Songye" proper, while those west of the river call themselves Kalebwe, Eki, Chofwe, etc. I therefore use the designation "Eastern Songye" to refer to the former area specifically, and to avoid confusion with the more general regional use of the label "Songye" which seems to have gained wider affirmation during the colonial period. According to Boone's map Kisengwa is a village in the chiefdom of the Bena Mwo (Boone 1961: 214); during my field work Kisengwa and the surrounding villages formed a separate, small chiefdom by that same name (Hersak 1986: 7).

5. The Songye distinction between witchcraft and sorcery corresponds to Evans-Pritchard's Zande model in which inherent, hereditary powers are differentiated from acquired mystical expertise (Evans-Pritchard 1937: 387).

6. Significantly, *mulela* (*Ricinodendron rautanenii*; identified by Roger Deschamps, botanist, Musée Royal de l'Afrique Centrale, Tervuren, 21 November 1978), the species preferred for the carving of *kifwebe* masks, has a distinctly white growth ring section and a red sap-filled core.

7. For a more precise breakdown of Plasmans' and my own data on the *bwadi* code see Hersak (1986: 60).

8. Identification of vernacular name, *ngulungu*, by R. Minne, zoologist, co-ordinator of Shaba National Parks, Lubumbashi, April 1978.

9. In Wauters' cosmogonic myth, the snake *nkongolo* is the rainbow "qui lie la pluie... qui lie la source à l'amont" (1949: 237).

10. *Marks of Civilization: Artistic Transformations of the Human Body* is the title of a 1988 publication on body arts edited by Arnold Rubin. The expression was specifically used by Susan Vogel in reference to Baule scarification.

11. De Heusch's text actually states that the word for "sorcery" loses its pejorative connotation when pronounced by the Luba in the Songye language. This interpretation is based on a slight oversight since de Heusch's reference to the term "*ma-zyende*" noted by Van Avermaet & Mbuya (1954: 212, 817) is pronounced exactly the same way as the form "*majende*" used by Mutimanwa Wenga-Mulayi. Both are Luba forms and differ only in the orthographic preference of the authors. I believe that my amendment of de Heusch's text still retains the conceptual essence of his idea.

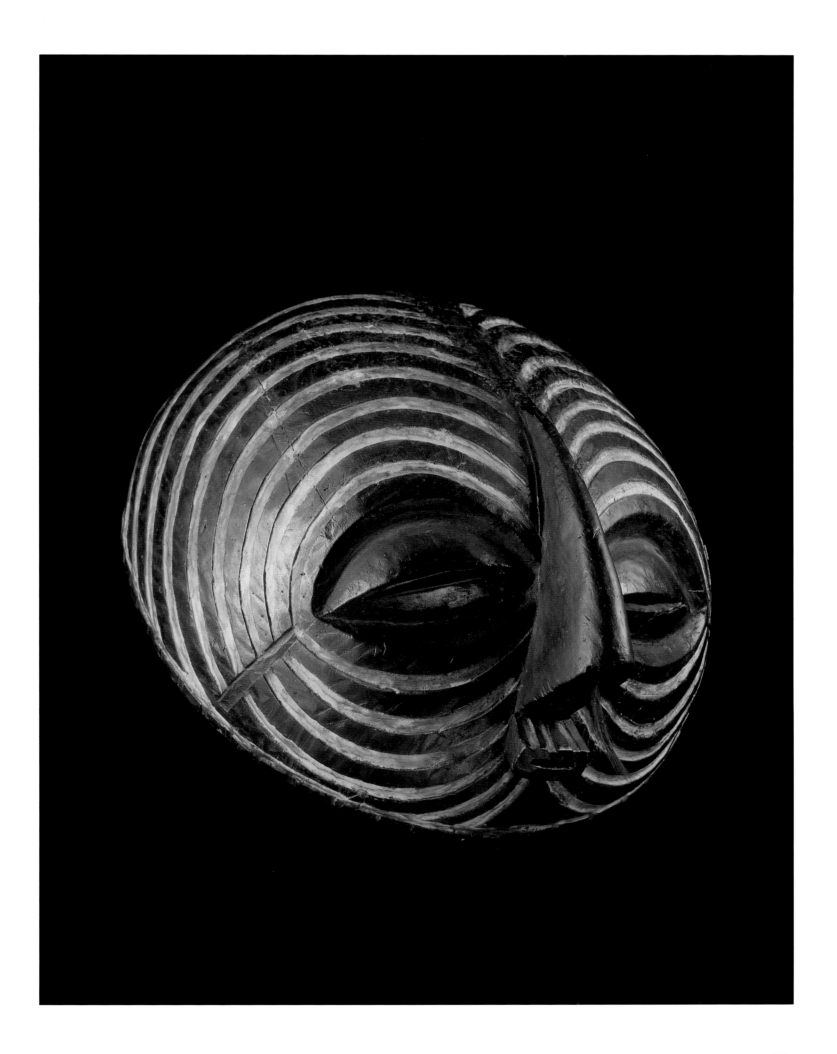

77
LUBA
Zaire, Shaba
anthropomorphic face mask
kifwebe
H. 30.5 cm. Wood, pigment

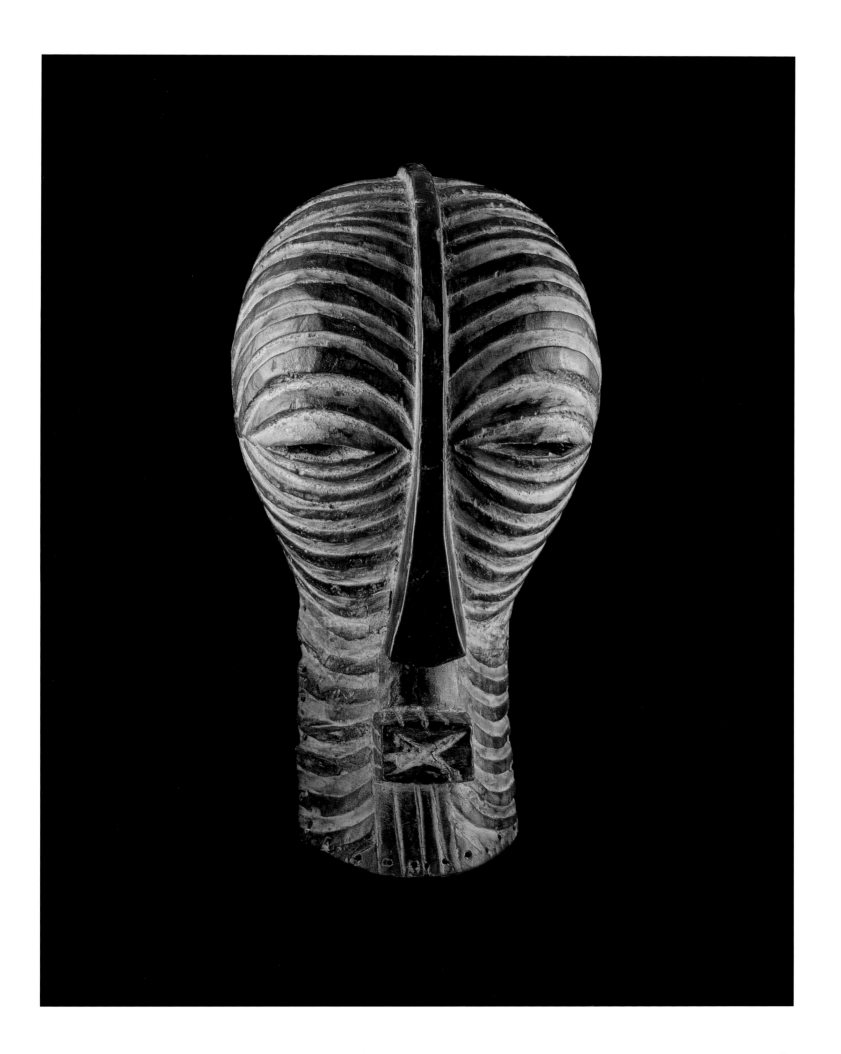

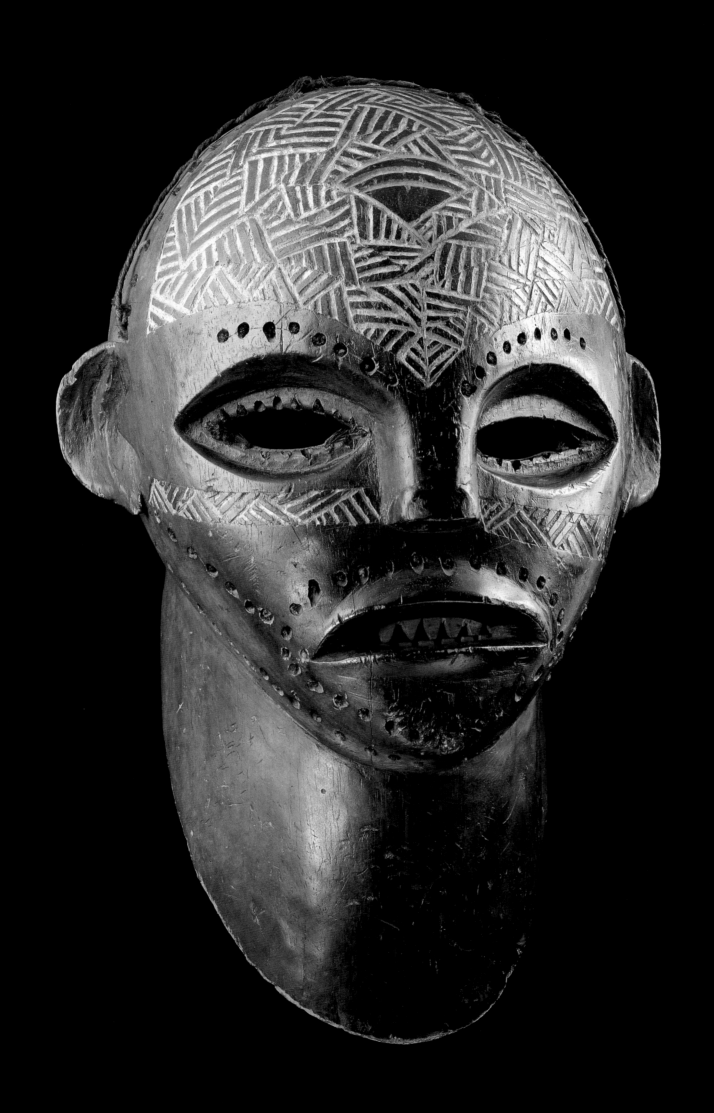

South-East Zaire: Masks of the Luba, Hemba and Tabwa

François NEYT

Any question which we ask is invariably delimited in time and space. From one age to another, our way of formulating the questions changes and derives from a viewpoint which inevitably changes, too. One cannot ask absolutely any question at any point in time, any more than one can ask absolutely any question in any one place. All questions are thus clearly set in their time and place.

In beginning this study by recourse to the illustrious arguments of classical rhetoric in Graeco-Latin culture, I am not looking for a ready-made model. But I am clearly aware of the relevance of these themes and how useful they can be as tools of analysis. What is a mask? How is it made? Who made it and wears it? Where are masks to be found? When do masks appear? Where do they come from? Why are masks used? etc... Each question is a means of assesssment which sheds light from a different angle on the traditions of the mask.

This exhibition presents the most typical masks from Zaire according to their geographical distribution. It also poses the first two questions which I raised, the questions of time and space. Where do masks come from and in what period were they collected? To these first points must be added those concerned with the process of artistic creation and the reasons for producing masks. The questions Where? and When? are followed by Who? and What? Finally I will come to the ultimate question Why?, and the definitive reasons for the existence of masks.

I have been asked to introduce the masks from the Luba, Hemba, and Tabwa regions. The geographical area is immense, extending from the fourth parallel South to the tenth parallel and from Lakes Tanganyika and Moero in the east (longitude 30° E) to the territory of the Kasai Luba in the west and right up to that of the Binji (longitude 23° E). In the presentation which follows I will deal in turn with Luba, Hemba and Tabwa production. Songye masks, especially *kifwebe*, are considered separately in this catalogue by Dunja Hersak.

Dating and Provenance

These first points are related to the question of who collected the first masks and introduced them into European museums and collections. One must examine the dates and places where they were acquired.

Luba Masks

A comment on methodology is required at the outset. Knowledge of Luba masks is fragmentary and Western scholars should beware of rapid judgements, based on too-slight evidence. The bell-shaped mask at the Musée Royal de l'Afrique Centrale (M.R.A.C.) at Tervuren (ill.1) is undoubtedly an outstanding mask from black Africa, and a striking example; its provenance is unknown and its date is indicated only by the laconic note "received before 1914" (Maesen 1960: ill. 36). The late Albert Maesen was aware of the gaps left by the collector, and Koloss, in a publication from the Linden-Museum in Stuttgart, takes up the author's same central point; "Es ist fast unglaublich, dass gerade für die schönsten Maskentypen der Luba jede Information fehlt" (Ferne Völker 1982(vol. 1): 108, ill. A60).

Against this background of awareness of the gaps in our knowledge, the first masks that were collected can be set, as just so many references to forgotten traditions lost in time. Anthropologists, historians, and missionaries have brought back valuable geographical and chronological

78

LUBA

Zaire, Shaba, Mwanza?
anthropomorphic half-helmet mask
H. 52 cm. Wood, pigment

It is striking how few masks have been collected that are of Luba origin. Perhaps this simply indicates that there were never many of them produced. The example illustrated under cat. 78 probably belongs to the better-known "lion masks" of the Central Luba or Shankadi-Luba, that more specifically originate from the Mwanza region. Eyebrows, lashes, mustache and beard, were originally suggested by the application of cat-hairs. Unusual in this mask are the kaoline-colored geometric patterns on the forehead, under the eyes, and especially the monumental neck. François Neyt opines that these "lion masks" may be seen as incarnations of the *vidye* spirits, and are associated with the secret *mbudye* society. The members of this society, an important pillar of the political organization, acted as guardians and propagators of the political charter. As diviners and prophets, they cared for the well-being of the ruler and the welfare of the kingdom. Among other functions, they formed part of a traveling dance group, and appeared on the occasion of "moon feasts", initiation rites and funerals. These performances were always organized at the chief's request, and were accompanied by songs of praise to his honor and exploits. During such dances, the *mbudye* diviners functioned as messengers of royal spirits, called *vidye*. It has been observed that normally no masks were used, but their faces were painted in a variety of colors. They wore a diadem crowned with hair of animals associated with the sun, while their broad loin cloth were covered with various cat-skins.

The mask illustrated under cat. 79, with remainders of two horns and adorned with animal-skin, was collected in the Kasongo region, in the north of Eastern Lubaland. It is a unique creation, and cannot be easily related with a known current of style. Its use and function are not known. (C.P.)

Lit.: Bastin (*in* Utotombo 1988: 303, no. 215); Nooter 1990; NEYT (p. 163)

information, beginning with the early German travellers. In the 1880s Franz Stuhlmann and Emin Pacha (Edouard Schnitzer) acquired a round anthropomorphic mask without striation from Tabora. At that time this Tanzanian city was a staging post for the Arab caravans going from the Indian Ocean to Lake Tanganyika, before penetrating into what is now South-East Zaire. This exceptional mask (no. III E 2453) belongs to the Museum für Völkerkunde in Berlin. Von Wissmann, in his turn, in 1883 had already brought back many Luba pieces for the same Berlin collection (Von Wissmann 1888: 215 ff). However, on his travels he found no masks. The Songye mask in the Vanderstraete collection at Lasnes, brought back to Europe by Liévin Vandevelde in the period 1885-87 and originating from the collection Stroobant-Vandevelde, is patinated by considerable use and the worn holes for attaching it confirm the great antiquity of this piece (cat. 68). With its eyes carved on a flat surface and two designs based on concentric shapes on the reverse, and by its inner appeal close to the Luba style, this mask bears witness to the great *kifwebe* tradition going back at least to the beginning of the 19th century (Cornet 1975: 248, ill. 131).

In 1891 Gravenreuth brought back another anthropomorphic face mask showing traces of polychrome paint on the nasal ridge and cheeks, as well as four designs of concentric circles on the temples and lower cheeks. The carving had been restored in the past on the right side. Gravenreuth's finds are the most ancient Luba artefacts in the Museum für Völkerkunde in Munich (Kecskesi 1982: 347 and 349, ill. 370).

The first decade of the 20th century was notable for two major expeditions organized to collect cultural artefcts, by Torday in 1904 for the British Museum, and by Frobenius in 1906 for museums in Germany. Frobenius collected a bell mask from the Kasai Luba (nr. 6352: 06) for the Museum für Völkerkunde in Hamburg and also a mask which is Kanyok (Zwernemann & Lohse 1985: ill. 45 and 47; Klein 1990).

From his expedition in 1904 in the Tanganyika-Moero region, Torday brought back a very elongated mask, reminiscent of the form of a bird, which was found on the shores of Lake Moero and is now no. 0611: 29 in the British Museum's collection (Mack 1990). Another mask, in the *kifwebe* mask style to which I will return in the second part of this study, is in the Museum für Völkerkunde in Munich, presented by Deininger in 1908 (Kecskesi 1982: 347, ill. 369).

From the years preceding the 1914-18 war, one should also note, in addition to the fine bell-shaped mask from the M.R.A.C., Tervuren mentioned above, the many works collected by the "White Fathers" living to the north of the Middle Luvua, the outfall of Lake Moero. This is the Kiambi/Lukulu region. Two round masks (R.G. 6794 and 6795) at the Musée Royal de l'Afrique Centrale were also collected by the same missionaries and came from Kifwamba (Soswa). The most famous of these round masks is that collected by Pierre Colle, sometimes shown with its costume in raffia and sometimes without (ill. 3, p. 158). It belonged to the Katheryn White Reswick Collection in Cleveland, and now is one of the most important masks in the Seattle Art Museum (no. 81.17.869) in the U.S.A. (Colle 1913: ill. 12; Olbrechts 1946: ill. 23; Fagg 1968: ill. 261; Fagg 1970: 145).

After World War I the collection of African works increased, but masks remained rare and the information gathered scarce. The pieces collected by Burton in 1928 should be mentioned and the sketches made by Peeraer in the 1930s. The fine mask in Philadelphia was brought back by Vignier in 1921.

The M.R.A.C., Tervuren contains anthropomorphic and zoomorphic masks, including an elephant mask. An ancient round mask which used to be in the Walschot collection, was given to the M.R.A.C., Tervuren in 1980 (R.G. 80.2.448). Around 1950-51 two miniature round masks were brought back by Mottoulle and Blondiau (R.G. 50.26.49 and 51.31.63). Dewit presented the mask R.G. 60.39.3 in 1960. Only one mask from this period, acquired in 1953 (R.G. 53.74.7535), has its provenance clearly attributed, to the village of Ilunga-Mwila.

A glance at the Luba masks now in American museums and collections adds no more precise information. There are masks in The Metropolitan Museum of Art in New York, the High Museum of Art in Atlanta, several round masks in the University of California Museum of Cul-

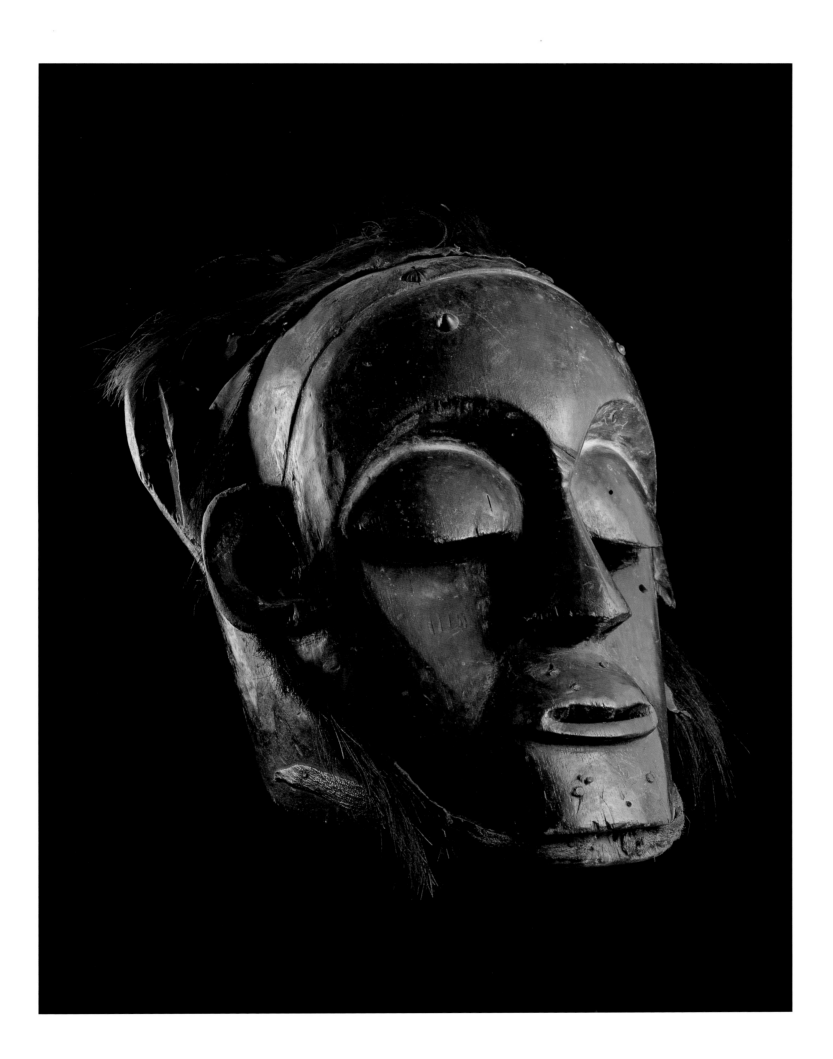

80
TABWA

Zaire, Shaba, Kilanga Zongw?
anthropomorphic bell mask
musangwe
H. 22 cm. Wood, pigment, shells, metal

There are but a limited number of known Tabwa masks, and information concerning them is rather scarce. Aside from recently "discovered" masks with inset beads (also used by neighboring peoples in the borderland between Zaire and Zambia), there are three known mask types in wood. They are probably all related to the activities of the *mbudye* and/or the *butwa* society. The anthropomorphic bell-shaped mask, called *musangwe*, with rich headdress, scarifications and nostril decoration (cat. 80), denotes a female clan ancestor. Moreover, magical substances would be applied to the ear openings. The name *musangwe* is related to sexual promiscuity. In the above-named societies it often appeared, and was party to the chaos which preceded the civilized life style imported by the *butwa* adepts. Masks were probably used in dances which praised sexual profligacy, and commemorated the animal excesses of the first people, who copulated with buffalo. Zoomorphic face masks (cat. 81), primarily originating from the central Tabwa zone, refer to buffalo which owing to their energetic character become the subject for metaphors, rituals, and magical practices. A buffalo mask in the collection of the University of Iowa Museum of Art in Iowa City, would be the companion piece to the above-named female bell mask. The name *kiyunde*, by which it is designated, has to do with healing or iron smelting. Both activities stand related to Mbidi Kiluwe — prized by the Eastern Luba as a buffalo — and other culture heroes. The question arises as to if these buffalo masks, at least among the Tabwa who dwell in the vicinity of the Eastern Luba, were used within the scope of *mbudye* practices of exaltation of the hero

tural History (U.C.L.A.) in Los Angeles, and at the University of Syracuse, or in the Buffalo Museum of Science in Buffalo (no. C 12776) or in The Brooklyn Museum. There is a mask at the Pittsburg Museum of Art (Carnegie no. 287) and an important Kasai mask in the Minneapolis Institute of Arts (ill. 2) (no. 53.14). In private collections, such as those of Vanderstraete, Schindler, Tishman, Blakely, etc., I would draw particular attention to the miniature round masks and to a Luba mask which used to be in the collection belonging to the painter Matisse.

After the first shock of the period when Zaire gained its independence, there was a revival of interest in the country's heritage and new research expeditions reaped a rich harvest of objects and most valuable information. Through the efforts of Nestor Seeuws and Charly Hénault, the Institut des Musées Nationaux du Zaïre (I.M.N.Z.), Kinshasa acquired four masks in 1972. These were found in the villages of Lubunda, Kiambi, Senga-Neshimba and Kasingo (I.M.N.Z. 72.302.94; 72.302.173; 72.302.174; and 72.302.257).

Thanks to the aid of Frère Cornet, one of my students has been able to examine recent acquisitions in the I.M.N.Z., Kinshasa. He analyzed 42 masks, 31 from the Kinshasa Museum and around 10 photographed at the Lubumbashi Museum. The group consisted of Luba masks from Shaba and Songye masks from eastern Kasai. All were of the *kifwebe* type (Mutimanwa Wenga Mulayi 1974).

One might also cite other masks, mostly zoomorphic, used in the *kifwebe* dances, which even nowadays are still performed in Africa. In 1990, on passing through Ankoro, at the confluence of the Luvua and the Upper Zaire rivers, I noted that groups of dancers were still active. So it should be no surprise that even in recent years various *kifwebe* Luba masks still turn up on the art market. These are the main chronological and geographical data on Luba masks (see also Felix 1992a).

Hemba Masks

Posing the same questions about the Hemba produces a very different set of answers. As with the great Hemba sculptures, their masks remained almost unknown until the 1960s. It might be argued that this was due to the region not being visited by the explorers in the last quarter of the 19th century, but this is not the case. Livingstone in 1869, Cameron in 1874-75, Von Wissmann in 1882, all took the traditional caravan route, following the shores of Lake Tanganyika to Kasongo, passing by Kabambare. Their route crossed the Luika River, which runs through the Mambwe territory, the region which is the center of Hemba monkey mask production.

However, the secret nature of hemba sculpture was a factor. Wynants records that in the 1930s a local administrator was able to admire several tutelary figures. The next day, the chief was poisoned. Here was evidence of the extent of the taboo, which reserved these statues to be seen only by initiates. It should be noted that the masks were also unknown and that they were used in activities which the local people wished to keep secret.

Whatever the reason, Hemba masks only appeared in Europe amongst the second wave of arrivals of ancestor statues, in the 1970s. The central region for these masks seems to be the north-east of the Hemba region, amongst the Mambwe, on the shores of the Luika River. But the area over which the masks are spread is vast and extends to the territory of the Niembo, to Mbulula in the north, beyond the Luika.

Today, these masks can be found in several museums and collections. Two American researchers, Pamela and Tom Blakely, spent nearly two years in the Hemba region. In 1987 they published a study on the masks in their social context. When it comes to questions of time and place, it should be noted that the Blakelys scrupulously refrain from giving information which would allow a mask to be identified with any particular village, even with a Hemba tribal sub-division. The intention is laudable, to prevent collectors coming to the village to buy that particular mask. But this takes no account of the fact that since 1960 local dealers have been combing through the villages, buying traditional carvings and reselling them. In 1975 Louis de Strycker and I were able to establish the provenance of several monkey masks and this information was published (Neyt & de Strycker 1975: 54, ill. 55-56, ill. 59-62; Neyt 1977: 489-499).

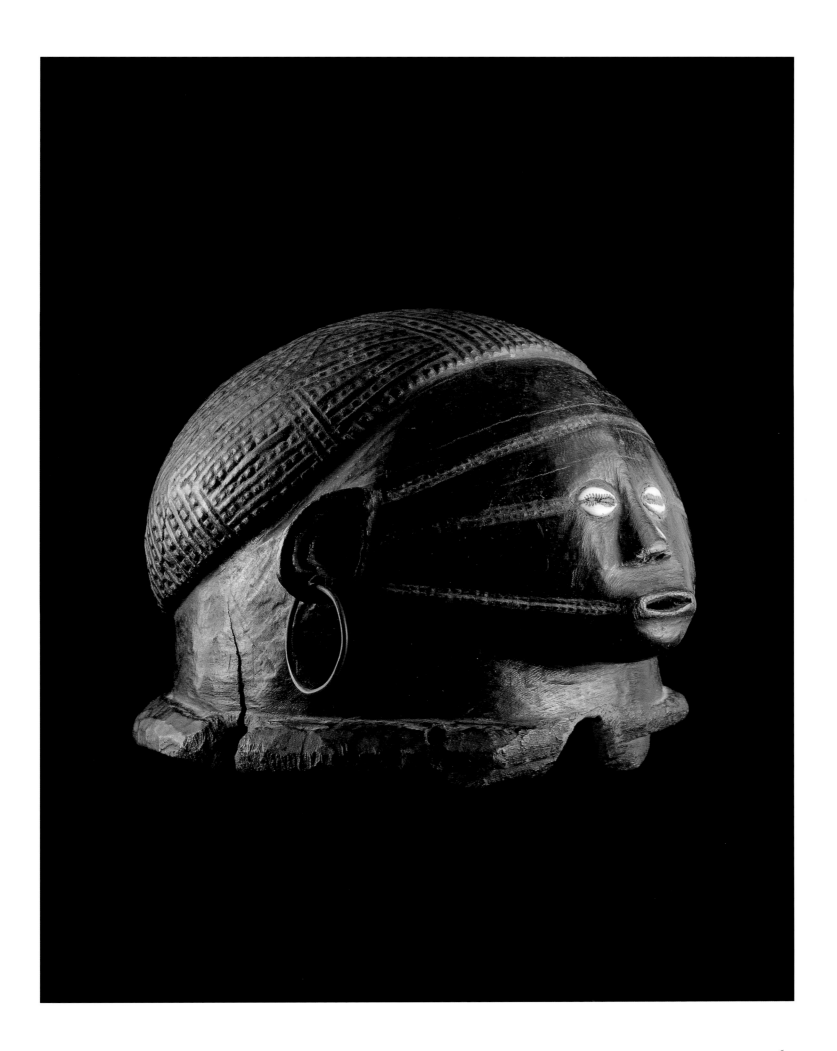

The I.M.N.Z., Kinshasa possesses several masks from this region (Cornet 1973: 19; Cornet 1975: 123, ill. 92-93), as does the M.R.A.C., Tervuren. The Linden-Museum in Stuttgart has a mask, together with its dance costume (Ferne Völker 1982(vol. 1): 116-117, ill. A. 67-69) (ill. 4), as does The Metropolitan Museum of Art in New York. This latter came from Freddy Rolin's collection (d'Udekem & Klobe 1979: ill. 36-38). This list is far from exhaustive, since Hemba monkey masks are found in other American museums, as well as in private European and American collections (Robbins & Nooter 1989: 458-459).

Tabwa Masks

The questions of provenance and dating of masks from the Tabwa and other groups beside Lake Tanganyika is an extension of what has been said about the Hemba. Though these areas had been visited by caravans since the second half of the 19th century, important Tabwa masks have only appeared in Europe since the 1950s. These masks are mainly of two types; an anthropomorphic bell-shaped mask and a buffalo mask. In the first category the following deserve special mention: the mask in the University of Iowa Museum of Art, which used to be in the Stanley collection; the mask in a private collection in Brussels, collected in 1976 (cat. 80); that in the Leloup collection in Paris, and a face mask which is closer to those of the southern people such as the Fipa (Maurer & Roberts 1986: 151-161, 251).

Buffalo masks are well known (cat. 81). The most typical examples belong to the Barbier-Mueller Museum in Geneva, the Linden-Museum in Stuttgart, the M.R.A.C., Tervuren, the Egloff collection at Neuchâtel in Switzerland and the Dierickx collection in Brussels (Fagg 1980: 152-153; Maurer & Roberts 1986: 162-163 and 252-253).

Buffalo masks are found throughout the Tabwa country beside Lake Tanganyika; they are also used by the Bwile (cat. 82) and other groups further south, towards Lake Moero. As for the anthropomorphic bell-shaped masks, rare though they are, they come from the Bena Tanga, Tabwa clans who live in the Marungu. Here, too, the tradition extends through the use of face masks to the south, and to the Pweto, near Lake Moero. More recently, anthropomorphic face masks have come to light. These are made of glass beads stitched onto raffia cloth (cat. 83, p. 23). The designs exhibit the scarification of which the Tabwa are so fond. The first of these were discovered in 1974.

The Artistic Production and Usage of Masks

Some basic methodological remarks are necessary at the outset, since the review of Luba, Hemba and Tabwa masks set out below follows as far as possible the chronology and place of their discovery. It must be stressed that it is very rare to acquire a mask, and that as a result our knowledge of them remains fragmentary. Only the *kifwebe* masks are to a certain extent an exception, and even when discussing *kifwebe* masks it is usual to link the production of these masks with that of the considerably more numerous Songye masks.

The bell-shaped mask in the M.R.A.C., Tervuren is a unique example; the round Luba masks, whether smooth or striated, are few in number; animal masks remain rare, though there are several examples of elephant masks; the fine anthropomorphic or zoomorphic Tabwa masks are not numerous; there are only a few *vidye* masks from Kinkondja. The monkey masks of the Hemba region give rise to another basic caveat. Here their production is more numerous and differs from that in times past, and one has to say that even if they were used in the last century, these masks were not discovered until the 1970s.

So in relation to the first two questions concerning date and place, it must be concluded that our evidence is too limited to allow us to reconstruct historical developments as some have tried to do. Perhaps masks in south-east Zaire really were rare, apart from the *kifwebe*, in which case they can never have exercised a strong stylistic influence on artistic production in neighboring cultures. Or, as seems more likely, our information is too scant and, moreover, too weak as to provenance to enable many questions to be answered satisfactorily.

81
TABWA
Zaire, Shaba
zoomorphic face mask
kiyunde
H. 25 cm. Wood, pigment, shells

Mbidi Kiluwe. Circumcision, as well, aiming toward the perfection of the human body, alludes to Mbidi Kiluwe. Worth note, is that the man who conducts the circumcision is termed "lion", while the circumcised boys acquire the appellation "buffalo". It is thus not inconceivable that buffalo masks likewise played (or play) a role in the circumcision rite. Seeing that the most important *mbudye* spirit, Lolo Inang'onbe, is described as the product of a woman and a buffalo, perhaps the two Tabwa masks are representations of this mythological couple. Another hypothesis holds that in bygone times buffalo masks were fabricated and used by hunters of the *bambwela* guild. In a photograph taken *in situ* by Marc Felix in the 1970s, one sees how the mask was worn with a thick raffia costume adorned with the skins of the genet, the serval, and ape.
The specimen of the bell-type with tusks in the prolongation of the snout (cat. 82), deviates from the other known Tabwa buffalo masks, rather being more closely related to the masks of the Kwango region (see cat. 9). François Neyt makes reference to a similar sculpture collected around 1950 among the Songye, in the Bena Kumbi chiefdom west of Kongolo. In part on the basis of the formal anomaly, Marc Felix nonetheless ascribes the example shown here to the Bwile, little-known western neighbors of the Tabwa. (C.P.)

Lit.: Maurer & Roberts 1986; Neyt 1986; Roberts 1986b; Roberts 1990a; Roberts 1990b; Felix (personal communication, 1992)

82

TABWA or BWILE

Zaire, Shaba

zoomorphic bell mask

H. 58 cm. Wood, pigment

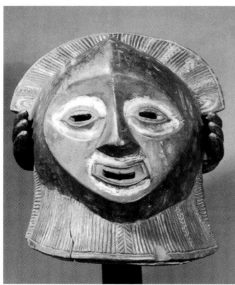

ill. 1. Luba (Shaba). H. 39 cm. Collected pre-1914. M.R.A.C., Tervuren (R.G. 23470).

ill. 2. Western Luba (East-Kasai). H. 46 cm. The Minneapolis Institute of Arts (no. 53.14).

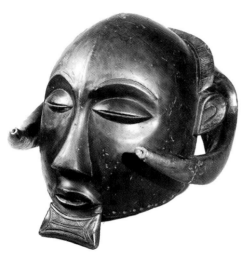

Thus, for example, it would seem impossible to advance socio-morphological studies on the production of masks now in collections, or to attempt to distinguish the work of particular workshops, or to identify the work of individual sculptors. However, such studies are valid in relation to the Hemba monkey masks.

Moreover, if one compares the production of Luba masks for example with that of other cultural objects such as the bowl figures, the caryatid stools or the staffs of office, one is struck by the vast artistic production of the Luba, where the number of items in each category can reach several hundreds of examples. But this is not the case for masks, and all that can be said about the artistic creation and usage of masks is inevitably limited, based on examples at our disposal.

Luba Masks

The first two questions related to time and place. These second ones, of Who? and Why? aim not only to identify the sculptor, the workshop and the style, but also to find out the meaning of such objects to the society which produced them. This is the area known as socio-morphological study. For the masks under discussion, this study has in many cases not been carried out. There is no systematic typology, nor have studies been made in the field. The way is signposted only by various scraps of information, gleaned here and there, and by a general knowledge of the finest masks gathered by museums and collectors. So this examination of Luba masks proceeds from west to east; that is, beginning with the Western Luba of Kasai, then the Central Luba tribes around Kabongo, Kamina and the Upemba depression, and finishing with the Eastern Luba along the Luvua and Lukuga valleys.

The Kasai Luba have large anthropomorphic bell-shaped masks, characterized by huge almond-shaped eyes set in immense eye sockets of the same shape (ill. 2). Often the flattened triangular nose is extended by a median line to the top of the head, which is topped by a large fan-shaped diadem. In the neighborhood of the Beneki Songye and also of the Lubilash River, (longitude 24° E, latitude 6° S), in addition to the headdress with the semi-circular crest diadem, often with two horned appendages, the masks also have a wide fan-shaped border of beard and a V-shaped mouth, usually open with the teeth visible, as is found regularly among the Beneki Songye. They also have some rare bell-shaped masks whose inspiration obviously comes from Songye *kifwebe* masks (see Felix 1987: 82). In this area of the Kasai Luba, stylistic influences are compounded with those of the Luntu and Binji to the north, the Songye in the east, the Kanyok and Kete to the south and the Luluwa in the west. The function of the masks remains little understood.

The Kanyok live to the east of the Bushimaayi River, in the territory of Mwene Ditu, and are culturally very close to the Luba. Sharing the history of the Luba kingdom since the 16th century, they were governed by a single chief until 1890. Various characteristics found in Kasai Luba masks can be recognized in a bell mask belonging to the M.R.A.C., Tervuren (R.G. 55.128.6). Here the diadem is less striking, a single horn is fixed at the back of the head, the eyes are half-closed and the open mouth allows all the teeth to be seen. This mask is not accompanied by any background information and the usage of Kanyok masks remains unknown (Art of the Congo 1967: 50).

The mask in the Museum für Völkerkunde in Hamburg brought back by Frobenius in 1906 and presumed to be Kanyok is of quite another style. This polychrome mask is highly original. Nevertheless, the characteristic cultural traits can be recognized; the semi-circular fan-shaped diadem, and the teeth visible within an immense mouth with lozenge-shaped lips. The use of this mask, too, remains problematic (Fagg 1966: ill. 54).

The large anthropomorphic face masks of the Central Luba are trimmed with animal hair on the eyebrows, moustache and beard. This decoration, derived from the big game animals such as lions, have led to these masks being called "lion masks" (cat. 78). These large masks were collected in the Mwanza territory, to the north-west of the Upemba depression. Aside from a mask once in the Morlet collection, other examples are to be found in the M.R.A.C., Tervuren. The mask R.G. 57.8.1 comes from Mwanza itself while R.G. 53.74.7535 comes from the chiefdom of Ilunga-Mwila and was shown in the Musée Dapper in Paris in 1992. Others were collected at Lubembay, at the village of Kalembe, and at Ngoi-Mani. In the Verheyleweghen collection there was a bell-shaped mask standing on two feet of human form.

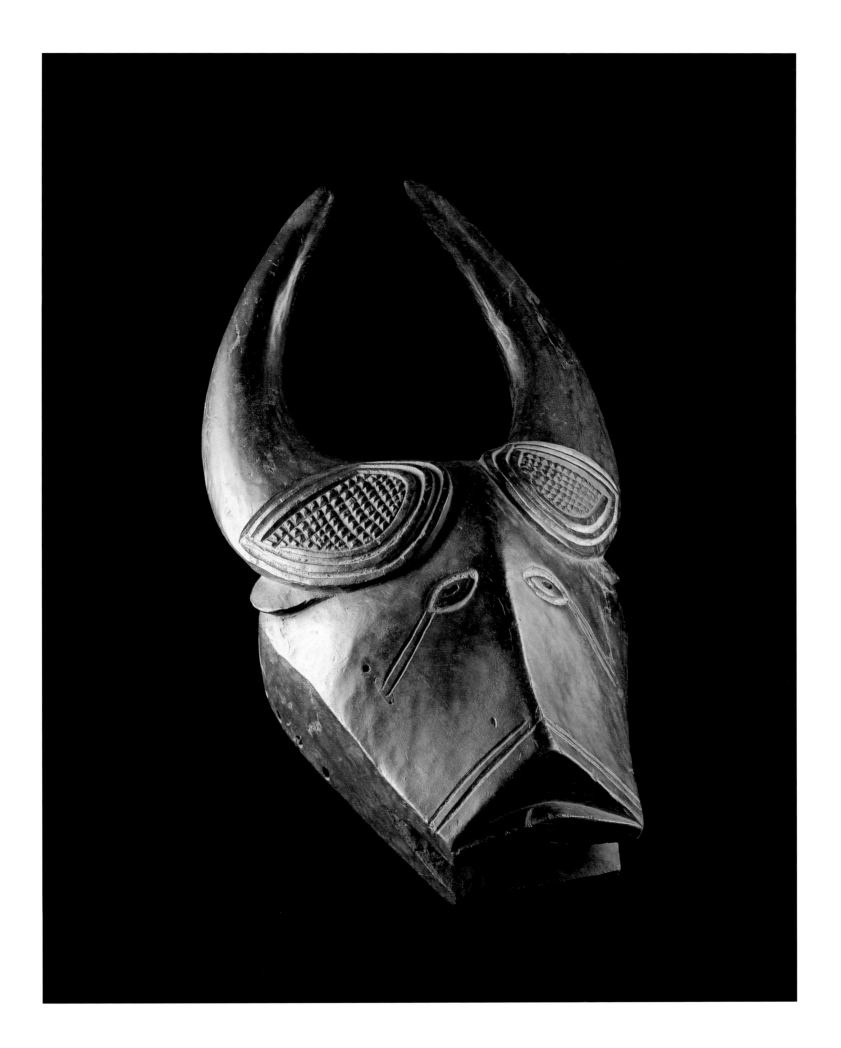

84

HEMBA

Zaire, Shaba, Maniema, Niembo?
anthropomorphic face mask
H. 34 cm. Wood, pigment

The fact that any knowledge of Hemba masks only came to light in the 1970s, is probably related to the secret nature of these sculptures. The best-known are undoubtedly the ape-masks, known by the name *so'o* and sometimes referred to by the Swahili term *soko mutu*. Aside from ape-masks, there are also a number of known anthropomorphic specimens which are closely related to ancestor-sculptures. Some of these sculptures reportedly originate from the southern-Niembo subgroup. The example shown here (cat. 84) also exhibits unmistakable characteristics of Niembo style. On the other hand, the primary zone for the *so'o* ape-masks seems to be the northeast of the Hemba land — more specifically, that area inhabited by the Mambwe subgroup on the banks of the Luka River. While some of these sculptures, such as the miniature mask under cat. 87, are worn either as a charm on the belt or adorn dwellings as protective amulets, others are indeed used for dance. To the Hemba, the ape-mask in the first instance is denoted by a fear-inspiring snout. The example with a gaping snout and bared teeth presented in the notched border of the "upper lip", as seen in the specimen under cat. 86, is indeed contrary to etiquette. The same may be said of the wrinkled brows, which are seen as a sign of wildness and even insanity. The *so'o* mask represents the chimpanzee of the same name, and is symbolic of the untouched and untamed wilderness. The split personality of the figure is also translated in the combination of forest and village elements in the costume. The masks appear during festivals which are important milestones in a long series of funerary activities. The *ubuzha malilo* festival is of crucial importance in the reconciliation between the living and the

Little is known of the use of these masks. However, from the references to big game and the provenance of the masks from the region where the *mbudye* prophet-dancers originated, it may be assumed that these masks evoke the *vidye* guardian spirits of the royal house. This point will be taken up in the last section of this study.

Not far from this area, on a line running from west to east, from the territory of the Kalebwe Songye and the Lubengule Luba (neighbors of the Ilande) over to Ankoro, are found the *kifwebe* (pl. *bifwebe*) associations of masked dancers who have a profusion of masks. These groups of dancers are found along the course of the rivers, from Ankoro to Kabalo, along the Upper Zaire, from Kabalo to Nyunzu, along the Lukuga, to Ankoro, in the north of Manono and in the Kiambi region by the Luvua. They are even found further south, in the Kamina region, amongst the Bena Samba (Mutimanwa Wenga-Mulayi 1974: 188).

Within various specific mask types, very stylized in form, with accentuated brow, nasal ridge, deep eye sockets and a protuberant mouth, decorated with parallel curving or broken lines, more than thirty different masks can be identified. In his study carried out at Ankoro in 1972-73, Mutimanwa Wenga-Mulayi discovered tree masks, a wasp mask, bird masks (cock, parrot and owl), animal masks (antilope, zebra, goat, monkey), and anthropomorphic masks. Often the shape of the crest determined whether the mask was male or female. This distinction has not been much stressed amongst the Luba. The use of ritual colors, such as white, ocher, black and red, scarification and small designs carved on the cheeks, further establish the identity of each mask. Thus the design of two tears above two crosses evokes the large antilope, while small inverted triangles suggest the forest. It appears that contemporary trends in *kifwebe* carving during the 1970s lean more towards realism in their representation.

White is the dominant color in female masks; in contrast, male masks more often use three colors, with red being predominant. Amongst the Luba, it is obviously the white masks which are the most common. In more recent masks new colors are added, like blue, green or orange. Hersak, who has studied Songye masks, sees white as the dominant unifying color, while red is ambivalent, the symbol of strength and courage but also announcing danger; black evokes the world of shadows and darkness (Hersak 1986: 71-115).

Kifwebe dancers sometimes come from Luba tribes and sometimes from those of the Songye. They extend over both regions and it seems impossible to find any chronological precedence, even if the quality and diversity of the Songye masks might tip the balance in their favor. Be that as it may, the region of the Luba of Lubengula, neighbors of the Songye, must be considered the nucleus from which *kifwebe* masks have spread both to the east and west. The round *kifwebe* masks, typical of Luba workmanship, are found particularly in the Middle Luvua region (Kiambi), in the Upemba depression and even further to the west, towards Kamina (cat. 76). As Father Colle noted, these masks were used during the festivals of the new moon.

As has already been noted, the Eastern Luba have associations of *kifwebe* dancers who travelled in the region irrigated by the Lukuga and Luvua Rivers. In the area to the north of Kiambi several masks with striations show the importance of new moon ceremonies.

Some isolated examples of animal masks have been collected to the east of the Upemba depression and to the south of the Luvua River. Two elephant bell-shaped masks are at the M.R.A.C., Tervuren (R.G. 56.81.1 and R.G. 3722). The elephant bell-shaped masks might have belonged to groups of hunters or to dancers in a secret society (ill. 3). Amongst these sects were the *bukasandji*, whose members carried out certain rituals at the tombs of the dead. (On the secret societies of the region, it is worth referring to Colle 1913: 527 ff, even if his general view is outdated). Perhaps the long drawn out and extended mask from the British Museum might be attributed to them (see above). Some see an allusion in these elephant masks to the Batempa and to the Pygmies, the first inhabitants of the country.

A very fine anthropomorphic face mask, with large globular closed eyes, the mouth in the form of a figure eight on its side and the head covered with an animal skin, was found in the north of Kasongo and reflects Luba/Songye influence (cat. 79) (Thompson & de Grunne 1987: ill. 155).

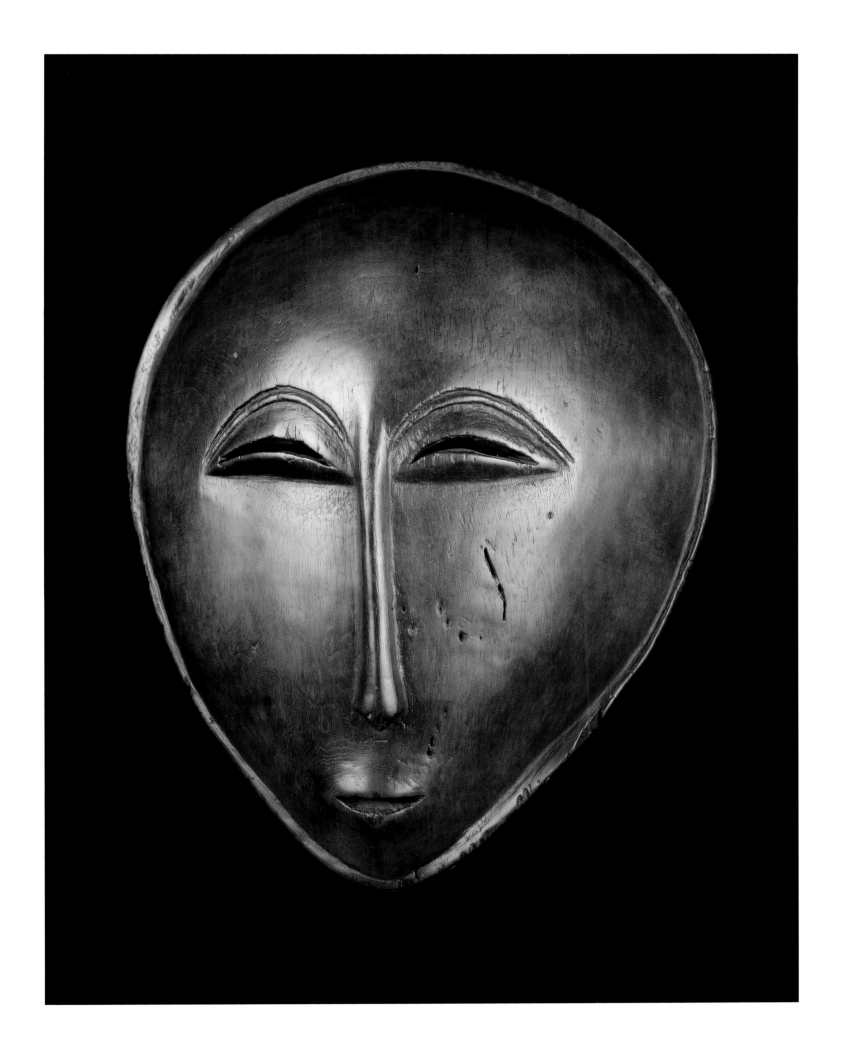

HEMBA

Zaire, Shaba, Maniema

anthropo-zoomorphic face mask

so'o

H. 17.5 cm. Wood, pigment, encrusted patina

dead. The normal order of things is restored and, as well, problems related to social relations and questions of leadership are handled. Questions of inheritance are also raised, and the party responsible for the death is also decided upon. The performance of the *so'o* mask-dancer in the festival knows a "wild" aggressive phase, and a comic "dance" phase. First he chases the villagers off, later inviting them to dance with him. As an allegory of death, the masker disturbs peace and harmony. At once he embodies the ambiguous state wherein the the deceased temporarily finds himself, between the community of the living and that of the ancestors. (C.P.)

Lit.: Neyt 1977; Blakely & Blakely 1987; NEYT (p. 163)

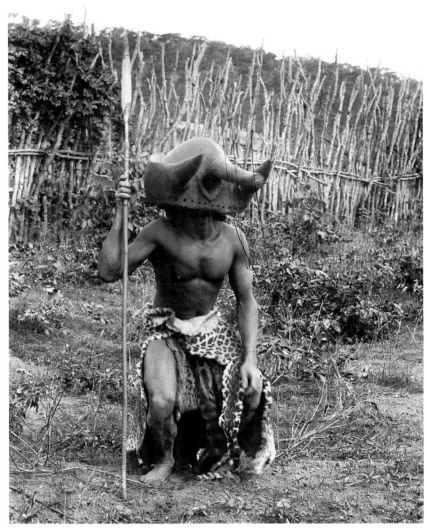

ill. 3. Eastern Luba (Shaba). Photo: C. Lemaire, 1898. M.R.A.C., Tervuren.

ill. 4. Hemba (Shaba). *So'o.* H. 18 cm. Linden-Museum, Stuttgart (no. VL 81.118). *See cat. 86*

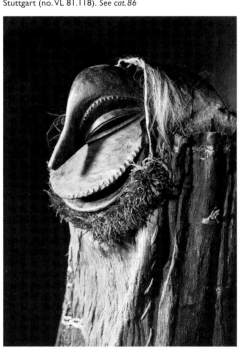

This isolated mask is difficult to associate with any other stylistic trend and its purpose, too, remains unknown.

In the neighborhood of Lake Moero, in the foothills, the Bwile made buffalo masks, similar to those carved by the Tabwa further north in the Marungu near Lake Tanganyika (see M.R.A.C., Tervuren, R.G. 3721). Some anthropomorphic face masks have been collected near Lake Moero on the Zaire side (see M.R.A.C., Tervuren, R.G. 3723). This tradition extends into East Africa (see e.g. the Ziba mask from Tanzania in the Musée de l'Homme in Paris; published in Vogel & N'Diaye 1985: 114 and 164, ill. 98).

Hemba Masks

Here there are two mask traditions. First, some anthropomorphic face masks, strangely similar to the ancestor statues. There is a mask of this type belonging to the I.M.N.Z., Kinshasa and another in the Mestach Collection in Brussels (cat. 84). A third mask in the M.R.A.C., Tervuren has the lower part of the cheeks carved into a heart shape on a flat surface, and the mouth forms an astonishing prognathous mass (Neyt & de Strycker 1975: 62).

But these masks are rare and the second type, that of the monkey masks, is better known (cat. 85-87). These are dance masks, contrary to what Frère Cornet and I myself once thought (Cornet 1973: 41, ill. 19; Fagg: 144-145). However, it remains obvious that some masks have never been used in dances (cat. 87). Some are worn attached to a belt, others protect houses. They seem

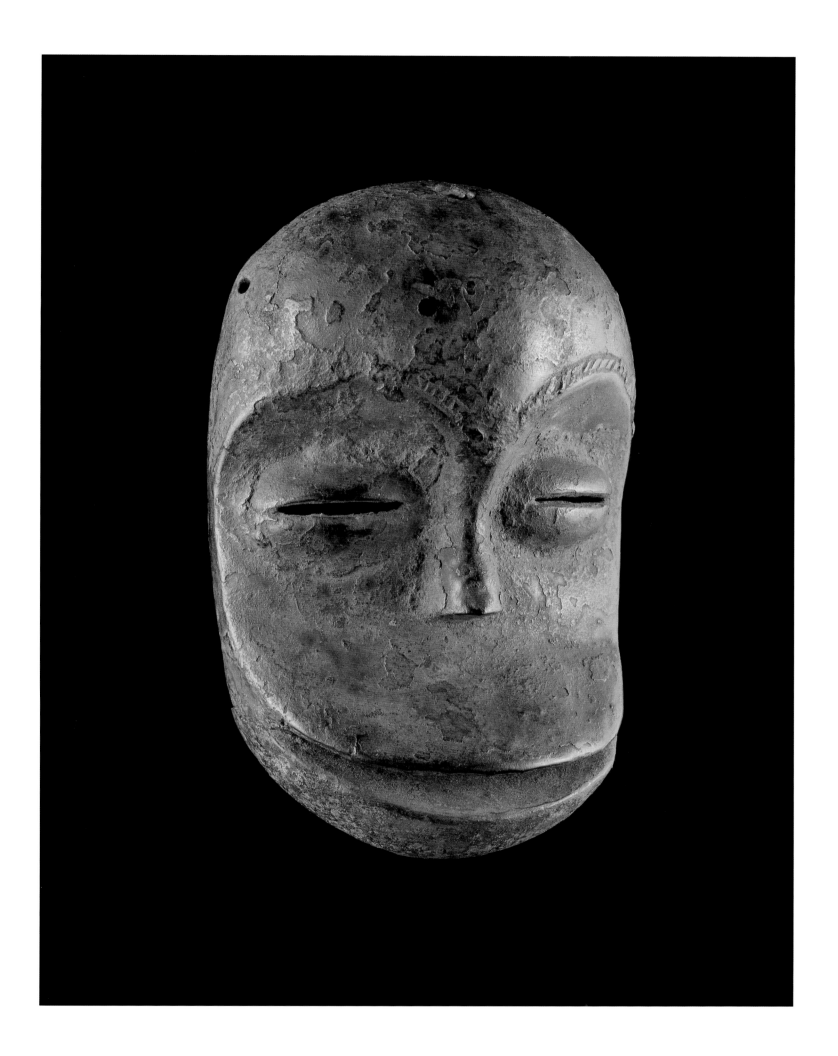

to protect the household and to encourage fertility at harvest. The excellent study by the Blakelys shows their importance in funeral rites (Blakely & Blakely 1987).

The simian *so'o* mask appears during the funeral rite in a kind of festival, sometimes celebrated several weeks after the burial of the deceased. The festival itself may last several days or several weeks according to the social status and wealth of the family concerned. It is a way of bringing the period of mourning to a close. The function of the monkey mask is to run around the village to frighten away youngsters and pregnant women. Then at a second stage it performs amid the spectators and amuses the crowd by its antics, accompanied by the sound of the drum and songs.

The monkey, a creature of the bush, is thus presented as a symbol of the passage of the deceased to the other world, the world of white clay (kaolin) and spirits. Through its appearances and its dances it demonstrates both the disruption of the social order in the period of mourning and the restoration of that order during the festival which concludes the funeral rites. The tradition of the monkey as trouble-maker and as one who takes part in the judgement of souls goes beyond Black Africa and extends to Egypt and to the Mediterranean basin.

Tabwa Masks

The mask tradition here is concentrated round two important bell-shaped masks; the buffalo mask and the anthropomorphic mask. Information on the sculptors' workshops and the usage of the masks is practically non-existant. The best documented example is that in the Brussels private collection (cat.80). The mask had belonged to "a Bena Tanga, from a part of the Sanga clan of chief Tumbwe". According to the same source, the anthropomorphic bell-shaped mask danced with the buffalo mask, whose acolyte it was (Maurer & Roberts 1986: 157). It represented a female ancestor, called *musangwe*, which means "key" or "sign". Other reports link the mask to fertility rites, particularly at the birth of twins. It could have been used by a secret association, the *butwa* (Colle 1913: 620 ff). It is also interesting to note that in certain stylistic traits and in its striation, the mask can be compared to a famous sculpture collected by Jacques Storms in 1884, after his victory over the chiefs Lusinga and Kansabale. This statue was Manda's, the Tabwa chief from the Marungu mountains, who was allied with Storms. However, five vertical lines of striation on the face of the sculpture of chief Manda are not repeated on the bell-shaped mask, where the marks are horizontal only. The headdress too is different, confirming the feminine identity of the mask, as do the earrings. Finally, in the left nostril is an ornament made from a button (called *kipini* by the Tabwa) which was a custom in fashion in the the 19th century along the trade routes linking Lake Tanganyika to the Indian Ocean. (See also a photo, taken in 1900, in the archives of the White Fathers in Rome; published in Maurer & Roberts 1986: 139).

Reverting to the anthropomorphic mask in the University of Iowa Museum of Art, the lozenge-shaped *balamwezi* motif evokes the sun and the moon. It may have served to discipline unruly adolescents (Robbins & Nooter 1989: 474, ill. 1217). Though the feminine anthropomorphic mask and the buffalo mask can be considered as two actors in the same drama, one representing the female element, the other virility and strength, we must return to the cosmic symbolism to enable us to detach ourselves from too anecdotal an interpretation, and to appreciate the profound symbolism of these particular masks.

Establishing the Definitive Meaning of Masks

After considering the initial questions of date and place, we have examined those relating to the identity of the sculptor and his workshop, and to the usage of the masks. Admittedly the information at our disposal is scarce, with the exception of the *kifwebe* masks studied by Dunja Hersak (1986). The sculpture workshops are scarcely known, the purposes of the masks hardly more so. Nevertheless, the general context of Luba culture and a series of interrelated features allow us to say a little more about the definitive role of masks in south-east Zaire. Three concepts will shed new light on our hypothesis: the term *kifwebe*, the sun/moon cult, and the ancestor tradition. The last two concepts make a link with the cosmic and social realities at the root of Luba culture and its history, while the first term explains the actual reason for the existence of masks.

86
HEMBA
Zaire, Shaba, Maniema
anthropo-zoomorphic face mask
so'o
H. 20 cm. Wood, pigment

87
HEMBA
Zaire, Shaba, Maniema
anthropo-zoomorphic miniature mask
so'o?
H. 9.5 cm. Wood, pigment

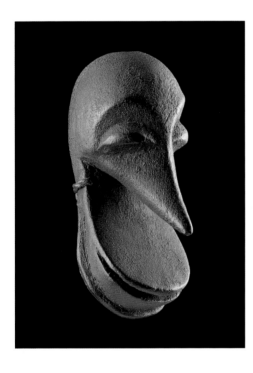

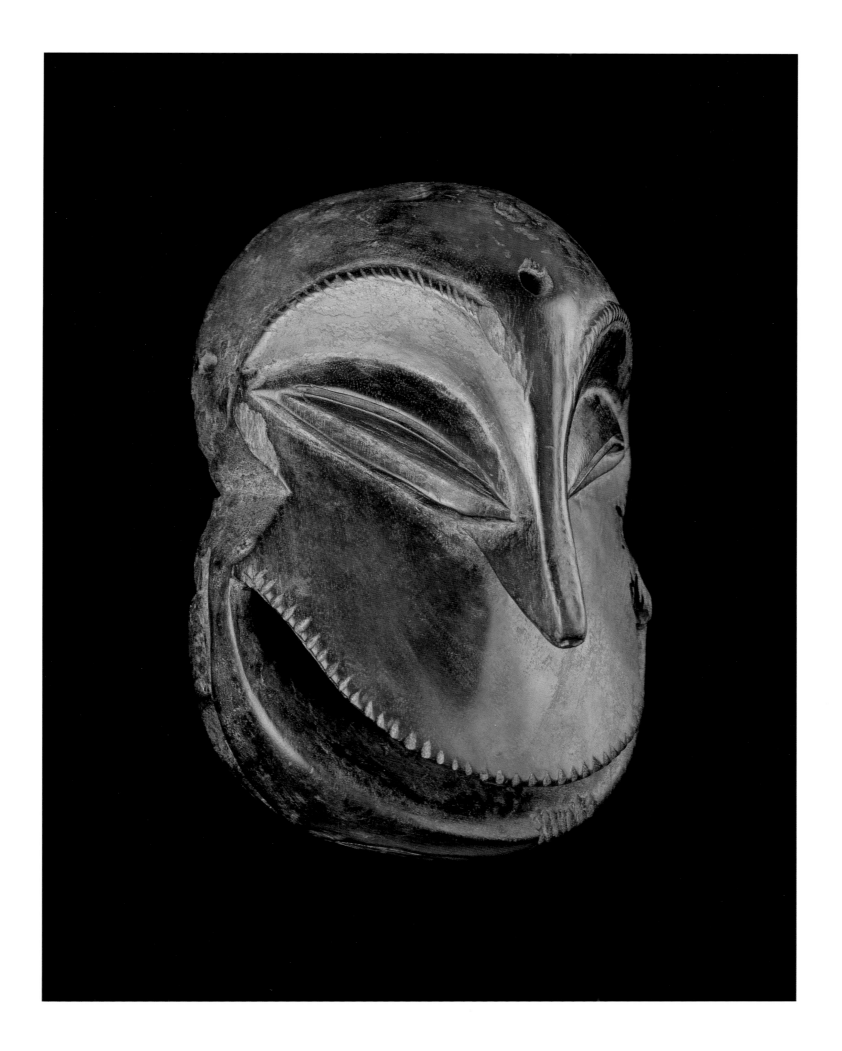

88

BANGUBANGU?

Zaire, Kivu, Maniema

anthropomorphic face mask

H. 34.5 cm. Wood, pigment

Little is known concerning the Bangubangu, neighbors of the Lega, the Hemba and the Buyu (amongst others) in southeastern Zaire. They would likely be of Luba-Hemba origin, and during the course of their northwest migration beginning from Lake Tanganyika, came into contact with the Buyu. The rare sculptures which are tentatively attributed to them exhibit various stylistic and typological influences. Aside from reminiscences of the Lega, the mask shown here betrays Hemba traits in the ape-like mouth (compare to the *so'o* mask, cat. 85), while the notched border indicative of a beard harks back to the physiognomy of certain Buyu sculptures. It is supposed that these masks play a role in initiation societies, called *muyi*, about which no detailed information is known. Other masks would then again function as didactic aids within the scope of initiations and meetings of a secret society. They are in this case not worn on the face, but rather held in the hand. (C.P.)

Lit.: Neyt 1977; de Kun 1979; Felix 1989

Indeed, the term *kifwebe* is a generic term for a mask. According to Faïk-Nzuji (personal communication), the word is formed from two roots, *fu* and *eb*. *Fu* is a root which is found in the verb *ku-fu-a*, *kufwa* means "to die", or in the noun *lu-fu* meaning "death". The root *eb*, giving the infinitive *kweba* comes from *ku-eb-a* meaning "to hunt, chase away, put to flight". From this *kifwebe* (which can be broken down *ki-fu-eb-e*) means "he who hunts, chases away or puts death to flight". The hypothesis put forward by Faïk-Nzuji, even if it remains a hypothesis, is interesting and corresponds well with the origin of the masks studied. It allows us to go back in time and to discover the purpose of the mask at the time of its creation.

The growth and development of mask traditions, their decline and sometimes their regeneration, which we can trace exactly in *kifwebe* masks, encapsulates the history of an entire people. In the case of the Luba and the use of *kifwebe* masks, the meaning of the mask seems to have evolved from an extremely strong religious reality, which was both feared and formidable, through a more festive context, in honor of the new moon, to become dance associations with a more recreational and folkloric flavor.

In parallel with this chronological development of Luba mask traditions, the evolution of the institution of kingship also has to be taken into account, from its mythic origins, through the period of expansion and decline of the kingdom, into the period which has followed the end of the Luba kingdom. The role of the *mbudye* prophet-dancers seems to me to totally exemplify this evolution. At the inception of the Luba kingdom and throughout its history, it is clear that the *mbudye* dancers occupied a priviledged position in the religious history of the kingdom. Their role, usually hidden and secret, was visibly demonstrated as diviners and prophets charged with watching over the king's person and over the prosperity of the kingdom (see Neyt *forthcoming*).

The *mbudye* accompanied the king on all his travels and appeared to the people performing their dances. Originally these dances were linked to the *vidye* guardian spirits of the royal house and the *mbudye* prophet-dancers were the messengers and interpreters of these royal spirits. Their dance costume was characterized by a diadem on the brow, decorated with alternating triangles. The top of the headdress was made of ram's or lion's hair, which are solar animals, linked to the symbols for the sun's trajectory. Two baldricks crossed on their chests, dividing the space into the four cardinal points. They were thus the masters of the heavenly and earthly cross-roads, charged with identifying and separating the bad spirits from the good and, above all, with preventing any evil which might befall the king or his kingdom.

But attention was also concentrated on the full loin cloth, covered with skins, recalling the big cats, lion, leopard, genet. When the *mbudye* prophets dance, they spin round and stop abruptly, so "lifting up the skins". The meaning of this dance step can be understood through the word for raffia fiber *manianga*. The root *kunianga* means to sprinkle or to purify. In their dance, by "lifting up the skins" the *mbudye* carry out a benediction ritual. They are the guardian spirits of the royal house, who bless the people through their collective dance.

The *mbudye* dance demonstrates the presence of the guardian spirits of the royal house, who show themselves afresh. Through the ritual of the dance, the institution of royalty is recreated and revitalized. The *mbudye* are also present at royal enthronements and are present when the king reappears from seclusion after four days. At that time, the royal dance is also the sign that the king is inhabited by the spirits of the kings who preceded him.

Two further points should be noted about masks. In general, in the Luba region, it must be said that there are many groups of dancers and that they do not usually use masks. However, the faces of the *mbudye* dancers are covered with paint, yellow ocher, red and black, and these colors indicate a stage in the original development and creation of the masks. Moreover, the *mbudye* prophets hold the insignia of royal authority in their hands, the spear, the axe and the adze.

Nevertheless, the large face masks collected in the Mwanza territory do correspond very closely to the facts described above, while the use of the skins of lions and other wild animals to make the eyebrows, moustache and beard obviously also evokes the *vidye* guardian spirits of the royal house (cat. 78). So here we are dealing with extremely important masks, worn by the leading dignitaries

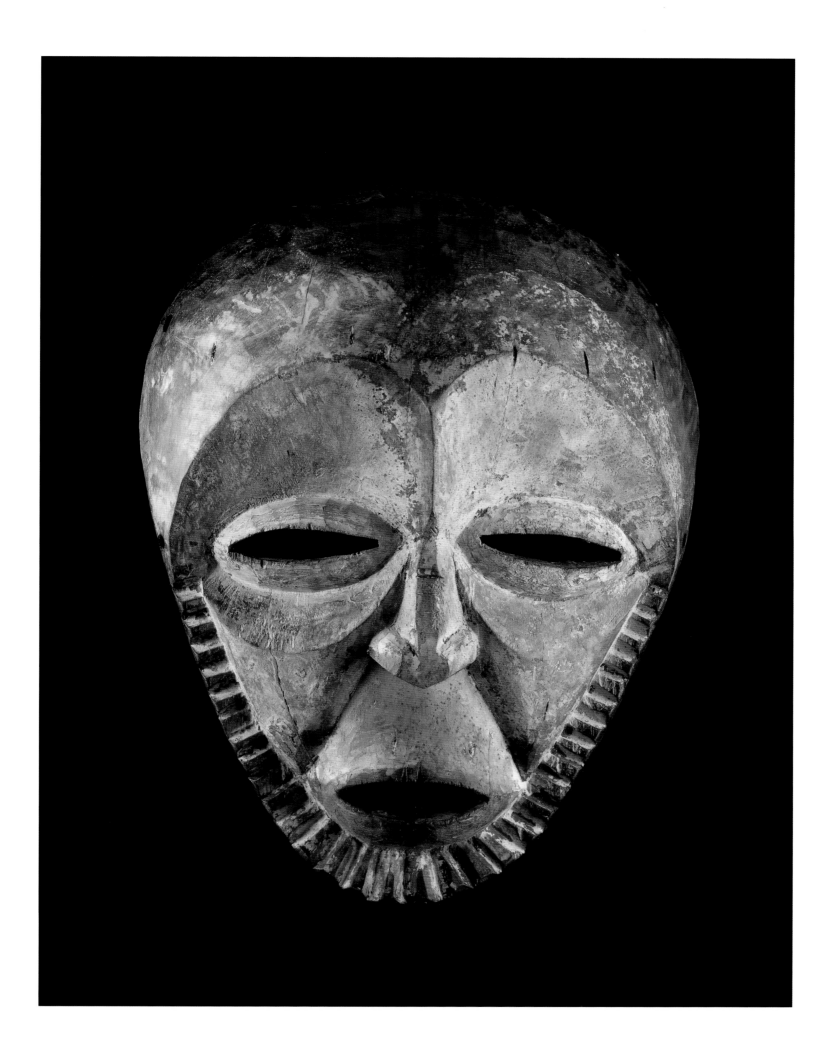

of the *mbudye* during certain dances. The Mwanza and Ngoi-Mani regions correspond exactly to the heartland of the *mbudye* institution.

Among the *vidye* guardian spirits of the royal house, the sun and moon occupy a special place. Colle recalls that in 1900 when he arrived in Lukulu (not far from Kiambi to the north of the Middle Luvua), a man and a woman climbed to the top of the Zanza mountain every month, and prayed there for several days "in honor of the moon, so it would return" (Colle 1913: 416 and 711). This same Colle brought back several round striated masks, which were used in dances at the funerals of the king, a chief or noble (ill. 3, p.158).

In the masks of the eastern Luba the presence of the sun and the moon is evoked partly by the general form of the mask and partly by different symbolic signs. Mutimanwa Wenga-Mulayi (1974) and Hersak (1986) note that on the face of the *kifwebe* mask which recalls the striped Bongo antelope, the right side is male, representing the sun, and the left female, representing the moon. On a round mask, brought back for the Museum für Völkerkunde in Munich by Graven-reuth in 1891, four double concentric circles decorate the face, two on the temples, two on the cheeks, and it is hard not to make a comparison of these designs with the Kongo cosmogram evoking the "four moments of the sun".

This involves a ritual transformation of the human being, who proceeds through four stages corresponding to the sun's journey around the earth. "Through this initiation", notes Fukiau, "man follows the sun, because he himself is a second sun". The cosmogram, which takes the form of the image of a cross surrounded by circles, mirrors these four stages. The birth of the individual is linked to the sunrise, (to the left, in the East); the full strength of the human being corresponds to the vertical line (South) of the sun at midday; death and declining strength are linked to the setting sun and its fall below the horizon (in the West). Finally, the moment of death corresponds to the mid-point of the sun's journey through the world of the dead, midnight in the living world (North). In this nether world of the guardian spirits and the dead, which the Kongo call *mpemba*, the land of kaolin (white clay), where everything is white, death rules and judges human lives, dissolving out the impurities of earthly life, giving a new freshness to existence and empowering the spirits to be re-incarnated in the bodies of the new-born. The Kongo cosmogram appears in many different designs, all dominated by the circle and the four compass points (Thompson & Cornet 1981: 43 ff).

Among the Eastern Luba this cosmic dimension of human existence is always present, at least in the origin of the symbols. The famous cruciform hairstyle of the eastern Luba and the Hemba consists of four braids of hair, coming from the four points of the compass, which are twisted horizontally and vertically. Often the horizontal braids cross over the vertical ones. This is what the Kongo call the divine line, which passes through Kalunga, God. In the Kongo theory of the origin of the universe, it is interpreted as representing water, in a river or the sea. For the Luba, the water runs from east to west and is invested with such importance that the course of a river may even be diverted in order to bury a king there (see Theuws 1968 and Neyt *forthcoming*). Moreover the Luba hairstyle is worked within a circle, and Tabwa mythical tales recall how the founding father of the tribe carried the seeds for cultivation in his hair during migration. (On the cruciform Luba and Hemba hairstyles, see Neyt 1977: 406-411; on the Tabwa myth and the importance of the sun, see Maurer & Roberts 1986: 32 ff).

These similarities between Kongo designs and Luba hairstyles have many nuances and variations. But at its heart there is unquestionably a unity of view of the cosmos and of man. The sun and moon occupy an essential role (Theuws 1978) and the animals are part of the cosmic order. Thus the patterned skins of leopard, zebra or antilope may evoke the night sky full of stars, the Milky Way, or the moon. The skins of the big cats, or the horns of a ram or buffalo recall the sun. Geometric designs, like the triangle or the lozenge, suggest the conjunction of the earth and the moon at the time of the new moon and are fertility signs.

Also, though the information which we have on the use of masks amongst the Luba is scarce, the importance of the new-moon festivities, when the masks appear, is confirmed by the general context. After three nights of concern, the darkest of the month, the return of the new moon was celebrated in the villages, just as the spring festivals were celebrated in Europe. On these occasions cult statues were placed in the moonlight to be regenerated and the great masks would appear to honor the spirits of those who gave them strength, light, and fertility. Animal symbols, body painting and scarification played their part in this regeneration. When the Luba kingdom was at its height, the king himself was considered possessed by the spirits of his predecessors; thus he became the man who represented the whole people, above all the clans and families, and was somehow part of the cosmic order.

Even the animal symbols, following the mask tradition in the fullest sense of its meaning, took part in this regeneration of the universe, at the new moon or at sunset, times when spirits of the ancestors might appear. It is in this sense that some of the mask symbols in the *kifwebe* mask tradition are to be understood.

This interpretation fits in with political realities and confirms Dunja Hersak's analysis of the Songye *kifwebe* (Hersak 1986: 43 and 50), which, as Marie-Louise Bastin (1984a: 353) says, "est un véritable macrocosme se référant symboliquement au pouvoir, à la nature et à la culture" and "[le masque] joue un rôle de contrôle social et politique". In the same way, among the Luba the *kifwebe* mask once had a religious function, and it could appear at the investiture or death of a chief; from this its role developed more widely on a social and judicial level.

The masks of the Tabwa dances, sometimes anthropomorphic, sometimes in the form of a buffalo, may also have cosmic references, recalling the sun and moon, linked to fertility and strength and showing in their own way the regeneration of life and the magical or religious authority of groups of dancers.

The Hemba monkey masks retain a more enigmatic element, linked to the symbolism of the forest cultures. One must compare this Hemba tradition with those of other tribes who produce monkey masks. These extend from the Ngbaka in north-west Zaire, to the Lega and the Hemba's neighbors in eastern Zaire. Their monkey masks are linked to funeral rites.

Finally, anthropomorphic masks most usually represent the ancestors of the tribe. They appear on special social occasions, such as the funeral of a noble or a chief. They are present to "keep death at a distance" — that is to say, to drive away the spirits who "eat the soul", and to bestow the blessing of the ancestors upon the people.

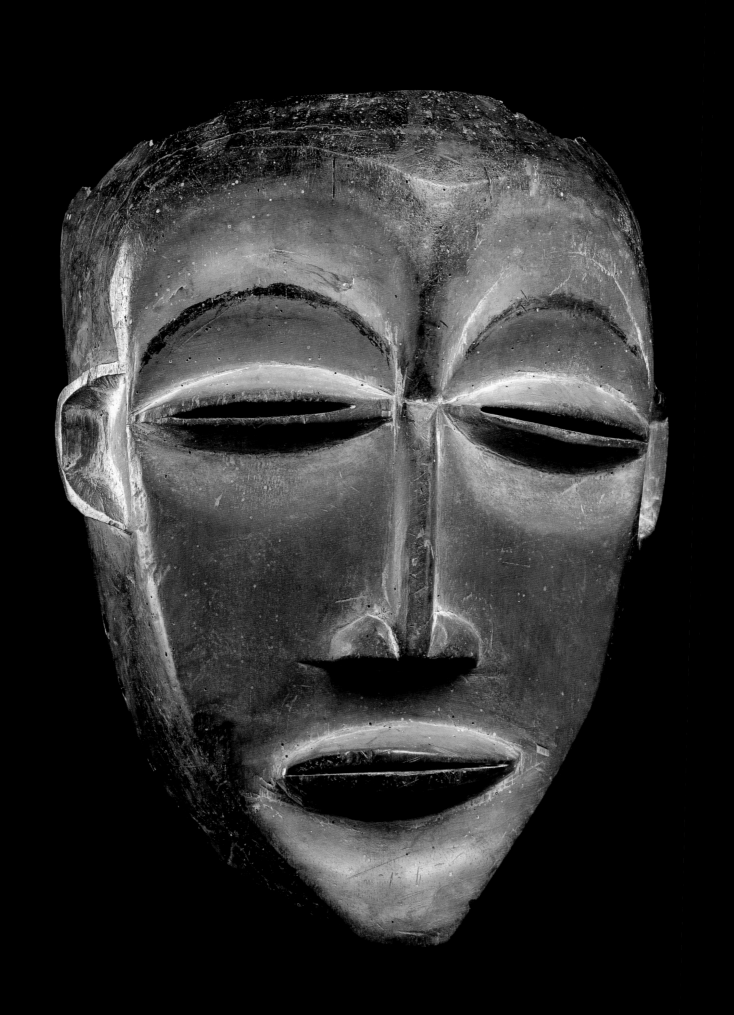

Masks and Initiation Among the Lega Cluster of Peoples

Daniel P. BIEBUYCK

In this study on the types, uses, functions and meanings of masks created and/or employed by peoples belonging to the Lega culture cluster and segments of other adjoining populations, I do not follow the usual format of geographical and tribal enumerations of forms and styles. Rather, I intend to show that the mask institutions in these various ethnic groups fit into a very few socio-cultural and ritual frameworks, leaving ample room for variations in detail. There is a fundamental purpose to all the masks and this situation probably reflects the close historical and cultural ties, past and present, existing among the mask-producing groups analyzed in this study.

The Lega Cluster of Peoples

The masks studied in this chapter all belong to a distinctive group of populations located in the eastern Zaire rainforest and overlapping in adjoining savanna areas. These peoples jointly exhibit similarities in fundamental cultural traits. These are the product of common origins, converging migrations, mutual influences and acculturation, cultural exchanges, local contacts, overlapping and subsequent mixtures of segments of originally distinctive groups. The cultural identities are not only distinguishable by comparative research. To a certain extent the peoples themselves have, in various degrees, an awareness of having a basic common culture. This awareness of commonality is particularly strong among the most enlightened native spokesmen and interpreters of these cultures; frequently these persons are high-ranking members in the extensive systems of initiations.

On the periphery of this vast cultural ensemble there are several ethnic groups or segments of them that have cultures basically different from those in the Lega cluster, but that exhibit one or more central institutions, similar to those of the Lega cluster, in which art production, art use, art interpretation and art ownership are essential and frequently exclusive privileges.

The core group is formed by the various divisions of the Lega properly speaking, the Bembe and some of the pre-Bembe hunters, some Leka, Songola and Binja (Zimba) subgroups, the Mitoko and Lengola. Others on the periphery like the Nyanga, the Pere, the Kanu, the Bemo, the Kwame, the Mbole and some Nande, Hunde, Tembo, Komo, Bangubangu and Buyu subgroups in the south, share basic features with the core units. It must be kept in mind that fragments (certain clans and lineages) of these various populations are widely scattered and partly integrated in heterogeneous tribal areas, thus providing the basis for the trans-cultural transmission and diffusion of certain institutions that seem to exercise a special appeal in these areas. To take one example, that I have been able to study in the field. Fragments of Lega clans and lineages can be found, more or less clearly distinguishable, in certain villages or sections of the Nyanga, Kumbure, Hunde, Havu, Tembo, Shi, Nyindu, Vira, Fuliru, Komo, Bembe, Songola, Lengola, Mitoko, Leka, Southern Binja (or Zimba), Bangubangu. Situated in-between the major ethnic complexes are small highly heterogeneous composites and little-known "buffer groups" that facilitate the cultural transitions and transmissions in this area.

Some of the cultural typology of this area has been discussed elsewhere (Biebuyck 1973a, 1978, 1981, 1986). Suffice it therefore to indicate the most significant socio-ritual frameworks with which the mask institutions are intimately linked among the peoples of this cluster.

The institutional frameworks revolve around initiation systems, which are directly linked with either the young men's initiations in the form of puberty cum circumcision rites, or the initiations and enthronement rites of chiefs and other dignitaries and status-holders, and the closed associ-

89
BEMBE?
Zaire, Kivu, Maniema
anthropomorphic face mask
H. 28 cm. Wood, pigment

In the extreme southeast of the former Kivu Province live the Bembe: a complex ethnic entity where diverse cultural traditions meet. Our knowledge of the Bembe's culture and art is scanty. As a general proposition, the morphology of Bembe sculptures refer to the Luba, while that of Bembe masks is related to the Lega and related peoples. Aside from cyclically held rites of circumcision, the Bembe are acquainted with the *bwami* society that functions according to Lega principles. There also exists a series of other societies and initiation rites. The mask shown here deviates strongly from the well-known Bembe pieces. It does appear similar to a specimen published by Marc Felix which, although collected in a Lega village as part of the paraphernalia of a local *bwami* society, would likely be of Bembe manufacture. However, during his stay with the Bembe, Daniel Biebuyck came across only one — totally different — mask in a *bwami* context, more specifically, within the scope of an initiation ritual to the *pinji* level of membership. All in all, it is not justifiable to couple, by analogy, the example shown here to the *bwami* society of the Bembe. Finally, the attribution, as well, is uncertain. (C.P.)

Lit.: Biebuyck 1972; Biebuyck 1986; Felix 1989

90

BEMBE

Zaire, Kivu, Maniema

anthropo-zoomorphic (face) mask

eluba or *emangungu*

H. 46 cm. Wood, pigment

Circumcision rites are described by the Bembe as being their most authentic tradition. These rites were also, however, adapted to the *bwami* circumcision, and are under the supervision of high-ranked *bwami* members. A distinction is drawn between two kinds of circumcision rites whereby only the *butende bwa eluba* makes use of a particular mask type. The *emangungu* mask, a polychrome and nearly rectangular plankboard mask, has a stylized anthropo-zoomorphic face with coffee-bean shaped eyes in white oval planes. Marc Felix suspects that two pairs of eyes refer to the male and female, or to opposing forces of nature. Jean Willy Mestach interprets the reference as being to divination. Above the forehead are often two excrescences which represent the tufts of an owl. Sometimes, the whole is crowned by two bent horns. The masks are attached to a costume of banana leaves and bark, or to a small conical hat of bark. They are worn by the initiated boys while begging for food in the village during the seclusion period. The *emangungu* masks are unmistakably related to the *alunga* bell masks (cat. 91). (C.P.)

Lit.: Biebuyck 1972; Biebuyck (*in* Schmalenbach 1989: 281, no.183); Felix 1989; Mestach (*in* Maurer 1991: 133, no.26)

ations (so-called secret societies), some of which admit male and female membership, while others among them accept only male or female membership.

The Initiation Systems

Students of comparative religion distinguish between three major types of initiations. The mandatory ones for all persons of a certain sex and approximately of the same age group. In the cases examined in this study, these initiations (variably called *mukumo, bwali, butende*, etc.) are linked with rituals of transition whereby young men achieve the status of marriageable men and full-fledged adult males. The transition is made through an elaborate and secret set of rites of passage, periodically and cyclically organized and generally held in seclusion.

Essential aspects of the rites include: formal abduction of the young men from the village context; circumcision; a period of healing and recovery; the imposition of hardships and severe rules of behavior; the systematic learning of essential techniques, modes of behavior, values, a secret lore; special codes of interpretation of symbols; and a glorious reintegration of the "new men" into the village context. In general, the organization of these initiations is presided over by a hierarchy of experts, from circumcisors to healers, tutors, expert dancers and teachers who achieve their status from certain positions in the kinship system.

There also exist in the region mandatory initiations for individuals who hold special positions and exercise particular functions in terms of established kinship roles, inheritance, succession, selection or vocation, and special skills. Among them are chiefs, certain ritual experts and dignitaries, blacksmiths, diviners, skilled preceptors and dancers, circumcision experts, specialized hunters, and healers. About this type of initiations we possess the least information in the available literature.

The non-mandatory or so-called voluntary initiations abound in the area, but our information on some of them is very scanty indeed. By the time some of the major anthropological field research was starting in this part of Africa, many of the key institutions based on initiations into various types of esoteric organizations had been severely damaged by colonial legislation and outlawed.

As far as the semi-secret and secret so-called voluntary associations are concerned it must be pointed out that, although not prescribed, membership in them is most ardently desired by men and, wherever possible, by women. To achieve membership at one or other level of the hierarchically graded associations that are structured on closed initiation systems, confirms and/or carries status, power and authority, prestige and privilege. They create new forms of solidarity and cooperation between individuals and groups. Every association consists of a number of hierarchically ordered grades, but the complexity differs greatly; in some cases there are parallel complementary grades for men and women (or for the wives of the initiated men).

The social frameworks within which these initiations and the resulting associational movements operate, closely follow the major outlines of the kinship divisions and alliances. In some instances, but not necessarily, the hierarchies achieved within the associations are a confirmation of already existing hierarchies in the socio-political system. But they also create new alliances between individuals, families and larger groups beyond the narrow kinship linkages. The initiations into the associations do occur at any time of the annual cycle, depending on the availability of eligible candidates and their acceptance by the leadership.

Apart from their distinctive social organization all initiations have their own exclusive paraphernalia, music, dance and songs, their own mostly temporary buildings, their own value and philosophical systems. Since initiations are destined for insiders to the exclusion of outsiders, much of what they do and say is secret and sacred; hence the elaboration of extensive symbolisms and cryptic ways of interpretation so as to diminish the possibilities of divulgation.

As in the ancient Greek mysteries, all initiations in the Lega culture cluster contain elements of the "unspoken and unspeakable" and the "forbidden". The non-descriptive character of most art

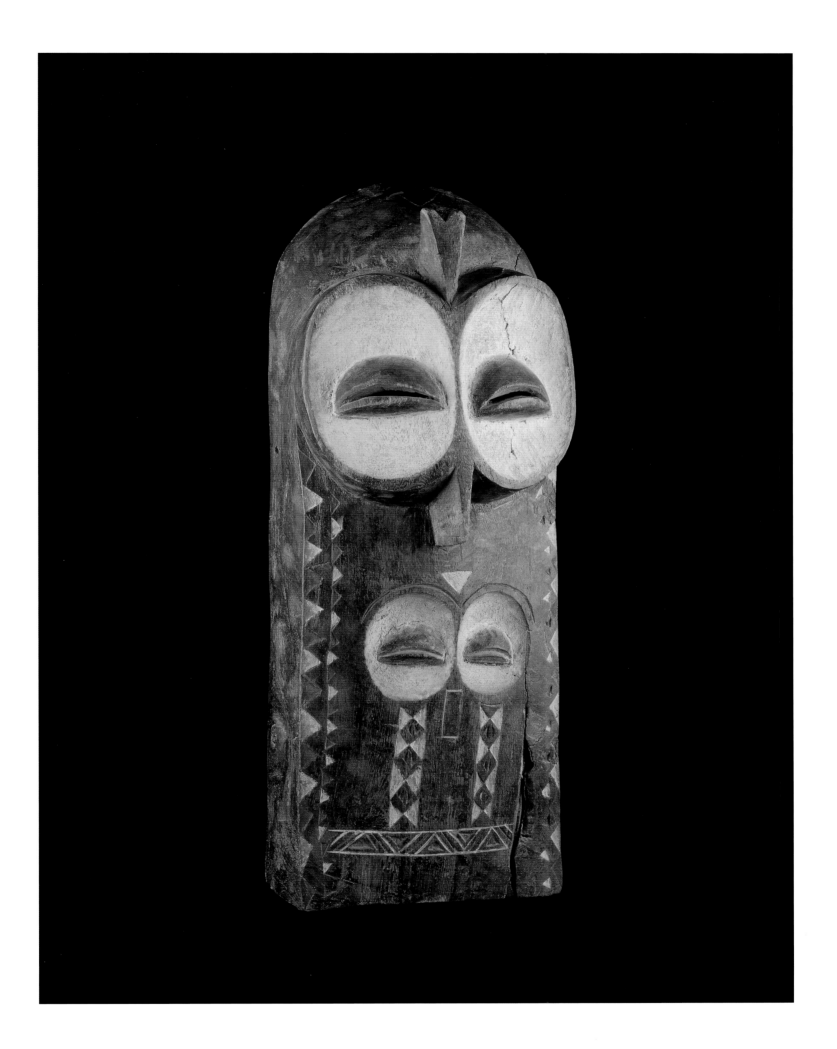

91

BEMBE

Zaire, Kivu, Maniema

anthropo-zoomorphic bell mask

alunga

H. 43 cm. Wood, pigment

The *alunga* society and the eponymous mask would likely originate from groups of hunters, with the masked figure originally operating as protector of the honey. The *alunga* mask, among the Bembe the focal point of all society-activities, is a Janus-form bell mask with two pairs of diamond-shaped eyes. On the two sides, a small bore-hole acts as a peep-hole for the wearer. The sculpture is crowned with a headdress of feathers and porcupine quills, and the masker wears a fiber collar and costume. In the hands is held a wooden billhook and a buffalo horn. For the Bembe, the mask is at once an *ebu'a* (something hidden, mysterious and unrecognizable) and a *m'ma* (an ancient spirit of the bush). Several boys of the same lineage group are collectively taken into the *alunga* society. They are initiated into the mysteries of the mask, worn during the initiation ceremony when new members parade toward the village. At regular intervals the masker will make known the wishes and desires of the society. The mask only operates as an instrument of social control for internal order, group cohesion, and the just division of duties and privileges. (C.P.)

Lit.: Biebuyck 1972; BIEBUYCK (p.193)

works used in these contexts contributes significantly to the impossibility of reading improvised meanings into these works. Many additional factors enhance the total element of secrecy: seclusion away from the villages and hamlets; vital activities taking place in a closed initiation house; special timing (early morning, evening, late night); complete exclusion of non-members or lower-ranking members if initiation is to a higher grade; unusual procedures and esoteric and unexpected interpretations of otherwise well-known acts and words. The sacredness of the procedures is illustrated and enhanced in numerous ways: initiations are surrounded with a mystique, a salutary but potentially dangerous and destructive force of their own; the rites, the words, the actions, the objects are imbued with a force of their own and are surrounded with omens and prohibitions and the threat of sanctions, some of them immanent in nature. As in the Greek mysteries those who carry the initiation objects are *hieraphoroi*, bearers of sacred things. In some cases, noninitiated persons who accidentally enter into even indirect contact with the bearer of the sacred objects are guilty of *itala*, a serious offence of "exposure" or "ritual pollution" that requires expiation (fines, threats, induced initiations, etc.).

Bwami (of the Lega and Bembe, elsewhere also called *bwami* or referred to by other terms such as *bukota, mbuntsu, mpunju, esambo*) is the most widespread and most complex voluntary association in this region. In fact, some independent associations in diverse ethnic areas are merely autonomous stages of *bwami*. However, there are other very important though more locally distributed associations such as *alunga, elanda, buhumbwa, butendamwa, bute'i* and *mpunga* among the Bembe; *lilwa* and *ekanga* among the Mbole, Lengola, Yela and some Lokele and Lalia groups; *bukota* of the Mitoko, Lengola and some Songola and Southwestern Komo; *mbuntsu* and *mumbira* of the Nyanga and some Hunde groups; *butumma* of some Nyanga and Komo groups (such as Baasa and Batiri); *esambo* of the so-called Ngengele and *nsubi* of the Songola or Northern Binja; *nsindi, mboho* and *isumba* of the Pere.

The Initiation Objects and the Art Works

A large variety of objects (things directly derived from nature, with or without minor modifications, manufactured items, and art works), some permanent, some ephemeral, occur in all initiations of the Lega cluster. The art works do not merely include diverse types of masks, but other sculptures as well, such as anthropomorphic and zoomorphic figurines, anthropomorphic and zoomorphic so-called trumpets, beautifully carved stools, scepters and staffs, miniature renditions of weapons, tools and implements, numerous ephemeral but artistic constructions in perishable materials, and exquisite body adornments, from body paintings to the paraphernalia for dance and the badges of office. But the density and nature of the geographical distribution of these various kinds of art works differ greatly.

Among the artistic manifestations, masks and or mask-like face-paintings are significant and seem to be dispersed throughout the cluster, although in highly different types and numbers. However, any discussion of the artistic productivity in this part of Africa must take into account the fact that the masks constitute only a small fraction of the total sculptural output and that involved ornamental, pictographic, architectural, musical, choreographic, dramatic, verbal and other artistic creations are correlated with them. These facts must be constantly kept in mind in the appreciation of the artistic contributions of the region, even though they cannot be analyzed in the context of this short article.

The masks sometimes have usages and functions outside the initiations and the related socioritual and juridical activities of the associations. This obvious fact has led some students of African art to confuse their primary and principal context with a more casual, corrolary activity. These masks are foremost the exclusive attributes and possessions of persons involved with the initiation rituals and the resulting associational groupings. Since persons concerned with these initiations are in leadership positions within the entire Lega cluster it is possible for them to use one or other mask as part of one of their leadership functions. Thus one or other mask can and does occur in a burial ceremony, a circumcision rite, a healing or divination session, or the settlement of a major litigation.

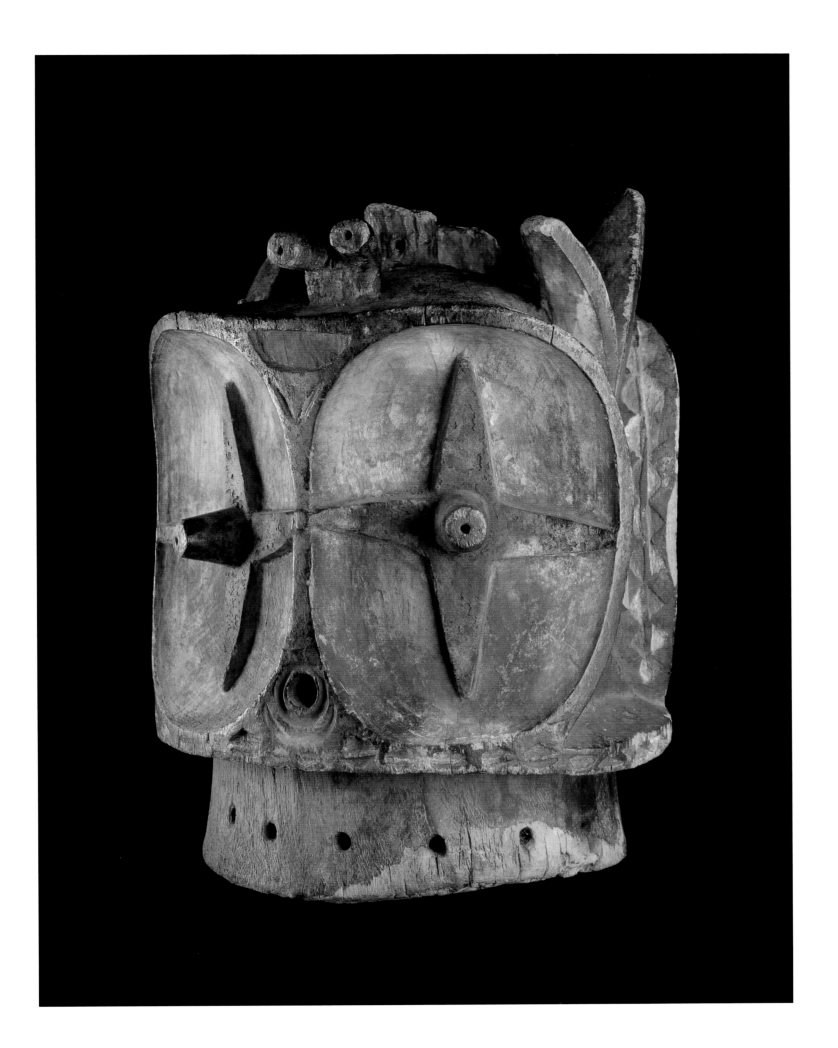

93
LEGA

Zaire, Kivu
anthropomorphic face mask
idumu?
H. 29.5 cm. Wood, pigment, fiber

The Lega live in the east of Zaire. Their authority structure is not centralized, having patrilinear clans consisting of different lineages. An important element that contributes toward the creation of their social cohesion is the *bwami* society. As a rule this consists of six grades, and within the two highest — the *yananio* and the *kindi* — are still other ranks. The *bwami* charges its members to strive for a line of moral comportment wherein the good, the true, and spiritual perfection stand central. To attain this the members learn in a stepwise fashion, obeying the rules applying to their respective ranks. Among other means, this knowledge is imparted via all manner of proverbs and aphoristic songs. At the same time they would manipulate a diverse array of objects, including statues and masks. These objects function as aids in the acquisition of spiritual knowledge. The manner by which they are later revealed to or used with the initiates, awakens the intended associations in them. The masks call up memories of the virtues to which their fathers strived, and the faults that they fought against. The reproduced mask (cat. 93) is probably of the *idumu* type and the two others (cat. 94 and 95) are *muminia* masks. Both mask types are constituent ritual objects of the *yananio* and the *kindi* ranks. These masks are the personal and hereditary property of the initiated, or are part of the collective property of the associated group. In the latter case, they stand under the care of a leading member of the *yananio* or *kindi* ranks. The social significance of these masks is far more important than their ritual value. They are primarily social symbols, signs of recognition and tools of instruction. The *muminia* and the *idumu* masks are worn on

Apart from the face-paintings that occur, for example, in the *buhumbwa* association for women and the *butendamwa* for men among the Bembe, the female face-paintings for women in some *bwami* rites, the men's face-painting in the hunters' *butumma* association of the Nyanga, the typology of masks in this area is as follows:

Carved Masks

Masquettes in wood, ivory, elephant bone, rarely in some other material like copal (cat. 96-99); the masquettes cannot cover a face unless several of them are used together with their appendages (fiber beards) and other paraphernalia. Patination of these objects is of the essence, although some of the wooden ones have whitened, rarely reddened, faces.

Wooden face masks, large enough to cover a human face (cat. 94-95), with or without appendages and special costumes. The faces of the masks may be whitened or blackened, some are reddish; few exhibit carved designs, such as dotted lines or waffle-shaped patterns.

Large wooden face masks (mostly bichrome), too large to merely disguise a face, but capable of covering part of the upper body or serving as some form of towering headdress.

Polychrome plankboard masks in wood, too narrow to cover a face without additions (cat. 90). Some of them are similar to small rectangular or ovoid shields (and are called *ngabo*, the term for shield); in dance contexts they may be carried like a shield.

Bichrome or polychrome helmet or bell masks in wood, made to cover the entire head (cat. 91); the elaborate fiber costumes attached to them cover the entire body of the wearer. Some of them have no open eyes, merely a hole through which the masker can peak to oberve the movements of a dance guide.

All carved masks, except the ivory and bone ones in the masquette group do have appendages and accretions such as fiber beards, headdresses, collarets, hides, and some have distinctive costumes and other paraphernalia (most of these additions are not available in collections). Nowhere, however, are these additions or accumulations developed as they are among the Pende or Chokwe in southwestern and southern Zaire.

The sculpted masks represent in various degrees of stylization the human face, mostly rendered in the for this area typical concave heart-shaped face style, a narrow nose bridge dividing the face into two more or less equal ovoid planes. Some masks, however, deviate from this pattern in that they are flat or barely show some concave outline. Animal faces are extremely rare, if at all traditional. However, both among the Lega and Bembe some of the human face masks have carved horns; such masks are rare and have special functions and meanings to represent a variety of characters. (It is naive to think, as some authors do, that such masks necessarily represent some horned animal). Some of the masks although clearly inspired by a stylized human face take the appearance of something *sui generis*, when they occur in a performance context with a multitude of hides, feathers, quills, etc.

Construction Masks

Few of these masks are known in collections and in the literature, partly because in the past some were extremely scarce in the societies where they occurred, others were ephemeral (dismantled and discarded after use) and extremely secret (that is, they were rarely if ever seen in public).

Various construction materials may be used to manufacture these masks (which often appear as hoods) such as hides, feathered snakeskins, cloth, barkcloth, bark, beads, cowries, quills, raffia and other fibers, dried grasses, frameworks in wicker, thick layers of colors and resins, etc. Some construction masks cover the face, others encompass the entire head like hoods, still others are huge transformation devices comparable to the little known gigantic construction masks of the Pende. The best known among these masks are the *elanda* association mask of the Bembe, and the *mukumo* circumcision masks of the Nyanga.

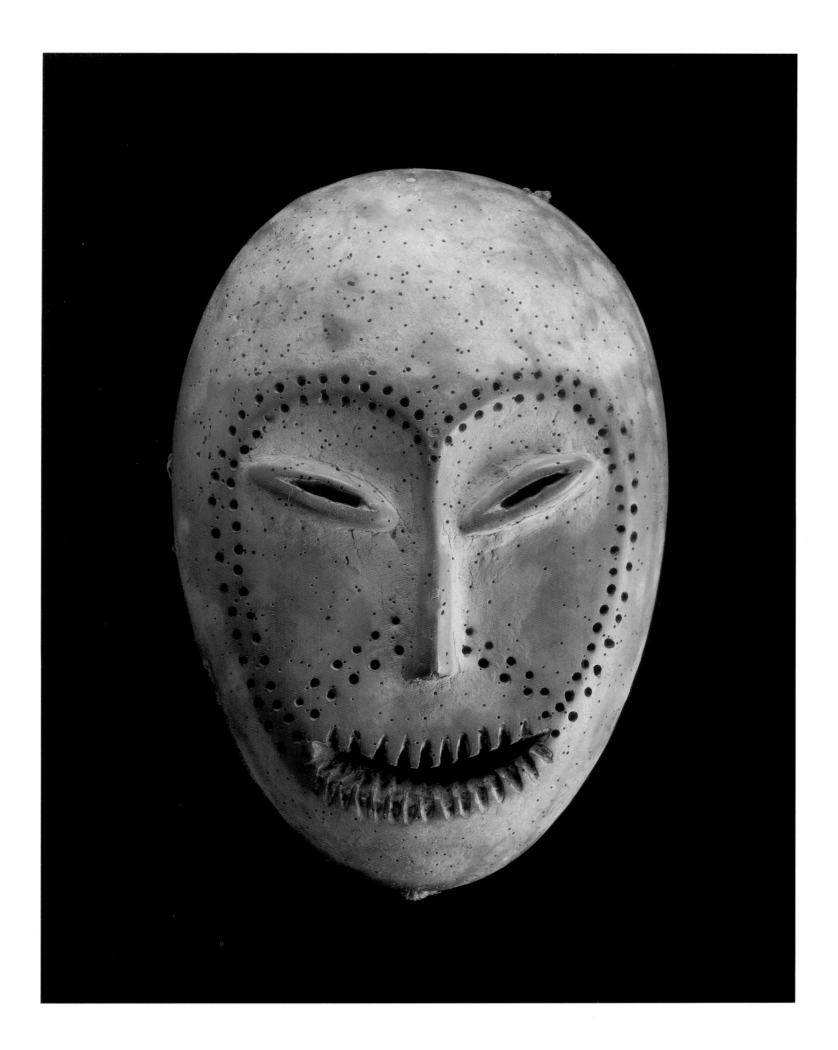

The Masks and Their Uses

The manner in which these various types of masks are used differs considerably. Here a distinction must be made between the masks used during different stages of the initiation ceremonies and, whenever this happens, the masks in public performance. Some masks are obviously worn to cover the entire face, or part of it, or the entire head, or even part of the upper body. Others, particularly the masquettes are not primarily made to be worn before the face. If worn they may be attached to the head, the forehead, the temples, the hat or belt; but often they are carried, hung up from a pole or a fence or placed on the ground and displayed in a heap or a file.

On rare occasions, all participant initiates carry a masquette on the forehead, the beard hanging before the face, the body dressed in white cloth. In other instances, a preceptor and his aides may wear several masquettes fixed to their hats and dress in a multitude of hides and feather-trimmed snake skins. Such masks, as the Lega masquettes, clearly do not function primarily as devices of transformation and transfiguration, to be worn by impersonators, that is by persons representing other beings such as divinities, ancestral and nature spirits, monsters and animals. The person handling the mask is not transformed into some other being, but by means of the mask and its various forms of manipulation is able to present a vast spectrum of honorable or reprehensible characters, not merely presented as human but disguised under animal names and abstractions.

Masks that are regularly worn before the face or over the head are usually seen, in and outside the initiations, in some form of dance movement; they also exhibit characteristic dance steps and gestures. Some are completely silent, others like the *alunga* (cat. 91) and *elanda* masks speak in a specially learned, raucous voice, or like the circumcision masks of the Nyanga hum as they pass by while their unmasked assistants sing in a particularly strenuous manner. Distinctive musical instruments are associated with the dance masks. For example the *alunga* mask is accompanied by one horn and three drums with double membranes that are carried horizontally by the drummers; the *elanda* mask is accompanied by stick percussion and the *mukumo* masks of the Nyanga by drums and message sticks.

When not worn some masks are carefully stored in bundles or in shoulderbags, others are in caves, or in shrines built outside the villages, or against the ceiling of men's assembly houses; still others are simply dismantled and most of the materials discarded after a performance.

Functions and Meanings of the Masks

From the outset it must be recalled that the masks primarily function within the closed contexts of the initiatory and related activities of closed associations. It must also be realized that virtually all masks, like so many other artistic creations of Africa, are polyvalent in function and polysemous in meaning. We have often assigned single, simplistic functions and superficial meanings to African art works and other material manifestations, merely because of our lack of in-depth information on the total context and range of their occurrences, or our Western tendency to set up clear-cut categories. Guesswork (of which there is plenty in the literature) is particularly misleading. Part of the difficulty in interpreting the facts is precisely due to the elastic and wide-ranging use of the masks, and the hazards involved in trying to penetrate the highly esoteric milieus in which they act.

Masks that are essentially linked with certain levels of covert activity in a voluntary association or semi-secret association may be used occasionally outside this framework, say in funerals, judicial procedures, ordeals, healing or divination ceremonies, and the preliminary and postliminary rites for boys. These occurrences are due to the fact that the members of the associations, as elders, leaders and persons of status are involved with many of these essential ritual and social activities.

The masks are owned by members of diverse grade levels and specific skills and privileges within the organizations that preside over the initiation rites. The patterns of ownership, individual and collective (in various shades of group involvement), and of acquisition (through inheritance, commissioning or purchase) represent extremely intricate social arrangements. Art, instead of being or becoming an instrument of personal wealth and prestige, is considered to be an element

94
LEGA
Zaire, Kivu
anthropomorphic face mask
muminia
H. 25 cm. Wood, pigment

the face and on the back of the head, hung on a frame between smaller masks, or placed upon symbolic graves. Morphologically the *idumu* mask is a larger replica of the *lukwakongo* mask (cat. 97 and 98). *Idumu* means ancestor. Among most Lega groups the mask is kept together with other ritual objects in the collective sacks, called *mulama*, of the *yananio* rank. The *muminia* (cat. 94) was property of the Banamungini clan and was photographed on-site, hanging on a frame. Around the eyes traces of kaoline are still visible. The Lega would apply this white pigment to their faces when preparing for battle. The format and the form of the face mask (cat. 95) suggest that this too is a mask of the *muminia* type. More detailed information concerning this mask's use and function is lacking. (F.H.)

Lit.: Biebuyck 1954; Biebuyck 1973a; Biebuyck 1986; BIEBUYCK (p. 183)

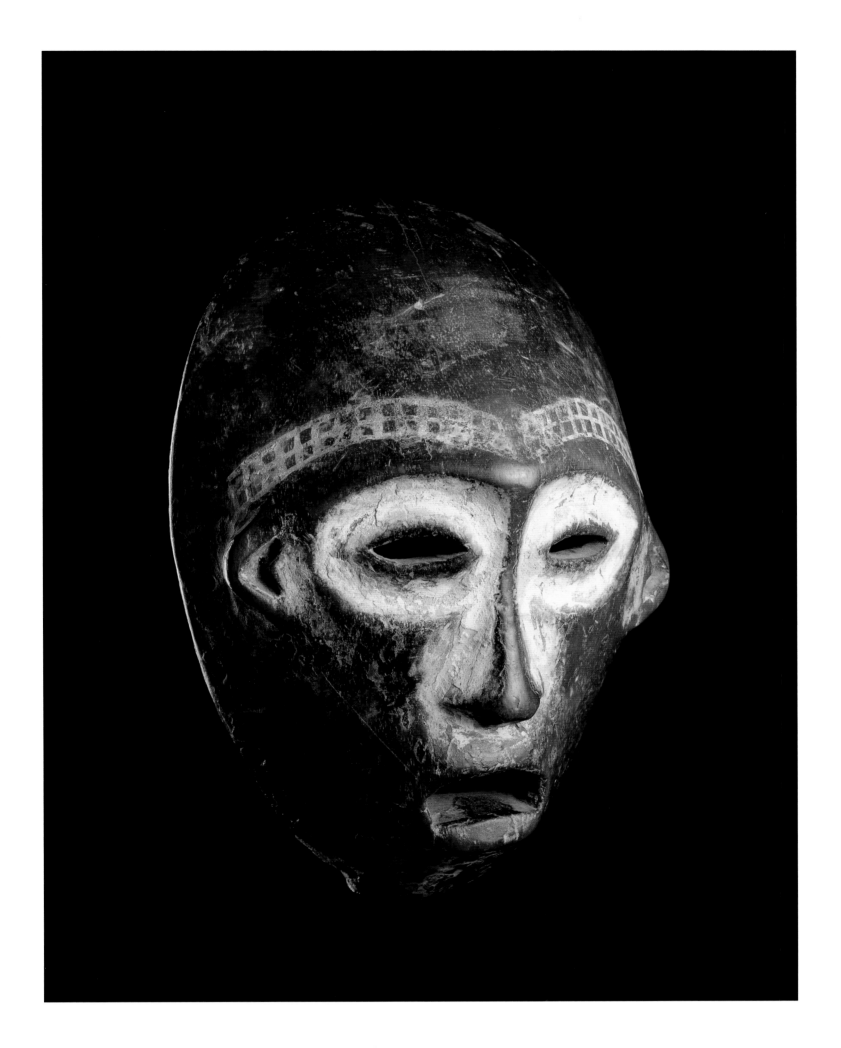

of social cohesion, solidarity and in-group spirit. The art works, in this case the masks, are furthermore initiation devices whose purposes and meanings are revealed to the initiates; they constitute a visual system by means of which deep thought, philosophical, moral and social values are conveyed in not immediately readable form to the initiates. Most of the revelation of these codes of knowledge and conduct is done in highly dramatic enactments, in a piecemeal manner and in aphoristic songs. These terse, metaphorical and metonymical statements allude to the forms, the primary materials, the components, the movements, the particular manipulation of the objects, the costumes, the beings represented by them and honored or ridiculed through them.

As exclusive objects the masks are elements of rank, status, privilege and prestige. In cultures like the Lega the masks are owned individually by initiates of a certain level, or guarded individually on behalf of a larger community of initiates by a ranking member of the group or by one who has special dance and/or singing skills. Among the Bembe the ownership of an *elanda* mask by a particular community implies several privileged positions: that of the person who has learned to dance with it (and knows its special voice pattern), the person who is in charge of guarding the mask and all its paraphernalia in a shrine located outside the village, the person charged with carrying the mask bundle to a place where some initiation or other performance will take place, the persons allowed to chaperone the bearer of the mask bundle, etc. Among some Bembe, the community that owns a mountain complex (associated also with its distinct ancestral and nature spirits) also possesses its own *alunga* mask.

Thus many masks, but not all of them, are indicators of social solidarity and unity within lines of common descent, extended families, larger kinship groups, such as lineages and clans, and even across kinship lines. Whichever other linkages they may have, persons and groups become ritually and even mystically linked together through their common allegiance to a mask.

Some masks, but not the majority of them, act as agents of social control: they establish a superior, irrefutable authority, they render justice, impose fines, compel forced entrance into an association; in some cases they may even administer the poison ordeal to a recalcitrant person or one accused of sorcery or witchcraft. The social control function of select masks is very prominent in this area. The *alunga* mask of the Bembe is a case in point (cat. 91). On some occasions the mask may come to the village for some form of entertainment, in the course of which the members of the association under the leadership of their mask obtain much food, drink and other gifts. But more often *alunga* comes to the village to settle a dispute and to impose fines; this happens particularly when a member of the association has been wronged, if a quarrel between two individuals or families cannot be settled through the regular modes for maintaining law and order. Among the Nyanga, the masked circumcisors are essential at the critical moment when the young men must be taken away from their homes to be circumcised in the bush. This generally leads to a pantomime whereby the mothers refuse to let their sons depart, until instructed by the masks to let them go. In a somewhat similar vein, construction masks among the Pere ambush one of the boys to be circumcised and carry him to the sacred stool where he is to be operated upon. Masks that occasionally are seen in a seance of divination, or at a funeral of an important member of one or other association, or at a poison ordeal, or at a public gathering are, in one way or another, manifesting their social control functions.

In some instances, ancestors, nature spirits and other transcendantal beings are honored and placated through masks, when e.g. sacrifices of chickens or libations of beer are made over them in the context of a ceremony intended to placate them or to obtain their goodwill. Without being classifiable among the so-called fetishes or power objects, as they occur in great quantities in southwestern Zaire, all masks (and also other art works, paraphernalia and simpler manufactured or natural objects) are permeated by a mysterious force, a force that is benevolent to those that have the knowledge of the masks and that is potentially detrimental to all others, striking them with mysterious diseases. In fact, many initiates when asked why they joined this or that association will refer to some mysterious disease that suddenly affected them after some form of "illicit exposure" that could be overcome only through adoption into the mask society.

Masks also function as media that create fear and bewilderment. For example, when a person is initiated into the *alunga* secrets, he is led around in the bush or forest for hours searching to find

95
LEGA
Zaire, Kivu
anthropomorphic face mask
muminia?
H. 28.5 cm. Wood, pigment, glass beads

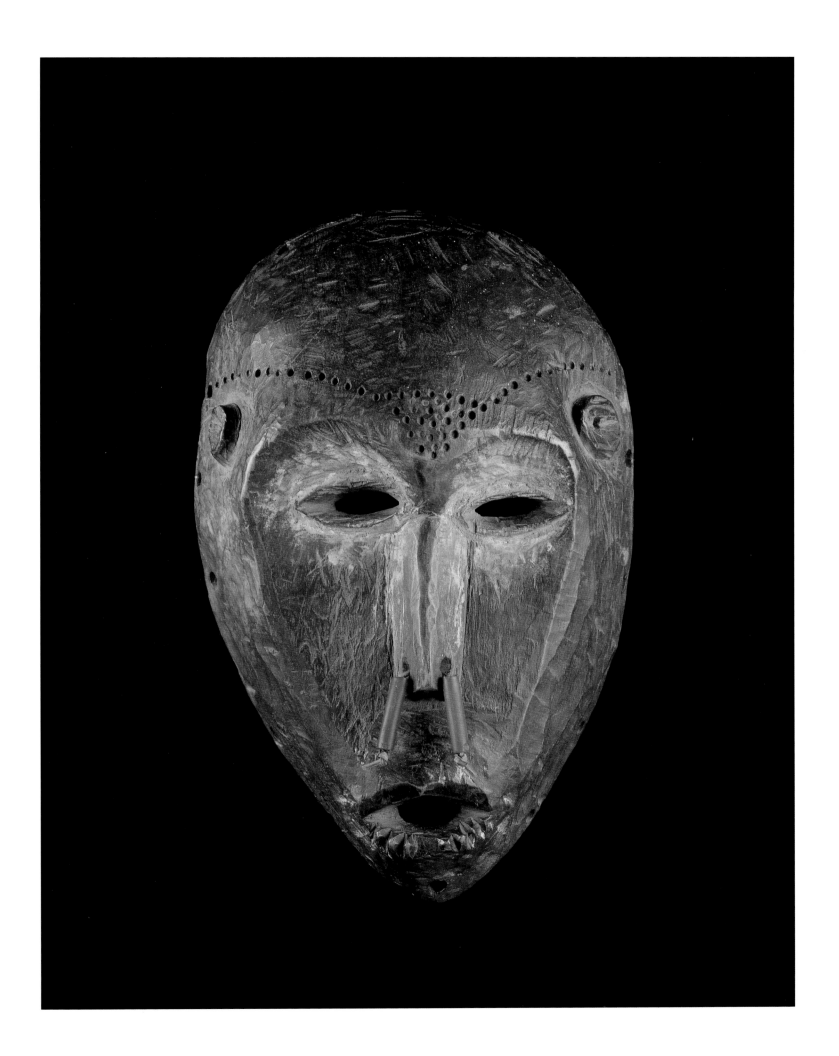

alunga, whom he hears now and then, but cannot see. Finally, totally bewildered and desillusioned the initiand is brought to an initiation house outside the village where the *alunga* masker is waiting for him. The initiand is not yet familiar with the real meaning of the mask; the masker is presented to him as a devouring lion, as "something" that is both lightning and lion. (The initiates sing: "Something comes from the mountain you are looking, lightning and lion come thence, you must flee.").

In general, the African language nomenclatures developed around masks, and more broadly around African art works, are insufficiently studied. The same holds true for the texts which, in the Lega cluster, are frequently formulated in highly synthetic proverb-like statements, in a difficult language. Songs of the *alunga* association, for example, frequently mingle in a single sentence Bembe and Buyu words with archaic terms probably derived from the languages of the pre-Bembe hunters. This makes the understanding of these texts extremely difficult for any outsider, including uninitiated Bembe individuals.

The nomenclatures and texts contain many clues to the exact meanings of the masks. Among the Nyanga, Bembe and Lega I have had the opportunity to study some of these aspects, and the results shed special light on what a given mask or a category of masks may really mean, above and beyond the other complementary, sometimes even contradictory, meanings that result from actual contexts of usage. For example, the Nyanga construction masks used in the circumcision ceremonies are generically referred to as *iromberombe*, a term that has semantic affinities with the word for shadow (not necessarily the shadow of a dead person, but the shadow cast by a tree, or an animal or a person) and with a verb that connotes the idea of hazing, tormenting, harassing. It makes no sense to describe these masks as representing ancestors or spirits or (because there is a hornbill beak hanging from them) as bird masks. Rather the mask in its totality is deliberately made as a composite that includes, apart from the carving itself, hides of genets and hyenas, hornbill beaks, feathers, even a certain red fruit to denote that it is something special, something unique, something that comes close to the extraordinary figments of the imagination with which the Nyanga people their world. It is not an ancestor, but making the mask, dancing with it and using it in the right context, honors and pleases the ancestors who have prescribed the models for the masks and their behavior.

The nomenclatures used for the *alunga* mask of the Bembe also contain several clues as to its meaning. The mask is called *ibulu lya alunga*, the head (but *ibulu* is not a human or animal head, but some very special head as represented by the mask) of *alunga*. *Alunga* among the Bembe, who adopted the tradition from pre-Bembe hunters now widely scattered in small numbers among the Bembe and neighboring groups, is "something of the bush, something of long ago, something awesome and mighty" whose secrets the initiate is told must never be revealed. *Alunga* is not merely associated with the water, but with the entire wooded savanna that is a characteristic physical feature for some large part of Bembeland. *Alunga* is omnipresent. One Bembe tradition states that whenever they went to collect honey they heard *alunga*'s voice (*alunga*, a guardian of honey among the Mbote Pygmy groups) that scared them away. *Alunga* is an *ebu'a*, something hidden and mysterious. The mask and its complex costume of raffia fibers, civet and hyena hides, and headdress of eagle feathers and porcupine quills represent the mystery and complexity of *alunga*. Some cult practices in the areas where *alunga* occurs seem to indicate that *alunga* is a sort of super-spirit, one through whom all others can be mediated. Offerings and placation ceremonies over which *alunga* presides are addressed to the ancestors, to the ghosts of famed dead hunters and to the spirits located in the mountains and hills.

I have discussed elsewhere the bewildering terminology and the range of meanings that are associated with the Lega masks (large and small, in wood, ivory or bone, with beards and without beards, worn before the face or handled in other ways) (Biebuyck 1973a, 1986). The most frequently occurring masquettes, generically called *lukwakongo* and *lukungu*, derive their nomenclature from death and the dead (cat. 96-99). They are monuments for the dead, pleasant memories of the dead, objects of piety and continuity; the main idea being that the dead are not really dead but survive in the objects they left behind and in the mind and actions of their descendants who continue the traditions. The masks do not represent any specific ancestor or particular dead person as such; obviously they are not portraits. But they are heirlooms, that recall pleasant memories (*kasina*) of the dead initiates who preceded the current owners.

96
LEGA
Zaire, Kivu
anthropomorphic miniature mask
lukwakongo
H. 18 cm. Wood, pigment, fiber

97
LEGA
Zaire, Kivu
anthropomorphic miniature mask
lukwakongo
H. 15.5 cm. Wood, pigment, fiber

This type of small wooden mask is possessed by members of the *yananio* rank, more particularly of those who have obtained the highest level, called *lutumbo lwa yananio*. According to the Lega, the dead live on in the objects they leave behind. However, these masks are not representations of specific ancestors, but rather remembrances of deceased initiated members. For this reason they are always handed on. They are most often provided with a fiber beard, *luzelu*, a sign of long life. They are not worn on the face, but rather affixed to the head, on the forehead, the temples, on the headdress or on the belt. They may also be attached to a pole, to a frame, or displayed in configuration on the ground. Just as with other Lega masks, they are not used to transform the identity of the wearer. They serve as aids in the representation of various characters. Double-masks (cat. 98) are seen less frequently. A quite similar example is found in the Musée des Arts d'Afrique et d'Océanie in Paris. The form of the face and the red-brown color (combined with kaoline) of the reproduced double-mask, shows similarities to the face mask under cat. 95. (F.H.)

Lit.: Biebuyck 1954; Biebuyck 1973a; Hunn 1985; Biebuyck 1986; BIEBUYCK (p. 183)

194

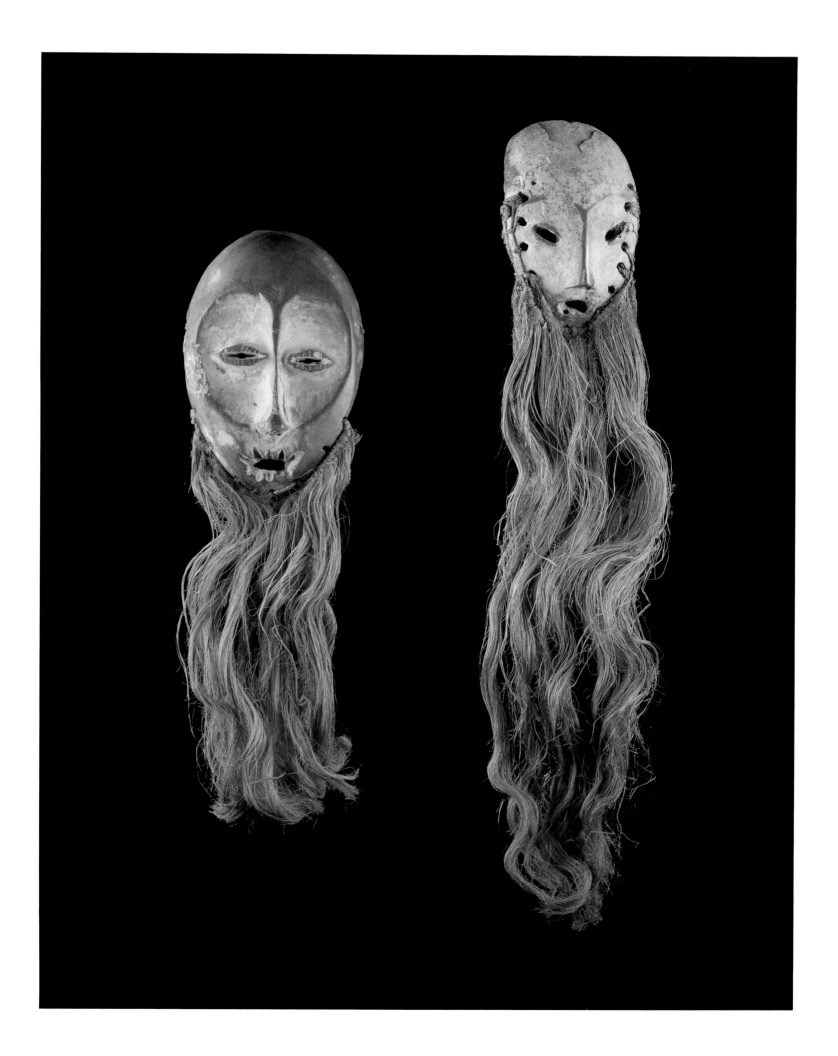

When all clearly known facts are put together, there emerge two fundamental aspects. In one set of instances the carved or constructed mask itself represents a complex, but rather vague entity, of surpassing mystery, with which a multitude of symbols are, or can be associated, in the dramatic context of the particular socio-ritual circumstances under which the mask performs. In another set of instances the masks are manipulated as devices by means of which the social, legal, moral and philosophical teachings, prevalent in a particular association and reflecting the will of the ancestors, can be demonstrated and transmitted in a mysterious, yet systematic, manner.

98
LEGA
Zaire, Kivu
anthropomorphic double-miniature mask
lukwakongo
H. 18.5 cm. Wood, pigment

99
LEGA
Zaire, Kivu
anthropomorphic face mask
lukungu
H. 10 cm. Ivory, pigment

Only one who has obtained the highest level (*lutumbo lwa kindi*) within the *kindi* rank is entitled to possess a *lukungu*. These facial representations are generally made in ivory or bone. Their design is similar to the wooden *lukwakongo* masks. The *lukungu* is not categorized as a true mask, seeing that it is held in the hand and not worn on the body. It, too, may be attached to a frame in configuration with other types of mask, including the large *muminia* mask (cat. 94). *Lukungu* means skull. Among the members of the *kindi* rank, this small sculpture awakens associations of the universality of death. The *lukungu* of a deceased member is first placed upon the grave, and then comes into the possession of a nephew or close blood relative. This makes of this small sculpture a symbolic medium, a bond between the deceased and its new possessor. (F.H.)

Lit.: Biebuyck 1954; Biebuyck 1973a; Hunn 1985; Biebuyck 1986; BIEBUYCK (p. 183)

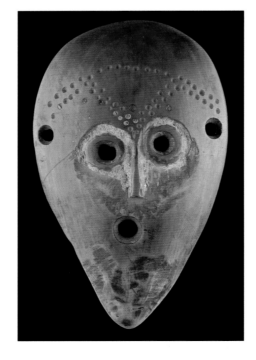

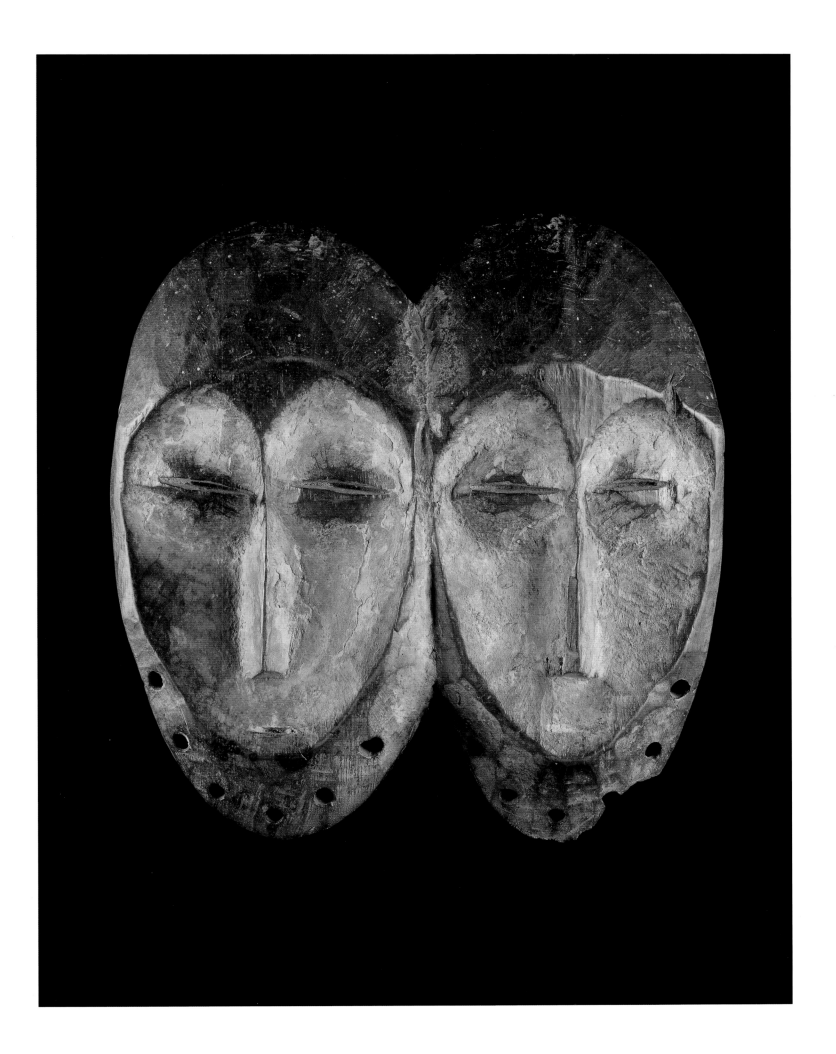

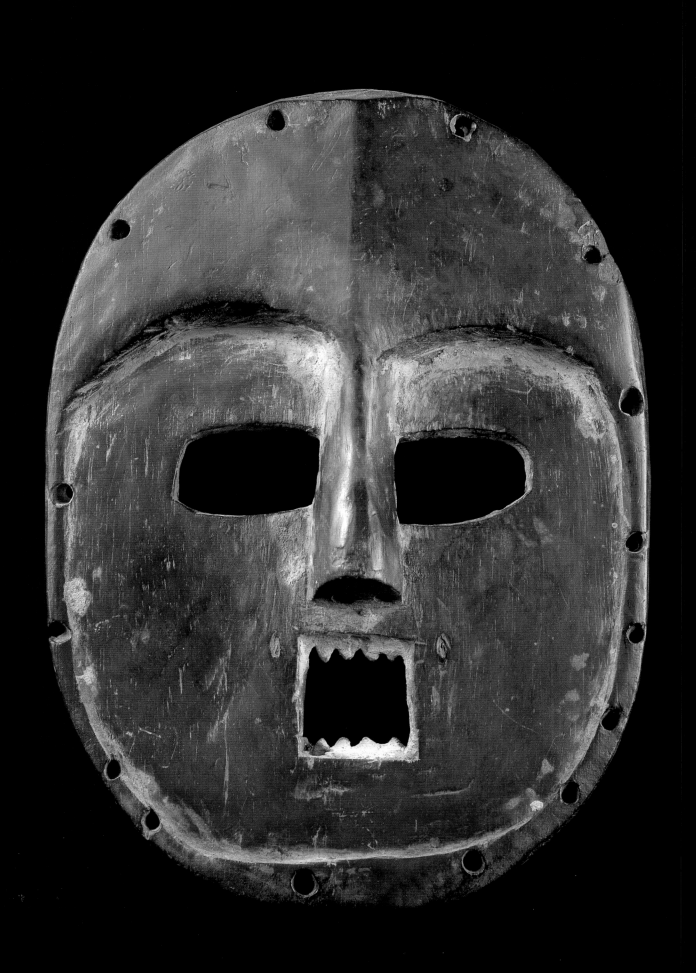

The Animal in Us: The Ubiquitous Zoomorphic Masking Phenomenon of Eastern Zaire

Marc Leo FELIX

The purpose of the following essay is to try to demonstrate the dominance in eastern Zaire of masks inspired by or depicting animals. The term "eastern Zaire" here refers to an area east of the mighty Lualaba River (which becomes the Zaire River as it flows westwards to the sea) which occupies a rectangle situated between long. 25° - 30° E and lat. 4° N - 12° S.

I will subdivide this geographical area into northeastern and southeastern Zaire at about lat. 4° S, roughly where the rainforests end and the savannas begin. This division is important, for while northeastern and southeastern Zaire share many common traits they are in fact culturally and geographically quite distinct.

Northeastern Zaire's ecosystem is made up of dense primary and secondary forests with a few hilly savannas on its eastern borders. The majority of its people speak a variety of Bantu languages classified under the C, D and J groups by Barreteau & Bastin (1978), but some speak languages of the Ubangian, Sudanese, and Nilotic families. The culturally dominant peoples are the Komo (or Kumu), the Boa, the Zande, the Mangbetu, the Bodo and the Lega, while the Pygmies, who were the area's earliest inhabitants and who still live in symbiosis with many of the above-mentioned groups, have left a visible cultural legacy to all of the peoples of northeast Zaire. The social structures are generally patrilineal and acephalic in villages which are relatively small and politically independent; population density is low. Hunting, fishing and subsistence farming are the main economic activities of the region. Historically the majority of its populations originated in the northern migrations of proto-Bantu, who were joined by peoples from the Ubangian, Sudanese and Nilotic language-speaking groups. These invaders merged with the aboriginal populations, most probably Pygmies, already *in situ*.

Southeastern Zaire's ecosystem, on the contrary, is mainly hilly savanna land dotted with small pockets of forest, with some wetlands and lacustrine areas. All the inhabitants speak Bantu languages classified by Barreteau & Bastin (1978) under the L and M groups. The two culturally dominant groups in the area are the Luba with their many subdivisions and clients, and the Lunda with their Bemba, Lwena, Lovale and Chokwe relatives. Traces of other cultural influences such as the East African Nyamwezi, Zaramo, Makonde, Yao and Chewa, as well as the South African Lozi and Ngoni, can be found in the typology as well as in the styles of traditional sculpture. Though few Pygmies remain, their cultural influence can still be felt. Societies are generally matrilineal and stratified with a tradition of powerful rulers. The generally large interdependent villages are densely populated and bound by client relationships.

Farming, fishing, some hunting, trading and a variety of crafts are the main economic factors of the region. Historically the majority of peoples now inhabiting southeastern Zaire originated in the southern migrations of proto-Bantu.

The distinctions between the two regions can also be clearly seen in the ritual artifacts produced in the last hundred years.

In northeastern Zaire these have been mainly masks as most of the peoples in the area seem to have used some type of mask over the last century. (It is impossible to ascertain whether they made them previously for no early 19th century samples are known). The sculpture of the human figure in the round is very rare in this area, but figurations such as the flat or high relief ancestor

100

KOMO

Zaire, Upper Zaire, Maniema
anthropomorphic face mask
H. 22.5 cm. Wood, pigment

The Komo, inhabiting the forest areas of the former Eastern Province, have a great degree of internal cultural diversity owing to their fragmented clan and lineage systems. Despite the existence of relevant ethnographic documents, information concerning the art of the Komo is extremely limited. The *esumba* rites encompass various closed initiations with the employ of sculptures and assemblages. However, masks seem primarily to be associated with divination. A mask-pair, called *nsembu*, performs during ritual occasions such as the investiture of a neophyte or the remembrance of a deceased diviner. The masks, personifications of the spirit of divination, are surrounded by much mystery, and may only be looked upon by those already initiated. The *nsembu* mask dance is the high-point of the nocturnal celebrations. Two masked figures perform an "arm dance" while still seated on a bench, during which their arms are contained within a structure of cane, bound with a cloth of tree bark. It should be noted that the mask shown here, similar to Lega pieces and therefore perhaps originating from the Southern Komo, cannot with certainty be linked to the *nsembu* tradition, owing to the lack of sufficient information. (C.P.)

Lit.: de Mahieu 1973; Biebuyck 1977; Biebuyck 1986; Felix 1989

panels found among the Komo, Nande and Hunde are most probably derivatives of masks (for examples of these panels, see Felix 1989: 271-272). These examples of early attempts to depict humans could be an evolutionary stage towards the carving of the human form in the round. When three-dimensional sculpture is found it is highly stylized.

In southeastern Zaire, on the other hand, three-dimensional figurative sculpture of the human image in a variety of forms or icons is the dominant visual art, and a vast range of sculpture in the round is produced by most of the peoples inhabiting the area. Masks, though present, are much rarer and, in contrast to the northeastern region, both masks and figures are rendered in a rather naturalistic style. Wishing to remain within the context of this exhibition I propose to limit myself to a study of the masks produced in the whole region of eastern Zaire, as defined in the first paragraph of this paper.

In northeastern Zaire, the first of my subdivisions, the picture is rather confused for the area is vast and has not been researched in depth. Recent discoveries have given us a better understanding of masking in some individual areas and by piecing this information together and adding it to what we already knew, a larger view of the production and use of masks in this region emerges.

Attempts to classify the existing masks produced some encouraging results and, though the scarcity and patchiness of the early information resulted in the inevitable lacunae and errors, we already know a lot more than we did a decade ago (Felix 1989). During the last ten years masks have been discovered among people previously believed to be unproductive of sculpture of any sort, and new types of masks have been found among peoples who were known to carve them. Also the stylistic subdivisions of the large mask-making groups are becoming clearer and, even though some confusion and blank areas still exist, preliminary conclusions can be drawn which I hope will be confirmed as new discoveries come to light.

An inventory of all the types of masks made in northeastern Zaire reveals that, contrary to general opinion, most peoples in the region make masks and that the great majority of these masks depict animals in one form or another. When the human icon is encountered it usually also has animal characteristics, symbols or patterns, or is used in conjunction with addenda from the animal world. The only animals represented in the northern part of the area are the ape, the leopard and the hornbill, while horned animals and the owl appear only south of the Equator — with the exception of a "freak" horned Liko mask. There are a few instances of masks used in male-female pairs (this icon can sometimes be encountered in the form of one mask with two faces or four eyes on one face).

Most of the masks are in wood, a few are in leather or bark, and the sculptural style is generally hyperstylized, or even abstract. All have painted surfaces, the most common combination of colors being a white background with red and black highlights, but some are ocher-colored. The masks are generally flat in the north, becoming deeper and noticeably more heart-shaped in the south. Almost all masks in the northern region carry a full fiber fringe surrounding the face while most of the southern examples carry only a beard.

Southeastern Zaire had been the subject of considerable ethnographic artistic and historical research since the early days of European colonization, even though no serious study of its masking as a regional phenomenon has ever been attempted. There is no comprehensive typological inventory of the masks used by the various peoples inhabiting the area, and their masking traditions have rarely been linked to those of other cultural groups in the surrounding areas, in spite of the clear evidence that masking in southeastern Zaire in all its different forms is part of a larger tradition that has its roots and extends its shoots far and wide.

Had I not limited my area of research on its western border by the Lualaba River, I would have included the various types of *kifwebe* masks (both Luba and Songye) for they are in fact anthropo-zoomorphic. I would also have included the lion masks made around Mwanza and the round anthropo-zoomorphic masks of the Western Luba. Around lat. 4°, which forms the northern border of my southeastern Zaire subdivision, we encounter among the Hemba (cat. 85-87), Buyu,

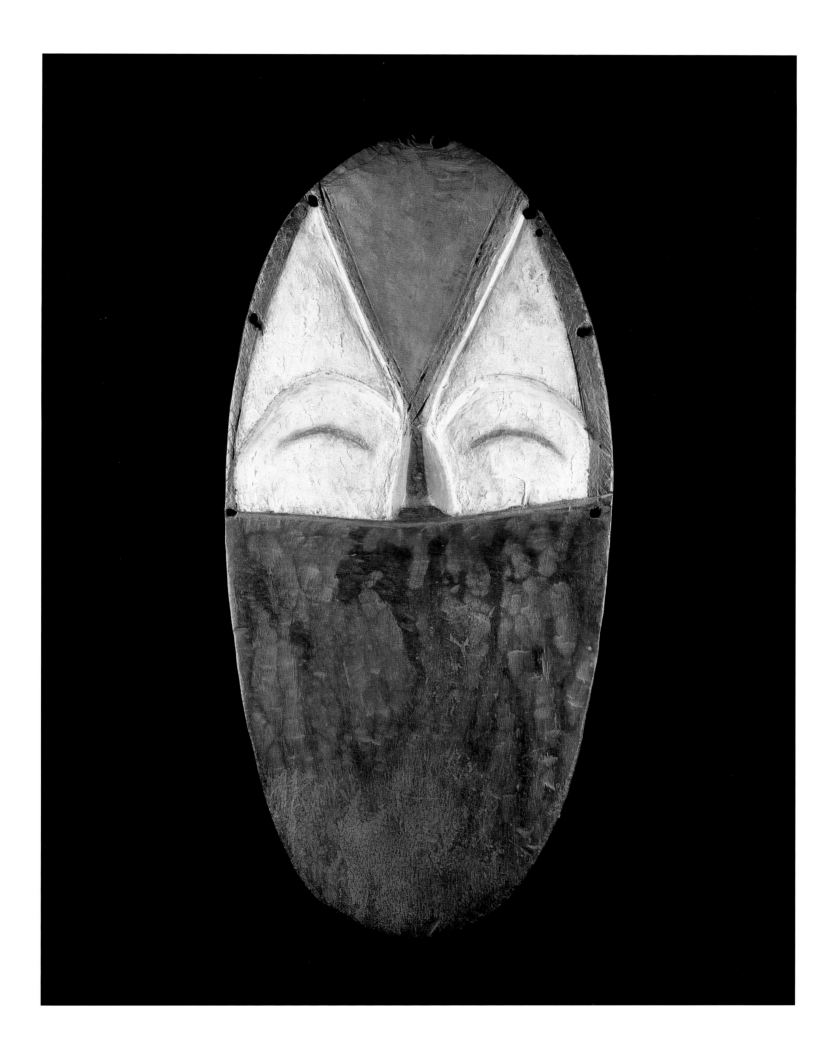

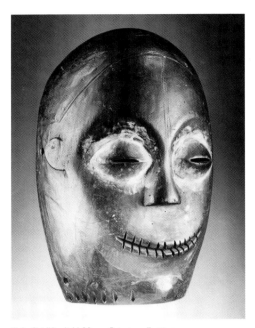

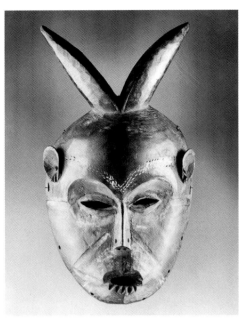

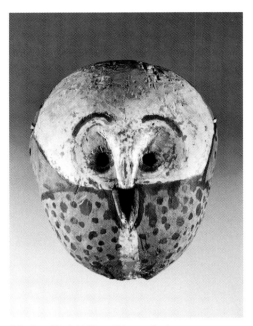

ill. 1. Shi (Kivu). H. 29 cm. Private collection.　　ill. 2. Nyindu (Kivu). H. 30 cm. Private collection.　　ill. 3. Pere (Kivu). H. 26 cm. Private collection.

Bangubangu (cat. 88) and Kusu the ape masks and leopard masks already found in northeastern Zaire. The Bembe (cat. 90) and Goma favor the icons of the owl and the ruminant overlayed on human figurations. The Hemba (cat. 80) and the Kunda make humanoid masks, whereas I believe that the striped surface of the bowl-like Luba masks (cat. 76), which apparently depict humans, proclaim their animal inspiration. What is certain is that the famous Luba mask of the Musée Royal de l'Afrique Centrale in Tervuren once had a bird figure on its crown and still has ram's horns, as can be seen in pre-war photographs — and is therefore obviously anthropo-zoomorphic (ill. 1, p. 170; see also cat. 79). The Luba of Kiambi depict a whole zoo in their *kifwebe*-style masks and in the Upemba marshes elephant, antelope and bird (heron?) masks have been found (Felix 1992a). In central Luba territory and around the Upemba Depression there are some round humanoid masks but further southwest animal masks once again abound, with a preference for horned species such as the buffalo (cat. 82) and the antelope, but also a few elephant and bird-shaped masks can be found. It is intriguing that in the vicinity of Lake Moero a human (female?) mask is danced together with an animal, possibly a buffalo (cat. 80 and cat. 81).

It can be said, therefore, that even though the human image is omnipresent it is often found in conjunction with animal representations. Furthermore, my recent work in Ituri (Felix 1992b), combined with previous research in Maniema and southeastern Zaire (Felix 1992a), has convinced me — a conviction that remains for the moment a working hypothesis, but one supported by certain important if fragmentary evidence — of the paramount importance of zoomor-phic masks in the early art forms of eastern Zaire as a whole.

At first sight most of these masks appear humanoid but closer examination reveals anatomical details such as closely-set eyes, an enlarged septum, an upturned smiling mouth (cat. 93), or a prognathous jaw that betray simian origins (see the Shi mask, ill. 1). Surfaces spotted with painted, scorched or engraved dots refer to the leopard (cat. 109), and certain shapes of noses and eyes are graphically bird-like (cat. 83, p. 23).

The most obvious of these masks depicting non-human beings are the horned ones and these form the first category. Since the horned devil is not part of the traditional Zairian pantheon, we can assume that they represent animals or zoomorphic spirits and that their presence implies that animals had a place in the belief system of their makers. It follows that some form of zoolatry or totemism is or was practiced in the area and that other zoomorphisms are probably to be found in the typological inventory of the ethnic unit. An example of these is the Nyindu mask (ill. 2) which, notwithstanding its obvious human attributes, such as a beard, probably depicts a rumi-nant of the buffalo or antelope families.

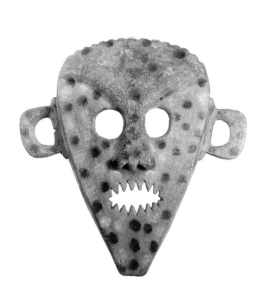

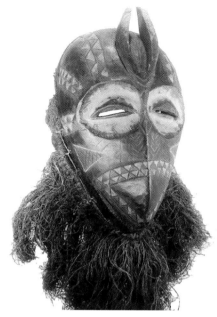

ill. 4. Boa (Upper-Zaire). H. 34 cm. Private collection.

ill. 5. Bembe (Kivu). H. 27 cm. Private collection.

The simian characteristics of the soko mutu masks of the Hemba (cat. 85-87) are obvious — even though some of these masks are polymorphic for the shapes of some noses will refer to bird beaks — but ape figurations are much harder to identify in certain Zande or Lega masks. Monkey-inspired masks form the second category.

In a third category the human icon is embellished with features from the avian world such as egrets, beaks, plumage patterns, owl-like eyes and beak-like noses (see the Pere mask ill. 3; see also cat. 90).

A fourth category covers the felines, the leopard being most frequently depicted either through the use of spots or the ocher color associated with that animal (see the Boa mask, ill. 4), while the lion can be suggested by manes or teeth.

The Eastern Luba produce now a whole zoo in an impressive series of *kifwebe*-style masks which represent rams, parrots, owls, hyenas, chimpanzees, baboons, chicken, roosters, lions, elephants, eagles, snakes, doves, buffaloes and a variety of antelopes (Felix 1992a). The buffalo masks of the Tabwa and neighbors are well known, as are the elephant masks from the Bwile and Bemba areas.

There are also masks representing either a combination of animals or animals that are purely mythical, such as the Bembe mask which certainly depicts a bird and a ruminant and probably also a human (ill. 5). Sometimes the animal reference can be metaphorical or achieved by means of symbolic designs or colors rather than shapes. Even more subtle zoomorphic references can be found in the costume or addenda to the mask where the use of feathers, pelts, horns, teeth and claws implies an animal or a combination of animals. (In Ituri some dancers wearing a mask and costume made of fibers and leaves were called birdmen. I failed to grasp the significance of the name until the mask was danced and the dancer mimicked a bird's movements). The inspiration can also be a spirit which may be a combination of forest animals, or of man and animal, and while an outsider will not decode these messages the iconographic and symbolic references to a given animal are obvious to a member of the group in which the mask was sculpted.

It is, as always, essential to establish what kind of piece was made by which ethnic group, and to this end I have drawn up a list of those peoples in eastern Zaire (starting in the north and finishing in the south) who we know produce masks, on a table (see p. 206) divided into the following columns:

Column l: Humanoid - anthropomorphic masks, either single males or females or pairs of faces.

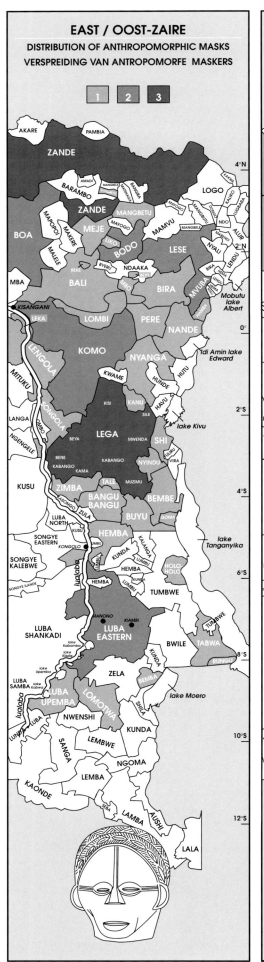

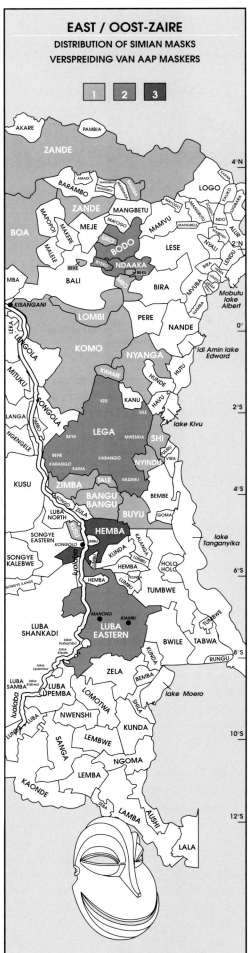

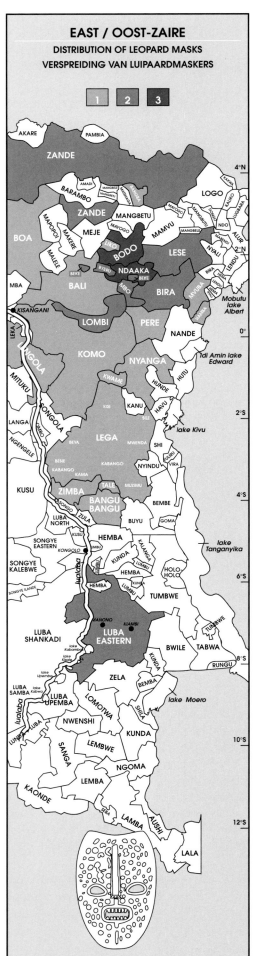

EAST / OOST-ZAIRE

DISTRIBUTION OF MASKS WITH HORNS
VERSPREIDING VAN MASKERS MET HORENS

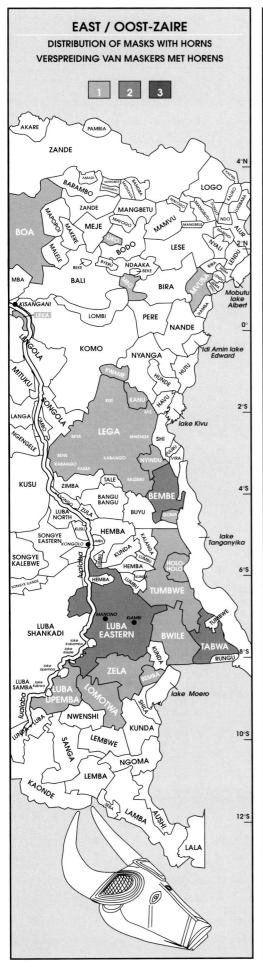

EAST / OOST-ZAIRE

DISTRIBUTION OF BIRD MASKS
VERSPREIDING VAN VOGEL MASKERS

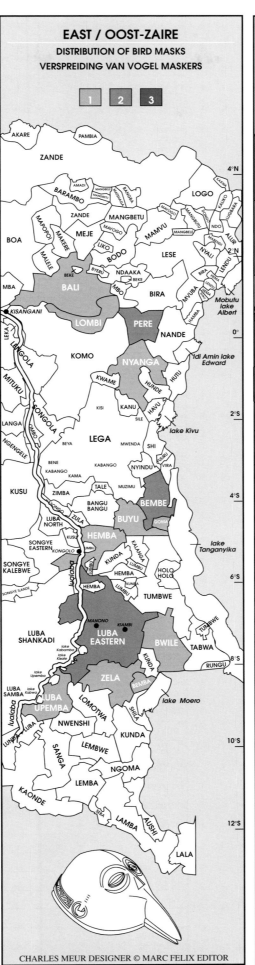

EAST / OOST-ZAIRE

DISTRIBUTION OF COMPOSITE MASKS
VERSPREIDING VAN SAMENGESTELDE MASKERS

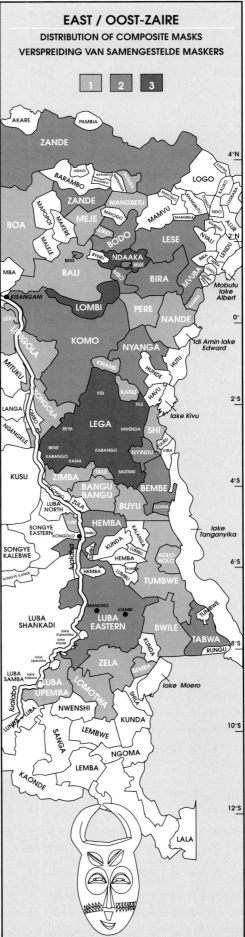

102

MBOLE or SONGOLA

Zaire, Upper Zaire, Lower Lomami
anthropomorphic plankboard mask
H. 75 cm. Wood, pigment

In the southwest part of the former Eastern Province live diverse ethnic groups with a long history of mutual contact and reciprocal influence. Pygmies, as well, have stamped their mark on the peoples of the region. The result of all this is a strong degree of cultural uniformity. In this area so-called "closed" societies occupy a preeminent position. They are characterized by a hierarchical membership and a complicated system of initiations. Among the Mbole people the *lilwa* society not only fulfills various functions of a political, social or ritual nature, but at the same time also acts as the principal commissioner of art works. Little is known concerning the organization and internal structure of the society. Scarce, too, is our knowledge of the art objects used within the scope of the secret initiation into the *lilwa*. For the rest, these objects seem to lead a hidden existence in bags, baskets, caves and shrines. There is no mention made of masks in the rare primary sources. The exhibited plankboard masks show, despite their mutual kinship, a surprising degree of diversity. The forms are simply oval or rectangular, and the polychromy is reduced to a minimum. The concise mirroring of facial traits makes it impossible to determine with certainty if these masks are anthropormorphic or not. The morphology of the example illustrated under cat. 103, unmistakably related to the so-called Lombi mask (cat. 104), is to a certain extent reminiscent of an owl's head. The attribution was based on comparability of style with the better-known sculptures of the Mbole, and indeed remains hypothetical. The example under cat. 101 does strongly resembles a mask classified as Mbole in the collection of the M.R.A.C., Tervuren. Although the example under

ETHNISCHE GROEP / ETHNIC UNIT	ANTROPOMORFE / ANTHROPOMORPHIC	AAP / SIMIAN	LUIPAARD / LEOPARD	VOGEL / BIRD	MET HORENS / WITH HORNS	SAMENGESTELDE / COMPOSITE
ZANDE	■	■	■			■
BANGBA		■				■
MANGBETU	■					■
LIKO	■				■	■
BODO	■		■			■
BOA	■		■			
MEDJE	■					■
LESE	■		■			■
BEKE			■			■
BYERU		■				■
NDAAKA			■			■
MBUTI		■				
LEKA	■				■	
BALI	■					■
MBO	■					■
BIRA	■					■
MVUBA	■					■
LOMBI	■					■
PERE	■			■		■
HAMBA	■					
NANDE	■					
LENGOLA	■		■			■
KOMO	■					■
NYANGA	■		■			■
KWAME	■					■
KANU	■					
SHI	■					
SONGOLA	■					
LEGA	■	■	■			■
NYINDU	■				■	
ZIMBA	■					■
KUSU		■				■
TALE	■					■
BANGUBANGU	■					■
BEMBE	■			■		■
BUYU	■					■
GOMA	■			■		■
HEMBA		■				
HOLOHOLO					■	
LUBA EAST	■					■
TUMBWE					■	
TABWA					■	
RUNGU	■					
LUBA UPEMBA	■			■		
ZELA	■					
BEMBA	■					
LOMOTWA	■					
BWILE						■

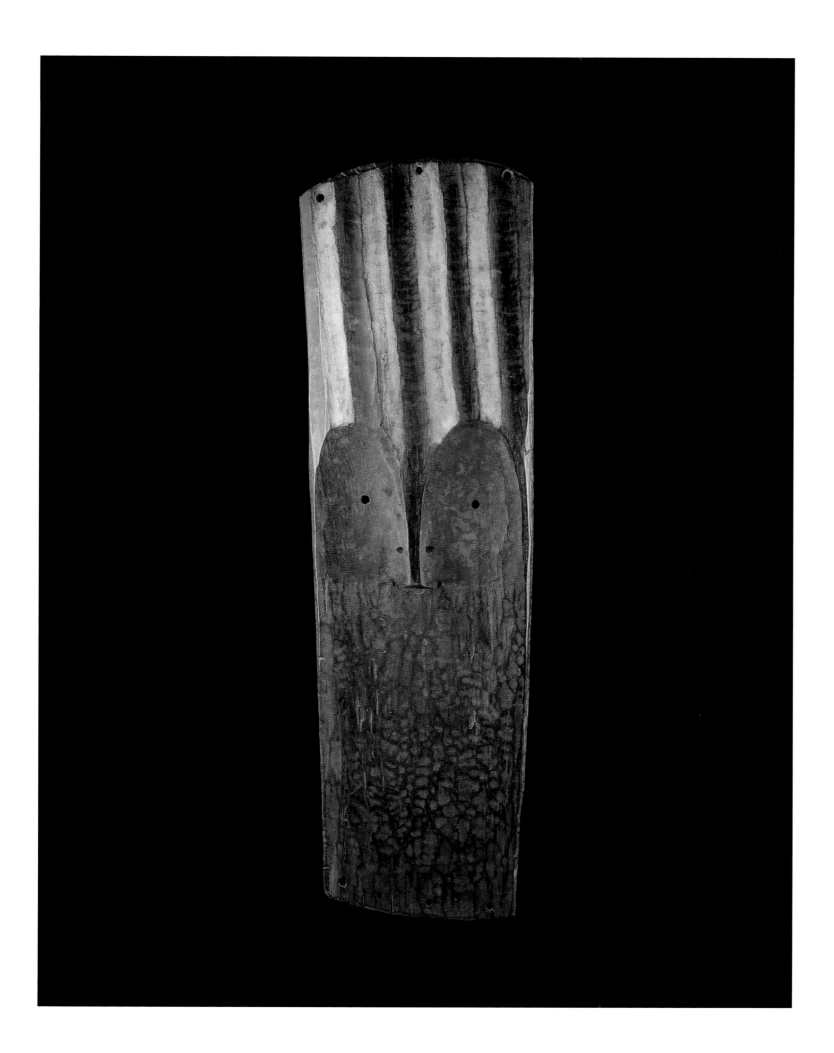

Column 2: Masks depicting apes.
Column 3: Masks depicting leopards.
Column 4: Masks depicting birds
Column 5: Masks depicting horned animals.
Column 6: Polymorphic masks representing a combination of animals or a combination of animals and humans.

It should be remembered that for the purposes of this study these masks are taken at face value, but that *in situ* their exact meaning varies according to the function and the degree of initiatic knowledge of the onlooker.

Column entries are made as follows:
1 = only a few masks of the type are known;
2 = several masks of the type are known;
3 = a considerable number of masks of the type are known.

When a category of mask does not figure in the table it means that until now no masks of this type have been found among the ethnic groups in question. This evaluation of mask typology is based solely on my interpretation of shape and is thus subjective.

This inventory was made in the "ethnographic present". This means that a certain type of mask, though unknown today, may well have existed in the past. It also means that masks found today have not necessarily always existed in their present form, for peoples can borrow ideas from their neighbors or invent new forms and abandon old ones in the never-ending process of cultural evolution.

This table is preceded by a series of maps on which the distribution patterns of each category of mask is traced, the density of the pattern indicating the frequency of encounter. I hope that the table and the maps, when consulted in conjunction with each other, will prove instrumental in arriving at some preliminary conclusions which may help to better our understanding of this area and its peoples.

Study of the preceding maps and tables confirms that most of the Bantu-speaking agrarian populations of the whole eastern region of Zaire make masks and a majority of them refer to animals. They are used in a variety of ritual contexts, the principal one being initiation. This can take many forms and the following are some of the main initiatic ceremonies during which masks are used.

1. The series of rituals during which young males pass from boyhood to manhood. In this case the masks are worn by the initiators.

2. The initiations preceded or accompanied by circumcision. Here the masks are worn by the circumcisers.

3. The rituals accompanying the induction of adult members of both sexes of an ethnic unit into an association which has philosophical, political or ideological motives. In this case the masks are worn either by the initiators or by a high-ranking member or members of this association.

4. The ceremonies marking the different levels attained by apprentices during their initiation into the secrets and practices of crafts such as divination or healing. Here masks or pairs of masks are worn by the instructors or high-ranking members of their guild or trade brotherhood.

5. The rites during which additional knowledge is imparted to previously initiated members of an esoteric association in order that they may advance to a higher rank or grade within the association.

Apart from initiation, however, masks have many functions. A mask may serve as an emblem of rank to be displayed by its owner as proof that he holds title or rank in an esoteric society. Masks

103
MBOLE?

Zaire, Upper Zaire, Lower Lomami
anthropomorphic plankboard mask
H. 32.5 cm. Wood, pigment

cat. 102 has been more than once published as Mbole, Marc Felix has attributed it to the Songola, neighbors of the Lega, the Mitoko and the Lengola, among others. The Songola adopted the *bwami* society from the Lega, and the circumcision ceremony from the Komo. Masks were made use of in the initiation rites of the *nsubi* society; this is presumably comparable to the *lilwa* of the Mbole. Sculptures of the sort shown here would more particularly have been the property of the highest rank within the society and worn by the executioner. Among the Mbole, according to Daniel Biebuyck (1976b), masks possibly played a role in the circumcision rite. Contrarily, François Neyt relates that they are worn by executioners of the *lilwa* society during executions and ritual processions in the village. With the help of the masks, ancestor spirits can mingle in the society of the living, in order to command the ritual silence of the neophytes. Given the shallow form, however, it seems rather unlikely that the masks were worn as face masks. (C.P.)

Lit.: Biebuyck 1976b; Neyt 1981; Biebuyck 1986; Felix 1987

LOMBI?

Zaire, Upper Zaire, Ituri
anthropomorphic face mask
H. 34 cm. Wood, pigment

This mask has been recently provisionally attributed to the Lombi, a little-known population group from North Zaire. Characteristic is the assymetric division of the surface into black and white sections. The two pairs of eyes of different form provide it a "double sight", and imply divination and clairvoyance. The intention is to relay the possibility of seeing into the future and the past, into the worlds of the living and the dead. The same ambivalence is found, among others, in the four-eyed mask attibuted to the Bembe (cat. 92). Masks among the Lombi are worn by diviners, during initiations of the *mambela* society, and for the funerals of members of this society. Because of the lack of descriptions of these masks, it remains unclear if the example shown here indeed functioned in connection with divination practice. (C.P.)

Lit.: Mestach (*in* Maurer 1991: 136, no. 66); Felix 1992b

are danced on a wide variety of occasions both sacred and profane (though this last appears to be a recent development) including the ceremonies at the beginning and end of an initiation cycle, the enthronement or appointment of dignitaries, the funerals of important people, religious ceremonies or festivals, dances celebrating healing or divination and the gatherings of members of associations or brotherhoods.

They can be worn during performances of the dramatic sketches which are staged for moralistic or didactic purposes. Not all masks are made to be worn for some are used as teaching aids to divulge their symbolic and esoteric messages to apprentices. Male-female pairs of masks can be kept in shrines where they come to represent the portraits of real or mythical ancestors and are worshiped accordingly. In rare cases very old masks are retained as power objects to be venerated as relics of the past. Loaded with long-accumulated power, they can be used to impregnate new masks with their special force. In most cases it is the men who wear the masks, but though women seldom wear them many possess a mask as an emblem of rank.

At face value the masks of eastern Zaire depict the following icons:

> a human, a man, a woman;
> a couple or pair of humans;
> an animal;
> a composite man-animal;
> a composite of man and several animals;
> a composite of several animals;
> a fabulous or mythical animal;
> a pair made up of a human and an animal;
> a spirit.

These icons, which can be read at many levels, are found throughout most of the area under study, a fact that intrigues both diffusionists and creationists. Why are they chosen to the exclusion of others?

The human icon, which usually takes the form of an asexual stylized face (cat. 89), represents, I believe, a primal ancestor of either sex, a combination of male-female ancestors, a clan founder or the portrait of a real or mythical leader or hero. Where the humanoid masks appear in pairs we assume that they represent one male and one female. In some rare instances a mask will have two faces (cat. 98) or four eyes (cat. 92, p. 245). I believe, therefore, that these pairs depict male-female couples or primal ancestors such as those found on the ancestor panels among the Nande, Hunde, Shi and Komo, or on ancestor posts, and I conclude that male-female human figurations on masks are a manifestation of some forms of early ancestor cults or rites to promote the fertility of humans, animals or crops.

Why are the same animals always depicted? Why are the ape, the leopard, the hornbill or the owl (in the north) and the buffalo (in the south) always chosen when there are hundreds of different animals in the forests and savannas of eastern Zaire? I believe the reason to be the sacred nature of these animals, for apes and leopards are not part of the usual alimentary diet whereas those on which the hunting populations depend for survival, such as antelopes or the bushpig, are not depicted. The answer probably also lies in local beliefs, for the evolutionary scenario described by many elders among the hunters-farmers in northeastern Zaire proceeds along classic lines.

"The first inhabitants of earth were apes and other animals, followed by beings half ape half man. Following a feud and the killing of an animal the two species separated into animals and androgynous humans. After a further calamity of a sexual nature the humans were divided into males and females. As these humans were not endowed with either knowledge or purpose some animals came to their aid and taught them much and in the process strong bonds were forged between the two species. Then among the humans gender roles were slowly defined, knowledge was passed on, technologies evolved and simple forms of leadership came into existence, bringing with them the birth of clans and organized communities." (I have received a few variants of this evolution scenario from elders in Ituri and northern Maniema).

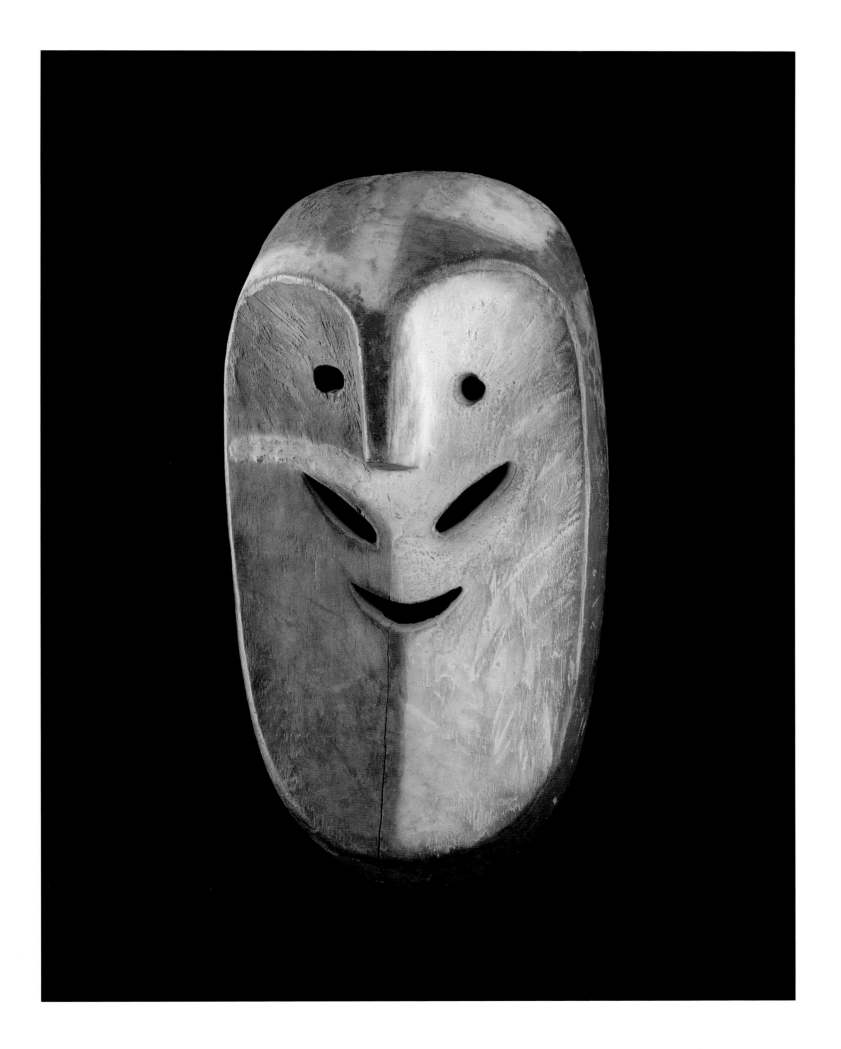

105
BALI

Zaire, Upper Zaire, Ituri
anthropomorphic face mask
H. 38 cm. Wood, pigment

Contact with diverse peoples during their long migrations to the south, have had a marked influence on the culture of the Bali. In the rare examples of masks which have recently been ascribed to them, too, one recognizes various traits of different ethnic origins. The example illustrated here is described as a combination of a sculptural style native to Bantu peoples, and a pictorial treatment inherent to Pygmies. For that matter, the Bali live in close symbiosis with certain Pygmy groups. Circumcision among the Bali has long since been replaced by the *mambela* rites, which have to do with the social emancipation of the individual. Masks would have been worn by the man in charge of the initiation ceremony. The vertical subdivision of the surface into two colors, probably refers to the split between those who are initiated and those who are not, while the small hands are seen as "stars" or as "the stamp of the spirit". (C.P.)

Lit.: Van Geluwe 1960; Felix 1989; Mestach (*in* Maurer 1991: 139, no.107)

I therefore believe that zoomorphic masks relate to the evolutionary stages during which the interrelationship and interdependency between humans and animals was of the utmost importance for the survival and multiplication of the humans. Anthropomorphic masks, on the other hand, (which are rarer than we think, for many masks which we take to represent humans are identified as animals by tribal elders) were used in the cult worship of individuals, either real or mythical ancestors, past leaders or founders of lineages and dynasties. It follows that anthropo-zoomorphism probably represents the intermediary stages in this long symbiotic relationship between humans and animals.

The tables show that in general animal masks far outnumber human masks (especially if we include the polymorphic examples) and that, while in northeastern Zaire almost all masks depict animals, zoomorphic masks only slightly outnumber anthropomorphic masks in southeastern Zaire. What can be deduced from this?

I conclude from the above that masks with animal associations constitute the predominant mask form in eastern Zaire. The omnipresent zoomorphic figuration proves the important religious and traditional place that animals still occupy in the cultures of the northeastern region, and it can be assumed that this was also the case in the southeastern region before stratified societies resulted in the exclusion of the zoomorphic icon in favor of human figurations. Some animal characteristics have survived here and there (as in the *soko mutu* (*so'o*) (brother of man) masks of the Hemba and the *kifwebe*'s), and some anomalies such as the odd couple formed by a pair of masks, one animal one human (female?), found among the Tabwa in the extreme southeast.

There has been a recrudescence of animal-shaped masks in the Luba area in the last thirty years (for example, in the Kiambi area) which perhaps reflects the diminishing power of traditional rulers and their dynastic icons as they are gradually replaced by political appointees.

Given that masks are found everywhere whereas figurative sculpture is only found in certain areas, can it be assumed that masking predated the sculpture of figures? I think it probable that when masking is found alongside figurative sculpture it is a survival of old cultural practices or has been inherited from the previous occupants of the land who were conquered or assimilated by the people at present *in situ* (as among the Luba). It is also possible that powerful rulers adapted this popular art form (masking) to their own needs and gradually grafted their own image onto the older animal icon to promote their own cause. I also believe that the more abstract the image of the animal the older is the tradition represented by the mask and, conversely, the more naturalistic the style the more recent the inspiration.

It is not surprising that the sculptors and the sculpted usually shared the same environment, for example the art of the forest dwellers is rich in ape figuration, and it can be argued that savanna-dwelling populations whose icons now include the ape may previously have lived in the forests, or at one time conquered and assimilated hunting peoples for whom the relation with apes was important (as among the Bangubangu).

It could follow that the people who depict buffaloes or antelopes have been settled in the savannas for a long time, for it is there that these animals are most common. Heron figuration could mean a marshy or lacustrine environment while the elephant, the mightiest and most impressive of all African animals, surprisingly only appears in sculpted form (masks) in the savannas of southeastern Zaire. The icon of the bushpig, an important source of food, is nowhere to be found in eastern Zaire, but south of Luba land in the Lunda sphere of influence pig-shaped masks are very common. Could this mean that Lunda iconography was never adopted by the people of southeast Zaire? Some riddles remain. If it is believed that leopards are related to chieftainship how can we explain the fact that their representation is most common among peoples where chieftainship and stratified societies are not the rule? And reference to hornbills are found in areas where the initiation into manhood is the main milestone in a man's life.

Figure sculpture is a coercive tool used by ruling castes, either political or religious, whereas masking, though equally coercive, is an art form reserved for the common man, either as an individual or organized into associations. Indeed, masks are often used by associations formed in

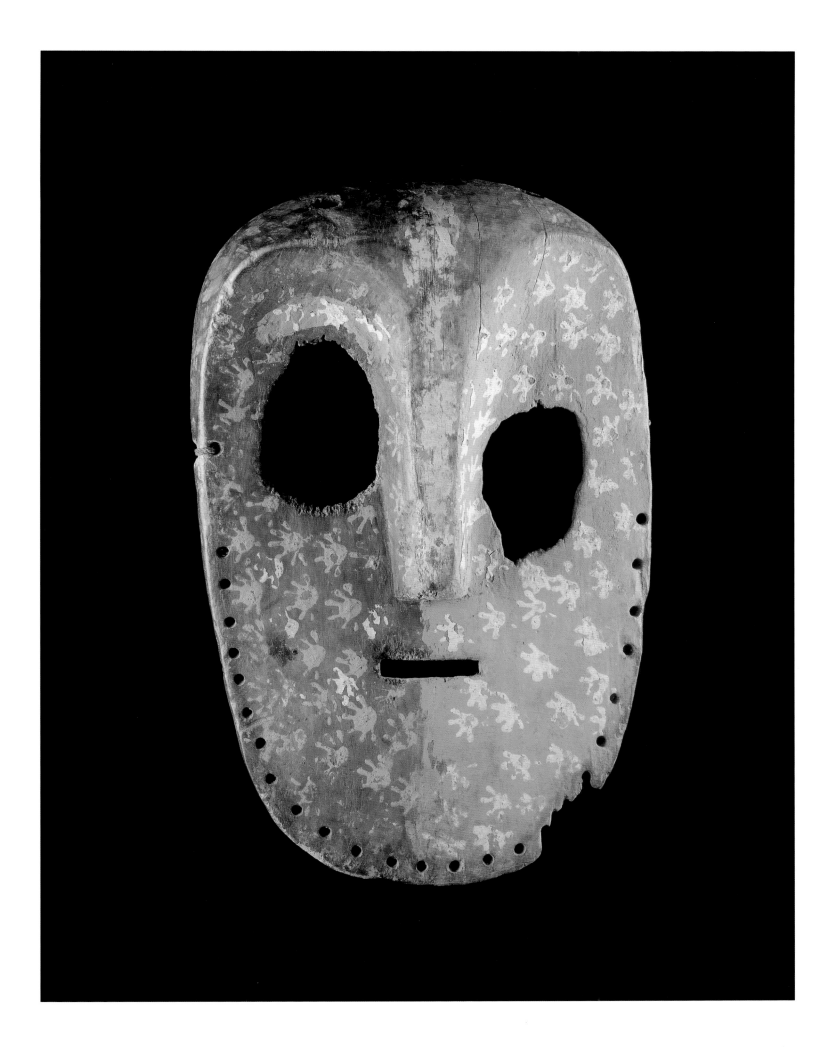

express opposition to chieftains or foreign oppressors. Given that mask making and mask usage are directly related to beliefs and that only zoomorphic masks have been found in areas populated by non-stratified, more "primitive" societies, I would suggest that some form of zoolatry was part of the early belief systems and that consequently zoomorphism predates anthropomorphism, which evolved later when the introduction of chieftainship, structured societies and lineages demanded the creation of a human icon to personify the power and importance of these new forms of authority, and justify the presence and pregoratives of dynasties and an elite. The notion of a human acting as a middleman between deities, spirits and living men was invented and only became important once genealogies with recognized leaders and (mythical?) dynasties were established.

I realize that I have here opened a Pandora's Box asking more questions than I have answered, but I believe it essential to underline the paramount importance of animal masks in this eastern region of Zaire. This type of mask has been unjustly neglected and its panethnic dispersion has not been accorded the importance it deserves. Study of zoomorphism in other art forms such as sculpture in the round, and further scrutiny of the local mythology could yield valuable clarification of the belief systems in the area, as well as confirming some of the hypotheses I have advanced in this paper. I hope others will take up the challenge and I await the publication of their findings with keen interest.

106
NDAAKA

Zaire, Upper Zaire, Ituri
anthropomorphic face mask
H. 26 cm. Wood, pigment, fiber

The equatorial forest of Ituri is populated by a large number of ethnic groups with common social and cultural characteristics. Aside from some old photographs, until recently no sources have reported on the existence and use of masks in this region. However, the example in wood illustrated here, was encountered some years ago in a Ndaaka village. The polychrome drawings are clearly reminiscent of the patterns seen on the bark paintings (*tapas*) of certain Pygmy groups. The question may be asked as to whether wooden masks in Ituri, just as with the painted *tapas*, may be traced back to the face-painting as practiced by Pygmies. At the same time, the sculptures exhibit stylistic and typological similarities to mask traditions of neighboring areas. Among the Ndaaka the initiation includes, among other practices, the appearance of masked personages. Also scarification, which here replaces circumcision, is carried out by a masked figure. The paintings on the mask, sometimes applied with the help of stamps, form esoteric messages. Though interpretations differ, dots or flecks are often associated with the skin of the leopard, and seen as references to leadership. (C.P.)

Lit.: Van Geluwe 1960; Felix 1992b

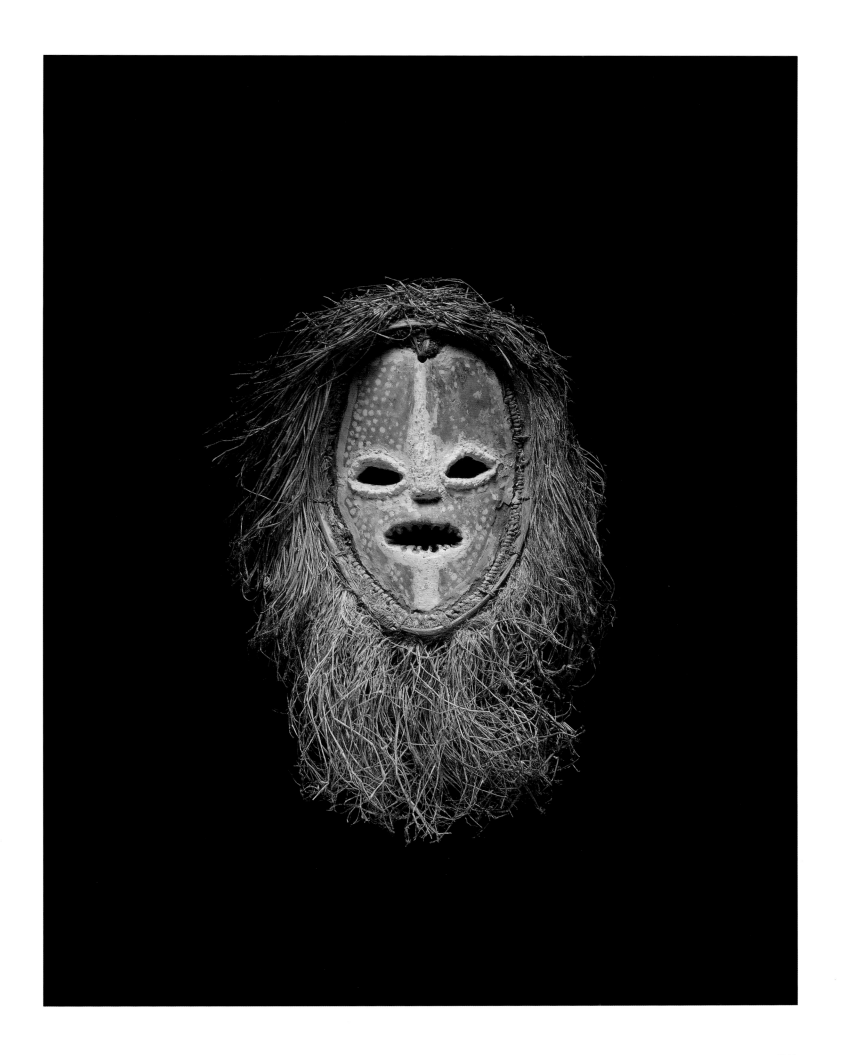

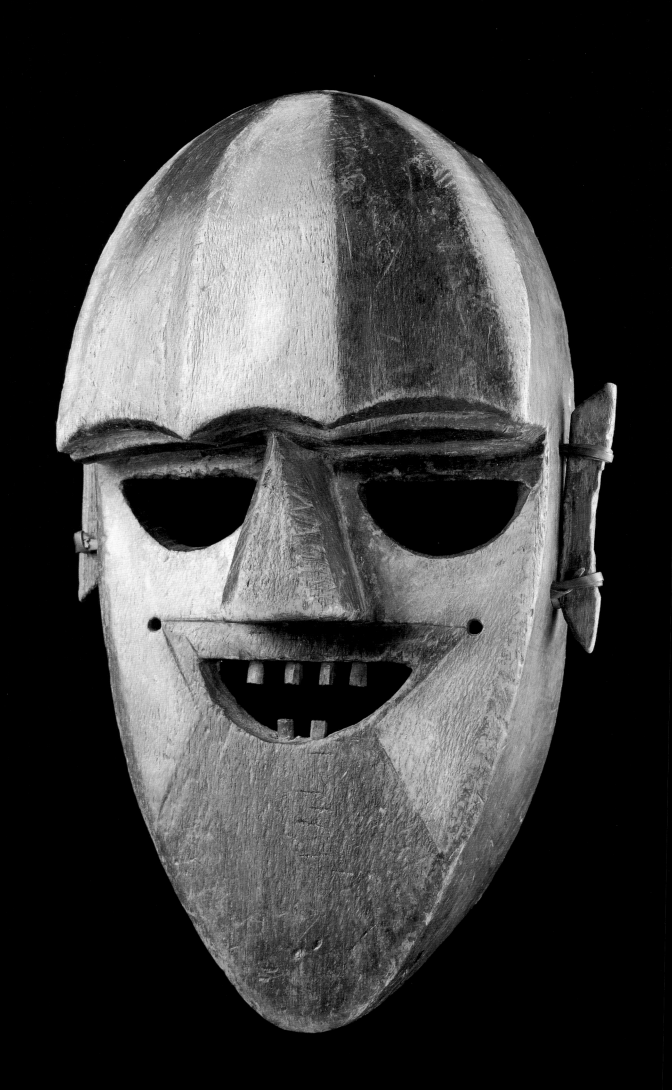

Mask Styles and Mask Use in the North of Zaire

Herman BURSSENS

When one considers those masks which, on the basis of data-of-origin or morphology, may with some measure of assurance be situated in the northern savannas of Zaire — and more specifically, in the Ubangi or Uele regions — then one rapidly comes to certain conclusions.

First, the total number of examples traceable from the 19th century on, is very small when compared to the respective number from the southern part of Zaire. It is evident that the peoples living in the north never had a great mask tradition. Second, the circumstances wherein the masks were used, and their meanings, are insufficiently known. Often we do not even know precisely which ethnic group is responsible for the creation of which masks. To present, there has been little or no profound scientific investigation directed toward the mask tradition in the Ubangi and Uele regions, and many questions still remain to be answered. In this contribution, we will assemble and critically review the existing body of knowledge on this subject. Although certain hypotheses will be offered below, we wish to refrain from any manner of speculation, however intriguing, but nonetheless not exempt from the requirement of proof.

The Ubangi Region

By the name "Ubangi", what here is meant is that part of the "Région de l'Equateur" that ranges north and west to the Ubangi River, and east to 23 degrees north latitude. To the south, the boundary extends from around 3 degrees eastern longitude, sloping downwards, then following the Mongala River and thereafter the Dua River, northwards. The entire area covers some 15,000 km², and is administratively part of the "Sous-région de l'Ubangi" and the upper-half of the "Sous-région de la Mongala".[1] The territory is populated by various ethnic groups, with the four most important being:

1. The Ngbaka[2] (pop. c. 400,000). They are in various respects related to the Manja (Mandjia, Manza) and the Gbaya, both located in the Central African Republic.
2. The Ngbandi (pop. c. 200,000). Together with the Mbati and the Sango, who live over the border on the Ubangi's right bank.
3. The Mbanja[3] (pop. c. 120,000). They are part of the much larger Banda group, who are mainly in the Central African Republic.
4. The Moswea Ngombe (pop. c. 6,000). They are a remaining part of the Southern Ngombe (pop. c. 200,000), who are known as the Gonji Ngombe.

In addition to the aforementioned peoples, there are a number of smaller groups, including the Togbo, the Mono, the Gobu, the Gbanziri, the Langbase, the Monzombo, the Furu, and the Ngbaka Ma'bo. With the exception of the Ngombe and the Furu, all of the above-named peoples speak languages which belong to the Ubangi branch of the "Adamawa-Eastern" family of languages, as described by Greenberg (1966). The respective vernaculars of the Ngbaka, the Ngbandi, the Ngbaka Ma'bo and the Monzombo, are all parts of the Gbaya-Ngbandi-Monzombo entity, that forms the western group of the Ubangi branch. The languages of the Mbanji, the Togbo, the Mono, the Gobu and the Langbase, are a linguistic subdivision of the Banda group. The Furu speak a Chari-Nile language; the Ngombe, a western Bantu language. Of the four first-cited peoples, only the Ngbaka have a geographically unified area — and this, only since 1920-24 — with the locality of Gemena as its center. All the others live dispersed throughout the Ubangi region. The majority of the Ngbandi live in the eastern portion, with Abumombazi as center. A smaller group is found to the north and south of Budjala, and a third group resides to the west of Kungu, to the Ubangi River. The Mbanja and related ethnic groups mainly populate the extreme north, but they are also encountered to the west, east, and south of the Ngbaka. The Moswea Ngombe are found in the vicinity of Bosobolo.

107
BOA
Zaire, Upper Zaire
anthropomorphic face mask
H. 32.5 cm. Wood, pigment

Of all the northern groups — where the use of masks is considerably less frequent — the Boa have developed a form-language with the most unity of style. Striking is the use of geometric planes from which the face is constructed. In most cases this is accomplished by carving demarcated surfaces, sometimes concave, which are subsequently colored with white and black pigments. Not uncommonly the markedly hypertrophied ears are inset in the form of ajour-worked circles. This was also the case for the mask under cat. 107. Little is known of the function of these masks. They would perhaps have been used as a sort of supernatural weapon in confrontations with hostile groups. The mask was worn by the bravest of the warriors, so rendering him invulnerable. (F.H.)

Lit.: BURSSENS (p. 217)

BOA

Zaire, Upper Zaire

anthropo-zoomorphic face mask

H. 29 cm. Wood, pigment

In reality, the situation is far more complex. Sub-groups of some ethnic groups live distributed here and there in the territories of other peoples. Migrations, multiple contacts and mutual influences over the course of centuries — together with similar ecological conditions and ways of life — have led to the respective populations of the Ubangi having quite a lot in common. Nonetheless, there are sufficient traits of particularity to descibe each of these groups as an entity apart. A reflection of this situation is at least partially apparent in masks from Ubangi (cat. 110-113). With the exception of a few examples which (correctly, or incorrectly) are attributed to the Ngbandi, these masks exhibit many points of correspondence without being anything like identical. In the main they may be said to be simple, largely flat, carved face masks. They are often ovoid — with the narrower pole pointing down — and sparsely detailed. Other examples are more carefully sculpted and more deeply worked. All masks have scarifications, usually in the shape of a ripple (consisting of coarse, or finer, bumps and/or incisions) which runs vertically over the forehead, and sometimes extends over the bridge of the nose, or even further. Additionally, notches may be seen on other facial parts, but there is a great deal of variation. Scarifications have always been subject to change, just like the headdress, and in the Ubangi region they were evidently sometimes adopted by one of the respective groups from another. Thus, this amounts to no infallible criterion upon which to base the attribution of certain masks to one particular people or another. Some examples have applications of gray, white and/or red pigments. Others are unpainted, but there is doubt as to if their original state was also thus.

The vast majority of masks were, and are still, attributed to the Ngbaka, but it remains far from certain if they indeed all originate with this group, and/or if they were even used by them. That they possess masks, albeit in relatively small numbers, is by now a fact. The oldest communications in this regard are from Perlo. This colonial civil servant in 1912 sent two examples to the then Musée Royal du Congo Belge in Tervuren, with the information that the Ngbaka people in that area of Bozagba call these masks *dagara*, and that they are employed during the boys' circumcision ritual (Perlo E.D. no. 295; masks in the M.R.A.C., Tervuren, R.G. 9205 and 14810). In 1923 the same museum again received a Ngbaka mask, this time sent by Hinjon. He had acquired the piece in the area of Budjala, and added that it was used during the *gaza*, the circumcision and initiation ceremony which, according to Hinjon, was practiced among both the Ngbaka and the Mbanja. Moreover, during the *gaza* both peoples use a series of geometric, polychromed objects such as wooden belts, arm rings and bracelets, mouth discs, and knives with a bell attached — to set the rhythm during the dance (ill. 1). According to the same source, the *dagara* mask is worn by the *moganga*, i.e. the man who instructs the initiates (*gaza-no*), and circumcises them. He uses this mask during the feast which immediately follows the initiates' period of seclusion. During the three-day duration of the feast, they are adorned with the related ceremonial embellishments.

ill. 1. Ngbaka (Equatorial Province). Mask and paraphernalia of the *gaza* initiation. Collected pre-1923 by E. Hinjon in Budjala. M.R.A.C., Tervuren.

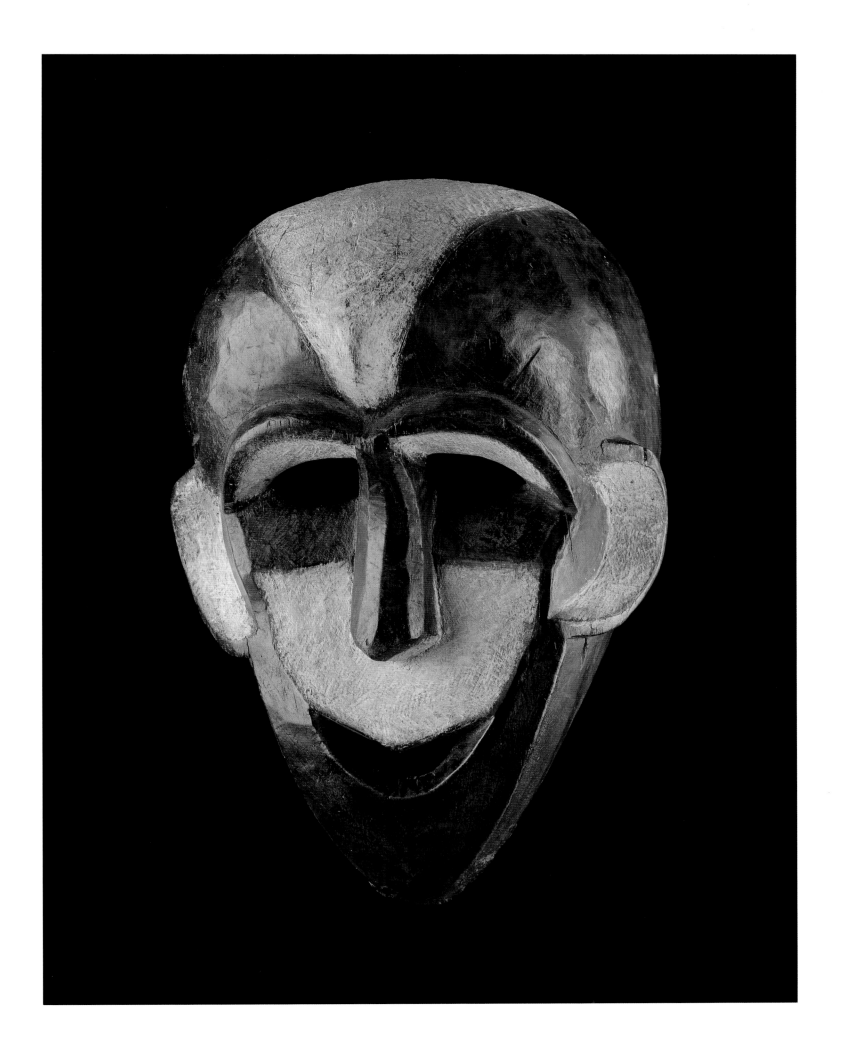

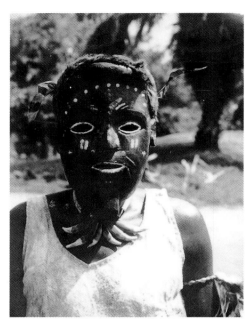

ill. 2. Ngbaka (Equatorial Province). Masker along the road from Gemena to Motenge. Photo: N. Seeuws, 1972.

The *moganga* has the mask on at the moment that the procession of boys leaves the enclosure where the *gaza* had taken place, to embark toward the village (Hinjon E.D. no. 409; the mask in the M.R.A.C., Tervuren — R.G. 36006, was illustrated by Maes 1924: ill. 52).

Claeys (1931) addresses this matter in a contribution on the *gaza* of the Ngbaka in the vicinity of Bwamenda. Here, it is the *gaza-no* who wear a mask (*moginda*) in an isolated, enclosed place of initiation, or *butu gaza* — and this, "in fun". Elsewhere, the author nonetheless relates that it is purportedly the *bu-gaza* — the initiator and disciplinarian — who wears the mask in the *butu gaza* (Claeys 1931: 388). It is made of wood or tree bark, and has an attached mustache. Claeys provides no specifics as to the circumstances of its use, though he does again note that the *gaza-no* take to amusing themselves in disguise, with some of them trying to scare the girls during the ceremonial exit. This, without much apparent success, seeing that the latter remain clearly unfrightened. Is this an early acculturation phenomenon, or is the reason for this sort of profanation to be sought in the fact that among the Ngbaka such masks did not originally form part of their own tradition? They would not initially have known of circumcision, but at sometime in the past would have had acquired this practice from the Banda, together with the masks and the various paraphernalia. The Ngbaka in the vicinity of Bamenda whereof Hinjon speaks, appear to show somewhat more respect in this regard. Such also seems to be the case for those from the area around Bagba, of whom Perlo in 1912 reported that the men who prepared the circumcision rite wore masks, and that they added lustre to the feast and also kept the children at a distance.

It is possible, though far from certain, that masks would also perform in conjunction with the practice of excision among the girls. Our only source in this regard is Claeys, but he writes rather cryptically that the newly excised go procession-like from house to house, accompanied by their mothers, to pick up gifts. The procession makes him think of a masquerade with its "disguised and painted persons" (Claeys 1931: 521).

That the Ngbaka some twenty years ago may have still occasionally used masks in conjunction with the *gaza* cannot be ruled out, seeing that examples were then encountered there (ill. 2 and ill. 3). These masks, however, differ strongly from the earlier traditional design, and apparently had long ceased to have a profound significance for those who used them.

Vedast Maes (1958) gives in his Ngbaka dictionary for "mask", only the word *ndakala*: the appellations *dagara* and *moginda* are not cited. In a monograph from the same author, there is mention made of the practice of circumcision (Maes 1984b: 63-65). The author notes most of the Ngbaka clans did indeed know this practice, but that it was nonetheless not widespread. The *gaza* is a veritable training for adulthood, in which the boys remain secluded for several months while undergoing severe trials. There exist two different rites: the *gaza gba da*, under the roof of a large shelter where the initiates remain isolated from the village by an enclosure; and the *gaza kola*, the cir-

ill. 3. Ngbaka (Equatorial Province). Entrance to a *gaza* initiation camp near the village Bogbase. Photo: N. Seeuws, 1972.

cumcision in a small wood where the boys remain in the open-air, with only the trees for shelter from the heat of the sun. The conclusion of the initiation formerly included an elephant hunt. From the fact that the *gaza* songs are in the Mbanja language, as is the name for the young girl (*yakose*) who brings food to the portal of the enclosure, following Maes one can conclude that circumcision itself is not an old Ngbaka custom. They did formerly have an initiation for the boys. The practice of excision of the girls is of an even older origin, and is more widespread than circumcision among the boys.

Although the Mbanja apparently were the first to know the institution of *gaza* in its full extent, nonetheless there have been practically no masks collected which allows credible attribution to this group. The exception is a group of six specimens which were acquired in the 1930s by the Tervuren museum (now, the Musée Royal de l'Afrique Centrale) (R.G. 34885 to 34890 respectively). They exhibit no trace of use and are probably from the hand of the same sculptor, seeing the great mutual similarity, apart from a few details. It is not clear whether these masks were collected before they could be put into use, or alternatively, that they were specially made for the occasion. Their style is somewhat akin to the heads of certain statues which at that time were field-collected along the Mongala River. It is well possible that a portion of the the Ubangi masks of unknown origin (and this forms the majority), are from the hand of the Mbanja, and not Ngbaka, sculptors. As to whether other Banda groups had also once made masks, the question remains quite problematic. Recently, examples have been attributed to the Togbo, but to our knowledge without anything in the way of supporting proof. True, it has earlier been established that they did sculpt statues, albeit in a very limited number.

Diverse masks have also been attributed to the Ngombe, here also without valid arguments to back up the claim. All evidence indicates that they made no sculpture, with the exception — as shown by Wolfe in 1955 — of the Moswea Ngombe, who made and used a few statues, most likely under the direct influence of their Mbanja neighbors, who encircle their territory near Bosobolo. As for the Ngbandi, in the many publications devoted to them by Tanghe and others, there is no mention of masks. Moreover, until a few generations back, circumcision — the context wherein apparently all masks in the Ubangi territory were used — was unknown to the Ngbandi, and they also did not have their own word for "mask". According to Lekens (1955: 456), they describe it as *ye ti handa*, "something by which to deceive people". It can then not be ruled out that the Ngbandi, whose territory is in closest proximity to the Ngbaka and the Mbanja, may indeed have once used masks within the framework of the circumcision ceremony, but this would have been exceptional. The fact remains that a few examples have been come across in or near their place of habitation. This includes the case of the mask that has resided in the collection of Leiden's Rijksmuseum voor Volkenkunde since 1889 (ill. 4). It was indeed acquired in Mobeka, but it would have originated from the upper reaches of the Mongala River. Another example with a similar base-structure is in the Tervuren museum's collection, and comes from the easterly-lying Monga locality. Surmounting this mask, just as with the previously mentioned specimen, is bound a tuft of feathers (see Burssens 1958a: ill. 46). Still another mask subsequently came into this museum's possession — again without statement of origin — which was clearly sculpted in the so-called "Ngbandi style"; that is to say, with a V-shape carved into the headdress's front. An identical headdress is also seen in statues of the Ngbandi.[4] The mask is markedly more deeply worked than most Ubangi examples.

A few other masks are also reputedly to come from the eastward-living Ngbandi, who are there territorially closest to the Zande-Bandia. If this is so, their exact use and function remain completely unknown. One particular mask, stylistically related, was photographed in 1972 by N. Seeuws during a prospecting trip in the vicinity of Yakoma for the Institut des Musées Nationaux du Zaïre in Kinshasa. Again, we have no information related to its role and meaning.

A provisional conclusion is that in the Ubangi region the Ngbaka people are the main users of masks, and this within the framework of circumcision coupled with the youths' initiation. Additionally, the Mbanja — from whom the Ngbaka had formerly acquired the practice — use masks within a like *gaza*. This is possibly also the case for a few other groups, but then most likely as exception rather than rule. Available data is much too inadequate for us to be any more concrete. The Ubangi masks which have hitherto been field-collected or photographed *in situ*, show a great degree of variation in form. They indeed have some common traits, but there is no true unity of

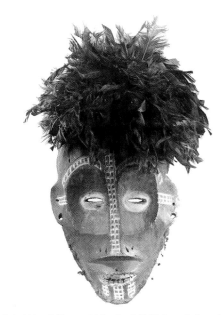

ill. 4. Ngbandi (Equatorial Province). H. 35.5 cm. Collected pre-1889 by A. Greshoff in Mobeka. Rijksmuseum voor Volkenkunde, Leiden (no. 708-11).

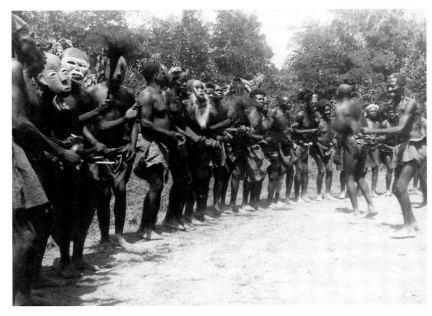

109
ZANDE

Zaire, Upper Zaire, Uele, Bandia
anthropomorphic face mask
bokolwali or *ngobatikpi*
H. 25 cm. Wood, pigment, animal hide and hair

The Zande most probably possess no true mask tradition. The rare examples attributed to them differ considerably. The example illustrated here has a concave heart-shape face enframed by white-painted areas. It was photographed in the 1950s in the heart of the Zande territory, then performing with five other specimens, during a feast associated with the *mani* society. The mask, called *bokolowali* or *ngobatikpi*, would indeed have primarily participated as a "death mask" in funerary dances. In bygone days all masks were presumably used in this context. The white flecks on the forehead refer to the leopard, which is the totem animal of the Bandia clan. It is possible that masks were also used in another society, called *mbanga*. (C.P.)

Lit.: Burssens 1960; BURSSENS (p. 217)

ill. 5. Zande (Upper-Zaire). *Mani* society adepts in the vicinity of the village Bili. Photo: J. De Loose, between 1952 and 1956. *See cat. 109*

style either as a whole group, nor among the masks of each of the mentioned peoples — something that indicates a poorly developed tradition. The Ngbaka masks with data of origin, are morphologically different from one another. There is, thus, no striking "Ngbaka style"; no more than there are mask styles which one can indisputedly attribute to one or the other of the Ubangi peoples. The custom current in the last decades to automatically associate the vast majority of Ubangi examples with the Ngbaka, because they seem to be the most abundant and we are relatively well-informed about them and their *gaza*, is a working method not grounded on a firm scientific footing.

A number of masks have a concave carved facial aspect (so-called "heart shape"), something characteristic of masks of other peoples from the Fang to the Lega, which could indicate some manner of mutual connection. It seems premature to put forth any sort of hypothesis in this regard. The same base-form, coupled with a few other characteristics, in some masks leave us in quite a quandry. Do they come from Ubangi or were they made elsewhere, for example in the Central African Republic, or in another country or territory? As for the apparently sparingly-developed mask traditions in the neighboring areas over the border, our knowledge is even more incomplete than for the Ubangi region. Certain collected examples of undetermined origin have only a few morphological traits in common with the familiar Ubangi masks, but otherwise are not directly akin to any known specimens from one people or another — unless with those of the Lega, and then only sporadically. There remain a great many unresolved problems, and apodictic assertions are best avoided.

The Uele Region

In the region to which we will now turn our attention, and which is broadly located in northeast Zaire between the Mbomu River to the north and the Aruwimi River to the south (administratively mainly in the "Sous-région du Bas-Uele" and the "Sous-région du Haut-Uele")[5], one encounters a lesser number of masks than in the Ubangi territory — at any rate, if based on the limited number that have been field-collected, photographed, or noted since European presence in the area. Among the Zande (pop. c. 1 million) who also live over the border in neighboring parts of the Central African Republic and southwestern Sudan, and who in their turn speak an Ubangi language, masks are hardly to be found. Striking in this regard, is that in the few examples of which one knows the origin, all were collected among the western Zande who live under the authority of the Bandia rulers, occupying the Lower Uele territory. More specifically, all these masks come from the former Bondo region (see Burssens 1960).

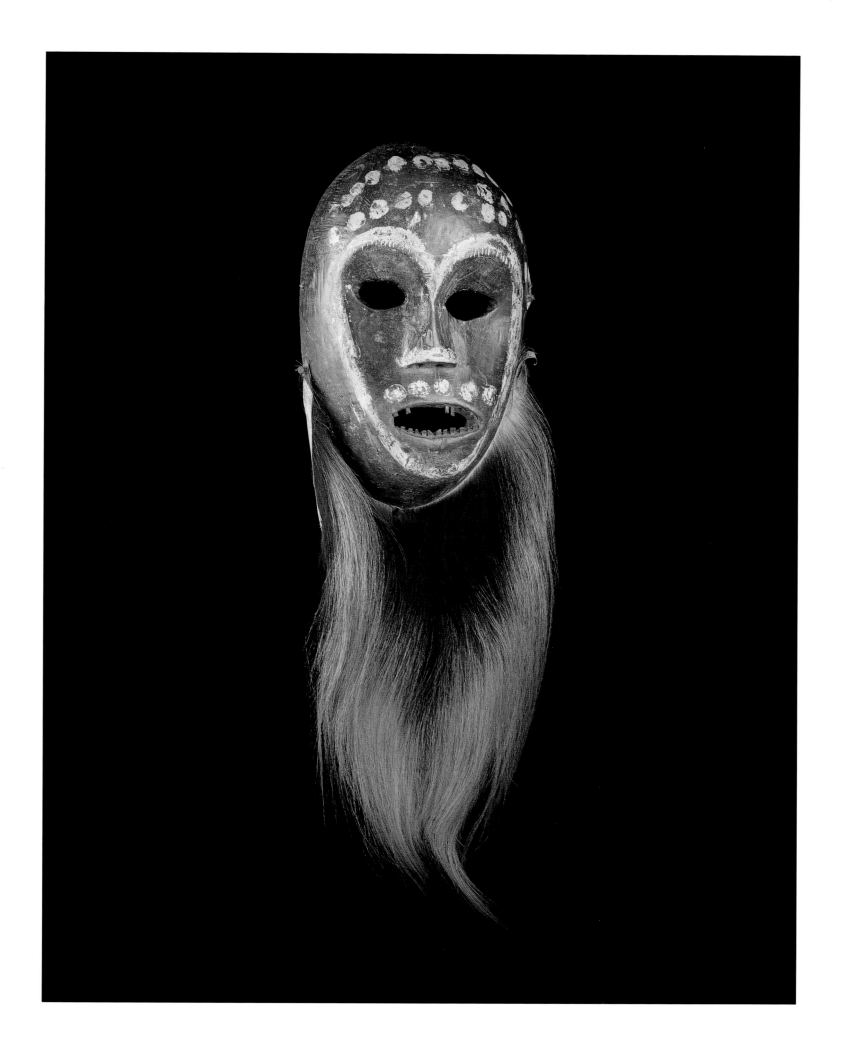

NGBAKA? or MBANJA?

Zaire, Equatorial Province, Ubangi
anthropomorphic face mask
H. 32 cm. Wood, pigment, hair

The ethnic situation of the Ubangi area is extremely complex. The many migrations, mutual contacts and interactions, have resulted in certain traits becoming shared among the various groups who inhabit this region. The Ubangi masks show, despite certain common elements, a wide diversity of forms. One finds flat and simple masks, as well as more detailed and deeply carved examples. Characteristic of nearly all these masks is the mirroring of a scarification pattern in the form of a vertical ridge over the forehead and nose. Because the practice of scarification was acquired by one group from another — and, moreover, given the accrued changes over the course of time — it is never possible to attribute a particular sculpture purely on the basis of this decorative element. Although most Ubangi masks are ascribed to the Ngbaka, one does not know with certainty if all these were indeed made by them. The fact that according to Ngbaka tradition the practice of circumcision, together with masks and paraphernalia, were acquired from the Mbanja, perhaps indicates that many "Ngbaka masks" were indeed the products of Mbanja sculptors. As to morphology the essential feature is a lack of stylistic unity, something also apparent from the four specimens shown here. Thus, talk of a putative "Ngbaka style" is hardly tenable, and definitive attribution impossible. It is, however, beyond dispute that the Ngbaka have used masks within the scope of the initiation and circumcision rituals, called *gaza*. Some sources speak of a *dagara* mask that is worn by the man who is charged with the instruction and circumcision of the initiates, during a festival which follows the the young mens' period of seclusion. Other sources relate that the initiates themselves wear a *moginda* mask to amuse themselves,

That masks only exist among the Zande-Bandia is emphasized by Lagae (1926: 100, 119); he states that the groups of the Upper Uele territory living under the authority of the Vongara nobility, had neither statues nor masks — this in contrast to the Zande-Bandia who, according to the same author, had the *zembele* mask, a term only encountered among this people. Lagae offers no further explanation concerning the specific role of the *zembele*, so we do not know on what occasions this sort of mask was used, and what it represented. At the same time, he poses the question of whether the Zande-Bandia had acquired this practice from elsewhere or, as another possibility, if here one has the case of a practice inherent to certain autochthonic groups from this region who subsequently were integrated into the large Zande-family. These are two pertinent questions which today remain just as unanswered as at the time of Lagae's investigations.

Hutereau, who during the period 1911-13 also traversed the Lower Uele, sent a mask to Tervuren that he had found among the Gaza chiefdom of the Zande-Bandia. He relates that this was a dance mask, locally called *batipi*. It was not used during battle (*vide infra*), but rather to "inspire children with fear" (Hutereau E.D. no. 312 and mask R.G. 12651), thus implying that by this time the mask had already lost its original function. The Reverend Fathers of the Cross were in later years able to secure possession of around seven Zande masks in their vicariate, but neglected to ascertain any further information.

In the 1950s it was determined by Jozef De Loose, a former health officer in the service of the colonial administration, that masks were occasionally used within the scope of the *mani*-society. As far as one can trace, this society originated at the end of the 19th century in the vicinity of Rafai, just over the border with the Central African Republic, from where it subsequently spread to the Lower Uele and, later still, to other areas and among other peoples (Burssens 1962). Between 1952 and 1956, De Loose was able to photograph five masks during a ceremonial gathering of the local *mani*-adepts from the vicinity of Bili, used to add lustre to the occasion. They were put on during a specific dance, called *bangbagulu*, which is particular to this society (ill. 5). With respect to one of these masks, De Loose was informed that this was also a "death mask", and primarily employed for mourning dances. The name for this in the region of Basekpio is *bokolowali*, and in the vicinity of Bili is known as *ngobatikpi*.[6] The mask in question (cat. 109) has a number of white spots on the forehead and above the mouth which, according to the informants, are indicative of the leopard — the animal totem of the Zande-Bandia. It seems not impossible that still other masks were once used in conjunction with funerals or remembrance of the departed, and perhaps this was even their primary occasion for use. The same investigator was also told by informants that adepts of the *mbanga*-society (where small stools adorned with iron and other objects are central to the rites), too, sometimes made use of masks in their dances (Burssens 1960: 107, n. 4; for the *mbanga*, see De Loose 1963). Seeing that a certain number of Zande from this region are members of both the *mani*-society and the *mbanga*, it is well possible that in both cases the same masks were occasionally employed. Among various peoples masks have a polyvalent use, and more than one sole function or significance.

In 1972 Nestor Seeuws, also to the north of Bondo, was able to photograph a mask revealed to him: further information concerning it was not forthcoming. Stylistically, it relates well to other examples of the Zande-Bandia. The twenty or so masks thusfar known to us, just as is the case for those from the Ubangi region, show much stylistic variation among themselves. These are indeed all face masks with a largely oval basic-form, but there is no true morphological unity. This, probably because also among the Zande-Bandia, masks have never been an essential component of their culture. It is a known fact that the less a people sculpt, the smaller the chance often is of finding stylistic unity or consistency. The five examples photographed by De Loose during their collective performance, show a wide morphological diversity. The majority of the masks that have ever been collected are not very deeply carved out. The portrayal of the face is limited to the essentials: a rather spherical forehead, round or rectangular eye-holes, a roughly defined nose, and a relatively large mouth, either oval or rectangular, practically always with inset teeth. The masks are partially provided with white-painted stripes: some have surmounting tufts of feathers, others are appointed with a beard of monkey-hide or fiber. With the exception of a few examples, no scarification is seen at all. The so-called heart-shaped face is seen in only a few examples.

From south of the Zande to beyond the Aruwimi River, where the forested area begins, live by rough estimation some 200,000 Boa.[7] According to Guthrie & Tucker (1956: 78-80), they form a linguistic bloc of six groups which, among others, includes the Benge and the Baati peoples. They

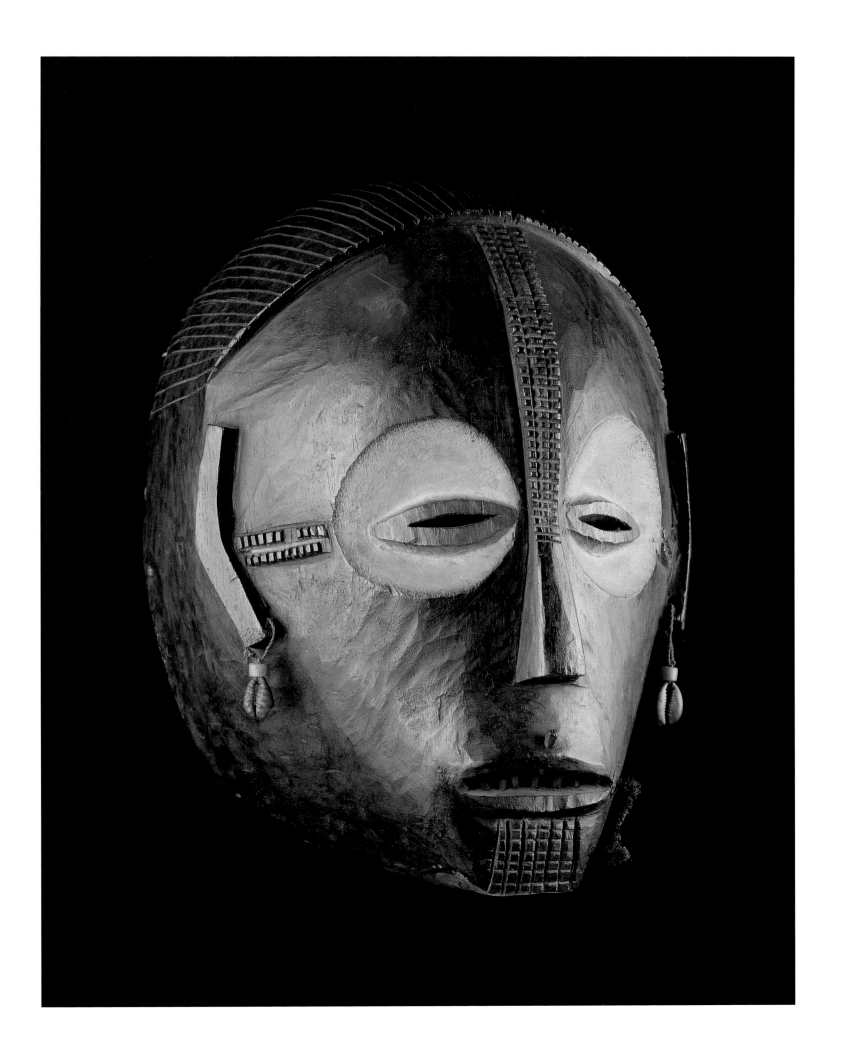

NGBAKA? or MBANJA?

Zaire, Equatorial Province, Ubangi
anthropomorphic face mask
H. 28 cm. Wood, pigment, metal

as well as to scare the girls during the initiates' exodus from their place of seclusion. Finally, the "discipline master" would also be adorned with a mask, inside the enclosure where the initiation itself takes place. All in all, masks do not occupy a fundamental place in the social and religious life of the Ngbaka. As for the Ngbandi, in publications concerning this people there is bare-mention made of masks — with the exception of a vague reference to masks of the *kokoro* sorcerers. Moreover, in former times circumcision was not practiced by them. Nonetheless, some examples are said to have been collected from among this group. (C.P.)

Lit.: Burssens 1958a; Burssens 1958b; BURSSENS (p. 217)

all speak related west-Bantu vernaculars which themselves are constituents of the large Benue-Congo language family.

To present around twenty masks are known of very similar design and which, not without reason, are designated as Boa examples. These are oval-shaped masks which, with few exceptions, have largely flat-worked foreheads (sometimes rather concave), and are intended to be carried in front of the face (cat. 107).

Also striking is the characteristic of markedly hypertrophied ears, added to the oval basic-form. In many cases the ears are in-set; that is, they are not sculpted with the rest of the mask from a single block of wood.[8] The auricle of the ear is here replaced by a large round opening, so that only the edges remain (ill. 4, p. 203). The Boa term such a rendering as the *bavongobo* decoration. Here, the helix is perforated, and the opening progressively broadened via the placement of a wooden disc. This aperture — according to De Calonne-Beaufaict (1909: 306) — can sometimes reach a diameter of five centimeters. This sort of "embellishment" is, following the same author, mainly encountered among the eastern Boa. Although the depiction of the *bavongobo* on the mask is in itself largely realistic, it is evident that the widely protruding round ears have at the same time a striking decorative effect, and that this contributes to the distinctive morphological appearance of the whole. In other cases the ears do not protrude, are not as large, and also lack the conspicuous central aperture. Instead of being completely circular, they may take on the shape of a circle-segment: the edge of the ear would at times be provided with a series of small holes, something indicative of the *bagonde* decoration which in bygone times was also practiced on the body. A few masks have no ears at all, but are provided with notches on the forehead which, according to the same source, the Boa term *beperiba* and represents a butterfly. There is another embellishment, known locally as *nyakuma*, consisting of a series of parallel vertical stripes which traverse the forehead from one ear to the other. A few masks exhibit similarities to this, but they then are lacking other Boa characteristics.

Still another eye-catching trait is the division of the face into simple geometric planes which are in turn white and dark. The bichromy is achieved by the application of, respectively, white kaolin (*pembe*) and a black pigment obtained from the fruit of a particular variety of liana (*libussa*), or from a base of pulverized charcoal (*mbiti*) (Halkin 1910: 155). One can also achieve a black surface by superficial carbonization. Exceptionally, one finds traces of paint, made from red camwood powder (*n'gaa*). In a number of masks the original paint has completely vanished. The colored-in patterning is largely strictly symmetrical, but may occasionally show a balanced assymetry. Through slight leveling and linear incisions, this geometric division may be accentuated. Meanwhile, none of the represented patterns can be said to be identical; what one has, is a series of variations on the same theme.

A final characteristic is the forehead. As a rule vaulted, and sometimes emphatically so, it is straight or obliquely cut-off at the level of the orbit, whereby the eyes (or at least the holes which represent them) appear to lay deep within their sockets. They are rather small and nearly closed shut or round, or contrarily, large and square, or rectangular. In some masks they are slanted. The nose is quasi-normal with respect to proportion, and often has a sharp nasal bridge with the nostrils extending on both sides straight to the cheeks, so that it appears triangular when viewed from below. Nostril-holes may be present, or not. All masks contain (or contained) implanted teeth, fashioned from pieces of bamboo or other type of wood, and placed in the mouth opening. This latter may be oval-shaped (which is the rule), but square or rectangular shapes are also seen. One mask originally had a short beard of monkey-hide. Possibly this may also have been the case with other examples. Another specimen has a small feather-decoration as finial, something that was probably an original feature of other examples.

Although there are small differences, primarily with respect to the eyes and mouth, the underlying stylistic unity of the masks is quite substantial. They may even be termed as exceptional for the northern part of Zaire. Based on appearance, some masks are so closely related that one has the impression that they originated from the hand of the same sculptor. The type of mask described here may be termed as "classic". Whether the Boa have also sculpted in other styles, remains a difficult question. Below, we will again briefly return to this problem.

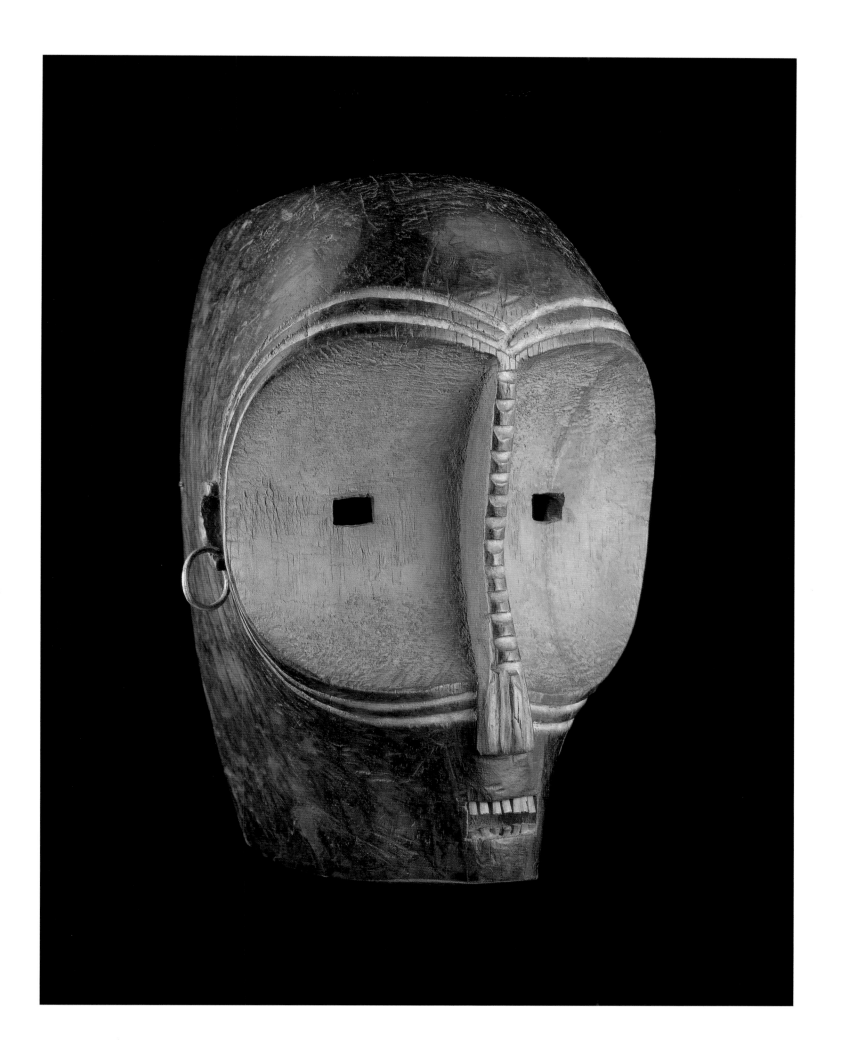

Six examples are known to have been acquired from the Boa. In the case of two of them this predates 1886, seeing that they were that year published in *La Belgique Coloniale*. Another mask was illustrated, together with those reported in 1906 by Coart and de Haulleville (1906: ill. LVIII, 652, 655 and 656). A fourth example was presented in 1907 to the University of Parma by Captain E. Piola (see Bassani 1977: 26, ill. 94)[9], and two others — acquired by Hutereau in 1912 — wound up in the Africa Museum in Tervuren.[10] Two other masks now in Swedish collections, with collection-dates from 1923 and 1925 respectively, were purportedly also found in the Boa's territory (see Före Picasso 1988: 160, ill. 492 and 493). Still another specimen, much less typical and certainly not to be termed "classic Boa", was presented to the Institut des Musées Nationaux du Zaïre in Kinshasa only in 1972 (see Cornet 1975: 131, ill. 98; Lema Gwete 1980: ill. 80). It is said to originate from the village of Mupengo in the Banalia-zone, but this information was provided by the seller and deserves to be treated with the necessary prudence (Nestor Seeuws, personal communication, November 1992).[11] All other known masks are attributed with Boa derivation purely on gross style-likenesses.

The oldest — and, for that matter, extremely concise — source providing information concerning the use of masks among the Boa, dates from the time of the Congo Free State. In a short contribution which appeared in *Le Congo Illustré* in 1895, Chaltin (1895: 116) writes that the "Mobati" (Baati) sculpt rather well in wood, and that they have masks which "are used as a means to terrify in times of war." At that time, and still today, no people of Central Africa was known who practiced such disguise to the same purpose, so that the initial measure of doubt concerning this report was not inappropriate. Another source, this time Vedy in 1904, is much less explicit. The author writes only that the "Ababuas" carved masks and that they are used "in certain circumstances", according to his informant "during dances". Vedy offers the opinion that the mask could indeed have had a religious significance (see Vedy 1904: 277-278).

In their book from 1906, Coart & de Hauleville relate somewhat laconically that the three illustrated examples are "war masks". These authors probably relied on Chaltin for this. Perin (in Halkin 1910: 583) is also of the opinion that masks were used in times of battle, indeed just as is Tisambi (in Halkin 1910: 582). This young man, of Boa origin and then residing in Belgium, had however previously maintained that his people did not use masks during dance, but rather that a Boa would "put on a mask during parleys" (Tisambi in Halkin 1910: 430). This last remark is quite improbable indeed, as is the assertion of some others that masks would be used during ape-hunts (*vide infra*). Of much significance is the fact that Tilkens (in Halkin 1910: 447), meanwhile, makes no mention of masks but does speak of statues[12] and other woodcarving. Also de Calonne-Beaufaict, who in 1909 had devoted an important monograph to the Boa and comes over as being a good observer, never makes any mention of masks or any other sculpted work. This at the least indicates that at the beginning of this century, and certainly thereafter, mask production was indeed quite spare. As has been mentioned, Hutereau did succeed in getting hold of two examples during his journey in the Uele region. In his dossier, archived at the Musée Royal de l'Afrique Centrale in Tervuren, one may read that these were *pondudu* masks, worn during "war and dances. One believed that the mask struck fear in the enemy." Hutereau adds in this regard that one of the examples was worn by what he terms a "sorcerer"; the man who during a battle at the mouth of the Gwara, wounded Commandant Christians during the Belgian campaign against the Boa uprising of 1900-01.[13] Here one may ask if this was indeed the same mask that Hutereau was to find nearly ten years later. In any case, Maesen — who was the first modern investigator to publish something on the Boa — had indicated as early as 1951 that the testimony of Hutereau concerning the use of the mask was consistent with reports from the first explorers and pioneers to this region, at least with repect to war masks. As for use in conjunction with dances, he adds that "unfortunately we do not know the circumstances and significance" (Maesen 1951: 4). A few others have subsequently merely written that masks among the Boa belong to "secret societies" or to "warrior societies" (see Cornet 1975: 131)[14], or else have to do with "ancestor-portrayals which are a weighty symbol of a male secret-association" (Lema Gwete 1980: ill. 93) — two assertions which to our knowledge are not supported by any explicit evidence. This also applies to the report that these are masks which would have been used in the *ebkudiko* dance (*vide infra*), or in connection with acts of divination.

McMasters (1990), who carried out ethnolinguistic fieldwork among the Boa people during

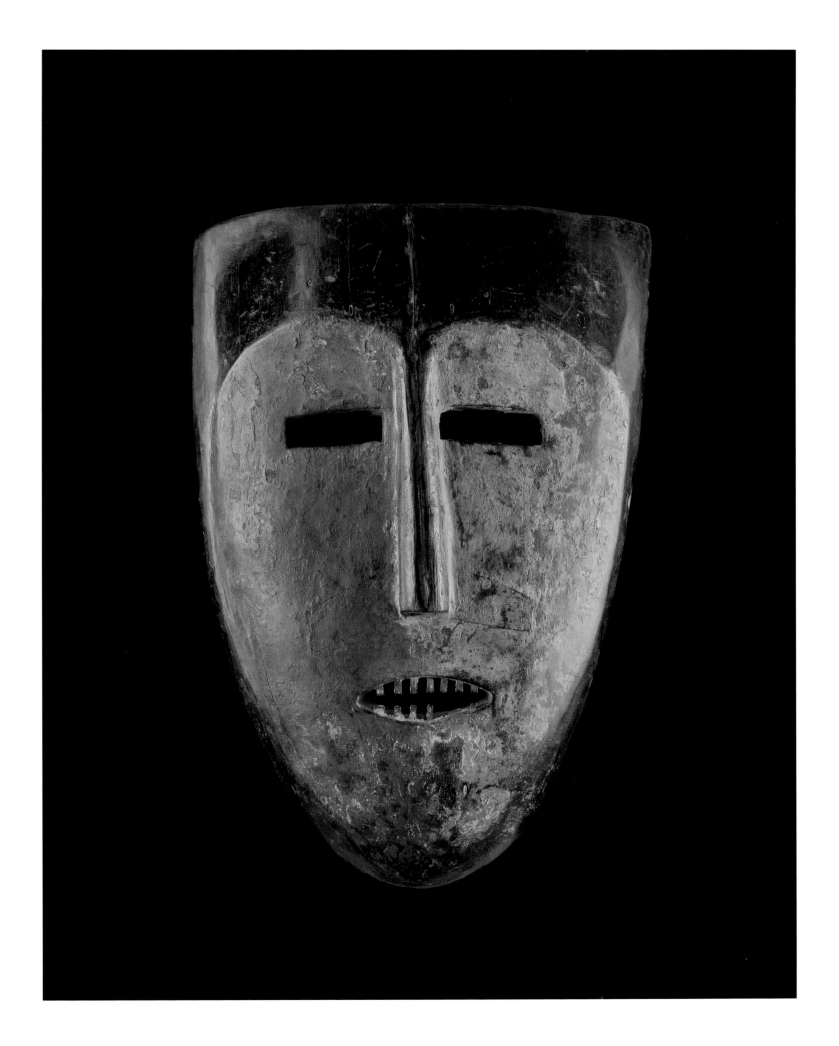

113

NGBAKA? or MBANJA?

Zaire, Equatorial Province, Ubangi
anthropomorphic face mask
H. 24 cm. Wood, pigment, metal

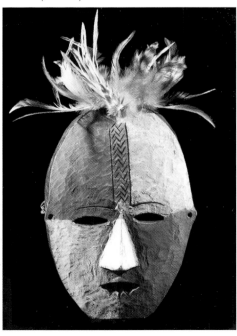

ill. 6. Binza (Upper-Zaire). *Ekukura-mbanda.* H. 25 cm. In 1911 collected by A. Hutereau in the village Badunga. M.R.A.C., Tervuren (R.G. 4084).

1978-79, offers some further information concerning the use and function of the masks. According to some of her informants, these masks were indeed used in battle, but not exclusively so. They speak of *kpongadomba* when referring to the earlier, large war mask. Its specific function was to make the bearer invulnerable during battle. The *kpongadomba* was so powerful that it was not brought out for lesser disputes between neighbors, but only when a deadly and infallible force was required. Such a mask was summoned by the *kumu* (the chief), who would then entrust it to the man he considered the most courageous. The warrior who led the way into combat wore the mask. He was, according to a certain informant, not the battle-commander (the *nzepeli*). McMasters suggests that Hutereau may have mistaken this figure with the man he named as "sorcerer", and who wore a mask. But in this case one may add that this could not have been the *nzepeli*, unless the informant was mistaken in his statement. Whatever the case, during periods that the *kpongadomba* was not in use it was under the guardianship of the wife of the warrior who wore the mask, at least according to an informant whose grandmother was once entrusted with a *kpongadomba*. The mask was not treated with any particular substance or other to render it more powerful; this, in contrast to the case of the warrior's themselves. Prior to the outbreak of hostilities a special powder was made, mixed with palm oil and introduced into a horn. Before battle each fighter would eat some of this, so becoming invulnerable. The horn was kept by the woman to whom the mask was entrusted. All informants concurred that the *kpongadomba* was not used in dance, because the Boa "do not consider the occasions when the mask was employed to be dances" (McMasters 1990: 10). The confusion must have arisen due to some *kpongadomba* being designated as a dance mask as well as war mask.[15]

McMasters further argues that the Boa uprising against the colonial administration in 1900-01, led to the *kpongadomba* losing its function. It had indeed failed in the struggle against Belgian military might, and thus appeared worthless during this ultimate resistance to colonial rule. This did not automatically mean, however, that after so many years of use masks were no longer employed. The *kpongadomba* retained a place in Boa culture, but acquired a totally different role. Frightening as it was, it would subsequently serve as "a last resort in the enculturation of children" (1990: 10), as the author puts it.[16]

McMasters brings no convincing argumentation to indicate that the Boa would have long after this time still made masks for this purpose, or even used them — as she seems to accept. There is much to indicate that they had never had many masks. If the Boa, at least originally, only employed the mask during important battles and then only by a single individual (per battle-unit?), then their production in large numbers would not have been necessary. That they would have been parts of a "secret-society" (*vide supra*) is completely uncertain, as is the case for their being ancestor-representations. No source, McMasters included, has written on this point. The contention that mask wearers were members of a warrior-society seems plausible in the given context, but here too one lacks supportive proof. With respect to dances with masks, as some have opined, here confusion may have arisen between dance movements made by the wearer of the mask, and true dances as such. Furthermore, it remains unclear if the Boa once exclusively made use of masks for important battles, and if this had always been their practice. Who or what did the mask represent? A powerful spirit that offered the bearer protection, and would strike fear into the enemy's heart? Or perhaps even a warlike clan-ancestor? This is likely to remain a mystery. Most peoples in the north of Zaire who have masks, use them mainly during the boys' circumcision/ initiation rites. Circumcision is also known among the Boa, but we have no indication that masks are employed in conjunction with this. Perhaps this was formerly the case. A definitive answer is not possible here. We will, therefore, have to be content with the limited data available to us.

With more specific regard to the Benge, the Musée Royal de l'Afrique Centrale in Tervuren possesses a mask (R.G. 4926; see Von Sydow 1954: ill. 127C) which in several respects deviates from those termed here as "classic" examples, owing to — among other reasons — the absence of (prominent) ears, and the face's partition into four horizontal color-bands; from above to below, respectively, dark colored, ochre colored with white stipples, white, and again dark colored. On the forehead, above the eyes, there is a single series of pointed notches which somewhat resembles the previously mentioned *nyakuma*. The same scarification is also to be seen in two short rows at the level of the temples. Concerning the specific use of this mask, there is next to nothing known. Perhaps this had the same function as the better-known Boa masks.

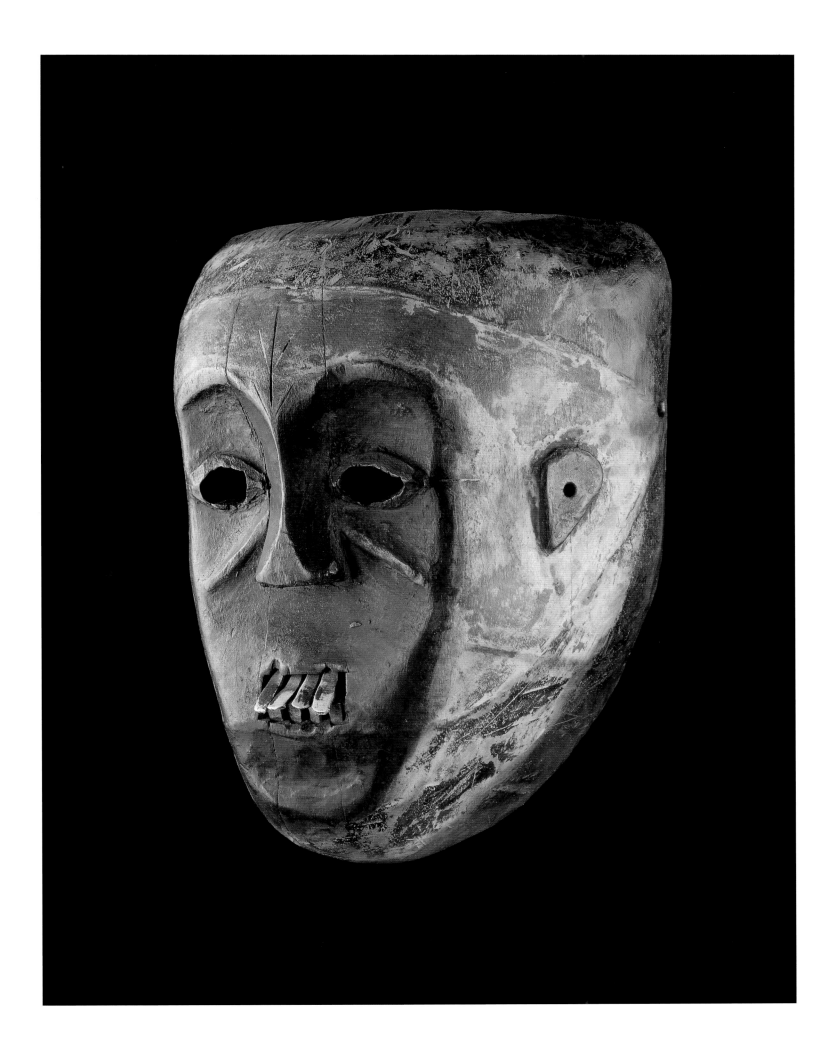

To the same museum was also sent three near-identical masks from the Binza people, southerly neighbors of the Boa (M.R.A.C., Tervuren, R.G. 4083 to 4085). These were acquired in 1911 by Hutereau in the village of Badunga on the Lower-Itimbiri (ill. 6). They exhibit in the middle of the forehead, a vertical band with carved incisions resembling a double-herringbone motif. The face is strikingly divided into four equal areas, alternately ochre colored and white.[17] Just as with the Benge mask, here one also finds an attached finial of feathers. Extensive information about this sort of mask is lacking: the collector only notes that the name is *ekukura-mbanda* and was danced, and further that the "Mobati" (Baati) would have formerly also made use of it, and called it *epwengogo*. No other examples of this mask type are known to us, that through the presence of striking color-composition reminds one inevitably of the Boa, and this despite the deviation in patterning.

Finally, we must also make mention of the Mangbetu people, because two masks of mutually similar appearance have formerly been attributed to this group. These masks are plankboard-like specimens with a vaulted forehead, round eyes, and a sharp nose. On the forehead are small vertical bands in white paint, with horizontal ones on the face proper. These masks — at present in London's Museum of Mankind — were acquired in 1895-96 by Burrows, who attributed them to the Mangbetu. Naturally, this is incorrect, seeing that this people neither made nor make use of masks. It is noteworthy that Burrows described these as war masks. Schildkrout & Keim (1990: 33 and 240), who designate these masks as nos. 3.6 and 3.7, suggest that they are of Boa or Budu origin. But on the one hand we know nothing further about any masks of Budu derivation, and on the other, both of these decidedly plankboard masks substantially deviate from other Boa examples, and most certainly from the typical pieces.[18] They also bear little resemblance to other masks from the area as a whole. Just who indeed, then, was responsible for these masks, will long remain an open question.

We may conclude this survey with the following remarks. All masks belong to the rather flat facial type, and are purely anthropomorphic. Of one sole Zande mask, informants maintain that its white flecks are indicative of the animal-totem of the Bandia. Most of the masks acquired from the Uele territory may be attributed to the Boa, or else secondarily to the Zande-Bandia. There are indications which go to show that the masks with hypertrophied, open ears — and others, similar in aspect — originate from among the eastern Boa. It cannot be ruled out that the Boa, who indeed consist of six different groups when broadly considered, also know other forms of design — as the single Benge mask might indicate. That the Zande masks are "probably also of Bua derivation", as believe Schildkrout & Keim (1990: 240), is something more easily asserted than effectively demonstrated. The Zande masks taken as a whole differ stylistically from the typical Boa examples, though occasional morphological similarities may be seen. But such may also be observed in some Ubangi masks or in other specimens from other regions of North-Zaire. Remaining unclear is the question of possible mutual influences, and precisely who may have acquired what from whom. One must take into account that the various ethnic groups who subsequently came under the authority of the Bandia rulers may have previously had their own — if limited — mask tradition, with a largely different design. This was suggested by Lagae as early as 1926, and is supported by the more recent production of so-called Zande masks. We have too little data at our disposal to be able to draw valid conclusions. This applies not only to this type of mask, but as well for all others which have been encountered in the Uele territory, and even in the whole of northern Zaire since the end of the 19th century. It remains far from evident that one will ever be able to resolve a number of these outstanding problems: traditional mask production has long since ceased, and everything which is connected with their use is — with few exceptions — only rarely able to be fully reconstructed.

Apart from the published sources listed in the bibliography, use was also made of the following unpublished documents (*Dossiers Ethnographiques*, E.D.), which are all archived in the Musée Royal de l'Afrique Centrale in Tervuren: Hinjon no. 409; Hutereau nos. 298 and 312; Perlo no. 295; Uytenhove no. 54.

1. More specifically, the "zones" of Mobaye and Busingi. During the official census of 1970 there were living in Ubangi, as here defined, 1,028,008 persons (de Saint Moulin 1976).

2. More precisely: Ngbaka mi-na-gen-de. The colonial administration formerly referred to them as "Bwaka". One must not confuse this group with the Ngbaka of the Lobaye from the Central African Republic, who are part of the Ngbaka Ma'bo — and the majority of whom occupy the same territory, with a lesser number residing in Ubangi (*vide infra*).

3. Also spelled "Mbanza" and "Mbandza". Linguists usually choose the spelling "Mbanja".

4. See Arte del Congo (1959: ill. 63), where it is designated as Ngbaka. For the statues, see Burssens 1958a. With specific regard to this headdress, it will not be maintained here that it existed exclusively with the Ngbandi: on the basis of old photographs it seems it would also have been known to some Ngbaka.

5. Both "sub-regions" in 1970 contained exactly 1,384,527 individuals (de Saint Moulin 1976).

6. Compare the word *batipi*, as reported by Hutereau.

7. Their exact number, which is indeed dependent upon the groups that one includes, is not known. Authors such as McMasters (1988, 1990), Schildkrout & Keim (1990), and more recently Vansina (1990), opt for the spelling "Bua". According to linguists, who also write "Bwa", the pronunciation of the word is between the "o" and the "u".

8. This type of ear has indeed disappeared from some masks, or has been partially or completely broken off. One can still clearly see the groove in which they were originally set. Sometimes the ears are extremely large, but have no openings in the middle.

9. In the same year (1907) the M.R.A.C. in Tervuren was sent an oblong and simply conceived mask (R.G. 512) by J. Uytenhove, "Head of the Uele-Bili zone", who had come across it among the Zande-Bandia in "the region of Djabir" (i.e. Bongo), but was according to him derived from the Boa, where it functioned as a war mask. Stylistically it relates much more to the known Zande masks, so that doubt remains as to its precise origin. The mask was designated as Boa by Von Sydow (1954: ill. 127C), and subsequently as possibly Zande by Burssens (1960: ill. 17).

10. They were acquired by Hutereau in the "Chiefdom Manzali, tribe Babwa, clan Bokadu-Bambili". Both masks were repeatedly published: the one (R.G. 11696) by — among others — in Radin & Sweeny (1952: ill. 30), Von Sydow (1954: ill. 127B) and Maesen (1960: ill. 48); the other (R.G. 11697) in Maes (1924: ill. 50), Kongokunst (1956: ill. 535) and in Arte del Congo (1959: ill. 61), and more recently in Schildkrout & Keim (1990: ill. 12.8).

11. Another two "Boa" examples were acquired in 1976 by the same museum in Kinshasa, and not from among the Boa themselves. One of these was published in Lema Gwete (1980: ill. 93) and in McMasters (1988: 90 and 1990: 2). The naturalistic aspect of the design, not least of all with regard to the mouth, is much more closely akin to that of the Yombe masks than to those of any other people from the Uele region, or indeed any other people from the whole of the northern region. Our opinion is that this is a case of a relatively early imported example from Lower-Zaire, if not a locally produced imitation of one. McMasters (1988) certainly draws premature conclusions when she, merely upon the basis of this rather dubious specimen, speaks of two different *kpongadomba* styles among the Boa.

12. This last observation is correct, but there are very few statues known which one may attribute to them (see Burssens 1963).

13. See Hutereau (E.D. no. 298), where one reads the following: "Masque de guerre et de danse. Se figuraient que ce masque donnait l'épouvante aux ennemis. Le sorcier qui a blessé le Commt Christians près de l'embouchure de la Gware portait ce masque. Après avoir reçu un coup de lanse dans la cuisse le Commt se refugia sur l'ile Magombo." Compare Maes (1924: 49), Schildkrout & Keim (1990: 241, ill. 12.8) and McMasters (1990: 9).

14. Sieber (1987: 85) — apparently drawing from Cornet — speaks of masks which "have been described as belonging to warrior or secret associations and are considered to be war masks...", and then adds, "or disguises in hunting" (Compare Kunst fra Kongo (1960: 114) where there is more specific mention of the "ape hunt"), something which is highly improbable.

15. McMasters here provides no further details. Hutereau speaks of *pongdudu*, and Cornet (1975: 130) mentions the *ebkudiko* dance (*vide supra*). There is no further information available on either of these dances.

16. This assertion may be compared to the report of Hutereau in 1913 with respect to the Zande-Bandia mask as not being a "war mask", but rather one that functioned "to frighten children" (*vide supra*).

17. Compare Maes (1924: 50) — where "Warega" is printed, incorrectly — and Von Sydow (1954: 88 and ill. 127A). According to map no. 2 in Guthrie & Tucker (1956), the lower course of the Itimbiri was during the period of their investigations populated by Mbudza speakers. The data of Hutereau, contrarily, point to the Binza. Masks which may be attributed with certainty to the Mbudza, and could eventually here serve by way of comparison, were to our knowledge never field-collected. The same sort of patterning as seen in the three masks discussed here, is encountered — among others — in some Kota masks and, exceptionally, on Yombe examples.

18. It is mainly the lowest portion that is markedly flat. The broad horizontal bands on the face are also seen in a few typical Boa masks, but Schildkrout & Keim (1990: 241) themselves write that "This dark/light patterning is clearly the most basic design element in the region..."

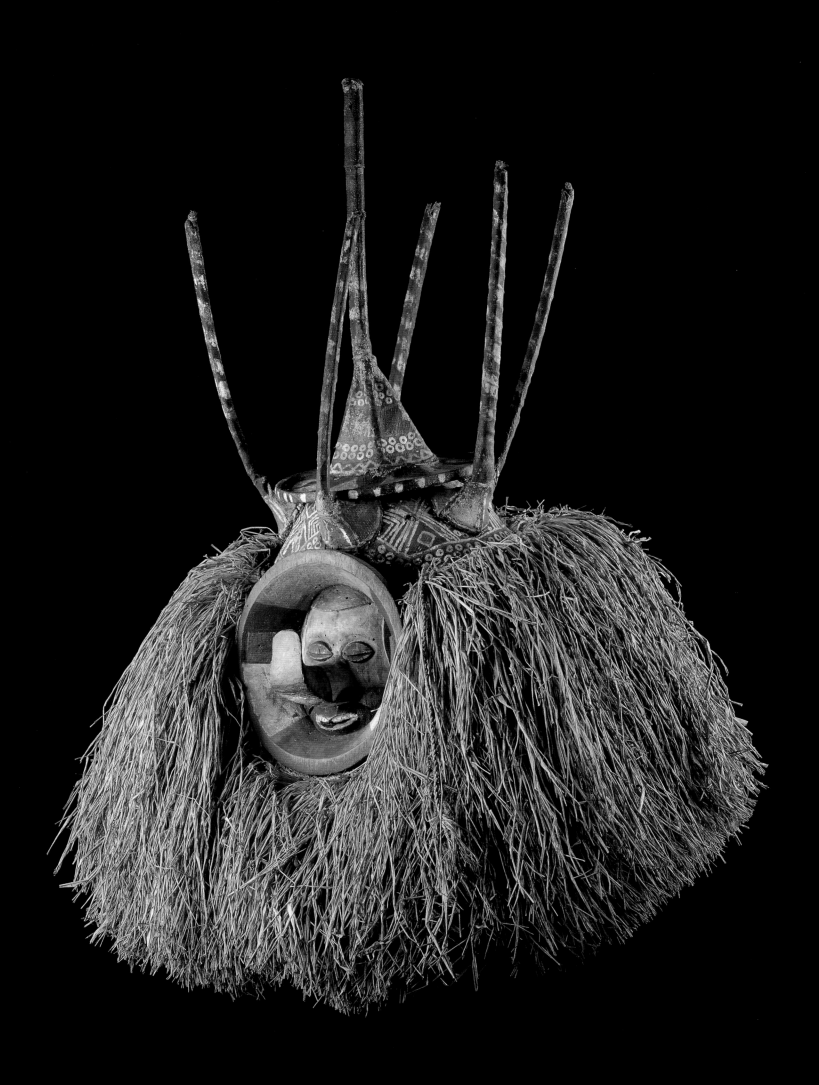

Zairian Masking in Historical Perspective

Jan VANSINA

The habit of masking in various circumstances and for various purposes is known from many cultures in all parts of the world. To don a mask in order to act out a role or to render an intangible supernatural entity concrete and visible easily comes into the mind of people. Hence the peoples in all parts of the world have invented masking over and over again. So masking, even in Central Africa, does not necessarily have a single origin. Yet masking is not universal nor does it serve the same purposes everywhere.

For the people of Zaire most masks represented spirits or ancestors, ideal roles such as "the ideal woman" or "the wise leader", or represented personified concepts in a didactic way. Usually masks were made for and used in a performance during which the masked actor danced the role of the entity or concept portrayed. Such performances were not spontaneous. They occurred at certain times and within a set institutional framework. Most peoples in Zaire used masks during the initiation of boys, during induction of men into various other associations, at funerals and sometimes for diviners. These are all rites of passage when a person leaves one identity in life to adopt another. Some populations used them also at the birth of twins (one person or two persons? spirits?), an occurrence that also poses problems of identity. In some cases masked dances appeared as political theater to act out principles of ideology or to exalt one's status in competition with others. Institutions consist of repetitive, regularized, and expected patterns of behavior and activities. In every community some institutions are perceived as central to its structure while others are more peripheral. The degree of effort lavished on art, including masking, varies according to that perception. Art that is associated with pivotal institutions is more carefully made or performed than art for less essential purposes. Thus today masks in the Western world are not taken very seriously and usually not classified as "great art", because they are used only in marginal institutions in contrast to most Zairian societies where initiations, healing, divining, or government were central institutions, a fact reflected by the care given to the associated masks and dancing.

Yet masks were not often kept as treasures or heirlooms. (There is nothing in Zaire comparable to the great ancestor masks of the Dogon which were preserved for centuries). In many cases they were discarded because they were part of a performance, an ephemeral art very susceptible to current fashion. Hence in many places it was felt that new masks should be made for every new cycle of performance, although in others old masks were used again. Then the masks were only part of a costume and of a dance. They were usually not all that valuable by themselves. Once acted out the performance became just a memory. Hence the sources for a history of masking will always remain unsatisfactory. In most cases only the masks remained, and even so they were often discarded. In the whole of Central Africa only one very old item has survived. It is a wooden headdress, carved in the shape of an animal, found at Liaveta in central Angola and dated to 750-850 A.D. (Van Noten 1972: 133-136; the uncorrected date is 750±35 A.D.). The oldest known references to masks date only from the middle of the 19th century while the oldest surviving masks date from the late 19th century. A comparative study of styles allows the art historian, however, to trace both internal artistic evolution and borrowing from one society to another. Sometimes linguistic data confirm conclusions reached on stylistic grounds, as in the case of Kuba masking which is derived from their southern neighbors and ultimately from the Pende. Even so the results of such studies are fully satisfactory only when masking is put in its institutional context. The Kuba borrowed their boy's initiation rituals from their southern neighbors and the diffusion of masks is but a part of that. But institutions themselves form part of a wider social and cultural framework, which throws light on their evolution. Hence a full historical context of masking requires one at last to sketch the main outlines of the overall histories of the peoples involved. That is the task of this presentation.[1]

15
YAKA
Zaire, Bandundu
anthropomorphic helmet mask
nkaka
H. 60.5 cm. Wood, pigment, fiber

In the Kongo-Kwango Museum in Heverlee is a mask with elements exhibiting a certain similarity to this example. In each case the face is wreathed with a flanged border, and has a prominent nose with an upturned tip. Although there are differences in the mutual relationship of the elements from out of which the headdress is assembled, there nonetheless remains a certain analogy of form. One notes that the execution of the example shown here is more detailed. To both masks is affixed a thick fiber coat. From the similarity one may presume that this mask represents the same figure, *nkaka* or grandfather. (F.H.)

Lit.: Bourgeois 1982; Bourgeois 1984

20
KWESE

Zaire, Bandundu, Lutshima
anthropomorphic face mask
H. 26.5 cm. Wood, pigment, metal

The Kwese inhabit an area between the
Kwenge and Lutshima Rivers, and are
strongly intermingled with the Mbala and
Pende peoples. There is little known about
the Kwese or their art. Therefore, it is near-
impossible to distinguish characteristics of
artistic uniqueness among the many related
small ethnic groups. Nonetheless, a few
masks of wood and fiber may be attributed
to the Kwese. Bell masks with a white heart-
shaped face and lobed headdress, are
constituent to the above-named interethnic
style-tradition (cat.19, p.15). Though in
theory it might be possible to ascribe mask
types to a particular people on the basis of
the headdress, the reality is far more
complex. Proper to the Kwese are small face
masks with a white colored heart-shaped
facies. Typical are the large closed eyelids,
and the small parallel vertical stripes under
the eyes — possibly suggesting tears. The
face is reminiscent of the atypical *gitenga*
mask of the neighboring Pende (cat. 21).
Originally the Kwese masks were
completely wreathed round with a wide ruff
of raffia fibers. As to the mask's use and
function, there is nothing known. (C.P.)

Lit.: de Sousberghe 1959; de Sousberghe & Mestach
1981; Biebuyck 1985

The most crucial process in the history of Zaire has been the arrival there of people who brought
both farming and sedentarized village life to the area between four and perhaps five millenia ago.
In a cultural sense those immigrants are the ancestors of present day Zairians to whom they
bequeathed their language and their culture. Most Zairians today speak languages belonging to a
single family, called Bantu. Only those who live in the northernmost part of the country speak
languages belonging to a number of other families. The original Bantu speakers lived about 3000
B.C., in an area which is now part of western Cameroun and nearby Nigeria. They had acquired
farming and were beginning to lead a sedentary life. Even though this was such a long time ago,
linguistic data yet allow us to reconstruct their way of life in some detail. With regard to a history
of masking the following points should be noted. Although these people did not use iron, their
technology was already well developed. They were potters, basketmakers, perhaps even weavers,
they knapped stones and they carved wood. They used a verb *-conga* to describe "whittling, sharp-
ening to a point", and its descendant in many languages now also means: "to carve". Yet carving
must have remained rudimentary until iron tools were available. Furthermore they conducted
initiation ceremonies to induct boys into adulthood. This is remarkable because in later times
masks are so often associated with such initiations. But there is no evidence that masks were used
this long ago.

At that time all of Central Africa itself was very thinly occupied by nomadic foragers and perhaps
semi-nomadic fishermen. In the eyes of farmers this was empty land. Around 2000 B.C. Bantu
speaking communities began slowly to intrude, one village a time, into these lands, going further
and further every generation. They moved from west to east and entered Zaire south of the
Ubangi and Uele Rivers. There they spread southwards as far south as northern Maniema and
eastwards into the fringes of the region of the Great Lakes. In the far west they occupied southern
Cameroun and northwestern Gabon. Then this linguistic group, which can be labeled the
northern Bantu, split up in several parts, perhaps by 1000 B.C. Two among these later expanded
much further. One of these, the eastern Bantu, then in the Great Lakes area, found and mingled
with other farmers and pastoralists and their expansion slowed down to a crawl. The western
Bantu, armed with rootcrops well adapted to some forest environments, spread southwards into
the rainforests. In time they occupied the forests in present-day Gabon, and Congo and the rain-
forests in present-day Zaire, and later others moved into the huge expanses of savanna and dry
woodland of present day Congo, Zaire and Angola, and Zambia. By the last centuries B.C. they
were expanding in Angola, in western Shaba, and moving towards Zambia.

Meanwhile, in the sixth century B.C. both the eastern Bantu in the Great Lakes area and the
western Bantu in Gabon and Cameroun invented or acquired the art of ironsmelting. Iron tools
became available and with them the possibility to make fine woodcarving. Metallurgy then
diffused from its cradle among the western Bantu even as their expansion continued. By the onset
of our era, however, the art had barely reached Lower Zaire and had not yet caught up with
western Bantu speakers in Angola or beyond the river Kasai.

At this point we return to the eastern Bantu. After having perfected a new economy and created a
new type of society with inputs from other East African communities in the Great Lakes region,
they began to expand again westwards into the rainforests of Maniema, the savanna of eastern
Kasai and the dry woodlands of Shaba and Zambia. Their traces have been found around 200
B.C. already on the Upper Zambezi, although these early pioneers may not yet have known how
to smelt metals. Thus, expanding western and eastern Bantu speakers met each other and mixed
in Maniema, eastern Kasai, Shaba and Zambia, as one can see on sites in Zambia around 300
A.D. Then small numbers of eastern Bantu speakers spread even further westwards among the al-
ready settled populations beyond the Luluwa and the Zambezi as far as the Atlantic Ocean, and
were absorbed by the western Bantu speakers there. Yet they left a linguistic, economic and social
imprint in this area.

Meanwhile, from the last centuries B.C. onwards, also farmers belonging to other language fam-
ilies and hence to other cultural traditions began to migrate from several directions towards the
fringes of the rainforests in northern Zaire. Very few among them adapted to life in the rain-
forests, and most of those who did were eventually absorbed by western Bantu speakers. But one
group did move into the forests of Ituri and northern Maniema, probably in the first centuries

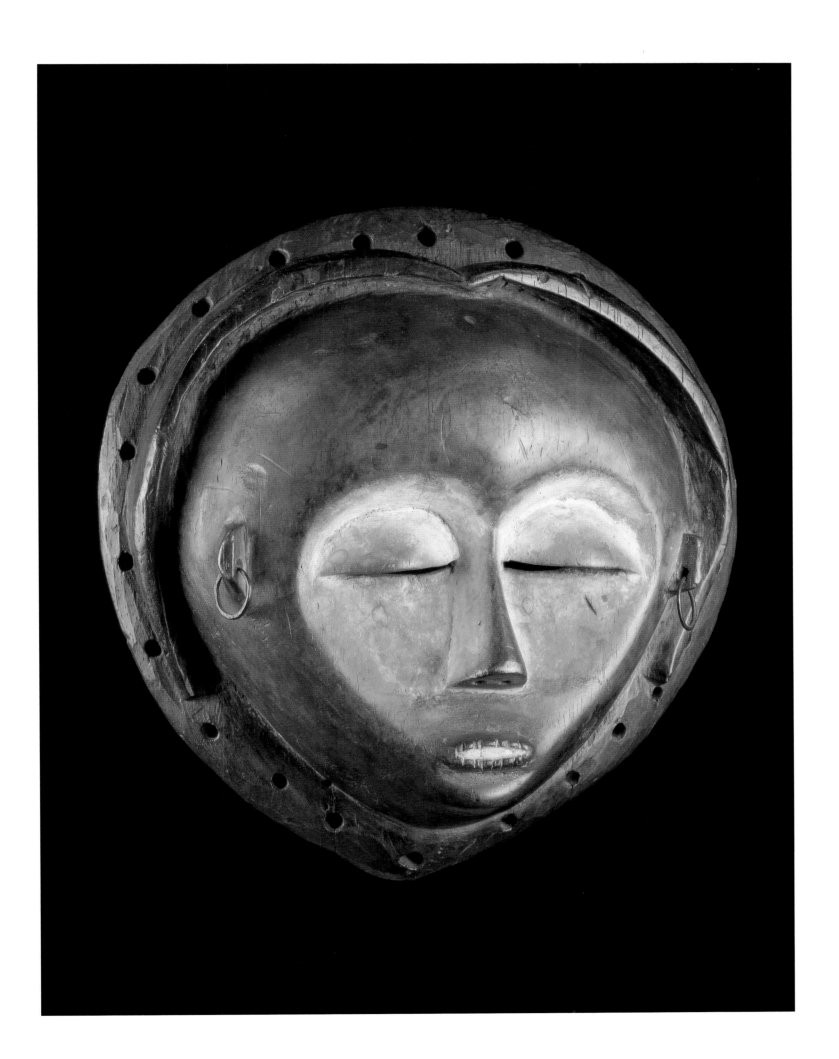

33
PENDE

Zaire, West Kasai
anthropomorphic face mask
kindombolo
H. 26 cm. Wood, pigment, fiber

The perforations seen on the cheeks of this mask type probably are imitative of scarring consequent to smallpox. Léon de Sousberghe relates that this personage was involved with pregnancy, and appeared in order to assure a successful delivery. It would carry out a particular ritual which included the sacrifice of a chicken. According to other authors, this mask type belongs to the category of village masks, known as *mbuya jia kifutshi*. As representation of the "sly one" or the "trickster", it is reminiscent of the *tundu* character of the Katundu-Pende. Established values are called into question, and fun is poked at respected village elders. The chaotic, irregular, and asocial comportment of this personage, in fact serves as a mirror to the community, and functions to maintain order and harmony in the society. (C.P.)

Lit.: de Sousberghe 1959; Janzen & Kauenhoven-Janzen 1975; Petridis 1992b

A.D., fused there with northern Bantu speakers such as the Komo, and left a strong imprint on their languages and cultures.

The whole era of migration and colonization ended well before 1000 A.D. except in northernmost Zaire. By then the cultural landscape of the area was fixed. The cultures of Zaire then fell into four groups: in southeastern Zaire the western Bantu and eastern Bantu traditions had fused. In southwestern Zaire the western Bantu tradition prevailed with eastern influences. In the rainforests west of the Lomami the western Bantu tradition remained unchallenged. In northern Zaire and in northern Maniema a fusion between the western and northern Bantu traditions and various non Bantu traditions had and was then still taking place. Even as late as 1000 A.D., however, all of Zaire was still far from settled. The immigrant farmers had at first chosen the most favorable locales to settle. As a result population densities rose higher in these areas than elsewhere. One can compare the distribution of such clusters of settlements, around say 500 A.D., to islands strewn in a sea of barely occupied lands. One still discerns traces of these old clusters in the Ubangi bend, in pockets north of the great Zaire bend, in tracts north and south of the middle Uele, in portions of Lower Zaire, in the middle Kwilu area, east of the Upper-middle Kasai River, in central Kasai and and in two places along the Lualaba valley. Within each "island" the populations began to interact with their specific environments in more intensive ways then before, while also developing new practices, institutions, values and ideologies. The divergences in social life, culture and art between the different population clusters grew rapidly, even though no single cluster remained totally isolated nor without influence from others.

This process of divergence lasted a few centuries. Then an increase in the intensity and frequency of communications between clusters occurred, accompanied by the diffusion of goods, people, ideas, values, institutions, and art styles. That process created more similarities between the cultures of the peoples involved. This convergence of cultures began to counterbalance the divergence which also continued as local cultures continued to innovate. Henceforth, in every region periods of strong convergence alternated with periods of strong divergence according to different rhythms in different regions. The complexity and multiplicity of these developments force one to focus on common trends which affected many societies in large regions, albeit at the cost of neglecting the internal innovations which are at least equally important, for instance for a history of masking. Such common trends have been strongest and are best known for southern Zaire, an area to which we now turn.

Our information about southern Zaire in early times rests to a large degree on the results of the only archaeological excavation on a large scale conducted in Zaire, that of the cemeteries of the region of the lakes of the depression of the Lualaba in Shaba (de Maret 1991: 235-241). Here one follows the economic growth of what later would be a Luba society and culture all the way back to c. 750 A.D. The most striking result is the amazing degree of continuity from the very beginning onwards to recent times. Undoubtedly these people were forerunners of the Luba we know. For example, a ceremonial axe found in a grave of the period before 1000 A.D. can be immediately identified as an emblem of rule, because such axes still were emblems here by 1900. But continuity does not exclude change! At first the population was smallish, but after 1000 A.D. it grew substantially and the area became a high density population cluster. Differences in the amount and type of grave goods show clear distinctions by gender and age as well as growing differentiation of wealth and social status from the outset, but not yet a sharp cleavage between rich and poor. That would only occur after 1400 when outsiders seem to have overrun the area.

The increase in the social division of labor is also evident in economic production. The quality and diversity of the goods buried increased at first until a high standard of excellence was reached. By 1000 A.D. the products were clearly the work of specialists in various crafts such as pottery, metalwork or ivory carving. In this context it is worthy of note that terms for "technical specialist in general" exist not just in the Luba languages but also in a number of other languages such as Chokwe, Kongo or Pende, all spoken by peoples reknowned for their sculpture. That fact draws attention to the link between the general level of economic development and the existence of artistic ateliers. Unfortunately no direct evidence for sculpture in wood survives in the Lualaba cemeteries, because organic material has not survived there.

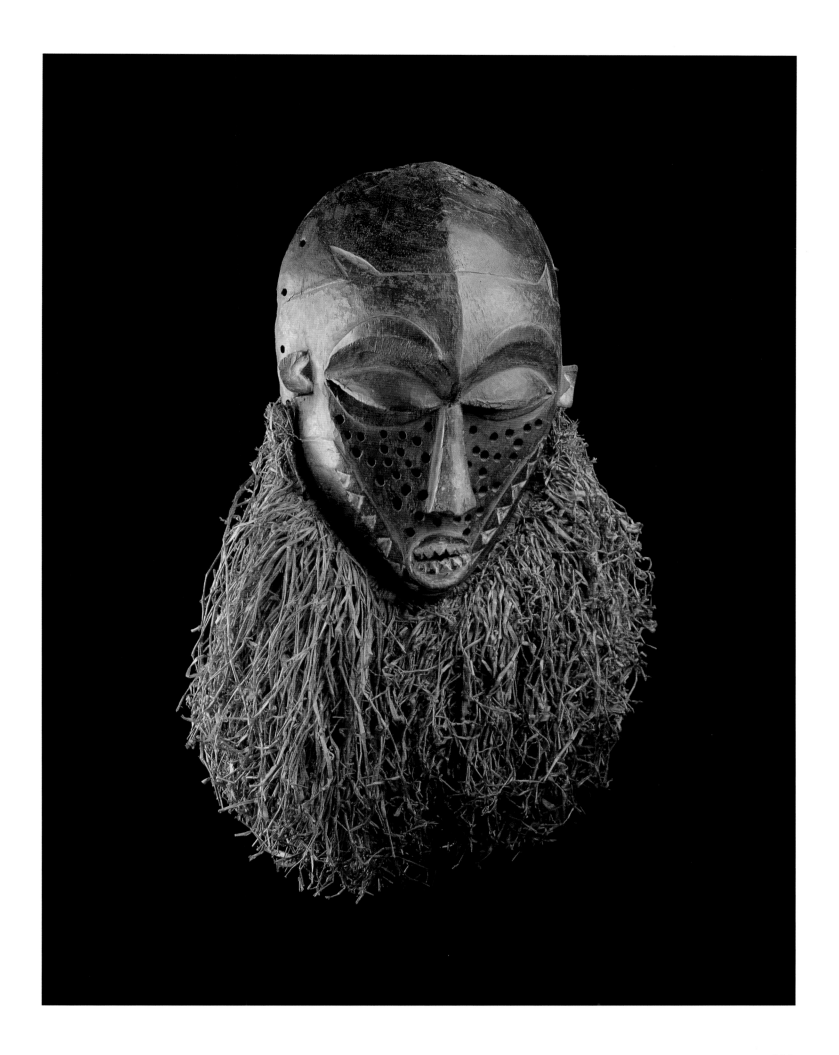

58
BIOMBO

Zaire, West Kasai

anthropomorphic bell mask

tshimwana

H. 45 cm. Wood, pigment, fiber

The Biombo live at the confluence of the Lulua and Kasai Rivers. Their culture is strongly similar to that of the Kete and the Bushoong. Just as the *bwoom* mask of the Kuba (cat. 60) and the *kamboko* mask of the Kete (cat. 65, p. 243), the *tshimwana* mask too has a bell-shape. The facial decoration with geometric patterning in its turn refers to the Kasai-Pende. Biombo masks are generally polychromed, with red being the dominant color, then white and black. The *tshimwana* mask is female and it appears together with other masks at initiation and funerary rituals. Further information concerning function is lacking. (F.H.)

Lit.: Cornet 1972; CORNET (p. 129)

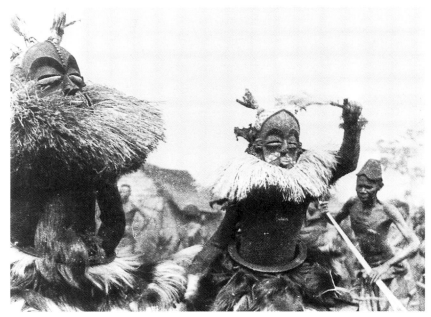

Biombo (West-Kasai). *Tshimwana.* Photo: E.Muller, 1930. M.R.A.C., Tervuren (E.PH.7420). *See cat. 58*

The presence of imports from elsewhere documents the growth of trade over the centuries. Few imports were found in the early tombs, but foreign trade blossomed after A.D. 1000 and grew to the extent that a regular metallic currency, the copper cross, came into use during the fourteenth century. Before 1400 a strong interconnected long distance trading network tied central Shaba to Zambia, Zimbabwe, Transvaal and the shores of the Indian Ocean, while indirect evidence also attests to such trade along the Lualaba to peoples to the north and for less intensive and perhaps indirect communication with peoples further west, all the way to the Atlantic Ocean. At the same time, though, the quality and variety of the grave goods deteriorated. The decline in quality reflects a strong concern with production costs in the context of a more commercial economy, not a loss of technological know how. The decline in variety relates both to a changing political environment and to change in how commercialization affected the notion of what were valuable and desirable goods.

The institutions of government are only indirectly documented in archaeological sites. From the earliest centuries onwards there were already emblems for chiefs whose graves were better appointed than others. In a small number of graves, strings of shells were found similar to those which were common in the late nineteenth century in the Lualaba valley and among the Lega, where they were used by closed associations ("secret societies") as a currency to pay for entry into the various ranks. Ranked associations of this type then played a major political role in the government of a huge area covering central and eastern Shaba, central and eastern Zambia, eastern Kasai and southern Maniema. Hence the early inhabitants of the Lualaba valley depression were possibly organized in units ruled by chiefs and a governing association.

By the 1300's there is evidence for a growing intrusion into the depression of the Lualaba lakes from the northeast. This probably was a conquest by Luba from their main kingdom in central Shaba which was then emerging on the plains to the north. It affected the whole area by 1400 and from then on one can assume that the political institutions were those of the later Luba (Reefe 1981).[2]

There are indications that around that time much further north in Songye country the population was divided into two status categories: hereditary 'aristocrats' and others. Men were grouped into age sets that were connected to a ruling association because entry into the age set, which was the first step in a hierarchy of initiations within the association, consisted in the initiation for boys. Songye government consisted of an elective and rotating presidency, assisted by the local ruling association. Whether or not any masking was associated with this system, we do not know. By the fifteenth or sixteenth century this type of government by association with the status

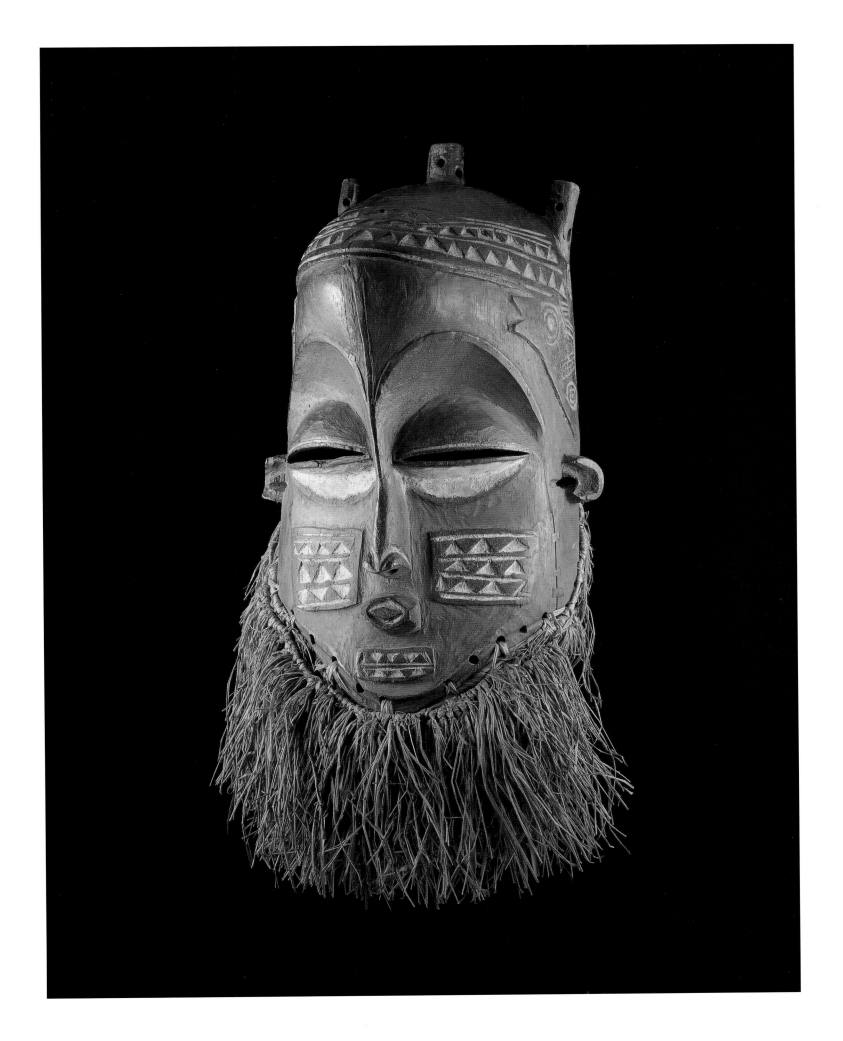

**Little is known concerning this mask type.
Joseph Cornet (1975) has published a mask
showing much morphological similarity,
called *kamboko*; it was collected in the
locality of Mubamba, in the Mweka zone.
The morphology is rather hybrid. The
massive form, without the long wooden
chin or beard, exhibits a certain likeness to
the *bwoom* or *bongo* masks. The conical
protruding eyes refer, on the other hand, to
the *pwoom itok*, *ishendemala* or *ishyeenmaal*
mask. The similarly protruding mouth and
the long chin suggest a morphological
likeness to the Biombo, a neighboring
people with whom they were once united.
An *imbol* motif in relief is represented on
the chin or beard. The *kamboko* mask
appears during mourning ceremonies for
men. (F.H.)**

Lit.: Cornet 1975; Neyt 1981; Cornet 1982

categories, and perhaps the rotating presidency (which was later abandoned in most places), spread northwards along the Lualaba valley into the rainforests to affect all the populations of the area, ultimately even the Mbole people of the Lower Lomami. The governing association, but without status categories and presidency, also spread into Lega country east of the Lualaba. But in the rainforests of Maniema there already existed many other associations, each serving a particular purpose and one of which was an initiation for boys during which masks seem to have been used. Many of these associations related to the cure for a particular affliction and one of them seems to have grouped diviners. Where the new governing association was adopted, the others were absorbed in it, which led to an increase in the number of ranks and status levels within ranks. Thus arose the celebrated complex overarching governing associations affecting all facets of life. This process reached its peak among the Lega, where it gave rise to the extremely complex and celebrated *bwami* association and among one of their groups to kingship when a new supreme rank of king, to be held by only one person, was added on top of the highest collective rank of the association. Masking may first have entered into the governing association during this process when the initiation for boys and perhaps also the association for diviners, were integrated in it. For among the Komo and related people of northern Maniema, masks were used by diviners when inducting a new member to their confraternity. Clearly Maniema was influenced by institutions from southern origin, but masking was not. Indeed the various styles of masks in the area do not seem to be related to those further south.

Also around 1400 several different systems of government based on very different principles existed between the Middle Kasai and Lubilash Rivers. Male age sets were politically important in two such systems located on both sides of the Middle Kasai River, and partly in an area of higher population density. At regular intervals all boys were initiated into a class of young men. These then formed a class of warriors at the disposal of village leaders. At a later age some members of the class, now consisting of older men, passed through another initiation to obtain a higher status, and at a later age this occurred again at least once more. The political role of these initiates of higher rank became comparable to that of associations among the Luba. The various initiations (*mukanda, mungonge, kela*) may well have been associated with masking in this area from the outset, as they were in the nineteenth century. The Pende term for constructed mask *munganji* used in these initiations has a direct connection to the vocabulary of the initiation for boys (*mukanda*) (for the connection with initiation, see Vansina 1990: 26). Hence masks were probably linked to this initiation from the first, a moment which we can unfortunately not date.

Not long after 1400 some Luba leaders from the Lualaba depression seem to have migrated westwards towards the lands of the Lubilash and Bushimaayi Rivers bringing Luba political principles with them. There they encountered local political systems, some of which at least used age classes. There followed a long struggle for supremacy in the area, which resulted in the creation of a Luba kingdom (c.1450) the Ruund kingdom (c.1500), later to become the Lunda "empire", and a Kanyok kingdom (c.1600), while groups further west and north kept their existing political organizations. During this struggle all parties borrowed political institutions, titles, myths and emblems from each other.[3] In the end a substantial overlap between Luba and Lunda culture resulted even though the principles of Luba and Lunda forms of government remained quite distinct.

During this struggle the Lunda developed military techniques far superior to those of the surrounding populations to the south and west. This led some ambitious leaders among them to conduct long distance razzias and soon to attempt to rule peoples far away. Thus forms of Lunda rule, and with them strong elements of Lunda culture, were brought to all the peoples of Angola east of the Kwango between 1550 and 1700. In the process groups of former leaders were sometimes displaced as happened to the now ruling families of the Pende who emigrated from a site on the Kwango River to finally settle in the lands which are now called "Pende" where they formed an aristocracy. But the Lunda also absorbed a number of local institutions and sometimes diffused them further. The effect of this first Lunda expansion was to give a considerable boost to the diffusion of various cultural institutions. Among these were initiation masks.

Linguistic and ethnographic evidence shows that the *mukanda* type initiations are now known from the Kwango valley to the Upper Zambezi and from there northwards to the Kuba kingdom,

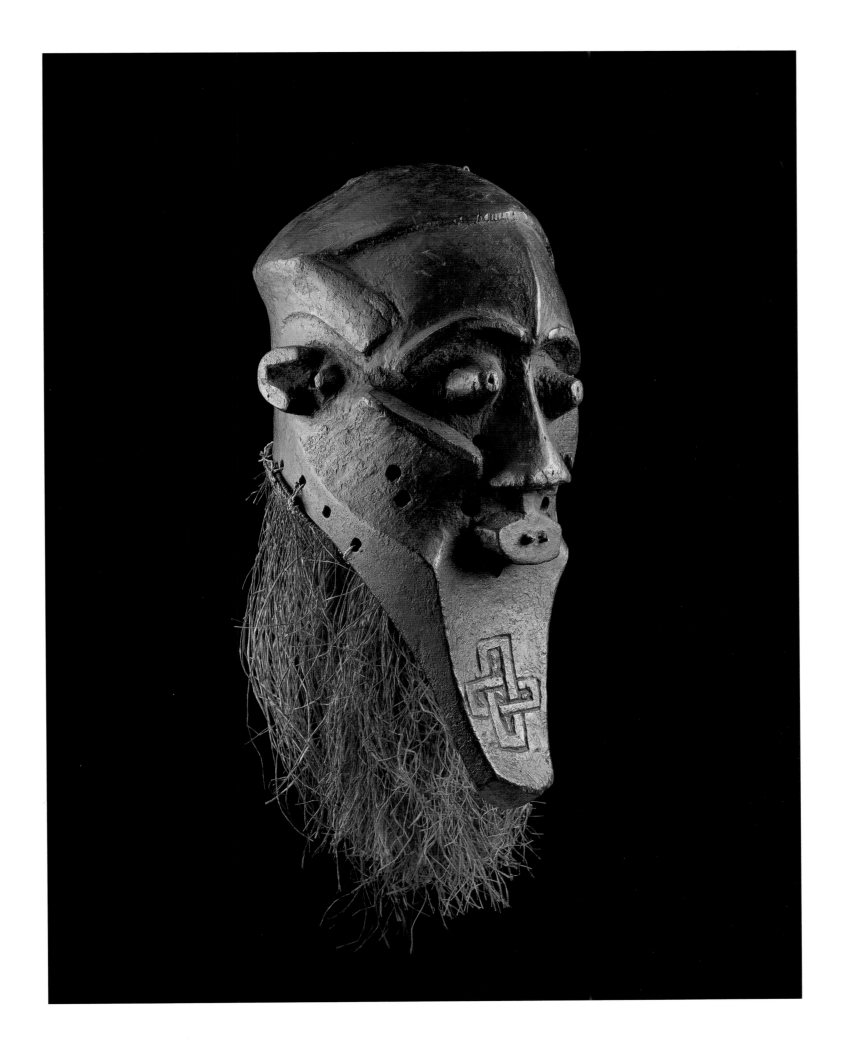

BEMBE?

Zaire, Kivu, Maniemba

anthropomorphic face mask

elanda?

H. 28 cm. Wood, pigment

Elanda is the name of one of the societies that has its roots with non-Lega groups. Membership in the society is attained by way of a long process of initiation. All activities focus around the *elanda* mask. Closed mask performances are preceded and followed by a ceremonial procession in the village. A key-figure in the initiations, called *abangwa*, also has the privilege to wear the mask and paraphernalia as a sign of his power, prestige and status. The mask is stored in a secret place and must on no occasion be looked upon by someone not initiated. As an *ebu'a* it denotes the hidden and fearsome power of the society. At the same time it imparts a feeling of solidarity among the members, and offers them protection against sickness and danger. Although Daniel Biebuyck only speaks of *elanda* masks from animal-skin and bark, the four-eyed mask attributed to the Bembe which is shown here, has also been related to the society and the rites. It is most likely a representation of the community's spiritual leader, who in addition to special wisdom, is noted by his "double sight". (C.P.)

Lit.: Biebuyck 1972; Neyt 1981; Mestach (*in* Maurer 1991: 136, no. 64)

but not in the core of the Ruund kingdom. The linguistic evidence shows that they diffused from a single central area. Already by c.1650 initiations were reported in the eastern part of the kingdom of Kongo[4] but that is not their origin. All available indications favor an area from the old homelands of the Chokwe around the sources of the Kasai and Kwango Rivers to the lands straddling the Upper-middle Kasai, now occupied by the Pende, Kete and Lwalu. Although the masks associated with them belong to two different types — the constructed masks more associated with the Chokwe and the carved wooden mask more associated with the Pende — we cannot assume two separate centers of origin, but rather a single larger interacting area.

The spectacular constructed masks spread over much of eastern and even central Angola, probably as a result of Lunda expansion there. It is less clear how the wooden masks diffused from their cradle to the lands of the Kwango and into eastern Kongo, only that the Lunda were not involved. One thinks of diffusion along trading routes. Be that as it may, it is certain that the diffusion was rather slow because a general term for such masks did not spread with them. Hence this diffusion may well have occurred over several centuries before 1650. A further expansion occurred to central Kasai and into the Kuba kingdom. The Kuba adopted the *mukanda* boy's initiation before 1680. They borrowed it from the Kete and ultimately from the Pende. For the generic Kuba name for a mask is *mbooy*, a term derived from the Pende *mbuya* the generic name for carved masks. Earlier the Kuba had not known any form of mask (as opposed to face paint). The initiation masks were the stimulus that led them to invent masks for other occasions as well. From the 1650's onwards Lunda generals also moved northwest and founded chiefdoms among the Pende. This may have led to the adoption by the Pende of new types of constructed masks. Other Lunda *conquistadores*, bringing such constructed masks with them, appeared in the Kwango valley by 1700, and created a large Yaka kingdom during the 18th century. Their enemies the Suku did not accept constructed masks and retained only the older carved masks in their initiations (Bourgeois 1981: 197-198).

North of the Lower Zaire and in Mayombe, masking is linked to the history of the kingdom of Loango and to southern Gabon. Masks have their roots in associations with a sequence of several initiations, the first of which was the initiation of boys. Associations, which played a role in government at the village level and regulated relations between villages, are of such antiquity in Gabon and in Cameroun that one can only guess at their origins. By the beginning of our era there were already sizeable settlements in the vicinity of Loango and their inhabitants may already have known some form of association (Denbow 1990: 155). The kingdom of Loango itself arose perhaps around 1400 out of the merger of several principalities which themselves had existed at least since 1200. Their roots in turn reach back well into the first millenium when recognized arbiters between competing leaders of Houses arose as the first district chiefs. By 1500 Loango controlled most of the coasts of southern Gabon and the immediate hinterland. By 1575 its capital was becoming a major center in the Atlantic trade, exporting mostly ivory and textiles but also some slaves. Its inhabitants, the Vili, soon became the best organized and most famous long distance traders in western Central Africa. Their influence on southern Gabon was enormous, as the diffusion of many items from crops or emblems to performances of the title system in usage at court as far away as the Gabon estuary indicate. This may also have happened to a style of masks. Yombe-masks used in initiations share stylistic similarities with "white faced" masks throughout southern Gabon, yet Yombe masks are actually quite different both in form and in use. It looks as if the Yombe style inspired the Punu to their north, who probably created the "white faced" masks.[5]

The next major historical trend in western Central Africa is the expansion of the Atlantic slave trade. This commerce began around 1500 but increased manyfold after the mid seventeenth century when two major networks were set up: one based on the Loango coast where the trade was conducted by the French, Dutch and British, the other based on the coasts of Angola where trade was in the hands of Portuguese and Brazilians. The increase of the slave trade at the Loango coast so enriched a coterie of rich merchants there and in two smaller kingdoms to its south, that they wrested control of the government from the hands of the kings. But, being merchants, they were also fierce competitors among themselves. This explains the creation of an association using masks. Such *ndunga* masks were "judges", i.e. they came out to proclaim and enforce the collective will of the association, usually to prevent one of the leaders from becoming too strong at the

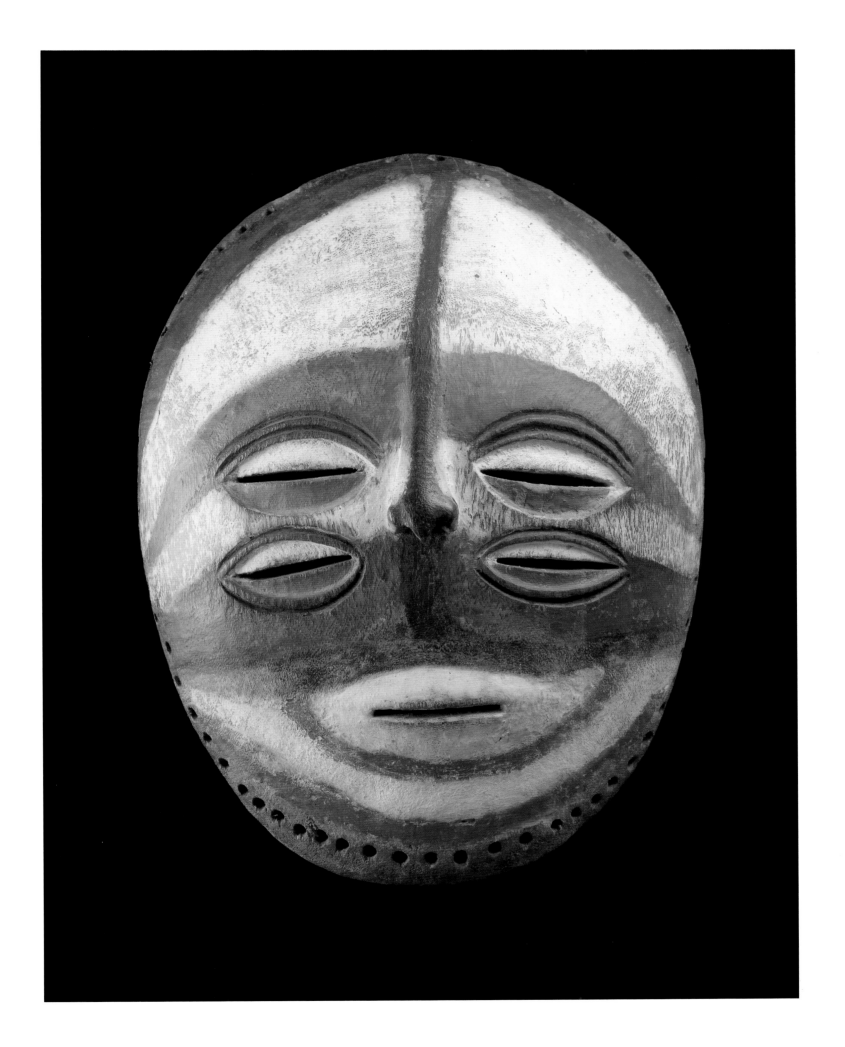

expense of the others. Once the colonial powers began to rule the coastal areas effectively, the association lost its *raison d'être* and the masks disappeared.

Before 1680 Angolan traders were already indirectly connected with the Ruund capital, and cultural influences were traveling along the road in both directions. During the eighteenth century the slave trade grew, and furthered the expansion of trading routes to more and more distant regions. By 1750's slave traders had reached the upper-middle Kasai and by 1800 they were on the Upper Zambezi. By then, however, trading routes from the east connected the Ruund capital indirectly with the Indian Ocean in Mozambique as well. This was the result of a further Lunda expansion eastwards which began around 1700 and led to the foundation of the kingdom of Kazembe on the Luapula in the 1740's. That brought the Lunda into the thriving commercial system of east Central Africa which has already been mentioned, and by 1790 Kazembe was trading directly with the Portuguese posts on the Lower Zambezi. Finally, one must also mention an expansion of the central Luba kingdom which began just before 1700 and affected most of northern and eastern Shaba by 1800. From about 1750, then, all of southern Zaire east of the Kwango was covered by a single network of interconnecting trading areas and Luba or Lunda influences were spreading far and wide.

Yet the impact of these routes on the diffusion and evolution of masking in the area remains unclear. The Ruund around the capital had neither age classes nor *mukanda* initiations themselves and they did not export them eastwards. Nor did the Luba. In fact the Luba world and the Ruund may not have used any masks at all at that time. In the western half of the region the impact of the slave trade on the spread of various types of masks remains unclear. We have seen that the diffusion of initiation rites and masks had occurred before the slave trade reached the area, but the use of specific masks and various elaborations of the rituals certainly diffused at this time. Detailed studies of these dynamics, however, still remain to be researched.

During the nineteenth century the slave trade continued unabated, but a trade in ivory and wax was added to it. This enriched one group in Angola, the Chokwe, in particular and allowed them to acquire many guns. From the later 1850s many Chokwe men left their homeland to trade and to wander far away in pursuit of elephants and bee hives. By 1860 the demand for rubber turned these wanderings into an emigration. Now whole families left Chokwe land and they left for good. By the last two decades of the century they were found in the Kwilu and Kwango areas, in central Kasai where they made contact with the Songye, and in western Shaba where they overran the Lunda heartland and came in contact with Luba in the Lubilash valley. Everywhere they went they influenced masking. They even had some influence on the Luba world. The generic term for "mask", *kifwebe*, used in all languages of the Luba group, is apparently of Chokwe origin (Van Avermaet & Mbuya 1954: 138). Yet the masks themselves and their uses owe little if anything to Chokwe influence. The introduction of the term probably occurred through central Kasai and from there to the Songye. Among the Songye a *kifwebe* "cult" using a special type of mask then arose alongside earlier cults. This type of mask diffused among the Luba further south and east. But it still remains unclear how *kifwebe*, a word designating one type of mask, became a generic term (Merriam 1978).

In northernmost Zaire neither masking nor sculpture have deep roots. Masks there show an unusual stylistic diversity, which is probably due to the fact that there exists no older sculptural tradition (Burssens 1960: 106). A few masks are known from northwest of Zaire where the

Ngbaka and their neighbors sometimes used them during the male initiation rituals instead of face paints. These masks share stylistic features with some of the masks of the Bekwil, Kota and other populations in the northern parts of both Gabon and Congo. Indeed, faint similarities between masks can be detected even as far away as the Yombe masks. But the initiation ceremonies among the Ngbaka are radically different from those of the Bekwil or the Kota. If any diffusion occurred it was limited to masks. The peoples of these areas must have been in contact with each other, even though one has no idea about either the nature or the timing of such contacts, because the distribution map for other items, such as a particular form of throwing knife and the crossbow, also includes the Ubangi bend and the neighboring lands of Congo, Gabon and Cameroun. Thus, the Ngbaka probably borrowed this style of mask from their Bantu speaking neighbors far to the southwest. Among the Ngbandi, further eastwards, masks were used by some healers during their curing dances and among the Boa they were clearly associated with divination and war. But the information known about their institutional setting is too deficient to provide any relevant historical background. Zande masks were used to enliven dances by members of the *mani* association, a closed association, that arose around 1900 in Lower Uele near Boa country in reaction to European rule. From there it spread over a large area (Evans-Pritchard 1937: 512-513; see also Schildkrout & Keim 1990: 240-241). The Zande and their neighbors probably borrowed masking along with the institution.

From this historical overview it appears that masking in Zaire is mainly an heirloom of the western Bantu tradition and was probably linked to the initiation of boys into adulthood. All other uses would be derivative from this first use. If so, however, then one must account for the absence of masking and the initiation in the whole of the central basin. Did these institutions exist and then die out? Yet even if one could show that indeed masking and initiations once existed even there, and that masking was an ancient western Bantu heirloom, there must be more to its history than that. The idea of masking occurs so often independently to express concepts or identities that one can hardly believe, first, that none of the autochtonous foraging and fishing groups did not know of masks, e.g. in connection with hunting. Nor can one believe that millenia passed by in such a vast area without the invention of completely novel uses of masks. Even though scholars may never unravel the complete history of masking and masks in Zaire, they can still discover much. Especially for the last half-millenium and in the south of the country, detailed histories of various aspects of masking are on the cards.

1. The essential bibliographic tools concerning the arts of Zaire are Biebuyck (1987) and the acquisition lists of the *Smithsonian Institution Libraries: National Museum of African Art*. For historical background see Birmingham & Martin (1983), Vansina (1990) and Vansina (1984b).

2. Luba rule included a major role for a political association (Reefe 1981: 267; "*Bambudye*"). Masks were not used in this association.

3. The Luba borrowed an association for master hunters, *buyanga*, from eastern Angola via the Lunda probably at this time. It is *just* possible that hunters used masks in this context.

4. The initiation was reported in 1649 by Buenaventura de Corella but he did not mention masks (see Jadin 1975: 1152). For the masks later linked to it among the Nkanu and Eastern Kongo, see Biebuyck 1985: 197-198.

5. After hesitating, Perrois (1977: 59) interpreted the stylistic sequence involved as showing a diffusion from the coast inland, but the data support the more precise hypothesis "from the Punu region, just north of the Mayombe" even better. That is more in line with the dynamics of other diffusions and better explains why they occurred. Perhaps Perrois also underestimates the age of the "white masks" (Perrois 1979: 266, ill. 5, n. 4).

CATALOGUE

Cat. 1, p. 25
WOYO or VILI, Angola, Cabinda & Zaire,
Lower Zaire
anthropomorphic face mask
H. 51 cm W. 33 cm D. 12 cm. Wood, pigment
Private collection
publ.: Lehuard 1993a: 744

Cat. 2, p. 27
YOMBE, Angola, Cabinda & Zaire, Lower Zaire
anthropomorphic face mask
H. 28 cm W. 22 cm D. 14.5 cm. Wood, pigment,
fiber, animal skin
Private collection
publ.: Lehuard 1993a: 785

Cat. 3, p. 29
YOMBE, Angola, Cabinda & Zaire, Lower Zaire
anthropomorphic face mask
H. 40 cm W. 22 cm. Wood, pigment
Formerly in the collection H. Pareyn, Antwerp
E.M., Antwerp (A.E. 3714)
publ.: Kunst van Afrika 1966: ill. 58; Herreman,
Holsbeke & Van Alphen 1991: 20
exhib.: Antwerp 1956; Antwerp 1960; Brussels 1966;
Antwerp 1972

Cat. 4, p. 31
VILI, Angola, Cabinda & Zaire, Lower Zaire
anthropomorphic face mask
H. 34 cm W. 18 cm D. 10.5 cm. Wood, pigment,
fiber
Private collection
publ.: Bastin 1984a: ill. 440; Lehuard 1993a: 837

Cat. 5, p. 33
ZOMBO, North Angola & Zaire, Bandundu
anthropomorphic helmet mask
H. 19 cm W. 20 cm. Wood, pigment, fiber, beads,
buttons
Private collection
publ.: Utotombo 1988: ill. XXIII; Lehuard 1993a: 813 and
ill. XXV
exhib.: Brussels 1988

Cat. 6, p. 38
SOSSO, North Angola
anthropomorphic helmet mask
H. 34 cm W. 36 cm. Wood, pigment, fiber
Collected prior to 1927 by J. Thienpont te Gingungi
Private collection

Cat. 7, p. 41
NKANU, Zaire, Lower Zaire and Bandundu
anthropomorphic helmet mask
H. 51 cm W. 51 cm D. 42 cm. Wood, pigment,
cotton
Private collection

Cat. 8, p. 43
HOLO, North Angola & Zaire, Bandundu
anthropomorphic helmet mask
H. 50 cm W. 25 cm D. 23 cm. Wood, pigment,
fiber
Private collection

Cat. 9, p. 45
SUKU, YAKA or HOLO, North Angola & Zaire,
Bandundu
zoomorphic bell mask
H. 58 cm W. 31 cm D. 20 cm. Wood, pigment,
fiber
Collected prior to 1940 in the Kwango
Private collection

Cat. 10, p. 48
SUKU, Zaire, Bandundu
anthropomorphic half-helmet mask
H. 82 cm. Wood, pigment, fiber, tortoiseshell
Collected in 1938 by A. Cauvin in the Kwango
Formerly in the collection A. Cauvin, Brussels
Private collection
publ.: Bourgeois 1984: ill. 137; Utotombo 1988: ill. 182
exhib.: Brussels 1958; Brussels 1988

Cat. 11, p. 51
YAKA or SUKU, Zaire, Bandundu
anthropo-zoomorphic bell mask
H. 165 cm. Wood, fiber, bamboo, pigment
Collected prior to 1932 by O. Butaye in Kimbau
M.R.A.C., Tervuren (R.G. 34147)
publ.: Bourgeois 1984: ill. 118; Bourgeois 1985: ill. 31;
Bourgeois 1991: ill. 6

Cat. 12, p. 53
YAKA, Zaire, Bandundu
anthropomorphic half-helmet mask
H. 65.5 cm. Wood, pigment, fiber, hair
Collected prior to 1924 by J. Van Wing in Popokabaka
M.R.A.C., Tervuren (R.G. 27628)
publ.: Art of the Congo 1967: ill. 4.4; Bourgeois 1982:
ill. 5; Bourgeois 1984: ill. 171
exhib.: Minneapolis 1967-69

Cat. 13, p. 55
YAKA, Zaire, Bandundu
anthropomorphic half-helmet mask
H. 31 cm W. 24 cm. Wood, pigment, fiber
M.R.A.C., Tervuren (R.G. 31424)
publ.: Bourgeois 1984: ill. 152

Cat. 14, p. 57
YAKA, Zaire, Bandundu
anthropomorphic half-helmet mask
H. 58 cm W. 23 cm. Wood, pigment, fiber
Collected prior to 1927 in the Kwango
Private collection

Cat. 15, p. 235
YAKA, Zaire, Bandundu
anthropomorphic helmet mask
H. 60.5 cm. Wood, pigment, fiber
Formerly in the collection H. Pareyn, Antwerp
E.M., Antwerp (A.E. 515)
exhib.: Antwerp 1956; Antwerp 1960

Cat. 16, p. 13
YAKA, Zaire, Bandundu
zoomorphic helmet mask
H. 46 cm D. 35 cm. Wood, pigment, fiber
Formerly in the collection P. Muller-Vanisterbeek, Sint-
Genesius-Rode
J.W.M., Brussels
publ.: Neyt 1981: ill. VI.5; Bourgeois 1984: 16 and
ill. 175a; Maurer 1991: ill. 28
exhib.: Kansas City & Minneapolis 1991-92

Cat. 17, p. 59
YAKA, Zaire, Bandundu
anthropomorphic helmet mask
H. 28 cm W. 20 cm D. 26 cm. Rattan, fiber,
pigment
Private collection

Cat. 18, p. 61
SUKU, Zaire, Bandundu
anthropomorphic bell mask
H. 38 cm. Wood, pigment, fiber, animal skin
Private collection
publ.: Herreman 1986: ill. 8
exhib.: Waasmunster 1986

Cat. 19, p. 15
MBALA, Zaire, Bandundu
anthropomorphic bell mask
H. 29 cm W. 24 cm D. 34 cm. Wood, pigment,
metal
Private collection
publ.: Kerchache 1988: ill. 1041

Cat. 20, p. 237
KWESE, Zaire, Bandundu
anthropomorphic face mask
H. 26.5 cm W. 25 cm D. 6.5 cm. Wood, pigment,
metal
J.W.M., Brussels
publ.: Het masker 1956: ill. 214; Lehuard 1972: 8; Neyt
1981: ill. 186; Utotombo 1988: ill. 186; Bassani 1989: 259,
ill. 102; Maurer 1991: ill. 89; Le grand héritage 1992:
ill. 205
exhib.: Antwerp 1956; Brussels 1988; Florence 1989;
Kansas City & Minneapolis 1991-92

Cat. 21, p. 62
PENDE, Zaire, Bandundu
anthropomorphic face mask
H. 45 cm. Wood, pigment, fiber, feathers
J.W.M., Brussels
publ.: de Sousberghe & Mestach 1981: 25; Neyt 1981:
ill. VII.11

Cat. 22, p. 65
PENDE, Zaire, Bandundu
anthropomorphic face mask
H. 25 cm. Wood, pigment, raffia, fiber
A. & J.-P. Jernander, Brussels
publ.: Oerkunsten 1977: ill. 94; Bastin 1984a: ill. 330
exhib.: Brussels 1977

Cat. 23, p. 67
PENDE, Zaire, Bandundu
anthropomorphic face mask
H. 25 cm W. 25 cm D. 38 cm. Wood, pigment,
fiber
Private collection
publ.: Bastin 1984a: ill. 331

Cat. 24, p. 69
PENDE, Zaire, Bandundu
anthropomorphic half-helmet mask
H. 51 cm W. 22 cm D. 24 cm. Wood, pigment,
fiber
Private collection
publ.: Sieber & Walker 1987: ill. 20
exhib.: Washington 1988

Cat. 25, p. 71
PENDE, Zaire, Bandundu
anthropomorphic face mask
H. 22 cm W. 15 cm D. 20 cm. Wood, pigment,
fiber, feathers
Private collection

Cat. 26, p. 21
PENDE, Zaire, Bandundu
anthropomorphic miniature mask
H. 6 cm W. 4 cm. Ivory
Formerly in the collection H. Pareyn, Antwerp
E.M., Antwerp (A.E. 832)
publ.: Herreman, Holsbeke & Van Alphen 1991: 25;
Petridis 1992a: ill. 3
exhib.: Antwerp 1956; Brussels 1958; Antwerp 1960;
Brussels 1966; Mannheim 1971; Antwerp 1972

Cat. 27, p. 21
PENDE, Zaire, Bandundu
anthropomorphic miniature mask
H. 7.5 cm W. 4 cm D. 3 cm. Ivory
C. Van Lierde, Brussels

Cat. 28, p. 21
PENDE, Zaire, Bandundu
anthropomorphic miniature mask
H. 6 cm W. 4.5 cm. Bone
Formerly in the collection H. Pareyn, Antwerp
E.M., Antwerp (A.E. 851)
publ.: Kunst van Afrika 1966: ill. 53; Kongo 1971: ill. 173;
Herreman, Holsbeke & Van Alphen 1991: 25; Petridis
1992a: ill. 5
exhib.: Amsterdam 1956; Antwerp 1956; Antwerp 1960;
Brussels 1966; Mannheim 1971; Antwerp 1972

Cat. 29, p. 21
PENDE, Zaire, Bandundu
anthropo-zoomorphic miniature mask in Janus-
form
H. 4.5 cm. Ivory
M. de Toledo, Antwerp

Cat. 30, p. 73
PENDE, Zaire, West Kasai
anthropomorphic bell mask
H. 36 cm W. 27 cm. Wood, pigment
Collected prior to 1946 by T. Fourche in Kasai
M.R.A.C., Tervuren (R.G. 43134)
publ.: Segy 1952: ill. 241; Arte del Congo 1959: ill. 21; Art
of the Congo 1967: ill. 9.13; Fagg 1967: ill. 14; Segy 1969:
ill. 360; Masques d'Afrique 1983: ill. 29; Biebuyck 1985:
ill. 86
exhib.: Oslo 1956; Rome 1959; Minneapolis 1967-69;
Binche 1983

Cat. 31, p. 75
PENDE, Zaire, West Kasai
anthropo-zoomorphic face mask
H. 19 cm W. 22.5 cm D. 15 cm. Wood, pigment
Private collection

Cat. 32, p. 77
PENDE, Zaire, West Kasai
anthropo-zoomorphic lintel mask?
H. 26 cm W. 43 cm. Wood, pigment
Formerly in the collection R. Budin, Geneva
Private collection
publ.: Arts africains 1973: ill. 57
exhib.: Geneva 1973

Cat. 33, p. 239
PENDE, Zaire, West Kasai
anthropomorphic face mask
H. 26 cm W. 15 cm D. 13 cm. Wood, pigment, fiber
Private collection

Cat. 34, p. 79
CHOKWE, East Angola & Zaire, Bandundu,
West Kasai and Shaba
anthropomorphic helmet mask
H. 69 cm W. 54 cm D. 79 cm. Bark, twigs, resin,
pigment
Private collection

Cat. 35, p. 80
CHOKWE, East Angola & Zaire, Bandundu,
West Kasai and Shaba
whistle
H. 9 cm W. 3 cm. Ivory
E.M., Antwerp (A.E. 60.46.4)
exhib.: Waasmunster 1983

Cat. 36, p. 81
CHOKWE, East Angola & Zaire, Bandundu,
West Kasai and Shaba
anthropomorphic face mask
H. 23.5 cm W. 16 cm D. 7.5 cm. Wood, pigment,
fiber, copper, brass
Private collection

Cat. 37, p. 80
CHOKWE, East Angola & Zaire, Bandundu,
West Kasai and Shaba
H. 12 cm W. 8 cm. Wood, pigment, copper
Formerly in the collection F.M. Olbrechts, Antwerp
E.M., Antwerp (A.E. 75.31.28)
exhib.: Antwerp 1976

Cat. 38, p. 83
CHOKWE, East Angola & Zaire, Bandundu,
West Kasai and Shaba
anthropomorphic face mask
H. 26 cm W. 22 cm D. 24 cm. Wood, pigment,
fiber, metal
Private collection

Cat. 39, p. 87
CHOKWE, East Angola & Zaire, Bandundu,
West Kasai and Shaba
zoomorphic face mask
H. 27 cm W. 12 cm D. 30.5 cm. Wood, pigment,
fiber
Private collection

Cat. 40, p. 89
LWENA, Angola, Zaire & Zambia
anthropomorphic face mask
H. 31 cm W. 22 cm D. 27 cm. Wood, pigment,
fiber, feathers, animal skin
Private collection

Cat. 41, p. 91
LWENA, Angola, Zaire & Zambia
anthropomorphic face mask
H. 18 cm W. 17 cm D. 11 cm. Wood, pigment, fiber,
beads
Private collection
publ.: Utotombo 1988: ill. 197; Bastin 1990: ill. 2
exhib.: Brussels 1988

Cat. 42, p. 93
NGANGELA, Angola
anthropomorphic face mask
H. 37 cm. Wood, pigment, fibers
Formerly in the collection J. Vanderstraete, Lasne
Private collection
publ.: Bastin 1969c: 17; Bastin 1971: ill. 14; Cornet 1972:
ill. 84; Utotombo 1988: ill. XXXIV; Bastin 1990: ill. 5
exhib.: Brussels 1988

Cat. 43, p. 96
KONGO-DINGA, Northeast Angola & Zaire,
West Kasai
anthropomorphic (face) mask
H. 29 cm W. 22 cm D. 21.5 cm. Copper
Private collection

Cat. 44, p. 101
LWALU, Zaire, West Kasai
anthropomorphic face mask
H. 32 cm W. 21 cm D. 16 cm. Wood, pigment
Formerly in the collection H. Kerels, Brussels
Private collection
publ.: Kerels 1937: 23; Olbrechts 1946: ill. 219; Van
Geluwe 1967: ill. 28; Cornet 1972: ill. 81
exhib.: Ixelles 1967

Cat. 45, p. 103
LWALU, Zaire, West Kasai
anthropomorphic face mask
H. 31 cm W. 21 cm D. 18 cm. Wood, pigment
Private collection

Cat. 46, p. 105
LWALU, Zaire, West Kasai
anthropomorphic face mask
H. 32 cm W. 23 cm D. 22 cm. Wood, metal
Private collection

Cat. 47, p. 107
BINDJI (MBAGANI), Zaire, West Kasai
anthropomorphic face mask
H. 32 cm W. 19 cm D 19.5 cm. Wood, pigment
Private collection

Cat. 48, p. 109
BINDJI (MBAGANI), Zaire, West Kasai
anthropomorphic face mask
H. 33 cm W. 22 cm D. 24 cm. Wood, pigment
Private collection

Cat. 49, p. 111
KETE, Zaire, West Kasai
anthropomorphic face mask
H. 46 cm W. 26 cm D. 16 cm. Wood, pigment
Carved in 1952 by A. Mapumbu or C. Mabila in Mzanz
Private collection
publ.: Ceyssens 1973: ill. 4B

Cat. 50, p. 114
SALAMPASU, Zaire, West Kasai
anthropomorphic face mask
H. 46 cm. Wood, metal, pigment, fiber, feathers
Private collection
publ.: Thompson & de Grunne 1987: ill. 147; Utotombo
1988: ill. 36
exhib.: Brussels 1988

Cat. 51, p. 117
SALAMPASU, Zaire, West Kasai
anthropomorphic face mask
H. 35 cm W. 19 cm D. 26 cm. Wood, pigment
Private collection
publ.: Kerchache 1988: ill. 753; Bassani 1989: 262, ill. 112;
Le grand héritage 1992: ill. 219
exhib.: Florence 1989; Paris 1992

Cat. 52, p. 119
SALAMPASU?, Zaire, West Kasai
anthropomorphic face mask
H. 31 cm W. 19 cm. Fiber, pigment
M.R.A.C., Tervuren (R.G. 55.117.4)
exhib.: Rennes 1980

Cat. 53, p. 121
LULUWA, Zaire, West Kasai
anthropomorphic face mask
H. 26 cm W. 14 cm. Wood, pigment, fibers, metal,
beads
Collected prior to 1919 by the Compagnie du Kasaï in
Tshitadi
M.R.A.C., Tervuren (R.G. 15401)

Cat. 54, p. 123
LULUWA?, Zaire, West Kasai
anthropomorphic face mask
H. 28.5 cm W. 17 cm D 13.5 cm. Wood, pigment,
teeth, seeds, metal
Private collection
publ.: Van Geluwe 1967: ill. 34; Cornet 1972: ill. 78;
Kerchache 1988: ill. 181
exhib.: Ixelles 1967

Cat. 55, p. 17
BAKWA MPUTU, Zaire, West Kasai
anthropomorphic face mask
H. 28 cm W. 24.5 cm D. 22 cm. Wood, pigment
Private collection

Cat. 56, p. 19
WONGO, Zaire, West Kasai
anthropomorphic face mask
H. 29.5 cm W. 17 cm D. 7 cm. Wood, pigment
Private collection

Cat. 57, p. 125
LELE, Zaire, West Kasai
anthropomorphic face mask
H. 28 cm W. 22 cm D. 6 cm. Wood, metal,
pigment, raffia, fiber, shells, beads
C. Van Lierde, Brussels

Cat. 58, p. 241
BIOMBO, Zaire, West Kasai
anthropomorphic bell mask
H. 45 cm. Wood, pigment, fiber
Formerly in the collection J. Vanderstraete, Lasne
Private collection
publ.: Cornet 1972: ill. 80

Cat. 59, p. 128
KUBA: BUSHOONG, Zaire, West Kasai
anthropomorphic bell mask (and costume)
H. 26 cm (mask). Wood, pigment, fiber, metal
M.R.A.C., Tervuren
exhib.: Tervuren 1989

Cat. 60, p. 131
KUBA: BUSHOONG?, Zaire, West Kasai
anthropomorphic bell mask
H. 31 cm W. 25.5 cm D. 32 cm. Wood, pigment
Private collection

Cat. 61, p. 133
KUBA: NGEENDE?, Zaire, West Kasai
anthropomorphic bell mask
H. 36 cm W. 30 cm D. 27 cm. Wood, pigment
Formerly in the collection P. Muller-Vanisterbeek, Sint-
Genesius-Rode
Private collection
publ.: Van Geluwe 1967: ill. 33; Cornet 1972: ill. 64
exhib.: Ixelles 1967

Cat. 62, p. 135
KUBA: BUSHOONG, Zaire, West Kasai
anthropomorphic face mask
H. 40 cm W. 17 cm. Wood, pigment, fiber, beads,
shells
Formerly in the collection H. Pareyn, Antwerp
E.M., Antwerp (A.E. 331)
publ.: Afrikaanse beeldhouwkunst 1983: ill. 10
exhib.: Amsterdam 1955; Antwerp 1960; Mannheim
1971; Waasmunster 1983

Cat. 63, p. 137
KUBA, Zaire, West Kasai
anthropomorphic bell mask
H. 48 cm W. 30 cm. Wood, fiber, cloth, beads,
shells, animal skin
M.R.A.C., Tervuren (R.G. 7089)
publ.: Maesen 1960: ill. 22
exhib.: Nice 1980

Cat. 64, p. 139
KUBA: BUSHOONG or NGEENDE, Zaire,
West Kasai
anthropomorphic face mask
H. 24 cm W. 18.5 cm. Wood, pigment, metal, fiber
Formerly in the collection H. Pareyn, Antwerp
E.M., Antwerp (A.E. 329)
exhib.: Antwerp 1956; Antwerp 1960; Mannheim 1971

Cat. 65, p. 243
KUBA: KETE, Zaire, West Kasai
anthropomorphic bell mask
H. 48 cm W. 25 cm. Wood, pigment, fiber, ivory
M.R.A.C., Tervuren (R.G. 45045)

Cat. 66, p. 141
KUBA: NGEENDE, Zaire, West Kasai
anthropomorphic face mask
H. 63 cm W. 26 cm D. 27 cm. Wood, pigment,
rattan
J.W.M., Brussels
publ.: Neyt 1981: ill. VIII.25; Rubin 1984(vol.2): 451;
Utotombo 1988: ill. 207; Bassani 1989: 261, ill. 110;
Kerchache 1988: back cover; Maurer 1991: ill. 85; Le
grand héritage 1992: 213
exhib.: New York 1984; Brussels 1988; Florence 1989;
Kansas City & Minneapolis 1991-92

Cat. 67, p. 143
KUBA: BUSHOONG or KETE, Zaire, West
Kasai
anthropomorphic bell mask
H. 42.5 cm W. 23.5 cm. Wood, pigment, hair
Collected prior to 1912 in Kasai
M.R.A.C., Tervuren (R.G. 3704)
exhib.: Paris & Dakar 1966

Cat. 68, p. 144
SONGYE, Zaire, Shaba
anthropomorphic face mask
H. 34 cm W. 16 cm D. 19 cm. Wood, pigment
Collected between 1885 and 1887 by Liévin Vandevelde
Formerly in the collection Stroobant-Vandevelde,
Brussels
Private collection
publ.: Cornet 1972: ill. 131; Kerchache 1988: ill. 205;
Meyer 1991: ill. 73

Cat. 69, p. 147
SONGYE, Zaire, Shaba
anthropomorphic face mask
H. 42 cm W. 26 cm D. 18 cm. Wood, pigment
Private collection

Cat. 70, p. 149
SONGYE, Zaire, Shaba
anthropomorphic face mask
H. 30.5 cm B. 19 cm. Wood, pigment
Formerly in the collection H. Pareyn, Antwerp
E.M., Antwerp (A.E. 335)
publ.: Kunst van Afrika 1966: ill. 43; Masques d'Afrique
1983: ill. 9
exhib.: Antwerp 1937; Antwerp 1956; Brussels 1958;
Antwerp 1960; Brussels 1966; Mannheim 1971; Antwerp
1972; Binche 1983

Cat. 71, p. 151
SONGYE, Zaire, Shaba
anthropomorphic face mask
H. 62 cm W. 26 cm D. 30 cm. Wood, pigment
J.W.M., Brussels
publ.: Lehuard 1972: 10; Utotombo 1988: ill. 212
exhib.: Brussels 1988

Cat. 72, p. 150
SONGYE or LUBA, Zaire, Shaba
anthropomorphic miniature mask
H. 9.5 cm W. 5 cm D. 4 cm. Wood, pigment
J.W.M., Brussels

Cat. 73, p. 153
SONGYE or LUBA, Zaire, Shaba
anthropomorphic face mask
H. 42 cm W. 26 cm. Wood, pigment
Formerly in the collection H. Pareyn, Antwerp
E.M. Antwerp (A.E. 334)
publ.: Afrikaanse kunst 1971: ill. 24; Herreman,
Holsbeke & Van Alphen 1991: 30
exhib.: Antwerp 1937; Amsterdam 1955; Brussels 1971

Cat. 74, p. 155
SONGYE, Zaire, Shaba
anthropomorphic face mask
H. 33 cm. Wood, pigment
Formerly in the collection J.W. Mestach, Brussels
Private collection

Cat. 75, p. 157
LUBA or SONGYE, Zaire, Shaba
anthropomorphic face mask
H. 28 cm W. 24 cm D. 24 cm. Wood, pigment
Formerly in the collections J. Walschot, Brussels; Baron
F. Lambert, Brussels
Private collection
publ.: Cornet 1972: ill. 136
exhib.: Brussels 1958

Cat. 76, p. 159
LUBA, Zaire, Shaba
anthropomorphic face mask
H. 41 cm W. 36 cm D. 21 cm. Wood, pigment, hair
Formerly in the collection A. Hilgers, Brussels
J.W.M., Brussels
publ.: Lehuard 1972: 7; Neyt 1981: ill. XII.16; Maurer
1991: ill. 29
exhib.: Kansas City & Minneapolis 1991-92

Cat. 77, p.161
LUBA, Zaire, Shaba
anthropomorphic face mask
H. 30.5 cm W. 16 cm D. 10 cm. Wood, pigment
Private collection

Cat. 78, p.162
LUBA, Zaire, Shaba
anthropomorphic half-helmet mask
H. 52 cm. Wood, pigment
Private collection
publ.: Utotombo 1988: ill. 215
exhib.: Brussels 1988

Cat. 79, p.165
LUBA?, Zaire, Shaba
anthropomorphic face mask
H. 40 cm. Wood, pigment, metal, animal skin and
hair
Collected in 1969 by P. Dartevelle in Kasongo
Private collection
publ.: Het masker 1974: ill. 80; Thompson & de
Grunne 1987: ill. 155
exhib.: Brussels 1974

Cat. 80, p.167
TABWA, Zaire, Shaba
anthropomorphic bell mask
H. 22 cm. Wood, pigment, shells, metal
Collected in 1976 by P. Dartevelle in Kilanga Zongwe
Private collection
publ.: Maurer & Roberts 1986a: ill. 50 en 212; Utotombo
1988: ill. 241; Roberts 1990a: ill. 3
exhib.: Washington, Ann Arbor & Tervuren 1986;
Brussels 1988

Cat. 81, p.169
TABWA, Zaire, Shaba
zoomorphic face mask
H. 25 cm W. 61 cm D. 24 cm. Wood, pigment,
shells
Formerly in the collection P. Dartevelle, Brussels
Private collection
publ.: Maurer & Roberts 1986: ill. 221; Utotombo 1988:
ill. 242
exhib.: Washington, Ann Arbor & Tervuren 1986;
Brussels 1988

Cat. 82, p.171
TABWA or BWILE, Zaire, Shaba
zoomorphic bell mask
H. 58 cm W. 35 cm D. 28 cm. Wood, pigment
Private collection

Cat. 83, p.23
TABWA?, Northeast Zambia & Zaire, Shaba
anthropomorphic face mask
H. 34 cm W. 16 cm. Animal skin, pigment, beads
Private collection

Cat. 84, p.173
HEMBA, Zaire, Shaba
anthropomorphic face mask
H. 34 cm W. 26.5 cm D. 12 cm. Wood, pigment
J.W.M., Brussels
publ.: Neyt 1981: ill. XIV.20; Maurer 1991: ill. 88
exhib.: Kansas City & Minneapolis 1991-92

Cat. 85, p.175
HEMBA, Zaire, Shaba
anthropo-zoomorphic face mask
H. 17.5 cm W. 11.5 cm. Wood, pigment, encrusted
patina
Private collection

Cat. 86, p.177
HEMBA, Zaire, Shaba
anthropo-zoomorphic face mask
H. 20 cm W. 14 cm D. 11 cm. Wood, pigment
Formerly in the collection J. Vanderstraete, Lasne
I. Landuyt, Heusden

Cat. 87, p.176
HEMBA, Zaire, Shaba
anthropo-zoomorphic miniature mask
H. 9.5 cm W. 4 cm D. 3.5 cm. Wood, pigment
J.W.M., Brussels

Cat. 88, p.179
BANGUBANGU?, Zaire, Kivu
anthropomorphic face mask
H. 34.5 cm W. 26 cm. Wood, pigment
Private collection

Cat. 89, p.182
BEMBE?, Zaire, Kivu
anthropomorphic face mask
H. 28 cm W. 20 cm D. 10 cm. Wood, pigment
Collected in 1988 by P. Loebart in Maniema
Formerly in the collection A. de Monbrison, Paris
L. Van de Velde, Schilde

Cat. 90, p.185
BEMBE, Zaire, Kivu
anthropo-zoomorphic (face) mask
H. 46 cm W. 18 cm D. 9.5 cm. Wood, pigment
Formerly in the collections J. Boussard, Paris; G.
Schindler, New York
L. Van de Velde, Schilde
publ.: Arts d'Afrique 1957: ill. 282; Arts primitifs 1967:
ill. 98; Leiris & Delange 1967: ill. 241; Wassing 1969:
ill. 41
exhib.: Cannes 1957; Paris 1967

Cat. 91, p.187
BEMBE, Zaire, Kivu
anthropo-zoomorphic bell mask
H. 43 cm W. 31 cm D. 29 cm. Wood, pigment
L. Van de Velde, Schilde

Cat. 92, p.245
BEMBE?, Zaire, Kivu
anthropomorphic face mask
H. 28 cm W. 22 cm D. 8 cm. Wood, pigment
Formerly in the collection M. Itzikowitz, Paris
J.W.M., Brussels
publ.: Neyt 1981: ill. XV.6; Maurer 1991: ill. 64
exhib.: Kansas City & Minneapolis 1991-92

Cat. 93, p.189
LEGA, Zaire, Kivu
anthropomorphic face mask
H. 29.5 cm W. 19.5 cm D. 6 cm. Wood, pigment,
fiber
Private collection

Cat. 94, p.191
LEGA, Zaire, Kivu
anthropomorphic face mask
H. 25 cm. Wood, pigment
Collected prior to 1960 by Corombokis in Kindu
Formerly in the collection J.W. Mestach, Brussels
Private collection
publ.: Biebuyck 1973a: ill. 39(*in situ*); Het masker 1974:
ill. 85; Utotombo 1988: ill. 243
exhib.: Brussels 1974; Brussels 1988

Cat. 95, p.193
LEGA, Zaire, Kivu
anthropomorphic face mask
H. 28.5 cm W. 18 cm. Wood, pigment, glass beads
Formerly in the collection J. Vanderstraete, Lasne
E.M., Antwerp (A.E. 55.4.4)
publ.: Kunst in Kongo 1958: ill. 16; Herreman 1988: 3
exhib.: Antwerp 1955; Antwerp 1956; Brussels 1958;
Antwerp 1960; Algers 1969

Cat. 96, p.195
LEGA, Zaire, Kivu
anthropomorphic miniature mask
H. 18 cm. Wood, pigment, fiber
Collected prior to 1960 by Corombokis in Kindu
Private collection

Cat. 97, p.195
LEGA, Zaire, Kivu
anthropomorphic miniature mask
H. 15.5 cm W. 8.5 cm. Wood, pigment, fiber
Private collection
publ.: Cornet 1972: ill. 156

Cat. 98, p.197
LEGA, Zaire, Kivu
anthropomorphic double-miniature mask
H. 18 cm. Wood, pigment
P. Sanders, Schiedam

Cat. 99, p.196
LEGA, Zaire, Kivu
anthropomorphic miniature mask
H. 10 cm W. 6 cm. Ivory, pigment
M.R.A.C., Tervuren (R.G. 38741)
exhib.: Rome 1959; Amsterdam 1967

Cat. 100, p.198
KOMO, Zaire, Upper Zaire
anthropomorphic face mask
H. 22.5 cm W. 16 cm D. 1.5 cm. Wood, pigment
Formerly in the collections J. Schwob, Brussels;
M.D. Simpson, New York
Private collection
publ.: Utotombo 1988: ill. 251; Leurquin 1988: ill. 3; Felix
1989: ill. 56
exhib.: Brussels 1988; Munich 1989

Cat. 101, p.201
MBOLE, Zaire, Upper Zaire
anthropomorphic plankboard mask
H. 49 cm W. 23 cm D. 4 cm. Wood, pigment
Formerly in the collection J.W. Mestach, Brussels
Private collection
publ.: Neyt 1981: ill. II.1

Cat. 102, p. 207
MBOLE or SONGOLA, Zaire, Upper Zaire
anthropomorphic plankboard mask
H. 75 cm. Wood, pigment
J. Blanckaert, Brussels
publ.: Oerkunsten 1977: ill. 76; Neyt 1981: ill. II.4
exhib.: Brussels 1977

Cat. 103, p. 209
MBOLE?, Zaire, Upper Zaire
anthropomorphic plankboard mask
H. 32.5 cm W. 16 cm. Wood, pigment
Formerly in the collection H. Pareyn, Antwerp
E.M., Antwerp (A.E. 3528)
publ.: Het masker 1956: ill. 215; Kunst van Afrika 1966:
ill. 36; Afrikaanse beeldhouwkunst 1983: ill. XIII
exhib.: Antwerp 1956; Antwerp 1960; Brussels 1966,
Brussels 1971; Antwerp 1972; Waasmunster 1983

Cat. 104, p. 211
LOMBI?, Zaire, Upper Zaire
anthropomorphic face mask
H. 34 cm W. 17 cm D. 10 cm. Wood, pigment
J.W.M., Brussels
publ.: Maurer 1991: ill. 66
exhib.: Kansas City & Minneapolis 1991-92

Cat. 105, p. 213
BALI, Zaire, Upper Zaire
anthropomorphic face mask
H. 38 cm W. 24.5 cm D. 7.5 cm. Wood, pigment
Formerly in the collection M.L. Felix, Brussels
J.W.M., Brussels
publ.: Maurer 1991: ill. 107
exhib.: Kansas City & Minneapolis 1991-92

Cat. 106, p. 215
NDAAKA, Zaire, Upper Zaire
anthropomorphic face mask
H. 26 cm. Wood, pigment, fiber
Private collection
publ.: Felix 1992b: ill. 1; Lehuard 1993b: 41
exhib.: Munich 1992

Cat. 107, p. 216
BOA, Zaire, Upper Zaire
anthropomorphic face mask
H. 32.5 cm W. 19 cm D. 11 cm. Wood, pigment
J.R. Van Overstraeten, Brussels

Cat. 108, p. 219
BOA, Zaire, Upper Zaire
anthropo-zoomorphic face mask
H. 29 cm W. 18 cm. Wood, pigment
Collected prior to 1951 by Blondiau in Northeast Zaire
M.R.A.C., Tervuren (R.G. 51.31.92)
exhib.: Paris & Dakar 1966

Cat. 109, p. 223
ZANDE, Zaire, Upper Zaire
anthropomorphic face mask
H. 25 cm W. 15.5 cm D. 5 cm. Wood, pigment,
animal hide and hair
Collected between 1952 and 1956 by J. De Loose in the
vicinity of the village of Bili (Biamange chiefdom,
Bondo region, Lower-Uele district)
Formerly in the collection A. Burssens, Mariakerke
Private collection
publ.: Burssens 1960: ill. 15 and ill. 19(*in situ*)
exhib.: Brussels 1958

Cat. 110, p. 225
NGBAKA? or MBANJA?, Zaire, Equatorial
Province
anthropomorphic face mask
H. 32 cm W. 21.5 cm D. 16.5 cm. Wood, pigment,
hair
Formerly in the collection P. Muller-Vanisterbeek, Sint-
Genesius-Rode
J.W.M., Brussels
exhib.: Antwerp 1956

Cat. 111, p. 227
NGBAKA? or MBANJA?, Zaire, Equatorial
Province
anthropomorphic face mask
H. 28 cm W. 22 cm D. 18 cm. Wood, pigment,
metal
J.W.M., Brussels

Cat. 112, p. 229
NGBAKA? or MBANJA?, Zaire, Equatorial
Province
anthropomorphic face mask
H. 27.5 cm W. 18 cm D. 7.5 cm. Wood, pigment
Private collection

Cat. 113, p. 231
NGBAKA? or MBANJA?, Zaire, Equatorial
Province
anthropomorphic face mask
H. 24 cm W. 18.5 cm D. 9.5 cm. Wood, pigment,
metal
Private collection

BIBLIOGRAPHY

Adelman, K. L. 1975. "The Art of the Yaka," *African Arts*, 9 (1): 40-43.

Afrikaanse beeldhouwkunst. 1983. *Afrikaanse beeldhouwkunst uit de landen ten zuiden van de Sahara.* Waasmunster.

Afrikaanse kunst. 1971. *Afrikaanse kunst - moderne kunst.* Brussel.

Anderson, R. L. 1979. *Art in Primitive Societies.* Englewood-Cliffs, New Jersey.

Arte del Congo. 1959. *Arte del Congo.* Roma.

Art et mythologie. 1988. *Art et mythologie. Figures tshokwe.* Paris.

L'art nègre. 1966. *L'art nègre. Sources, évolution, expansion.* Paris, Dakar.

Art of the Congo. 1967. *Art of the Congo.* Minneapolis.

Arts africains. 1973. *Arts africains dans les collections genèvoises.* Genève.

Arts d'Afrique. 1957. *Arts d'Afrique et d'Océanie.* Cannes.

Arts primitifs. 1967. *Arts primitifs dans les ateliers d'artistes.* Paris.

Atlas linguistique. 1984. *Atlas linguistique de l'Afrique Centrale. Inventaire préliminaire. La République Centrafricaine.* Paris.

Baeke, V. 1992. "Peintures corporelles en Afrique," in *Kaiapo. Amazonie. Plumes et peintures corporelles*, pp. 88-111. Tervuren.

Barreteau, D. & Y. Bastin (eds.). 1978. *Inventaire des études linguistiques sur les pays d'Afrique noire d'expression française et sur Madagascar.* Paris.

Bascom, W. 1967. *African Arts. An Exhibition at the H. Lowie Museum of Anthropology of the University of California, Berkeley.* Berkeley.

Bassani, E. 1977. *Scultura Africana nei musei Italiani.* Bologna.

Bassani, E. (ed.). 1989. *La grande scultura dell'Africa Nera.* Firenze.

Bastian, A. 1874-75. *Die Deutsche Expedition an der Loango-Kuste.* 2 vols. Iena.

Bastin, M.-L. 1961a. *Art décoratif tshokwe.* 2 vols. Lisboa.

Bastin, M.-L. 1961b. "Un masque en cuivre martelé des Kongo du nord-est de l'Angola," *Africa-Tervuren*, 7 (2): 29-40.

Bastin, M.-L. 1968. "L'art d'un peuple d'Angola. I: Chokwe," *African Arts*, 2 (1): 40-47, 63, 64.

Bastin, M.-L. 1969a. "L'art d'un peuple d'Angola. II: Lwena," *African Arts*, 2 (2): 46-53, 77-80.

Bastin, M.-L. 1969b. "L'art d'un peuple d'Angola. III: Songo," *African Arts*, 2 (3): 50-57, 77-81.

Bastin, M.-L. 1969c. "Masques et sculptures ngangela," *Baessler-Archiv*, 17 (1): 1-23.

Bastin, M.-L. 1971. "Y a-t-il des clés pour distinguer les styles tshokwe, lwena, songo, ovimbundu et ngangela," *Africa-Tervuren*, 17 (1): 5-18.

Bastin, M.-L. 1976. "Les styles de la sculpture tshokwe," *Arts d'Afrique Noire*, 19: 16-35.

Bastin, M.-L. 1981. "Quelques œuvres tshokwe: une perspective historique," *Antologia di Bella Arte*, 17/18: 83-104.

Bastin, M.-L. 1982. *La sculpture tshokwe.* Meudon.

Bastin, M.-L. 1984a. *Introduction aux arts d'Afrique noire.* Arnouville.

Bastin, M.-L. 1984b. "Ritual Masks of the Tshokwe," *African Arts*, 17 (4): 40-45, 92-93, 95-96.

Bastin, M.-L. 1984c. "Mungonge: initiation masculine des adultes chez les Tshokwe (Angola)," *Baessler-Archiv*, 23 (2): 361-403.

Bastin, M.-L. 1986. "Ukule. Initiation des adolescents chez les Tshokwe (Angola)," *Arts d'Afrique Noire*, 57: 15-30.

Bastin, M.-L. 1988. *Entités spirituelles des Tshokwe (Angola)*. Milano (*Quaderni Poro 5*).

Bastin, M.-L. 1990. "Arts majeurs de l'Angola," in *De l'art nègre à l'art africain*, pp. 32-40. Arnouville.

Baumann, H. 1935. *Lunda. Bei Bauern und Jägern in Inner-Angola*. Berlin.

Baumann, H. 1969. *Afrikanische Plastik und sakrales Königtum*. München.

Baumann, H. & D. Westermann. 1948. *Les peuples et les civilisations de l'Afrique. Les langues et l'éducation*. Paris.

Beumers, E. & H.-J. Koloss (eds.). 1992. *Kings of Africa. Art and Authority in Central Africa. Collection Museum für Völkerkunde Berlin*. Maastricht.

Biebuyck, D. P. 1954. "Function of a Lega mask," *International Archives of Ethnography*, 47 (1): 108-120.

Biebuyck, D. P. 1972. "Bembe Art," *African Arts*, 5 (3): 12-19, 75-84.

Biebuyck, D. P. 1973a. *Lega Culture. Art, Intitiation, and Moral Philosophy among a Central African People*. Berkeley.

Biebuyck, D. P. 1973b. "Nyanga Circumcision Masks and Costumes," *African Arts*, 6 (2): 20-25, 86-92.

Biebuyck, D. P. 1976a. "Sculpture from the Eastern Zaïre Forest Regions," *African Arts*, 9 (2): 8-15, 79-80.

Biebuyck, D. P. 1976b. "Sculpture from the Eastern Zaïre Forest Regions: Mbole, Yela, and Pere," *African Arts*, 10 (1): 54-61, 99-100.

Biebuyck, D. P. 1977. "Sculpture from the Eastern Zaïre Forest Regions: Metoko, Lengola, and Komo," *African Arts*, 10 (2): 52-58.

Biebuyck, D. P. 1978. *Hero and Chief. Epic Literature from the Banyanga (Zaire Republic)*. Berkeley.

Biebuyck, D. P. 1981. *Statuary from the Pre-Bembe Hunters*. Tervuren.

Biebuyck, D. P. 1985. *The Arts of Zaïre. Volume one. Southwestern Zaïre*. Berkeley.

Biebuyck, D. P. 1986. *The Arts of Zaïre. Volume two. Eastern Zaïre. The Ritual and Artistic Context of Voluntary Associations*. Berkeley.

Biebuyck, D. P. 1987. *The Arts of Central Africa. An Annotated Bibliography*. Boston.

Biebuyck, D. P. & Kahombo Mateene. 1969. *The Mwindo Epic from the Banyanga*. Berkeley.

Binkley, D. A. 1987. "Avatar of Power: Southern Kuba Masquerade Figures in a Funerary Context," *Africa*, 57 (1): 75-97.

Binkley, D. A. 1990. "Masks, Space and Gender in Southeastern Kuba Initiation Ritual," in *Iowa Studies in African Art. Vol. 3. Art and Initiation in Zaïre*, ed. C. D. Roy, pp. 157-178. Iowa City.

Binkley, D. A. 1992. *The Teeth of the "Nyim". The Elephant and Ivory in Kuba Art*. Los Angeles.

Birmingham, D. & P. Martin. 1983. *History of Central Africa*. London.

Bittremieux, L. 1936. *La société secrète des Bakhimba au Mayombe*. Bruxelles.

Bittremieux, L. 1937. *Symbolisme in de negerkunst*. Brussel.

Blakely, T. D. & P. R. Blakely. 1987. "So'o Masks and Hemba Funerary Festival," *African Arts*, 21 (1): 30-37, 84-86.

Blier, S. P. 1991. "Visage de fer: matière, masque et sens au Danhomé," *Art Tribal*, 1-2: 19-41.

Bogaerts, H. 1950. "Bij de Basala Mpasu, de koppensnellers van Kasaï," *Congo*, 4 (4): 379-419.

Boone, O. 1961. *Carte ethnique du Congo. Quart Sud-Est*. Tervuren.

Boone, O. 1973. *Carte ethnique de la République du Zaïre. Quart Sud-Ouest*. Tervuren.

Bourgeois, A. P. 1979. *Nkanda Related Sculpture of the Yaka and the Suku of Southwestern Zaïre*. Unpublished Ph. D. dissertation, Indiana University, Bloomington.

Bourgeois, A. P. 1980. "Kakungu Among the Yaka and the Suku," *African Arts*, 14 (1): 42-46, 88.

Bourgeois, A. P. 1981. "Masques suku," *Arts d'Afrique Noire*, 39: 26-41.

Bourgeois, A. P. 1982. "Yaka Masks and Sexual Imagery." *African Arts*, 15 (2): 47-50, 87.

Bourgeois, A. P. 1984. *Art of the Yaka and Suku*. Meudon.

Bourgeois, A. P. 1985. *The Yaka and the Suku*. Leiden (*Iconography of Religions 7,D.,1*).

Bourgeois, A. P. 1990. "Helmet-shaped Masks from the Kwango-Kwilu Region and Beyond," in *Iowa Studies in African Art. Vol. 3. Art and Initiation in Zaïre*, ed. C. D. Roy, pp. 121-136. Iowa City.

Bourgeois, A. P. 1991. "Mbawa-Pakasa: l'image du buffle chez les Yaka et leurs voisins," *Arts d'Afrique Noire*, 77: 19-32.

Bourgeois, A. P. 1992. "Figurative Pipes of the Kwango Region of Zaire," unpublished paper read at the *Ninth Triennial Symposium on African Art*, held at the University of Iowa, Iowa City, April 24.

Brincard, M.-T. (ed.). 1982. *The Art of Metal in Africa*. New-York.

Bruyninx, E. 1970. *De figuratieve ijzerplastiek in Negro-Afrika*. Unpublished M.A. dissertation, Universiteit Gent.

Bruyninx, E. 1986. *L'art du laiton chez les Dan et les Guéré-Wobé de la région du Haut-Cavally (Côte d'Ivoire-Libéria)*. Gent (*Africana Gandensia 2*).

Buchner, M. 1884. "Afrikanische Waldteufel," *Schorers Familien Blatt*, 5 (4): 168-169.

Burssens, H. 1958a. "Sculptuur in Ngbandi-stijl: een bijdrage tot de studie van de plastiek van Noord-Kongo," *Kongo-Overzee*, 24 (1-2): 1-52.

Burssens, H. 1958b. "La fonction de la sculpture traditionnelle chez les Ngbaka," *Brousse*, 11: 10-28.

Burssens, H. 1958c. *Les peuplades de l'entre Congo-Ubangui (Ngbandi, Ngbaka, Mbandja, Ngombe et Gens d'Eau)*. Tervuren.

Burssens, H. 1960. "Enkele Zande-maskers uit Uele," *Congo-Tervuren*, 6 (4): 101-108.

Burssens, H. 1962. *Yanda-beelden en Mani-sekte bij de Zande (Centraal-Afrika)*. 2 vols. Tervuren.

Burssens, H. 1963. "Sculptuur bij de Boa. Morfologie en culturele context," in *Handelingen van het 25ste Vlaamse Filologencongres*, pp. 223-225. Antwerpen.

Cameron, E. L. 1988. "Sala Mpasu Masks," *African Arts*, 22 (1): 34-43, 89.

Cameron, E. L. 1992. *Reclusive Rebels. An Approach to the Sala Mpasu and their Masks*. San Diego.

Cameron, V. L. 1885. *Across Africa*. London.

Capello, H. & Ivens, R. 1881. *De Benguella as terras de Jacca*. Lisboa.

Carvalho, H. Dias de. 1890. *Expedição portuguesa ão Muatiânvua (1884-1888)*. Ethnographia e historia tradicional dos povos da Lunda. Lisboa.

Celenko, T. 1983. *A Treasury of African Art from the Harrison Eiteljorg Collection*. Bloomington.

Ceyssens, J. H. C. 1984. *Pouvoir et parenté chez les Kongo-Dinga du Zaïre*. Nijmegen.

Ceyssens, R. 1973. "Les masques en bois des Kete du Sud (Région du Kasaï Occidental, République du Zaïre)," *Africa-Tervuren*, 19 (4): 85-96.

Ceyssens, R. 1974. "Les masques en bois des Kete du Sud (Région du Kasaï Occidental, République du Zaïre)," *Africa-Tervuren*, 20 (1): 3-12.

Ceyssens, R. 1990. "Les masques des Kete du sud-est," *Africa-Tervuren*, 32 (1-4): 10-23.

Ceyssens, R. *forthcoming*. "Sens du "Grand Masque" dans le Haut-Kasayi," *Baessler-Archiv*, submitted for publication in 1993.

Ceyssens, R. & W. W. Kankunku. 1982. "Kongoville 1981," *Cultures et développement*, 14 (1): 41-65.

Chaltin. 1885. "Le district de l'Aruwimi Uele," *Le Congo Illustré*, 4: 108-110, 122-123.

Claeys, F. 1931. "Gaza, de besnijdenis bij de Bwaka (Ubangi)," *Congo*, 2 (2): 223-241; 2 (3): 381-396; 2 (4): 506-533.

Coart, E. & A. de Hauleville. 1906. *Notes analytiques sur les collections ethnographiques du Musée du Congo. Tome 1. Fasc. 2 Les arts, la religion*. Bruxelles.

Cole, H. M. (ed.). 1985. "Introduction: the Mask, Masking, and Masquerade Arts in Africa," in *I Am Not Myself: The Art of African Masquerade*, ed. H. M. Cole, pp. 15-27. Los Angeles.

Colle, P. 1913. *Les Baluba*. 2 vols. Antwerpen.

Cornet, J. 1972. *Art de l'Afrique noire, au pays du fleuve Zaïre*. Bruxelles.

Cornet, J. 1973. *Trésors de l'art traditionnel*. Kinshasa.

Cornet, J. 1975. *Art from Zaïre. 100 Masterworks of the National Collection*. New York.

Cornet, J. 1978. *A Survey of Zairian Art. The Bronson Collection*. North Carolina, Raleigh.

Cornet, J. 1980. *Pictographies woyo*. Milano (*Quaderni Poro 2*).

Cornet, J. 1982. *Art royal kuba*. Milano.

Cornet, J. 1989. *Zaïre. Peuples. Art. Culture*. Antwerpen.

Darish, P. J. 1990. "Dressing for Success: Ritual Occasions and Ceremonial Raffia-Dress among the Kuba of Southeastern Zaïre," in *Iowa Studies in African Art. Vol. 3. Art and initiation in Zaïre*, ed. C. D. Roy, pp. 179-191. Iowa City.

de Calonne-Beaufaict, A. 1909. *Les Ababua*. Bruxelles.

Degrandpré, L. 1801. *Voyage à la côte occidentale d'Afrique, fait dans les années 1786 et 1787*. Paris.

de Heusch, L. 1972. *Le roi ivre ou l'origine de l'état*. Paris.

de Heusch, L. 1988. "La vipère et la cigogne," in *Art et mythologie. Figures tshokwe*, pp. 19-47. Paris.

de Heusch, L. 1989. "Art et mythologie en Afrique," in *Estudos em homenagem a Ernesto Veiga de Oliveira*, pp. 253-274. Lisboa.

de Kun, N. 1966. "L'art lega," *Africa-Tervuren*, 12 (3-4): 66-99.

de Kun, N. 1979. "L'art boyo," *Africa-Tervuren*, 25 (2): 29-44.

De Loose, J. 1963. "Nota's over de Mbanga-sekte bij de Azande-Bandia," in *Miscellanea Ethnographica*, pp. 171-191. Tervuren.

de Mahieu, W. 1973. "Het Komo-masker: oorsprong en functie." *Africa-Tervuren*, 19 (2): 29-32.

de Maret, P. 1985. *Fouilles archéologiques dans la vallée du Haut-Lualaba, Zaïre. II. Sanga et Katongo, 1974*. Tervuren.

de Maret, P. 1991. "L'archéologie du royaume luba," in *Aux origines de l'Afrique Centrale*, Lafranchi R. & Clist B. (eds.), pp. 235-241. Libreville.

Demoor-Van den Bossche, P. 1981. "Contouren van de Westelijke Kongo-sculptuur," in *Vioka Vana Lumoni Lu Nkisi. Kunst uit de verzamelingen van de K.U. Leuven*, pp. 41-55. Leuven.

Denbow, J. 1990. "Congo to Kalahari," *The African Archaeological Review*, 8: 139-175.

Dennett, R. E. 1887. *Seven Years among the Fjort*. London.

Dennett, R. E. 1906. *At the Back of the Black Man's Mind*. London.

Dereine, A. 1964. "Le soulèvement des Babua (1900-1901)," *Africa-Tervuren*, 10: 29-48.

de Saint-Moulin, L. 1976. *Atlas des collectivités du Zaïre*. Kinshasa.

Deschamps, R. 1978. "L'identification des bois utilisés pour des sculptures en Afrique. IX. La sculpture kongo du Zaïre et d'Angola," *Africa-Tervuren*, 24 (1): 23-27.

de Sousberghe, L. de. 1956. *Les danses rituelles mungonge et kela des ba-Pende*. Bruxelles.

de Sousberghe, L. 1959. *L'art pende*. Bruxelles.

de Sousberghe, L. 1960. "De la signification de quelques masques pende. Shave des Shona et mbuya des Pende," *Zaïre*, 14 (5-6): 505-531.

de Sousberghe, L. 1962. "Quelques pièces sculptées de la région de Kingandu (Kwenge)," *Africa-Tervuren*, 7 (1-2): 54-55.

de Sousberghe, L. 1975. "Mumbira et Limombo des Nyanga," *Africa-Tervuren*, 21 (1-2): 36-38.

de Sousberghe, L. & J. W. Mestach. 1981. "'Gitenga'. Un masque des Pende," *Arts d'Afrique Noire*, 37: 18-29.

Devisch, R. 1972. "Signification socio-culturelle des masques chez les Yaka," *Boletim da Instituto de Investigação Cientifica de Angola*, 9 (2): 151-176.

Devisch, R. 1985. "Approaches to Symbol and Symptom in Bodily Space-Time," *International Journal of Psychology*, 20 (4-5): 389-616.

Dorst, J. & P. Dandelot. 1978. *A Field Guide to the Larger Mammals of Africa*. London.

Doutreloux, A. 1959. "Fétiches d'investiture au Mayombe," *Folia Scientifica* 5 (4): 69-70.

Escultura Africana. 1968. *Escultura Africana no Museu de Etnologia do Ultramar*. Lisboa.

Escultura Africana. 1985. *Escultura Africana em Portugal*. Lisboa.

Evans-Pritchard, E. E. 1937. *Witchcraft, Oracles, and Magic among the Azande*. Oxford.

Fagg, W. 1966. *Sculptures africaines*. 2 vols. Paris.

Fagg, W. 1967. *L'art de l'Afrique centrale. Sculptures et masques tribaux*. Paris.

Fagg, W. 1968. *The Tribal Image*. London.

Fagg, W. 1970. *African Sculpture*. Washington.

Fagg, W. 1980. *Masques d'Afrique dans les collections du Musée Barbier-Mueller*. Paris.

Felix, M. L. 1987. *100 Peoples of Zaïre and their Sculpture. The Handbook*. Brussel.

Felix, M. L. 1989. *Maniema: an Essay on the Distribution of the Symbols and Myths as depicted on the Masks of Greater Maniema*. München.

Felix, M. L. 1992a. *Luba Zoo: Kifwebe and other Striped Masks*. Brussel.

Felix, M. L. 1992b. *Ituri*. München.

Fermino, A. J. 1970-71. *Monografia sobre o grupo Cacongo do Nordeste de Angola*. Lisboa.

Ferne Völker. 1982. *Ferne Völker-Frühe Zeiten. Kunstwerke aus dem Linden-Museum Stuttgart*. 2 vols. Recklinghausen.

Före Picasso. 1988. *Före Picasso. Afrikansk konst i svensk agö*. Stockholm.

Fourche, T. & H. Morlighem. 1973. *Une bible noire*. Bruxelles.

Fritze, G. A. 1928. "Draht als Negerschmuck," *Afrika Nachrichten (Leipzig)*, 9: 473-475.

Frobenius, L. 1898. *Die Masken und Geheimbunde Afrikas*. Leipzig.

Frobenius, L. 1907. *Im Schatten des Kongostaates*. Berlin.

Fry, J. 1978. *Vingt-cinq sculptures africaines/Twenty-five African Sculptures*. Ottawa.

Gardi, B. 1986. *Zaïre, Masken, Figuren*. Basel.

Glaze, A. J. 1986. "Dialectics of Gender in Senufo Masquerades," *African Arts*, 19 (3): 30-39, 82.

Greenberg, J. 1966. *The Languages of Africa*. Bloomington, Den Haag.

Guthrie, M. & A. N. Tucker. 1956. *Linguistic Survey of the Bantu Borderland*. London, New York, Toronto.

Hagenbucher-Sacripanti, F. 1973. *Les fondements spirituels du pouvoir au royaume de Loango*. Paris.

Halkin, J. 1910. *Les Ababua*. Bruxelles.

Hart, W. A. 1987. "Masks with Metal Strips from Sierra Leone," *African Arts*, 20 (3): 68-74, 90.

Hart, W. A. 1988. "Limba Funeral Masks," *African Arts*, 22 (1): 60-67, 99.

Hart, W. A. 1990. "Le masque d'une dynastie Temné," *Art Tribal*, 1: 3-15.

Herbert, E. W. 1984. *Red Gold of Africa. Copper in Precolonial History and Culture*. Madison.

Herreman, F. 1986. *De huid van het beeld. Scarificatie en lichaamsbeschildering op Centraal-Afrikaanse sculptuur*. Waasmunster.

Herreman, F. 1988. "Enkele kleinsculpturen van de Lega," *De Vrienden van het Etnografisch Museum Antwerpen*, 15 (2): 2-4.

Herreman, F., Holsbeke, M. & J. Van Alphen. 1991. *Het Etnografisch Museum Antwerpen*. Brussel (*Musea Nostra*).

Hersak, D. 1986. *Songye Masks and Figure Sculpture*. London.

Hersak, D. 1990. "Powers and Perceptions of the Bifwebe," in *Iowa Studies in African Art. Vol. 3. Art and Initiation in Zaïre*, ed. C. D. Roy, pp. 139-154. Iowa City.

Himmelheber, H. 1939. "Les masques bayaka et leurs sculpteurs," *Brousse*, 1: 19-39.

Himmelheber, H. 1960. *Negerkunst und Negerkünstler*. Braunschweig.

Holas, B. 1966. *Arts de la Côte d'Ivoire*. Paris.

Huber, H. 1956. "Magical Statuettes and their Accessories Among Eastern Bayaka and their Neighbours," *Anthropos*, 51 (1-2): 265-290.

Huet, M. 1978. *Danses d'Afrique*. Paris.

Hulstaert, G. 1948. *Carte linguistique du Congo Belge*. Bruxelles.

Hunn, J. 1985. "Lega," in *I Am Not Myself. The Art of African Masquerade*, ed. H. M. Cole, pp. 88-93. Los Angeles.

Jacobson-Widding, A. 1980. "The Red Corpse, or the Ambiguous Father," *Ethnos*, 45 (3-4): 202-210.

Jacques, V. & E. Storms. 1986. *Notes sur l'ethnographie de la partie orientale de l'Afrique Equatoriale*. Bruxelles.

Jadin, L. 1975. *L'ancien Congo et l'Angola, 1639-1655*. Bruxelles.

Janzen, J. M. & R. Kauenhoven-Janzen. 1975. "Pende Masks in Kauffman Museum," *African Arts*, 8 (4): 44-47.

Kandert, J. 1990. "Tradition of Metal-Casting in Eastern Nigeria and Western Cameroon between 1840 and 1940," *Annals of the Naprstek Museum Praha*, 17: 7-110.

Kerchache, J., et al. 1988. *L'art africain*. Paris.

Kerels, H. 1937. "Où en est l'art nègre," *Les Beaux-Arts*, 227: 20-23.

Kesckesi, M. 1982. *Kunst aus dem Alten Afrika*. Innsbruck.

Kesckesi, M. 1987. *African Masterpieces and Selected Works from Munich: the Staatliches Museum für Völkerkunde*. New York.

Klein, H. (ed.). 1985. *Leo Frobenius: Ethnographische Notizen aus den Jahren 1905 und 1906, I, Volker am Kwilu und Unteren Kasai*. Wiesbaden.

Klein, H. (ed.). 1990. *Leo Frobenius: Ethnographische Notizen aus den Jahren 1905 und 1906, IV, Kanyok, Luba, Songye, Tetela, Songo, Meno, Nkutu*. Stuttgart.

Koloss, H. J. 1990. *Arts of Central Africa. Masterpieces from the Berlin Museum für Völkerkunde*. New York.

Kongo. 1971. *Kongo. Gestalten und Zeiten*. Mannheim.

Kongokunst. 1956. *Kongokunst. Kunst og kunstindustri fra Belgisk Kongo*. Oslo.

Kunst fra Congo. 1960. *Kunst fra Congo. Udvalgt blandt samlingerne i Musée Royal du Congo Belge, Tervuren*. Lyngby.

Kunst in Kongo. 1958. *Kunst in Kongo. De bijdrage van Belgisch Kongo en Ruanda-Urundi tot het kunstpatrimonium der mensheid*. Brussel.

Kunst van Afrika. 1966. *Kunst van Afrika, Oceanië, Amerika. Keuze uit de verzamelingen van het Etnografisch Museum van de stad Antwerpen*. Brussel.

Lagae, C.-R. 1926. *Les Azande ou Niam-Niam*. Bruxelles.

Lagercrantz, S. 1989. "Wire-Drawing in Africa," *Jahrbuch des Museums für Völkerkunde zu Leipzig*, 37: 224-247.

Lavachery, H. 1954. *Statuaire de l'Afrique noire*. Bruxelles.

Le grand héritage. 1992. *Le grand héritage*. Paris.

Lehuard, R. 1972. "La collection Mestach," *Arts d'Afrique Noire*, 4: 4-11.

Lehuard, R. 1989. *Arts bakongo. Les centres de style*. 2 vols. Arnouville.

Lehuard, R. 1993a. *Art bakongo, les masques*. Arnouville.

Lehuard, R. 1993b. "Ituri," *Arts d'Afrique Noire*, 85: 39-41.

Leiris, M. & J. Delange. 1967. *Afrique noire. La création plastique*. Paris.

Lekens, B. 1955. *Ngbandi-idioticon. I. Nederlands-Frans en Ngbandi*. Tervuren.

Lema Gwete, A. 1980. *Kunst aus Zaire. Masken und Plastiken aus der Nationalsammlung*. Bremen.

Lema Gwete, A. 1986. *L'art et le pouvoir dans les sociétés traditionnelles*. Kinshasa.

Leurquin, A. 1988. "Utotombo. L'art d'Afrique noire dans les collections belges," *Arts d'Afrique Noire*, 66: 9-16.

Leuzinger, E. 1963. *Afrikanische Skulpturen*. Zürich.

Leyder, J. 1950. *Le graphisme et l'expression graphique au Congo Belge*. Bruxelles.

Lima, M. A. 1967. *Subsidios para a historia, arqueologia e etnografia dos povos da Lunda. Os akixi (mascarados) do Nordeste de Angola*. Lisboa.

Lux, A. E. 1880. *Von Loanda nach Kimbundu (1875-1876)*. Wien.

Mack, J. 1990. *Emil Torday and the Art of the Congo, 1900-1909*. London.

Maes, J. 1924. *Aniota-kifwebe. De maskers in Belgisch-Congo en het materiaal der besnijdenisritussen*. Antwerpen.

Maes, V. 1958. *Dictionnaire Ngbaka-Français-Néerlandais. Précédé d'un aperçu grammatical*. Tervuren.

Maes, V. 1984a. *Les peuples de l'Ubangi. Notes ethnographiques*. Limete.

Maes, V. 1984b. *Les Ngbaka*. 1. Histoire, coutumes, langues. 2. Composition ethnique. Limete.

Maesen, A. 1951. "L'acquisition de la semaine au Musée du Congo Belge (Masque Babwa)," *L'Eventail*, 65 (49): 4.

Maesen, A. 1955. Unpublished field notes, 36, Musée Royal de l'Afrique Centrale, Tervuren.

Maesen, A. 1960. *Umbangu. Art du Congo au Musée de Tervuren*. Bruxelles.

Maesen, A. 1975. "Un masque de type Gitenga des Pende Occidentaux du Zaïre," *Africa-Tervuren*, 21 (3/4): 115-116.

Maesen, A. 1982. "Statuaire et culte de fécondité chez les Luluwa du Kasaï," *Quaderni Poro*, 3: 49-58.

Martins, J. 1972. *Cabindas. Historia crenças e costumes*. Cabinda.

Het masker. 1956. *Het masker: alle volken - alle tijden*. Antwerpen.

Het masker. 1974. *Het masker in de wereld*. Brussel.

Masques d'Afrique. 1983. *Masques d'Afrique*. Binche.

Maurer, E. M. 1991. *The Intelligence of Forms. An Artist Collects African Art*. Minneapolis.

Maurer E. M. & A. F. Roberts (eds.). 1986. *Tabwa. The Rising of a New Moon: a Century of Tabwa Art*. Ann Arbor.

Mbiti, J. S. 1969. *African Religion and Philosophy*. New York.

McMasters, M. 1988. *Patterns of Interaction. A comparative Ethnolinguistic Perspective on the Uele Region of Zaire, ca. 300 B.C. to 1900 A.D.*. Unpublished Ph.D. dissertation, University of California, Los Angeles.

McMasters, M. 1990. "The Mask that Failed: the Colonial Impact on the Art of the Babua," unpublished paper read at a symposium held at the American Museum of Natural History, New York, October 12-13.

McNaughton, P. R. 1987. "African Borderland Sculpture," *African Arts*, 20 (4): 76-77, 91.

McNaughton, P. R. 1991. "Is there History in Horizontal Masks," *African Arts*, 22 (2): 40-53, 88-90.

Merriam, A. P. 1978a. "Kifwebe and other Masked and Unmasked Societies among the Basongye," *Africa-Tervuren*, 24 (3): 57-73.

Merriam, A. P. 1978b. "Kifwebe and other Masked and Unmasked Societies among the Basongye," *Africa-Tervuren* 24 (4): 89-101.

Mertens, J. 1942. *Les chefs couronnés chez les Ba-Kongo orientaux*. Bruxelles.

Mestach, J. W. 1985. *Etudes songye. Formes et symbolique. Essai d'analyse*. München.

Meyer, L. 1991. *Zwart Afrika. Maskers, beelden, sieraden*. Paris.

Moeller, A. 1937. "Danses," *Beaux-Arts*, 227: 18-19.

Mudiji-Malamba, G. 1989. *Le langage des masques africains. Etude des formes et fonctions symboliques des mbuya des Phende*. Kinshasa.

Mutimanwa Wenga-Mulayi. 1974. *Etude socio-morphologique des masques blancs luba ou "bifwebe"*. Unpublished M.A. dissertation, Université Nationale du Zaïre, Lubumbashi.

Muyaga Gangambi. 1974. *Les masques pende de Gatundo*. Bandundu.

Ndambi Munamuhega. 1976. *Les masques pende de Ngudi*. Bandundu.

Neyt, F. 1977. *La grande statuaire hemba du Zaïre*. Louvain-la-Neuve.

Neyt, F. 1981. *Arts traditionnels et histoire au Zaïre. Cultures forestières et royaumes de la savane*. Louvain-la-Neuve.

Neyt, F. 1986. "Tabwa Sculpture and the Great Traditions of East-central Africa," in *Tabwa. The Rising of a New Moon: a Century of Tabwa Art*, eds. E. M. Maurer & A. F. Roberts, pp. 65-89. Ann Arbor.

Neyt, F. (forthcoming). *Les arts luba*.

Neyt, F. & L. De Strycker. 1975. *Approche des arts hemba*. Arnouville.

Ngolo Kibango. 1976. *Minganji, danseurs de masques pende*. Bandundu.

Nooter, M. H. 1990. "Secret Signs in Luba Sculptural Narrative: A Discourse on Power," in *Iowa Studies in African Art. Vol. 3. Art and Initiation in Zaire*, ed. C. D. Roy, pp. 35-60. Iowa City.

Oerkunsten. 1977. *Oerkunsten van Zwart-Afrika*. Brussel.

Olbrechts, F. M. 1946. *Plastiek van Kongo*. Antwerpen.

Olbrechts, F. M. 1959. *Les arts plastiques du Congo belge*. Antwerpen.

Oliveira, J. O. de. 1954. *Uma acção cultural em Africa*. Lisboa.

Oliveira, J. O. de. 1958. *Flagrantes da vida na Lunda*. Lisboa.

Paulme, D. 1956. *Les sculptures de l'Afrique noire*. Paris.

Perrois, L. 1977. *Sculpture traditionnelle du Gabon*. Paris.

Perrois, L. 1979. *Arts du Gabon. Les arts plastiques du bassin de l'Ogoué*. Paris.

Petridis, C. 1992a. "Enkele ikoko-hangers in Katundu-stijl van de Pende (Zaïre)," *De Vrienden van het Etnografisch Museum Antwerpen*, 19 (3): 3-7.

Petridis, C. 1992b. *Wooden Masks of the Kasai Pende*. Gent (*Working Papers in Ethnic Art* 6).

Plancquaert, M. 1930. *Les sociétés secrètes chez les Bayaka*. Louvain.

Plasmans, K. 1955-74. Unpublished field notes, Belgium.

Pruitt, W. 1973. *An Independent People. A History of the Sala Mpasu of Zaire and their Neighbors*. Unpublished Ph.D. dissertation, Northwestern University, Evanston.

Radin, P. & J. Sweeney. 1952. *African Folktales and Sculpture*. New York.

Ravenhill, P. L. 1986. "A Central Ivory Coast Bronze Helmet Mask: the Historical Connectedness of Casting Traditions," in *Arte in Africa. Realtà e prospettive nello studio della storia delle arti africane*, ed. E. Bassani, pp. 64-66. Modena.

Redinha, J. 1956. *Subsidios para a historia, arqueologia e etnografia dos povos da Lunda. Mascaras de madeira da Lunda e Alto Zambezi*. Lisboa.

Redinha, J. 1964. "Cruzetas de cobre ou cruzetas-dinheiro (moeda nativa)," *Portugal em Africa*, (mai-août): 230-232.

Redinha, J. 1965. *Subsidios para a historia, arqueologia e etnografia dos povos da Lunda. Mascaras e mascarados angolanos (uso, formas e ritos)*. Lisboa.

Reefe, T. 1981. *The Rainbow and the Kings: a History of the Luba Empire to c. 1891*. Berkeley.

Robbins, W. M. & N. I. Nooter. 1989. *African Art in American Collections*. Washington.

Roberts, A. F. 1986a. "Social and Historical Context of Tabwa Art," in *Tabwa. The Rising of a New Moon: a Century of Tabwa Art*, eds. E. M. Maurer & A. F. Roberts, pp. 1-48. Ann Arbor.

Roberts, A. F. 1986b. "Les arts du corps chez les Tabwa," *Arts d'Afrique Noire*, 59: 1515-29.

Roberts, A. F. 1990a. "Tabwa Masks: an Old Trick of the Human Race," *African Arts*, 23 (2): 36-47, 101-103.

Roberts, A. F. 1990b. "Initiation, Art and Ideology in Southeastern Zaïre," in *Iowa Studies in African Art. Vol. 3. Art and Initiation in Zaïre*, ed. C. D. Roy, pp. 7-32. Iowa City.

Roy, C. D. 1985. *Art and Life in Africa. Selections from the Stanley Collection*. Iowa City.

Roy, C. D. 1992. *Art and Life in Africa. Selections from the Stanley Collection, Exhibitions of 1985 and 1992*. Iowa City.

Rubin, A. (ed.). 1988. *Marks of Civilization; Artistic Transformations of the Human Body*. Los Angeles.

Rubin, W. S. (ed.). 1984. *Primitivism in 20th Century Art. Affinities of the Tribal and the Modern*. 2 vols. New York.

Samain, A. 1923. *La langue kisonge*. Bruxelles.

Schildkrout, E. & C. Keim (eds.). 1990. *African Reflections. Art from Northeastern Zaïre*. New York.

Schmalenbach, W. (ed.). 1989. *Afrikanische Kunst aus der Sammlung Barbier-Mueller, Genf*. München.

Segy, L. 1952. *African Sculpture Speaks*. New York.

Segy, L. 1969. *African Sculpture Speaks*. (Fourth Edition Enlarged). New York.

Sieber, R. & R. A. Walker. 1987. *African Art in the Cycle of Life*. Washington.

Strother, Z. S. 1993. "Eastern Pende Constructions of Secrecy," in *Secrecy: African Art that Conceals and Reveals*, ed. M. H. Nooter, pp. 156-178. New York.

Struyf, Y. 1948. "Kahemba. Envahisseurs Badjok et conquérants Balunda," *Zaïre*, 2 (4): 351-390.

Sundström, L. 1965. *The Trade of Guinea*. Lund (*Studia Ethnographica Upsaliensia* 24).

Sura Dji. 1982. *Sura Dji. Visages et racines du Zaïre*. Paris.

Tanghe, B. 1929. *De Ngbandi naar het leven geschetst*. Brugge.

Theuws, T. J. A. 1968. "Le Styx ambigu," *Bulletin du Centre d'Etude des Problèmes Sociaux Indigènes*, 81: 5-33.

Theuws, T. J. A. 1978. "Sun and Symbols. A Luba Story," *Anthropos*, 73 (3-4): 561-583.

Thomas, J. M. C. 1963. *Les Ngbaka de la Lobave. Le dépeuplement rural chez une population forestière de la République Centrafricaine*. Paris, Den Haag.

Thompson, R. F. 1971. *Black Gods and Kings. Yoruba Art at UCLA*. Los Angeles.

Thompson, R. F. & J. Cornet. 1981. *The Four Moments of the Sun*. Washington.

Thompson, R. F. & B. de Grunne. 1987. *Chefs-d'œuvre inédits*. Paris.

Timmermans, P. 1966. "Essai de typologie de la sculpture des Bena Luluwa du Kasaï," *Africa-Tervuren*, 12 (1): 17-27.

Timmermans, P. 1967. "Les Lwalwa," *Africa-Tervuren*, 13 (3-4): 73-88.

Torday, E. 1925. *On the Trail of the Bushongo*. London.

Torday, E. & T. A. Joyce. 1911. *Notes ethnographiques sur les peuples communément appelés Bakuba, ainsi que sur les peuplades apparentées: les Bushongo*. Tervuren.

Torday, E. & T. A. Joyce. 1922. *Notes ethnographiques sur les peuplades habitant les bassins du Kasaï et du Kwango oriental*. Tervuren.

Turner, V. W. 1967. *The Forest of Symbols. Aspects of Ndembu Ritual*. Ithaca, London.

Tylecote, R. S. 1976. *A History of Metallurgy*. London.

Utotombo. 1988. *Utotombo. Kunst uit Zwart-Afrika in Belgische privé-verzamelingen*. Brussel.

Van Avermaet, E. & B. Mbuya. 1954. *Dictionnaire kiluba-français*. Tervuren.

Van Bulck, G. 1955. *Carte linguistique*. Bruxelles.

Van Geluwe, H. 1960. *Les Bali et les peuplades apparantées*. Tervuren.

Van Geluwe, H. 1967. *La collection J. Vanderstraete. Arts africains et océaniens*. Bruxelles.

Van Geluwe, H. 1989. *Maskers. Masques*. Tervuren.

Van Noten, F. 1972. "La plus ancienne sculpture sur bois de l'Afrique Centrale," *Africa-Tervuren*, 18 (34): 133-136.

Van Overbergh, C. 1908. *Les Basonge*. Bruxelles.

Vansina, J. 1954. *Les tribus Ba-Kuba et les peuplades apparentées*. Tervuren.

Vansina, J. 1962. "Long-Distance Trade-Routes in Central Africa," *Journal of African History*, 3 (3): 375-390.

Vansina, J. 1966. *Introduction à l'ethnographie du Congo*. Kinshasa, Kinsangani.

Vansina, J. 1984a. *Art History in Africa. An Introduction to Method*. London.

Vansina, J. 1984b. "Western Bantu Expansion," *Journal of African History*, 25 (2): 129-145.

Vansina, J. 1990. *Paths in the Rainforest*. Madison.

Van Wing, J. 1921. "Nzo Longo ou les rites de la puberté chez les Bakongo," *Congo*, 1: 48-59, 365-389.

Van Wing, J. 1938. *Etudes bakongo II. Religion et magie*. Bruxelles.

Vatter, E. 1926. *Religiöse Plastik der Natürvölker*. Frankfurt.

Vedy. 1904. "Les Ababua," *Bulletin de la Société Royale Belge de Géographie*, 23: 191-205, 265-294.

Vellut, J.-L. 1972. "Notes sur le Lunda et la frontière luso-africaine (1700-1900)," *Etudes d'Histoire Africaine*, 3: 61-166.

Verhulpen, E. 1936. *Baluba et Balubaisés du Katanga*. Antwerpen.

Vogel, S. M. (ed.). 1981. *For Spirits and Kings. African Art from the Paul and Ruth Tishman Collection*. New York.

Vogel, S. M. & F. N'Diaye. 1985. *African Masterpieces from the Musée de l'Homme*. New York.

Volavka, Z. 1976. "Le ndunga: un masque, une danse, une institution sociale au ngoyo," *Arts d'Afrique Noire*, 17: 28-43.

Von Sydow, E. 1954. *Afrikanische Plastik*. Berlin.

Von Wissmann, H. 1888. *Im Innern Afrika. Die Erforschung des Kasaï, 1883-1885*. Leipzig.

Von Wissmann, H. 1891. *My Second Journey through Equatorial Africa from the Congo to the Zambese, in the Years 1886 and 1887*. London.

Wardwell, A. 1986. *African Sculpture from the University Museum, University of Pennsylvania*. Philadelphia.

Wassing, R. S. 1969. *L'art de l'Afrique noire*. Paris.

Wauters, G. 1949. *L'ésotérie des noirs dévoilée*. Bruxelles.

Wolfe, A. 1955. "Art and the Supernatural in the Ubangi District," *Man*, 55 (76): 64-67.

Wolfe, A. 1961. *In the Ngombe Tradition. Continuity and Change in the Congo*. Evanston.

Zwernemann, J. & W. Lohse. 1985. *Aus Afrika. Ahnen-Geister-Götter*. Hamburg.

Algers. 1969. "Premier festival culturel pan-africain." Musée National des Beaux-Arts, Algers, July 21 - August 1, 1969.

Amsterdam. 1955. "De Congolees in Westerse en eigen kunst." Tropenmuseum, Amsterdam, 1955.

Amsterdam. 1967. "Van top tot teen." Koninklijk Instituut voor de Tropen, Amsterdam, 1967.

Antwerp. 1937. "Tentoonstelling van Kongo-kunst." Stadsfeestzaal, Antwerpen, December 24, 1937 - January 16, 1938.

Antwerp. 1955. "Rond fetisj, totem en taboe. Keuze-tentoonstelling uit 15 jaar aanwinsten van het Ethnografisch Museum." Museum Vleeshuis, Antwerpen, October 15, 1955 - January 15, 1956.

Antwerp. 1956. "Het masker. Alle volken - alle tijden." Koninklijk Museum voor Schone Kunsten, Antwerpen, September 16 - November 15, 1958.

Antwerp. 1960. "West - Zuid - Oost. Kunst buiten Europa. Uit de verzamelingen van het Etnografisch Museum." Stedelijke feestzaal, Antwerpen, July 23 - September 25, 1960.

Antwerp. 1972. "De wereld te gast. Keuzeverzameling Etnografisch Museum Antwerpen." Feestzaal Meir, Antwerpen, July 20 - September 24, 1972.

Antwerp. 1976. "Tentoonstelling aanwinsten. Antwerpen." Hessenhuis, Antwerpen, December 4, 1976 - February 20, 1977.

Antwerp. 1981 - 1982. "Kunst uit Zwart-Afrika." Mercator n.v., Algemene Verzekeringsmaatschappij, Antwerpen, December 11, 1981 - January 31, 1982.

Binche. 1983. "Masques d'Afrique." Musée International du Carnaval et du Masque de Binche, Binche, May 6 - September 30, 1983. (*bib.* Masques d'Afrique 1983)

Brussels. 1958. "Kunst in Kongo, de bijdrage van Belgisch Kongo en Ruanda-Urundi tot het kunstpatrimonium der mensheid," Algemene Wereldtentoonstelling, Sectie van Belgisch-Kongo en Ruanda-Urundi, Groep II-III: De kunst en haar uitdrukkingsmiddelen. Brussel, 1958. (*bib.* Kunst in Kongo 1958)

Brussels. 1966. "Kunst van Afrika, Oceanië, Amerika. Keuze uit de verzamelingen van het Etnografisch Museum van de Stad Antwerpen." Paleis voor Schone Kunsten, Brussel, 1966; Palais des Beaux-Arts, Charleroi, 1966; Cultureel Centrum "De Beyerd", Breda, 1966; Cultureel Centrum, Oostende, 1966. (*bib.* Kunst van Afrika 1966)

Brussels. 1971. "Afrikaanse kunst. Moderne kunst." Sobepa Public Relations, Brussel, 1971. (*bib.* Afrikaanse kunst 1971)

Brussels. 1974. "Het masker in de wereld." Generale Bankmaatschappij, Brussel, June 28 - July 31, 1974. (*bib.* Het masker 1974)

Brussels. 1977. "Oerkunsten van Zwart-Afrika." Gemeentekrediet, Brussel, March 5 - April 17, 1977. (*bib.* Oerkunsten 1977)

Brussels. 1988. "Utotombo. Kunst uit Zwart-Afrika in Belgisch privé-bezit." Paleis voor Schone Kunsten, Brussel, March 25 - June 5, 1988. (*bib.* Utotombo 1988)

Cannes. 1957. "Première exposition internationale rétrospective des arts d'Afrique et d'Océanie." Palais Miramar, Cannes, July 6 - September 29, 1957. (*bib.* Arts d'Afrique 1957)

Florence. 1989. "La grande scultura dell'Africa Nera." Forte di Belvedere, Firenze, July 15 - October 29, 1989. (*bib.* Bassani 1989)

Geneva. 1973. "Arts africains dans les collections genèvoises." Genève, 1973. (*bib.* Arts africains 1973)

Ixelles. 1967. "La collection J. Vanderstraete: arts africains et océaniens." Musée des Beaux-Arts d'Ixelles, Ixelles, May 18 - June 11, 1967. (*bib.* Van Geluwe 1967)

Kansas City & Minneapolis. 1991-92. "The intelligence of forms. An artist collects African art." The Nelson-Atkins Museum of Art, Kansas City, October 5 - November 34, 1991; The Minneapolis Institute of Arts, Minneapolis, December 21, 1991 - March 22, 1992. (*bib.* Maurer 1991)

Mannheim. 1971. "Kongo. Gestalten und Zeiten." Reissmuseum, Mannheim, March 27 - May 30, 1971. (*bib.* Kongo 1971)

Minneapolis. 1967-69. "Art of the Congo." Walker Art Center, Minneapolis, November 4 - December 31, 1967; The Baltimore Museum of Art, Baltimore, February 3 - March 31, 1968; Museum of Primitive Art, New York, May 4 - June 30, 1968; Dallas Museum of Fine Arts, Dallas, September 7 - November 3, 1968; Milwaukee Art Center, Milwaukee, December 7 - February 2, 1969; Montreal Museum of Fine Arts, Montreal, March 8 - May 4, 1969. (*bib.* Art of the Congo 1967)

Munich. 1989. "Maniema." Galerie Fred Jahn, München, January 16, 1988 - February 25, 1989. (*bib.* Felix 1989)

Munich. 1992. "Ituri: Masken aus Nordost-Zaïre." Galerie Fred Jahn, München, July 17, - September 26, 1992. (*bib.* Felix 1992b)

New York. 1984. "Primitivism in 20th Century art. Affinity of the tribal and the modern." The Museum of Modern Art, New York, 1984. (*bib.* Rubin 1984)

Nice. 1980. "Esprits et dieux d'Afrique." Musée National Message Biblique Marc Chagall, Nice, June 5 - November 3, 1980.

Oslo. 1956. "Kongokunst. Kunst og kunstindustri fra Belgisk Kongo." Kunstindustrimuseet, Oslo, 1956. (*bib.* Kongokunst 1956)

Paris. 1967. "Arts primitifs dans les ateliers d'artistes." Musée de l'Homme, Paris, 1967. (*bib.* Arts primitifs 1967)

Paris. 1992. "Le grand héritage." Musée Dapper, Paris, May 21 - September 15, 1992. (*bib.* Le grand héritage 1992)

Paris & Dakar. 1966. "L'art nègre. Sources. Evolution. Expansion." Musée Dynamique, Dakar, 1966; Grand Palais, Paris, 1966. (*bib.* L'art nègre 1966)

Rennes. 1980. "Festival des masques." Maison de la Culture, Nice, May 28 - June 5, 1980.

Rome. 1959. "Arte del Congo." Palazzo Venezia, Roma, November 1959. (*bib.* Arte del Congo 1959)

Tervuren. 1989. "Maskers. Masques." Koninklijk Museum voor Midden-Afrika, Tervuren, 1989. (*bib.* Van Geluwe 1989)

Waasmunster. 1983. "Afrikaanse beeldhouwkunst uit de landen ten zuiden van de Sahara." Galerij van de Akademie, Waasmunster, January 15-16 and 22-23, 1983. (*bib.* Afrikaanse beeldhouwkunst 1983)

Waasmunster. 1986. "De huid van het beeld." Galerij van de Akademie, Waasmunster, 1986. (*bib.* Herreman 1986)

Washington. 1988. "African art in the cycle of life." National Museum of African Art, Washington, D.C., September 28, 1987 - March 20, 1988. (*bib.* Sieber & Walker 1987)

Washington, Ann Arbor & Tervuren. 1986. "Tabwa. The rising of a new moon. A century of Tabwa art." National Museum of African Art, Washington, D.C., January - March 1986; University of Michigan Museum of Art, Ann Arbor, April - August 1986; Musée Royal de l'Afrique Centrale, Tervuren, September - October 1986. (*bib.* Maurer & Roberts 1986)

At the suggestion of Burgomaster Cools, the European Council of Ministers of Culture nominated the City of Antwerp Cultural Capital of Europe 1993.

ANTWERP 93 has the support of the City of Antwerp, the Province of Antwerp, the Flemish Community, the Belgian Government and the European Community. The Government of Flanders conferred the title of Cultural Ambassador of Flanders on ANTWERP 93.

Many foreign governments and cultural institutions are also lending their support, including the Goethe Institut, the Association Française d'Action Artistique, the Service Culturel de l'Ambassade de France, the British Council, the European Cultural Foundation, the Ministerie van Welzijn, Volksgezondheid en Cultuur van Nederland, and the Theatre Institute of the Netherlands, the Ministerio de Cultura from Spain and Italian Trade Commission.

As major institutional partners, we would like to mention the Flemish Tourist Office (the VCGT) and the National Lottery.

ANTWERP 93 also receives substantial support from its sponsors/partners. Its prime sponsors are: ASLK - CGER, BELGACOM, Belgian Railways, De Lijn, Electrabel, General Motors Continental, IBM, Interbuild, noord natie, Petrofina SA, Gazet van Antwerpen, Radio 1 and TVTWEE.

The ANTWERP 93 project is carried out under the Gracious patronage of Their Royal Highnesses King Boudewijn and Queen Fabiola.

Cultural capital of Europe